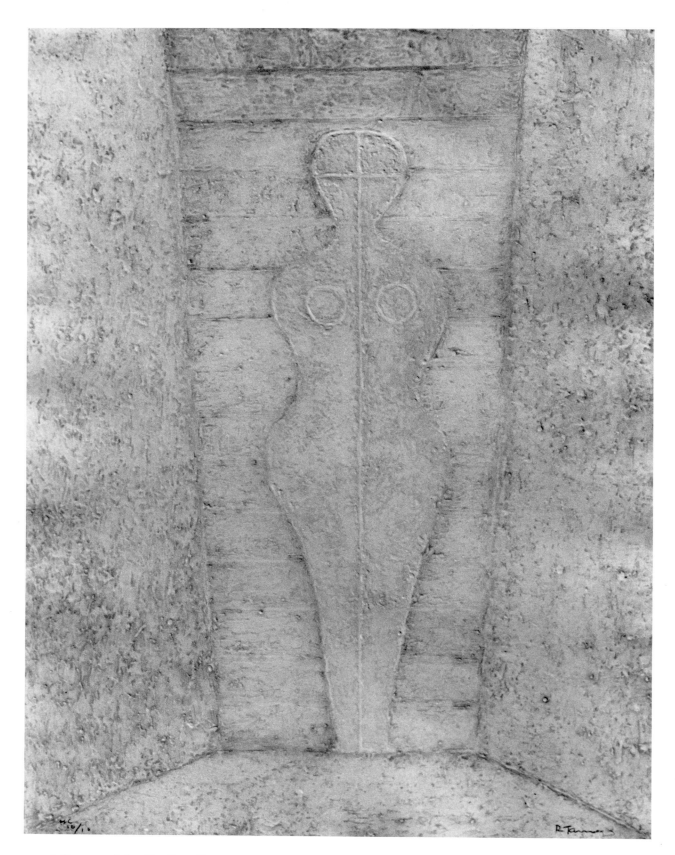

Mixograph by Rufino Tamayo, *Mujer en Blanco* (Woman in White), 1976, 30"x22".
Collection of A. and A. J. Casciero.

Exhibitions at the
Organization of American States
1941-1964

Edited by

Annick Sanjurjo

The Scarecrow Press, Inc.
Lanham, Md., and London
1997

SCARECROW PRESS, INC.

Scarecrow Press, Inc.
4720 Boston Way
Lanham, Maryland 20706

4 Pleydell Gardens, Folkestone
Kent CT20 2DN, England

British Library Cataloguing in Publication Information Available

Library of Congress Cataloging-in-Publication Data

Contemporary Latin American artists : exhibitions at the Organization of
 American States 1941–1964 / edited by Annick Sanjurjo.
 p. cm.
 Includes bibliographical references and indexes.
 ISBN 0-8108-3281-X (cloth : alk. paper)
 1. Art, Latin American —Exhibitions. 2. Art, Modern—20th century
 —Latin America—Exhibitions. 3. Organization of American States—
 Exhibitions—History—Chronology. 4. Artists—Latin America—
 Biography. I. Sanjurjo, Annick. II. Organization of American States.
 N6502.5.C659 1997
 709'.8.074753—dc21 96-51854

ISBN 0–8108–3281–X (cloth : alk. paper)

CONTENTS

FOREWORD

When I assumed the functions of Specialist in Art of the Division of Intellectual Cooperation of the Organization of American States in 1945, then the Pan American Union, there were activities promoting the Latin American culture and the doors of the institution were open to artists who wanted to exhibit their works there. Based on this premise, I decided to establish the program of temporary exhibitions of art. That program consisted of monthly exhibits by yet unknown but meritorious artists. One of the first to exhibit under this program was the then young Venezuelan painter Héctor Poleo, today considered a master. Poleo humorously recalls that he had to bring his own hammer and nails to hang his paintings!

This incident is but one example that there was never sufficient funding for the required task and neither was there unanimous support from the delegates of the member countries. My objective to promote the art of Latin America and the Caribbean outside of its parochial sphere was nevertheless clear and strong. I was committed to gaining respect for our art. The only self-imposed prerequisite guiding my selections for exhibitions was the quality with which each artist was able to translate an aesthetic message as a member of the Latin American culture.

Too frequently I was asked where could I possibly find enough artists to keep this program going on. Undoubtedly, this question reflects a reality: Latin American art was, and to a certain degree still is, a forgotten art. With my unwavering faith in art, I repeatedly answered that there are, and always will be, artists who in one way or another will communicate through a chosen medium their feelings and the feelings of their communities in spite of economic problems and the indifference of local institutions. In Latin America, as in any other place, there are very many talented people. It would be impossible to enumerate them all. By now, many of these individuals have achieved, and many more will continue to achieve, recognition, but they do it through their own effort, without hope or support as if doomed to accept an inexorable destiny.

In retrospect, as I reflect on my own contribution, I realize that more could have been done. It is like wanting to develop an airplane factory and ending up with a bicycle shop. One always wants to have what one loves the most to be appreciated and unconditionally supported by everyone, in this particular case, especially by the political institutions that purport to serve that cause. Reality is at times disheartening.

However, as regards the art from our hemisphere, I am thoroughly optimistic. There are those who do not yet acknowledge the existence of a clearly identifiable Latin American form of expression. This point, however, is open to debate. It is true that Latin American art appeared on the international scene rather late. Nevertheless, since the beginning of this century, it has advanced with gigantic strides. There are already many internationally recognized maestros. They are the ones who have created, almost in a vacuum, a history of the art of Latin America. They combined universal aesthetics with transformed elements of a surviving heritage, long forgotten or neglected by most. They shaped new cultural prototypes by reinterpreting the traditions of other ethnic groups who settled in the new lands. By drawing on diverse and at times even antagonistic physical and spiritual geographies, our artists have set milestones and have defined our art. They have done it by using a diversity of expressions as a testimony of an honest and difficult search within the varied cultural spectrum of our hemisphere.

To promote this art still in its developing stages, first it was necessary "to discover" what each country had to offer. There was a need to set marks and develop criteria. That was a very rewarding task for me. It is just as gratifying for me to see the unflagging search of our artists to be the *raison d'être* of this publication. This publication documents the history of the birth of Latin American modern art, and gives evidence of its worth and strength.

This publication is also positive proof for the skeptics that the then incipient program of monthly exhibitions was well worth it. Although not everyone who exhibited in the monthly temporary program is now a well-

established artist, there are many who have acquired international recognition. I believe that for many artists, to be selected for the monthly exhibition program was to climb to the first rung in the success ladder. Many among them sacrificed their international renown by remaining in their own countries to foster the development of a new local art. Many others moved on looking for new horizons and triumphed in the international arena.

This publication should also be a source of pride for the Organization of American States, and stimulate the Organization to be the beacon by which our cultural achievements are illuminated.

Many years of dedicated and difficult labor have elapsed since 1945. They were years filled with many other related activities: conferences, lectures, traveling exhibitions within the United States and throughout the world, production of films and media materials, establishment of an archive of artists for more in-depth information about our art, attempts to create museums in many of our communities. They were years filled with both frustration and satisfaction, but above all, with an intense and honest search for quality art conveying the essence of the Latin American and Caribbean community.

Many years also elapsed before the Council of the Organization of American States assigned me to select and acquire art works to develop a collection that eventually was to become the permanent collection of the Museum of Modern Art of Latin America inaugurated in 1976 under my direction.

I am personally content with the achievements to date, but much remains to be done. My hope is that this important publication may awaken the enthusiasm in those who are in the position to support and foster cultural and artistic endeavors and that it fortifies their commitment. Our artists deserve it. They forge and shape our culture. They carry the torch outside of our regional boundaries and keep alive the flame of our Latin American essence. This compilation of catalogues is a tribute to them because they are the real authors.

José Gómez-Sicre

PREFACE

This volume is a companion book to *Contemporary Latin American Artists: Exhibitions at the Organization of American States 1965-1985*. Due to the size of the work, a record of approximately 750 exhibitions including more than 2,000 artists spanning almost half a century, it was necessary to divide the publication into two volumes. The present volume includes over 320 exhibitions of more than 950 artists.

Since the beginning of my tenure as the archivist for the Museum of Modern Art of Latin America of the Organization of American States (1978-1989), small folded pages came across my desk sporadically. They noted an exhibition of a Latin American or a Caribbean artist in some room of the OAS, and I filed them without much notice.

Over time, however, I realized that I spent many hours searching for answers, sometimes unsuccessfully, in these unpretentious, colorless pages in order to respond to hundreds of calls and letters of inquiry from students, researchers, collectors, museums, art galleries, or simply, lovers of Latin American art.

It was around 1984 when, within the limits of my possibilities, I began to develop an index of those artists who had exhibited at the OAS. The results, then still unfinished, were astonishing. There was the history of the artistic happenings of an entire continent since the turn of the century! Immediately, I decided that it was well worthwhile to compile the catalogues of the exhibitions, even though I had to do it on my own time.

These exhibits were important not only because they included most of the artists that today are regarded as the masters or precursors of modern Latin American or Caribbean art (sometimes even before they were recognized in their own countries), but, moreover, because they documented the history of a crucial moment in the evolution of an original art within the international art context: the birth of modern Latin American art.

This printed record of the uninterrupted work of the OAS in promoting the plastic arts of Latin America has several purposes. It is a sort of encyclopedia of Latin American and Caribbean artists who, observing their own still unknown and at times even rejected local cultures, have been able to reinterpret them in works of extraordinary quality. It is one of the few records in the English language providing information about Latin American artists who have exhibited in the United States, and it is, therefore, a rich and unique reference source.

This publication is also a recognition of the work of the late, well-known critic and Latin American art expert, José Gómez-Sicre, who from the 1940s until 1983, as Director of the Audiovisual Unit first, and the Museum of Modern Art of Latin America later, provided continuity in the temporary exhibitions program with a fervent and unmitigated faith in the art of his continent. He is the real author of these pages, since he was responsible for selecting the majority of these exhibitions and of writing most of the catalogues' notes. To him goes my appreciation for the clarifications he provided me when I needed them.

EDITORIAL METHOD

All the catalogues have been faithfully compiled and arranged in chronological order, which is the reason for having some American, Canadian, and European artists included in this publication.

The changes introduced were dictated by the need to add clarity to the texts and to correct all data. Although the majority of the comments were conceived by Mr. José Gómez-Sicre (signed *J.G-S.* in the catalogues), some were written by other persons, most of them in Spanish, and translated by different translators. This accounts for the diversity of styles.

Many artists' *curricula vitae* were missing, particularly in group exhibitions. Whenever that was the case, they have been added following the list of works exhibited, under **Biographical Notes**, whereas the original catalogues used **About the Artist**, or some other heading for this section. To keep the unity of the work, the *vitae* added were

completed up to the date of that particular exhibition. No additional information was added for artists not from Latin America or the Caribbean.

Dates of birth have been carefully checked and corrected, when necessary, in accordance with forms signed by the artists. In some other cases the information was taken from other catalogues or publications, including newspaper clippings.

Whenever a catalogue was missing, the Press Release for that particular exhibition was used. Two catalogues of exhibitions that have not been held were included, as they were part of a planned schedule.

A list of the works exhibited has been added when it was missing from the original catalogue, and some others have been corrected in accordance with the list used during the exhibition. Titles of the works were kept in the language in which the artists originally named them. The English translation appears in italics in parentheses when it was given in the original catalogue, or in regular typeface when it was done by me.

To facilitate the use of this volume, two indexes were added: an Index of Artists and an Index of Exhibitions by Country. The first records the name of all the exhibitors in alphabetical order, followed by date of birth and death, and media. As all these shows are listed in the book in chronological order, instead of page numbers, it has been considered more useful to indicate the dates of the exhibitions. A date in italics means that it is an individual exhibition or that information on the artist can be found there. Due to the fact that this is the second volume released, yet it is chronologically the first, artists that appeared in the previous volume may appear in this book as well.

The Index by Country lists the exhibitions held by artists of that particular country or in which they have participated; therefore, one group exhibition may appear under several countries.

To avoid confusion, last names such as Di Cavalcanti, de Szyszlo, de la Rosa, and other similar ones, appear under Cavalcanti, Szyszlo, or Rosa. It is also appropriate to keep in mind that it is customary in Latin America to use the father's last name followed by the mother's last name, i.e., Ramírez Villamizar or Roca Rey. In the Index, they are listed under Ramírez or Roca.

ACKNOWLEDGMENTS

My sincere appreciation to all the persons who have graciously given their time and knowledge to make this publication possible:

The Friends of the Art Museum of the Americas, whose contribution made it possible to start this project;

Ms. Leslie Judd Ahlander, art critic, and one of the first to show Latin American artists at the OAS, who shared some of the missing catalogues;

Ms. Adelfa Fernández, OAS editor, who helped with language problems and editing on her own time;

Mr. Juan Carlos Gómez, whose computer knowledge solved some problems when this project started;

Mr. Tom Kelly for his editing assistance;

Ms. Travis Kranz, whose interest and professional help was valuable during her one-year internship at the Museum;

Ms. Alicia Maldonado, who did an excellent initial typing job; and

Mr. Albert J. Casciero, without whose help and expertise this publication would have never been a reality.

Annick Sanjurjo

EXHIBITIONS

YEARS 1941-1945

May 22 - June 28, 1941

BOLIVIAN SCULPTURES BY MARINA NUÑEZ DEL PRADO

Marina Núñez del Prado, Bolivian sculptress born in La Paz, 1910. Latin American fellow of the American Association of University Women, 1940-41. Graduate of the Academy of Fine Arts, La Paz, Bolivia, 1930. Teacher of sculpture and artistic anatomy at the Academy of Fine Arts, 1931-40; teacher of Indo-American art at American Institute, La Paz, 1935-36. Fourteen exhibitions in Bolivia, Peru, Chile, Argentina, Uruguay, and Germany. Prizes: Gold Medal, Municipality of La Paz, 1930; First Prize (Gold Medal), *Indigenist Exhibition*, La Paz, 1930; Gold Medal, *Concurso Bolivariano*, Caracas, Venezuela, Gold Medal, 1934; Sixth Exhibition of Women Artists of Argentina, First Prize for a Foreign Artist, Gold Medal, 1936; International Exhibit of Arts in Berlin, Gold Medal, 1938. Some works have been acquired by the National Museum of Art of Argentina, Uruguay, and Germany.

CATALOGUE

Sculptures

1. *Danza de cholas (Dance of the Cholas)*,[1] 1937, walnut, 25"
2. *Danza de khusillos (Dance of Khusillos)*, wood
3. *Danza de huaka-tokoris (Dance of Huaka-Tokoris)*, 1937, mahogany, 18"
4. *Dance of the Condors*, 1941, walnut, 23"
5. *Danza de huaka-tokoris (Dance of Huaka-Tokoris)*, wood
6. *Danza aymará (Aymará Dance)*, terra-cotta
7. *American Indian Dance*, wood
8. *Plegaria (Prayer)*, 1935, walnut, 15"
9. *Abandonada (Abandoned)*, wood
10. *Madre (Mother)*, wood
11. *Mother Earth*, wood
12. *Indian Mothers*, wood
13. *Llamas*, terra-cotta
14. *Alpacas*, terra-cotta
15. *Tenderness*, terra-cotta
16. *Flowers of the Earth*, terra-cotta
17. *Llokalla*, 1938, terra-cotta, 9"
18. *Imilla*, terra-cotta
19. *Aynaru*, 1937, terra-cotta, 11"
20. *Miko*, terra-cotta
21. *Jhiska*, terra-cotta
22. *Lullaby*, terra-cotta
23. *Aymará*, 1938, terra-cotta, 11"

[1] A *chola* is a woman of Indian and white ancestry. —*Ed.*

November 4 - 22, 1943

WATERCOLORS AND DRAWINGS BY FRANCISCO AMIGHETTI RUIZ OF COSTA RICA

Francisco Amighetti Ruiz was born in San José, Costa Rica, July 1, 1907. He graduated from the Liceo de Costa Rica and subsequently enrolled in the Academy of Fine Arts. From 1930 to 1941 he was professor of drawing in the Normal School, and since 1941 has occupied the same position at the Liceo.

In 1932-33 he traveled through South America, exhibiting his works in Argentina, Peru, and Bolivia. Subsequently, in 1940-41, he exhibited in El Salvador, Guatemala, and Nicaragua. He won First Prize in the National Exhibition of Plastic Arts, Costa Rica, 1937, and several of his works were included in the Costa Rican exhibit sponsored by the Morse Gallery of Art at Rollins College, Florida, in 1942 and later shown in New Orleans and Memphis.

Amighetti Ruiz has had a rich and varied career in Latin America as an illustrator of books and magazines. He has also contributed many articles on art and literature to Latin American periodicals. But painting is the persistent vocation of this quiet, intense seeker of line and color. From each country he has visited, he has been able to draw the essential features of landscapes and people and interpret them with fine technique and imagination.

CATALOGUE

Watercolors and Drawings

1. *Mercado* (Market)
2. *La carreta* (Ox-Cart)
3. *Tríptico* (Triptych)
4. *La Gigantona*
5. *Entierro macabro* (Macabre Burial)
6. *Mercado* (Market)
7. *Mujer de Atitlán* (Woman of Atitlán)
8. *Cofradía* (Brotherhood)
9. *India de Guatemala* (Guatemalan Indian)
10. *Viejos en el parque* (Old People in the Park)
11. *Parque* (Park)
12. *Feria de ganado* (Cattle Fair)
13. *Paisaje* (Landscape)
14. *Taos*
15. *Plaza, Santa Fe*
16. *Mujeres de Atitlán* (Women of Atitlán)
17. *Iglesia de Taos* (Church in Taos)
18. *Vendedores* (Vendors)
19. *Niña dibujando* (Little Girl Drawing)
20. *Mercado de Guatemala* (Guatemalan Market)
21. *Alfarería* (Pottery Factory)
22. *A la orilla del camino* (On the Ridge of the Road)
23. *Palomas* (Doves), *Taos*
24. *Dora y Flora* (Dora and Flora)
25. *El gato* (The Cat)
26. *Niña* (Girl)
27. *Taos*
28. *Niño* (Boy)

29. *Calle de Granada* (Street in Granada)
30. *Muchacha dibujando* (Girl Drawing)
31. *Madre con su hijo* (Mother and Son)
32. *Campesina* (Country Woman)
33. *Santa Fe*
34. *Retrato* (Portrait)
35. *Santos de Guatemala* (Saints of Guatemala)
36. *Hombres y Máscaras* (Men and Masks)
37. *El entierro* (The Burial)
38. *Vendedora* (Vendor)

December 27, 1944 - January 10, 1945

SCULPTURED MINIATURES BY FEDERICO MENDOZA LIMON OF MEXICO

Federico Mendoza Limón was born in Huatusco, Veracruz, in 1910 and started painting and sculpture in Mexico City. In 1929 he was awarded a scholarship by the government of Mexico and studied in New York for three years.

"Sculptured miniatures" is what the artist himself calls his small statuettes. During a recent exhibition in Mexico City his work won the following acclaim from a well-known critic:

> Mendoza Limón is not a rival of the Italian Renaissance miniaturists. He is a creator in his own right. He has fulfilled the dream of every artist: to create.

CATALOGUE

Miniature Sculptures

1. *President Roosevelt*
2. *President Manuel Avila Camacho*
3. *Vice-President Wallace*
4. *Secretary Hull*
5. *Foreign Minister Ezequiel Padilla*
6. *Ambassador Francisco Castillo Nájera*
7. *Lázaro Cárdenas*
8. *Winston Churchill*
9. *Attorney General Biddle*
10. *Secretary of the Interior Ickes*
11. *Secretary of Commerce Jesse Jones*
12. *Secretary Maximino Avila Camacho*
13. *Under Secretary of State Stettinius*
14. *Dr. Rowe*
15. *Nelson Rockefeller*
16. *Miguel Alemán*
17. *Roosevelt, Churchill, Stalin, and Hitler*
18. *Uncle Sam and Hirohito*
19. *Stalin*
20. *Chamberlain*
21. *Hitler*

22. *The Swastika*
23. *Mussolini*
24. *Hirohito*
25. *Leopold Stokowski*
26. *Ex-King Carol*
27. *Dolores del Río*
28. *Diego Rivera*
29. *Vicente Lombardo Toledano*
30. *Agustín Lara*
31. *Mario Talavera*
32. *Manuel Horta*
33. *Guillermo de Luzuriaga*
34. *Ernesto García Cabral*
35. *Robert Soto*
36. *Self-Portrait*
37. *Joe Louis*
38. *Mein Kampf*
39. *Seventh Symphony of Shostakovich*
40. *The White Bear*

March 1 - 21, 1945

CARLOS MERIDA: COLOR PRINTS OF MEXICO AND GUATEMALA[1]

Carlos Mérida needs no introduction as a painter of international reputation whose work is as well known in Paris and New York as it is in Mexico. Mérida's oil paintings, which combine abstract elements with forms which derive from his interest in and close association with his Maya-Quiché heritage, are ample proof of his artistic ability. But Mérida has also presented, in a series of five portfolios of color prints, a beautiful and scholarly record of his study of the Indian cultures of Guatemala and Mexico.

The earliest work of this series, *Images of Guatemala*, was printed in Paris while Mérida was there in 1928. Mérida was at that time no stranger to Europe, for he had studied in Paris from 1910 to 1914 under Van Dongen and Camarasa, but he returned to Guatemala in 1914 convinced that his work must be based on and grow out of the art forms indigenous to his own land if it was to have value as a strong and personal expression. He painted for several years in Guatemala, and then in 1919 went to Mexico, where he became a member of the revolutionary group of painters. The *Images of Guatemala*, painted between the years 1924 and 1927, mark the end of Mérida's early period of formalized decorative watercolors, for after his return from Paris in 1929 he turned to looser, more flowing lines and he began incorporating in his work the abstract forms which have been one of its characteristics since that time.

Several years later Mérida became the director of the Dance School of the Secretariat of Public Education in Mexico City, where his work consisted in recording the historic dances of the Mexican Indians. His records took the form

[1] With a showing of color prints of Mexico and Guatemala by Carlos Mérida, the Division of Intellectual Cooperation of the Pan American Union inaugurates a series of small exhibitions from its Loan Collection, which is available to educational institutions, including libraries and museums. This service has recently been greatly stimulated through a grant from the Rockefeller Foundation. —From the Press News No. 5073, Pan American Union, Washington, D.C., no date.

of a series of color lithographs which were published in 1938 under the title of *Dances of Mexico*, followed in 1940 by a second set called *Carnival in Mexico*, both albums devoted to the colorful native fiesta dances and costumes of Mexico. In 1941 a third portfolio, *Mexican Costume*, was published in which, for the first time, the richness of Mexican regional costume was shown in a series of beautifully simplified and stylized silk screen prints which are a tribute to Mérida's scholarly and thorough research.

Mérida's preoccupation with the expressions of Mexican Indian culture did not in any way modify his intense, close association with his own Mayan heritage. His painting reveals a constant return to the use of Mayan symbols and art forms, and his mystic, deeply emotional identification with the art of his own people is constantly apparent. He has always been haunted by the ancient Mayan legends of the founding of the world and the early days of the great Mayan people. Many of these legends had been brought together in the form of a book, first published in Vienna in 1857, called the *Popol Vuh*. Mérida's study of this book found concrete form in a series of ten lithographs, published in 1943 under the title of *Estampas del Popol Vuh*, in which he combines Mayan art forms with abstract elements to produce a brilliant and personal interpretation of the history of his people.

With the publishing of the *Estampas del Popol Vuh* Mérida seems to have completed a cycle which, starting with the early *Images of Guatemala* and following the course of his study and work in Mexican costume and dance, returns once more to the world of his forefathers. —*Leslie Switzer*

CATALOGUE

1-65. Color prints of the following portfolios:

 a. *Images of Guatemala*
 b. *Dances of Mexico*
 c. *Carnival in Mexico*
 d. *Mexican Costume*
 e. *The Popol Vuh*

BIOGRAPHICAL NOTES

1891 Born in Quetzaltenango, Guatemala
1910 Went to Paris to study painting
1914 Returned to Guatemala
1919 Went to Mexico to live
1920 One-man show, National Academy of Fine Arts, Mexico City, of Guatemalan folklore themes
1921 Joined the group of Mexican revolutionary painters
1923 Mural decorations in the children's library of the Ministry of Education, Mexico City
1927 Went to Paris where he exhibited at the Galerie des Quatre Chemins
1929 Returned to Mexico where he became the director of the Galería de Arte Moderno in Mexico City
1930 Became professor of painting in the Central School of Plastic Arts in Mexico City
1931 Became director of the School of Dance, Secretariat of Public Education in Mexico City
1932 Began experimenting with pure abstract painting
1937 Abandoned pure abstraction for present style which combines flowing, abstract lines and color with motifs from Mayan art forms

SOME BOOKS ABOUT CARLOS MERIDA

Helm, MacKinley. *Modern Mexican Painting*. New York: Harper and Brothers, 1941.
Brenner, Anita. *Idols Behind Altars*. New York: Payson and Clark Ltd., 1929.
Charlot, Jean. *Art from the Mayans to Disney*. New York: Sheed and Ward, 1939.

March 23 - April 10, 1945

SIXTY-FIVE WOODCUTS FROM ARGENTINA

Press News No. 5174, Pan American Union, Washington, D.C. *Sixty-five Woodcuts from Argentina*, the second of a series of exhibitions of Latin American art to be held in the Map Room of the Pan American Union, opened to the public on the 23rd of March to run through the 10th of April. This is the second time that examples of Argentine graphic arts have been shown in Washington, the Corcoran Gallery having held an exhibition several years ago which was later circulated throughout the country by the Pan American Union. The present collection, which was presented to the Pan American Union by the National Committee on Intellectual Cooperation of Argentina, is further testimony to the outstanding work of the Argentine school and of those Uruguayan artists who are closely identified with it. The work of thirty-two artists, the exhibition reflects in its breadth of technique and vision the cosmopolitan quality of Argentine life and the influence of the many nationalities which make up the Argentine population.

The exhibition is part of the Loan Collection of the Division of Intellectual Cooperation, and is available to educational institutions, libraries, and museums.

May 1 - 21, 1945

ENGRAVINGS OF MEXICO BY LEOPOLDO MENDEZ

Press News No. 5306, Pan American Union, Washington, D.C. Twenty-five wood engravings by Leopoldo Méndez of Mexico will be on view in the Map Room of the Pan American Union from May 1st to 21st.

The engravings, which originally appeared in a portfolio published in Mexico in 1943, consist of political cartoons, book illustrations, and scenes of Mexican life. Although Méndez is one of the youngest of the Mexican group of artists—he was born in 1902—he has been widely acclaimed by fellow artists and art critics both in Mexico and abroad. He has been called the logical successor to the great line of Mexican graphic artists and particularly to Posada, the nineteenth-century engraver whose work has recently been shown in the principal art centers of the United States.

Juan de la Cabada, the noted Mexican critic, writes of Méndez in his introduction to the portfolio of engravings, "a great artist, the best engraver in Mexico, and professor of extraordinary human values."

These engravings make the third exhibition in a series composed of selections from the Loan Collection of the Division of Intellectual Cooperation, and are available for exhibition to schools, colleges, and art centers.

June, 1945[1]

WATERCOLORS OF GUATEMALA BY CAROLYN BRADLEY

Press News No. 5361, Pan American Union, Washington, D.C. In showing *Watercolors of Guatemala* by Carolyn Bradley, the Pan American Union takes pleasure in presenting a gay and colorful record of the life and customs of the Guatemalan Indian.

[1] No exact date for this exhibition could be found in the records. The Press News number, nevertheless, indicates that it was held between June and September 1945. *—Ed.*

Carolyn Bradley has traveled extensively in Mexico and Guatemala studying Mexican and Guatemalan costume and published a book on costume design in 1937. She also traveled and painted in many European countries and has won more than fifty prizes for her work in group and one-man shows in the United States, including exhibitions at the Art Club of Washington in 1931 and 1937. The artist has acted as consultant on Latin American art at the Latin American Workshop in Louisville, Kentucky.

CATALOGUE

Watercolors

1. *Washing in Guatemala*
2. *Ruins at Antigua*
3. *Lake Atitlán*
4. *Cecilia at the Market*
5. *Church in Chichicastenango*
6. *Quetzaltenango*
7. *San Marcos*
8. *Santa María*
9. *Market in Antigua*
10. *Making Tortillas*
11. *Weavers at San Antonio*
12. *The Ceiba Tree*
13. *Busy Market*
14. *Lilies for Sale*
15. *Mayan Indian*
16. *Market in San Francisco*
17. *Indian Woman*
18. *Gaspar*
19. *Flower Market*
20. *Felicia and Granddaughter*

October 1 - 31, 1945

PAINTINGS AND DRAWINGS BY HECTOR POLEO OF VENEZUELA

Press News No. 5726, Pan American Union, Washington, D.C. An exhibition of the work of Venezuela's new young "find," Héctor Poleo, a painter who has been called an "old master" by the *Art News*, will be held at the Pan American Union from October 1 to 31.

This artist has already had a distinguished showing of his work in New York at the Arnold Seligman Rey Galleries, who heretofore have dealt only with "old masters." Their faith in the talents of the young Latin American, however, is such that they not only have exhibited his work but also have become his permanent representatives in the United States. The success of his first one-man show would seem to justify this interest.

Poleo was born in 1918 in Caracas and studied at the School of Plastic Arts there. In 1937 he went to Mexico where he stayed for three years, studying and painting. After visiting the United States, Ecuador, and Colombia—where he held an exhibition of his work—he returned to Venezuela in 1940. Poleo's eyesight was seriously injured in early youth and he has been threatened with blindness ever since. His preoccupation with this has manifested itself in his paintings, in which many of the subjects with closed eyes seem to live within themselves, "sightless but lighted by

an inner vision," as Rosamund Frost of the *Art News* has pointed out. The John Herron Art Institute of Indianapolis and the International Business Machines Company have already purchased examples of Poleo's work, and his paintings are said to sell in Caracas almost before the paint is dry.

The Pan American Union takes pleasure in being among the first to present the work of so distinguished a fellow American.

CATALOGUE

Oils

1. *Paludismo (Malaria)*, Caracas, 1944
2. *De la tierra a la tierra (Dust to Dust)*, Caracas, 1944
3. *El curandero (The Quack Doctor)*, Caracas, 1944
4. *Nostalgia*, Caracas, 1944
5. *Nueva generación (New Growth)*, Caracas, 1944
6. *Comisarios (Village Constables)*, Caracas, 1944
7. *Panorama*, Caracas, 1944
8. *Fecundidad (Fecundity)*, New York, 1944
9. *Retrato (Portrait)*, Mexico, 1940
10. *Dolor (Sorrow)*, New York, 1945
11. *Destruction*, New York, 1945
12. *Sin hogar (Homeless)*, New York, 1945
13. *Retrato (Portrait)*, New York, 1945
14. *Paisaje andino (Andean Landscape)*, Mucuchíes, 1944

Drawings

15. *Angustia de la espera (Anguish of Waiting)*, Caracas, 1944.
16. *Anxiety*, New York, 1945
17. *Country People*, New York, 1945
18. *Dolor (Sorrow)*, New York, 1945

October 7 - 31, 1945

SCULPTURES BY GENARO AMADOR LIRA OF NICARAGUA[1]

Genaro Amador Lira was born in Managua, Nicaragua, in 1910. As a result of an exhibition of miniature carvings held by the newspaper *La Noticia*, in Managua, 1935, the government awarded the artist a scholarship to study in Mexico. There he attended the School of Fine Arts and exhibited with the Independent Artists Group. In 1941 the Nicaraguan government asked Amador Lira to return to his country to organize and direct the School of Fine Arts. The Department of State of the United States invited him to this country in 1945 to study the organization of art schools and museums. The artist was a visiting professor at Mills College, California, during the summer of 1945. Although this is Amador Lira's first exhibition in the United States, his work is represented in several North American collections.

[1] This exhibition was held at the National Museum, Washington, D.C., sponsored by the Pan American Union. —*Ed.*

In the following simple words Amador Lira has expressed the meaning and content of his work:

> I seek the simple and noble form most appropriate to a lofty ideal content, utilizing to the utmost the possibilities inherent in the material used. The artist is visionary and can be prophet; my sculpture is a message of love and hope for mankind.

CATALOGUE

Sculptures

1. *Walnut*

 Tree that feigns humanity; the gesture sleeps in the contortions of its trunk. The artist captures the idea, develops and gives form to the liberated gesture: age-old eagerness to blossom. Love is the universal law of attraction.

2. *Oak*

 In the human trinity, the child rests safely in the loving lap of his parents; the woman, with her trust in her stalwart companion; and the man, with his faith in God.

3. *Marble*

 Homeless children sleep huddled together in the open air with their faithful dog stretched out at their feet. The dusk of the chilly twilight permits only a glimpse of a shapeless heap of ailing humanity.

4. *Basalt*

 The Greek artist created the centaur. This new monster also is a symbol: the victims of destiny who only find suffering.

5. *Andesite*

 Instinctive love.

6. *Diorite*

 Since the beginning of time man has tried to wrench the secrets of the earth.

7. *Madroño*

 Struggle with the environment.

8. *Oak*

 This is how the artist sees humanity: beyond and above the fundamental support of the so-called exact sciences everything relating to the spirit is wrapped up in dim and labored uncertainty.

9. *Mahogany*

 The swift vision of country people who, descending from the mountain to celebrate the fiesta of the patron saint, hurry down the road in a cloud of dust.

10. *Cedar*

 The Hellenic symbol of the Spirit that makes Matter fruitful.

11. *Ceramic*

 Conscious love.

12. *Miniatures*, wood and ivory

YEAR 1946

April 1946[1]

SOTOMAYOR
Exhibition of Watercolors and Drawings under the patronage of Ambassador and Mrs. de Andrade

It is fitting and proper that Antonio Sotomayor exhibit his work at the Pan American Union, for he has been a Pan American man these past two decades. Born and trained in Bolivia, he has lived for twenty years in the United States—specifically in San Francisco—and throughout his painting runs the theme of Bolivian reminiscence seen through the perspectives of time and space. He has shown us the Bolivian Indian, lonely, remote and tragic, *chola*[2] types in more colorful garb but scarcely less remote or tragic; and the bourgeois life of Bolivian towns. His emphasis is always on people. Landscape interests him only insofar as it influences human thought and behavior. You feel he is a gregarious soul, and that with him to know people is to know everything that matters.

That is also the reason why Sotomayor, the painter of the wistful Indian of the Andes, is also one of the best of the North American caricaturists. He has a magnificent sense of humor, to be sure, and a singularly impish genius for what is essential in the design and the reference of a cartoon, but he is never grotesque for the sake of grotesquerie. To him caricature is another way of examining people, finding out how they think and act and what they really are. Although his subject matter here is largely conditioned by everyday life in a North American city, it is worth noting that his caricature is reserved for the people of our continent. Bolivia is the land of romance—the United States he sees with sophisticated realism.

In art, there is line that defines space and line that lives as line. Sotomayor is a past master of both. There are few things in contemporary draughtsmanship so fresh and free as his brush-line, few so exquisitely fluid and meaningful as the line of his pen. Drawing has for long been the backbone of everything he has done, but in some of his most recent pictures he reaches out toward a richer palette, a stronger organization of volumes, and a fuller orchestration of space. He is no longer content simply to draw with watercolor much as he would draw with ink. Strong, painterly imagination is reflected in these works, a delight in the eloquence of color and an equal delight in subtleties of modeling. And with this his Bolivian reminiscence also takes on a kind of universal value. It is no longer one man remembering one country: design and color beautifully handled transcend all localisms.

Watercolors, drawings, and caricatures in line and pastel make up the bulk of this exhibition, but they do not by any means represent every side of Sotomayor's work. He is, for one thing, an excellent mural painter, as is shown by his work in several California buildings. He is a sensationally expert ceramist and a very able cartographer; these two aspects of his art came together in the huge relief-map of the Western Hemisphere which he made in the form of a glazed terra-cotta fountain for Pacific House at the Golden Gate International Exposition in 1939. He is, finally, one of the best designers of scenery and costumes for the stage who I know.

[1] The exact exhibition period of this show was not found in the records. It was made possible by courtesy of the Council for Inter-American Cooperation, Inc., New York, under whose auspices it toured a number of museums in the United States, 1946-47. —*Ed.*

[2] A *chola* is a woman of Indian and white ancestry. —*Ed.*

We of San Francisco have admired him for a long time, have watched him grow and develop, and have delighted in the enrichment he has contributed to our journalistic gaiety and our serious artistic life. And it is one of the most pleasant of the year's privileges to take part in introducing him to a larger audience. —*Alfred Frankenstein*, Art Critic, *San Francisco Chronicle*.

CATALOGUE

Watercolors and Drawings

1. *Pastel Drawing*
2. *Lake Titicaca Fisherman*
3. *Woman with White Hat*
4. *Dancer*
5. *Holiday Eve*
6. *The Street*
7. *Woman Resting*
8. *Chola¹ Washing Clothes*
9. *Women of the Altiplano*
10. *Cholitas² with Gardenias*
11. *Miner*
12. *The Parade*
13. *Women in Church*
14. *The Coca Leaf Pickers*
15. *Man Resting*
16. *Aymará*
17. *Pen and Ink Drawing*
18. *Pen and Ink Drawing*
19. *Pen and Ink Drawing*
20. *Pen and Ink Drawing*
21. *Pen and Ink Drawing*
22. *Pen and Ink Drawing*
23. *Prayer*

Caricatures

24. *Poet Robinson Jeffers*
25. *Henry A. Wallace*
26. *Henry Kaiser*
27. *Ezio Pinza*
28. *William Randolph Hearst*
29. *Josef Stalin*
30. *Pablo Picasso*

¹ A *chola* is a woman of Indian and white ancestry. —*Ed.*

² *Cholitas* are young *cholas*. —*Ed.*

BIOGRAPHICAL NOTE[1]

SOTOMAYOR, Antonio. Painter, muralist, illustrator, caricaturist, ceramist, stage designer, born in Chulumaní, Bolivia, 1904. Studied at the School of Fine Arts, La Paz. Has held individual exhibitions in Latin America and the United States, including museums in Mexico City, La Plata (Argentina), San Francisco, Washington, D.C., and other cities in the United States. Participated in group exhibitions mainly in the United States, including the Golden Gate International Exposition, San Francisco, 1939, where he executed mural paintings and ballet stage designs. Illustrated magazines and books published in the United States and England. Lives in the United States since 1923.

August 5 - 31, 1946

JOSE ALONSO: SCULPTURES

José Alonso was born at Mar del Plata, Argentina, in 1911. Entirely self-taught, he has exhibited in the National Salon in Buenos Aires and many different places in Argentina, where he has won several prizes as well as a scholarship from the Comisión Nacional de Cultura de Buenos Aires.

He came to the United States through a fellowship from the Guggenheim Foundation in 1945. He is here making a study of the modeling and carving techniques of instructors in this country.

His works are to be found in museums in Buenos Aires, La Plata, and Mar del Plata, and he is the author of an important monument to Mitre in this last city.

CATALOGUE

Sculpture

 1. *Woman Reading*
 2. *Pirulín*
 3. *Head*
 4. *Woman's Head*
 5. *Reclining Figure*
 6. *Chaqueña*[2]
 7. *Mother and Child*
 8. *Indian Woman*
 9. *Sitting Figure*
10. *Quechua Woman*
11. *Girl's Head*
12. *Negro Boy*
13. *Boy*
14. *Mother and Child*
15. *Man's Head*
16. *Dancer*
17. *Polychrome Study*
18. *Portrait of the Dancer Cecilia Ingenieros*

[1] Not included in the original catalogue. —*Ed.*

[2] A *Chaqueña* is a woman from the northern Argentine province of the Chaco. —*Ed.*

September 3 - 22, 1946

PEDRO FIGARI (1861-1938)

ACKNOWLEDGMENTS

The President and the Trustees of the Council for Inter-American Cooperation, Inc., express their gratitude to the Office of International Information and Cultural Affairs, Department of State, for the grant-in-aid which made this exhibition possible.

They are deeply indebted to M. Knoedler & Company for their splendid cooperation in lending the paintings for circulation throughout the country.

Special thanks are due to Mr. Lincoln Kirstein and the *Magazine of Art* for permission to reprint the article on Pedro Figari, and to Señor José Gómez-Sicre, Art Specialist, Pan American Union, for valuable advice and assistance in the preparation of the exhibition.

INTRODUCTION

The exhibition of eighteen paintings by one of South America's foremost artists, Pedro Figari (1861-1938), has been organized by the Council for Inter-American Cooperation under a grant from the Department of State. Sponsored by the Representative of the Republic of Uruguay on the Governing Board of the Pan American Union, Señor Don Mateo Márques Castro, and the Chargé d'Affaires of the Republic of Uruguay, Señor Dr. José A. Mora, the exhibition was formally inaugurated at the Pan American Union, Washington, D.C., in September 1946. The paintings will be shown in twenty leading museums throughout the United States.

The Council for Inter-American Cooperation is proud to present the work of this Uruguayan master as part of its cultural program in the Latin American field. This program is but one of the Council's varied activities designed to promote better understanding between the Americas.

Since its establishment in 1944, the Council, a non-profit organization sponsored by private enterprise, has devoted increasing attention to the promotion of commercial relations throughout the hemisphere and has carried on the domestic program initiated by the former Office of Inter-American Affairs in furthering educational and cultural projects of considerable scope and variety.

In this work, the Council is assisted by a network of twenty affiliated Inter-American Centers located in principal cities throughout the United States. These centers act as clearing houses for general information on Latin America, as hosts to visitors from that area, and as sponsors of educational programs, including art exhibitions, concerts, films, and lectures on the other American republics.

PEDRO FIGARI

Due to the ample possibilities afforded by our museums, there is a rapidly diminishing gap between the creation of an artist's work and its public exhibition, no matter how special his imagination or remote his studio from our cities. For example, it is unlikely that an important contemporary painter of international reputation should not be at least superficially known throughout the United States within a decade of his death. While there are always surprises in first one-man shows, there seem few novelties left us when we are shown the lifework of a personal and authoritative hand.

Yet suddenly, such is the case with Pedro Figari, who died in Montevideo some nine years ago. To be sure, he has often been noticed with pleasure by travellers, and the Museum of Modern Art has hung one of his pictures since

1941, the gift of Robert Woods Bliss, acquired when U.S. Ambassador to Argentina. But he is a many-sided artist, and it takes more than a dozen separate pictures to demonstrate his diverse and fascinating gifts. The great series of retrospective exhibitions, illuminating his long career, held in Montevideo by the Ministry of Public Instruction from August through September 1945, has now made it possible to send to this country a fair choice of his paintings. It is not too much to predict that within a short time, Figari will be represented in many of our museums and private collections, not as a "Latin American" artist, but as the author of delicious and intensely felt paintings.

Figari may also become the focus of the popular biographer, for his was a romantic and melodramatic life, the curve of which suggests the publicized mystery and incidental tragedy of certain European artists, like Van Gogh and Gauguin. Indeed his work, as his life, is in the style of the international post-impressionists. Having spent many years in Paris, technically he certainly felt the influence of Vuillard, and to a perhaps greater degree, of Bonnard. However, in using the idiom of the advanced expression of his time, his subjects were generally drawn from his own large memory—an exile's obsessive nostalgia for his own childhood, and of the childhood of his country, thousands of miles away, across the South Atlantic.

It is good, in approaching him for the first time and in estimating his work, to know a little of Uruguay. Uruguay is often called the Denmark of South America, and it bears certain historical resemblances also to Holland and Switzerland. After a long period of bitter civil wars, the Oriental Republic of Uruguay in recent years has enjoyed a dominantly liberal regime, in which there has been active progress toward social practice and democratic policy. Montevideo is traditionally a haven of political exiles. Its ancient French colony has insured close ties with Paris. Its strategic position commanding the estuary of the River Plate is symbolic of the country's independent watchfulness, between Brazil and Argentina. The little country of the Banda Oriental (the Eastern Bank, from Buenos Aires) has a sturdy tradition in the arts, letters, and in jurisprudence, three branches of activity in which Figari distinguished himself.

He was born in Montevideo in 1861, from a dominantly Italian Riviera heritage. He was strictly trained in the law, and, as far as most of Montevideo might know, the greater part of his life would certainly be spent in her service. In 1886 he received his degree as *abogado*, was accredited defender of the poor in the Civil and Criminal Courts, married, and sailed for France. It is commonly repeated that Figari did not commence to paint until he was forty-seven. Actually, he seems always to have painted. His early, tight watercolor and oil sketches have more than an academic charm. His double portrait of himself and his young wife at the easel recalls the expert domestic intimacy of Manet and Degas. It is true that in the early part of his life he considered himself a professional jurist and an amateur painter. But from 1918 until 1938, he certainly painted to the exclusion of the practice of law, or of writing. In the recent retrospective shows in Montevideo, a selection from all his paintings was shown in three fortnightly groups; the catalogue[1] numbered some 650 separate items, many from public and private collections.

During his career as a public servant, Figari was the focus of a violent *cause célèbre*, in which he found himself projected into the rôle of an American Zola. In 1895 he consecrated himself to the defense of a poor youth, in the notorious *crimen de la calle Chana*. The affair of the murder on Chana Street had been prejudged with an appalling unanimity, both by the press and in public feeling. It cost Figari four years to obtain not only the freedom of an innocent but a complete vindication of himself, whose reputation as deputy, state counsellor, attorney, and politician had been gravely questioned due to the brilliance, eloquent agility, and clever strategy of his unpopular defense, which also forced a reformation in the criminal code.

Finally, however, his honors were restored to him, and he served his country in France as cultural commissioner, founded with his son the National School of Fine Arts in 1911, and two years later published *El arte, la estética y el ideal*, the summation of his philosophical and critical thought. The recent excellent studies, by his friend, the

[1] Salón Nacional de Bellas Artes, *Catálogo de la Exposición Pedro Figari 1861-1938* (Montevideo, Agosto-Septiembre 1945).

distinguished historian and architect, Señor Carlos A. Herrera MacLean, the article in *Cuadernos Americanos* by Jorge Romero Brest, and the monograph of Griselda Zani,[1] furnish an extended treatment of his biography and supply full bibliographies and catalogues of exhibitions and individual pictures. Here, there is room only for an introductory word as to his painting.

He was, primarily, the painter of a time and a place. The time was the epoch of 1830 to 1860, when the ex-colony, which three European empires had warred between them like dogs a disputed bone, was suffering intermittent civil disorders, attendant upon its emergence as an independent state. It was the epoch of the American life of Figari's emigrant parents, the épopée of the *criollo*—the local River Plate amalgam of Spaniard, colonial, and perhaps a dash of Guaraní blood, added before all the Indians had been killed or driven south by battle or massacre even before the wars of independence. The *criollo*'s place is either the single port, Montevideo, the seat of governor, dictator, the army, society ladies, and African servants, or the plain, vast pampas studded with the solitary *ombú*, the ranch-house with dancers in the courtyard, or the diligence tracking across the roadless grass, linking the *estancias* with each other and the faraway town. Figari peoples his time and place with a recurring cast of characters, the bands of pioneers of the early national migrations, the first gauchos, their roughbred horses, their dancing and fighting partners, and the soldiers and their camp-followers sent out from the town quarters, against them. There are also the figures from the train of the Argentine dictator Juan Manuel de Rosas, his terrible secret police, and the crowded salons of the provincial aristocracy which opposed him.

Figari painted in series of subjects. First of all there are his landscapes, with a tall powder-blue sky, the large vibration of the pampas' wide aerial room, landscapes with a single *ombú*, or an oasis-like clump of this huge pithy plant, so well described by W. H. Hudson, enormous in its overbranching expansion, which somehow gathers into its shadows the loneliness of the plain's arid nostalgia. There are landscapes with gauchos working, their painted ponies spotting the grass with leathery white and russet accents. Among many others, there is a particularly memorable image of a wild, abandoned, neighing horse, the stubby creole beast Figari knew so well how to render, caught in its shrill, echoless protest, as if drowning in a sea of endless grass. There are landscapes given their human scale by the placement of zinc-white *estancias*, the square-cut, low ranch-houses, like sugarblocks against the unlimited horizon, alone and locked.

There is a beautiful series of dances, traversing the wheel of the *pericón nacional*, in butterfly dusk or moth-like moonlight, under groves of lanterned oranges, or inside the wings of a ranch courtyard, in open fields, or in enclosed town-house patios, tiled and dripping with bougainvillea. One almost hears the insistent plucked guitar, the scuff of heels and the clapped accompaniment of the quadrille, with its processional, wind-mill figures—a kind of gaucho Polonaise.

Another rich sequence is devoted to intimate domestic interior, some from the colonial epoch, but the most impressive laid about 1840, panels of musical evenings with ladies of the *Epoca Federal* in crinolines, shawls, and high tortoise-shell combs, their ample décolletage repeating the sweep of the winged rosewood sofas, and the symmetrical damask window drapes, all in rose, scarlet, crimson, the colors of the dictator Rosas which even the animals were forced to carry. The women are shrewdly indicated, part gossip, part matriarch, parrot, or witch, as they push forward their eligible or ineligible daughters, buzzing behind stiff fans, dozing through interminable parties, primping hideously before long cheval-glasses, or sitting in low rockers, taking the citron-scented sunlight in their patios, wainscoted with Talavera tile.

Some have thought of Figari as a Latin American Gauguin of the local Negroes. Indeed many of his finest

[1] Carlos A. Herrera MacLean, *Pedro Figari* (Buenos Aires: Editorial Poseidón, 1943).

Jorge Romero Brest, "Pedro Figari, Pintor Americano," *Cuadernos americanos* (Mexico), año 4, no. 5 (September-October 1945).

Zani, Griselda. *Pedro Figari*. Buenos Aires: Editorial Losada, 1944.

compositions are occupied with the manners of the Black people who had wandered down into Uruguay from Brazilian slavery, even before the days of the early Republic, and who stayed on as a doomed, fantastic, enclosed colony, domestic servants for the rising class of shippers and merchants of the port. Their brilliant clothes and strange private rituals at their weddings and wakes are mocked in a half-tamed jungle shadow, the elegant provincialism of their exiled masters. Now, one can search for a dozen Negroes in all of Uruguay. There cannot be two hundred left in Argentina; the climate completed what disease and slavery began. But their world is immortalized in Figari's sardonic series, the men in their tall crepe-hung beaver hats, women in elaborate turbans, advancing in straggling silhouette relief to scarecrow cemeteries, followed by mangy pink and black cats and curs. Or lurking in doorways, to emerge *en fête* as atavistic kings for one day in the year, or dancing their *candombe* to a battery of huge African painted calabash drums, beaten high up on a balcony, above a court, filled like a fluttering pool with magenta bandannas and animal gestures. Figari's Negroes are less static than Gauguin's South Sea people; in a way less decorative, less exotic, more actively real. Their dyed plaster walls are splashed with intense semitransparent washes. Figari always painted on an absorbent *cartón*, or cardboard panel, not in gouache but in oil, a dry, richly flaked impasto, thinly laid on but entirely satisfactory. The Negro series approximates, in its fierce clash of orange, purple, pink, and coffee, the almost aromatic vibration of the transplanted African atmosphere, not fixed in an idealized flat pattern but fresh and living in air, as a suddenly remembered incident from a miraculous and all but forgotten childhood.

Certainly his pictures are nostalgic, but it is not merely their nostalgia that moves us. After all, to our colder northern eye, there is no personal connection—splendor of his rotting calcimine, his cracked cerise plaster, ruined tiles and grass oceans—it has nothing to do with any lost youth of ours. It is rather that Figari manages to convince us of the validity of his time and place by his pictorical insistence, and he makes an alien antiquity live for us in the intimacy of his specific, assimilable fragments. Through him, we absorb history not in anecdote but by atmosphere. One of these fragments is unforgettable; seen in the sequence showing the spectacular variations of the assassination of Facundo Quiroga, the hero of Sarmiento's classic biography, "the Caudillo of ferocious splendor" in Mitre's phrase, who still kindles the *criollo* lyric genius, that same Facundo who rode to meet death in the fine poem of Jorge Luis Borges, mounted on the box of a mailcoach. Figari fixes him with a flurry of lather and horse-hoofs spilled over the pampa grass, the coach hauled up short, the driver sprawling against the reins. The sky is a storm-promising sunset, heavy green clouds brooding over the bloody sundown action. It is almost cinematic. One can easily imagine the next sequence, the windy plain's night with its cotton-fleece rinsings swirling around the acid moon, a lone hound baying, the lone horseman in flight from the ubiquitous loneliness of the cooling murder.

Figari's most-loved light is dawn, dusk, or moonlight, a crepuscular minor vibrance, whose hash green-whites and acrid blues are the solid indicators of porous tree-trunk or ranch-house wall. He liked a shadowless time of day, or the pale luminous flare of a single lantern giving slight relief to muslin dancers in the white-washed yard, or under the muted glow of olive orange trees in the sage green eucalyptus grove.

He has been likened to Constantin Guys, but perhaps a North American would think of him more as a southern parallel to Prendergast, who was his contemporary. Both sought a mosaic vibration of textures, close values, textile color, and a rich powdery surface. As his work will be increasingly revealed to us, we shall be shown one more example of the powerful influence of impressionist methods, in an unexpected quarter, and we will be delighted by another personal and entirely fresh painter from a period that we may have imagined was exhausted of surprise.
—*Lincoln Kirstein*

CATALOGUE

Paintings

1. *El Palito* (Gaucho Dance)
2. *Are You Leaving Me?*

 3. *Colonial Party*
 4. *Cabaret*
 5. *Negro Dancers*
 6. *Alarmed Horses*
 7. *Obsession*
 8. *Negro Funeral*
 9. *The White Horse*
10. *Candombe*
11. *The Declaration*
12. *The Visit*
13. *Dance under the Orange Trees*
14. *The Seven Sisters*
15. *The Funeral*
16. *The Visitors*
17. *Praying*
18. *The Insinuation*

September 23 - October 10, 1946

CASTAGNA: OILS. SAFORCADA: PRINTS

Rodolfo Castagna was born in Buenos Aires in 1910. He studied at the National School of Decorative Arts from 1922 to 1932. After this he attended the Escuela Superior Ernesto de la Cárcova, the leading art school of Argentina, where he was a pupil of the famous Argentine painter Alfredo Guido. In 1938 Castagna himself became a professor of that institution. Both oil painting and engraving have claimed the artist's attention, and he has won prizes in national exhibitions in Argentina in both media.

His work is represented in the museums of La Plata, Córdoba, Tandil, and Rosario in his native country, the Public Library and Riverside Museum of New York City, and the Richmond Museum in Virginia. He is visiting the United States on a scholarship granted by the Comisión Nacional de Cultura of Buenos Aires.

Hemilce Saforcada, who in private life is the wife of painter Rodolfo Castagna, was born in Buenos Aires in 1912. There she attended the same art schools as her husband, and she now holds the position of art instructor in Argentina.

Saforcada is one of her country's foremost engravers and has won awards in all the Argentine exhibitions and competitions since 1935.

Her work as an engraver and as a painter has been widely shown throughout Argentina and is represented in the principal museums there as well as in galleries and private collections in Chile, Italy, and the United States. She is at present visiting this country with her husband.

CATALOGUE

Rodolfo Castagna

Oils

 1. *Cactus by the Sea*

2. *Tree on the Beach*
3. *Barranca de los Lobos*
4. *Jacarandá Blossoms*
5. *Jacarandá Tree at the Corner*
6. *Roofs in the Rain*
7. *Woman with Braided Hair*
8. *Criolla*

Hemilce Saforcada

Drypoints

 9. *Drawing Class (School Scenes Series)*
10. *Head*
11. *Consecration*
12. *Angel of the Sea*
13. *The Message*
14. *Springtime in the Forest*
15. *Ilse and Mónica*
16. *Allegory*
17. *Death of the Hero*
18. *Consolation*
19. *National Holiday (School Scenes Series)*

Lithographs

20. *Marion*
21. *Florina*

November 3 - 28, 1946

THE DRAMA OF THE AZTEC MANUSCRIPTS
An Exhibition of Watercolor Reproductions and Commentaries by Katharine Birdseye Lang

Katharine Birdseye Lang, of Washington, D.C., has for many years specialized in watercolor reproductions of the Aztec codices.

By means of a series of full-color drawings from all the Aztec manuscripts, this exhibit seeks to reveal the beauty, diversity, and deep human interest in these unique and famous books.

It shows how war obliterates the artistic talents of a conquered nation, so that a whole new generation of artists arises with no knowledge of ancient skills and produces art that is directed and influenced by the conquerors.

Although the pre-Columbian codices display a wide variety in the use of color and in the beauty of their execution, the transition from these ancient manuscripts to those of Aztec-Hispanic origin is startling. Parts two and three of the exhibit show how the young Aztec artists, schooled by the early Spanish priests, sought to portray the life and customs of their ancient land and the events of the Conquest which had made them orphans and wards of the church.

The entire sequence forms a dramatic picture-record of how the old order passed for the Aztecs, as it has done for

many other nations of the world throughout history.

CATALOGUE

Watercolors

Part I
The pre-Columbian codices depict the religious life of the ancient Aztecs

Panel 1. *A Modern Republic*
 It bears upon its flag the hieroglyphic symbol of an ancient race; the flag and coat-of-arms of Mexico are reproduced in full color. The purpose of the exhibit is explained.
Panel 2. *The Wanderings of the Aztecs*
 An ancient picture-writing in the National Museum of Mexico portrays the journey of the Aztecs from their mythical place of origin to the spot that, according to prophecy, would be the site of their great city, Tenochtitlán, which the Spaniards called Mexico.
Panel 3. *Reproduction of Cortés's Map of Tenochtitlán* (as he found it in 1519)
 It shows how the Aztec capital was built on pilings in the Lake of Tezcuco.
Panel 4. *Photograph of the Codex Borgianus*
 It shows the appearance of the old sacred books of the Aztecs. Information on the other codices is given in this panel.
Panel 5. *The Ceremony of the New Fire* (Codex Borbonicus)
 Ushered in each Aztec cycle of 52 years, it was the most important celebration of the religious calendar. This panel has an explanation of the picture and its hieroglyphics.
Panel 6. *The Water Goddess* (Codex Borbonicus)
 Famous for her rich blue robe and crown, she appears with three other deities in brilliant garb.
Panel 7. *The Sorcerers and Tales of Their Magic* (Codex Borbonicus)
 The Maguey Goddess, and her importance (Codex Borbonicus)
Panel 8. *Other remarkable figures* (Codex Borbonicus)
Panel 9. *Chief God of the Aztecs, Tezcatlipoca, Astrologer and God of the Days* (Codex Borgianus)
 Also included is an interpretation of the significance of the 20 day-signs of the Aztec calendar, which are pictured in his costume. This picture is greatly enlarged.
Panel 10. Further examples of intricate figures (Codex Borgianus)
Panel 11. *The Sun God and His Legend*, with other pictures (Codex Laud)
Panel 12. *Five Regions of the World*, enlarged (Codex Fejervary-Mayer)
Panel 13. *The Rain God, the Bat God*, and others (Codex Vaticanus 3773)
Panel 14. *The Death God* and other figures (Codex Cospi or Bologna)

Part II
The post-Columbian or Aztec-Hispanic manuscripts portray the life and customs of the Aztecs as drawn and painted by the Aztec pupils of priests from Spain

Panel 15. *A Page from Emperor Moctezuma's Tribute Roll*, Aztec numbers, place names, etc. (Codex Mendoza)
Panel 16. *The Fine Arts of Ancient Mexico*: goldsmiths at work, artists in featherwork at their tasks (Codex Florentino, Codex Mendoza)
Panel 17. Examples of *Aztec Weaving* (Codex Maggliabecchi)

Panel 18. *Hunting in Ancient Mexico*, sequence of pictures; *Fishing in Ancient Mexico*, sequence of pictures (Codex Florentino)

Panel 19. *Farming Among the Aztecs: A Procession in Celebration of Ripe Corn* (Codex Maggliabecchi)
 Women Gathering Edible Beans (Codex Mendoza)
 Gathering Maguey Plants (Codex Florentino)
 A Farmer's Routine (Codex Florentino)

Panel 20. *Birth, Christening, Marriage, and Burial Customs of the Aztecs* (Codices Mendoza, Florentino, Maggliabecchi)

Panel 21. *Young Aztec Artists Portray the Old Gods* (Codices Florentino and Telleriano-Ramensis)

Part III
The post-Columbian or Aztec-Hispanic manuscripts portray the Conquest of Mexico

Panel 22. *Emperor Moctezuma Views the Comet of Evil Omen* (Codex Duran)
 The Aztec Emperor Gets Bad News from the Magic Bird
 The Indecision of Moctezuma Which Proves Fatal
 Cortés Makes a Surprise Landing at Vera Cruz
 The Spaniards Inquire the Way to the Aztec Capital
 Mounted Crossbowmen of Cortés's Army (Codex Florentino)

Panel 23. *Friendly Native Chiefs Bring Food Supplies to the Spaniards* (Lienzo de Tlascala)
 Indian Allies Carry Military Supplies into Mexico from the Coast for Cortés (Lienzo de Tlascala)

Panel 24. *The Ships That Marched Across a Mountain Range* (Codex Florentino)
 They Are Reassembled for the Attack on the Aztec Capital (Codex Duran)
 Cortés Launches an Amphibious Operation (Codex Florentino)
 The Aztecs Evacuate Civilians (Codex Florentino)
 Battle Scenes in Tenochtitlán (Lienzo de Tlascala)
 The Surrender of the Aztecs to Cortés (Codex Florentino)

Panel 25. *The Old Order Passeth* (Codex Vaticanus 3738)

December 1, 1946 - January 3, 1947

CUBAN MODERN PAINTINGS IN WASHINGTON COLLECTIONS

CATALOGUE

Paintings

Cundo Bermúdez
 1. *The Supper*, gouache. Coll. Mr. Robert J. Portner
 2. *Interior*, oil. Coll. Dr. Albert R. Miller
 3. *Musician*, gouache. Coll. Mr. Francisco Aguilera

Carmelo
 4. *Portrait*, drawing. Coll. Howard University Art Gallery
 5. *Man and Beast*, drawing. Coll. Mrs. Caresse Crosby

Mario Carreño
 6. *The Horse of the Village*, oil. Coll. Dr. Albert R. Miller
 7. *Looking at the Moon*, scratchboard. Coll. Mr. James H. Whyte

8. *The Farm*, scratchboard. Coll. Mr. Robert J. Portner
9. *Struggle in the Cane Field*, gouache. Coll. Ms. Aubrey H. Starke

Roberto Diago
10. *Flowers*, gouache. Coll. Ms. Aubrey H. Starke

Carlos Enríquez
11. *Silhouette*, oil. Coll. Mr. Carlos Blanco

Julio Girona
12. *Woman*, oil. Private collection

Mariano
13. *Cocks Fighting*, oil. Coll. Ramón G. Osuna
14. *Cathedral of Havana*, gouache. Coll. Mr. Felipe Pazos

Luis Martínez Pedro
15. *Drawing*, pencil. Private collection

Felipe Orlando
16. *Fruit*, oil. Coll. Mr. Carlos Blanco
17. *Fish and Fruit*, oil. Coll. Mr. Valentín Riva

Osvaldo
18. *Fish and Flowers*, oil. Coll. Ms. Concha Romero James
19. *Matanzas Landscape*, gouache. Coll. Mr. Ramón G. Osuna

Amelia Peláez
20. *Fruit*, gouache. Coll. Dr. Albert R. Miller
21. *Still Life*, gouache. Coll. Mr. Enrique Pérez-Cisneros

Fidelio Ponce
22. *Women*, oil. Coll. Mr. Felipe Pazos

René Portocarrero
23. *Crucifixion*, oil. Coll. Mr. Ramón G. Osuna
24. *Colonial Interior*, watercolor. Coll. Mr. Carlos Blanco

Víctor Manuel
25. *Women's Heads*, watercolor. Coll. Mr. Enrique Pérez-Cisneros

BIOGRAPHICAL NOTES[1]

CARMELO (Carmelo González). Painter, draftsman, printmaker, born in Havana, 1920. Studied at the Escuela Nacional de Bellas Artes San Alejandro, Havana, where he was awarded a scholarship and studied at the Art Students League, New York, 1945. Held individual exhibitions in Havana and Washington, D.C. Participated in group exhibitions in Cuba, Honduras, and the United States.

[1] Not included in the original catalogue. See Index of Artists for reference on those not listed here. —*Ed.*

GIRONA, Julio. Sculptor, painter, draftsman, born in Manzanillo, Cuba, 1914. Graduated as a sculptor from the Escuela Nacional de Bellas Artes San Alejandro. Also studied under Juan José Sicre, Havana. Through different scholarships attended the Académie Ranson, Paris, 1934; the Taller Gráfico Popular, Mexico, 1940; the Art Students League, New York, 1941. Held individual exhibitions in Havana, New York, and Mexico. Participated in national and international group shows, including the Venice Biennial and other exhibitions held at the Museum of Modern Art in Paris and Museo de Bellas Artes in Buenos Aires. Lives in the United States since 1941.

MARIANO (Mariano Rodríguez). Painter, ceramist, graphic artist, born in Havana, 1912. Self-taught as an artist. In 1936-37 worked under Rodríguez Lozano, Mexico. Executed a fresco painting, Normal School, Santa Clara (Cuba), 1939. Held individual exhibitions in Havana and New York. Participated in national and international group exhibitions, including those held in New York at the Riverside Museum (1939), Museum of Modern Art (1943), and Brooklyn Museum (International Watercolor, 1944-46); and in Argentina at the Museum of Art (La Plata, 1946). Won a prize at the Exposición Nacional de Pintura y Escultura, 1938.

VICTOR MANUEL or GARCIA, Manuel (Víctor Manuel García). Painter, draftsman, printmaker, born in Havana, 1897. Lived in Paris, 1925-27, where he started signing Víctor Manuel instead of Manuel García. Returned to Europe in 1929. Co-founded Ensayo Experimental del Estudio Libre para Pintores y Escultores, Havana, 1937. Considered one of the founders of the modern art movement in Cuba, participated in many national and international group exhibitions, including the New York World's Fair, 1939. Received prizes at national salons in 1935 and 1938.

YEAR 1947

January 6 - 26, 1947

DJANIRA: PAINTINGS
SCENES AND PEOPLE OF BRAZIL AND NEW YORK

The Brazilian woman painter Djanira Gomes Pereira—she always signs her canvases simply Djanira—was born in the town of Avaré, State of São Paulo, in 1914. Her family was of both Austrian and Indian descent.

Djanira is largely self-taught. She began painting for the fun of it while earning her living as a dressmaker and managing a boarding house in Rio de Janeiro. The European painter Emeric Marcier, now a resident of Brazil, became interested in her work and taught her much of technique and principles in 1941.

She held her first individual exhibition in Rio de Janeiro in 1943, followed by others in Argentina, Uruguay, and England, as well as other cities of Brazil. Rio de Janeiro saw her second show there in 1945.

In July 1945, Djanira came to the United States to carry on her artistic work here. Her first personal exhibition in this country was held at the New School for Social Research, New York, in the spring of 1946.

CATALOGUE

Oils

1. *Retrato de menina (Portrait of a Little Girl)*, New York, 1946, 51 x 41 cm.
2. *Autorretrato (Self-Portrait)*, New York, 1946
3. *Brazilian Interior*, 1941
4. *Church in Ouro Preto*, Brazil, 1942
5. *Two Portraits*, Brazil, 1944
6. *Portrait of Young Girl*, Brazil, 1944
7. *Retrato (Portrait)*, Brazil, 1944
8. *Parque de diversões (Amusement Park)*, Brazil, 1942
9. *Angels' Orchestra*, Brazil, 1941
10. *Portrait of Miss Baun*, New York, 1946

Mixed Media

11. *Head of a Girl*, New York, 1946, tempera and oil
12. *Church in Ouro Preto*, Brazil, 1942, tempera and oil
13. *Via Crucis*, after O Aleijadinho, Brazil 1944, tempera and oil
14. *Cabeça de mulher (Head of a Woman)*, New York, 1946, tempera
15. *Crianças na praça (Children in the Square)*, New York, 1946, tempera
16. *Crasto Ielo*, Brazil, 1942, watercolor
17. *Café Selection*, New York, 1946, tempera
18. *Children at Play*, Brazil, 1942, ink

19. *Cabeça (Head)*, Brazil, 1943, monotype
20. *Parque de diversão (Amusement Park)*, New York, 1945, watercolor
21. *Crianças na praça (Children in the Square)*, New York, 1946, oil and tempera on canvas, 57 x 68 cm.

January 31 - February 28, 1947

EDUARDO KINGMAN: OILS AND GOUACHES

Eduardo Kingman is no newcomer to United States art circles. His works have been seen on a number of occasions in group exhibitions in American museums. In 1939, along with Camilo Egas, he painted mural decorations in the Ecuadorian Pavilion at the New York World's Fair. His woodcuts have been widely circulated in this country. In the spring of 1946 the Museum of Art of San Francisco, California, exhibited a large collection of his most recent works, part of which we now present to the Washington public through the courtesy of that institution.

Kingman was born in Loja, Ecuador, in 1913. He studied for two years at the Fine Arts Academy in Quito and then decided to devote himself to stronger and freer work which would bring him closer to the intimate aspects of the life of the Ecuadorian people. The Peruvian Indigenist movement and Mexican mural development both influenced the formation of his artistic personality. However, in his recent work Kingman has been following a concept which has become less and less local. He says:

> I consider my recent paintings are reactions against local, picturesque expression of Ecuadorian life. They try to show a more universal vision and to portray the image of man's soul and the complexity of the world around him.

The artist won the Mariano Aguilera Prize, the highest art award in his country, in 1936 in Quito. He has traveled through almost all the South American countries and has held one-man shows in Guayaquil, Quito, Bogotá, and Caracas. He executed the first murals commissioned by the Ecuadorian government in the Ministry of Agriculture, Quito, in 1944. Since 1945 he has been living in the United States, most of the time on the West Coast. He moved to New York late in 1946.

CATALOGUE

Gouaches

1. *The Patriot*
2. *Ruins and Figures*
3. *La cena miserable (The Poor Supper)*, 1945, gouache on paper, 15 x 20"
4. *Tristeza (Sorrow)*, 1945, gouache

Oils

5. *Alfarera (Pottery Maker)*
6. *The Sower*
7. *Interior*
8. *Blind Singer*
9. *The Prayer*
10. *Women with Religious Figure*
11. *Ruins*
12. *Street Corner*

13. *Indian Dance*
14. *End of Fiesta*
15. *Pietà*
16. *Beggar and Child*
17. *Procesión (Procession)*

March 3 - 15, 1947

LEATHER PORTRAITS OF THE PRESIDENTS OF THE UNITED STATES BY JAVIER A. MONTERO

Press Release No. NA-6635.8181, Pan American Union, Washington, D.C., March 1947. Javier A. Montero of Havana will hold an exhibit of his work at the Pan American Union from March 3 to 15. The exhibit consists of a three-dimensional gallery of leather portraits of the thirty-two presidents of the United States.

The artist, who worked on this collection over a period of seven years, uses a new technique which combines painting, sculpture, and leather embossing. Mr. Montero learned this technique during his years in Spain in the old Spanish cities of Córdoba and Granada and in Morocco. He learned from the Arabs the secrets of this old art, which are not recorded in any book but are passed on from father to son.

Javier Montero exhibited his collection in New York last October at the Ateneo Cubano. His work has received very favorable press comments.

The *Miami Herald* said:

> The collection of presidential portraits . . . and the process of repoussage involved in embossing the leather is history in itself.

Miami Daily News said:

> The features of the men stand out in bold relief of about two inches, giving a three-dimensional and lifelike quality to the portraits.

Diario de la Marina of Havana called his work:

> . . . entirely original. These portraits are immune to the ravages of time and it might be said that Professor Montero works for the centuries to come.

—*L.V.V. Lee*, Director, Press Relations.

CATALOGUE

Portraits, Embossed Leather and Paint

1. *George Washington*
2. *John Adams*
3. *Thomas Jefferson*
4. *James Madison*
5. *James Monroe*
6. *John Quincy Adams*
7. *Andrew Jackson*

8. *Martin Van Buren*
9. *William Henry Harrison*
10. *John Tyler*
11. *James K. Polk*
12. *Zachary Taylor*
13. *Millard Fillmore*
14. *Franklin Pierce*
15. *James Buchanan*
16. *Abraham Lincoln*
17. *Andrew Johnson*
18. *Ulysses Simpson Grant*
19. *Rutherford B. Hayes*
20. *James A. Garfield*
21. *Chester Alan Arthur*
22. *Grover Cleveland*
23. *Benjamin Harrison*
24. *William McKinley*
25. *Theodore Roosevelt*
26. *William Howard Taft*
27. *Woodrow Wilson*
28. *Warren G. Harding*
29. *Calvin Coolidge*
30. *Herbert C. Hoover*
31. *Franklin Delano Roosevelt*
32. *Harry S. Truman*

BIOGRAPHICAL NOTE[1]

MONTERO MOREJON, Javier Adolfo. Painter, sculptor, born in Cuba. Studied in Cuba, Spain, and Morocco. Has been for many years professor at the Polytechnic Institute of Ceiba del Agua in Havana, and this series of portraits have been executed under the sponsorship of that institute. They were exhibited for the first time in the United States at the Cuban Pavilion, World's Fair, New York, 1939, and toured the United States thereafter. Montero was awarded a Gold Medal at the Salón Nacional del Círculo de Bellas Artes, Havana, 1940.

March 4 - 31, 1947

LOPEZ-REY: PAINTINGS FROM MEXICO

Lucio López-Rey, born in Spain in 1904, has lived in Mexico for many years and is now a citizen of that country. He is a self-taught painter. He had already devoted himself to art for some time before he held his first one-man show in Spain in 1926.

His work has also been exhibited in Mexico, France, Belgium, and Sweden. From 1945 to 1946 López-Rey was in the United States and he has held one-man exhibitions in this country at the Bonestell and Demotte Galleries in New York, at the Today Art Gallery in Boston, the School of Fine Arts of the University of Pennsylvania, and the Raymond and Raymond Gallery in Beverly Hills, California. López-Rey won Second Prize in the 1946 Painting

[1] Not included in the original catalogue. —*Ed*.

of the Year Contest sponsored by the Pepsi-Cola Company at the National Academy of Design in New York. He is represented by the Knoedler Gallery of New York.

CATALOGUE

Paintings

1. *The Boss*
2. *The Picador*
3. *Monos (Monkeys)*
4. *Chez Madame X*
5. *Tempestad (Storm)*
6. *Iglesia de Tepoztlán (Church in Tepoztlán)*
7. *Fusilamientos (Executions)*
8. *El jacal (The Little Hut)*
9. *A Pause on the Way*
10. *Adán y Eva arrojados del Paraíso (Adam and Eve Expelled from Paradise)*
11. *En el jacal (Inside the Hut)*
12. *Nature morte à la guitare (Still Life with Guitar)*
13. *Siesta*
14. *El Patriarca Lacandón Chankín (The Patriarch Lacandón Chankín)*
15. *El Valle del Minotauro (Valley of the Minotaur)*
16. *Save Me, Lord!*
17. *Tragedia (Tragedy)*
18. *Billiards*

April 4 - May 6, 1947

CONTEMPORARY LATIN AMERICANS
A Loan Exhibition of Paintings in Celebration of Pan American Day

CATALOGUE

Horacio A. Butler (Argentina)
1. *El camalote, El Tigre*, oil. Coll. The Museum of Modern Art, New York

Antonio Sotomayor (Bolivia)
2. *Indian*, gouache. Coll. M. Knoedler & Co., New York

Cândido Portinari (Brazil)
3. *Retôrno da feira (Return from the Fair)*, 1940, oil on canvas, 39 x 31 1/2". Coll. of the artist, courtesy of Mrs. Beatrice Rudes, Washington, D.C.

Israel Roa (Chile)
4. *El Día del Pintor (The Painter's Birthday)*, oil. Coll. The Museum of Modern Art, New York

Luis Alberto Acuña (Colombia)
5. *La Ciudad Dorada (The Golden City)*, oil. Private collection, courtesy of The Museum of Modern Art, New York

Francisco Amighetti (Costa Rica)
 6. *La carreta (Ox-Cart)*, watercolor. Coll. Miss Elsie Brown, Arlington, Va.

Mario Carreño (Cuba)
 7. *Paisaje (Landscape)*, oil. Coll. Mr. Ramón G. Osuna, Washington, D.C.

Jaime Colson (Dominican Republic)
 8. *Desnudo (Nude)*, monotype. Private collection

Eduardo Kingman (Ecuador)
 9. *Girl with Bird*, oil. Coll. of the artist

Luis Alfredo Cáceres (El Salvador)
10. *Allegory of Cuscatlán*, watercolor. Coll. Miss Elsie Brown, Arlington, Va.

Carlos Mérida (Guatemala)
11. *Indian Women*, watercolor. Coll. Mrs. Concha Romero James, Washington, D.C.

Philomé Obin (Haiti)
12. *Toussaint Louverture Reçoit une Lettre du Premier Consul (Toussaint Louverture Receiving a Letter from the First Consul)*, oil. Coll. Mr. José Goméz-Sicre, Washington, D.C.

Rufino Tamayo (Mexico)
13. *Carnaval (Carnival)*, oil. Coll. Phillips Memorial Gallery, Washington, D.C.

José Sabogal (Peru)
14. *Huachafas*, oil. Coll. Mr. Guillermo Suro, Washington, D.C.

Pedro Figari (Uruguay)
15. *Candombe*, oil. Coll. Mr. Juan Felipe Yriart, Washington, D.C.

Héctor Poleo (Venezuela)
16. *Cabeza (Head)*, pencil drawing. Coll. Arnold Seligmann, Rey and Co., New York

BIOGRAPHICAL NOTES[1]

CACERES, Luis Alfredo. Painter and draftsman, born in San Salvador, 1908. Studied at the Escuela Nacional de Artes Gráficas, 1920-23. Since 1929 has held individual exhibitions in El Salvador. Organized and participated in many national group shows as well as international exhibitions, including the *Exposición Centroamericana*, San José (Costa Rica), 1935 and the Golden Gate International Exposition, San Francisco, 1940.

COLSON, Jaime. Painter, draftsman, printmaker, born in Puerto Plata, Dominican Republic, 1901. Studied in Spain under Julio Romero de Torres and Cecilio Plá, Barcelona, and at the Academia de San Fernando, Madrid. Lived in Mexico, 1934-37; returned to Paris, 1937-39; moved to Barcelona, where he lives at present. Executed fresco paintings in Mallorca. Published the book *El Neo-Humanismo* about his theories on art and philosophy. Held individual exhibitions in Mexico City, including the Palacio de Bellas Artes, and in Havana, Paris, Barcelona, and Santo Domingo. Participated in many group exhibitions in the Dominican Republic, Europe, and the United States, including *Latin American Exhibition of Fine and Applied Art*, Riverside Museum, New York, 1939.

[1] Not included in the original catalogue. See Index of Artists for reference on those not listed here. —*Ed.*

SABOGAL, José. Painter, printmaker, born in Cajabamba, Peru, 1888. Visited Spain, France, and Africa, 1908. Studied at the Academia de Bellas Artes, Buenos Aires, 1912-18. Worked with Rivera and Orozco, Mexico, 1922-25. Invited by the Department of State, visited the United States, 1942. Leader in his country of the movement known as *Indigenismo*, held individual exhibitions in Peru and Mexico. Participated in many national and international group shows, including the Golden Gate International Exposition, San Francisco, 1940. Was awarded Gold Medal at the *Exposición Iberoamericana*, Seville (Spain), 1928.

April 20 - 30, 1947

FATHER GUILLERMO BUTLER: LANDSCAPES

Guillermo Butler was born in Córdoba, Argentina, in 1880. Of Irish and Italian descent, he spent his early youth in Buenos Aires and Córdoba. At the age of twenty he joined the Dominican Order, of which he is a priest. The Order sent him to Rome in 1908 to study canonical law and in 1909, in Florence, he began to study painting under the guidance of Father Berthier, who restored the Church of Saint Sabina in Rome.

Father Butler continued his studies in Paris in 1911 and traveled through Spain, England, Switzerland, and Belgium. Returning to Buenos Aires, he founded the Beato Angélico Art School, where he still serves as director. The school is now a part of the National Academy of Fine Arts.

Father Butler's work has been shown every year at the National Salon in Buenos Aires, where he has held several one-man shows in leading galleries. His paintings are constantly on view in various salons throughout Argentina and have been included in exhibitions in Venice, New York, and other cities.

This exhibition at the Pan American Union is his first one-man show in the United States.

CATALOGUE

Paintings

1. *El Parral, Segovia*, Spain
2. *Self-Portrait*
3. *Trees in Winter*
4. *Tree by the River*
5. *Landscape, Tucumán*
6. *Orchard*
7. *Hills, Córdoba*
8. *Farm House, Córdoba*
9. *Chapel, Córdoba*
10. *Cloister, Córdoba*
11. *Afternoon in the Hills, Córdoba*
12. *Cloudy Day in the Pampas*
13. *Villa Carlos Paz, Córdoba*
14. *Dead Tree*
15. *By the River*
16. *Monastery, Segovia*, Spain
17. *Cathedral, Valencia*, Spain
18. *Sierras, Córdoba*
19. *Cloudy Day on the River*

20. *In the Hills of Córdoba*
21. *Church in Junquillo, Córdoba*
22. *Stones, Córdoba*
23. *House in the Hills, Córdoba*
24. *Tree*

May 8 - June 10, 1947

ANCIENT PERUVIAN TEXTILES
A Loan Exhibition, Courtesy of the Textile Museum of the District of Columbia

Through the generosity of George Hewitt Meyers, president of the Textile Museum of the District of Columbia, we are able to present a selection of items from the *Ancient Peruvian Textiles* exhibition from the Museum's collection, which was circulated throughout the United States in 1945 and 1946, first by the Division of Intellectual Cooperation of the Pan American Union and later by the Council of Inter-American Cooperation of New York.

These textiles go back to the very beginnings of our era, though it is difficult to assign precise dates to the pieces. Thanks to the extreme dryness of the climate in which they were made, they are remarkably well preserved. The weavers used cotton and the wool of three animals native to South America: the llama, the alpaca, and the vicuña. These western relatives of the camel have been a great economic resource for the Indians of the region, providing them not only with wool for their cloth but also with meat for food and with their strength as beasts of burden.

In his preface to the catalogue[1] printed for the circulating exhibition, Alfred Kidder II describes these early textiles in these words:

> Precision and color mark the styles of the various periods and localities.

> A wealth of inorganic and organic dyes made possible a great variety of color combinations. Design, sometimes naturalistic or depictive, is frequently highly conventionalized. In recognizable forms there is emphasis of the puma (mountain lion), so important in Andean religion and mythology, and the fish and plant life of the coast. The beings, human or human with animal attributes, in some cases probably represent mythical conceptions—demons, deities or spirits, or men in the guise of such beings, participating in elaborate ceremonies. Many of the figures, both in pottery and textile designs, can be discerned and analyzed, but the full significance of most has been lost with the disappearance of the culture that inspired them.

> Geometric design, in a variety of pleasing forms, was used for its own decorative effect, to fill spaces and to form borders. Intricate combinations of depictive and geometric patterns in alternating position and repetitive color sequence, often require study for fully appreciation, but as in other sophisticated styles, effect does not depend upon analysis of detail.

> These early fabrics of coastal Peru are the work of a people remote in space and time, alien in culture to contemporary North America, yet whose collateral descendents inhabit the Andes today. Regardless of whatever technical, artistic, or historical aspects of these fabrics may interest one particularly, they are surely indicative of the high abilities of the Andean Indians of the past, and of the potentialities of the same people in the future.

[1] Textile Museum, *Ancient Peruvian Textiles* (Washington, D.C.: The Textile Museum of the District of Columbia, 1945), 13 pages and 14 illustrations.

CATALOGUE

Textiles

1. *Fragment of Paracas Mantle*, wool embroidery on wool cloth
2. *Tapestry Border with Woven Fringe and Raw Cotton Tassels*, tapestry sewn on to cotton
3. *Fragment of Cotton Band*, probably a sash, compound weave
4. *Fragment of Tapestry*, tapestry with compound weave, cotton warps, wool wefts
5. *Fragment of Tapestry*, two pieces of tapestry joined together by sewing, cotton warps, wool wefts
6. *Painted Cloth*, painted cotton duck
7. *Fragment of Tapestry*, two pieces of tapestry joined together by sewing
8. *Panel from Large Tapestry*, tapestry weave, cotton warps, wool wefts
9. *Fragment of Cotton Cloth*, plain cotton cloth with embroidered or brocaded figures in wool
10. *Fragment of Tapestry*, tapestry weave, cotton warps, wool wefts
11. *Painted Cloth*, painted cotton duck
12. *Fragment of Tie-and-Dye Textile*, two pieces of tie-and-dye fabric on wool, joined together by sewing
13. *Fragment of Brocade*, basic cloth dyed brown cotton, decoration in brocade weaving
14. *Fragment of Cotton and Wool Cloth*, plain cotton base fabric with compound weave in wool at the border
15. *Fragment of Tapestry*, tapestry weave, cotton warps, wool wefts, warps do not appear on the surface
16. *Coca Bag*, double cloth weave, cotton
17. *Coca Bag*, tapestry weave, cotton warps, wool wefts
18. *Fragment of Embroidery*, basic cloth of wool with woolen embroidery
19. *Fragment of Cloth*, basic fabric cotton voile with compound weave of wool in weft design
20. *Fragment of Cloth*, tapestry border, cotton warps, wool wefts, panels of gauze or leno technique, figures embroidered to simulate tapestry
21. *Border of Paracas Mantle*, basic cloth cotton, wool embroidery
22. *Grotesque Human Figure*, cotton duck cloth brocaded with wool and cotton, two cloths joined together by sewing
23. *Standing Human Figure*, tapestry weave
24. *Border of Paracas Mantle*, cloth base, cotton, the entire surface is covered with wool embroidery
25. *Tapestry Bag*, tapestry, cotton warps, wool wefts, the tassels are suspended from a needle knitted core
26. *Tapestry Fish*, slit tapestry, all cotton
27. *Tapestry Band*, tapestry, cotton warps, wool and cotton wefts
28. *Needle Filet Square*, needle filet, cotton
29. *Tie-and-Dye Patchwork*, cloth of all wool. The greater portion of the fragment is made by the tie-and-dye technique, a resist method of decoration. The vertical slits are sewn together and the thread used in sewing them is caught through the alternate loops of the warp of the two pieces, closing the horizontal openings
30. *Feather Band*, cotton base. Feathers of their natural colors, previously sewn and knotted to a cord, have been stitched to the base
31. *Painted Fragment*, cloth weave, painted

June 15 - 30, 1947

PEÑALBA OF NICARAGUA: PAINTINGS

Rodrigo Peñalba was born in León, Nicaragua, in 1908, and he had already acquired a reputation as a caricaturist in his country by the time he was fifteen. Coming to the United States in 1926, he studied for four years at the Chicago Academy of Fine Arts. On his return to Nicaragua, he was awarded a scholarship to continue his studies in Spain at the San Fernando Academy in Madrid. When the civil war forced him to leave Spain, he journeyed to

Mexico, studying and helping teach at the School of Fine Arts in the capital. In 1938 he went to Italy and resumed his studies at the Royal Academy in Rome, graduating in 1941 after winning several prizes.

During the critical years of the war, Peñalba lived in a small village in central Italy, where he continued to paint and found ways to help the allied cause. In June 1945, he held a one-man show at the San Marco Gallery in Rome, displaying most of the works done during the war years.

Peñalba's works have also been exhibited in Nicaragua, Mexico, and Spain. Upon his arrival in the United States in February of this year, the Marquié Gallery of New York held an exhibition of his paintings, which were warmly received by the New York art critics.

The magazine *Art News* commented: "Peñalba's simple compositions now depend on rhythmical swirls of brilliant impasto. His flowers and still lifes have a turbulent beauty, though his forte is portraiture." The *New York Times* described the exhibition as "showing oils in rich impasto, bright in color and solidly put together."

CATALOGUE

Paintings

1. *Thinker*
2. *Still Life*
3. *Boy, Arrangement in Gray and Yellow*
4. *Lemons*
5. *The Straw Hat*
6. *Monte Rotondo, Rome*
7. *Flowers*
8. *Sleeper*
9. *The Moorish Singer*
10. *Grape, Shadow and Wine*
11. *After Cassino*
12. *Flowers on Red Background*
13. *Italian Peasant*
14. *Three Oranges*
15. *Memories*
16. *Flowers, Arrangement in Blue*
17. *Anticoli Corrado*, Rome, 1944
18. *Domenico and His Rooster*, 1943
19. *Hellena*, 1941
20. *Flower*
21. *Hallucination*
22. *Fruit*, 1943
23. *Mirella*, 1941
24. *Golden Flowers on a Black Table*, 1945
25. *Still Life*, 1944
26. *The Little Red Saucer*, 1941
27. *Profile*, 1944

Works for which there are no dates listed were painted in 1946 and 1947.

June 30 - August 3, 1947

PORTINARI OF BRAZIL

Nearly seven years have passed since the last exhibition in Washington of the works of Cândido Portinari. Many of the paintings then displayed remained in this city in the hands of the artist's friends. They are soon to be returned to Brazil to be shown there. It is our good fortune that we now have this opportunity to exhibit them at the Pan American Union, as a well-deserved tribute to Brazil's most distinguished contemporary painter. To the group of oils, mainly done around 1940, we have added examples of his work in other media, dating from the same period, to give an even broader idea of what he was producing at the very time when he was being recognized in this country as one of the outstanding artists of Latin America. The paintings were included in the group first presented in the United States by the Museum of Modern Art of New York. They bear a close relationship to the murals Portinari painted in the Hispanic Foundation of the Library of Congress in 1941, which are represented here by some of the artist's interesting preliminary studies.

Throughout the years since these works were painted, and despite his recent participation in political activities, Portinari has remained untiringly devoted to his work. He has executed murals in his country, has held several exhibitions there, and in 1946 he presented a one-man show of his latest work at the Galerie Charpentier in Paris.

Cândido Portinari was born in Brodowski, State of São Paulo, December 29, 1903.

CATALOGUE

Paintings

1. *End of Carnival*
2. *Checkerboard Kite*
3. *Dead Scarecrows*
4. *Laundresses*
5. *Checkered Scarecrows*
6. *Masked Scarecrow*
7. *Pink Scarecrow*
8. *Scarecrow and Kite*
9. *Cabeça de mulher (Head of a Woman)*
10. *Girl with a Blue Chest*
11. *Sunday Morning*
12. *Galo (Rooster)*
13. *Brodowski*
14. *Estudio para un mural (Study for a Mural)*. Coll. Ambassador of Brazil and Mme. Martins.
15. *Lovers*, watercolor. Coll. Ambassador of Brazil and Mme. Martins
16. *A familia (Family)*, lithograph. Coll. Ms. Beatrice Rudes

Studies for the murals in the Hispanic Foundation of the Library of Congress. Coll. Library of Congress

1. *The Discovery of the Land*, ink and oil
2. *The Entry into the Forest*
 a. ink and oil
 b. ink
3. *The Teaching of the Indians*
 a. ink and oil
 b. ink
4. *The Mining of Gold*, ink and oil

August 4 - 31, 1947

FELIPE ORLANDO: RECENT PAINTINGS

Among the contemporary painters of Cuba, Felipe Orlando stands out as one of the most distinguished artists of his generation. Although he has been in the United States less than a year, his work has been widely seen in this country in group exhibitions since 1943. The Pan American Union now has the honor of presenting his first one-man show outside of Cuba.

Born in the city of Quemados de Güines in 1911, Orlando has engaged in a variety of occupations. He early took an interest in painting and, more recently, has devoted all his time to it both as a creative artist and as an art teacher in elementary and secondary schools and summer camps.

Orlando has participated in exhibitions in Haiti, Costa Rica, Guatemala, Argentina, and Russia. His work is represented in the Museum of Modern Art of New York, the San Francisco Museum of Art, the Fine Arts Museum of La Plata (Argentina), Le Centre d'Art in Port-au-Prince (Haiti), and many private collections.

CATALOGUE

Oils

1. *Small Town*, 1946
2. *Small Town under the Storm*, 1946
3. *Woman in the City*, 1947
4. *Head*, 1947. Coll. Mrs. M.S. Frank
5. *Arrangement*, 1947
6. *Mangoes*, 1945. Coll. Mr. Ramón G. Osuna
7. *Fish Heads and Glass*, 1947
8. *Sail Boat*, 1947
9. *Woman with a Clock*, 1947
10. *Fruit*, 1945. Coll. Mr. Carlos Blanco
11. *Fish and Fruit*, 1945. Coll. Mr. Valentín Riva

Gouaches

1. *Woman with a Flower Basket*, 1947
2. *Brigantine*, 1947. Coll. De Aenlle Inc., New York
3. *Still Life*, 1947. Coll. Mr. Maxwell T. Cohen
4. *Small Town*, 1947
5. *Woman*, 1945. Coll. Mr. Carlos Blanco
6. *Still Life*, 1947
7. *Fish*, 1947
8. *Cherries and Glass*, 1947

September 4 - 30, 1947

MEXICAN MODERN PAINTERS IN WASHINGTON COLLECTIONS
A Loan Exhibition

CATALOGUE

Paintings, Drawings, and Prints

Dr. Atl
1. *Volcano*, resin. Coll. Mr. Luis Quintanilla
2. *Valley*, watercolor. Coll. Mr. Luis Quintanilla

Federico Cantú
3. *Madonna*, oil. Coll. Mr. Kemper Simpson

Jean Charlot
4. *Mexican City Night*, oil. Coll. The Phillips Memorial Gallery
5. *The Leopard Hunter*, oil. Coll. The Phillips Memorial Gallery

Francisco Dosamantes
6. *Women*, lithograph. Coll. Mr. Aubrey H. Starke
7. *Weaving*, lithograph. Coll. Mr. Aubrey H. Starke

Delfino García
8. *Landscape in Taxco*, tempera. Coll. Mr. Aubrey H. Starke

Carlos González
9. *Dance of the Moros*, oil. Coll. Mr. Luis Quintanilla

Xavier Guerrero
10. *Three Figures*, pencil drawing. Coll. Mr José Gómez-Sicre

María Izquierdo
11. *Mexican Madonna*, oil. Coll. Mr. Francisco Aguilera
12. *The Great Circus Rider Adelita*, oil. Coll. Mr. Francisco Aguilera

José Clemente Orozco
13. *Coney Island*, oil. Coll. Mr. Francis Biddle
14. *Women*, lithograph. Coll. Mr. José Gómez-Sicre
15. *Soldaderas*, lithograph. Coll. Mr. Luis Quintanilla

Diego Rivera
16. *Landscape*, 1911, oil. Coll. Mr. Luis Quintanilla
17. *Pottery Seller*, watercolor. Coll. Mrs. Edith Randon Bennett
18. *Old Woman*, watercolor. Coll. Mrs. Edith Randon Bennett
19. *Nude*, lithograph. Coll. Mr. Francis Biddle
20. *Portrait of Frida*, drawing. Coll. Mr. Clark Foreman

David Alfaro Siqueiros
21. *Centaur*, lithograph. Coll. The Library of Congress
22. *Aristocrat*, woodcut. Coll. The Library of Congress
23. *Deported*, woodcut. Coll. The Library of Congress

Rufino Tamayo
24. *Still Life*, oil. Coll. The Phillips Memorial Gallery
25. *Women Bathing*, gouache. Coll. Mr. Rafael de la Colina
26. *Indian*, gouache. Coll. Mr. Albert R. Miller

Villanueva
27. *Old Farmer*, oil. Coll. Mr. Rafael de la Colina

BIOGRAPHICAL NOTES[1]

CHARLOT, Jean. Painter, muralist, draftsman, printmaker, born in Paris, 1898. Studied in Paris. Joined the French Army, 1917. Moved to Mexico, 1921. Executed his first fresco murals at the National Preparatory School, 1922, and the Secretariat of Education, 1923, Mexico City. Was influential in reviving José Guadalupe Posada and lithography in Mexico. Art editor of *Mexican Folkways*, 1925. Staff draftsman of the Sterling Archaeological Expedition to Yucatán, 1926-29. Moved to the United States, 1929, to work on the color illustrations of *Temple of the Warriors*, published by the Carnegie Institute. Illustrated many books and publications, including *Christopher Columbus* and *Commentaries on the Apocalypse*, by Paul Claudel, and *The Sun, the Moon and the Rabbit*, by Amelia del Río. Instructor of Art at the Art Students League, New York, 1929-30; Chouinard School, Los Angeles, 1933-34, and others. Author of *Art from the Mayas to Disney*, New York, 1939, and of articles on Mexican art. Returned to Mexico, 1940, where he now lives. Held many individual exhibitions in the United States and Canada.

GARCIA, Delfino. Painter, born in Zacoalpán, Mexico, 1915. Exhibited in Mexico and the United States, including the Golden Gate International Exposition, San Francisco, 1940; *Mexican Art Today*, Philadelphia Museum of Art, 1943.

GUERRERO, Xavier. Painter, muralist, draftsman, born in San Pedro de las Colonias, Mexico, 1898. During his youth lived in Guadalajara and moved to Mexico City in 1919. Began painting with his father who was a decorator. Founding member of the periodical *El Machete*, also collaborated with Diego Rivera on the frescoes at the Secretariat of Education and later at the Agricultural School in Chapingo. Executed many other murals in Mexico and Chillán (Chile), where he spent two years working and lecturing. Exhibited in Mexico, the United States, and Cuba. Won a prize in industrial design awarded by the Museum of Modern Art, New York, 1941, where his work has also been shown.

October 1 - 22, 1947

ENGRAVINGS BY ANDRE RACZ ON THE PROPHETS BY ALEIJADINHO

It would be difficult to find anywhere a temperament more ideally suited than that of André Racz for the interpretation of the imposing work of Aleijadinho, that almost legendary figure of the art of the Americas who lived in the interior of Brazil in the eighteenth century.

A subtle mixture of the emotional depth and austerity of medieval art with the tropical vigor of the American baroque gives Aleijadinho's work, especially his statues of the prophets in Congonhas do Campo, perhaps greater native flavor than that of any of the other works which rank as the foundation stones of art in Latin America. It seemed better to us to present them to the Washington public, not through the cold and external record of photographs but through the vision of a great engraver who has been vividly impressed by them. These sculptures, the work of an artist who appeared almost a monster and lived as a fugitive from human society, represent one of the most impressive moments of the dawn of Latin American culture.

Aleijadinho, crippled, his hands and feet paralyzed, and disfigured by leprosy, fled from the world and poured out his anguish in the frenzied work with which he decorated the churches of his beloved State of Minas Gerais. André Racz, born in Rumania and considered one of the most distinguished engravers in the United States, offers us a faithful, though very personal, version of the tortured art of Brazil's great sculptor through this series of plates,

[1] Not included in the original catalogue. See Index of Artists for reference on those not listed here. —*Ed.*

many of them made at the site of the statues, executed with flawless technique.

We are indebted to Curt Valentin of New York, who graciously lent the proofs of the portfolio of André Racz's etchings of Aleijadinho's prophets, published by him in August, for this exhibition.

CATALOGUE

Line Engravings

1. *Head of Isaiah*
2. *Head of Nahum*
3. *Head of Daniel*
4. *Head of Joel*
5. *Head of Jeremiah*
6. *Head of Jonah*
7. *Daniel, Hoseah*
8. *Isaiah, Jeremiah*
9. *Amos, Baruch*
10. *Ezekiel*
11. *Nahum*
12. *Obadiah, Habakkuk*
13. *Jonah, Joel*

Etchings

14. *Isaiah*
15. *Jonah*
16. *Nahum*
17. *Amos*
18. *Baruch*
19. *Joel*
20. *Daniel*
21. *Habakkuk*
22. *Obadiah*
23. *Ezekiel*
24. *Hosea*
25. *Jeremiah*
26. *XII Prophets*

Preliminary Studies

27. *Isaiah*, pencil and ink
28. *Jonah*, pencil and ink
29. *Nahum*, pencil and ink
30. *Imprisonment*, watercolor
31. *Bearing of the Cross*, watercolor
32. *Crucifixion*, watercolor
33. *XII prophets*, pen and ink
34. *First State: XII Prophets*, etching
35. *Second State: XII Prophets*, engraving-etching
36. *Third State: XII Prophets*, engraving-etching

37. *Fourth State*: *XII Prophets*, engraving-etching
38. *Fifth State*: *XII Prophets*, engraving-etching

October 23 - November 11, 1947

MARY ST. ALBANS: PHOTOGRAPHS OF MEXICO

Press Release 9401, Pan American Union, Washington, D.C. From October 23 to November 11, the Pan American Union is presenting an outstanding collection of black-and-white photographs of Mexico, the work of the distinguished photographer Mary St. Albans.

Formerly editor of *Modern Mexico* magazine, the Seattle-born photographer has spent the past ten years south of the border making camera recordings of the many facets of Mexican life. Besides traveling thousands of miles with Mexican government officials for a pictorial portrayal of history in the making, she has explored remote corners of the country by car, train, bus, burro, and on foot to catch the real spirit of Mexico.

Her highly dramatic style in landscape and genre studies identify a "St. Albans" to all who know photography. Using a reflex camera, she has taken nearly 10,000 prints of wrinkled faces and laughing children, thatched roofs and elaborate palaces, shining seacoasts and countless unstudied portraits of her beloved Indians at work and at play. The Pan American Union exhibit features some of her spectacular shots of the Paricutín Volcano and the magnificent Mayan ruins of Yucatán.

Critics have compared Mary St. Albans with Steiglitz and Weston. Dr. Atl, distinguished Mexican painter and volcanologist, terms her portrayals of Paricutín "incomparable" and is using fifty of her photographs to illustrate his new book.

The present exhibition was shown earlier this year at the Brooklyn Museum in New York under the sponsorship of President Miguel Alemán of Mexico.

CATALOGUE

Photographs

1. *Sunrise on Paricutín*
2. *Water Carrier in Michoacán*
3. *Ricefield in Panchimalco*, Morelos
4. *Playa de Santiago*, Manzanillo
5. *Pyramid at Cholula*
6. *Looking over the Tourists*
7. *Capilla Real*, Cholula
8. *Mt. Popocatépetl from Cholula*
9. *Huichol Girl from Nayarit*
10. *Churchyard, Los Remedios*
11. *Volcano over Angahuán*
12. *Shelling Corn*
13. *Boy from Tlaxcala*
14. *Manzanillo*, Colima
15. *Sugarmill of Miacatlán*, Morelos
16. *Malinche from Puebla*

17. *Paricutín, July 1945*
18. *Church of San Francisco in Cholula*
19. *The Pulido Family of Paricutín*
20. *Old Man from San Juan Parangaricutirio*
21. *Doves at Churubusco*
22. *Street in Cholula*
23. *Hacienda San José*
24. *Los Remedios*, Federal District
25. *Fishing Nets*, Acapulco
26. *Lake Pátzcuaro*, Michoacán
27. *Dr. Atl at Paricutín*
28. *Temple of the Tigers*
29. *Temple of the Warriors*, Yucatán
30. *Columns*, Chichén Itzá,
31. *Uxmal*, Yucatán
32. *Yesterday and Today*
33. *Spanish and Mayan*, Yucatán
34. *Zacatecas*, Zacatecas
35. *Port of Veracruz and Mt.Orizaba*
36. *Pyramid El Castillo*, Chichén Itzá
37. *Cupolas in Oaxaca*
38. *Plowing in Tehuantepec*
39. *Mexico's Pedregal*
40. *Chichén Itzá*, Yucatán

November 12 - 24, 1947

CAROLYN BRADLEY: IMPRESSIONS OF CHILE

Watercolor is Carolyn G. Bradley's favorite medium, and she has won many prizes for her work in this field. The artist studied both in the United States and in Mexico. In the latter country she attended the University School of Fine Arts in San Miguel Allende and studied with Rufino Tamayo, Chávez Morado, and Carlos Mérida. Her painting travels have taken her to Canada, Portugal, Spain, Italy, France, Germany, Guatemala, and Chile. Many of the works in this exhibit were painted while Miss Bradley was in Chile for the Inter-American Educational Foundation in 1946. During that year she taught at the Summer School of the University of Chile.

CATALOGUE

Watercolors

1. *El Canelo*
2. *Chilean Landscape*
3. *The Stormy Surf*
4. *Rocks along the Coast*
5. *Autumn in Chile*
6. *Windblown*
7. *Copihues*
8. *The White Rock*
9. *From San Cristóbal*

10. *A Mountain Lake*
11. *The Pacific*
12. *Blizzard in the Distance*
13. *Snow in the Andes*
14. *Mountain Top*
15. *Lilies for Sale*, Guatemala
16. *Las Cruces*
17. *The Gorge*
18. *Rooftops*
19. *Rocks and Surf*
20. *Santos*, Guatemala
21. *Juan*, Mexico
22. *Gloria*, Mexico
23. *Cerro Quemado*, Guatemala

November 25 - December 9, 1947

ST. JOHN'S DAY IN BARLOVENTO
PHOTOGRAPHS BY FRANCISCO EDMUNDO PEREZ

The Pan American Union takes pleasure in showing, for the first time in the United States, a series of photographs of the celebration of St. John's Day in the Barlovento region of Venezuela, by Francisco Edmundo Pérez, photographer of the Caracas newspaper *El Nacional*. The striking ceremonial dances performed by the Negroes of that region for the occasion are of great interest to students of folklore.

These photographs, which make up a documental report, were made June 23 to 25, 1946, in the town of Curiepe, District of Brión, when the photographer accompanied Juan Liscano, founder and director of Venezuela's National Bureau of Folklore Research, to the scene. They were exhibited at the inauguration of the Folklore Bureau in Caracas and later in Bogotá and Havana. We are indebted to the Ambassador of Venezuela and to the Folklore Research Bureau for their courteous cooperation in making this exhibition possible.

In explanation of the subjects of these notable photographs, we quote from the text written by Mr. Liscano for the catalogue of the exhibition in Caracas:

THE DAY OF ST. JOHN THE BAPTIST

Every year the Negro and mestizo farmers and fishermen of the hot coasts and lush valleys of the State of Miranda—the Barlovento coast—of Venezuela celebrate the Day of St. John the Baptist by dancing to the beat of great drums.

St. John's Day comes on June 24, but the festivities with which it is celebrated sometimes begin as much as a week before and extend to the end of the month. The custom of celebrating this saint's day is of purely European origin. The eminent English authority on folklore, Sir James Frazer, in his remarkable book *The Golden Bough* wrote that this festival, to which a Christian touch has been added through the name of St. John, undoubtedly dates from a much earlier, pre-Christian era. He related it to the ancient solar rites of the summer solstice.

In Europe, fire is the basic element in the celebration of St. John's Day. Young and old sing and dance around bonfires and march through the fields in torchlight processions. In the Barlovento

region of Venezuela, in contrast, the principal element, if there is one, in the Negro population's celebration of the occasion is water. On the morning of St. John's Day it is customary to bathe in the river, which is thought to have the power at that time of purifying the human body and improving the accuracy of shotguns. In certain places they bathe not only themselves but also their weapons and the very image of the Saint, which is given brandy to keep it from catching cold. These beliefs and customs, it should be noted, are dying out. The great rite of the drum dances, on the other hand, is carried on enthusiastically and finds its best expression in those parts of Venezuela where the population is predominantly Negro.

Drum Dances of Barlovento

Drum dances are performed in honor of St. John throughout the Barlovento and Tuy Valley regions of the State of Miranda, on the Caribbean coast. In Curiepe, Brión District, where we studied these celebrations with particular interest, three great groups of drum dances are performed: the round drum dance (baile de tambor redondo), photos nos. 3 to 19, the large drum dance (baile de tambor grande), photos nos. 27 to 38, and the quichimba drum dance (baile de tambor quichimba), photo no. 37. All these dances and the instruments used in their performance are survivals of African culture.

Instruments

The drums used for the large drum dance and the quichimba drum dance are called *el mina* and *la curveta*, photo no. 24. The sides of *el mina* are beaten rhythmically with sticks of pui or araguaney wood known as *laures* or *paletas* to accompany the sharper drum beat on the taut skin, photos nos. 27 and 28.

The instruments used for the round drum dance are called generically *tamborcitos*, *los redondos*, *tambores pequeños*, or *culo e'puya*. A battery of three is made up of drums known respectively as *el pujao* or *guía* (guide), *el cruzado*, and *el corrío*, photo no. 13. Maracas are the only instruments other than the drums which are used in these dances.

Choreography: Large Drum Dance

This is a group dance in which innumerable individuals of both sexes take part, dancing either in couples or in arbitrary groups of a man and two women, or two women together or separately. This dance has no fixed steps. More than a dance it is an outburst of shouts, songs, and movements, which attain an impressive frenzy.

Round Drum Dance

Various dances, rhythms, and songs with names of their own make up the round drum dance. The rhythms and songs are known as *toques*, *pasajes*, or *tonadas*. These dances are performed by a single couple, dancing in the center of the circle of drummers. One couple after another takes its turn. The steps of the various round drum dances are of great variety, beauty, and artistic richness.

Quichimba Drum Dance

A number of different dances make up this one, which has now almost disappeared. *El mina* and *la curveta* drums are placed horizontally, one beside another, and the drummer, astride the instrument, beats the skin with his hands. *Laures* are used to accompany the drumming.

Locking up the Saint

On the afternoon of June 25 the procession of St. John the Baptist is held. Vigil is kept over images of the Saint in various houses of the community the night before. The procession winds through all the streets of the town. *El mina* and *la curveta* go first and are set up on the corners to greet the Saint as he is carried by. The image of St. John is returned to the church to the accompaniment of the *toque el encierro* (the locking up). The dances conclude with the *toque* called *malembe*.

CATALOGUE

Photographs

1. *The House*
2. *Offering to St. John*

The Round Drum

3. *Battery of Round Drums and Their Drummers*
4. *Round Drum Drummers*
5. *The "Tocalipto" Family and Their Drums*
6-7. *Joaquín Rivas "Tocalipto" and El Pujao Drum*
8. *Round Drum Dance: Entrance of the Dancer*
9-12. *Steps of the Round Drum Dance*
13. *Group of Round Drum Players: El Cruzado, El Pujao, and El Corrío Drums*
14-17. *El Rasguñao. Pasaje of the Round Drum Dance*
18-19. *Steps of the Round Drum Dance*
20. *The Old Negress*
21. *The Young Negress*
22. *The Boy*
23. *The Young Man*

The Large Drum

24. *Battery of Large Drums: El Mina, La Curveta*
25. *Mina Drummer*
26. *Hands of El Mina Drummer*
27. *Striking El Mina with Laures*
28. *Laures Player*
29. *Heriberto Cobo, El Mina Drummer*
30-32. *Steps of the Large Drum Dance*
33-36. *Frenzy in the Large Drum Dance*
37. *Step of the Quichimba Drum Dance*
38. *Returning the Image of the Saint to the Church*
39. *The Acolyte*
40. *Girl with Mantilla*

December 10, 1947 - January 5, 1948

CARLOS PRADO: PAINTINGS OF BRAZIL

Carlos Prado is outstanding among the group of contemporary painters of São Paulo, Brazil, for his mastery of tempera, his favorite medium. As a painter he is entirely self-taught, though he obtained his degree as an architect in the Polytechnic School of his native city. He has painted a number of frescoes in private homes as well as many canvases of landscapes and local types.

Prado's work has been seen in group shows in Buenos Aires, Santiago de Chile, and London, as well as in Brazil. His first one-man show took place in São Paulo in 1943. The artist has been living in the United States for several months, and in October of this year his paintings were shown at the Kleeman Gallery, New York. The works which the Pan American Union is pleased to present in this exhibition represent the majority of those which figured in the New York one-man show.

CATALOGUE

Temperas

1. *Fisherman*
2. *In the Café*
3. *Fish*
4. *Man and Bull*
5. *The Statue*
6. *The Violinist*
7. *The Lovers*
8. *Nudes in Landscape*
9. *Street Corner*
10. *Spring*
11. *Night Scene*
12. *Cock*
13. *Evening Shadows*
14. *The Cellist*
15. *Landscape*
16. *Landscape with Figures*
17. *Woman with Child*
18. *Flowers*
19. *Family*
20. *Still Life*
21. *Dancers*
22. *Salomé*

YEAR 1948

January 7 - 18, 1948

JUAN MANUEL STURLA: PAINTINGS OF ARGENTINA

Juan Manuel Sturla, who was born in the Province of Córdoba, Argentina, in 1907, is a self-taught artist. He held his first exhibition in Buenos Aires in February 1947. Country scenes of his homeland provide his favorite subject matter for these oil paintings. Mr. Sturla is at present visiting the United States. —From Press Release No. 9827, Pan American Union, Washington, D.C.

CATALOGUE

Oils

1. *The Ombú Tree*
2. *Tree Trunks at Lake Gutiérrez*
3. *Shadows on the Wall*
4. *The Chapel of the Sarmientos*
5. *Light and Shadow*
6. *The Old Water Tank*
7. *On the Road to Mercedes*
8. *The Hour of Prayer*
9. *Gold in the Fields*
10. *In the Sierra*, Córdoba
11. *Mist*
12. *Cold*, Nahuel Huapí
13. *At Sunset*
14. *The House of the Eucalyptus Trees*
15. *The Road to Progress*
16. *After the Rain*
17. *Pulpería*
18. *The Hillocks*
19. *The Foothills*
20. *House of the Rancher*

January 19 - February 8, 1948

FRANCISCO DOSAMANTES

The Pan American Union takes pleasure in presenting this group of oils, pastels, and drawings by Francisco Dosamantes, which has been widely circulated among the museums and galleries of the United States for more than a year. It represents the work of one of the outstanding members of what has been called "the third generation of

modern Mexican painters."

Born in Mexico City in 1911, Dosamantes studied in the Fine Arts School there and worked alongside Diego Rivera as his protégé.

He has done murals in Oaxaca, Michoacán, Chihuahua, and Mexico City. His work is included in important collections in Mexico and in the Museum of Modern Art, the Fogg Museum of Harvard University, the Metropolitan Museum of New York, the Philadelphia Museum of Art, the Chicago Art Museum, the International Business Machines Collection, and other institutions in this country.

Dosamantes's work as an engraver has become well known through the editions of the Taller de Gráfica Popular of Mexico and the Associated American Artists in the United States. The artist has also been a teacher of drawing and painting in his native country.

He recently returned to Mexico from New York to complete a new set of murals in Michoacán and to resume teaching.

CATALOGUE

Oils

1. *Portrait of a Girl*
2. *Lucy*
3. *Self-Portrait*
4. *Still Life with Jar*
5. *The Unemployed*
6. *Still Life with Watermelon*
7. *Three Women*
8. *Mayan Women*
9. *Still Life with Fish*
10. *Landscape, Yucatán*
11. *Mexican Shells*
12. *The Philosopher*

Pastels

13. *The Mayan Women No. 1*
14. *The Mayan Women No. 2*
15. *The Market Place*
16. *Two Dock Workers*

Drawings

17. *Three Mayan Women*
18. *Weaving the Hammock*

Lithographs and Linoleum Cuts[1]

[1] Titles are unavailable. —*Ed.*

February 9 - 23, 1948

LUIS ALBERTO ACUÑA: PAINTINGS FROM COLOMBIA

The Pan American Union takes pleasure in presenting this group of paintings and lithographs by one of the three Latin American artists who were awarded Guggenheim Fellowships in 1947, Luis Alberto Acuña of Colombia.

Born in Suaita, Colombia, in 1904, Acuña attended the School of Fine Arts in Bogotá and won a government scholarship to study at the Ecole des Beaux-Arts in Paris in 1924. His work was exhibited in Paris in 1926, with the French government buying one of his paintings for the Luxembourg Museum. Returning to Bogotá in 1930, he taught at the School of Fine Arts there. An appointment as attaché to the Colombian Legation in Mexico gave him the opportunity for further study and painting in that country. Subsequently Acuña became director of the Colón Theatre in Bogotá and in 1944 director of the School of Fine Arts.

In his early work Acuña showed a preference for sculpture, but more recently has devoted more of his time to painting. He is also known as a writer on contemporary art and an authority on pre-Columbian culture. His work has been exhibited in France, Mexico, Colombia, and the United States and is represented in collections in this country, Colombia, and France.

CATALOGUE

Oils

1. *Sailor's Wife*
2. *The Human Still*
3. *Amazonic Jungle*
4. *Mascarada (Masquerade)*, 1943
5. *Souvenir of Cartagena*
6. *View of the Andes*
7. *Double Portrait*
8. *Ancient Street Corner in Cartagena*
9. *Tragic Tauromachy*
10. *Indian Inspiration*
11. *Strange Characters*
12. *Fantastic Flowering*
13. *Huitaka*
14. *Don Quixote and Sancho*
15. *Village Baptism*
16. *El beso (The Kiss)*
17. *Mystic Melody*
18. *The New Bride*

Lithographs

19. *Internal Struggle*
20. *Composición espectral (Spectral Composition)*
21. *Tañedor de flauta (The Flutist)*
22. *Huitaka*
23. *Autorretrato (Self-Portrait)*
24. *Andean Landscape*
25. *Romances of the Peasants*

February 24 - March 31, 1948

PAINTINGS FROM HAITI

The work of Haiti's primitive painters has become widely known in the United States in the past two years. The American public has not had the opportunity to become so familiar with Haiti's trained modern artists. They have been hard at work in Le Centre d'Art in Port-au-Prince, the same center which stimulated the self-taught painters. If these artists are not primitive, neither can they be called academic. They are free, independent artists who have had varied training, and their work shows great variety.

The Pan American Union takes great pleasure in presenting these modern Haitian paintings and drawings, which were exhibited at the Jacques Seligmann Galleries in New York in December.

DeWitt Peters, founder and director of Le Centre d'Art, writes of the collection: "It is the hope of the Centre d'Art that this show will bring about a realization that Haitian painting is not all primitive."

CATALOGUE

Paintings

Father Parisot
 1. *Paysage Haïtien (Mountain Landscape)*

Maurice Borno
 2. *Tambourineur (Drummer)*
 3. *Cérémonie vodouesque (Voodoo Rite)*
 4. *Coq de combat (Fighting Cock)*

Géo Remponeau
 5. *Femmes du marché (Market Women)*

Léon Agnant
 6. *Le musicien (Musician)*

Luce Turnier
 7. *Jeune fille en train de se coiffer (Young Girl Combing Her Hair)*

Watercolors

Jean-Baptiste Bottex
 8. *Idylle paysanne (Peasant Idyll)*
 9. *Cérémonie des poules (Voodoo Rite)*

Lucner Lazard
 10. *Maisons de campagne (Native Houses)*
 11. *Le chemin (The Road)*

Drawings

Lucien Price
12-20. *Nine Studies*

BIOGRAPHICAL NOTES[1]

AGNANT, Léon. Painter, born in Port-au-Prince, 1929. His first vocation was to be a Catholic priest and is at present studying Humanities at the Petit Seminaire Collège Saint-Martial. Joined the Centre d'Art, 1944, where he participated in group exhibitions.

BORNO, Maurice L. Painter, draftsman, lawyer, born in Port-au-Prince, 1917. Started sketching and doing caricatures since an early age, but devoted consistently to painting when the Centre d'Art was founded. Exhibited in Haiti and the United States.

BOTTEX, Jean-Baptiste. Painter, wood carver, born in Port-Margot, Haiti, 1918. Self-taught artist, started as a cabinetmaker later becoming a wood sculptor. At present works mainly with watercolor painting.

LAZARD, Lucner. Painter, draftsman, born in Haiti, 1928. Started painting at the Centre d'Art in 1944.

PARISOT, Father Jean. Catholic priest, painter, born in Port-au-Prince, 1918. Studied in Rome, receiving a degree in philosophy. Started painting at an early age, but abandoned it until 1944, when he began to frequent the Centre d'Art. Since 1934 exhibited in group and individual exhibitions in Haiti and the United States. Was awarded a First Prize for Oil Painting in Port-au-Prince.

REMPONEAU, Géo (George Remponeau). Painter, born in Haiti, 1916. Self-taught as an artist, started painting in 1932. Belongs in the same group with Pétion Savain and Edouard Preston. He is assistant instructor in drawing and painting at the Centre d'Art.

April 1 - 30, 1948

CUNDO BERMUDEZ: OILS AND GOUACHES

This is Cundo Bermúdez's first one-man show in the United States. Previously, his work has been seen in group shows organized by the Council of Inter-American Cooperation and the Museum of Modern Art, both of New York. Born in Havana in 1914, Bermúdez is largely a self-taught artist. He has traveled in Mexico, Haiti, and the United States. His interpretations of the details of daily life in his native country lie between humor and irony. They reveal a thorough knowledge of color and a fine decorative sense. His favorite forms are based on the richly ornamented colonial Cuban interiors and stained glass windows.

Bermúdez has held one-man shows at the Lyceum, Havana, since 1942 and at the Centre d'Art, Port-au-Prince, Haiti, in 1947. He has figured in group exhibitions in Argentina, Guatemala, Haiti, Mexico, Venezuela, and Costa Rica. On the occasion of the first showing of one of his works at the Museum of Modern Art in 1943, the late Edward Alden Jewell, art critic of the *New York Times*, said it demonstrated "that color propelled to brazen pitch can, when kept in hand, be made to accomplish capital results."

Works of the artist are included in the collections of the Museum of Modern Art, the William Rockhill Nelson Gallery of Art in Kansas City, the Museo de la Plata, Argentina, the Centre d'Art, Port-au-Prince, and numerous private collections.

[1] Not included in the original catalogue. See Index of Artists for reference on those not listed here. —*Ed.*

CATALOGUE

Oils

1. *Street in Havana*
2. *The Barber and His Wife*
3. *Balcony and Landscape*
4. *Nudes in the Afternoon*
5. *Near the Cathedral, Havana*
6. *Figure*
7. *Corner in a Park*
8. *Woman at the Table*
9. *The Goblet*
10. *Street in Old Havana*
11. *After Dinner*. Coll. Ms. Concha Romero James

Gouaches

12. *The Yellow Rocking Chair*. Coll. Mr. Albert R. Miller
13. *Flowerpot*. Coll. Mr. Joaquín Meyer
14. *Sitting Girl*. Coll. Mr. Luis D. Gardel
15. *Family on the Balcony*. Coll. Mr. Enrique Pérez-Cisneros
16. *Woman*. Coll. Ms. Leticia Guerrero
17. *Lovers*
18. *The Striped Robe*
19. *Toilette*
20. *Interior with Figures*
21. *Still Life*
22. *Woman at the Table*
23. *Flowers*. Coll. Mr. Carlos Blanco

May 3 - 31, 1948

LASAR SEGALL

Although born in Vilna, Lithuania, in 1890, Lasar Segall is considered a Brazilian painter. Except for a few short absences he has lived in Brazil since 1923 and stimulated a completely new plastic movement in the city of São Paulo, his adopted home.

The Pan American Union takes pleasure in exhibiting this group of paintings with the cooperation of the Associated American Artists, who represent the artist in the United States. It is part of the collection displayed at the Associated American Artists Galleries in New York during the month of March in Segall's first one-man show in this country.

At that time Howard Devree, *New York Times* critic, said of Segall's work: "On more strict aesthetic grounds Segall's work is of special interest because of his consistent low palette throughout—grays and soft browns in infinite variety, with occasional low gray-greens. His arrangements are sound and do not lack strength, being based on semi-abstract use of forms." Jo Gibbs wrote in *Art Digest*: "For all the range in time, size, subject, media, and the artist's own background, this is strangely homogeneous." And Emily Genauer, writing in the *New York World Telegram*, described his technique in these words: "His palette at first glance seems reticent to the point of dullness.

Examine it longer and you see how subtle it is, how carefully and effectively it has been compounded of an infinite range and variety of delicate tone."

Segall has previously exhibited in Dresden, Hagen, Frankfurt, Leipzig, Berlin, Stuttgart, Paris, Rome, Milan, and in Brazil. His work is represented in important museums and collections both in Europe and in America.

CATALOGUE

Oils

1. *Cinco figuras (Five Figures)*
2. *A mulher reclinada (Reclining Girl)*
3. *Jovem leitora (The Girl Reader)*. Coll. Dr. K. Arnhold, São Paulo
4. *A casinha preta (The Black Cabin)*, 1931, 73 x 54 cm.
5. *A jovem dos cabelos compridos (The Girl with the Long Hair)*, 1942, 50 x 65 cm.
6. *Gado em pirâmide (Pyramids of Cattle)*, 1946, 50 x 65 cm.
7. *Nú na floresta (Nude in the Forest)*
8. *Vacas na montanha (Cows in the Mountains)*
9. *Passeio no campo (Walk in the Fields)*, 1941, 42 x 55 cm.
10. *Natureza morta (Still Life)*
11. *Perfil de Lucy (Profile of Lucy)*
12. *Mãe cabocla (Caboclo Mother)*, 1944, 35 x 47 cm.
13. *Primavera (Springtime)*, 1936, 36 x 43 cm.
14. *Moça da guitarra (Girl with Guitar)*
15. *Girl's Head No. 2*
16. *Natureza morta (Still Life)*

Gouaches

17. *Cows in the Moonshine*
18. *Mulas (Mules)*
19. *Grupo (Group)*
20. *The Couch*

Drawings

21. *Estudo (Study)*
22. *Cow and Her Calf*

June 1 - 27, 1948

WATERCOLORS, DRAWINGS, TEMPERAS BY ARTISTS OF ARGENTINA

The notable Buenos Aires magazine of arts and letters, *Saber Vivir*, had the happy idea of organizing an exhibition of watercolors, drawings, and temperas by some of the most distinguished exponents of modern art in Argentina, offering it to the Pan American Union to be presented to the Washington public and then circulated throughout the United States.

Thus we are able to acquaint ourselves with some of the currents of the new art in Argentina. These works, while not of great proportions or painstaking execution, possess the interest of fresh and spontaneous expression, in which

the artist acts with greater freedom than he can when making a definitive work. These small paintings and drawings reveal to the American public one of the most progressive aspects of art in Argentina. The Pan American Union is therefore particularly grateful to *Saber Vivir* for its kindness in making this exhibition possible, and to all who cooperated in bringing it about.

CATALOGUE

Paintings and Drawings

Aquiles Badi
1. *The Death of Caesar*, tempera

Héctor Basaldúa
2. *Afternoon*, tempera
3. *Woman and Child*, tempera

Antonio Berni
4. *Portrait of E. Castelnuovo*, pencil drawing
5. *Boy*, pencil drawing

Mane Bernardo
6. *Corner*, La Plata, watercolor
7. *Rooftops*, La Plata, watercolor

Alfredo Bigatti
8. *Figure*, ink drawing
9. *Figure*, watercolor and ink

Rodrigo Bonome
10. *Procession in Belén*, Catamarca, watercolor
11. *Landscape of Maimará*, Jujuy, watercolor

Norah Borges
12. *Girl*, pencil drawing
13. *Mermaid*, watercolor

Horacio Butler
14. *El Tigre*, pencil drawing
15. *Interior*, pencil drawing

Carybé
16. *Composition*, ink drawing
17. *Figures*, ink drawing

Lucía Capdepont
18. *Nude*, charcoal

J.C. Castagnino
19. *El baqueano*, ink drawing
20. *Mother and Child*, ink drawing
21. *Composition*, ink drawing

Domínguez Neira
22. *Landscape of Córdoba*, watercolor
23. *Landscape of Córdoba*, watercolor

Raquel Forner
24. *Sketch for "The Judgement,"* pencil
25. *Icarus*, tempera
26. *Sketch for "Man,"* pencil and crayon

Jorge Larco
27. *Delta*, pencil drawing
28. *Bullfighter*, watercolor
29. *Nude*, watercolor

Juana Lumerman
30. *Street Corner*, watercolor

Raúl Soldi
31. *House by the River*, tempera
32. *Still Life*, tempera
33. *Paving the Street*, tempera

Demetrio Urruchúa
34. *Figure*, monotype
35. *Untitled*, pencil drawing
36. *Untitled*, ink drawing

Photographs of some of the artists represented were taken by Grete Coppola of Buenos Aires.

BIOGRAPHICAL NOTES[1]

BADI, Aquiles. Painter, draftsman, born in Buenos Aires, 1894. While still very young, went with his family to Italy and studied in Milan. In 1909 returned to Argentina and enrolled at the National Academy. In 1920-33 was in Europe, living most of the time in Paris and Italy and traveling through Germany, Austria, Switzerland, Greece, and Spain. While in Paris studied under Charles Guérin and Le Fauconnier. In 1933 returned to Argentina and spent some time teaching in his own school. In 1939 visited Brazil and since 1941 has made his home in Milan, Italy. Participated in national salons in Buenos Aires; International Exposition, Paris, 1937; New York World's Fair, 1939; Museum of Modern Art, New York, 1943; and *Exposición Panamericana de Pintura Moderna*, Caracas, 1948.

BASALDUA, Héctor. Painter, illustrator, set designer, born in Pergamino, Argentina, 1895. Studied at the National Academy of Fine Arts in Buenos Aires and in 1923 was awarded an Argentine fellowship to study in Europe. Visited Spain and lived in Paris, 1923-30, where he studied under André Lhote and Othon Friesz. In recent years, the National Cultural Committee sent him to Europe for short periods of study. At present he is the stage design director of the Teatro Colón, having done more than fifty opera and ballet sets. Held one-man shows in Buenos Aires. Participated in the International Exposition, Paris, 1937; New York World's Fair, 1939; Museum of Modern Art, New York, 1943, and many group exhibits in Argentina.

[1] Not included in the original catalogue. See Index of Artists for reference on those not listed here. —*Ed*.

BONOME, Rodrigo. Painter, born in Buenos Aires, 1906. Studied at the Escuela Nacional de Bellas Artes. Since 1924 held one-man shows in Buenos Aires and participated in many national and international exhibitions, including those held at the Riverside Museum, New York, 1939, and the Virginia Museum of Fine Arts, Richmond, 1940. Was awarded first prizes in Buenos Aires art salons, 1942 and 1943.

BORGES, Norah (Norah Borges de Torre). Painter, draftsman, illustrator, born in Buenos Aires, 1901. Studied at the Ecole des Beaux-Arts, Geneva. Also lived and studied in Spain, where she designed the sets for the University Theatre directed by García Lorca, 1934. Illustrated many books. Held individual exhibitions in Buenos Aires. Participated in group exhibitions in Buenos Aires; Museum of Modern Art, Madrid, 1933; Harvard University, Cambridge, 1934; Museum of Modern Art, New York, 1943.

BUTLER, Horacio A. Painter, draftsman, illustrator, stage and costume designer, born in Buenos Aires, 1897. Studied architecture and later painting at the Academia Nacional de Bellas Artes, 1914-19. In 1923 went to Europe and spent the next ten years traveling in Germany, Italy, and France. Worked under André Lhote and Othon Friesz in Paris. In 1942 was invited to the United States by the Department of State. Has lived in Buenos Aires since 1937, working as stage designer, book illustrator, and professor of interior decoration at the Academy of Fine Arts. Held individual exhibitions in Argentina. Participated in group exhibitions in Paris, Montevideo, Caracas, New York (Riverside Museum, 1939), San Francisco (Golden Gate International Exposition, 1939), among others.

CAPDEPONT, Lucía (Lucía Capdepont de Butler). Painter, draftsman, born in Buenos Aires, 1899. Has exhibited in national salons since 1938.

DOMINGUEZ NEIRA, Pedro. Painter, born in Buenos Aires, 1894. Studied at the Academia Nacional de Bellas Artes, Buenos Aires, and under André Lhote, Paris, 1929-30. Traveled in Italy, Spain, and Germany. At present teaches art courses in Buenos Aires. Held one-man shows in Buenos Aires. Participated in national salons, New York World's Fair, 1939, the Golden Gate International Exposition, San Francisco, 1939, among others. Was awarded several prizes in Buenos Aires, including First Prize, *Exhibition of Applied Arts*, 1925.

LUMERMAN, Juana. Painter, draftsman, born in Buenos Aires, 1905. Held individual exhibitions in Buenos Aires. Participated in national and international group exhibitions.

URRUCHUA, Demetrio. Painter, muralist, draftsman, printmaker, born in Pehuajó, Argentina, 1902. Studied at the Sociedad Estímulo de Bellas Artes, Buenos Aires; in Paris, 1924; with sculptress Cecilia Marcovich, Buenos Aires. Executed the mural at the Women's University, Montevideo, 1939-41. Works as a cabinetmaker. Held one-man shows in Buenos Aires, Montevideo, New York. Participated in national salons and group exhibitions at the Museum of Modern Art, New York, 1943; Institute of Modern Art, Boston, 1947, among others.

June 28 - July 14, 1948

CARLOS OTERO

Carlos Otero was born in Venezuela and received his early training at the School of Plastic Arts in Caracas. After graduating from this institution with a number of awards, he studied for two years at the National Art School in Buenos Aires and later went to Paris, where he spent fourteen years under the tutelage of the well-known French painter Cormon.

Otero's work has been featured in a number of Paris exhibitions as well as in group showings in Italy, Belgium, Colombia, Argentina, Venezuela, and the United States. He was the recipient of a prize at one of the Paris exhibits and was also awarded a gold medal for one of his paintings displayed at the Universal Exposition of Liège in

Belgium. In his own country, Otero has been director of the School of Plastic Arts and of the Museum of Fine Arts in Caracas, as well as one of the founders of the Salón de Independientes de Venezuela.

Principally devoted to work on landscapes, Otero in recent years has given more time to painting the different aspects of Venezuelan life. His work is characterized by the impressionistic treatment of his subject matter and by the use of brilliant color in depicting the natural beauties of his native land.

The current exhibit at the Pan American Union is Otero's first one-man show in the United States.

CATALOGUE

Paintings

1. *Old Woman*
2. *Catia La Mar*
3. *La Guaira*, sketch
4. *Road to Macuto*
5. *Sacristy*
6. *Caribito, Macuto*
7. *Docks, La Guaira*
8. *Carenero*
9. *Guaiquerí*
10. *Boleíta*
11. *Araguaney*
12. *Street in Baruta*
13. *Beaches of Macuto*
14. *Petare*, Boleíta
15. *Las Mercedes*
16. *Tanaguarena*
17. *Caigüire*
18. *El Avila*
19. *Hills, La Guaira*
20. *Cardones*
21. *Arepera*
22. *Fisherman*, sketch

July 15 - July 31, 1948

JOSE SOLARI HERMOSILLA: WATERCOLORS OF LATIN AMERICA

For several years the Peruvian painter José Solari Hermosilla has made a practice of traveling through the Americas and conveying the impressions gained from his travel in a series of watercolors which he has later exhibited in each of the countries visited.

The Pan American Union is now presenting a selection from that extensive series, the lack of sufficient exhibit space rendering impossible a display of the work in its entirety. In any case, the group being shown in Washington at this time is large enough to reveal the ability of this artist.

Solari Hermosilla has studied in New York, Havana, and Lima. He has exhibited his work in Mexico, Colombia, Costa Rica, Guatemala, Ecuador, El Salvador, and Cuba, where the artist is at present preparing, before his return to Peru, new watercolors that will add to his already extensive works.

CATALOGUE

Watercolors

Peru

1. *Balsa de totora (Balsa Rafts)*, Lake Titicaca
2. *Roofs in the Highlands*
3. *Templo del Sol (Temple of the Sun)*, Inca Ruins in Cuzco
4. *Town on the Coast*, Paita
5. *Street Scene in the Highlands*
6. *Convento de San Francisco (San Francisco Convent)*, Lima
7. *Temple of San Francisco*, Lima
8. *Landscape in the Andean Mountains*
9. *Old Jesuit Convent*, Cuzco
10. *Colonial Balcony*, Trujillo
11. *India tejiendo (Indian Woman Weaving)*, Canchaque, Piura

Guatemala

12. *Mayan Indian Women on Lake Atitlán*
13. *Guatemalan Daybreak*

Mexico

14. *Moonlight in Acapulco*
15. *Landscape of the Mexican Valley*
16. *Scene in Puebla*

Panama

17. *Tropical Landscape*

Colombia

18. *Barco en el río Magdalena (Canoe on the Magdalena River)*
19. *Rincón del río Magdalena (On the Banks of the Magdalena River)*

Ecuador

20. *Outskirts of Pichincha*
21. *In an Ecuadorian Town*

August 2 - 31, 1948

ARMANDO PACHECO OF BOLIVIA

Armando Pacheco was born in La Paz in 1910 and first became known in the art world as a cartoonist, his works appearing in various Bolivian publications since 1928.

Between 1930 and 1932 he studied architecture and engineering at the University of San Andrés and attended the School of Fine Arts in La Paz, at the same time contributing to several group exhibitions in his country. On two later occasions his works were exhibited in Peru, and in 1942 he was named art editor of the La Paz newspaper *La Razón*.

From 1945 to 1947, on a scholarship awarded him by the Bolivian government for study abroad, he remained in New York, where he studied at the Art Students League and in the workshops of Yasuo Kuniyoshi and Vaclav Vytlacil. In 1947 he was granted a fellowship by the Guggenheim Foundation.

This exhibition, his first in the United States, will present some of the works Armando Pacheco has completed during these years of study. The artist will return to Bolivia at the end of 1948.

CATALOGUE

Oils

1. *Dawn*
2. *The Ferryman, Cisco*
3. *The Kid*
4. *Toiler*
5. *Motherhood*
6. *First Letter*
7. *Two Women*
8. *Terror*
9. *Landscape*
10. *Sweethearts*
11. *Indian Miserere*
12. *Dreamer*
13. *Landscape*
14. *News Vendor*
15. *Still Life*

Temperas

16. *Head*
17. *Fugitives*
18. *Untitled*, drawing
19. *Untitled*, drawing

September 1 - 30, 1948

FACULTY ARTISTS, DEPARTMENT OF FINE ARTS, THE AMERICAN UNIVERSITY[1]

The Art Faculty of the American University has been a pioneer in the teaching and the promotion of interest in modern art in the capital of the United States.

Now, after more than twenty years of activity in this field, this university is recognized both nationally and internationally as one of the foremost educational centers where a student of art may pursue his work in close touch with recent aesthetic developments and, at the same time, benefit from the discipline of academic training.

The Department of Fine Arts of this university, however, has not limited its activities to those of instruction in the field of plastic arts, but has also contributed a great deal to the development of an interest in modern art among the general public in Washington by means of the Watkins Gallery. This gallery, a "growing, permanent collection of contemporary art," is located on the university campus and is open to all who wish to visit it and enjoy the exhibits regularly held there.

As the first step in a plan of close cooperation between the Department of Cultural Affairs of this organization and other institutions devoted to the stimulation and diffusion of culture throughout the entire continent, the Pan American Union is happy to be able to present at this time a selected group of works executed by the artists of the Art Faculty of the American University.

CATALOGUE

Paintings

Sarah Baker
1. *Clown*, oil
2. *Still Life with Grapes*, 1947, oil
3. *The Blue Salt Box*, 1948, oil

William Calfee
4. *Pegasus*, 1948, oil
5. *Birds*, 1948, oil
6. *Abstraction*, 1948, oil

John Galloway
7. *The Child's Holiday*, 1948, oil
8. *Duo*, 1948, tempera
9. *Expectant Figures*, 1948, tempera

Robert Gates
10. *Squid and Sanderlings*, 1948, tempera
11. *Birds in Winter*, 1947, tempera
12. *Fireflies*, 1947, tempera

[1] This exhibition was also shown in Havana, under the auspices of the Pan American Union, January 10-19, 1949. —*Ed.*

Pietro Lazzari
13. *Head of Evelyn*, fresco
14. *Face*, fresco
15. *Two Figures*, fresco

Leo Steppat
16. *Abstraction*, 1947, gouache
17. *Abstraction*, 1947, gouache
18. *Martial Head*, 1947, gouache

Joe Summerford
19. *Still Life with Glass Pitcher*, 1948, oil
20. *Still Life with Cantaloupe*, 1948, oil
21. *The Net*, 1948, oil

Jack Tworkov
22. *Blue Still Life*, 1948, oil
23. *Standing Figure*, 1948, oil

ABOUT THE ARTISTS

BAKER, Sarah. Born in Memphis, Tennessee. Studied at the Pennsylvania Academy and with André Lhote in Paris. Represented in the collections of the Brooklyn Museum, the Phillips Memorial Gallery, and the Watkins Gallery. Assistant professor of painting at the American University.

CALFEE, William. Born in Washington, D.C., 1909. Studied at the Phillips Memorial Gallery, under Paul Landowski at the Ecole des Beaux-Arts in Paris, at the Catholic University and at the Cranbrook Academy of Fine Arts in Detroit. Represented in the collections of the Baltimore Museum of Art, the Phillips Memorial Gallery, the Philbrook Art Center, the Cranbrook Academy, and the Edward Bruce Memorial Collection. Executed many murals under the Section of Fine Arts Program of the United States government. Chairman of the Department of Painting and Sculpture, the American University.

GALLOWAY, John. Born in Cabot, Arkansas, 1915. Studied at George Washington University, in the studio of Theodora Kane, and with William Calfee at the American University. Painted large mural in Mary Graydon Hall, the American University. Represented in many private collections. Instructor in art at the American University and editor of the art journal *Right Angle*.

GATES, Robert. Born in Detroit, Michigan, 1906. Studied in the Detroit School of Arts and Crafts, at the Phillips Memorial Gallery, and with C. Law Watkins and Henry Varnum Poore. Has executed several murals. Represented in the collections of the Phillips Memorial Gallery, the Baltimore Museum of Art, and in the Dumbarton Oaks Collection. Assistant professor of painting at the American University.

LAZZARI, Pietro. Born in Rome, 1898. Now an American citizen. Studied at the Ornamental School of Rome. Has executed several murals. Represented in the collections of the Watkins Gallery and the Phillips Memorial Gallery. Works in a great variety of media, including cement panels, etching, etc. Instructor in painting and sculpture at the American University.

STEPPAT, Leo. Born in Vienna, 1910. Resident and citizen of the United States since 1940. Studied at the Academy of Fine Arts of the Republic of Austria. Represented in the collections of the Smithsonian Museum, Museo Nacional de Mexico, and in private collections in Vienna, London, New York, and Washington. Teaches sculpture in the Department of Fine Arts, the American University.

SUMMERFORD, Joe. Born in Montgomery, Alabama, 1924. Studied at the American University and under Karl Knaths at the Phillips Memorial Gallery. During the summer of 1948, instructor in painting in the Department of Fine Arts, the American University.

TWORKOV, Jack. Born in Poland, 1900. Resident of the United States since 1913. Represented in private collections in New York, Cambridge, Baltimore, and Washington. During the summer of 1948, instructor of painting at the American University.

October 1 - 31, 1948

LANDSCAPES OF GUATEMALA: OILS BY HUMBERTO GARAVITO

Humberto Garavito was born in 1897 in Quezaltenango, where he completed his first studies. His first one-man show was held in the capital of Guatemala in 1916, and since that time he has worked continually, specializing in landscapes and always endeavoring to develop his creative talents further in that field.

In 1919 Garavito went to Mexico, where he remained until 1922, studying at the Escuela de Bellas Artes. Later he went to Europe to pursue his studies and traveled through Spain, France, Italy, Belgium, and Germany. In 1928 he returned to Guatemala and was appointed a professor in the Academia de Bellas Artes, a position he held until 1935.

His work has been exhibited in Madrid, Paris, Mexico, San José, San Salvador, and Quito, and since 1920 he has been represented in numerous group expositions in the United States. In March of this year he presented an extensive series of his work for display in the International House in New Orleans. Henry E. Jacobs, critic for the *New Orleans States*, referred to Garavito's paintings as "the finest contemporary examples of their style." Concerning his skill in the use of color, Alberta Collier said in the *Times Picayune*: "He plays with color as with a familiar friend."

In these *Landscapes of Guatemala* which the Pan American Union has the pleasure of presenting to the public of Washington, the artist has captured, in his usual style, the most interesting aspects of the beauties of his native country. These works not only show clearly Garavito's superiority as a painter, but also depict the scenic wonders of Guatemala in such a way as to inspire us with the desire to become better acquainted with this beautiful Central American republic.

CATALOGUE

Oils

1. *Ruins of San Francisco and the Fuego and Acatenango Volcanoes*, Antigua
2. *Colonial Fountain La Merced*, Antigua
3. *Church of La Natividad*, Antigua
4. *Street in Zunil*, Quezaltenango
5. *Street of El Calvario*, Cobán, Alta Verapaz
6. *A Family*, San Cristóbal, Totonicapán
7. *View of the Town*, San Cristóbal, Totonicapán
8. *Colonial Street*, San Cristóbal, Totonicapán
9. *The Cerro Quemado*, Quezaltenango
10. *Volcano Santa María*, Quezaltenango
11. *Public Fountain*, Chichicastenango, Quiché

12. *The Central Square*, Chichicastenango, Quiché
13. *Scene in the Church Entrance*, Chichicastenango, Quiché
14. *San Pedro Volcano from Santander*, Lake Atitlán, Sololá
15. *Panajachel after the Rain*, Sololá
16. *Atitlán and San Lucas Volcanoes from San Jorge*, Sololá
17. *The Lake Atitlán and Volcanoes from Sololá*
18. *View of the Town and the River*, Salcaja, Quezaltenango
19. *The Abandoned Hermitage*, Salcaja, Quezaltenango
20. *The Cuchumatanes*, Huehuetenango

October 27 - November 9, 1948

ARMANDO SICA: PAINTINGS OF THE AMERICAS

Armando Sica, professor in the Escuela Nacional de Bellas Artes of Buenos Aires since 1944, has been traveling throughout the Western Hemisphere, painting the most interesting scenes and people encountered on his journey. Up to the present time his travels have taken him to Bolivia, Peru, Ecuador, Colombia, Panama, Honduras, El Salvador, Guatemala, Mexico, the United States, and Canada. The Pan American Union now presents the paintings that have resulted from the artist's experiences in those countries, as well as some other works he has done depicting typical scenes in his native Argentina.

Professor Sica was born in Buenos Aires in 1917 and studied in the same school where he now teaches, later continuing his studies in the Escuela Superior de Bellas Artes in the capital. His paintings have been exhibited in almost all those countries through which he has traveled, and his work is represented in the collections of the Casa de la Moneda and the Museo de la Universidad, both in Potosí, Bolivia, the Museo Nacional de Bellas Artes in Buenos Aires, the Museo de La Plata in Argentina, and in many private collections.

Sica now hopes to become well acquainted with the United States and to paint some of its most attractive scenes. These works he will eventually show in other countries to be visited before his return to Argentina.

CATALOGUE

Paintings

Bolivia

1. *Head*
2. *Girl*
3. *Orange Market*, La Paz
4. *Tiquina Strait*

Peru

5. *Portrait of the Photographer Martín Chambi*
6. *Ruins of Huiñi-Huaina*
7. *Feast in Quiquijana*

Ecuador

8. *Colorado Indian*, Santo Domingo
9. *Road to the Lake*, Otavalo
10. *Indian Cemetery*, Otavalo

Colombia

11. *Cartagena*
12. *Cerro Montserrate*

Panama

13. *Houses*

Honduras

14. *Proletarian*
15. *Blind Man*

El Salvador

16. *Patio*

Guatemala

17. *Chichicastenango*
18. *Ghosts in the Ruins of San Francisco*, Antigua
19. *Angel Bricklayer*, Antigua
20. *Boy's Head*

Mexico

21. *The Red House*, Mexico City
22. *Children*, Chiapas

United States

23. *Pines*, Yellowstone Park
24. *Houses*, Washington, D.C.

Canada

25. *Rooftops*, Quebec

Argentina

26. *The Letter*
27. *Figure*
28. *Girl*, Córdoba
29. *Boy*, Córdoba

30. *Native Farm Boy*
31. *Country Boy*, Córdoba
32. *Summer*, Bariloche
33. *Geese*, Bariloche
34. *Man Resting*, Córdoba
35. *Late Afternoon*, Bariloche
36. *Town in the South*, Bariloche
37. *Fishing Boats*, Mar del Plata
38. *Seashore*, Mar del Plata

Drawings and Prints[1]

November 1 - 16, 1948

OLGA MARY: PAINTINGS OF BRAZIL

Born in Rio de Janeiro, Olga Mary began her artistic studies in the Escola Nacional de Belas Artes of that city. Later she went to Europe to pursue her studies. After completing a course in the improvement of painting technique in Florence in 1928, she moved on to France, where toward the end of 1929 she studied in the Académie Julian in Paris.

Olga Mary belongs to a family of artists. Her husband is the well-known Brazilian painter and engraver Raul Pedroza, and her daughter Misabel has just made her own debut as a painter, having held her first personal exhibitions this year in Rio de Janeiro and New York.

Olga Mary's work has appeared in more than ten individual shows in Brazil. She has held individual shows in many cities outside Brazil: in Paris in 1933 and 1937, at the Galerie Mona Lisa and the Galerie Durand-Ruel, respectively; in Berlin in 1937 at the Ibero-Amerikanischer Institut; in Buenos Aires in 1935 at the Dirección Nacional de Bellas Artes; and in Montevideo in 1946 at the Galería Berro.

In addition, her work has appeared in numerous group shows in Paris, São Paulo, Buenos Aires, among others, and she is represented in museums and important private collections in Brazil, Argentina, and Germany. The Pan American Union now presents the second exhibition of works by Olga Mary in the United States; the first was held in New York's Carroll Carstair's Gallery in September of this year.

CATALOGUE

Paintings

1. *Marília*
2. *Pivoines (Peonies)*
3. *Market Day*
4. *Itacurussa*
5. *Manacás (Manacas Blossoms)*
6. *Studio of the Sculptor Aleijadinho*, Ouro Preto
7. *Jesus, Fisherman of Souls*

[1] Titles are unavailable. —*Ed.*

8. *Egyptian Head*
9. *Carnaval (Carnival)*, Rio de Janeiro
10. *Salinas (Salt Hills)*, Cabo Frio
11. *Quarta Féria de Cinzas (Ash Wednesday)*, 1941
12. *Mocidade (Youth)*
13. *Casas de Pescadores (Fisherman's Huts)*
14. *Basket of Flowers*
15. *Igreja de São Benedito (Church of Saint Benedict)*, Cabo Frio
16. *New World Hill*, Rio de Janeiro
17. *Baiana das cocadas (Bahiana Selling Sweets)*
18. *Velho Pôrto (Old Port)*, Angra dos Reis
19. *Flores (Flowers)*
20. *Praia do Arpoador (Beach of Arpoador)*, Rio de Janeiro
21. *Old Street*, Minas
22. *Dunas (Dunes)*, Cabo Frio
23. *Bairro dos pescadores (Fisherman's District)*, Rio de Janeiro
24. *Orquídeas (Orchids)*
25. *Anêmonas (Anemones)*

December 6, 1948 - January 8, 1949

SOME RELIGIOUS PAINTINGS OF LATIN AMERICA

The Pan American Union takes great pleasure in presenting some examples of religious painting of Latin America belonging to public and private collections in the United States. Although some of these works were executed after political independence was achieved in the countries of their origin, all bear one unquestionable mark of unity—the imprint of Spain. Despite the differences in school and style, this one feature which the group has in common has remained intact since the colonial period and, assimilating indigenous expression as an inevitable part of its development, has produced in Latin America a blending which has brought about fruitful results.

This exhibition, which does not pretend to be a representative showing of the works of all the schools and much less of all the Latin American countries that possess a pictorial tradition from colonial times, serves nevertheless to give an approximate idea of the most important trends in religious painting from a time shortly after the Conquest until the end of the nineteenth century. Evidence of both professional and self-taught or unsophisticated styles is present in this selection, which clearly shows the effect of native elements tinged with reminiscences of European schools. That is to say, works of accomplished painting technique as well as popular paintings, even though the latter may appear primitive and uncouth, can offer proof of devotion and poetic feeling equal to that achieved by professional painters in their respective eras.

In presenting this group of religious works to the public of Washington, we wish to express our gratitude to the Ambassador of Ecuador, Señor Augusto Dillón, who has so kindly permitted us to show two extremely important paintings of the Quito school. At the same time, we wish to express our appreciation of the fine cooperation of the Philadelphia Museum of Art and the Brooklyn Museum, as well as of those private collectors whose fine contributions have helped to make this exhibit possible.

CATALOGUE

Fray Pedro Bedón (Ecuador, 1556-1621)
1. *Virgen de la Escalera (Virgin of the Stairway)*, 16th century, oil on canvas

Joaquín Pinto (Ecuador, 1842-1906)
2. *Dies irae*, 19th century, oil on tin. Coll. Ambassador of Ecuador, Sr. Augusto Dillón

Unknown (Ecuador)
3. *Virgin of Quinche*, 18th century, oil on tin. Coll. Mr. and Mrs. John Connor

Unknown (Guatemala)
4. *Saint Raphael*, 19th century, oil on canvas. Private collection
5. *Ex-Voto from Antigua*, 19th century. Coll. Mr. Ramón G. Osuna
6. *Ex-Voto from Antigua*, 19th century. Private collection

Manuel Caro (Mexico, 1761-1820)
7. *Image of the Virgin*, 18th century, oil on canvas

Unknown (Mexico)
8. *Rev. Mother María Antonia de Rivera*, 18th century, oil on canvas. Coll. Philadelphia Museum of Art
9. *Virgin of Guadalupe*, 18th century, oil on canvas. Coll. Mr. Oswald W. Bridge

Unknown (Peru)
10. *The Christ Child as an Apprentice Carpenter*, 17th century, Cuzco school
11. *Saint Joseph and Child*, oil on canvas
12. *Virgin of Mercy*, oil on canvas
13. *Virgin of Pomata*, oil on canvas
14. *Marriage of the Virgin*, oil on canvas. Coll. The Brooklyn Museum

Unknown (Venezuela)
15. *Virgin*, 19th century, oil on wood
16. *Nun and Two Angels*, 18th century, oil on wood
17. *Saint Michael, the Archangel*, 18th century, oil on wood. Private collection
18. *Virgin*, oil on wood. Coll. Mr. Ramón G. Osuna

BIOGRAPHICAL NOTES[1]

BEDON, Fray Pedro. Catholic brother, painter, draftsman, born in Quito, 1556. Died in the same city in 1621. At the age of twelve entered the Dominican Order in Quito. Was sent to Lima, 1576-1586, where he probably studied under the Italian Jesuit priest and painter Bernardo Bitti, and to the Nuevo Reino de Granada, now Colombia, 1593-1597. Founder of several convents, taught art, decorated many churches, and painted several murals. He is the main representative of mannerism in the Quito school.

CARO, Manuel. Painter, born in Tlaxcala, Mexico, 1761. Died in Puebla, 1820. Executed a considerable number of paintings in Puebla at the end of the eighteenth century and beginning of the nineteenth century. His work belongs to the transition period between the baroque and the neo-classic.

PINTO, Joaquín. Painter, born in Quito, 1842. Died in the same city, 1906. Studied under the main artists of his time, completing his education by himself. Executed religious scenes, landscapes, portraits, and genre paintings.

[1] Not included in the original catalogue. —*Ed.*

December 28, 1948 - January 12, 1949

ALEJANDRO OTERO: STILL LIFE, THEMES, AND VARIATIONS

After three years of study in Europe on a scholarship first awarded him by the French government from 1945 to 1947 and later extended by the government of Venezuela, Alejandro Otero is coming to America to exhibit in Caracas and in Washington part of the work he has done in Paris.

Otero was born in Upata, Venezuela, in 1921 and began his artistic studies in the Escuela de Artes Plásticas in Caracas, where he later became a professor of mural painting and stained glass technique, a position he held until going to France. He exhibited his work regularly in Caracas in the Salón Anual from 1941 to 1944, and was also represented in group shows in Bogotá. In Paris his work was shown in the Salon des Surindépendents in 1947 and in 1948 as well as in one-man shows in the galleries Gay-Lussac and Maeght. After these exhibitions the critic Robert Ganzo said: "In the burning and stormy work of Otero one sees the true painting of the age." In a Paris radio commentary another critic, François Sego, spoke of "an impression of vertigo . . . like the presence of death itself or of a great void" found in the work of this young painter.

At this time the Pan American Union is presenting a small selection of the paintings that Otero will show in Caracas early in 1949—a group of his experiments and "variations" on static themes, studies that establish his reputation as one of the most progressive artists in the new generation of creators in Latin America.

CATALOGUE

Oils on Canvas

1. *Two Pans*, 1946
2. *The Coffee Pot*
 -*Variation A*, 1946
 -*Variation B*, 1947
 -*Variation C*, 1947
3. *The Coffee Pot and the Pan*
 -*Variation A*, 1947
 -*Variation B*, 1947
4. *The Florentine Candelabra*
 -*Variation A*, 1947
 -*Variation B*, 1947
5. *The Green Candlestick*
 -*Variation A*, 1947
 -*Variation B*, 1947
6. *The Pan and the Triple Mirror*, 1947
7. *The Skull and the Triple Mirror*, 1947
8. *Skulls*
 -*Variation A*, 1947
 -*Variation B*, 1947
 -*Variation C*, 1947
 -*Variation D*, 1947
 -*Variation E*, 1947
9. *Cup with a Yellow Line*, 1947
10. *The Pink Coffee Pot*
 -*Variation A*, 1948
 -*Variation B*, 1948
 -*Variation C*, 1948

YEAR 1949

January 12 - February 15, 1949

FIRST INTERNATIONAL EXHIBITION OF LATIN AMERICAN PHOTOGRAPHY

This collection of works of Latin American photographers represents the first effort of the Pan American Union to introduce in the United States examples of an art which is developing within most of those countries.

In order to facilitate the organization of the exhibition and to offer equal opportunities, selection of the photographs to be included was made by the invited participants, either individual photographers or institutions.

In spite of the fact that numerous Latin American professional photographic organizations accepted the invitation to participate, at the last moment causes beyond our control rendered impossible the representation of many of the artists who had expected to contribute. The scarcity of photographic material still existing in many countries and the difficulties encountered in transporting these works are the principal reasons for the lamentable omissions in the collection. This first exhibition, as well as those which are to follow in succeeding years, will be circulated throughout the United States upon its termination at the Pan American Union.

We wish to take this opportunity to thank the following institutions which have demonstrated such splendid cooperation in making this exhibition a realization:

Club Fotográfico de Costa Rica, San José
Instituto Nacional de Bellas Artes, Mexico, D.F.
Dirección General de Turismo, Asunción
Corporación Nacional de Turismo, Lima

CATALOGUE

Photographs

Alfredo Linares (Bolivia)
 1. *Ostrich Dance*
 2. *Ox-Cart*
 3. *Dance*
 4. *Puna Dance*

Esteban A. de Varona (Costa Rica)
 5. *Airport*, San José
 6. *Pan American Highway*
 7. *National Theater*, San José
 8. *Milkman*
 9. *Coffee Grinder*

Julio Zadik (Guatemala)
10. *Village of San Antonio*
11. *Hunapú*

Luis Márquez (Mexico)
12. *Zapotec Tombs*, Oaxaca
13. *Cocotitlán*
14. *Church of Santa Prisca*, Taxco
15. *Indian Carrying Fish*
16. *Parish of Tulpetlac*
17. *Cross of My Parish*

Agustín Mayo (Mexico)
18. *Indian*
19. *Family*

Pedro Camps (Mexico)
20. *Old Men*
21. *Ruins*

Jesús M. Talavera (Mexico)
22. *Musician*
23. *Cliffs*

Raúl Conde (Mexico)
24. *Seashore*
25. *Carrying Water*

Lola Alvarez Bravo (Mexico)
26. *Cemetery*
27. *A Visit*

Marianne (Mexico)
28. *Totonac Mother*
29. *Offering*

Federico Donna (Paraguay)
30. *String Quartet*
31. *Sugarcane Juice*
32. *Toys*
33. *The Photographer*

A. Friedrics (Paraguay)
34. *Explorer*
35. *Women Washing*
36. *Cavern*
37. *Boy*
38. *Plaza Uruguaya*, Asunción

Martín Chambi (Peru)
39. *Samaritan*

40. *Merienda*
41. *Andean Voyager*

Rómulo M. Sessarego (Peru)
42. *Tomb*, Machu Picchu
43. *Cathedral of Arequipa*

González Salazar (Peru)
44. *Cathedral of Cuzco*
45. *Church of Seminario*, Cuzco
46. *Church of Santo Domingo*, Lima

A. Guillén M. (Peru)
47. *Ollantaytambo*, Cuzco
48. *Chincheros*, Cuzco
49. *Wheat*, Cajamarca
50. *Machu Picchu*
51. *Convent of Saint Francis*, Cuzco

J. De Ridder (Peru)
52. *Reverie*
53. *Chat*
54. *Sunday*
55. *Lunch Time*

Alfredo Boulton (Venezuela)
56. *Three Trees*
57. *Corn*

BIOGRAPHICAL NOTES[1]

ALVAREZ BRAVO, Lola (Dolores Alvarez Bravo). Photographer, born in Lagos de Moreno, Jalisco, Mexico, 1906.

BOULTON, Alfredo. Art critic and historian, photographer, born in Caracas, 1908. Studied in Venezuela, Switzerland, and England. Published *Imágenes del occidente venezolano*, with text by Arturo Uslar Pietri and notes by Julián Padrón, Tribune Printing Company, New York, 1940. Has exhibited in Caracas and at the Museum of Modern Art, New York.

February 16 - March 15, 1949

ANTONIO FRASCONI

Although he has resided in the United States only since 1945, Antonio Frasconi is well known in this country as a painter and engraver. During the last three years his work has been exhibited in one-man shows in the Brooklyn Museum, the Santa Barbara Museum of Art, Pasadena Art Institute, Philadelphia Art Alliance, New School for

[1] Not included in the original catalogue. —*Ed.*

Social Research, and Weyhe Gallery in New York City, and also in numerous group exhibits in various institutions throughout the country.

Frasconi was born in Buenos Aires, Argentina, in 1919. However, he spent most of his youth in Uruguay, becoming a citizen, and completing his early artistic studies in the Círculo de Bellas Artes in Montevideo. It was in Montevideo at the age of twenty that he presented his first one-man show, and from that time on, until he came to the United States six years later, his work was shown in every important art exhibition in Uruguay. In 1945 he was awarded a scholarship to study at the Art Students League in New York, where he became a pupil of the well-known Yasuo Kuniyoshi. He later obtained a scholarship for study at the New School for Social Research, where he devoted most of his time to the improvement of his technique in creating woodcuts, a media in which he has already achieved considerable success.

The noted painter William Gropper describes Frasconi's work as "direct and forthright," adding that it "speaks for itself with simplicity and conviction." Also referring to the work of Frasconi, Karl Kup, curator of prints at the New York Public Library, states similarly: "His manner is that of a strong personality."

The work of this young Uruguayan artist is represented in the Museo Municipal de Bellas Artes in Montevideo, the Brooklyn Museum, the New York Public Library, the Santa Barbara Museum of Art, Fogg Museum at Harvard University, Princeton University, and in important private collections. The Weyhe Gallery is his exclusive representative in the United States.

CATALOGUE

Oils

 1. *Days' Haul*
 2. *Fighting Cocks*
 3. *Don Quixote*
 4. *Head of Don Quixote*
 5. *The Hay Tedder*

Monotypes

 6. *Lemon Tree*
 7. *Three Birds*
 8. *Santa Barbara Landscape*

Color Woodcuts

 9. *Mother*
 10. *Trawling*
 11. *Landworker*
 12. *Summer Night Ride*
 13. *Man and Landscape*
 14. *Preciosa y el aire* (Preciosa [Beautiful] and the Air)
 15. *Don Quixote and Rocinante*
 16. *Boy in Field*
 17. *Strange Machine*
 18. *Boy with Cock*
 19. *Girl and Birdcage*

Black and White Woodcuts

20. *Farmer*
21. *Leek Pickers*
22. *The Fisherman*
23. *Family Portrait*
24. *Downtown*
25. *Man with Hay Loader*
26. *Daybreak*
27. *Roofs*

May 2 - 31, 1949

NEMESIO ANTUNEZ

Nemesio Antúnez was born in Santiago, Chile, in 1918. In 1936 at the invitation of the French government he made a trip to Europe, visiting France, Italy, and Switzerland. Upon his return to Chile in 1937, he became a student of architecture, completing the course in 1943. That same year he was awarded a scholarship for study in the United States, and received a M.S. in architecture from Columbia University in 1945. While studying architecture, Antúnez also found time to paint. Interested in the art of America, he traveled in Peru, Mexico, and Cuba in 1945 and 1946, returning finally to the United States. In 1947 he obtained a scholarship which gave him the opportunity to study engraving techniques with Professor William S. Hayter in the Atelier 17 in New York, thus acquiring a new medium of expression for his art.

Antúnez presented one-man shows in Santiago between 1941 and 1943, and most recently in 1948. His first one-man exhibition in New York was held at the Norlyst Gallery in 1945.

His work has been represented in group shows in the Brooklyn Museum in 1946, in the Laurel and Argent Galleries in New York, and in various institutions in California and New Jersey during the past year.

Antúnez's work as an illustrator-engraver has been extensive both in Chile and in the United States. His latest contribution in this field is the series of engravings for the book *Tres cantos materiales* published in 1948 by East River Editions, New York.

This presentation of his work at the Pan American Union constitutes the artist's first exhibition in Washington.

CATALOGUE

Oils

1. *City Dwellers with Status*
2. *Man*
3. *Wall*
4. *City Spectators*
5. *Woman*
6. *City Dwellers with Flies*
7. *Habitantes de la ciudad (City Dwellers)*
8. *Man and Moon*
9. *Mountain*

10. *Orange Hills*
11. *Moon and Men*
12. *Double Mountain*
13. *Mountain, Alive*
14. *Volcano*

Drawings

15. *Torso*
16. *Panorama of Crowd*
17. *Suspense*
18. *City Dwellers at the Seashore*
19. *Spaces and Two Figures*
20. *Victim*
21. *Night Figures*
22. *City Dwellers, Black Sky*

Engravings

23. *Endless Nudes*
24. *Dawn is Born at Night*
25. *Center of the Blood*
26. *Street Fight*
27. *Habitantes de la ciudad (City Dwellers)*

June 1 - June 30, 1949

GUATEMALA, FIFTY PHOTOGRAPHIC STUDIES BY HANS NAMUTH

Through the courtesy of the American Federation of Arts, the Pan American Union presents a series of photographs of Guatemala taken by the eminent photographer Hans Namuth during two trips to this colorful Central American country in 1947 and 1948.

The collection is noteworthy, not only for its artistic value but also for its documentary importance, displaying as it does the most varied aspects of the human and physical geography of a country rich in natural beauty and in traditions derived from its early Mayan culture.

The photographer Hans Namuth was born in 1915 in Essen, Germany, and received his early schooling in that city, later traveling extensively in France, Spain, Italy, and Greece. He became a professional photographer in 1935, while living in Paris. Serving in this capacity, he covered the Spanish Civil War for one year, 1936-37. In 1939 he joined the French Foreign Legion "for the duration of hostilities," and was honorably discharged in October 1940. He was one of the few persons to receive a special State Department "danger visa," which allowed him to come to the United States via Martinique in 1941. Drafted into the United States Army, he spent three years in the Military Intelligence Service, seeing action in Normandy, Brest, the Battle of the Bulge, Belgium, Luxembourg, Germany, and Czechoslovakia, and was awarded the Purple Heart and Croix de Guerre. He now works as a free-lance photographer in New York.

Most of the pictures in this exposition were taken with a Standard Rolleiflex 2 1/4 x 2 1/4, Tessar lens f3.5. The portraits were taken with a 2 1/4 x 2 1/4 Primarflex camera, equipped with an 18 cm. Heliar lens (Voigtlaender).

Daylight was used in all instances, except in no. 39, which was taken with a flash. A Norwood exposure meter was used to measure shutter speeds. Negatives were developed with Edwal Minicol developer. Most of the enlargements were made on Defender Velour Black "DL" paper and were developed with Eastman Kodak "Dektol" formula. A green filter was used for some of the landscapes, and a red filter for no. 4. A tripod was used for long exposures such as no. 4 and no. 43.

CATALOGUE

Photographs

1. *Typical Indian Hotel in San Antonio*, Palopó, Lake Atitlán
2. *Weaving a Huipil*, or Indian Blouse, San Lucas, Sololá
3. *Church of the Franciscan Monastery*, Antigua
4. *Saint Joseph at the Cathedral of Ciudad Vieja*
5. *Luis*, a 13 year old Ladino
6. *Dance of the Conquest*, San Juan, Quezaltenango
7. *María Fernández*
8. *María Fernández and Her Brother*
9. *A Cacique of San Pedro*, Sololá
10. *Rosario Florez of Guatemala City*
11. *A Road Worker of the Highlands Wears a Poncho against the Bitter Climate*
12. *City Council of Todos Santos*, Huehuetenango
13. *Domingo of Todos Santos*
14. *Domingo's Children Smoke as Eagerly as Their Parents*
15. *This Shepherd of Huehuetenango Speaks Only Mam* (a Maya dialect)
16. *Blind Beggar of Chichicastenango*
17. *Los Altos*, the Guatemalan Highlands, Huehuetenango
18. *Valley near Chichicastenango*
19. *Rock Formation near Momostenango*, Totonicapan
20. *Road to Quiché*
21. *The Red Owl*, a ten-foot idol found in the jungle of El Baúl, Escuintla
22. *Detail of a Hammered Silver Case*
23. *Idol from El Baúl*, Escuintla
24. *Salt Mine near Sacapulas*
25. *Salt Cakes Sell for One Cent in the Market*
26. *Lake Atitlán and the Volcanoes Atitlán and Tolimán*
27. *The Pyramids of Zaculeo*
28. *A Boy in Prayer*
29. *Island in the Pacific*, near Iztapa
30. *Indian Courtyard*, San Pedro Atitlán
31. *Sierra de los Cuchomatanes*
32. *Carrying Pottery to the Capital 100 Miles Away*
33. *Young Boys of San Antonio Palopó*
34. *Franciscan Emblem over the Door of the Escuela de Cristo*, Antigua
35. *Murals in the Ruined Monastery of San Francisco*, Antigua
36. *Dance of the Conquistadors*, San Juan, Quezaltenango
37. *Bashful Indian Girls Giggle behind Their Hands*
38. *They Pray to the Native Gods and Burn Copal Incense as an Offering Before Entering the Church at Chichicastenango*
39. *In the Church at Chichicastenango, Indians Pray to Their Ancestors*
40. *Political and Religious Leaders of Todos Santos*, Huehuetenango

41. *Men and Boys of Todos Santos*
42. *Statue of a Virgin*
43. *The Silver Virgin of Candelaria*, Chiantla
44. *Boy of San Antonio Palopó*
45. *Indian Family*, San Antonio Palopó
46. *Silver-Studded Church Door*, Santa María de Jesús, Sacatepéquez
47. *Weaving at San Antonio Aguas Calientes*, Sacatepéquez
48. *Young Girls of San Pedro Atitlán*
49. *A Fair-Skinned Type of Indian*
50. *Carrying Water from the Lake*, San Pedro Atitlán

July 1 - 31, 1949

ARTISTS' GUILD OF WASHINGTON

In accordance with the policy of the Pan American Union to collaborate with artistic institutions in this area, the gallery of the Union is devoted during the month of July to an exhibit of works by members of the Artists' Guild of Washington.

The artists themselves have made the selection of the paintings and sculpture to be shown, keeping in mind the limitations of the available exhibit space.

In the following paragraphs Mr. Prentiss Taylor, President of the Guild, outlines briefly the history and the purposes which have animated the activities of the organization over which he presides:

> The Artists' Guild of Washington was organized December 17, 1941 by a group of artists who felt there was a place in Washington for an art organization which would be creatively and socially democratic, unrestricted in all senses of the word, one that would hold a high standard and not a point of view as its common bond.
>
> In the following years the Guild has chosen to maintain its membership at about fifty resident and nonresident artists, of whom thirty-eight are represented in this exhibit.
>
> Six annual exhibitions have been held, the first four at the Corcoran Gallery of Art, with a fifth at the Arts Club, and the sixth at the Watkins Gallery, the American University. There have been several summer exhibits of prints, drawings, and small paintings.
>
> The Guild's principle of creative freedom, together with its lack of bias and its consequent variety in expression, will be evident to those who view this exhibit.
>
> It was a respect for craft as well as this belief in individual expression which first brought the artists of the Guild together, and since many of the Guild members teach in the schools and universities of the Washington area, the influence of the Guild's viewpoint has been felt throughout the community.
>
> In this exhibit will be seen several evidences of the inspiration some Washington artists have found in other countries of the Western Hemisphere.

CATALOGUE

Paintings, Drawings, and Sculpture

Sarah Baker
 1. *Clamshells*, watercolor. Coll. Mr. and Mrs. Sterling Ely

Douglas Brown
 2. *Savannah Georgia*, watercolor

Marguerite Burgess
 3. *Whirligig*, watercolor

William H. Calfee
 4. *Haitian Dancer*, charcoal and tempera

Walter T. Carnelli
 5. *Transfiguration*, ink drawing

Alexander Clayton
 6. *Arrangement*, ink and watercolor

Alida Conover
 7. *Old Sea Gull*, ink and watercolor

Alice Decker
 8. *Dachshund*, bronze

Laura Glenn Douglas
 9. *Fantasy*, crayon and pencil

Julia Eckel
10. *Pastel*, pastel

Maxim Elias
11. *Odalisque*, cypress

Lucile Evans
12. *Exotic Fruit*, wax drawing

Frances Ferry
13. *Portuguese Pension*, crayon

Aline Fruhauf
14. *Llama*, lithograph

John Crozier Galloway
15. *Shovel*, ink drawing

Margaret Casey Gates
16. *Herbs*, ink drawing

Robert Franklin Gates
17. *Cock*, ink drawing

Harold Giese
18. *Kitchen Window*, casein gouache

Mitchell Jamieson
19. *Wakening in the Woods*, encaustic on paper

Lois Mailou Jones
20. *Menemsha Bight*, drypoint

Sheffield Kagy
21. *Flats Workman*, linoleum cut

Jacob Kainen
22. *The Island*, aquatint and drypoint

Pietro Lazzari
23. *Calm*, ink drawing

Herman Maril
24. *Erosion*, gouache

Norma Mazo
25. *Beach*, watercolor

Carl Nyquist
26. *Church at Tepepem*, Mexico, watercolor

Eliot O'Hara
27. *Church in Sonora*, watercolor

Jack Perlmutter
28. *The City*, lithograph

Helen Rennie
29. *Urban Pavane*, ink drawing

John Robinson
30. *Old House*, watercolor

Sarah Silberman
31. *Mexican Head*, antique brick

Leo Steppat
32. *Bird*, gouache

Celine Tabary
33. *Old Cemetery*, Artois, watercolor

Prentiss Taylor
34. *San Agustín Acolmán*, watercolor

William N. Thompson
35. *Gulls*, watercolor. Coll. Mr. Richard Herman

Heinz Warneke
36. *Swamp Growth*, mahogany

Mary Bradley Watkins
37. *Marina Key*, watercolor

Andrea Pietro Zerega
38. *In Georgetown*, graphite lead

September 12 - October 12, 1949

THREE ENGRAVERS OF ARGENTINA: AMADEO DELL'ACQUA, ALBERTO NICASIO, VICTOR REBUFFO

Although the art of engraving has been practiced for many years in most of the Latin American countries, it has achieved in Argentina a particularly remarkable degree of technical perfection. Most of the art schools of the country are well equipped to teach this art form, and they have produced many prolific and highly skilled engravers. Among these are the three artists whose work appears in this exhibit.

Amadeo dell'Acqua was born in 1905 in Buenos Aires. After studying at the Academia Nacional de Bellas Artes of that city, he became professor of aesthetics there in 1922. He was also professor of mechanical drawing and drafting at the Academia de la Mutualidad de Estudiantes de Buenos Aires from 1921 to 1935, serving as director of that institution for four years. He has won many prizes for engraving and the decorative arts and has employed these various techniques in illustrating more than sixty books.

Alberto Nicasio was born in 1902 in Córdoba and received his first training in drawing and painting at the academy of that city. In 1939 he founded the first school of engraving in the Asociación de Pintores y Escultores in Córdoba and was its director until 1941, receiving in that same year the First National Prize for Engraving. In 1942 he became the first professor of the studio of engraving of the Escuela Nacional Superior de Córdoba, a position which he held until 1947. During these years he gained a wide reputation as a skillful teacher of engraving, and many of his pupils have distinguished themselves as masters of the medium. His work has been exhibited in the leading museums of Argentina, Chile, and Uruguay, as well as in many universities and museums of the United States.

Although born in Italy in 1903, Víctor Rebuffo has been a resident and citizen of Argentina almost all of his life. He studied at the Academia de Bellas Artes in Buenos Aires and is now represented in the municipal museums of that city, as well as in the museums of the provinces of La Plata and Mendoza. He has received many awards for his work, which has been shown in all the major salons of Argentina and in a one-man show in New York.

CATALOGUE

Amadeo Dell'Acqua

Woodcuts

1. *Gaucho*

2. *Garden Well*
3. *Homecoming*
4. *Prophet*
5. *Solitude*
6. *Cupid*
7. *Swimming Hole*
8. *Homeward*
9. *Allegory*
10. *Fishermen*

Drypoints

11. *Going to Market*
12. *Logs*
13. *Injured Woodsman*
14. *Man Asleep*

Alberto Nicasio

Woodcuts

15. *The Meeting*
16. *River*
17. *Still Life*
18. *Suburb*
19. *Cathedral*
20. *The Lesson*
21. *Abel*
22. *Córdoba Landscape*
23. *Woman Drawing*
24. *Church at Santa Catalina*
25. *The Catch*
26. *Horses on the Plain*
27. *Old Gaucho*
28. *Gaucho on Horseback*
29. *In the Pasture*
30. *Córdoba Landscape*

Víctor Rebuffo

Woodcuts

31. *Slum*
32. *Sun in the City*
33. *Corral*
34. *Bread*
35. *The Wires*
36. *The Last Clipper*
37. *Sorrow*
38. *The Plow*
39. *Spiritual Unity*

40. *Freedom Never Dies*
41. *Stravinsky's Music*
42. *Factory*
43. *The Ports*
44. *Willows by the River*
45. *Sleepwalker*

October 17 - November 2, 1949

TOMAS NEWBERRY

Tomás Newberry was born in Buenos Aires in 1928. A self-taught artist, he began to paint on his father's ranch in the southern lake region of Patagonia.

In Argentina today he is considered by art critics to be one of the country's most promising young artists. Examples of his work in both painting and sculpture have been shown during the past three years in the Salón Nacional de Bellas Artes in Buenos Aires, in the Salón de Bellas Artes in Córdoba, 1947, and in several group exhibitions.

Upon the occasion of the presentation of his first one-man show in Buenos Aires in 1948, the magazine *Mundo Argentino* made the following comment: "Seldom have we had the privilege of witnessing a more propitious beginning." Also referring to this exhibition, *La Prensa* stated: "This young Argentine artist is joining, in an auspicious manner, the ranks of the outstanding painters of Patagonia."

Newberry came to this country five months ago on a grant from the Williams Foundation in Buenos Aires. This is his first show in the United States.

CATALOGUE

Oils

1. *La playa (The Beach)*, 24 x 20"
2. *Después de la lluvia (After the Rain)*, 24 x 20"
3. *La vega (The Valley)*, 20 x 16"
4. *Mañana diáfana (Clear Morning)*, 20 x 16"
5. *Arrayanes (Myrtle Trees)*, 20 x 16"
6. *Coihués*, 20 x 16"
7. *Invierno (Winter)*, 20 x 16"
8. *Mallín (Moor)*, 20 x 16"
9. *Troncos quemados (Burnt Stumps)*, 20 x 16"
10. *Placidez (Tranquility)*, 20 x 16"
11. *Mi calle (My Street)*, 20 x 16"
12. *Brooklyn,* 14 x 11"
13. *White Birch*, 14 x 11"
14. *Woods*, 14 x 11"
15. *Chimneys*, Fort George, 14 x 11"
16. *The Purple Barn*, 14 x 11"
17. *Anacostia River*, 14 x 11"
18. *Washington*, 14 x 11"

Sculpture

19. *Portrait of María Elena Corominas*, plaster

November 2 - 30, 1949

THE HIGHLANDS OF SOUTH AMERICA:
PHOTOGRAPHS OF BOLIVIA AND PERU BY ELENA HOSMANN

Elena Hosmann was born in Buenos Aires of Dutch and Argentine parents. She was educated at home by European tutors and spent much time each year at one of the farms owned by her family. There she gained an intimate knowledge of the countryside. Impressed by the historic aspects of life in Europe, which she observed on many trips abroad, she became interested in what America had to offer in this respect. After mastering the art of photography, she began to put it to use in perpetuating the past of South America. Her work soon brought her wide recognition.

In 1941 she made her first trip to Bolivia and Peru, making notes and taking over 7,000 photographs. The results of that visit appeared in the volume *Ambiente de altiplano* (Buenos Aires: Ediciones Peuser, 1944), which includes many of the photographs shown in this exhibit. In the introduction to the book, Mrs. Hosmann writes of the highlands:

> The landscape unfolds in vast horizontal expanses of magnificent solitude and monotony, scarcely broken by the peaks in the distance and the little Indian villages which are lost in the immensity of the sky and the land. Even the color appears to adapt itself to this theme of uniformity: the earth, the skin of the Indians, the little adobe houses, all are brown. But the apparent monotony deceives one only at first glance; in the highlands are mingled the most diverse civilizations and cultures. Another America appears, opening vistas into the past. . . . In many places, the remains of the different epochs appear side by side, or superimposed upon each other, palpable to the hand of any passer-by, visible to the naked eye, with the indisputable truth of physical reality. Within this world of the highlands the Indian of today moves with his slow and regular pace . . . representing within himself a synthesis of cultures, preserved in belief and legend, in dance, music and speech, in custom and dress.

Many of the photographs taken by Hosmann in Paraguay and northern Argentina have been used to illustrate a recent book entitled *Los instrumentos musicales aborígenes y criollos de la Argentina*, by the eminent folklorist Carlos Vega. Her work has also appeared in the leading newspapers of Buenos Aires and has been shown in expositions in all parts of the world. At the present time she is living in Italy, contributing photographs to Swiss newspapers and magazines.

Following the showing in the Pan American Union, these photographs will be circulated throughout the United States by the Department of Cultural Affairs.

CATALOGUE

Photographs

Bolivia

1. *A Patio in Potosí*
2. *Church of San Benito*, Potosí
3. *Ancient Adobe Tower near Potosí*
4. *Old Houses*
5. *Road to the Cemetery*
6. *Monolithic Pillars*, Tiahuanaco
7. *Stairway of Kalasasaya*, Tiahuanaco
8. *Colonial Arch of Stone*, Tiahuanaco

9. *Chipaya Indian Boy*, La Paz
10. *Entrance to the Patio of a Colonial House*, La Paz
11. *Scene on the Outskirts of La Paz*
12. *Indian Muleteer Drinking Chicha*, Sucre
13. *Andean Indian Woman*
14. *Tile Rooftops of Sucre*

Peru

15. *Tower of Santo Domingo*, Cuzco
16. *Patio of a House near the Arch of Santa Clara*, Cuzco
17. *Indian Woman of Cuzco*
18. *Wall of the Sacsahuamán Fortress*, Cuzco
19. *Entrance to a Cuzco Mansion*
20. *La cuesta de la amargura*, Cuzco
21. *House in Cuzco*
22. *Llamas Resting in the Plaza of San Blas*, Cuzco
23. *The Balcony of Herod*, Cuzco
24. *Entrance to a Picantería*, Cuzco
25. *Detail of the Façade of the Cathedral of Puno*
26. *Dancing La Chokela*, Puno
27. *An Ancient Chulpa near Puno*
28. *Detail of the Façade of the Cathedral of Puno*
29. *Entrance to a Plaza in Chincheros*
30. *Indian of Chincheros*
31. *Indian Street Vendor*, Sicuani
32. *Playing the Tarka*, Sicuani
33. *Mother and Child in the Market at Sicuani*
34. *Street in Ayacucho*
35. *Town near Ayacucho*
36. *Ruins of Machu-Picchu*
37. *Stone Fortress*, Machu-Picchu
38. *Entrance to an Incan Palace*, Machu-Picchu
39. *An example of Incan Masonry*, Machu-Picchu
40. *Andean Street*

December 1 - 14, 1949

SOME CONTEMPORARY PAINTERS OF COLOMBIA

Acceding to many requests from various organizations in the United States for an exhibition of contemporary Colombian painting, Mrs. B. Forrest Uhl, director of the Colegio Estados Unidos in Bogotá, has brought to this country a large part of her private collection.

The collection was begun ten years ago when Mrs. Uhl first went to Colombia to live, and it now represents most of the important names and trends in the contemporary art of Colombia. To the group of her own paintings Mrs. Uhl has added other works which are being lent for this exhibit by the artists themselves. Although some of the painters whose works appear in this selection are already well known in the United States, this is the first time that such an extensive exhibition of Colombian painting has been shown here.

Following this initial exhibit in the Pan American Union, the paintings will be displayed in New York, Oklahoma City, Dallas, and Los Angeles.

CATALOGUE

Paintings and Drawings

Luis Alberto Acuña
1. *Diana*, oil
2. *Dressing Room of the Maids*, oil
3. *Orchids and Ferns*, oil
4. *Santander Wedding*, oil
5. *The New Bride*, oil
6. *Three Horses*, oil
7. *The Witch*, oil

Gonzalo Ariza
8. *Stream in the Jungle*, oil
9. *Misty Morning*, oil
10. *Mountain Majesty*, oil
11. *Mountain Road*, oil
12. *Road to Sopó*, oil
13. *Trees in the Rocks*, oil
14. *University on the Savanna*, oil
15. *Wild Orchids in a Gourd*, oil
16. *Afternoon Light*, watercolor
17. *Rainbow*, watercolor

Estela Escobar
18. *Portrait of Penny*, watercolor

Marco Ospina
19. *Fire*, oil

Alfonso Ramírez Fajardo
20. *Boyacá Family*, watercolor
21. *Easter Morning*, watercolor
22. *Going to the Doctor*, watercolor
23. *Market Day*, watercolor
24. *The Music Makers*, watercolor

Eduardo Ramírez Villamizar
25. *Jacob and the Angel*, oil
26. *Sunflowers*, oil
27. *Woman Sewing*, oil

Marco Salas Vega
28. *Nude*, oil

César Salas
29. *Arrieros (Muleteer)*, oil

Gilberto Salas
30. *Patio*, oil

Marco Salas
31. *Boy*, oil

Mercedes Salas
32. *Andean Pastoral*, oil

Piedad Salas
33. *Patio de San Carlos*, oil

Rafael Salas
34. *Market Group*, oil

Guillermo Silva
35. *Felipe*, oil
36. *Mountain Cottage*, oil

Antonio Toro
37. *Human Bronze*, oil

Sergio Trujillo
38. *Annunciation*, oil
39. *Bay of Santa Marta*, oil
40. *Don Quixote*, watercolor

Francisco Tumiñá
41. *The Wind*, pen and ink
42. *La Minga*, pen and ink

BIOGRAPHICAL NOTES[1]

RAMIREZ FAJARDO, Alfonso. Painter, draftsman, born in Boyacá, Colombia, ca. 1900. Considers himself a self-taught artist. Since 1940 has exhibited in individual and group shows in Colombia. Won prizes in the Second and Sixth Salon of Colombian Artists, 1941, 1945.

TUMIÑA, Francisco. Draftsman born in Guambía, Colombia, 1926. A Guambian Indian and self-taught artist, worked for the Ethnological Institute of the University of Cauca in Popayán, as an informant and draftsman recording data on the Guambian Indians. Although an individual exhibition of his drawings was held in Bogotá and sold out the first day, he is not interested in exhibiting but continues doing drawings and selling them while teaching in an elementary school of El Pueblito, in the heart of the Guambía countryside.

[1] Not included in the original catalogue. See the Index of Artists for reference on those not listed here. —*Ed.*

December 5, 1949 - January 16, 1950

FEDERICO CANTU

Federico Cantú is not unknown to the public of Washington, D.C., nor to the rest of the United States. His paintings appeared here in group shows in 1942 and 1947 and have been shown in both group and one-man exhibits in the most important museums and galleries of this country, including the Museum of Modern Art in New York, Philadelphia Museum of Art, Seattle Art Museum, Fogg Art Museum in Cambridge, M.H. de Young Memorial Museum in San Francisco, and many others. This is, however, the artist's first one-man show in the District of Columbia, and consists of a selected number of his works which have been circulating during the past two years among museums on the West Coast.

Cantú was born in Cadereyta Jiménez, State of Nuevo León, Mexico, in 1908 and began his study of art at the age of fourteen in the Escuela de Pintura al Aire Libre of Coyoacán. In 1924 he made a trip to France and Spain, returned to Mexico in 1926, and then came to the United States, residing in Los Angeles and later in New York, where he stayed until 1931. In that year he again went to France, remaining there three years. Upon his return to Mexico, he painted a mural in the capital city which has now been destroyed. Since 1934, except for an interval of three years spent in New York, 1938-41, he has lived in Mexico, where his work is widely appreciated and exhibited.

Cantú is one of the few contemporary Mexican painters interested in religious themes. During the exhibition of his works at the Santa Barbara Museum of Art in 1948, Donald Bear, art critic for the *News Press* of that city, made the following comment:

> Cantú's work, his composition of angels, madonnas, and his simple character portraits, are very direct and sincere in feeling. They have an integrity and a simplicity of attitude in spite of their technical complexity, which makes them highly original and almost naively honest.

CATALOGUE

Oils

1. *Retrato de mi hijo (Portrait of the Artist's Son)*
2. *Annunciation Theme*
3. *Landscape*
4. *Epifanía (Epiphany)*, 1941
5. *Retrato de Gloria (Portrait of Gloria)*
6. *Autorretrato (Self-Portrait)*
7. *Sunflower*
8. *Star of the Morning*
9. *The Four Horsemen of the Apocalypse*
10. *Crucifixion*, 1942, temple. Coll. of the artist
11. *Tobías*
12. *Still Life with Ivy*
13. *La Anunciación (Annunciation)*

Temperas

14. *Angels*
15. *Ciego (Blind Harp Player)*, 1942
16. *Angels*

Prints[1]

[1] Titles are unavailable. —*Ed.*

YEAR 1950

January 18 - 31, 1950

HONDURAS AND THE MAYANS: PHOTOGRAPHS[1]

Due to the generosity of the Ambassador of Honduras, Don Rafael Heliodoro Valle, we are able to present a group of photographs of that country. Predominant among them are examples of archaeological discoveries from the region of Copán where an intense center of Mayan culture once existed. This exhibit, which is an excellent documentary record, will later be circulated throughout the United States by the Department of Cultural Affairs of the Pan American Union, through the courtesy of Ambassador Valle, who says:

> Fourteen centuries ago in this land of sun and palms, pine and jasmine, there originated one of the three most important cultures in this hemisphere. The Mayas gave Honduras a permanent place in history; the Aztecs supplied it with musical names that are still in use; the Spanish contributed a distinct personality and a magnificent language. But all of them united in a common richness, which is the humble pride of these people who love peace in order to dedicate themselves to their work and await the future without fear.

CATALOGUE

Photographs

Raúl Agüero Vera
 1. *Los caciques*, Jicaque Indians

Bob Edgerton
 2. *Entrada a un templo (Entrance to a Temple)*, Copán
 3. *Cancha de pelota (Ball Field)*, Copán
 4. *Fachada de la acrópolis (Façade of the Acropolis)*, Copán
 5. *Estela en la plaza (Stela in the Plaza)*, Copán
 6. *Cabeza de "El Viejo" en perspectiva (Head of "The Old Man" in Perspective)*, Copán
 7. *Una estela (Stela)*, Copán
 8. *Cabeza de "El Viejo" (Head of "The Old Man")*, Copán

Raúl Estrada Discua
 9. *Ruinas de Copán (Ruins at Copán)*
10. *Dios del Viento (God of the Wind)*
11. *Templo de la Meditación (Temple of Meditation)*
12. *Estela S (Stela S)*

[1] Following its showing at the Pan American Union, the exhibit of photographs of Honduras was lent to the following museums in the United States: Southwest Museum, Los Angeles; Nashville Children's Museum, Nashville; Davenport Public Museum; Miami Beach Public Library and Art Center, Miami Beach. —*Ed.*

13. *Estela F (Stela F)*
14. *Monumento a Morazán (Monument to Morazán)*, Tegucigalpa
15. *Iglesia de Los Dolores (Church of Our Lady of Sorrows)*, Tegucigalpa
16. *Barrio La Leona (Suburb La Leona)*, Tegucigalpa
17. *Tegucigalpa*

Mateo Mercado
18. *Ruinas de Copán (Ruins at Copán)*
19. *Piedra de los sacrificios (Sacrificial Stone)*
20. *Estela S (Stela S)*
21. *Una estela (Stela)*
22. *Estela sin denominación (Unclassified Stela)*
23. *Idolos mayas (Mayan Idols)*
24. *Vista de escultura maya (View of Mayan Sculpture)*
25. *Estela P (Stela P)*
26. *Vista de una estela maya (View of a Mayan Stela)*
27. *Escalinata de un templo maya (Perron of a Mayan Temple)*
28. *Estela y subterráneo (Stela and Vault)*
29. *Juego de pelota (Ball Game)*
30. *Piedra de los sacrificios (Sacrificial Stone)*

M. A. Sánchez
31. *Los taburetes (The Taborets)*, Ojojona
32. *Vendedora de ollas (Seller of Earthenware)*
33. *¿Quere blanquillos? (Want Eggs?)*
34. *El canastero de Texiguat (Basketmaker of Texiguat)*
35. *De vuelta del mercado (Return from the Market)*
36. *Centenaria iglesia (Centenary Church)*
37. *Vámunus mija (Come, My Daughter)*

Doris Stone
38. *Escalera jeroglífica (Hieroglyphic Stairway)*

February 2 - March 13, 1950

TORRES-GARCIA AND HIS WORKSHOP

Before his death in August of last year, Joaquín Torres-García prepared the exhibition of paintings which is presented here, for the first time in the United States, through the courtesy of the Embassy of Uruguay in Washington. It is a group of works by a master—one of the outstanding figures in the history of Latin American art—and by a few of his disciples, and represents an artistic concept in which teacher and pupils combine their talents in expressing a common idea. Torres-García believed in the necessity of creating an art for America. He believed also that the most effective means of doing so was through the collective effort of masters and students, as in the guilds of the Middle Ages.

His background of strict academic discipline and thorough grounding in the principles of art served him well in carrying out such a program. He was born in Montevideo in 1874, and at the age of seventeen went to Spain to study at the Academy of Fine Arts in Barcelona. Because of its proximity to France, Catalonia felt, more forcibly than any other region of Spain, the impact of the new trends in French art. At the same time and in the same art

circles of Barcelona, Torres-García and Picasso became acquainted with modern French ideas, and in the beginning both artists followed the style of Toulouse-Lautrec. During this period Torres-García also came under the influence of Puvis de Chavannes, as revealed in the murals which he did in Barcelona and for the Uruguayan Pavilion at the 1910 World's Fair in Brussels. A series of trips to several countries further contributed to the development of his artistic personality. After a two year residence in New York, 1920-22, he went to Italy and to France. He lived for several years in Paris and later in Madrid, and in 1934 returned to Montevideo, where he remained until his death.

During his stay in Paris, Torres-García became intensely interested in the principles of the constructivist group. Allying himself with some of its members, he began to paint along similar lines and to participate in their expositions. With Theo van Doesburg he founded the magazine *Cercle et Carré*. Although he also studied the work of Paul Klee and Piet Mondrian, he always attempted to avoid experimentation with purely nonobjective forms. "Nature, in one form or another," he once wrote, "must be the basis for any plastic system."

Torres-García's theories, expressed through bi-dimensional spacial concepts and a few recurring themes, have been adopted by his students. Teacher and pupils collaborated in producing several murals in Montevideo, the most outstanding of which is the *Cosmic Monument*, a work in stone, in Rodó Park.

In 1944 the government of Uruguay conferred upon Torres-García the Grand National Prize for Painting. His works are found in various museums in his country and Argentina, as well as in the Philadelphia Museum of Art, the Museum of Modern Art in New York, the Yale University Art Gallery, the Clausen Museum of Copenhagen, the Jeu de Paume Museum in Paris, the Museum of Fine Arts in Barcelona, and in numerous private collections in Europe and America.

Following its showing at the Pan American Union, the exhibit will be circulated throughout the United States.

CATALOGUE

Joaquín Torres-García
 1. *Composition 1*
 2. *Port*
 3. *Sugar*
 4. *Composition 10*
 5. *Planismo*
 6. *Composition 2*
 7. *Head*
 8. *Ships*
 9. *Cooking Utensils*

The Workshop of Joaquín Torres-García

Julio U. Alpuy
10. *Kettle, Bottle, and Pan*
11. *Race*

Elsa Andrada
12. *Races, Variation 1*
13. *Races, Variation 2*
14. *Fruit Bowl*

Gonzalo Fonseca
15. *Yerba (Yerba Mate)*

16. *Composition*

José Gurvich
17. *Objects*

Anhelo Hernández
18. *Composition*

Jonio Montiel
19. *Smokestack*
20. *S.S. Etar*

María Olga Piria
21. *Objects*

Salvo
22. *Vat 69*
23. *Kettle*
24. *Ship*

Augusto Torres
25. *Alarm Clock and Ruler*
26. *Clock, Coffee Pot and Bottles*
27. *Ink Bottle, Palette Knife and Clock*

Horacio Torres
28. *Composition 50*
29. *Solar*

María L. Vasconcellos
30. *Factory*

BIOGRAPHICAL NOTES[1]

ALPUY, Julio U. Painter, muralist, draftsman, printmaker, born in Tacuarembó, Uruguay, 1919. Sudied at the Taller Torres-García, 1939-1950. Held one-man shows in Montevideo and Buenos Aires. Participated in all the group exhibitions of the Taller Torres-García in South America, Europe, and the United States, 1943-1950.

ANDRADA, Elsa. Painter, born in Montevideo, 1920. Studied under Renée Geille Castro de Sayagués, 1943, and at the Taller Torres-García, 1944-48. Participated in all the exhibitions of the Taller Torres-García, including in New York. Won the Purchase Prize, Municipal Salon, Montevideo, 1946.

FONSECA, Gonzalo. Painter, sculptor, born in Montevideo, 1922. Founding member of the Taller Torres-García, where he studied since 1942. Executed murals in Uruguay and abroad. Participated in the Latin America Art Exhibit, Paris, 1946, and other group exhibitions in Latin America, Europe, and the United States.

GURVICH, José (Zusmanas Gurvicius Galperaites). Painter, born in Lithuania, 1927. Studied with José Cúneo at the Escuela Nacional de Bellas Artes, Montevideo, 1942. Founding member of the Taller Torres-García, where he

[1] Not included in the original catalogue. —*Ed*.

studied since 1943, participating in its group exhibits in Uruguay and abroad. Held individual exhibitions in Montevideo and participated in group exhibitions in Montevideo and Rome. Won the Purchase Prizes, Municipal Salon, Montevideo, 1946. Lives in Uruguay since 1933 and is an Uruguayan citizen since 1953.

HERNANDEZ RIOS, Anhelo. Painter, draftsman, printmaker, muralist, born in Montevideo, 1922. Studied sculpture under Alberto Savio; with Edmundo Prati and Antonio Pena at the Escuela de Artes Plásticas; with Severino Pose at the Escuela Nacional de Bellas Artes, Montevideo. In 1944-1949 attended the Taller Torres-García, participating in all its group shows in Uruguay and abroad. Was awarded, among others, the First Prize for Portrait at the National Salon of 1949. Executed murals and won, with Jonio Montiel, the Second Prize at the mural contest for the Palacio de la Luz, 1949.

MONTIEL, Jonio. Painter, born in Catania, Italy, 1924. Studied in Montevideo architecture for five years, School of Architecture; sculpture; with Alberto Savio, 1940-42; and at the Taller Torres-García, 1944-50, participating in its group exibitions in Uruguay and abroad. Traveled in Chile, Bolivia, and Peru, doing archeological studies in the two last countries, 1946-47. Held one individual exhibition, Amigos del Arte, Montevideo, 1948. Participated in national salons and Uruguayan group shows. One of his mural projects executed with Anhelo Hernández was awarded Second Prize in 1949 and in 1946 won the Purchase Prize, Municipal Salon, Montevideo. Lives in Montevideo and is an Uruguayan citizen.

PIRIA, María Olga. Painter, musician, born in Montevideo, 1927. Studied at the Círculo de Bellas Artes in 1941-43 and the Taller Torres-García. Exhibited in Uruguay, Argentina, the United States, France, and Italy.

SALVO, Lily. Painter, born in La Plata, Argentina, 1928. Emigrated to Uruguay as a child. Studied at the Círculo de Bellas Artes and the Taller Torres-García until 1949. Held individual exhibitions in Montevideo and Buenos Aires.

TORRES, Augusto. Painter, muralist, sculptor, born in Terrasa, Spain, 1913. Son of Joaquín Torres-García, went with his family to Barcelona, 1916; New York, 1920; Italy, 1922; and Paris, 1924. There, studied at the Académie Ozenfants, 1925-1927, Musée du Trocadéro, and under the sculptor Julio González. Later studied at the Taller Joaquín Torres-García and participated in all its exhibitions in Uruguay and abroad. Also exhibited in national salons, where he was awarded prizes in 1941 and 1946.

TORRES, Horacio. Painter, born in Italy, 1924. The youngest son of Joaquín Torres-García, lived in France until 1932, traveled to Madrid and took up residence in Montevideo, 1934, where he studied at the Taller Torres-García. Held individual exhibitions in Montevideo, Buenos Aires, the United States, and Paris. Participated in all the exhibitions sponsored by the Taller Torres-García in Uruguay and abroad; Salon des Superindépendents, Paris, 1940-49. Was awarded several prizes in national salons, including Gold Medal, 1944.

March 14 - 31, 1950

HELENA ARAMBURU: DRAWINGS

Helena Aramburú Lecaros is known in her native Peru as an author and a feminist. She has published several books of poetry and philosophy, and writes regularly for one of the country's leading newspapers. It was not until 1948 that she surprised the public of Lima with an exposition of her drawings, although she had been doing them for as long as she could remember. Hers, she says, is "the work of one who has neither learned nor tried to be a painter I never intended to create the Mad or the Reasonable, the Ugly or the Beautiful, the Perfect or the Monstrous . . . from a vagueness born of ignorance these unoccupied things and vagrant beings emerged. They made use of me in order to appear, and slid down my fingers! . . . My eyes always beheld them in astonishment and awe."

Her efforts in the field of art have not been exhibited publicly outside her own country, but some of her works have been acquired by collectors who have shown them privately abroad. After one of these unofficial showings, Jean Cassou, director of the Museum of Modern Art of Paris, commented that the drawings were "of a rare and singular charm, arresting, surprising, and somewhat disturbing. There is in them much of talent, skill, and poetry."

In an extensive critical commentary, the great Peruvian writer Ventura García Calderón calls Aramburú "a creator of myths and symbols," and refers to her work as "graphic poetry." C. Alberto Seguin writes in Lima's *El Comercio* that "in her drawings we see the incomprehensible and ineffable miracle of the instinct which produces beauty." Eugenio Delgado Arias, Cultural Attaché of the United States Embassy in Peru, has remarked:

> The strange dream world evoked by Helena Aramburú's work is highly charged with intellectual images. It does not quite resemble anything else, and has a disquieting effect on the beholder. Her kind of "primitive" art is unique, strangely compelling.

CATALOGUE

Watercolors

1. *Extinction*
2. *Butterfly*
3. *Iridescent Butterfly*
4. *Brown and Red Butterfly*
5. *The Phantom*
6. *Guignol (Puppet Show)*
7. *The Atomic Bomb*
8. *Indian Masquerade*
9. *Design for Porcelain*
10. *Ninfas del Bosque de Agua (Wood Nymphs)*

Pencil Drawings

11. *Sinbad*
12. *The Lioness Had Twins*
13. *The Midwife*
14. *Veiled Woman*
15. *Greece*
16. *Incan or Pre-Incan Monsters*
17. *The Modern Plato*
18. *Sor Pecado[1] and the Physician*
19. *Escapulario (Scapulary)*
20. *Quixote Today*
21. *Triumph of Venus*
22. *La hija de Leda (Daughter of Leda)*
23. *Unconsciousness*
24. *Virgin without Tears*
25. *Esfinge (Sphinx)*
26. *Credentials*
27. *Portrait of Ventura García Calderón*
28. *Margarita*

[1] *Sor Pecado* means literally "Sister Sin." —*Ed.*

29. *Palo Hu, Queen of El Dorado*
30. *Daughter of Ada, the Seamstress*
31. *Temptation*
32. *El secreto (The Secret)*

Colored Pencil Drawings

33. *Mi perro (My Dog)*
34. *Traición (Treachery)*

Ink Drawings

35. *Egyptian*
36. *Bullfighter*
37. *El duende loco (The Mad Ghost)*
38. *El hijo ajeno (Another's Child)*
39. *El santo (The Saint)*
40. *Bulls in My Patio*
41. *Baile (Dance)*
42. *Fecundidad (Fertility)*
43. *Ballet*
44. *Sevillana (Sevillan Dance)*
45. *Hambre (Hunger)*
46. *Monjas (Nuns)*

Pencil and Ink Drawings

47. *Carnaval (Carnival)*
48. *Modesty*
49. *The Gravedigger*

April 3 - 29, 1950

PABLO BURCHARD, Jr.

Grandson of an architect and son of an eminent Chilean painter who also studied architecture, Pablo Burchard, Jr., is carrying on a family tradition. After earning his degree in architecture, he went on to study painting and graduated in 1945. In 1941, during the course of his studies, he came to the United States for a period of three months, during which he attended a class in drawing at New York's Columbia University. In 1947 he was named professor of architecture at his alma mater, the Catholic University of Chile. At the present time he is studying in the workshop of Abraham Rattner in the New School for Social Research in New York, on a scholarship from the Henry and Grace Doherty Foundation.

Burchard, Jr., has held one-man shows since 1942 and has taken part in group shows since 1939. All of these have taken place in his own country, except the exposition of *Chilean Contemporary Art* presented at the Toledo Museum of Art in Toledo, Ohio, in 1942. His works are to be found in the Museum of Contemporary Art of the University of Chile; the Municipal Museum of Antofagasta, Chile; University of Rio de Janeiro, Brazil; Chilean-North American Cultural Institute, Santiago; and in many private collections in Chile, the United States, Colombia, and Egypt.

CATALOGUE

Tempera

1. *Ferris Wheel*
2. *The Cow's Ballet*
3. *The Turkey's Ballet*
4. *Cranes*
5. *Girasol (Sunflower)*
6. *Rural Scene*
7. *Eclipse*
8. *Peanut Jar*
9. *Fiesta*
10. *Pheasant*
11. *The Traveler*
12. *Sunset*
13. *Puchuncavi*
14. *Village of La Laguna*
15. *Northern Village*

Casein and Oil

16. *Fishing Village I*
17. *Triptych*
18. *Windows*
19. *Fishing Village II*
20. *Pennsylvania Farm*
21. *Chilean Calligraphy*
22. *Chilean Types*
23. *Composition with Three Elements*

May 1 - 31, 1950

GABRIEL FIGUEROA, MEXICAN CINEMATOGRAPHER: STILL PICTURES FROM SOME OF HIS FILMS

An exceptional record of international prizes has established Gabriel Figueroa as the most important figure in Mexican cinematography. Motion pictures which he has photographed have been winning awards in his country since 1936. International film competitions in Italy, Czechoslovakia, Belgium, Spain, and France have been giving special recognition since 1938 to the work of Figueroa, making him one of the most widely-known cameramen in the world today.

Figueroa was born in 1907 in Mexico City and completed his primary and secondary education there. After studying drawing and violin at the School of Fine Arts and the National Conservatory, he became interested in photography and began to do creative work in the field. During the 1930s, when the film industry was just getting started in Mexico, he worked as a still photographer assisting Alex Phillips and Jack Draper, two pioneer cameramen in Mexican movies. Upon discovering his innate talent for photography, the Clasa Studios sent Figueroa to Hollywood to study for four months with Gregg Toland. When he returned to Mexico in 1935, he was given his first motion picture assignment as photographer for *Allá en el Rancho Grande*, a memorable film which enjoyed tremendous

popularity in Latin America and won for Figueroa his first triumph in his country and abroad.

Following its presentation at the Pan American Union, this collection of photographs will be circulated throughout the United States by the Department of Cultural Affairs. Although still pictures cannot do full justice to the extraordinary quality of Figueroa's work on celluloid, we believe that these photographs of the best scenes of some of his prize-winning films will help to familiarize the North American public with the work of this great Latin American artist who has been responsible for Mexico's most significant contributions to the twentieth-century art of cinematography.

In cooperation with the Embassy of Mexico, the Pan American Union is presenting showings of the following motion pictures photographed by Gabriel Figueroa:

The Pearl	May 1
María Candelaria	May 5
Pueblerina	May 8
Río Escondido	May 12

All films except *The Pearl* are made available through the curtesy of Clasa-Mohme, Inc., film distributors of Los Angeles, San Antonio, Denver, and New York.

The Pearl is obtained from RKO Radio Pictures, Inc.

CATALOGUE

 1. *Gabriel Figueroa*
 2. *Enemigos* (last still picture taken by Figueroa before he became a cinematographer)
 3-15. Scenes from *María Candelaria*
 Produced by Films Mundiales, S.A. - Agustín J. Fink, 1943
 Directed by Emilio Fernández
 Original story by Emilio Fernández
 Starring: Dolores del Río, Pedro Armendáriz, Margarita Cortés, Alberto Galán
16-19. Scenes from *La perla (The Pearl)*
 Produced by RKO Radio Pictures Inc. and Aguila Films, S.A., 1945
 Directed by Emilio Fernández
 Based on a story by John Steinbeck
 Starring: Pedro Armendáriz, María Elena Marques
20-25. Scenes from *Enamorada*
 Produced by Productores Asociados Mexicanos, S.A., 1946
 Directed by Emilio Fernández
 Story by Iñigo de Martino, Fernando Fernández, and Benito Alazraki
 Starring: María Félix, Pedro Armendáriz, Fernando Fernández
26-36. Scenes from *Río Escondido*
 Produced by Raúl de Anda, 1947
 Directed by Emilio Fernández
 Based on a story by Emilio Fernández
 Starring: María Félix, Carlos López Moctezuma, Fernando Fernández, Domingo Soler
37-51. Scenes from *Maclovia*
 Produced by Filmex, S.A., 1948
 Directed by Emilio Fernández
 Based on a story by Mauricio Magdaleno
 Starring: María Félix, Pedro Armendáriz, Carlos López Moctezuma, Columba Domínguez

52-57. Scenes from *Salón México*
 Produced by Clasa Films Mundiales, S.A., 1948
 Directed by Emilio Fernández
 Starring: Marga López, Miguel Inclán, Rodolfo Acosta
58-64. Scenes from *Pueblerina*
 Produced by Producciones Reforma, S.A. - Jaime A. Menasce, 1948
 Directed by Emilio Fernández
 Story by Mauricio Magdaleno
 Starring: Columba Domínguez, Roberto Cañedo
65-73. Scenes from *La Malquerida*
 Produced by Francisco de P. Cabrera, 1949
 Directed by Emilio Fernández
 Based on a play by Don Jacinto Benavente
 Starring: Dolores Del Río, Pedro Armendáriz, Columba Domínguez, Roberto Cañedo
74-78. Scenes from *The Torch* (English version of *Enamorada)*
 Produced by Productores Asociados Mexicanos, S.A., 1949
 Directed by Emilio Fernández
 Story by Iñigo de Martino, Fernando Fernández, and Benito Alazraki
 Starring: Paulette Goddard, Pedro Armendáriz, Gilbert Roland

PRIZES WON BY GABRIEL FIGUEROA

NATIONAL AWARDS

Periodistas Cinematográficos

1936 *Allá en el Rancho Grande*
1937 *Bajo el cielo de México*
1938 *Mientras México duerme*

Ateneo Nacional de Arte Cinematográfico

1939 *La noche de los mayas*

Asociación de Periodistas de México

1941 *La casa del rencor*
1942 *Historia de un gran amor*
1943 *Flor silvestre*
1943 *Distinto amanecer*
1944 *María Candelaria*

Academia Mexicana de Ciencias y Artes

1946 *Enamorada*
1947 *La perla*
1948 *Río Escondido*

INTERNATIONAL AWARDS

Biennial Contest, Venice

1938 *Allá en el Rancho Grande*

International Exposition, Cannes

1946 *María Candelaria*

International Fair, Brussels

1947 *Enamorada*
1949 *Salón México*

International Fair, Locarno

1947 *María Candelaria*

International Film Festival, Venice

1947 *La perla*
1949 *La Malquerida*

International Contest, Madrid

1948 *Río Escondido*

International Festival, Prague

1948 *Río Escondido*
1949 *Maclovia*

Hollywood Foreign Correspondents

1949 *The Pearl*

MOTION PICTURES PHOTOGRAPHED BY GABRIEL FIGUEROA

1936 *Allá en el Rancho Grande*
1937 *Jalisco nunca pierde*
 Bajo el cielo de México
 La canción del alma
 Mi candidato
 La Adelita
1938 *Refugiados en Madrid*
 Los millones del Chaflán
 Mientras México duerme
 La casa del ogro
 El monje loco
 La bestia negra
1939 *La noche de los mayas*
 Papacito lindo
 La canción del milagro
 Los de abajo
 Que viene mi marido
1940 *Allá en el trópico*
 El Jefe Máximo
 Creo en Dios
 El rápido de las 9.15
 Ni sangre ni arena
1941 *¡Ay que tiempos Señor Don Simón!*
 El gendarme desconocido

La gallina clueca
La casa del rencor
Virgen de media noche
Mi viuda
1942 *Cuando viajan las estrellas*
Los tres mosqueteros
Historia de un gran amor
La Virgen que forjó una patria
1943 *Flor silvestre*
Fu Man Chu
Distinto amanecer
María Candelaria
El circo
La fuga
1944 *El Corsario Negro*
El intruso
Más allá del amor
Las abandonadas
Bugambilia
1945 *Un día con el diablo*
Cantaclaro
La perla (The Pearl)
1946 *Su última aventura*
Enamorada
El buen mozo
The Fugitive
1947 *La casa colorada*
Río Escondido
María la O
1948 *Maclovia*
Dueña y señora
Media noche
Salón México
Pueblerina
Prisión de sueños
1949 *El embajador*
Opio
La Malquerida
Un cuerpo de mujer
Duelo en las montañas
The Torch (English version of *Enamorada*)
Nuestras vidas
1950 *Un día de vida*

May 9 - 20, 1950

PARKS, GARDENS, AND PUBLIC BEACHES
OF THE CITY OF MONTEVIDEO, URUGUAY: PHOTOGRAPHS

The provision of adequate and beautiful parks, playgrounds, and gardens is one of the essential elements of contemporary city planning. One of the cities of Latin America which has best applied this principle is Montevideo, the capital of Uruguay.

This collection of photographs of Montevideo was assembled by the city's mayor, Germán Barbato, and was brought to the Pan American Union by the Uruguayan architect J.A. Scasso, Director of Parks in Montevideo and designer of many of the projects shown here. Mr. Scasso explains:

> The policy of open-space planning, carried out during the past twenty-five years in Montevideo, has been based upon three fundamental ideas: to provide adequate open areas in relation to the number of the city's inhabitants; to plan these areas so that they may be accessible to people living in all sections of the city; to design and lay out the areas in a manner which will permit them to fulfill their important function in modern community development. Our constant aim has been to provide city dwellers with open recreation areas which are pleasant, comfortable, and close to their homes, so that their leisure time may be spent in a landscaped environment where trees and flowers are a center of visual and spiritual attraction. We believe that the parks, squares, and public beaches of Montevideo contribute to the well-being of its people.

This exhibit was prepared in cooperation with the Section of Housing and City Planning and the Visual Arts Section of the Pan American Union. Following its presentation here, it will be circulated by the Department of Cultural Affairs to interested organizations throughout the United States.

CATALOGUE

1. *Park in the Center of Montevideo*, used chiefly for sport events
2. *View of the City from Rodó Park and Ramírez Beach*
3. *College of Engineering, Rodó Park*
4. *Riverside Drive South of the City*
5. *Palms along Riverside Drive*
6. *Flower Beds Laid Out beneath Palm Trees*
7. *Public Square at Pocitos Beach*
8. *Public Square with Skating Rink*
9. *Artigas Boulevard*, an important parkway
10. *Artigas Boulevard*, showing roadside planting
11. *Congress Gardens*
12. *Rodó Park*, the most popular park in Montevideo
13. *Formal Gardens in Rodó Park*
14. *Children's Playground in Rodó Park*
15. *One of Montevideo's Many Landscaped Playgrounds*
16. *Entrance to the Municipal Golf Course*, from Rodó Park
17. *Ramírez Beach and Rodó Park*, with the municipal golf course in background
18. *Pocitos Beach*, one of the most popular in Montevideo
19. *View of Pocitos Beach*, showing nearby hotels
20. *Buceo Beach*, many sections of the city have their own beaches such as this one
21. *Garden and Club in the Recreational Area of Carrasco Beach*
22. *Public Gardens in the Residential Area of Carrasco Beach*
23. *Pool with Native Aquatic Plants*
24. *Public Gardens Decorated with Beds of Perennial Plants*
25. *One of the Most Recently Planned Squares*
26. *Rock Garden in a Public Square in the Residential District of Carrasco*
27. *Public Park above the Beach*, showing flower beds laid out among natural rock formations
28. *Monument to the Uruguayan Writer José Enrique Rodó*, in the park which bears his name
29. *The Covered Wagon*, monument in the José Battle and Ordóñez Park
30. *Gardens Surrounding the Monument of the Covered Wagon by Uruguayan Sculptor José Belloni*

May 24 - June 3, 1950

REYNALDO LUZA: PORTRAITS

Reynaldo Luza was born in Lima, Peru, in 1893. He decided early in life that he wanted to be an architect, but when his studies at the University of Louvain, Belgium, were interrupted by World War I, he returned to Peru and began an intensive study of drawing. By 1918 he had made up his mind to follow art as a career. He came to the United States and earned his living by contributing drawings to several publications, principally *Vogue*. In 1921 he joined the staff of *Harpers Bazaar* as a fashion artist, a position which he held for twenty-seven years. He spent most of these years in London and Paris, where he worked closely with leading fashion designers of the period.

In 1940 Mr. Luza returned to New York to live, continuing his activities in the fashion and commercial fields. He has received several honorary appointments from the government of Peru, including the artistic direction for the Peruvian Pavilions at the Paris Exposition of 1938 and at the New York World's Fair, 1939, and the decoration of the new Lima airport. Recently he has devoted his time to portrait painting, and has exhibited his work in Paris, New York, and Palm Beach.

CATALOGUE

Portraits: Pencil, Crayon, Pastel, and Watercolor

1. *Señora de Berckemeyer*
2. *Señora de Dillon*
3. *Mrs. Frank Rediker*
4. *Princess Nevine Halim*
5. *Princess Ulvia Halim*
6. *Señora Elvira de Villa-García*
7. *Countess Dorelis*
8. *Mrs. Edward G. Miller*
9. *Mrs. Henry O.H. Frelinghuysen*
10. *Mrs. Ken Regan*
11. *Madame Wellington Koo*
12. *Madame Elovious Mangor*
13. *Mrs. Winston Guest*
14. *Mrs. Thomas Leiter*
15. *Mrs. Sidney Rogers*
16. *Mrs. William Woodward, Jr.*
17. *Señorita Zoila Berckemeyer*
18. *Mrs. Rodman de Heeren*
19. *Mrs. Marshall Hemingway*
20. *Baroness Constantine de Stacklenberg*
21. *Miss Sheila Johnson*
22. *Señorita Cielo Aramburú*

June 6 - 30 1950

SIMON ARBOLEDA: CARICATURES AND DRAWINGS

Art has been only a sideline in Simón Arboleda's checkered career. He was born in Popayán, Colombia, in 1912,

where he attended the University of Cauca. His last mission to New York as consul general of Colombia culminated his foreign service career to which he had devoted his life from 1936 to 1948. He retired into private business, which at the present time he supplements with his work as secretary of the Colombian-American Chamber of Commerce in New York.

Despite the lack of formal art training, Mr. Arboleda has been producing sketches and caricatures for almost twenty years. Much of his work has been exhibited throughout Latin America, but this is the first time they will be presented in the United States.

CATALOGUE

Caricatures

1. *President Harry S. Truman*
2. *Senator Robert A. Taft*
3. *Secretary of State Dean Acheson*
4. *Mrs. Eleanor Roosevelt*
5. *Mayor William O'Dwyer*
6. *Governor Thomas E. Dewey*
7. *Dr. Alberto Lleras*
8. *General Douglas MacArthur*
9. *Cardinal Francis J. Spellman*
10. *Mr. John L. Lewis*
11. *Joseph Stalin*
12. *Albert Einstein*
13. *Pope Pius XII*
14. *Mahatma Gandhi*
15. *Charlie Chaplin*

Drawings

16. *Toros (Bullfight)*
 -El toro
 -El picador
 -La pica
 -Capa
 -Banderillas
 -Muleta
17. *Polo*
18. *Bailarinas (Ballerinas)*
19. *Figuras de ballet (Ballet Forms)*
20. *Carro romano (Roman Chariot)*
21. *Orquesta (Orchestra)*
22. *Bailes modernos (Modern Dances)*
23. *Don Quijote y Sancho (Don Quixote and Sancho)*

July 3 - 17, 1950

PEDRO LEON: WATERCOLORS OF ECUADOR

Pedro León, Ecuadorian landscapist, has also worked as a muralist and stage designer. Born January 18, 1895, in Ambato, Ecuador, Mr. León graduated from the National School of Fine Arts in Quito in 1908. His work as a teacher of decorative painting at the same institution and also at the Juan Montalvo Normal Institute was interrupted in 1936 by a European tour, which included France, Spain, and Belgium.

Works by this well-known Ecuadorian artist have been widely exhibited in the Americas: the Golden Gate International Exposition in San Francisco, in New York at the Riverside Museum and the Grand Central Art Galleries, and in Buenos Aires, Guayaquil, Bogotá, and Quito, where he has held many one-man shows, winning twice the Mariano Aguilera Prize in annual salons. In his last show in Quito's School of Fine Arts, the critic Edmundo Ribadeneira said:

> Pedro León captures the essence of Ecuador with sincere feeling. His painter's eye has a great capacity to understand the various aspects of the country.

The collection contained in this exhibition, due to difficulties of transportation of the heavier, more representative works, is necessarily composed of small examples of Mr. León's work.

CATALOGUE

Oils

1. *Cabeza de indio (Head of an Indian)*
2. *Cabeza de indio (Head of an Indian)*
3. *Joven india (Young Indian Girl)*

Watercolors

4. *Puerto de Manta (The Port of Manta)*
5. *Una calle de Otavalo (A Street in Otavalo)*
6. *Guápulo*
7. *Una calle de Cotocollao (A Street in Cotocollao)*
8. *Mercado (Market)*
9. *Mercado indígena (Native Market)*
10. *Viejo molino (Old Mill)*
11. *Paisaje de Manabí (Landscape of Manabí)*
12. *Paisaje del Oriente Ecuatoriano (Landscape of Eastern Ecuador)*
13. *Puerto de Guayaquil (The Port of Guayaquil)*
14. *Guápulo*
15. *Playa de Salinas (The Beach of Salinas)*
16. *Pueblecito (Village)*
17. *Mercado (Market)*
18. *Iglesia de pueblo (Church)*
19. *Paisaje (Landscape)*
20. *Fiesta indígena (Native Festival)*
21. *Madre negra (Negro Mother)*
22. *Trabajador (Worker)*
23. *Lago de Cuicocha (Lake of Cuicocha)*
24. *Puerto (Port)*

September 13 - 29, 1950

ICONOGRAPHY AND BIBLIOGRAPHY OF *POPOL VUH*

Popol Vuh is one of the classics of American Indian literature belonging to the Maya-Quiché civilization whose principal center was Yucatán and Guatemala. It is religious, legendary, and historical and is considered by some critics as the Bible of the Mayas. The original text is not known. It was undoubtedly transmitted orally until the days of the Conquest. Father Francisco Ximénez gathered these versions and translated them into Spanish. The Maya-Quiché text of Ximénez and his Spanish intepretations have been the source of the various versions which have been written in occidental languages: English, German, and French. Among the most famous are those of Villacorta-Rodas, Brasseur de Bourbourg, Raynaud, and Recinos.

On the occasion of the latest edition of *Popol Vuh* in a literary interpretation by Ermilo Abreu Gómez with illustrations by José García Narezo published in Mexico by Editorial Leyenda, we present photographs of the original manuscript of Father Ximénez located in the Newberry Library, Chicago, Illinois, and loaned by the Library of Congress; portfolio of colored lithographs by Carlos Mérida; previous publications collected with the assistance of the Columbus Memorial Library of the Pan American Union; and original drawings and illustrations as well as examples of the latest volume.

BIOGRAPHICAL NOTE[1]

GARCIA NAREZO, José. Painter, draftsman, illustrator, born in Madrid, 1922, from a Mexican mother and a Spanish father. Born deaf, turned to drawing at an early age, encouraged by his father. Lived in Mexico, 1928-34; returned to Spain, and after the Spanish Civil War went back to Mexico. In 1938 the Spanish Ministry of Public Education published *Un niño y la guerra*, an album containing the young artist's impressions on the war. Executed murals in Mexico. Exhibited his work in Spain, Cuba, Mexico, and the United States, including the M. H. de Young Memorial Museum, San Francisco. Lives in Mexico since 1939.

[1] Not included in the original catalogue. —*Ed*.

YEAR 1951

February 14 - March 15, 1951

HIGHLIGHTS FROM THE COLLECTION OF THE PERUVIAN AMBASSADOR, HIS EXCELLENCY DON FERNANDO BERCKEMEYER

The Ambassador of Peru, Don Fernando Berckemeyer, has loaned a selected group of works from his Washington collection for the opening of the improved exhibition hall of the Pan American Union. Since the collection comprises a group of works of high quality, belonging to the ambassador of a member state and may, some day, become a national collection of Peru, we consider it to be the finest display the Pan American Union could offer to resume its local activities in the field of art.

Ambassador Berckemeyer has dedicated much time and thought to the collection of works of art. To a nucleus of paintings of the Spanish and Peruvian schools belonging to his family, he has constantly added new and valuable objects. Lately, his collection has specialized in the unusual theme of the bullfight. Today, this aspect alone of the Berckemeyer collection has made it a charming depository of a passionate phase of Spanish culture, the art of bullfighting, which has been depicted not only by the great painters of Spain but also by many artists of other countries.

This exhibit presents a selection of interesting works from what may be considered the general part of the collection, as well as a select group dealing with the art of the bullfight.

Ambassador Berckemeyer honors the Pan American Union in making possible the opening of our newly decorated gallery with so distinguished and noteworthy a collection of Spanish and colonial art.

CATALOGUE

SPANISH ART

Oils

Juan de Arellano (1614-1676)
 1. *Flores (Flowers)*

Domingo Chavarito (1676-1750)
 2. *Príncipe Don Luis (Prince Don Luis)*

Eugenio Lucas y Padilla (1824-1870)
 3. *Sancho Panza*

Pedro de Moya (1610-1666)
 4. *La Virgen y el Niño (Virgin and Child)*

Palomino Castro de Velasco (1653-1726)
 5. *Retrato de Doña Mariana de Austria (Portrait of Doña Mariana de Austria)*
 6. *Carlos II (Portrait of Carlos II)*

Francisco de Zurbarán (1598-1664)
 7. *Monje músico (Musical Monk)*

School of Castile
 8. *Crucifixión (Crucifixion)*

Drawings

Francisco de Goya y Lucientes (1746-1828)
 9. *Manteo de muñeco (Tossing the Dummy)*
 10. *Brujas (Witches)*

PERUVIAN ART

Watercolors

Pancho Fierro (1803-1879)
 11. *Procesión (Procession)*
 12. *Las tapadas (The Veiled Women)*

Oils

Cuzco School
 13. *Cristo con la corona de espinas (Christ with Crown of Thorns)*

Peruvian School
 14. *Retrato de María Ramos (Portrait of María Ramos)*
 15. *Retrato de hombre (Portrait of a Man)*

Spanish Colonial School
 16. *La Virgen y el Niño (Virgin and Child)*

ART OF THE BULLFIGHT

Engravings

Pharamond Blanchard (1805-1873)
 17. *Corridas de toro (Bullfight Series: Bull Attacking Horses)*

Antonio Carnicero (1748-1814)
 18. *Vista de la Plaza de Madrid (View of the Plaza of Madrid)*

Francisco de Goya y Lucientes
 19. *Lluvia de toros (Rain of Bulls)*

Watercolors

Pancho Fierro
 20. *Picadores (Picadors)*

Paul Philip Rink (1862-1903)
 21. *Picador*

Oils

Mariano Fortuny (1838-1874)
 22. *El quite (The Pass)*

Francisco de Goya y Lucientes
 23. *Cornada (Horn Blow)*

Luis Juliá (18?-1910)
 24. *Toro (Bull)*

Eugenio Lucas y Padilla
 25. *El toro blanco (The White Bull)*

Manuel Rodríguez de Guzmán (1818-1867)
 26. *Suerte de varas (Party of Bullfighters)*

Lithographs

Francisco de Goya y Lucientes
 27. *Bravo toro (The Brave Bull)*

German Engraving
 28. *Plaza de Madrid*, early 18th century

Spanish Popular Engraving
 29. *La muerte de Pepe-Hillo (The Death of Pepe-Hillo)*, early nineteenth century

European Engravings
30-33. *Bullfighter Costumes*

BIOGRAPHICAL NOTES[1]

BLANCHARD, Pharamond (Henri Pierre Léon Pharamond Blanchard). Painter, engraver, born in Guillotière (France), 1805. Died in Paris, 1873. Studied at the Ecole des Beaux-Arts and with Gros and Chasselat, Paris. Traveled in Russia, Africa, and Spain, where he painted many Spanish scenes. Participated in the French expedition to Mexico and painted some well-known combat scenes. Exhibited in Paris salons.

FIERRO, Pancho. Self-taught painter, draftsman, born in Lima, 1803. Died in the same city, 1879. His genre paintings, that recorded the life and customs in nineteenth-century Lima, were exhibited several times in this century at the Museo Nacional de Arte in Lima.

[1] Not included in the original catalogue. —*Ed.*

May 7 - June 2, 1951

ARTS OF PERU

With the exception of Mexico, there is no other country in the Hemisphere which has wider manifestations in the field of art than Peru. The variety and intensity of its artistic expression has been one of its most distinctive characteristics from pre-Columbian times to the present. This continuity in tradition gives it great validity, since such an art must be considered as a living current through which the people express themselves throughout time. There is an unbroken line of vitality and creative energy from the ancient pre-Inca weavers and ceramists and the homogenous and rich production of the colonial painters of Cuzco to the silversmiths and retablo makers of today.

This exposition, planned simultaneously with the one which resumed our activities after the remodelling of the salon, could not be shown at the same time because of space limitations. We now present a selection of paintings and objects of art of Peru, assembled from different collectors in the Washington area who have graciously loaned their works to promote the understanding and appreciation of Peruvian artistic expression. We extend our sincere thanks to them.

We want to take this opportunity to acknowledge our indebtedness to Mrs. Virgil De Vault, for her care and effort in the gathering of the material exhibited, and Dr. Fernando Romero, of the Division of Education of the Pan American Union, a Peruvian writer and scholar of the popular arts of his country, for his assistance in the preparation of the catalogue.

NOTES ON PERUVIAN POPULAR ART

Painting

The Cuzco school of painting was the most important in the Peruvian highlands and influenced the painting of other localities. It reached its height during the seventeenth century, when creole and mestizo masters such as Gamarra, Baca, and Quispe Tito flourished and decayed in the eighteenth century. It is characterized by its monochrome use of color, gilding, at times profuse, the use of flowers and birds as decorative features, slightly subdued tones, and a certain amount of stiffness in the figures. In its incipiency, this school was influenced by the Spanish school and later by the Flemish and Italian schools.

Retablos

The art of the retablo had its inception in eleventh-century Spain. Imported by the conquistadors, it flourished with unusual brilliance in Peru, especially in the retablo of larger size, but still sculptured, and in the architectural examples seen in the churches of Peru.

In the last twenty-five years a renaissance in the art of the retablo has taken place in the Central Region of Peru, characterized by mestizo technique and themes. The retablo maker of Huancavelica and Ayacucho, with humble materials, has developed beautiful polychromed works of scenic interest and ingenuity, based upon pagan-Christian or frankly pagan themes.

Textiles

In their report to Spain with respect to Peru, the conquistadors noted that the textiles were better than any in Europe and that some of them resembled silk. In spite of a tremendous variety, the textiles from pre-Inca times attained a very high quality, extremely complicated technique, and intricate design. During the reign of the Incas there were special factories directed by the *kumpi-kamayoq* or experts in *kumpi* (fine weaving) for the Incas. Today, as in the past, men, women, and children weave, using the wool of the llama, the alpaca, the vicuña, and the sheep, as well

as cotton and textile fibers. Vegetable and mineral dyes are combined with refined taste. At least half of the population of Peru makes fabrics for its own needs, either at home or in primitive weaving workshops. In this exhibit we present examples of the weaving of the Paracas (ca. 500 B.C.), the Incas, and modern Peruvians.

Silverwork

The pre-Inca and Inca civilizations used gold, silver, and copper alloys in the fabrication of ceremonial artifacts, table service for the royal court, jewelry, etc. This art did not decline during the Spanish colonization and continues to be one of the principal crafts of contemporary Peru. The colonial pieces, such as those included in the present exhibit, are distinguished by their heavy weight, the purity of the metal, and the perfection of the hammer workmanship. In modern work the finishing is more perfect and the metal thinner.

Pottery

The prestige of the ancient Peruvian as a ceramist is based upon the excellent Chimú, Mochica, Nazca, Paraca, or Inca pieces which are to be found in museums throughout the world. Although present day production does not attain the heights of its predecessor, the Indians and mestizos continue to work in plastic clay throughout Peru, especially for utilitarian purposes. Pottery is an instrument of exclusively artistic expression in two regions: Pucará de Puno and Quinua de Ayacucho. In both regions the themes are of animals but are concentrated upon those brought from Europe, which made a strong impression upon the Indians: bulls, sheep, and horses.

Carving

Architectural carving in wood and stone in colonial Peru reached an unusual degree of proficiency which can be appreciated at the height of its excellence in the famous pulpit of Saint Blase and in the stone churches in Puno, Juli, and Pomata. Carving did not attain the same perfection in sculpture, but many magnificent examples are to be found. Generally, the best wood sculpture is religious in subject and invariably incrusted with gold leaf. In respect to stone sculpture, the finest is done in the alabaster of Ayacucho, called *Huamanga* stone.

Mates Burilados (Engraved Gourds)

The *Lagenaria vulgaris* (Cucurbitaceae) was much used in Peru from the pre-Inca period in religious and daily life, having the name *mate*. The Indian and the mestizo continue to use the gourd as a utensil and also as an object of art. Its relatively hard exterior and beautiful skin permit delicate chisel work and the use of transparencies, inks, aqua regia, and tooling to produce contrasts, *velaturas* and polychromes. The art of engraving the *mate* has reached its height in three places in Central Peru: Mayoc, San Mateo, and Huancayo. The gourd as treated in these places is not only an object of artistic creation but also a sort of circular papyrus, recording historic occasions, religious dances, religious festivals, communal or family events, etc.

Apparel

The Incas required that each tribe wear a distinctive costume. Traditionally, each city or valley of present-day Peru has its special costume. Native apparel contains elements of pre-colonial times, of Spanish influence of the sixteenth and seventeenth centuries, and of modern days, with the predominance of influence varying according to the region. The apparel shown is from the region of Cuzco. The women's generally consist of the *montera*; the *jubona* or jacket heavily trimmed with buttons and frets; the *lliclla*, closed in front with the silver pin called *tupu*; the skirt of thick flannel with the *cinta de aguas* or the *cinta labrada* on the edge; the *chumpi* or belt; and the *ojotas* or sandals. Except for the *montera* and the *jubona*, the other pieces are autochthonous.

The men of the same region wear doublet, dress coat, short trousers, cloth cap, *chumpi*, cap or *chullo*, poncho, *chuspa* or bag for coca, and *ojotas*. The first four are Spanish and the remaining are indigenous.

Although the apparel is generally brightly colored, it is occasionally very somber. The Huanca women dress entirely in black with the only note of color supplied by the sleeves, examples of which are shown here.

Jewelry

The Chimús, Mochicas, Tiahuanacos, Paracas, and Incas used metal jewelry, frequently enameled and combined with coral and fine stones, especially emeralds and amethysts, and beautiful collars and armbands of colored seeds. The most common feminine jewel was the *tupu*, used to close the *lliclla* at the front, which the modern Indian continues to use. Even the most humble woman of the Central Region has one or several silver *tupus*. Most of them are made in the traditional technique although some show a European influence. Indians of the Forest Region use collars of seeds and armbands of colored beads. The last mentioned were brought to Peru by the Spaniards to trade for gold.

Featherwork

The colorful bird's feathers contributed by the vassals of the Forest Region were much used by the Incas in parasols, crowns, and other pieces, as well as combined with vicuña wool in the finest textiles (*kumpi*). The art of featherwork has almost completely disappeared, and there remain only a few places in which it is performed but without the ancient skill.

LENDERS TO THIS EXHIBIT

Mrs. Roland B. Anderson, Mrs. Frederick Barcraft, Mrs. Maurice Broderick, Mrs. Eugene Delgado-Arias, Mrs. Virgil T. DeVault, Mrs. William E. Holy, Mrs. Gordon A. McLean, Mrs. A. Ogden Pierrot, Mrs. L.H. Rhodes, Dr. and Mrs. Fernando Romero, Mr. Brenton Sherwood, Mrs. R. Spilsbury, Mrs. Robert M. Stegmaier and Mrs. Charles Walton.

CATALOGUE

PAINTING

1. *Virgin of the Rosary*, Ayacucho, 17th century, oil on canvas
2. *Saint Gabriel*, Cuzco, 17th century, oil on wood
3. *The Adoration of the Magi*, Cuzco, colonial, oil on canvas
4. *The Madonna of the Candelabra*, Cuzco, 18th century, oil on canvas
5. *Saint Dominic*, Cuzco, 18th century, oil on canvas
6. *Saint John the Baptist*, Cuzco, 17th century, oil on canvas
7. *Saint Francis*, Cuzco, 17th century, oil on canvas
8. *Saint Cecilia*, with scroll for use in processionals, Ayacucho, 19th century, oil on canvas
9. *Virgin and Child*, Cuzco, 18th century, oil on canvas
10. *Saint*, Cuzco, late 17th century, oil on canvas
11. *The Baptism of Christ*, oil on wood
12. *Saint Francis*, Ayacucho, colonial, oil on wood
13. *The Virgin*, Cuzco, 17th century, oil on wood
14. *Saint*, Cuzco, 18th century, oil on wood
15. *Saint*, Ayacucho, colonial, oil on wood
16. *Saint in Secular Dress*, Ayacucho, late 19th Century, oil on wood

RETABLOS

17. *Virgin*, Cuzco, 17th century

18. *The Virgin of Copacabana*, Puno, colonial
19. *Saint Anthony*, Huancavelica, contemporary
20. *Saint Anthony and the Christ Child of Lachoj*, Huancavelica, contemporary
21. *Adoration of the Magi and Branding of Cattle*, Huancavelica, contemporary
22. *The Apostle St. James, the Fiesta of Taita-Huamani*, Huancavelica, contemporary
23. *The Baptist, Evangelists and the Fiesta of Rataycuy*, Ayacucho, contemporary
24. *The Evangelists and the Fiesta of Luci-Luci*, Ayacucho, contemporary, *Huamanga* stone
25. *The Holy Family, Christ Mendicant, Saint James on Horseback and Branding*, Huancavelica, contemporary

MASK

26. *Zoomorphic*, Puno, contemporary, pressed paper

TEXTILE

27. *Fragments of Paraca or Inca Weaving*, in cotton, vicuña or llama wool, with geometric designs, mythological figures, feline figures, winged serpents, etc. Included are fragments of ceremonial costumes, clothing, mantles, etc., of various techniques. They are from mummies of Paracas and other places.
28. *Examples of Contemporary Weaving*, in vicuña, alpaca, llama wool, and in cotton from Cuzco, Puno, and the Central Region of Peru.

SILVERWORK

29. *Chalice*, colonial
30. Tableservice, colonial
31. *Crown*, colonial
32. *Duck, Baptismal Vessel*, early 19th century
33. *Calling Card Receptacle*, contemporary
34. *Chest*, contemporary

POTTERY

Pre-Columbian

35. *Costal Bird*, Chicama, pre-Inca, Chimú technique
36. *Vase,* Department of Lima, *pre-Inca, nievería* technique
37. *Porongo (Gourd)*, Department of Lima, pre-Inca, Chancay technique

Contemporary

38. *Frog and Llama*, Northern Coast, imitation of black Chimú pottery
39. *Warrior*, Northern Coast, imitation of black Chimú pottery, made in a mold
40. *Pitcher*, Alto Ucayali, firing technique
41. *Plate*, Alto Ucayali, Chama technique
42. *Bull, Horse, Llama, and Dancers*, Puno, Pucará technique
43. *Bull, Sheep, and Musician*, Ayacucho, Quinua technique

HUAMANGA ALABASTER

Religious Themes

44. *Saint Christopher*, framed
45. *Head of Jesus*, colonial, polychrome
46. *Heart of Jesus*, contemporary, polychrome
47. *The Baptist*, colonial, in two colors
48. *Saint Toribio of Mogrovejo*, colonial, with touches of color
49. *Saint Toribio of Mogrovejo*, contemporary, with touches of color

Secular Themes

50. *Fruit Dish*, colonial, polychrome
51. *Guitarist*, colonial, polychrome
52. *Lion*, colonial, polychrome
53. *Figures in Religious Dress*, colonial, polychrome
54. *Temptation*, colonial, polychrome. Inspired by the *Temptations of Saint Anthony*. A soldier is substituted for the saint.
55. *Indian*, colonial, polychrome

MATES BURILADOS (Engraved gourds)

56. *Huanca Sugar Bowl*, Cochas Grande, Huancayo in the Central Region of Peru, polychromed. It has three scenic bands, showing rural activities, weaving, preparation of *chicha*, loading llamas, etc., and animals playing musical instruments and dancing.
57. *Huanca Cococha*, San Mateo, Huancavelica in the Central Region, dyed in three colors. It shows scenes from the cattle branding fiesta.
58. *Mate Huanta*, Ayacucho in the Central Region, tooled from Mayoc. It shows scenes from a family party.
59. *Huanca Sugarbowl*, Huancayo in the Central Region, polychromed. It shows scenes from the Fiesta de Los Chunchos.
60. *Huanca Sugarbowl*, Huancayo in the Central Region, polychromed. It shows scenes from the Umbrella Fiesta.
61. *Mutated Gourds*, Northern Coast, tooled, Lambayeque technique. They show symbolic scenes.
62. *Baby Rattles*, Huancayo in the Central Region, dyed. They show rural scenes.

WOODCARVING

63. *Farming Instrument Handle*, Chimú or Mochica, pre-colonial
64. *Jesus in the Garden*, colonial, polychrome
65. *Saint*, colonial, polychrome
66. *Saint Mark*, colonial, polychromed altarpiece
67. *The Virgin*, colonial

STIRRUPS

68. Colonial, bronze. They preserve the form of the 16th-century tournament stirrup.

69. Late 19th century, wood, repoussé leather and silver. They preserve the form of the Spanish stirrup of the cowboy but are called *de cajón*.

APPAREL

70. *Woman's Dress*, Pisac, Cuzco
71. *Man's Suit*, Pisac, Cuzco
72. *Woman's Dress*, Tinta, Cuzco
73. *Pre-Inca Collar of Gold*, found in a mummy
74. *Collars*, Forest Region, made of seeds
75. *Bracelets*, Forest Region, one of glass beads and the other of monkey teeth
76. *Lliclla*, Huancayo, wool, dark tones
77. *Lliclla*, Cuzco, wool
78. *Chullos of Wool*, various parts of Peru. Some show traditional techniques and others were produced for tourists. One has the inscription: "Viva the United States with Peru. They are Friends of Peruvians."

79. *Chuspa of Wool,* bag for coca
80-81. *Ponchos of Wool*, one is for an adult, the other for a child
82. *Chumpis or Belts*, various parts of Peru, wool and cotton
83. *Huanca Sleeves*, Valley of Mantaro in the Central Region of Peru

FEATHERWORK

84. *Fans*, Forest Region, contemporary. Imitation of the featherwork technique of the Incas.

DOLLS

85. *Llama*, made of llama fur
86. *Cast Dolls*, showing apparel of Pisac, Cuzco and Ayacucho
87. *Woollen Dolls*, showing apparel of Huancayo and Cerro de Pasco
88. *Dolls of Papier-Mâché*, showing apparel of the Central Region
89. *Wooden Dolls*, Central Region, polychrome

June 5 - July 7, 1951

TWO ARTISTS OF GUATEMALA:
ROBERTO OSSAYE, ROBERTO GONZALEZ GOYRI

Two young artists of Guatemala are presented to the Washington public for the first time. Belonging to the generation of intellectuals who have appeared in that Central American republic since 1945, these young men, painter and sculptor respectively, have passed a great part of their apprenticeship in the United States, where they have both resided since 1948 on scholarships provided by their government. Now, as professionals, they are preparing to return to their country and join its cultural movement.

Roberto Ossaye was born in Guatemala City in 1927. He studied for five years at the National Academy of Fine Arts in that capital, where one-man exhibitions of his work were held annually from 1946 through 1948. Since coming to New York, his painting has been shown in that city at the Roko Gallery in 1950 and 1951.

Roberto González Goyri was born in Guatemala City in 1924. After studying at the National Academy of Fine Arts, he assisted the Guatemalan artist Julio Urruela Vásquez in his execution of the stained glass windows for the National Palace. He also worked as draftsman and assistant to the head of the Department of Ceramics in the National Archaeological Museum. The Guatemalan Academy of Fine Arts held his first one-man show in 1948. Since coming to New York, he has joined the Sculpture Center, and exhibitions of his work have been held at the Clay Club in 1949 and the Roko Gallery in 1950 and 1951.

We wish to acknowledge our indebtedness to the Roko Gallery of New York, representative of both artists, in making it possible for us to present this exhibit through the loan of the paintings and sculpture contained therein.

CATALOGUE

Roberto Ossaye

Painting

1. *Niña y eclipse (Girl and Eclipse)*, duco enamel

2. *Mujer enlutada (Woman in Mourning)*, duco enamel on canvas, 25" x 54"
3. *Casas en fuego (Houses on Fire)*, duco enamel
4. *El rosalito*, duco enamel
5. *Incidente trágico (Tragic Incident)*, duco enamel
6. *El payaso (The Clown)*, oil
7. *Pintura (Painting)*, oil
8. *Primera comunión (First Communion)*, oil on canvas, 20" x 35"
9. *El torito*, encaustic on cardboard, 10" x 6"
10. *Serenata en Grazioso (Serenade in Grazioso)*, encaustic on cardboard, 10" x 6"
11. *Región de lo fértil (Growth of the Soil)*, encaustic
12. *Toro de la prehistoria (Prehistoric Bull)*, encaustic on cardboard, 10"x 7"

Roberto González Goyri

Sculpture

13. *Pelea de gallos (Cocks Fighting)*, tin alloy direct
14. *La edad de oro (The Golden Age)*, terra-cotta
15. *Cazadora de pájaros (Hunter of Birds)*, plaster for bronze
16. *Luchadores (Wrestlers)*, bronze
17. *Cabeza (Head)*, stone

July 9 - August 18, 1951

MARTIN FIERRO. PHOTOGRAPHIC INTERPRETATION BY ARNOLD HASENCLEVER

Born in Germany in 1908, Arnold Hasenclever studied music in Cologne, Berlin, and Milan. While studying in Italy, his interest veered from music to painting and from painting to photography. To finance further work with his camera, he worked in German films as an actor, an experience of great value to him in his later work with documentary films. The first of these was made in Rome on the theme of Resphigi's *The Fountains of Rome*. After a successful series of documentaries in both color and black and white, Mr. Hasenclever opened a studio in Rome and traveled to Hungary, Austria, France, Yugoslavia, Switzerland, North Africa, and South America.

During his first visit to Argentina, he was invited to a large *estancia* in the Province of Santa Fe. He became acquainted with *Martín Fierro* there and conceived the idea of making a photographic interpretation of this classic of the Argentine literature.

Mr. Hasenclever came to the United States in 1938, becoming a citizen of that country during the war. Later, he returned to the same *estancia* he first visited in Argentina and spent three years traveling through this great country, studying and interpreting it photographically. The collection of photographs included in this exhibit was first shown in Rome at the Palazzo Farnesio in 1949 and in 1950 in Buenos Aires under the auspices of the Cultural Department of the American Embassy. It will be circulated throughout the United States under the auspices of the Pan American Union at the close of the showing in Washington.

In the seventy-nine years since its appearance in Buenos Aires, *Martín Fierro* has not only come to be regarded as one of the masterpieces of Argentine literature but has also won a permanent place among the classics of the entire continent. This work by José Hernández represents the pinnacle of gaucho poetry devoted to the life and deeds of the hardy, freedom-loving cowboys of the pampas. Its hero, by now a legendary figure, is the embodiment of their

rugged qualities and defender of their claim for social justice. In Martín's struggle against the corruption of government officials, his flight from the police, his sufferings among Indian tribes, and his wanderings across the endless desert, gauchos have seen the reflection of their own arduous existence. Even though the quickening pace of life in the industrial age has forced the gaucho to modify many of his ways, his spirit still lives in Argentina.

So great was the success of this book that in 1879 the author published a sequel entitled *La vuelta de Martín Fierro (The Return of Martín Fierro)*. During the seven years between the first and second parts, the work had run through fifteen editions in Argentina alone, with a total of some 60,000 copies. Aside from its literary excellence, the political implications of the poem account for much of its popularity. The racy idiomatic style of gaucho speech, combined with the identification between the author and the character he creates, produce the realism and vitality of the poem. In addition to the numerous Spanish editions, two English translations of *Martín Fierro*, one in verse and the other in prose, have been published.

Arnold Hasenclever has taken the book *Martín Fierro* as a base for the free creation of an interesting study of the Argentine countryside, the gaucho and his customs, work and habits.

CATALOGUE[1]

1. *Todo es cielo y horizonte (A great green plain ringed rim to rim)*
2. *¡Ah tiempo! ... pero si en él (I never so happy was before)*
3. *Sólo tenía cuatro frascos (Another time, to wet my throat)*
4. *Mi gala en las pulperías (Ah, happy was I 'neath my rancho's roof)*
5. *Y sentao junto al jogón (They would gather there the blaze around)*
6. *Vamos, suerte, vamos juntos (Come then, my luck, let's be off together)*
7. *Estaba el gaucho en su pago (Ah, my mind goes back and I see again)*
8. *Su esperanza es el coraje (His prairie-craft and his own stout heart)*
9. *Monté y me largué a los campos (I mounted and made for the open plain)*
10. *Para correr en el campo (And through the gap of the open gate)*
11. *Es triste dejar sus pagos (Though where he starts from he doesn't know)*
12. *Solo nací... solo muero... (And whether we keep or lose our lives)*
13. *Tendiendo al campo la vista (And while some bridled the pampa colts)*
14. *Juntando toda la hacienda (And when the last of the herds they round)*
15. *Sé correr en un rodeo (I can rope on foot a running steer!)*
16. *¡Ricuerdo!, ¡qué maravilla! (Since the day I could climb)*
17. *Rejuntábamos la hacienda (I can ride in the round-up)*
18. *Siempre el mesmo sacrificio (And when the time of the branding came)*
19. *Y apenas la madrugada (I mind me well when the star of dawn)*
20. *Me sé sentar en un pértigo (I can sit as firm on a wagon-shaft)*
21. *¡La pucha, que se trabaja!... (By the toil of his hands)*
22. *Llegó a mi conocimiento (There were gauchos came from far and near)*
23. *Y se cría viviendo al viento (I'd a bunch of cattle and sheep)*
24. *Aquello no era trabajo (There was work for all...or rather play)*
25. *Mi gloria es vivir tan libre (And this is my pride: to live as free)*
26. *Tal vez no te vuelva a ver (She was the song-bird that lighted down)*
27. *Dende chiquito gané (Ah, my mind goes back and I see again)*
28. *Cantando me he de morir (When you that listen and I who sing)*
29. *¡Amigo, qué tiempo aquél! (To stick to your brother's a good old law)*
30. *Allí mis hijos queridos (There was a time when I knew this land)*

[1] In most of the cases the titles in Spanish do not correspond to their English translations. —*Ed.*

31. *Para mí el campo son flores (A son am I of the rolling plain)*
32. *Era un pingo que alquirí (A mount was that of the finest breed)*
33. *De Dios vida se recibe (From the ocean's deeps to the skies above)*
34. *Y en esa hora de la tarde (At the peaceful hour of the afternoon)*
35. *Muchos quieren dominarlo (And the colt would thrash)*
36. *Ansí todo el que procure (He handles it softly for a start)*
37. *Soy gaucho, y entiendanló (I was born on the mighty pampa's breast)*

August 13 - 31, 1951

SAMUEL MALLO LOPEZ: PAINTING, SCULPTURE

Samuel Mallo López of Argentina has pursued a dual career with singular success. Specializing in the treatment of mental disease, he is on the staff of the Gaelic Center and the Ramos Mejía Hospital in Buenos Aires. Dr. Mallo López studied at the National Academy of Art in Buenos Aires and was awarded the title of Professor of Drawing in 1925. Since 1937 his work has been shown widely in his own country in various galleries of the capital and in Rosario, Bahía Blanca, Avellaneda, and Mendoza. He won the prize of Honor in a recent exhibit organized by the physicians of Buenos Aires. His canvases have also been displayed in Santiago de Chile and Valparaíso. Recently, Dr. Mallo López has become interested in small sculptures, using bread dough as a media, and these *caprichos* (caprices), as he calls them, were awarded a special prize at the Seventh Congress of Surgery held in 1950 in Buenos Aires.

CATALOGUE

Oils on Cardboard

United States

1. *Great Falls*, Washington

Argentina

2. *Ombú*, Ezeiza
3. *Escuela-Hogar Eva Perón (Home-School Eva Perón)*, Mendoza
4. *Casa Rosada*, Buenos Aires
5. *Contraluz (Against the Light)*
6. *Entrevía (Railway Track)*
7. *Calle Espora (Espora Street)*
8. *Paseo Colón*
9. *Paseo Colón*
10. *Calle Ingeniero Huergo (Ingeniero Huergo Street)*
11. *Calle Almirante Brown (Almirante Brown Street)*
12. *Calle Estados Unidos (Estados Unidos Street)*
13. *Calle Carlos Calvo (Carlos Calvo Street)*
14. *Calle Humberto I (Humberto I Street)*
15. *Calle Tucumán (Tucumán Street)*
16. *Calle del bajo (Street on the Outskirts of Buenos Aires)*
17. *Después de la lluvia (After the Rain)*
18. *Bajo de Flores (Outskirts of Flores)*

19. *Suburbio (Suburb)*
20. *Riachuelo*
21. *Mediodía (Noon)*
22. *Grúa, Riachuelo (Crane on the Riachuelo)*
23. *Playa Chica,* Mar del Plata
24. *Club de Nácar*
25. *Acequia (Canal)*
26. *Saucedal (Willows)*
27. *Costura (Needlework)*
28. *Lectura (Reading)*

Brazil

29. *Santos*
30. *Calle de Bahía (Street in Bahía)*
31. *Calle de Bahía (Street in Bahía)*
32. *Iglesia Monserrat (Monserrat Church),* Santos
33. *Playa Caiobá (Caiobá Beach)*
34. *Bananos (Bananas)*
35. *Puerto de Paranaguá (Paranaguá)*

Uruguay

36. *Rancho (Ranch),* Piriápolis
37. *Punta del Este*
38. *Médanos al sol (Sunny Dunes),* Piriápolis
39. *Playa Grande,* Piriápolis
40. *Playa (Beach)*
41. *Desde el cerro San Antonio (View from San Antonio Hill),* Punta Fría
42. *El balcón (The Balcony)*

Sculpture: *Caprichos (Caprices)*

43. *Dolce far niente,* bread dough
44. *Chola,* bread dough
45. *The Prodigal Son,* terra-cotta
46. *Winter,* bread dough
47. *Vintager,* bread dough
48. *Clown,* bread dough
49. *Faun,* bread dough
50. *Labourer,* bread dough
51. *Globe-Trotter,* bread dough
52. *Flute Player,* bread dough
53. *Peddler,* papier-mâché
54. *Narcissus,* plasticene
55. *Native Girl,* plaster of Paris
56. *Franciscan Monk,* bread dough
57. *Faun,* plaster of Paris
58. *Clay*
59. *Eurythmy,* bread dough
60. *Mother,* bread dough

61. *Awakening*, bread dough
62. *Despair*, bread dough
63. *Tanagra*, bread dough
64. *Tango*, bread dough
65. *Coquetry*, bread dough
66. *Pan*, bread dough
67. *Musician*, bread dough
68. *Poet*, bread dough
69. *Rascal*, bread dough
70. *Tramp*, bread dough
71. *Quarrelsome Fellow*, bread dough
72. *Grief*, bread dough
73. *Fusion*, bread dough
74. *Canillita (Newspaper Boy)*, bread dough

September 24 - October 20, 1951

LUIS MARTINEZ PEDRO

Luis Martínez Pedro was born in Havana, Cuba, in 1910. He had no formal academic training in art although he attended the School of Architecture of the University of Havana for a short period and also studied under the Cuban painter Víctor Manuel. For several years, during his early youth, he lived and studied in the United States, first in Florida and later in New Orleans. He is at the present time art director of a successful Havana advertising agency.

Martínez Pedro's position among contemporary artists of his country is primarily based upon his outstanding ability as a draftsman. He was first interested in the indigenous and almost extinct culture of the Taíno Indians who inhabited Cuba in the pre-Columbian period and is at present concerned with that of the Afro-Cubans. He has worked seriously in the fusion of elaborate forms based upon natural elements and components of these cultures into modern expression. The different manifestations of the Negro religious secret societies, such as *ñañiguismo*, form the subject matter of much of his work. The *Cuarto de Fambá* or secret room, used for initiation and secret rites in this cult, has absorbed his attention. Martínez Pedro's interpretations are free and in the field of abstract expression, and do not pretend to be documents of ethnological or scientific importance but rather lyric and chromatic versions of one aspect of the culture arising from the intermingling of races in Cuba.

The work of Martínez Pedro has been shown in Havana, Mexico City, San José (Costa Rica), Guatemala City, Buenos Aires, La Plata (Argentina), Caracas, Panama City, Stockholm, Paris, and in New York at the Museum of Modern Art and the Perls Galleries, his sole agent in the United States. Although he has participated in group shows in Washington, this is his first one-man show in this city. It is composed of paintings and drawings not previously shown outside of Cuba.

CATALOGUE

Oils

1. *Personajes del Cuarto de Fambá (Personages of the Fambá Room)*, oil on masonite, 36 x 48"
2. *Personajes del Cuarto de Fambá (Personages of the Fambá Room) II*, oil on canvas, 33 1/2 x 42"
3. *Personajes del Cuarto de Fambá (Personages of the Fambá Room) III*, oil on masonite
4. *Hombre con tambor (Man with Drum)*, 1951, oil on cardboard, 41 x 32"
5. *Naturaleza muerta (Still Life)*, oil on cardboard, 27 x 21 3/4". Coll. Mrs. Gilda Dahlberg

6. *Músico (Musician) I*, oil on cardboard, 20 x 30"
7. *Hombre con pájaro (Man with Bird)*, oil on canvas, 16 x 19 3/4"
8. *Plantas (Plants)*, oil on cardboard, 9 1/2 x 16 1/2"
9. *Figura en rojo (Figure in Red)*, oil on cardboard, 23 1/4 x 3 1/4"
10. *Mariposa y hombre (Butterfly and Man)*, oil on cardboard, 24 x 32"
11. *Personajes del Cuarto de Fambá (Personages of the Fambá Room) IV*, oil on canvas, 24 x 20"
12. *Músico (Musician) II*, oil on cardboard, 23 1/2 x 30"
13. *Mujer (Woman)*, oil on cardboard, 20 x 30"
14. *Dos figuras (Two Figures)*, oil on canvas, 18 x 24"
15. *Figura (Figure)*, oil on canvas, 18 x 24"
16. *El cazador (The Hunter)*, oil on cardboard

Gouaches

17. *Los músicos (The Musicians)*, 32 x 40"
18. *Personajes de la cortina verde (Personages of the Green Curtain)*, 24 x 32"

Drawings: Ink on Paper

19. *Personaje (Personage)*, 5 1/4 x 8 1/2"
20. *Personaje (Personage)*, 5 3/4 x 9"
21. *Personajes (Personages)*, 6 1/2 x 9"
22. *Personajes (Personages)*, 8 x 8 1/2"
23. *Personajes (Personages)*, 6 1/2 x 8 1/2"
24. *Personajes (Personages)*, 6 1/2 x 8 1/2"
25. *Personajes (Personages)*, 7 1/2 x 8 1/2"
26. *Personajes (Personages)*, 13 x 8 1/2"
27. *Personajes (Personages)*, 8 1/2 x 14 1/2"

October 22 - November 10, 1951

ARTURO PACHECO ALTAMIRANO

Since his early youth Arturo Pacheco Altamirano has dedicated all his energies to painting. He was born in 1905 in Chillán, Chile, a country distinguished by its extensive coastline of various climates. Self-taught, Pacheco Altamirano dedicated himself to painting the endless variations presented by the sea of Chile, its ports, its coves and beaches.

His marines had been shown in exhibits of his native land prior to 1929, when one of his paintings won the First Medal in the National Salon of Fine Arts of Chile. Pacheco Altamirano was also awarded prizes in collective exhibitions in Valparaíso in 1934 and Viña del Mar in 1936. He has had one-man shows in Lima and Buenos Aires.

Today, examples of his work are to be found in the principal museums of Chile and in the National Museum of Fine Arts in Buenos Aires as well as in numerous private collections of Chile, Peru, and Argentina.

This is Arturo Pachecho Altamirano's first one-man show in the United States. At the close of its presentation at the Pan American Union, this exhibit will be shown at the Van Diemen-Lilienfeld Galleries in New York.

CATALOGUE

Oils

1. *Southern Bazaar*, Puerto Montt
2. *Rocky Landscape*, Quinteros
3. *Market*, Valdivia
4. *Interior*, Puerto Montt
5. *Reefs*, Quinteros
6. *Landscape*, Ancud
7. *Rainy Day*, Valdivia
8. *People on the Wharf*, Valdivia
9. *Old Cathedral*, Ancud
10. *Schooner*, San Antonio
11. *Rocks*, Cartagena
12. *Foggy Morning*, Puerto Montt
13. *Small Village*, Ancud
14. *Small Port*, Puerto Montt
15. *Rocks and Sea*, Cartagena
16. *Rainy Day*, Puerto Montt
17. *Afternoon Clouds*, Puerto Montt
18. *South Wind*, Puerto Montt
19. *Return from Fishing*, Puerto Montt
20. *Afternoon Sun on the Rocks*, Cartagena
21. *Small Shipyard*, San Antonio
22. *Work in the Port*, Puerto Montt
23. *Street after the Rain*, Puerto Montt
24. *Reef*, Cartagena
25. *Rocks in Grey*, Cartagena
26. *Rocks in the Afternoon Sun*, Cartagena
27. *Boats in the Afternoon Sun*, Puerto Montt
28. *Street in Puerto Montt*
29. *Mapocho River*, Santiago
30. *Tugboat*, Talcahuano

November 19 - December 18, 1951

ARTISTS OF THE UNITED STATES IN LATIN AMERICA

Even though the great centers of European art still attract large numbers of North American artists yearly, the affluence of those traveling in different regions of Latin America continues unchanged.

Because of its many attractions, Mexico, of all Latin American countries, is most popular. Lately, Haiti has become a center of activity for North American artists. In spite of the fact that the majority are attracted by these two countries, painters and sculptors from the United States also visit Central America, the Antilles, and South America.

This exhibit comprises works of different tendencies, from documentary realism to nonobjective interpretations. It is a selection of statements of the creative spirit, attempting to interpret a different milieu. All of them, moreover, are evidence of the desire for understanding among peoples, an achievement that can be realized first of all through

art. Similar exhibits are planned yearly or when the work of a sufficient number of artists is available. In this way, we shall keep abreast of the prevailing tendencies in the art of this country through its artists' impressions of the Latin American scene.

CATALOGUE

Eugene Berman
1. *Los angelitos*, Mexico, oil. Loaned by M. Knoedler Gallery, New York

Carolyn Bradley
2. *Market House*, Costa Rica, watercolor
3. *The Marimba Players*, Costa Rica, watercolor

William Calfee
4. *Haitian Dancers*, tempera

Richard Dempsey
5. *Hills of Haiti*, oil
6. *View from My Room*, Haiti, oil

Paul England
7. *Swimmers*, Haiti, oil
8. *Funeral March*, Mexico, oil

Eugenie Gershoy
9. *The Sisters*, Yucatán, Mexico, gouache
10. *Street in Chiburran*, Yucatán, Mexico, gouache

Edith Hoyt
11. *Fiesta of St. Thomas*, Guatemala, oil

Walter Iler
12. *Women of Mexico*, oil. Loaned by Weyhe Gallery, New York.

Harlan Jackson
13. *The Flight of Eyes*, Haiti, oil. Loaned by Barnett Aden Gallery, Washington, D.C.
14. *Composition*, Haiti, 1947, oil

Theodora Kane
15. *Taxco Cathedral*, Mexico, duco
16. *Village in the Sun*, Ajijic, Mexico, oil

Miriam McKinnie
17. *Taxco Market*, Mexico, watercolor
18. *Taxco*, Mexico, watercolor

Ruth Starr Rose
19. *High Wind on Lake Chapala*, Jalisco, Mexico, silk screen

Jason Seley
20. *Maternité*, Haiti, bronze

21. *Rondo*, Haiti, bronze

Edward John Stevens
22. *Mexican Masquerade*, oil
23. *Vision of Mexico*, oil. Loaned by Weyhe Gallery, New York

Prentiss Taylor
24. *Passing through Zamora*, Mexico, oil
25. *Tepotzotlán Rooftops*, Mexico, oil

December 20, 1951 - January 16, 1952

CARLOS MERIDA: PAINTINGS AND MURAL PROJECTS

Although Carlos Mérida is often presented in books and exhibitions as a Mexican, he was born in Guatemala City of Maya-Quiché origin, in 1891. He traveled to Europe in 1910, where he studied under Anglada Camarasa, and in Paris he met and was influenced by Modigliani. Upon his return to Guatemala in 1914, he began to experiment with painting based on Mayan folklore themes. In 1921 he went to Mexico where he lived until 1950, when he was appointed cultural attaché to the Guatemalan Legation in Italy. Since that time he has returned to Mexico and has made frequent trips to the United States. In 1947 he visited his native country at the invitation of the Guatemalan government. During his residence in Mexico he has directed the Department of Folklore and Dance of the Ministry of Education, besides teaching, illustrating, and designing stage sets, as well as continuing to paint. He also served as director of the Mexican Art Workshop in Taxco in 1949 and 1950.

His work is included in the private collections of many prominent Americans and Mexicans, as well as in the Museum of Modern Art of New York, and in the Philadelphia and San Francisco museums of art. Since 1920, when his work was first displayed in Mexico City, it has been shown there on innumerable occasions, in addition to three exhibits in Paris. He has held eleven one-man shows in New York and the following American cities: San Francisco, Los Angeles, Milwaukee, Madison, Hollywood, Pittsburgh, Chicago, San Antonio, Boston, Washington, D.C., and at the universities of Michigan and Minnesota. His latest exhibition was held early in 1951 in Rome. Some of the works of that show are included in the present exhibit at the Pan American Union and will be presented again in February at the New Gallery in New York.

CATALOGUE

Temperas, 1948

1. *Lázaro y la noche (Lazarus and Darkness)*
2. *El cielo de los negros (Negro Heaven)*
3. *La bestia alucinada (Charmed Beast)*
4. *El cometa y el caballo (The Comet and the Horse)*
5. *El paraíso perdido (Paradise Lost)*
6. *Danza de la muerte (Dance of Death)*
7. *Retablo en tono menor (Retablo in a Minor Key)*

Oils, 1949

8. *Romeo y Julieta (Romeo and Juliet)*
9. *Zobeida y Shahryar (Zubaydah and Shahryar)*

10. *Tristán e Isolda (Tristan and Isolde)*

Painting Toward Architecture, 1950

11. *Mural Project for a Building Lobby*, carved stone of different tones, partially painted in vinylite
12. *Project for a Mural in a Garden*, metallic tile

Oils, 1951

13. *Los Tres Reyes (The Three Kings)*
14. *La luna y el venado (The Moon and the Deer)*
15. *La pavana del moro (The Pavane of the Moor)*
16. *El pájaro Cu (The Bird Cu)*
17. *El zanate*
18. *Las doncellas bajo el signo (The Maids under the Sign)*
19. *El ciervo y el ángel (The Fawn and the Angel)*
20. *Geometría en la forma (Geometry in Form)*
21. *La endecha (The Soothsayer)*
22. *Canto al maya (Song to the Maya)*
23. *Ensueño en la tarde (Dreaming at Dusk)*
24. *El beso del hada (The Kiss of the Fairy)*

YEAR 1952

January 23 - February 19, 1952

SPANISH INFLUENCE IN THE POPULAR ARTS
OF THE SOUTHWEST OF THE UNITED STATES
A Selection from the Index of American Design

During the early years of President Franklin D. Roosevelt's administration, the art critic Holger Cahill was appointed national director of the Index of American Design, one of the many activities carried out under the Federal Art Project of the Works Progress Administration. The Index of American Design contributed to the cause of American art in two ways. It gave work to artists who were unemployed in the difficult days of the great economic crisis, and it preserved for posterity the legacy of the different cultures that have given shape to an American culture.

The artists who were commissioned to survey the popular arts of the different regions were taught to copy faithfully, in order to give an exact and analytical representation of objects, wood carvings, ceramic and metal works, textiles, etc., thereby keeping various creative expressions alive. The work rendered by each artist clearly depicts, better than a photograph, all of the characteristics of the furniture, lace, toys, etc., included as examples of popular art in the United States from before 1700 until the beginning of 1900.

The work of different groups of artists in various regions of the United States resulted finally in the precise and analytical recording of some 15,000 different items, which constitute today the Index of American Design, deposited for study in the National Gallery of Art in Washington, D.C., where it is under the expert supervision of its curator, Erwin O. Christensen.

Through the courtesy of the National Gallery of Art, the Pan American Union presents an exhibit which is an example of an aspect of United States culture in the Southwest, which sprang from the same source as the art of its Latin neighbors. Historical events have contributed in a large degree to the characteristics that are peculiar to it, as may be seen, for example, in the art developed through the Franciscan missions in California, or through the Spanish-taught Indians of New Mexico and Colorado who created the *retablos* and *santos*, which although closely related to the popular wood carving and painting of Mexico, gradually took on distinctive features of their own.

CATALOGUE

California[1]

1. *Lamb of God*, plaque
2. *Cross*, wrought iron
3. *Child's Saddle*
4. *Ornamental Carvings*

[1] The states mentioned in this exhibition are those in which the originals copied by the artists were found. They do not necessarily represent the region in which the work was originally done.

5. *Water Spout*
6. *Tabernacle*
7. *Skirt*
8. *Armchair*
9. *Baptismal Font*, copper
10. *Cruet*, copper
11. *Spur*
12. *Frame*
13. *Candleholder*, tin
14. *Grease Lamp*
15. *Book Cover*
16. *Wall Painting*

Colorado

17. *Death Angel and Cart*
18. *Retablo, Madonna*
19. *Retablo*
20. *Cross*, wood
21. *Bulto, Penitent Christ*
22. *Bulto*
23. *Bulto*
24. *Retablo, St. Joseph*
25. *Bulto, St. Michael*
26. *Retablo, St. Rita*
27. *Bulto, Holy Family*
28. *Unknown Saint*

New Mexico

29. *Bulto, Immaculate Conception*
30. *Candelabrum*, wood
31. *Chest Design*
32. *Chest Design*
33. *Hutch Table*
34. *St. George*
35. *Retablo, Virgin*
36. *Retablo, St. Mary*
37. *Chest*
38. *Retablo, Virgin and Child*
39. *Retablo*
40. *Nazarene Christ*
41. *Saint Loginus*
42. *Penitente Santo Entierro*
43. *Penitent Christ*
44. *Job*

Texas

45. *Fountain*, limestone
46. *Doorway*, limestone

February 25 - March 10, 1952

ALEJANDRO ALONSO ROCHI

Alejandro Alonso Rochi was born in León, Nicaragua, in 1898. For the past thirty years he has been living in Europe, where he studied at the School of Fine Arts in Rome, painted in Paris and Spain, and represented his country as a diplomat in Czechoslovakia and Spain. At present he is counselor of the Nicaraguan Embassy in Madrid.

He has held more than twenty-five one-man shows in Spain since 1941, having shown his paintings in galleries in Bilbao, San Sebastián, Barcelona, Valencia, Granada, Sevilla, and Madrid. In 1931-32 his work was exhibited in the National Salon in Paris, and last year he came to America where he held one-man shows in San Salvador and Mexico City. His exhibit here in Washington represents the first display of his work in the United States and will be followed by shows in California and New York.

Critics in San Salvador compared the artist's technique and subject matter with those of the Spaniard Santiago Rusiñol. In Mexico the critic for the newspaper *El Universal* states: "Alonso Rochi is to the plastic arts what his fellow countryman Rubén Darío is to poetry." Cecilio Barberán, a critic in Madrid, feels that the artist belongs to the realist tradition in his painting of flowers, "which surpasses in beauty the flowers themselves. Greater perfection could not be obtained in this genre." Another critic in Madrid, L. de Fontes, classified the artist as belonging to the Spanish *costumbrista* (genre) tradition of the present century.

CATALOGUE

Oils

 1. *Garden*, Aranjuez
 2. *Gardens of Alcázar*, Sevilla
 3. *Port of Ondárroa*
 4. *Seascape*, Ondárroa
 5. *Cueva de Plata*, Arcos de la Frontera
 6. *Cueva de Gitanos*, Arcos de la Frontera
 7. *Patio de las Damas*, Alcázar de Sevilla
 8. *Patio del Príncipe*, Alcázar de Sevilla
 9. *Garden of San Nicolás*, Granada
 10. *Garden, Palacio de las Dueñas*, Sevilla
 11. *Glorieta*, Aranjuez
12-15. *Still Life*
16-28. *Flower Compositions*

March 17 - April 12, 1952

PERSONALITIES IN THE AMERICAS: PHOTOGRAPHS BY BERESTEIN-TAGLE

While serving their country in a diplomatic capacity, these two young artists, professional photographers for several years in Cuba, took their camera with them, first to Mexico, then to Argentina, and now to the United States. Having been more interested in the people than in the landscapes and customs in these countries, they have succeeded in creating a gallery of portraits which reveal true psychological insight into the personalities of the subjects. Some are Latin American writers, politicians, and painters; others are motion picture directors, artists, and dancers. The artists have given us, then, a highly expressive interpretation of a group of people representing different aspects of contemporary culture in this hemisphere. For this exhibit we have selected a group of portraits significant not only for the importance of the personalities portrayed but also for the quality of the portraits.

Julio López Berestein and Augusto de Castro Tagle were born in Havana, Cuba, in 1917 and 1920 respectively. Although they both received higher education and have served in the foreign service for the past seven years, they have been interested in photography since they were very young, having practiced it professionally in Cuba until they entered government service in 1945. Exhibitions of their work have been shown in Havana, Mexico City, Buenos Aires, Santiago de Chile, and Montevideo, this being the first time they have shown their work in the United States, where they have been living for the past few months.

CATALOGUE

1. *His Excellency Miguel Alemán*, President of Mexico
2. *Diego Rivera*
3. *David Alfaro Siqueiros*
4. *Gastón Baquero*
5. *Benito Quinquela Martín*
6. *Hugo Fregonese*
7. *Fay Domergue*
8. *A. Werber*
9. *Adriano Vitale*
10. *Aníbal Navarro*
11. *Amelia Bence*
12. *Delia Garcés*
13. *Mecha Ortiz*
14. *Fernando Lamas*
15. *Ursula Hirselfeld*
16. *Eusebia Cosme*
17. *Víctor Manuel*
18. *Nicolás Guillén*
19. *Alfredo Lozano*
20. *Fidelio Ponce*
21. *Mario Carreño*
22. *Cundo Bermúdez*
23. *Amelia Peláez*
24. *René Portocarrero*
25. *Louis Jouvet*
26. *Irina Baronova*
27. *Nina Verchinina*
28. *Michael Orloff, Nina Popova*

29-31. *Compositions*
32-34. *Still Life*

April 14 - May 12, 1952

SIMON BOLIVAR AND HIS TIME: FIFTY-ONE MINIATURES BY ARTHUR SZYK

In 1932 the Polish government sent Arthur Szyk to the United States to exhibit his work at the Library of Congress. The show consisted of a series of thirty-eight paintings depicting *George Washington and His Time* and had previously been exhibited in Paris in the Colonial Exposition of 1931. The government of Poland presented this graphic history of Washington to the President of the United States and it hung in the White House until 1943. It is now in the Franklin D. Roosevelt Library at Hyde Park.

The artist showed his work in England from 1937 to 1940, at which time he came to the United States and stayed until his death in 1951. Having begun studies of the life of Bolívar in 1926, he devoted the years 1948 to 1951 to the completion of a series of miniatures on Bolívar's life. We are presenting them here in commemoration of Pan American Day.

Szyk's illustrations have been reproduced in this country in such leading magazines as *Fortune, Time, Look, Esquire, Colliers, Saturday Evening Post, Liberty, Reader's Digest*, etc. He has illustrated more than twenty books and his collection of satirical drawings on war entitled *The New Order*, published in *Esquire* in 1941, was very popular among servicemen. An outstanding illustrated historical work is his *An Illumination of the Declaration of Independence of the United States*.

Arthur Szyk was born in Lodz, Poland, in 1894. As a child he was a fervent illustrator of historical events. He studied in his native town, at the Academy of Fine Arts in Krakow, at the Académie Julian and the School of Fine Arts in Paris, and on a scholarship from 1914 to 1915 in Syria, Palestine, and Damascus. He died in New Canaan, Connecticut, in September 1951.

CATALOGUE

1. *Frontispiece*
2. *Simón Bolívar, Sitting*
3. *George Washington*
4. *José de San Martín*
5. *Antonio José de Sucre*
6. *José Antonio Páez*
7. *Daniel O'Leary*
8. *Santiago Marino*
9. *Francisco de Miranda*
10. *Anzoátegui*
11. *Carlos Costello*
12. *Andrés Bello*
13. *Juan Uzlar*
14. *Nariño*
15. *Simón Rodríguez*
16. *José Gabriel Lugo*
17. *Juan Bautista Arismendi*
18. *José Francisco Bermúdez*

19. *Carlos Soublette*
20. *José Tadeo Monagas*
21. *Rafael Urdaneta*
22. *Francisco de Miranda, Sitting*
23. *José María Cariño*
24. *Leonardo Infante*
25. *Alexandre-Marie Pétion*
26. *Manuel Manrique*
27. *Francisco de Paula Santander*
28. *Juan Ramón Burgos*
29. *José Félix Rivas*
30. *Pedro Zaraza*
31. *El Negro Primero*
32. *Páez on Horseback*
33. *Bolívar Meeting San Martín*
34. *Death of Negro Primero*
35. *Bombana*
36. *Bolívar and Sucre at Junín*
37. *Bolívar's Proclamation to the "Colombianos"*
38. *Sucre, Sitting*
39. *Vencedores de Boyacá*
40. *Les Cayes, L'Intrépide*
41. *Ricaurte*
42. *Crossing of the Andes*
43. *Córdoba at Ayacucho*
44. *The Llaneros*
45. *Bolívar's Battle*
46. *Araure*
47. *Death of Girardot at the Battle of Trincheras*
48. *San Martín*
49. *Páez during the Battle*
50. *Tribute of Admiration to Bolívar*
51. *Portrait of Bolívar*

April 15 - May 5, 1952

DANCES AND TYPES OF MEXICO: WAX FIGURES BY CARMEN DE ANTUNEZ

During the first meeting of the Inter-American Cultural Council held recently in Mexico, an exhibit of wax figures executed by the Mexican sculptress Carmen de Antúnez and representing dances and indigenous types of Mexico received very favorable comment from the delegates. Partly as a result of the desire expressed by many of them that the wax figures be shown in this country, the National Institute of Anthropology of Mexico decided to sponsor this exhibit, the first presentation of the figures outside of Mexico. The Pan American Union has the privilege of showing them for the first time in the United States.

Señora de Antúnez has worked in the field of ethnology for more than twelve years. She has been employed for the past ten years as sculptress in the Institute, where she hopes eventually to depict all of the customs and Indian types of Mexico.

Carmen de Antúnez is self-taught. Without formal education she has learned to produce masterful copies of nature, which constitute extraordinary documents in wax that will preserve for posterity Mexico's Indian types and customs destined to disappear with the advance of civilization.

The Director of the Inter-American Indian Institute, Manuel Gamio, said: "The Indian culture of Mexico will live through the marvelous work of this artist." Alfonso Caso, Director of the Mexican Indian Institute, stated: "The realism of the figures will enable any visitor to become acquainted with the life of the region they depict." Señor Jaime Torres Bodet, Director General of UNESCO, saw in the work of Señora de Antúnez a possible international application, remarking that he wished circumstances were such that she could see and capture the life of the other Americas as well.

CATALOGUE

Dances

 1. *Danzante de* La pluma *(Feather Dance)*, Oaxaca, 60 cm.
 2. *Danzante de* Los viejitos *(Dance of the Old People)*, Michoacán, 60 cm.
 3. *Danzante de* Los paragüeros *(Umbrella Dance)*, Tlaxcala, 60 cm.
 4. *Dance of the Yearling*, Sonora, 60 cm.

Types

 1. *Grupo otomí (Otomí Group)*, Hidalgo, 150 cm.
 2. *Grupo de tarascos (Tarascan Group)*, Michoacán, 150 cm.
 3. *Arquero tarahumara (Tarahumaran Archer)*, Chihuahua, 150 cm.

May 15 - June 20, 1952

THE GRAPHIC WORKS OF OROZCO

The great contribution modern Mexico has made to universal art is not only the renaissance of mural painting in the twentieth century, but also of engraving. At any rate, both artistic media pursue a common end: to make accessible to a vast number of people the works and ideas of the artists in their own time.

In America, Mexico is the country with the most extensive and oldest tradition in engraving. In the eighteenth century, Mexico not only sheltered itinerant European engravers, but also artists who devoted themselves to the task of illustrating and graphically reproducing portraits, landscapes, and religious subjects. And, in the same way as with other artistic manifestations in Mexico, engraving also passed from the sphere of the professional to the field of the amateur and became firmly established among the people. In the field of popular and spontaneous engraving in the nineteenth century, two great figures arose, Manilla and Posada. The latter, who lived to witness the Agrarian Revolution of this century, has perhaps been the most decisive influence in the contemporary art of Mexico, by means of his humble prints of illustrations for popular ballads: in them he combined the most expressive elements of the Spanish tradition with a genuine Mexican accent.

Among those who years later continued to carry forward the expression of Posada, no one developed his ideas more fully than José Clemente Orozco. The great dramatic sense of Spanish art, of "Black Spain," is present in all the works of Orozco, as is the terrifying expression of the monumental sculpture of the Aztecs.

Orozco left to the history of art not only a series of portentous and violent murals, which he painted in Mexico and

the United States; in his engravings he left a legacy of his plastic ideas, and his very personal expression. It is for this reason that Orozco has become, among the great Mexican muralists, the one who can best be studied by means of his graphic works, which contain the same sense of grandeur as his frescos.

Also, this evaluation is possible because Orozco's vision as a painter was monochromatic, like certain Italian artists of the Renaissance. Even when some of his murals are resplendent with color, the pigments never serve to construct the form but only to illuminate it; to accentuate rather than produce it. Orozco, therefore, is chiefly a draftsman, whose creative vision can be considered "black and white."

In his graphic works, especially in his lithographs, there appear themes treated with slight variations, which the artist used later in his murals. In other cases, he reproduced in his prints fragments of his murals. In his lithographs we always find a perfectly controlled and fluid line which he uses with the vehemence of a whip. Therefore, his lithography is, more than any other medium, the one most closely related to his murals, or the one which reflects best his ideas as a muralist. His engravings, on the other hand, are more like his easel painting; we find the message more hidden, and the expression more formalistic.

In this exhibition we have tried to gather together all the graphic work of Orozco. We have succeeded in doing so in the case of the engravings, but not in the case of the lithographs, various examples of which have been impossible to obtain. What is lacking from his lithographic production, however, are not fundamental works, but, rather, variations of the same lithographs. Therefore, it can be said that this collection presents all the important works of Orozco in the graphic arts.

We wish to express our gratitude, especially, to the widow of the artist, Señora Margarita Valladares de Orozco, for the generosity and promptness with which she attended to our request for the engravings and two of the lithographs which could not be obtained in this country. The rest of the lithographic works has been furnished by the Weyhe Gallery of New York, the best depository in the United States of the lithographs of Orozco; and by the Abby Aldrich Rockefeller Print Room of the Museum of Modern Art in New York, which placed at our disposal two necessary examples. We are grateful to both of these institutions.

CATALOGUE

Lithographs

 1. *Manos (Hands)*, 1926
 2. *Mujer mejicana (Mexican Woman)*, 1926
 3. *Tres generaciones (The Family*, also entitled *Three Generations)*, 1926
 4. *Campesino (Peasant)*, 1926
 5. *Vaudeville in Harlem*, 1928
 6. *El fraile y el indio (The Friar and the Indian*, also entitled *The Franciscan)*, 1926
 7. *Soldaderas*, 1928
 8. *Magueyes y nopales (Magueyes and Nopales)*, 1928
 9. *El maguey (The Maguey)*, 1928
10. *Stony Ground*, 1928
11. *Ruined House*, 1928
12. *El basurero (Scavengers)*, 1928
13. *Tourists*, 1928
14. *Rear Guard*, 1929
15. *Requiem*, 1928
16. *The Flag*, 1928
17. *Mexican Pueblo*, 1930
18. *The Unemployed*, 1932

19. *Dead Woman*, 1935
20. *Brothel*, 1935
21. *Zapatistas*, 1935
22. *Demonstration*, 1935
23. *Las masas (The Masses)*, 1935
24. *Lynching*
25. *Indians*, 1928

Engravings

26. *Prometheus*, 1935, drypoint
27. *Omens*, 1935, drypoint
28. *Woman* (head), 1935, drypoint
29. *The Unemployed*, 1944, aquatint
30. *The Cripple*, 1944, aquatint
31. *Head of a Woman*, 1944, drypoint
32. *Profile of a Woman*, 1944, aquatint
33. *Two Women*, 1994, drypoint
34. *Insane*, 1994, aquatint
35. *Demon I*, 1944, etching (unfinished)
36. *Demon II*, 1944, etching
37. *Clown*, 1944, etching
38. *Clowns*, 1944, etching
39. *Contortionists I*, 1944, aquantint
40. *Contortionists II*, 1944, aquatint
41. *Woman* (meditating), 1944, etching (unfinished)
42. *Woman* (head), 1944, aquatint (unfinished)

CHRONOLOGY

1883 Born November 23 in Ciudad Guzmán, Jalisco, Mexico
1897-99 Studied in the San Jacinto Agricultural School, Mexico City
1904-08 Attended the National Preparatory School, Mexico City
1908-14 Attended in irregular periods the National Academy of Fine Arts, Mexico City
1910 First exhibit of drawings in the Academy of Fine Arts
1916 First one-man show in Mexico
1917-18 First trip to the United States
1922-27 First mural paintings in the National Preparatory School
1923 Married on November 23 to Margarita Valladares. Children: Clemente, Alfredo, Lucrecia
1925-26 One man show in Paris. Murals in Sanborn's, Mexico City, and in the Orizaba Industrial School, Veracruz, Mexico
1927-34 Second visit to the United States
1929-31 Showings in Paris, Vienna, New York, Los Angeles. Painted murals in the New School for Social Research in New York
1932 Trip to Europe
1932-34 Murals at Dartmouth College, New Hampshire. Mural in the Palace of Fine Arts, Mexico City
1936-39 Guadalajara, Jalisco: Murals in the University, Government Palace, Cabañas Hospice
1940 Murals in the library at Jiquilpam, Michoacán, Mexico. Third visit to the United States
1940-44 Murals in the Supreme Court of Justice and in the building which was formerly the church of the Hospital of Jesús, Mexico City
1945 Fourth visit to the United States

1946-47 Received the National Prize in Arts and Sciences. National Show in the Palace of Fine Arts, Mexico City

1947-48 Murals in the Open Air Theatre of the National School of Teachers and in the Chamber of Deputies in Guadalajara

1949 Started a mural in the building project *Multi-familiar*, in Mexico City, left unfinished. On September 7, a heart condition caused his death. He was buried in the *Rotonda de los Hombres Ilustres*, an honor usually granted by the Congress of the Nation twenty years after the death of the person honored; but, in the case of Orozco, the honor was bestowed immediately after his death

May 20 - June 5, 1952

ENRIQUE CRUCET: PAINTINGS[1]

BIOGRAPHICAL NOTE

CRUCET, Enrique J. Painter, born in Havana, 1895. Studied at the Centro Gallego, Havana, under the guidance of Spanish painter Baldomero Moreira; under a Cuban scholarship also studied in Spain with Luis Graner in Barcelona and Academia de San Fernando in Madrid, 1919. Visited Paris and Rome. Since 1920, held individual exhibitions in Madrid, Havana, and the United States. Participated in national salons since 1918.

June 23 - July 12, 1952

RICARDO ESCOTE: LANDSCAPES OF ARGENTINA

Ricardo Escoté was born in Buenos Aires in 1912. As a youth he was taken to Spain, where he began his studies and graduated from the School of Fine Arts and the School of Perspective, both in Barcelona. Later the artist went to France and studied in the School of Decorative Arts in Paris, where he was a pupil of the sculptor Pablo Gargallo.

In Switzerland Escoté devoted himself to the field of decorative and industrial design, specializing in jewelry, an activity in which he is still engaged in Argentina. At the same time, however, he has cultivated painting, especially in the genre of landscape. He has presented exhibitions in Buenos Aires, Barcelona (Spain), and recently in the Ward Eggleston Gallery in New York.

This exhibit, Escoté's first in Washington, consists of oils which he painted during the two years he spent in the northern provinces of Argentina.

CATALOGUE

Oils

1. *La Cuesta*, Catamarca
2. *La Chacrita*, Córdoba
3. *En La Boca (In La Boca)*, Buenos Aires
4. *Picnic in Córdoba*

[1] No catalogue or press release is available. —*Ed.*

5. *Canal in El Tigre*
6. *Procesión en Belén (Procession in Belén)*, Catamarca
7. *El algarrobo (Carob Tree)*, San Luis
8. *La acequia (Trench)*, Córdoba
9. *La promesante (The Promise Keeper)*
10. *Capilla de Purmamarca (Chapel of Our Lord, Purmamarca)*
11. *Misa en Belén (Mass in Belén)*, Catamarca
12. *Almacén (Store)*, La Rioja
13. *Calle de Tilcara (Street in Tilcara)*, Jujuy
14. *Los Colorados*, Salta
15. *El velorio (The Wake)*, San Luis
16. *Domingo en el río (Sunday on the River)*
17. *Merlo*, San Luis
18. *Bialet Masse*, Córdoba
19. *El puente (The Bridge)*, Córdoba
20. *La tranquera*, San Luis
21. *Los Sarmientos*, Chilecito, La Rioja
22. *El Rincón*, San Luis
23. *Monticello*, New York

July 15 - August 13, 1952

SUSANA GUEVARA

Susana Guevara was born in Santiago, Chile, in 1896, but spent the early years of her life in Europe, receiving her education in England, Germany, and France. Later she came to the United States and in 1936 studied at the Art Institute of Chicago.

Married to the North American architect Floyd Mueller, she has lived for several years in Pasadena, California, where she has devoted her time to teaching art to underprivileged children.

Besides having exhibited her work in Chile, Susana Guevara has presented one-man shows in California at the San Francisco Museum of Art, the Pasadena Art Institute, and the San Diego Museum of Art. Her paintings also have appeared in several group shows in the United States, and her work is represented in the permanent collections of the Museum of Art in Santiago, Chile, and the Pasadena Art Institute.

CATALOGUE

Temperas

1. *The Broom Vendor*, tempera on masonite, 30 x 24"
2. *The Toy Vendor*, tempera on masonite, 30 x 24"
3. *The Chair Vendor*, tempera on masonite, 30 x 24"
4. *Cargador*, tempera on masonite, 30 x 24"
5. *El matadero (The Slaughterhouse)*, tempera on masonite, 30 x 24"
6. *Curiosity*, tempera on canvas, varnished, 25 x 32"
7. *The Earthquake*, tempera and ink on gelotex, 31 1/2 x 25 1/2"
8. *Sunlight*, tempera on masonite, 30 x 24"
9. *The Quarry*, tempera on canvas, 31 x 25 1/2"

10. *Looking at Television*, tempera on gelotex, 31 x 25 1/2"
11. *Composition with People*, tempera on gelotex, 31 x 25 1/2"
12. *At the Railroad Station*, tempera on gelotex, 33 1/2 x 25 1/2"
13. *Banana Vendor*, Brazil, tempera, varnished, 19 x 25"
14. *The Fidget*, tempera and chalk on paper, 18 1/2 x 24"
15. *Valparaíso*, tempera on masonite, 30 x 24"
16. *Kites,* tempera on gelotex, 33 x 25"
17. *Los chinos*, tempera on masonite, 30 x 24"
18. *The Machi*, tempera and crushed wax paper
19. *The Intruder*, tempera and ink
20. *The Wake*, tempera and ink
21. *Children Sweeping*, tempera
22. *Curious Llama*, tempera and ink on masonite
23. *Pájaro imaginario (Imaginary Bird)*, tempera, varnished, on crinkled wax paper
24. *Study*, tempera on corrugated paper
25. *Nude*, tempera on wax paper
26. *Rainy Night*, tempera on wax paper
27. *Carmela*, tempera on paper
28. *Dance*, tempera on wax paper
29. *Child*, tempera on wax paper
30. *Fish*, tempera on wax paper

Mixed Media

31. *Josefina*, oil, ink, and crayola
32. *Horacio*, oil and tempera
33. *Devastation*, tempera and oil on paper, 17 x 15 1/2"

Silk Screen

34. *Oriental*
35. *The Slums*
36. *Composition*

August 15 - September 20, 1952

SEVEN CUBAN PAINTERS: BERMUDEZ, CARREÑO, DIAGO, MARTINEZ PEDRO, ORLANDO, PELAEZ, PORTOCARRERO

This group of works by Cuban painters was first shown in Boston, at the Institute of Contemporary Art, during the month of May, and now the Pan American Union is the second to present it to the American public. At the conclusion of the current showing, the exhibit will circulate throughout this country until 1954.

Although these paintings have not previously been displayed outside of Cuba, the artists have been known in the United States since 1944. At that time works by them were included in a comprehensive Cuban exhibit which was presented at the Museum of Modern Art of New York, and later was on view at a number of other American museums.

The Museum of Modern Art owns works by all the artists figuring in this exposition. Some are also represented

in other public collections of the United States, not to speak of many private ones. The artists have been included in group exhibitions in Washington and other cities, and they have held one-man shows at various institutions throughout this country.

Concerned with expressing themselves in modern idiom, tending toward abstraction, these painters evidence the two trends prevailing in Cuba today. The first of these is the study and adaptation of elements of Spanish colonial art; the second is an interest in the interpretation of African forms employed by Afro-Christian sects in Cuba. Standing out over both these tendencies, which represent primarily a search, in subject matter, for a vehicle of formal expression, there is a common and dominant characteristic: brilliance and variety of color.

Aside from their frequent exhibits in the United States, all the artists in this group have participated in shows in Argentina (Museo de Arte of La Plata and Comisión Nacional de Cultura in Buenos Aires), Mexico (Palacio de Bellas Artes, Mexico City), Guatemala (Escuela de Artes Plásticas, Guatemala City), Haiti (Centre d'Art, Port-au-Prince), Venezuela (Museo de Bellas Artes, Caracas), Brazil (Museu de Arte Moderna, São Paulo), Honduras (Escuela de Bellas Artes, Tegucigalpa), France (Musée d'Art Moderne, Paris), Sweden (Liljevalch Konsthall, Stockholm).

At the present moment they are represented in a Latin American show touring nine cities in Western Germany, and their works appear with those of other Cuban artists at the current Biennial at Venice, Italy.

CATALOGUE

Paintings and Drawings

Cundo Bermúdez
1. *Figura en verde (Green Figure)*, 1951, oil
2. *Mujer sentada (Seated Woman)*, 1951, oil
3. *Cuatro mujeres (Four Women)*, 1951, oil
4. *Músicos (Musicians)*, 1951, oil
5. *Trío (Trio)*, 1951, oil
6. *Mujer con instrumento (Woman with an Instrument)*, 1951, oil
7. *Siesta*, 1951, oil
8. *Pájaro rojo (Red Bird)*, 1951, oil

Mario Carreño
9. *Shadows on the Wall*, 1952, oil
10. *Sentinel*, 1952, oil
11. *At the Malecón*, 1952, oil
12. *Sailor*, 1952, oil

Roberto Diago
13. *Sagitario*, 1951, drawing
14. *Onen*, 1952, drawing

Luis Martínez Pedro
15. *Los músicos (The Musicians)*, 1949, gouache, 32 x 40"
16-19. *Estudio para el personaje del Cuarto de Fambá (Study for Personage of the Fambá Room)*, 1949, ink drawings
20. *El cazador (The Hunter)*, 1950, oil on cardboard
21. *Figura en rojo (Figure in Red)*, 1951, oil on cardboard, 23 1/4 x 3 1/4"
22. *Músico (Musician)*, 1951

23. *Hombre con tambor (Man with Drum)*, 1951, oil on cardboard, 41 x 32"
24. *Personaje del Cuarto de Fambá (Personage of the Famba Room) II*, 1951, oil on canvas, 33 1/2 x 42"

Felipe Orlando
25. *Still Life with Fruits*, 1949, oil
26. *The Lamp*, 1950, oil
27. *Still Life*, 1950, gouache
28. *Composition*, 1950, gouache
29. *Still Life with Fish*, 1950, gouache
30. *Still Life*, 1950, gouache
31. *Woman Reading*, 1950, gouache

Amelia Peláez
32. *Figura (Figure)*, 1943, gouache
33. *Figuras (Figures)*, 1943, gouache
34. *Naturaleza muerta (Still Life)*, 1945, gouache
35. *Naturaleza muerta (Still Life)*, 1945, gouache

René Portocarrero
36. *Marina (The Shore)*, 1949, drawing
37. *Retrato (Portrait)*, 1951, oil
38. *Figura en amarillo (Yellow Figure)*, 1952, oil
39. *Figuras en el espacio (Figures in Space) I*, 1952, gouache
40. *Figuras en el espacio (Figures in Space) II*, 1952, gouache
41. *Figuras en el espacio (Figures in Space) III*, 1952, gouache
42. *Figuras en el espacio (Figures in Space) IV*, 1952, gouache

ABOUT THE ARTISTS

BERMUDEZ, Cundo. Born in Havana, 1914. Self-taught with the exception of a brief period at the National Academy of Fine Arts in Cuba and three months study in Mexico. One-man shows in Havana, Washington, and Port-au-Prince. Two visits to the United States. Traveled extensively in Europe, 1952. Lives in Havana.

CARREÑO, Mario. Born in Havana, 1913. Studied one year at the National Academy of Fine Arts. Worked as illustrator for different publications. Went to Spain in 1932; Mexico, 1937; France, 1938-39; New York, 1944-1951, where he taught at the New School for Social Research; Argentina and Chile, during 1948-1949. Has held one-man shows in Paris, New York, Santiago de Chile, Buenos Aires, Madrid, Havana. Now lives in Havana.

DIAGO, Roberto. Born in Havana, 1920. Graduated from the National Academy of Fine Arts. Worked as illustrator for an advertising agency. Has traveled in the United States and Mexico. One-man shows in Havana and Port-au-Prince. Now teaches at the School of Plastic Arts, Matanzas, Cuba.

MARTINEZ PEDRO, Luis. Born in Havana, 1910. Studied architecture at Havana University, but did not graduate. Studied art in Florida and New Orleans. Has traveled throughout the United States. One-man shows in Havana, New York, and Washington. At present, is the art director of a large advertising agency in Havana.

ORLANDO, Felipe. Born in Quemados de Güines, Cuba, 1911. Self-taught. One-man shows in Havana, Mexico, San Francisco, Washington, Port-au-Prince. Traveled extensively in Europe, 1952. Now lives in Mexico City.

PELAEZ, Amelia. Born in Yaguajay, Cuba, 1897. Graduated from the National Academy of Fine Arts. Studied in Paris under Alexandra Exter. Has traveled extensively in Europe, Mexico, and the United States. One-man shows

in New York, Havana, and Paris. Murals in various buildings in Cuba. Teaches drawing in a night school in Havana, where she lives.

PORTOCARRERO, René. Born in Havana, 1912. Self-taught. Has done book illustration and stage designing. One-man shows in Havana, New York, and Guatemala. Painted several murals in public buildings in Cuba. Traveled in the United States, 1945. Lives in Havana.

September 22 - October 11, 1952

LAGUARDIA: PAINTINGS OF PARAGUAY

Laguardia is the pseudonym of Señora Carmen Fernández de Herrera, born in Asunción, Paraguay, in 1918. Señora Herrera started painting at an early age, while traveling in the Orient, during long visits to China and Japan. In the latter country she became interested in the lacquer technique, which she later developed and adapted to her own mode of expression. She has studied at art schools in Germany, Italy, Spain, and France; she is also a graduate of the Academy of Fine Arts in Buenos Aires, and has taken courses in Rio de Janeiro, Lima, Santiago de Chile, Montevideo, and La Paz.

This is the artist's first trip to the United States. The present show is likewise the first exhibit of her work in a public gallery in this country, although it has been featured on a television program in New York. Señora Herrera specializes in religious subjects and portrayals of native types of the Guaraní culture in Paraguay. She works exclusively in lacquer on celotex panels, using a process that is the result of long experimentation with this medium.

CATALOGUE

Paintings

Religious Works

1-8. *Christ Head*
9. *Santa Lucía (Saint Lucia)*
10. *Blue Virgin*
11. *The Sacred Heart*
12. *Magdalene*
13. *Santa Helena (Saint Helen)*
14. *Kiss of Judas*
15. *Pietà*
16. *Saint Joseph*
17. *Mater Dolorosa*
18. *Virgen de Caacupé (Virgin of Caacupé)*
19. *Santa Ana (Saint Anne)*
20. *The Purest One*

Indians

21. *The Witch*
22. *The Mirage*
23. *Indian Girl with a Parrot*
24. *Witch Doctor*

25. *Mbói jukaha (The Snake Killer)*
26. *Women Waiting*
27. *Temptation*
28. *India opivo (The Resentful One)*
29. *Witch Doctor*
30. *Nostalgia*
31. *Indian Weaver*
32. *Study of an Indian*
33. *Indian Warrior*
34. *Ñanduti*
35. *Rekovaguy (Weed Medicine Man)*
36. *Mburuvicha rajy (Daughter of the Chief)*
37. *Indian Girls*
38. *Mburuvicha rembireko (Wife of the Chief)*
39. *Ka'aruete (Sunset)*
40. *Indian Force.* Coll. Ambassador Luis Oscar Boettner

Types of the Countryside

41. *Burreritas (Women on Donkeys)*
42. *Woman by the Road*
43. *A Grandmother*
44. *Chipera (Vendor of Chipa)*
45. *Residenta (Survivor of the Great War)*
46. *The Breadwinner*
47. *Mitã'i (Poor Child)*
48. *Girl in Festive Costume*
49. *Colla (Bolivian Indian Child)*
50. *Alojera (Vendor of Refreshments)*
51. *Market Woman*

October 14 - November 15, 1952

TAMAYO

After the success of the Mexican muralists and their international consecration in the years 1920 to 1930, there arose a group of artists who, while retaining the interest of their predecessors in national themes, have nevertheless avoided making their painting political in content and polemic in character. They have drawn away from the doctrinaire, and from art with a "message." Their art represents, rather, a search, an exploration into purely plastic values. National themes have been for them merely a point of departure.

In this group, which appeared around 1930, the outstanding personality has been that of Rufino Tamayo, considered today one of the most important figures in the history of Mexican art and one of the most notable of all contemporary artists.

Perhaps better than any other of his countrymen, Tamayo has employed the forms of pre-Columbian art, especially those of Tarascan pottery, within a new, international mode of expression. His bond with the post-cubistic and intimist tendencies of the school of Paris is not that of a mere external influence; Paris has offered rather technical aid, of which the artist has availed himself in order to give expression to the Mexican spirit. His vision of that

which is national to Mexico is deeper and more penetrating, since it neither portrays nor reflects externally, as in a folkloric pageant, the ethnic elements of his country, but strives instead to express universal themes—the portrait or the still life—through Mexican culture, and Tamayo's art acquires thereby a profoundly national stamp.

The artist has not taken mural painting as the field for the development of his pictorial concepts, although he has executed some frescoes both in Mexico and in the United States. The feeling of monumentality is present in his works, as in those of the Tarascan potters, but this is due not to their dimensions, but to the grandiose strength of their austere and hieratic forms.

In little less than twenty years, Tamayo has established his personality and his prestige both in and out of Mexico. Exhibitions of his work in America and Europe have won him universal acceptance, and a position of distinction in contemporary art. All the important museums of the United States own works by him, as do the Museum of Modern Art in Mexico City, Paris, Rome, and Brussels.

The critic Robert Goldwater, in his extensive monograph about the artist (New York, Quadrangle Press, 1947), said:

> Tamayo has developed a style that is at once objective and expressive, strong, even striking upon first meeting, yet containing nuances of color and construction that cannot be taken in at a glance.

On the occasion of the presentation of his work at the Biennial in Venice in 1950, the Italian critic Umbro Apollonio wrote:

> Without hesitation I classify Rufino Tamayo among the most noteworthy figures in the history of modern world art. In my opinion, there can be no doubt that something of European culture has penetrated his spirit, but it has served only to nourish a root which was already strong, and planted in free soil.

Another Italian critic, Lionello Venturi, declared:

> The transformation of reality into forms valid in themselves explains the potency of its images: these forms function through color. The originality of Tamayo's color is absolute. The base of his paintings is generally of a strong chromatic intensity. Against his intense and warm tones images disappear delicately, in neutral, cold, and frequently sour tones.

The French critic Jean Cassou remarked:

> Tamayo is one of the greatest poets of our time, and one of the greatest poets in the world.

A Frenchman who is himself a poet, André Breton, defined the artist's career in these terms:

> The whole of Tamayo's procedure is inspired in two vital necessities: on the one hand, the need to reopen the broad channel of communication which painting, as a universal language, should provide between continents, and to this end *technical* research, which is the sole basis for unification; and, on the other hand, the need to free that which is eternally Mexican from all that may be accidental in its aspects or episodic in its struggles, in order to pour this into the crucible of the human soul.

Thanks are expressed to M. Knoedler and Company, of New York, exclusive agents of the artist in the United States, for help given in assembling the present exhibition.

CATALOGUE

Oils

1. *Ruins*, 1935
2. *Helado de fresa (Strawberry Ice Cream)*, 1938, 44 x 59 cm.
3. *Still Life with Blue Glass*, 1940
4. *Mexican Woman*, 1941
5. *Portrait of Olga*, 1941
6. *Nude*, 1942
7. *Butterflies*, 1944
8. *Rooftops*, 1945
9. *Man Amazed by Aviation*, 1946
10. *Late Passengers*, 1946
11. *Myself*, 1946
12. *Dancer in the Night*, 1946
13. *Mujer caminando (Woman Walking)*, 1947, 100 x 74.5 cm.
14. *Volcano*, 1947
15. *Constellation*, 1947
16. *Constructor*, 1948
17. *Man Catching a Bird*, 1949
18. *Serenade to the Moon*, 1949
19. *Butterfly Chasers*, 1949
20. *Dancing Figures*, 1950
21. *Woman Pursued*, 1950
22. *Man with Birds*, 1950
23. *Lovers Contemplating the Moon*, 1950
24. *New Moon*, 1951
25. *Woman in Movement*, 1951
26. *Watermelon*, 1951

Lithographs

1. *Two Women*, 1952
2. *Man with Hands Clasped*, 1952
3. *Coyote*, 1952

CHRONOLOGY

1899 Born in Oaxaca, of Zapotec Indian parentage
1907 After death of his mother, moves to Mexico City, to live with his aunt
1915-16 Attends art classes in the evening; works during the day in the market at his aunt's fruit-stand
1917 Enrolls in San Carlos Academy of Art, Mexico City
1918 Leaves the Academy to paint by himself
1921 Appointed head of the Department of Ethnographic Drawing in the National Museum of Archaeology
1926 Teaches drawing and painting in the public primary schools of the capital. First one-man show in an empty shop on Avenida Madero, Mexico City. In September has first one-man show in New York, where he remains until June 1928
1929 Teaches at the San Carlos Academy, Mexico City
1930 Trip to New York
1932 Appointed chief of the Department of Plastic Arts in the Mexican Secretariat of Education

1933 Fresco mural in the National School of Music, Mexico City
1936 In New York, attends Artists Congress as delegate of Mexican painters
1938 Appointed art instructor at the Dalton School, New York. Since this time has lived regularly in the United States during the winter, in Mexico City during the summer
1943 Fresco mural in the Hillyer Art Library, Smith College, Northampton, Massachusetts
1946 Appointed art instructor at the Brooklyn Museum Art School
1950 Trip to Europe. Works included in Mexican section of the Venice Biennial arouse the interest of European critics
1952 In September, finishes first mural for the National Palace of Fine Arts in Mexico City, commissioned by the government

SOME ONE-MAN SHOWS OF TAMAYO

1926 Mexico City, empty shop in Avenida Madero; New York, Weyhe Gallery
1927 New York, Art Center
1929 Mexico City, Galería de Arte Moderno
1931 New York, John Levy Gallery
1935 San Francisco, Paul Elder Gallery; Mexico City, Galería de Arte Mexicano
1937 New York, Julien Levy Gallery; San Francisco, Howard Putzel Gallery
1938 Mexico City, Galería de Arte Mexicano; Chicago, Katherine Kuh Gallery
1939-47 New York, Valentine Gallery (seven shows)
1944 Mexico City, Galería de Arte Mexicano
1945 Chicago, Arts Club
1947 Cincinnati, Modern Art Society, Cincinnati Art Museum; Mexico City, Galería de Arte Mexicano
1948 Mexico City, Instituto Nacional de Bellas Artes (retrospective); New York, Pierre Matisse Gallery
1950 New York, Knoedler Gallery; Paris, Galerie Beaux-Arts
1950 Brussels, Palais des Beaux-Arts
1951 Buenos Aires, Instituto de Arte Moderno; New York, Knoedler Gallery

November 21 - December 20, 1952

HALTY DUBE: PAINTINGS AND STAGE DESIGN

For several years the Uruguayan Adolfo Halty Dubé has been in the United States studying, teaching, and creating. He is known in the various art circles of this country and has held exhibits on several occasions.

Adolfo Halty Dubé was born in San Carlos, Uruguay, in 1915. He studied architecture at the university in Montevideo and graduated in 1940. During 1941 and 1942 he was in this country under a grant from the Department of State of the United States, which permitted him to study fine arts at the University of Illinois. From 1942 to 1944 he held a scholarship from the Office of the Coordinator of Inter-American Affairs to study fresco at the New School for Social Research in New York. In 1950 he received a degree in architecture from the University of California. With the exception of the years 1945 and 1946 which he spent in his native country, he has resided in the United States since 1941.

For Halty Dubé, the two careers of painting and architecture have been fused in the common work of stage design, which permits him to use his knowledge of both fields. More recently he has been experimenting with light and the medium of painting. We are glad to present at the Pan American Union examples of all his creative talents.

When the artist held an exhibit in New York in 1944, the *New York Times* spoke of "purposive work with promise

of development;" the *New York Herald Tribune* also found "a promise of richer future development." Today, Halty Dubé, without abandoning experimentation and adventure in his art, has arrived at the maturity forecast by the New York critics, as can be seen in this, his first one-man show in Washington.

CATALOGUE

Paintings

1. *The Kite*
2. *Our Country*
3. *The Summer and the Child*
4. *The Wise Men*
5. *The Big Fish Eats the Small Fish*
6. *Armadillo*
7. *The Red Horse*
8. *Cielito*
9. *Three Gauchos*, 1951, oil
10. *The Eye of the Fan*
11. *Fireworks*
12. *Carnival*
13. *Drum Rhythms*
14. *Acrobats I*
15. *Acrobats II*
16. *Desperation*

Paintings with Light

17. *Abstraction No. 3*
18. *Abstraction No. 4*, 1951
19. *Abstraction No. 9*

Also, illustrations for a poem by Jorge Guillén and scale models of stage and costume design

SOME ONE-MAN SHOWS OF HALTY-DUBE

1937 La Peña, Buenos Aires
1940 Casino, Punta del Este, Uruguay
1942 Public Library, Champaign, Illinois
1942 Middlebury College, Vermont
1943 International House, New York City
1944 Lilienfeld Galleries, New York City
1944 Ateneo, Montevideo
1944 Amigos del Arte, Montevideo
1944 Intendencia Municipal, Mercedes, Uruguay
1945 Arte Bella, Montevideo
1947 Galería Müller, Buenos Aires
1948 Ateneo, Montevideo
1950 Van Diemen-Lilienfeld Galleries, New York City
1950 Museum of Art, San Francisco, California
1951 Windsor Gallery, Montevideo
1951 Ohio State University, Columbus, Ohio

December 22, 1952 - January 17,1953

HIGHLIGHTS OF THE CARIBBEAN:
PHOTOGRAPHS BY ALBERT GREENFIELD, APSA

Since 1933 Albert Greenfield has made fourteen trips to South America and the Caribbean region. In recognition of his work he has received many honors, including the Medal of the National Order of Honor and Merit of the Republic of Haiti, a commendation from the President of Venezuela, and has become an associate in the Photographic Society of America. The present exhibit will be his twenty-fifth one-man show.

Born in 1906 in New York City, Greenfield was engaged for many years in the advertising field on the eastern coast and in California. He is now living in El Paso, Texas, where he devotes his time to nonobjective painting.

His photographs have been exhibited in museums and galleries throughout the United States—Joslyn Memorial Museum in Omaha, the Brooklyn Museum in New York, the Palace of the Legion of Honor in San Francisco, and the Smithsonian Institution in Washington, D.C.

CATALOGUE

Photographs

Dominican Republic

201. *Avenida George Washington*, Ciudad de Trujillo
208. *Ruins of First Hospital Built in the Americas*
210. *Tomb of the Three Fathers*
211. *Statue of Christopher Columbus*
213. *Panorama*, Santiago
215. *Santo Domingo Cathedral, Oldest Cathedral in the New World*
216. *Chance Acquaintance*
220. *Dr. William Morgan Hospital*
223. *Modern Apartment House*, Ciudad Trujillo
225. *Replica of Tree Trunk to Which Columbus Moored the Santa María*
226. *Statue of the General Maceo*
230. *Woman of La Vega*

Haiti

 2. *Le Monument de Dessalines*
 5. *Interested and Willing*
 6. *Wharf Scene*
 7. *Haiti Dawn*
11. *Tropic Profile*
12. *Two Up*
20. *Sidewalk Vendors*
23. *La Citadelle Walls*
27. *Going to Market*
28. *Barge Workers*
30. *Sisal*
38. *At the Art Center*

Venezuela

51. *Where the Andes Rise out of the Waters*, La Guaira
52. *Refrescos Trópicos*
53. *Swimming Boys*
54. *After the Swim*
55. *Beast of Burden*
58. *Going to Market*, Caracas
64. *Hora de siesta (Siesta Time)*, Carupano
65. *Public Square*, Caracas
69. *Donkey Caravan*
74. *Street Scene*, Caracas
76. *Going Ashore at Pampatar*
81. *Chestnut Vendor*

Suriname (Dutch)

159. *Kottie Missies*
160. *Gandhi Bazaar*
161. *Three of a Kind*
165. *Indian Pottery Maker*
176. *Palm Shaded Street*
178. *Along the Saramacca*
183. *Bushmen of Santigron*
184. *Women at the Marketplace*

Trinidad (British)

102. *Governor's Residence*
105. *Loading Bananas*
107. *Hindu Temple*
108. *Hindu Priest*
109. *Wearing the Old School Tie*
110. *Giant Samaan Tree*
115. *Trinidadian*
123. *British East Indian*

YEAR 1953

PEDRO RESTREPO: PAINTINGS

Pedro Restrepo Peláez was born in Colombia in 1919. Before finishing secondary school, he left home to travel about his native land and through several foreign countries—Argentina, Bolivia, Brazil, and Chile. In the last mentioned, he studied at the National School of Fine Arts. Returning to Colombia, he took a position with the government and in 1947 was named vice-consul in Paris. This post he held only briefly. Restrepo has traveled in nearly all the countries of Europe, the Near East, and North Africa. He has had one-man shows in Bogotá, Medellín, London, and Mexico City. In recent years he has resided in the Mexican capital, publishing books and bringing out articles there. At the present moment he is in New York, and this exhibition is his first in the United States.

With regard to his aesthetic position, Restrepo's fellow-countryman, the noted writer Germán Arciniegas, has declared:

> I believe that Pedro Restrepo, who has partaken avidly in vanguard movements, in the choice between the dehumanization of art and the new humanism is inclined toward the latter.

CATALOGUE

Paintings

1. *Las Tres Gracias (The Three Graces)*, 1948
2. *Tormenta (Storm)*, 1948
3. *Huérfanos (Orphans)*, 1948
4. *Muchacha india (Indian Girl)*, 1948
5. *Máscara de Beethoven (Death Mask of Beethoven)*, 1948
6. *Cabeza de mulata (Head of a Mulatto Woman)*, 1948
7. *Cabeza de negro (Head of a Negro)*, 1948
8. *Cabeza de Job (Head of Job)*, 1948
9. *Las dos hermanas (The Two Sisters)*, 1948
10. *Desnudo (Nude)*, 1948
11. *Bodegón (Still Life)*
12. *Paisaje de Andalucía (Landscape of Andalusia)*, 1948
13. *Cabeza del Bautista (Head of John the Baptist)*, 1949
14. *Lily*, 1949
15. *Cabeza de niña (Head of Girl)*, 1951
16. *Cabeza de mexicana (Head of a Mexican Woman)*, 1951
17. *Cabeza de mestiza (Head of a Mestiza)*, 1951
18. *Autorretrato (Self-Portrait)*, 1952
19. *Flores (Flowers)*, 1952
20. *Flores (Flowers)*, 1952

21. *Flores (Flowers)*, 1952
22. *José Martí*, 1952
23. *Simón Bolívar*, 1952
24. *Naturaleza muerta (Still Life)*, 1952
25. *Naturaleza muerta (Still Life)*, 1952
26. *Paisaje mexicano (Mexican Landscape)*, 1952
27. *Paisaje mexicano (Mexican Landscape)*, 1952
28. *Niños (Children)*, 1952
29. *Estudio (Study)*, 1952
30. *Estudio (Study)*, 1952
31. *Estudio (Study)*, 1952

February 18 - March 12, 1953

THE ART OF BRAZIL:
A PHOTOGRAPHIC SURVEY IN COLOR BY ANITA MOORE

Anita Moore is an outstanding lecturer on art, who has been very active in cultural centers throughout the United States. She is the former director of the Cornish School of Art in Seattle, Washington, a contributor to art magazines and newspapers, and a member of the National League of American Penwomen.

Mrs. Moore has recently returned to the United States after a sojourn of several years in Brazil. While there, as an amateur photographer, she carried out a research project of unusual interest, recording many of the most important examples of Brazilian art. The results of her study are to be seen in the present exhibition, assembled and organized by Mrs. Moore.

CATALOGUE

1. *Prehistoric Pottery of the Amazon*
2. *Stone Sculpture of the Amazon*
3. *Prehistoric Cave Paintings*
4. *Colonial Architecture*
 a. Religious
 b. Secular
5. *Nineteenth Century Architecture*
 a. Religious
 b. Secular
6. *Twentieth Century Architecture*
 a. Religious
 b. Secular
7. *Painting*
 a. Nineteenth Century
 b. Contemporary
8. *Sculpture*
 a. Colonial
 b. Contemporary
9. *Popular Art*: Ceramics
10. *Crafts*
 a. Glass

b. Needlework
c. Tile
d. Metal

March 16 - April 11, 1953

CARLOS FAZ: PAINTINGS AND PRINTS

Carlos Faz belongs to the newest generation of Chilean artists. Born in Viña del Mar in 1931, he studied at the School of Fine Arts there in 1946 and 1947. In 1948 he received Third Prize for Painting in the Annual Salon held in his native city. He has displayed his work in group exhibitions and one-man shows in Santiago. At the end of 1952 Faz received a scholarship from the Henry L. and Grace Doherty Charitable Foundation for study in the United States. Since his coming to this country, he has been attending Atelier 17 in New York City, where he is experimenting with engraving and printing techniques. This exhibit is the first display of his work in the United States.

With reference to his last one-man show in the Chilean-American Cultural Institute in Santiago, the critic Enrique Lafourcade said:

> Here is an artist who has studied attentively, deeply, and intelligently not only contemporary painting, but the Renaissance painters of Italy and Germany.

CATALOGUE

Oils

1. *Mineros (Miners)*
2. *Velorio (The Wake)*
3. *El herido (The Wounded)*
4. *Madre e hijo (Mother and Son)*
5. *Hospital*
6. *Ciego en la privamera (Blind Man in Springtime)*
7. *¡No te mueras! (Do not Die!)*
8. *Galvarino (Chilean History)*
9. *Lautaro (Chilean History)*
10. *La muerte acecha el sueño (Death in Pursuit of the Dream)*
11. *La guerra (War)*
12. *¿Por qué me has abandonado? (Why Have You Abandoned Me?)*

Duccos

13. *Amanecer (Dawn)*
14. *El sueño (The Dream)*

Engravings

15. *El pájaro (The Bird)*
16. *Pastoral*
17. *Funeral*

18. *La poderosa muerte (All-Powerful Death)*
19. *¿Por qué me has abandonado? (Why Have You Abandoned Me?)*
20. *Galvarino (Chilean history)*
21. *Miseria y muerte (Misery and Death)*
22. *Nocturno (Nocturne)*
23. *El sueño (The Dream)*

Woodcuts

24. *Fusilamiento (Execution) I*
25. *Músicos (Musicians)*
26. *Organillero (Organ Grinder)*
27. *Fusilamiento (Execution) II*
28. *Muerte (Death)*
29. *Sin trabajo (Unemployed)*
30. *Muerte marítima (Death at Sea)*
31. *Músico y enferma (Musician and Sick Woman)*

April 14 - May 5, 1953

ARTISTS OF THE AMERICAS
AN EXHIBITION IN COMMEMORATION OF PAN AMERICAN DAY

Paintings, Drawings, and Prints

Raquel Forner (Argentina)
 1. *Icarus*, gouache sketch

Roberto Berdecio (Bolivia)
 2. *Head of a Girl*, pencil drawing

Cândido Portinari (Brazil)
 3. *Retôrno da feira (Return from the Fair)*, 1940, oil on canvas, 39 x 31 1/2

Peggy Kelbaugh (Canada)
 4. *Park Scene*, New Brunswick, casein

Pablo A. Burchard (Chile)
 5. *Araucanian Toys*, gouache

Alejandro Obregón (Colombia)
 6. *La mesa negra (The Black Table)*, pastel and pencil

Ranucci (Costa Rica)
 7. *Church in Orosí*, oil. Coll. Mr. and Mrs. Julio E. Heurtematte

Carlos Enríquez (Cuba)
 8. *Nude*, oil. Coll. Mr. and Mrs. Ramón G. Osuna

Gilberto Hernández Ortega (Dominican Republic)
9. *Market Woman*, oil

Eduardo Kingman (Ecuador)
10. *Mujer (Woman)*, oil

Mauricio Aguilar (El Salvador)
11. *Still Life*, oil

Carlos Mérida (Guatemala)
12. *Figures on the Wall*, tempera

Hector Hyppolite (Haiti)
13. *African Memory*, oil. Coll. Mr. and Mrs. James H. Whyte

J. Antonio Velásquez (Honduras)
14. *Vista de San Antonio de Oriente (Landscape View of San Antonio de Oriente)*, oil. Coll. Ambassador of
 Honduras and Señora de Valle

José Clemente Orozco (Mexico)
15. *Maguey*, oil. Private Collection

Rodrigo Peñalba (Nicaragua)
16. *Ritual Dance*, oil on paper

Roberto Lewis (Panama)
17. *Tamarind Trees of Taboga Island*, oil. Coll. Embassy of Panama

Laguardia (Paraguay)
18. *Head of Christ*, lacquer. Coll. Ambassador of Paraguay and Señora de Boettner

Fernando de Szyszlo (Peru)
19. *Homenaje a Vallejo (Homage to Vallejo)*, color lithograph

Richard Miller (United States)
20. *Egg Beater and Urn*, oil. Coll. The Phillips Collection, Washington, D.C.

Pedro Figari (Uruguay)
21. *The Market*, oil. Coll. Banco de la República Oriental del Uruguay

Alejandro Otero (Venezuela)
22. *Composition*, oil

BIOGRAPHICAL NOTES[1]

ENRIQUEZ, Carlos. Painter, muralist, writer, born in Santa Clara, Cuba, 1901. Studied for a short period at the
Pennsylvania Academy of Fine Arts, 1924. Traveled in Europe and studied in Madrid, Paris, and Rome, 1930-1934.
Executed several murals in Cuba and in 1939 published a novel, *Tilín García*. His work was exhibited in Cuba,

[1] Not included in the original catalogue. See Index of Artists for reference on those not listed here. —*Ed.*

Haiti, Argentina, the United States, and Europe. Was awarded several first prizes at national salons.

LEWIS, Roberto. Painter, muralist, sculptor, born in Panama, 1874. Died in 1949. Studied at the Académie des Beaux-Arts, Paris, with Léon Bonnat. Was consul of Panama in Paris, 1904-1912, professor of drawing at the Instituto Nacional, and director of the Academia de Pintura, Panama, 1913-1938. Executed many murals in public buildings in Panama, including the National Theatre and the Presidential Palace. Exhibited in Paris and Panama.

RANUCCI, Luciano. Painter, born in Milan, Italy, where he studied with several local artists and at the Academy. Held individual exhibitions in Europe and Latin America. Has lived in Costa Rica since 1951.

May 6 - June 6, 1953

NOEMI MELLA

Noemí Mella belongs to the most recent generation of artists of the Dominican Republic—one which started to develop about twelve years ago. She was born in Ciudad Trujillo in 1929 and began to attend the National School of Fine Arts in that city in 1945. After she had been at the school for but a short time, the outstanding quality of her work was recognized in student exhibitions presented at the National Gallery of Fine Arts. Upon graduation in 1948, she was appointed to do drawings for the Institute of Anthropological Investigation at the University of Santo Domingo, and held this position for over a year. In 1948 she won the Presidente Trujillo Grand Prize for Painting.

At present the artist is professor of painting and art history at the Normal School for Teachers in the Dominican capital. Señorita Mella has also done work in the field of book illustration. Her paintings were exhibited in her country's National Gallery of Fine Arts in 1950 and 1952, and they have figured in group shows there and abroad. The present exhibition is the first display of Señorita Mella's work in Washington, and this is the first time that an entire exhibit has been devoted to her production in the United States.

Manuel Valldeperes, art critic of the newspaper *La Nación*, commenting on Noemí Mella's most recent exhibit, said: "Her work is characterized by a sober and restrained modeling of the forms which also bears the imprint of emotion. Her palette is dark and colors are merely suggested."

The Dominican painter Jaime Colson considers the work of Señorita Mella to be "an accomplishment of rare beauty."

CATALOGUE

Oils

1. *La fábrica (The Factory)*, 1948. Coll. Galería Nacional de Bellas Artes, Ciudad Trujillo
2. *Arboles y fuego (Trees and Fire)*, 1948. Coll. Ms. Julia D. Gerardino
3. *Composición (Composition)*, 1950. Coll. Galería Nacional de Bellas Artes, Ciudad Trujillo
4. *Paisaje de la ciudad (The City)*, 1950
5. *Malantcha*, 1950, oil on paper
6. *Interior con rosas (Interior with Roses)*, 1950
7. *Still Life with Horse Skull*, 1950
8. *Bodegón con potisa (Still Life with Water Jug)*, 1951. Coll. Licenciado Osvaldo Peña Battle
9. *Adolescente (Adolescent)*, 1951, oil on paper
10. *La calavera del caballo (Horse Skull)*, 1952. Coll. Galería Nacional de Bellas Artes, Ciudad Trujillo
11. *Pinos y techos (Pines and Rooftop)*, 1952

12. *Bohíos del sur (Huts in the South)*, 1952
13. *Naturaleza muerta con pan y cactus (Still Life with Bread and Cactus)*, 1952
14. *Paisaje del Lago del Fondo (Landscape of Lago del Fondo)*, 1952. Coll. Ms. Aida Bonnelly
15. *Naturaleza muerta con farol (Still Life with Lantern)*, 1952, oil on cardboard
16. *Picos del norte (Northern Peaks)*, 1952, oil, canvas on cardboard
17. *Naturaleza muerta con frutas (Still Life with Fruit)*, 1952, oil, canvas on cardboard
18. *Estudio (Study)*, 1952, oil, canvas on cardboard
19. *Still Life with Horse Skull*, 1952
20. *Naturaleza muerta con botellas (Still Life with Bottles)*, 1952, oil, canvas on cardboard

Gouache

21. *Naturaleza muerta con aguacates (Still Life with Avocados)*, 1948
22. *Composición (Composition)*, 1951
23. *Naturaleza muerta con farol (Still Life with Lantern)*, 1952

Ink Drawing

24. *Cabeza de muchacha (Head of a Girl)*, 1952

June 8 - July 4, 1953

FERNANDO DE SZYSZLO

In 1947 a new personality appeared in Peruvian art: Fernando de Szyszlo. In that year his first one-man show was held at the Peruvian-American Cultural Institute of Lima. In the years following, Szyszlo gradually moved from a realistic conception of art to a greater abstraction of form, and his painting today is completely nonobjective in character.

Szyszlo has been closely connected with the group of modern architects and artists of Lima whose association is known as *Espacio*. His production today marks a complete break with the Indianist school which has dominated Peruvian art for twenty years. However, his work is closely linked with, and finds inspiration in, native culture, for he considers the Inca and pre-Inca designers, with their fine sense of the abstract, as the most important influence on his present manner of expression.

The artist was born in Lima in 1925. He first studied architecture, but little by little his interest was drawn to the plastic arts and in 1944 he enrolled in the Academy of Art of the Catholic University of Lima, directed by Adolfo Winternitz. In 1946 for the first time he entered a work in the National Salon, and about the same period he initiated his exploration into modern forms of art. An accomplished draftsman, he has done extensive illustration for books and periodicals. His work in the graphic arts has been chiefly in the field of the woodcut, but its culmination is marked by the portfolio of lithographs entitled *Homage to Vallejo*, published in Paris in 1950.

Szyszlo was in Europe from 1949 to 1950, at which time he returned to Lima. There he entered upon a variety of artistic activities and found himself the protagonist in a number of aesthetic controversies. He has had one-man shows in Lima in 1947, 1948, 1951, and 1953; and in Paris in 1950. He has participated in group shows in his native Peru, and also in France and Germany. He is currently on his first visit to this country, and this is his first exhibition in the United States.

The Peruvian poet Jorge E. Eielson expresses his feeling toward the artist thus:

Among us, it is Szyszlo who, despite his incredible youth, has made the cleanest, the most austere and spiritual use of painting.

And reviewing the exhibition at the Galerie Mai in 1950, the Parisian critic Guy Marester defined the essence of Szyszlo's painting as follows:

There is nothing dry or impoverished about Szyszlo's work; it is rich in sensitivity and mystery.

CATALOGUE

Painting[1]

 1-9. Oils
10-11. Oils on tempera
12-14. Temperas
15-16. Pastels
17-20. Wash-drawings based on Rembrandt etchings
21-22. Lithographs from the portfolio *Homage to Vallejo*, Paris, 1950

July 8 - August 8, 1953

AS I SEE IT: LATIN AMERICA IN THE IMAGINATION
OF THE MEMBERS OF THE SOCIETY OF WASHINGTON ARTISTS

This exhibition is the result of a unique project initiated as a gesture of friendship toward the countries of the Pan American Union and recently carried out by the Society of Washington Artists. In this project, each of twenty artists was assigned the task of portraying one Latin American country as he imagined it to be, through the medium of his choice. The only requirement was that he should depict a country with which he had no personal acquaintance. The works stemming from this challenge to artistic imagination represent all types of expression, from the completely objective through the abstract to the non-figurative. Whatever the medium adopted, the resultant creation is indicative of a spiritual affinity of the artist for the country he selected.

The Society of Washington Artists was founded in 1891 and is the oldest of such organizations in the District of Columbia. It was the first to invite outside artists to present exhibits in this city. The year after its establishment, it counted twenty-six artists as members; and today it has one hundred forty-six. Mr. Robert E. Willis is now president of the group. Exhibitions by associates are limited to oils and sculpture, no other media being admitted. The chief aim of the Society is to encourage artistic effort by maintaining open competition for artists within a radius of twenty-five miles of Washington.

CATALOGUE

Oil and Sculpture

Ralph de Burgos
1. *José de San Martín Crossing the Andes*, Argentina, oil

[1] Titles are unavailable. —*Ed.*

Charles Dunn
2. *Bolivia*, oil

Melvin Buckner
3. *Progress in Brazil, The New Jungle*, oil

Mary Ruth Snow
4. *Place Where the Earth Ends*, Chile, oil

Hazel Van Natter
5. *Spirit of Chile*, sculpture

Charles Hoover
6. *The Cattleya Orchid*, Colombia, oil

Mary Hovnanian
7. *The Ox-Cart*, Costa Rica, oil

Anthony Qualia
8. *Carnival in Cuba*, oil

Joyce Field
9. *Of Santo Domingo*, Dominican Republic, oil

Minor Jameson
10. *In Ecuador*, oil

Jack Perlmutter
11. *Before the Mountains*, El Salvador, oil

Helen Rennie
12. *Guatemala: Mayan Forms*, oil

Omar Carrington
13. *Christophe's Land*, Haiti, oil

Jane Love
14. *Dance Motif*, Haiti, sculpture

Theodora Kane
15. *Honduran Maize and Mayan Masque*, Honduras, oil

Lila Asher
16. *Mexican Hat Dance*, Mexico, sculpture

Inez Leinbach
17. *Lady from León*, Nicaragua, oil

Mimi DuBois Bolton
18. *Altarpiece*, Panamá, oil

Arvid Hedin
19. *Iguassu Falls*, Paraguay [*sic*], oil

Lee Atkyns
20. *Peruvian Echoes*, Peru, oil

Sam Bookatz
21. *Geodes, Uruguayan Amethyst Rock Formation*, Uruguay, oil

Elaine Hartley
22. *View of Caracas*, Venezuela, oil

Bob Willis
23. *Venezuela*, oil

August 13 - September 16, 1953

LATIN AMERICA THROUGH EUROPEAN EYES: PRINTS OF THE SEVENTEENTH, EIGHTEENTH, AND NINETEENTH CENTURIES

America became a source of inspiration to European artists almost from the moment of its discovery. The exotic nature of the American scene made it a preferred favorite with a long line of illustrators—first engravers, and later lithographers. Perhaps the earliest of these was Théodore de Bry. He never left Europe, but allowed intuition—a none-too-accurate guide—to direct his hand in depicting the surprise-filled "Indies." From de Bry's work it is over two centuries to the very different drawings of the scientist Alexander von Humboldt, whose extensive record of America was to prove an inexhaustible mine for commercial illustrators. Little by little, however, the New World was revealed to the Old through the medium of prints.

Engraving was introduced into Latin America at an early date, but for a long time the sole practitioners of the art were members of religious orders, who treated only themes relating to the propagation of the faith. From the seventeenth century well into the nineteenth, however, various artists of minor importance wandered about the Hemisphere making sketches which were later transferred to copper plates or to stone by German, Dutch, French, and English engravers, who frequently added imaginary details of their own invention. The resulting prints served to illustrate travelers' accounts of America and were occasionally issued in portfolios, in response to the demand of a public whose imagination had been stirred by the unknown wonders of the New World. During the nineteenth century lithographic production was begun in a number of cities of the Americas, and prints were exported to Europe to compete with the ones made there. The most interesting work was done in Buenos Aires, Mexico City, and Havana. The artists, however, were still for the most part European.

The chief purpose of early prints was propaganda, either political or economic. The English and Dutch had engravings made of their exploits in Cuba and Brazil, as evidence of their penetration into a world supposedly dominated by Spain and Portugal. Later, in the 1860s, the French sought to glorify in lithographs their ephemeral empire in Mexico. (It is worthy of note that even an artist so unconcerned with historical events as Edouard Manet was moved by the execution of Maximilian and fixed on lithographic stone the sketch of his Goyesque picture in which the unfortunate Habsburg is brought down by the bullets of Mexican patriots.)

Engravings and lithographs served, moreover, to advertise the riches of the New World, drawing investors to enterprises of exploitation. Vast panoramas depicted ample ports, ideally suited to shipping. Minerals, fruits, and above all those three precious commodities, tobacco, coffee, and sugar, were treated extensively both by itinerant

artists in the Americas and by illustrators who remained comfortably at home in Europe. The elegant form of publicity which resulted circulated through public libraries and formed part of the print collections of prominent men of the time.

Engraving and lithography also served to popularize artistic tendencies. The man of limited means could never afford even one costly original, but he could decorate every room in his house with prints, some colored by hand. For minds in which romanticism had aroused an avid interest in unknown lands and exotic types, there was no greater source of visual delight.

Keeping all these factors in mind, we have made a selection illustrating ill-fated attempts at conquest, the glamorization of economic products, and a few of the novelties which aroused the intellectual curiosity of men in the Age of Reason.

This exhibition has been rendered possible by the cooperation of the Old Print Shop of New York. In this specialized gallery's carefully indexed collection, one can find the most varied examples of the work of those artists who, in person or in imagination, roamed the lands of the New World in bygone centuries.

Additional items, without which the intentions of this exhibit could not have been fully realized, come from the private collection of Mr. Luis D. Gardel, of Washington, and from the Rosenwald Collection of the National Gallery of Art. We take this occasion to thank The Old Print Shop, Mr. Gardel, and the National Gallery for their kindness in making these works available to us.

CATALOGUE

Argentina

1. *Buenos-Ayres a vista de pájaro*, about 1850-60, colored lithograph, 18 x 36-1/4"
2. *Buenos-Ayres. La boca del Riachuelo cerca de Barracas*, colored lithograph by Lemercier, 11 1/4 x 17 1/2". Published about 1850 from a drawing by Dulin
3. *The Market Place, Buenos Ayres, La Recova, and Jesuit College*, about 1827, hand colored aquatint engraving by Fumagalli, 6 3/4 by 10 1/4"
4. *El Asado*, lithograph printed by Pelvilain, after a design by Pallière, Buenos Aires, 1865, 9 1/2 x 6 1/8"
5. *Buenos Aires: lechero y panadero*, same as above, 7 1/2 x 13"

Bolivia

6. *Caravana en el desierto de Atacama*, same as above, 7 1/2 x 13"

Brazil

7. *Porto Calvo*, 1637, black and white engraving, 10 3/4 x 13 1/4"
8. *La Grande Rue à Rio Janeiro*, about 1820-30, hand colored aquatint engraving by Himely, after Lauvergne, 8 1/4 x 12 1/4"
9. *San Salvador*, about 1690-1700, hand colored line engraving by Pieter Schenck, 8 x 10"
10. *Rio Parahybuna*, about 1830-40, hand colored lithograph by Engelmann, drawn from nature by Rugendas, 9 1/4 x 12 1/4"
11. *Sugar Mill, Brazil*, about 1827, hand colored aquatint engraving by Fumagalli, 6 1/4 x 12 1/2"
12. *Street Scene, Rio de Janeiro*, about 1827, hand colored aquatint engraving by Fumagalli 6 1/4 x 9"
13. *Récolte de Café*, lithograph by Deroi, after a drawing by Rugendas. Printed by Engelmann, Paris, 1835, 9 1/4 x 12 1/4"

Colombia

14. *Colombia. Jarabite sopra un torrente*, about 1830, hand colored line engraving by Buttazzon 3 1/2 x 5"
15. *Falls of Tequendama*, about 1827, hand colored aquatint engraving by Fumagalli, 11 1/2 x 8"
16. *Volcans d'Air de Turbaco*, about 1815-30, colored aquatint engraving by Bouquet, after a sketch by Louis de Rieux. Printed in Paris by Langlois, 11 3/4 x 16 1/4"
17. *Passage du Quindin dans la Cordillère des Andes*, engraving by Duttenhofer, Stuttgart, after a drawing by Koch based on a sketch by Humboldt. Printed by Langlois, Paris, 1810, 11 7/8 x 16 1/2"

Cuba

18. *Habana, 1851*, by Smith Hermanos y Ca., colored lithograph published in London about 1851, 26 x 40"
19. *Market Place in Havana*, hand colored line engraving by C. Canot and T. Morris, from a drawing by Elias Durnford, Engineer. Printed in London for John Bowles, about 1760-70, 13 x 20 1/4"
20. *Perspective view of British land forces going to take possession of the north gate of the city and La Punta Castle*, hand colored line engraving by Mason, from a painting by Serres, 16 x 24 1/4"
21. *Vue générale de La Havane à vol d'oiseau*, about 1850-60, colored lithograph by Asselineau. Published in Paris by Wild, 14 1/4 x 23"
22. *Havana: Vista de la Plaza de San Francisco*, about 1840-50, hand colored lithograph by Jacottet, from a drawing by Sawkins, 10 x 15 1/4"
23. *Ingenio Sta. Teresa, Agüica*, about 1860, colored lithograph by L. Marquier. Published for Marquier and Laplante, Havana, 8 1/4 x 13 1/4"
24. *Isla de Cuba pintoresca: Puerto Príncipe*, about 1850-60, colored lithograph by Santiago Martín for Eduardo Laplante, drawn by Leonardo Barañano, 15 3/4 x 26 3/4"
25. *Isla de Cuba pintoresca: El valle del Yumurí, Matanzas*, same as above, 15 3/4 x 26 3/4"

Chile

26. *Valparaíso*, about 1820-30, hand colored aquantint engraving by Himely, after Lauvergne, 8 3/4 x 12 1/2"
27. *Port de Mer d'Amérique-Chili. Vista general de Valparaíso*, about 1860, colored lithograph by Duruy, 12 1/2 x 18 3/4"

Ecuador

28. *Pont de cordage près de Penipe*, about 1815-25, colored aquatint and line engraving by Bouquet, from a sketch by Humboldt. Printed in Paris by Langlois, 8 1/4 x 10 3/4"
29. *Radeau de la rivière de Guayaquil*, Paris, 1810, hand colored engraving by Bouquet of a design by Marchais based on a sketch by Humboldt (the fruits and flowers were designed after sketches by Turpin and Poiteau), 11 1/2 x 16 1/2"

Honduras

30. *Truxillo*, about 1690-1700, anonymous, black and white engraving about 11 x 13 1/2"

Mexico

31. *Vue de la Ville du Mexique prise du côté du Lac*, about 1750-70, hand colored line engraving issued in Paris by Daumont, 9 x 15"
32. *Départ de Mexico, de S.E. le Mal. Bazaine, le 5 Fevrier, 1867*, anonymous, colored lithographs issued at the time, 13 1/2 x 18 1/2"
33. *México y sus alrededores. Trajes mexicanos*, about 1860, colored lithograph by Debray, from a drawing by

C. Castro and J. Campillo, 9 x 13 1/4"

34. *México y sus alrededores. Trajes mexicanos*, same series as above, 9 1/4 x 13"
35. *México y sus alrededores. Cascada de Tizapán (Sn. Angel)*, same series as above, 13 1/2 x 10"
36. *Monterrey, as seen from a house top in the Main Plaza* (to the West), October 1846, colored lithograph on stone by Chas. Fenderich, from a drawing by Captain D. P. Whiting. Printed by Endicott and published in 1847 by Whiting, 12 1/2 x 18 1/4"
37. *Molino del Rey—Attack upon the Molino*, about 1850, colored lithograph by Bayot, from the drawing by C. Nebel. Printed in Paris by Lemercier, 10 3/4 x 17"
38. *Vista general de Zacatecas*, about 1850, colored lithograph by Cuvillier, from a drawing by C. Nebel. Printed in Paris by Lemercier, 8 1/4 x 13"
39. *Death of Maximilian at Querétaro*, lithograph by Edouard Manet, 13 1/4 x 17 1/4"

Nicaragua

40. *San Juan de Nicaragua*, issued about 1850, hand colored lithograph on stone by J. Cameron, from a drawing by G.V. Cooper, 4 3/4 x 8"

Panama

41. *Panama*, about 1690-1700, hand colored line engraving by Pieter Schenck 8 x 10 1/4"
42. *Les Cordellières avec le Volcan de Chiriquí...*, about 1840-50, colored lithograph by A.J. Warsewicz, 8 x 13 3/4"

Paraguay

43. *Paraguay. Fodero sul Rio-Grande nel Gran Chaco*, about 1800-1820, hand colored line engraving by Zanetti, 4 x 5 1/4"

Peru

44. *Lima, Ciudad de los Reyes*, probably late seventeenth century, hand colored line engraving by Joseph Mulder, 14 1/2 x 20 1/4"
45. *Callao de Lima*, issued probably about 1680-1700, anonymous, hand colored line engraving, 11 1/4 x 13 3/4"

NOTE:

Numbers 4, 5, 6, 13, 17 and 29 belong to Luis D. Gardel, Washington, D.C.
Number 39 belongs to the Rosenwald Collection, National Gallery of Art, Washington, D.C.
The rest of the prints belong to The Old Print Shop, New York City, N.Y.

BIOGRAPHICAL NOTES[1]

BARAÑANO, Leonardo. Draftsman, active in Cuba during the mid-nineteenth century. In 1856 executed the series *La isla de Cuba pintoresca*, lithographed by Eduardo Laplante. The works of Barañano and Laplante were shown at the exhibition *300 Years of Art in Cuba*, Havana, 1940.

CASTRO, Casimiro. Mexican lithographer active in the nineteenth century. Illustrated many books, including

[1] Not included in the original catalogue. Information is given only on those artists who were born or have actually been in Latin America. —*Ed.*

México y sus alrededores.

DULIN, J.D. Draftsman, lithographer, cartographer, born in France, 1839. Died in Paris, 1919. Lived in Buenos Aires the second half of the nineteenth century, where he was a professor of painting and drawing at the Seminario Inglés. Made a considerable number of drawings and lithographs of Buenos Aires and Montevideo.

HUMBOLDT (Alexander Friedrich Heinrich, Baron von Humboldt). Explorer and scientist, born in Berlin, 1769, where he died in 1859. In 1799-1804, made a study and research trip to Latin America and the Caribbean with the botanist Aimé Goujaud Bonpland. They spent five years in the Amazon and Orinoco region, and in Venezuela, Ecuador, Colombia, Peru, and Mexico. Described over 3,000 new species and formulated accurate conclusions of great significance even today. His numerous drawings of people of ancient and contemporary civilizations, of animals, plants, landscapes, and every day scenes were widely reproduced and published in Europe.

LAPLANTE, Eduardo. Painter, draftsman, lithographer, active in Cuba during the mid-nineteenth century. Around 1856 executed the lithographs for *Lai Isla de Cuba pintoresca*, after the drawings made by Leonardo Barañano. Illustrated the book *Colección de vistas de los principales ingenios de la Isla de Cuba* by Justo Germán Cantero, with thirty-eight colored lithographs, 1858.

LAUVERGNE, Barthélemy. Painter, draftsman, lithographer, born in Toulon, France, 1805. Died in Carcès, France, 1871. Traveled all over the world as a draftsman in several scientific expeditions, 1826-1839. After the La Bonite expedition, 1836-1839, an album was published with seventy illustrations made by him and thirty made by Théodore Auguste Fisquet, the other draftsman of the expedition, reproducing scenes of Rio de Janeiro, Montevideo, Lima, and other South American cities. Exhibited in the Paris Salon, 1828-1849, winning a medal, 1835.

NEBEL, Carl. Architect, archaeologist, draftsman, born in Germany, 1800, where he died in Frankfurt, 1865. Made a study trip to Mexico, 1829-34, to visit archaeological sites, executing drawings of ancient monuments. Published *Voyage pittoresque et archéologique dans la partie la plus intéressante du Mexique*, Paris, 1836, with fifty lithographs of his drawings. A second edition was published in Spanish, Mexico, 1839. After accompanying the troups during the Mexican War, 1846-48, published *The War between the United States and Mexico, Illustrated*, New York, 1851.

PALLIERE, Jean Léon (Jean Pierre Léon Pallière Grandjean Ferreira). Painter, draftsman, lithographer, born in Rio de Janeiro, 1823, of French parents. Died in Lorris, France, 1887. Moved with his family to Paris, 1830. Started his art education under François Edouard Picot, 1836. Studied with Emilio Taunay, Imperial Academy of Fine Arts, Rio de Janeiro, 1848-1849; Academy of France in Rome, under a Brazilian scholarship, 1950-1955. Lived in Buenos Aires, 1856-1866. Traveled extensively in Europe and South America. Executed genre, historical, and allegorical paintings; decorated the ceiling of the National School of Fine Arts, Rio de Janeiro, and the walls of the Coliseum in Buenos Aires; his drawings and lithographs were published in Europe, and his famous *Album Pallière. Escenas americanas. Reproducción de cuadros, acuarelas y bosquejos* appeared in Buenos Aires, 1865, printed at the Julio Pelvilain printshop. Since 1859 exhibited individually and in group shows in Rio de Janeiro, Buenos Aires, and Paris, where he won several prizes.

PELVILAIN, Julio. French lithographer established in Buenos Aires in the mid-nineteenth century. His printshop was among the most important ones in Argentina until his death, in 1871.

RUGENDAS, Johann Moritz. Painter, draftsman, engraver, lithographer, born in Augsburg, Germany, 1802. Died in Weilheim, Germany, 1858. Trained from an early age by his father, Johann Lorenz Rugendas, director of the Augsburg Academy of Art. Also studied in that Academy and at the Academy of Painting, Munich, 1817. Baron Georg von Langsdorff took him as a painter and draftsman in his expedition to Brazil, 1821. Separated from that expedition, traveled in Brazil alone, 1922-1925. Engelmann published his *Voyage pittoresque au Brésil*, with 100

lithographs of his drawings and paintings, Paris, 1927 and 1935, of which there is also a German edition. Went back to Latin America visiting and working in Haiti and Mexico, 1831-34; Chile, 1834-42; Peru, 1842-44; Argentina, Uruguay, and Brazil, 1844-47. Back in Munich, sold over 3,000 of his art works to the State Collections, kept now at the Staatlich Graphische Sammlung München.

SAWKINS, James Gay. Painter, draftsman, geologist, born in Yeovil, England, 1806. Died in London, 1878. Lived in Cuba, about 1835-47, where he was a professor of drawing and executed numerous portraits, drawings, and watercolors on Cuban people, scenes, and landscapes, from which many printed reproductions were done.

SERRES, Dominique. Painter, draftsman, navy officer, born in France, 1722, where he died, 1793. Witnessed the take over of Havana by the British, 1762, painting and making a series of eight prints on this event. Also painted naval episodes of the United States Independence War, 1776.

WHITING, Daniel Powers. North American painter and military active in the nineteenth century. Participated in the campaign against Mexico, 1847. Some of the paintings he executed then were later lithographed by different artists and published.

September 17 - October 20, 1953

ROBERTO DIAGO: OIL, DRAWING, SCRATCH-BOARD, WATERCOLOR, AND PROJECTS FOR CERAMIC

Since 1943 Roberto Diago has held a place of note among Cuban painters following modern trends. He had previously studied at the National School of Fine Arts in Havana, from which he graduated in 1941. Soon after finishing his academic training, he began to develop a distinctive style of expression in which dexterous draftsmanship was combined with great imaginative sensitivity. Much of Diago's effort has been devoted to the interpretation, in his characteristically fluid yet meticulous manner, of Negro themes, expressive of universal values rather than a mere reflection of regional environment. Diago has been successful in the practice of the graphic arts, especially the woodcut, and has illustrated several books and short stories in Cuba and the United States. At present he is professor at the School of Plastic Arts in the city of Matanzas, Cuba.

The artist had his first one-man show in Havana in 1944 and several more have followed since. In 1947 he traveled to Haiti, where another individual exhibition was held. Diago's paintings and drawings have been displayed in group shows in Mexico City, Stockholm, Guatemala City, Moscow, Paris, and Buenos Aires. One of his drawings is included in the collection of the Museum of Modern Art in New York, and another in the Museum of Fine Arts, La Plata, Argentina.

Drawings and oils by Diago have formed part of several Cuban exhibitions in the United States, but this is his first one-man show in this country. It has been made possible through the courtesy of a number of collectors who have lent works for this showing. A few of the most recent items were brought by the artist from Cuba.

CATALOGUE

Oil

 1. *Flowers*, 1945. Coll. Mr. and Mrs. David A. Slattery
 2. *Figure*, 1953

Ink and Varnish

 3. *Forms*, 1953
 4. *Twins*, 1953

Watercolor

 5. *Head I*, 1949
 6. *Head II*, 1949
 7. *Three Figures*, 1950
 8. *Firecrackers*, 1950

Scratch-Board

 9. *Face I*, 1948
 10. *Face II*, 1950. Coll. Miss Catharine Ryan
 11. *Nocturne*, 1950
 12. *Musical Instrument I*, 1948. Coll. Miss Angela Soler
 13. *Twilight*, 1950
 14. *Musical Instrument II*, 1950
 15. *Bird*, 1951. Coll. Dr. Aurelio Giroud
 16. *Face III*, 1950
 17. *Heaven*, 1950

Ink Drawing

 18. *Ancestral Face*, 1946
 19. *Angels*, 1946. Coll. Mr. Aubrey H. Starke
 20. *Angel*, 1946. Coll. Mr. and Mrs. George C. Compton
 21. *Head*, 1946. Coll. Dr. Aurelio Giroud
 22. *Judith*, 1946. Coll. Ambassador of Mexico and Señora de Quintanilla
 23. *Musicians*, 1946. Coll. Mrs. M.G.W. Nunan
 24. *Haitian Peasant Woman*, 1947
 25. *Head*, 1949
 26. *Head*, 1950
 27. *Bird*, 1951
 28. *Composition on Canvas I*, 1953
 29. *Composition on Canvas II*, 1953
 30. *Composition on Canvas III*, 1953
31-47. *Projects for Ceramic and Chinaware*

October 21 - November 11, 1953

FLOWERS OF ARGENTINA BY BIBI ZOGBE

For a number of years Bibí Zogbé has devoted a large share of her artistic production to studies of Argentine flora. The current exhibit presents some of the work which she has done in this line.

Señora Zogbé was born in Lebanon and was educated at the Collège de la Sainte Famille in Beyrouth. She has,

however, lived in Argentina for more than twenty years and is now a citizen of that country.

She began the study of art in Buenos Aires with the Bulgarian painter Klin Dimitroff, and her first show was held at the Galería Witcomb in the same city in 1934. In 1935 her work was presented at the Galerie Charpentier in Paris, and she spent a year traveling in Africa and exhibiting at the Salon des Amis de l'Art in Dakar. Since that time she has had shows in Argentina, France, and Cuba. Her first individual exhibition in the United States was held at the Grand Central Art Galleries in New York during the first two weeks of October of this year.

Examples of Bibí Zogbé's work are to be found in the Museu de Belas Artes of Rio de Janeiro and in the art museums of Buenos Aires, Corrientes, La Boca, Beyrouth, and Dakar. Señora Zogbé has also done a mural for the Museum of Natural Sciences in Buenos Aires.

Of her first exhibition in Paris the critic Camille Mauclair wrote:

> This is an excellent debut, by a painter of sincerity and great talent. She has given new life to hackneyed themes, and has endowed her flowers with their full power of mysterious seduction.

CATALOGUE

1. *Flor de ceibo (Ceibo Flowers)*
2. *Pampa argentina (The Argentine Pampa)*
3. *Ramo de primavera (Spring Branch)*
4. *Retama blanca (White Broom)*
5. *Ramas secas (Dry Branches)*
6. *Magnolias*
7. *Bouquet de otoño (Autumn Bouquet)*
8. *Crisantemos amarillos (Yellow Chrysanthemums)*
9. *Flores de mi jardín (Flowers from My Garden)*
10. *Cardos argentinos (Argentine Thistles)*
11. *Pinos (Pines)*
12. *Gladiolos (Gladiolus)*
13. *Cactus en flor (Flowering Cactus)*
14. *Esterlitzias y antorios (Sterlitzias and Anthuriums)*
15. *Bouquet d'automne (Autumn Bouquet)*, Paris
16. *Camelias*
17. *Naranjas (Oranges)*
18. *Paisaje con figuras (Landscape with Figures)*, Africa
19. *Estudio (Two Figures in the Studio)*

November 12 - December 28, 1953

TEN ARTISTS OF PANAMA

Following the death of Roberto Lewis and Humberto Ivaldi, painters who treated Panamanian themes competently, but without venturing beyond the bounds of realism or impressionism, there appeared, beginning about ten years ago, a generation of artists which has been seeking new directions in plastic expression.

If aspects of Panamanian life find reflection in the work of some of these painters, others have definitely turned their backs on the local scene, endeavoring through abstraction to give a more international character to their art.

With a few exceptions, it was this group which, for the first time, gave Panama representation abroad in the 1951 Biennial in São Paulo, Brazil. The present exhibit of works by the same artists forms part of the Pan American Union's commemoration of the Semicentennial of the Republic of Panama, and at the same time serves to present the most significant group of contemporary painters of that country to the American public.

At the end of the current showing, the exhibit will circulate throughout the United States.

CATALOGUE

Paintings

Bartley, Lloyd
 1. *En la ventana (At the Window)*, oil
 2. *Fin de la jornada (End of the Day)*, oil

Benítez, Isaac
 3. *Canción al amor (Song)*, oil
 4. *Impresión campestre (Impressions of the Country)*, oil

Cedeño, Juan M.
 5. *Viernes Santo interiorano (Good Friday)*, oil
 6. *Sacando arena (Digging Sand)*, oil
 7. *Talco en sombra (Embroidery)*, oil

Jeanine, Juan B.
 8. *Composición: paisaje (Landscape)*, oil
 9. *Bailarín (Dancer)*, oil
10. *Tres tamboreros (Three Drummers)*, oil
11. *Composición: tamborero (Drummer)*, oil

Muntañola, Roser
12. *Cabeza (Head)*, oil
13. *Dos desnudos femeninos (Nudes)*, oil

Oduber, Ciro S.
14. *Desnudo (Nude)*, oil
15. *Dos indias (Two Indian Women)*, oil

Runyan, Pablo
16. *Composición (Composition)*, oil

Silvera, Eudoro
17. *Velorio (Wake)*, oil
18. *Composición (Composition)*, oil

Sinclair, Alfredo
19. *Figuras y paisaje (Figures in a Landscape)*, oil and glass
20. *Composición (Composition) I*, oil and glass
21. *Composición (Composition) II*, oil
22. *Composición (Composition) III*, oil and glass

Trujillo, Guillermo
23. *Bosque viejo (Old Forest)*, oil
24. *Suburbios de Madrid (Outskirts of Madrid)*, watercolor
25. *Suburbios de Panamá (Outskirts of Panama City)*, watercolor

Supplementing the work of the painters, there is an exhibit of photographs featuring various aspects of Panama: natural beauties, native types, and architecture, both colonial and modern.

ABOUT THE ARTISTS

BARTLEY, Lloyd. Born in Panama, 1915. Studied with Todd Banach and Roberto Lewis. Later attended the National School of Painting where he was a pupil of Oduber. Has exhibited in Costa Rica.

BENITEZ, Isaac Leonardo. Born in Panama, 1927. Started studying with Humberto Ivaldi in 1941. In 1950 went to Italy and attended the Academy of Fine Arts in Florence.

CEDEÑO, Juan Manuel. Born in Panama, 1916. Studied at the National Academy of Painting under Humberto Ivaldi, at the Chicago Art Institute, and at the Polytechnic School of Mexico. Reorganized the School of Plastic Arts of Panama, where he is currently teaching.

JEANINE, Juan Bautista.[1] Painter, draftsman, sculptor, born in Panama City, 1922. Studied sculpture under John Amores, Escuela de Artes y Oficios, and painting under Roberto Lewis, Escuela Nacional de Pintura, both in Panama City. Also studied painting in Buenos Aires, Escuela Superior de Bellas Artes, 1948, and under Alfredo Guido, 1949-1952. Has exhibited in group shows in Panama since 1945.

MUNTAÑOLA, Roser. Born in Barcelona, Spain, 1928. Studied at the San Jorge School in Barcelona and at the School of Fine Arts in Buenos Aires. Has exhibited in Spain.

ODUBER, Ciro. Born in Panama, 1921. Studied under Roberto Lewis and Humberto Ivaldi. Attended the School of Fine Arts in Buenos Aires from 1945 to 1951. In 1952 studied at the San Jorge School in Barcelona, Spain. Teaches at the National Institute of Fine Arts of Panama.

RUNYAN, Pablo. Born in Panama, 1925. Self-taught. Exhibited in the First Hispanic-American Biennial in Madrid, 1951. At present lives in Spain.

SILVERA, Eudoro. Born in Panama, 1917. Studied at the National School of Painting under Roberto Lewis from 1935 to 1937. Went to New York in 1942 where he studied at the Cooper Union School. Has exhibited in New York and Oberlin, Ohio. Edits the art magazine *Tierra Firme*.

SINCLAIR BALLESTEROS, Alfredo. Born in Panama, 1915. Started studying painting in his own country in 1941, and later went to Buenos Aires where he attended the School of Fine Arts. Won awards in Panama and Buenos Aires. Has exibited in Argentina and Brazil.

TRUJILLO, Guillermo. Born in Panama, 1927. Studied architecture at the University of Panama, receiving his degree in 1950. The same year went to Spain and enrolled in the San Fernando Academy in Madrid.

[1] Not included in the original catalogue. —*Ed.*

December 29, 1953 - January 25, 1954

BONAMPAK, MAYAS OF YESTERDAY AND TODAY
PHOTOGRAPHS BY G. GERARD

Even "forbidden" Tibet is less shrouded in mystery today than the land of the Lacandones—that strange, virtually unexplored, unmapped, and all but impenetrable jungle vastness, where the last descendants of the fabulous Maya Old Empire stand guard over the ruined temples and palaces of a civilization that flourished many centuries before Columbus discovered this continent.

Here, in the heart of some sixty thousand square miles of tropical wilderness, stretching from southern Mexico into Yucatán, Guatemala, and parts of Central America, the Maya city-states developed the finest indigenous culture of the Americas. In fact, the Mayas were so far advanced in mathematics, astronomy, and the arts as to deserve the name of "Egyptians of the New World." Suddenly, however, sometime after 810 A.D., disaster befell the Empire. To this day, nobody knows what stupendous cataclysm forced the Mayas to abandon their magnificent cities and flee in great migrational waves toward the coast of Yucatán to start a new life.

Today, only the Lacandones possess the secret of the hundreds of ruined temples and palaces, reconquered by the jungle and buried beneath the tropical undergrowth accumulated over a thousand years. It was a Lacandón by the name of Chan-Bor who showed the now famous Temple of Bonampak—subsequently found to contain mural paintings of breathtaking beauty, which have revolutionized our knowledge of ancient Maya history—to Herman Charles Frey, the young American "archaeological vagabond" from Staunton, Illinois. From what little is known about this fascinating Maya tribe, it seems that when the Spaniards arrived in Mexico, the Lacandón clans were living in settlements around the Laguna de Miramar, beyond the edge of their present jungle domain. But whereas the Aztecs, Tezcucans, and other powerful Indian nations, including the New Empire Mayas of Yucatán, were subjugated one after the other, the Lacandones fought tooth and nail for their freedom and succeeded for many years in repulsing every effort of the white man to subdue them.

The Spaniards finally organized a great punitive expedition, reportedly on special orders from the King himself, and attacked the Lacandones with forces so crushingly superior in numbers and equipment that the Lacandones decided to avoid annihilation by taking refuge where no conqueror could pursue them—deep in the very jungle where their ancestors' Old Empire had flourished and died in earlier times. Protected by this rampart of utter isolation, they have remained for centuries out of sight and out of mind, unconquered and unchanged to this very day. They still speak the ancient Maya tongue and have preserved to a remarkable extent the religion and physical characteristics of their illustrious forefathers. On the other hand, however, there is nothing left among the Lacandones of the brilliant culture, social organization, and way of life of the Old Empire. They have no knowledge whatsoever of the elaborate hieroglyphic writing which the ancient Mayas created as early as the fifth century B.C. They live with stone-age primitivism in small family groups of ten to fifteen persons. Worst of all, these clans are widely scattered across thousands of square miles of mountainous wilderness, perpetually suspicious and afraid of one another. In case of dissension or trouble, these clans usually split up still further into even smaller and weaker groups, each of which goes its own lonely way, carrying on an ever more difficult struggle for survival against the forces of the jungle. Thus it would seem that the Lacandones are paying a fearfully heavy price for their freedom from alien domination and from contamination by the mechanized civilization of the outside world. They have sentenced themselves to death as a people. It is estimated that there are no more than two hundred Lacandones today and there can be little doubt that the curse of ceaseless dispersion and disintegration which hangs over them will soon wipe out the last remnants of this noble race.

George H. Gerard, who took the pictures shown in this exhibition, is a young man with an unusual group of occupations. For one thing, he is a conference interpreter—one of the small group of experts who provide the simultaneous translations at international conferences where discussions are conducted in two or more languages. He is also a writer and photographer whose work has appeared in various newspapers and magazines in the United

States and abroad, and he is at present connected with the Worldwide Press Service. As an interpreter, Mr. Gerard has served scores of important international conferences held in many different countries of Europe, the Near East, Africa, and the Americas. As a writer and photographer, he portrays the people and places he has learned to know in the course of these travels.

It was during one of his conference jobs in Mexico City that Mr. Gerard happened to meet Herman Charles Frey, who had become famous south of the border as Carlos Frey, the discoverer of Bonampak. Frey invited Gerard to join him a few weeks later in the Lacandón jungle to search for additional "lost cities" of the Maya Empire. When Gerard arrived from New York at the rendezvous on the edge of the wilderness, however, he learned that Herman Frey had died two weeks earlier, near the ruined temple which had come to mean more to him than anything else in the world. Gerard had to go through with his plan alone. From his one-man expedition to Bonampak and his stay with the Lacandones, during which he lived as one of them, he brought back the photographs that make up this exhibition.

Mr. Gerard's home is in Hastings-on-Hudson, New York. He was educated in France and in the United States, where he graduated from Harvard in 1942 and obtained a Master's degree from Columbia's Graduate School of Journalism in 1945. He was formerly cable editor for the International News Service and served fourteen months in China as information specialist for the United Nations Relief and Rehabilitation Administration (UNRRA) in 1946-47.

CATALOGUE

Photographs

1. Tenosique, in the State of Tabasco, is the gateway to the land of the Lacandones. This is the last outpost on the edge of the jungle where the Old Empire of the Mayas flourished some sixteen centuries ago.
2. Sixty thousand square miles of virtually unexplored jungle surround Bonampak.
3-4. Rising on top of a tall stone pyramid, the temple of Bonampak was the center of one of the Old Empire's flourishing city-states, until it was abandoned a thousand years ago as a result of a mysterious cataclysm which drove the Mayas out of this area centuries before Columbus discovered the American continent. Bonampak was discovered by Carl Frey, a young American adventurer and explorer who perished on his second expedition to the temple in 1949.
5. This carved god on Bonampak's crumbling façade illustrates the exquisite sophistication of the art of the Old Empire (sixth century A.D.). Bonampak means, in Maya, painted walls or walls with paintings.
6. Photographer Gerard inspects a fragment of a stela, outside the temple. Save for the dates, the riddle of the Maya glyphs is as yet unsolved.
7. Na-Ha-Kin, of the Lacandón tribe, direct descendant of the Old Empire of the Maya, wears a dress of hammock canvas, given her by members of Frey's Bonampak expedition. The Lacandones are direct descendants of the Mayas of the Old Empire.
8. Na-Ha-Kin peeling manioc. Compare her profile with the figures of the murals.
9. The Lacandones live in *caribales*—clearings in the jungle—where they build their huts and grow their corn and fruit. Photographer Gerard lived in the hut shown, which was also used for storing corn.
10. The Lacandones live mainly on tortillas made of corn, manioc, and fruit. They also eat monkeys, wild boars, and snails. The mosquito net shown at the left was left behind by the expedition led by Carl Frey before his death.
11-12. This little girl of ten is one of the best tortilla-makers in her tribe. The Lacandones are dying out: there are only two children in this community (*caribal*).
13-16. A boy of about nine is the other child in this group. His name is Kayom, and he loves to swim in the little jungle water hole near the *caribal*.
17-18. The two children inside one of the huts with one of the group of smiling young girls shown in the next photograph.

19. Chan-Kin, chief of the tribe. Lacandón men let their hair grow long, believing it a source of strength.
20. Chan-Kin surveying the collective property of his clan.
21. One of Chan-Kin's wives feeding her pet parrots.
22. This picture taken by the late Carl Frey shows a Lacandón beauty.
23. A matron of dignified mien making a necklace of beads given to the women of the clan by the Bonampak expedition. When photographer Gerard brought them gaudy trinkets, the Lacandones turned them down in disgust, preferring the refined, pastel colored beads given before.
24. A young girl wearing the necklace.
25. The whole clan accompanied photographer Gerard to the improvised airfield to await the plane that brought him back to civilization.

Also included in the exhibition are thirty-six color transparencies on the same subjects mentioned above.

YEAR 1954

February 3 - March 6, 1954

PRINTS AND WATERCOLORS BY OTTA

Francisco Otta, a citizen of Chile, was born in Bohemia in 1908. Since 1926 he has been traveling throughout the world and has exhibited his work in Chile, Argentina, Uruguay, Brazil, France, England, Spain, Czechoslovakia, and Australia. For some years he has been living in Santiago de Chile, where he is active as a teacher and creative artist.

This group of prints and watercolors constitutes his first one-man show in the United States.

CATALOGUE

Prints

1. *Anchor Composition*, 1950, burin engraving, soft ground and direct biting
2. *Still Life with Grapes*, 1950, burin and soft ground etching
3. *Sitting Nude*, 1950, burin and aquatint etching
4. *Spanish Bridge*, 1950, burin and drypoint engraving
5. *Hands*, 1950, etching
6. *Quartier Latin*, 1950, aquatint etching
7. *Old Face*, 1950, burin engraving and direct biting (2 plates)
8. *Biblical Face*, 1953, etching
9. *Archaic Face*, 1952, etching and burin engraving
10. *Veiled Face*, 1952, etching and soft ground
11. *Problematic Face*, 1952, etching
12. *Greenish Face*, 1953, etching and mezzotint (2 plates)
13. *Paper-Kite's Face*, 1953, etching
14. *The Four Elements*, 1953, etchings, printed from relief. Illustrations to a volume of poems published in Santiago (2 plates each)
15. *Fish*, 1953, etching and aquatint (2 plates)
16. *Peacock*, 1953, aquatint etching
17. *Butterfly*, 1953, etching and burin engraving
18. *Bull*, 1953, aquatint etchings (2 plates)
19. *Horse*, 1953, etching and aquatint
20. *Jug and Cup*, 1953, soft ground etching
21. *Saint Francis and the Birds*, 1953, burin engraving and aquatint etching
22. *Adam and Eve*, 1953, etchings (2 plates)

Ink and Watercolors

23. *Bull's Eye*, 1950
24. *Valparaíso*, 1951

25. *Medieval Bridge*, 1950
26. *Sailing through the Canal*, 1951
27. *Piece of Wood*, 1951
28. *Amsterdam, from My Window*, 1950
29. *Pitcher and Fruit*, 1950
30. *Net*, 1950

March 12 - April 12, 1954

PAINTERS OF VENEZUELA:
ABREU, BARRIOS, MANAURE, JAIMES SANCHEZ, VIGAS

During the past ten years, a modern art movement has been developing in Venezuela with a tendency toward the abstract.

After 1945, when a small group of painters traveled to Paris, the idea of a non-representative art has grown extensively among the new generations of painters. Besides being very active in individual and group exhibitions, these young creative painters have founded new magazines, opened small galleries, and extended their knowledge among the Venezuelan people in favor of a new art that is trying to use a universal language.

Each of these painters took part as representatives of Venezuela in the Second Biennial in São Paulo, Brazil, which closed recently. Most of them, together with artists from other countries, are at the present time taking part in the execution of murals for the new buildings of the modern University City in Caracas, the site of the Tenth Inter-American Conference.

This exhibit, including works of some artists of the non-figurative trends of their country, was made possible by the Director of Culture at the Ministry of Education in Caracas, Manuel Felipe Rugeles, who cooperated in its organization and in the transportation of the paintings from Venezuela.

Complementing this exhibit there are special glass cases, containing a collection of books and pamphlets dealing with literature and history, published by the Ministry of Education of Venezuela.

CATALOGUE

Oils

Mario Abreu
1. *El gallo (The Rooster)*, watercolor and ink
2. *Flora*
3. *Paisaje de los Andes (Landscape of the Andes)*

Armando Barrios
4. *Abstracción (Abstraction) No. 1*
5. *Abstracción (Abstraction) No. 2*
6. *Abstracción (Abstraction) No. 3*
7. *Abstracción (Abstraction) No. 4*

Angel Humberto Jaimes Sánchez
8. *Orígenes (Origins)*

9. *Divinidades (Divinities)*
10. *Composición (Composition)*

Mateo Manaure
11. *Composición (Composition)*
12. *Negro, rojo y blanco (Black, Red, and White)*
13. *Composición (Composition)*
14. *Composición (Composition)*
15. *Negro, rojo y verde (Black, Red, and Green)*

Oswaldo Vigas
16. *Bruja (Witch)*
17. *Ritmo (Rhythm)*
18. *Rostro (Face)*
19. *Composición (Composition)*
20. *Composición (Composition)*
21. *Personaje (Personage)*
22. *Personaje (Personage) No. 1*
23. *Personaje (Personage) No. 2*

ABOUT THE ARTISTS

ABREU, Mario. Born in Turmero, Aragua, Venezuela, 1918. Studied at the School of Plastic Arts, Caracas. Participated in several group exhibits in Venezuela. One-man show at the Museum of Fine Arts, Caracas. Awards: Federico Brandt Prize, 1951, and Pérez Mujica Prize, 1952. Resides in Paris.

BARRIOS, Armando. Born in Caracas, 1920. Studied at the School of Plastic Arts, Caracas. Participated in group exhibitions in France and Venezuela. One-man shows in Caracas and Paris. Awarded the José L. Arismendi and John Boulton prizes, 1945 and 1946. Resides in Caracas.

JAIMES SANCHEZ, Angel Humberto. Born in San Cristóbal, Táchira, Venezuela, 1930. Studied at the School of Plastic Arts, Caracas. Participated in group exhibits in Venezuela. Awarded the Second Prize for Painting at the Salon Planchart, 1952. Resides in Caracas.

MANAURE, Mateo. Born in Uracoa, Managas, Venezuela, 1926. Studied at the School of Plastic Arts, Caracas. Participated in group exhibitions in Venezuela, France, Germany, and several countries of Latin America. Awarded the National Prize for Painting in 1947, and the José L. Arismendi Award and John Boulton Prize, 1947 and 1950. Now teaches at the School of Plastic Arts, Caracas.

VIGAS, Oswaldo. Born in Valencia, Carabobo, Venezuela, 1926. Self-taught as an artist. Graduated as a physician from the University of Caracas. Participated in group exhibitions in Venezuela and France. One-man show at the Museum of Fine Arts, Caracas, 1952. This same year he was awarded the National Prize for Painting, the Arturo Michelena Award, and John Boulton Prizes. Resides in Paris.

April 20 - May 16, 1954

AGUSTIN FERNANDEZ: FIFTEEN PAINTINGS

Agustín Fernández Mederos stands out as one of the most promising of the generation of modern artists of Cuba

formed of painters and sculptors under thirty.

Born in Havana in 1928, Fernández Mederos, when he was very young, entered the San Alejandro National School of Fine Arts and studied there until he graduated. Later, he came to the United States and attended the classes of Yasuo Kuniyoshi and George Grosz at the Arts Students League in New York. He returned to Havana and had his first one-man show at the Lyceum Club in October 1951. Five months later he tried to exhibit his works at the San Alejandro School, but was refused permission due to the modern trend he followed. The show was finally held at the cultural society *Nuestro Tiempo*, and the whole incident aroused an enormous controversy in which all the critics of Havana newspapers praised Fernández Mederos and championed him.

In the same year, 1952, the artist exhibited again, this time in the Lyceum of Santiago de Cuba, and then left for Europe to study until the end of 1953. He traveled in France and Spain and presented a one-man show at the Buchholz Gallery in Madrid in April 1953. The Spanish art critic, Sánchez Camargo, was enthusiastic about his work: "We have seen few exhibitions with such a diffusion of elements so purely executed." Another critic from Madrid, Castro Arines, found in Fernández Mederos "a keen knowledge of the functions of a painter; a clean brush, natural and harmonious, serving art's greatest purpose."

This exhibit at the Pan American Union is the first showing of the artist's work in the United States.

CATALOGUE

Oils

1-3. *Tríptico (Triptych)*, 1953, 200 x 150 cm. (central panel), 200 x 75 cm. (lateral panels)
 4. *Retrato (Portrait)*, 1954, 72 x 98 cm.
 5. *Clownesa (Woman Clown)*, 1952, 127 x 75 cm.
 6. *Taller (Workshop)*, 1951, 130 x 79 cm.
 7. *Baco (Bacchus)*, 1953, 150 x 100 cm.
 8. *Juglar (Jester)*, 1953, 143 x 78 cm.
 9. *Perfil (Profile)*, 1952, 78 x 78 cm.
10. *Los tres limones (Three Lemons)*, 1952, 107 x 94 cm.
11. *Porrón (Leeks)*,[1] 1953, 130 x 97 cm.
12. *Granadas (Pomegranates)*, 1953, 150 x 100 cm.
13. *La mesa (Table)*, 1952, 125 x 88 cm.
14. *Las frutas (Fruits)*, 1952, 118 x 95 cm.
15. *El mago (Magician)*, 1953, 90 x 129 cm.

May 18 - June 12, 1954

LANDSCAPE ARCHITECTURE IN BRAZIL: ROBERTO BURLE MARX

Notable as have been the achievements of modern Brazilian art in the fields of sculpture and painting, they have been surpassed by accomplishments in the realm of architecture. The prestige of Brazilian building is worldwide; its influence throughout the Hemisphere can be compared only with that exercised at one time by the Mexican muralists.

[1] Literal translation is "Earthenware Jug." —*Ed*.

The economic progress and industrial development of Brazil in the early 1930s was accompanied by feverish activity in the field of building, with a marked leaning to the modern style. In 1936 the French architect, Le Corbusier, arrived in Rio to act as consultant in the plans for the new Ministry of Education. This structure, executed by a group of outstanding Brazilian architects, among them the celebrated Oscar Niemeyer, stands today as a milestone in the history of construction in the country. A notable feature of the plan is the landscape design, a project of the painter Roberto Burle Marx, whose previous work comprised only gardens for private residences in Rio and public parks in Pernambuco. For the first time in Latin America, modern architecture was combined with gardens of imaginative and contemporary expression, closely integrated with the accompanying structure.

Burle Marx was born in São Paulo in 1909 of German and Brazilian parentage, but went to live in Rio in 1913. In 1928 his father sent him to Germany to study music and art, and in 1930 he enrolled in the Fine Arts School in Rio to study painting. He received the Gold Medal of that institution in 1937.

Although his interest in plants and garden planning dates from his childhood, Burle Marx did not begin to work as a landscape architect until 1933, at the request of the architect Lucio Costa, who had seen the garden of Burle Marx's old house in suburban Leme.

Burle Marx joins to a well-founded knowledge of botany a pictorial sense of composition which takes full advantage of the varying colors of vegetation. His work is characterized by the use of local plants and the ones native to similar climates which adapt themselves to permanent growth, leaving no gaps in the design. He has made several expeditions to the Amazon region in search of rare plants and little-known species, for incorporation into his contemporary gardens.

We shall see in this exhibition, in the photographs of his work and his tempera renditions of landscape designs, how his power and imagination as a painter are paired with an intelligent approach to space, varying levels, and the use of different materials and textures. These are striking examples of the work of an artist who paints with plants.

At the Second Biennial in São Paulo, held in the latter part of 1953, Roberto Burle Marx won First Prize for Landscape Design. The jury for this award comprised such outstanding authorities as Walter Gropius, José Luís Sert, and Alvar Aalto.

The present exhibition is the first comprehensive view of Burle Marx's work to be displayed in the United States. In addition to the main subject of modern gardens, it provides examples of his craftsmanship in tiles and fabrics. At the close of the showing in the Pan American Union, the exhibit will be circulated throughout the United States, under the auspices of the Smithsonian Institution.

CATALOGUE

1. *State Park of Araxá*, Minas Gerais. Architect F. Bolonha
2. *Garden of Petrópolis Town Hall* (now destroyed)
3. *Garden of Juscelino Kubitschek*, Pampulha. Architect Oscar Niemeyer
4. *Garden for Instituto de Puericultura da Universidade do Brasil*, Rio de Janeiro. Architect Jorge Machado Moreira
5. *Garden of Roberto Marinho*, Aguas Férreas
6. *Garden of Hungria Machado*, Leblon Canal. Architect Lúcio Costa
7. *Garden for Prudencia e Capitalização Building*, São Paulo. Architect Rino Levi
8. *Roof Garden of Resseguros Insurance Institute Building*. Architects Marcelo and Milton Roberto
9. *Garden for the Residence of Paulo Sampaio*. Architect Sérgio Wladimir Bernardes
10. *Da Solidão Lake in the Tijuca Forest*
11. *Tile Panel for the Residence of Architect Miguel Ribeiro*, Ipanema, Rio de Janeiro

12. *Botafogo Parkway*, Rio de Janeiro
13. *Garden and Wall Panel of Dr. Olavo Fontoura*, São Paulo
14. *Design of Silk-Screen Textile*, executed by Lilí Correia de Araujo
15. *Tiles*, São Paulo, executed by Ossirarte
16. *Garden of Mrs. Odette Monteiro*, Correias, Petrópolis. Architect Wladimir Alves de Sousa
17. *Marquee of Casino on Pampulha Lake*. Architect Oscar Niemeyer
18. *Garden of Ambassador Walter Moreira Salles*, Gávea District. Architect Olavo Redig de Campos
19. *Garden of Ministry of Education and Health Building*. Architects L. Costa, A.E. Reidy, O.S. Niemeyer, Jorge M. Moreira, Carlos Leão, E. Vasconcellos
20. *Garden of Tito Livio Carnasciali*, Rio de Janeiro
21. *Residence of Architect Paulo Antunes Ribeiro*
22. *Terrace Garden of Jean-Marie Daniel Diestl*
23. *Panel for a Group of Houses*, Pedregulho. Architect Affonso Eduardo Reidy
24. *Tile Panel on Edge of Rodrigo de Freitas Lagoon*, Rio de Janeiro
25. *Tile Wall for the Vasco da Gama Nautical Club*. Architect A. Campello
26. *Garden for Rio de Janeiro Santos Dumont Air Terminal*. Architect Marcelo and Milton Roberto
27. *Project for Ibirapuera Park*, São Paulo (not executed). Architects Oscar Niemeyer, Helio Uchoa Cavalcanti, Eduardo Kneese de Mello, Zenon Lotufo

June 16 - July 12, 1954

IMPRESSIONS OF THE U.S.A. BY A HAITIAN PAINTER: ANTONIO JOSEPH

Since the foundation of the Centre d'Art in Port-au-Prince, Antonio Joseph has stood out, among the younger painters with a progressive attitude, as one of the most promising figures of his generation.

Joseph was born of Haitian parents in 1921, in Barahona, Dominican Republic, and lived there until 1938. This period he devoted to the study of music. Later, in 1944, with the establishment of the Centre d'Art, his artistic inclination was turned toward painting and he studied there under the American artist DeWitt Peters, director of the institution. For several years Joseph's only medium was watercolor. His interest in oil has been recent. He has also studied sculpture under the American Jason Seley.

In 1952, after Joseph had held two-one man shows in Port-au-Prince and had presented his work in different group exhibits, the Guggenheim Foundation granted him a fellowship to study and paint in this country. The present exhibit reflects his sojourn in the United States, in the form of impressions of the city of New York, where he has been feverishly engaged in his work. Joseph held one-man shows at Skidmore and Williams Colleges during the first months of this year. This presentation at the Pan American Union is the first showing of his works in the Washington area.

CATALOGUE

1. *The Cloisters*, 1953
2. *From My Window*, 1953
3. *Souvenir of Washington, D.C.*, 1954
4. *First Snow*, 1954
5. *The Church*, 1954
6. *New York*, 1954
7. *First Impression*, 1953
8. *La Japonaise (The Japanese Woman)*, 1954

9. *Broadway*, 1954
10. *Flowers*, 1954
11. *Head of a Model*, 1954
12. *Charlemagne (Charles the Great)*, 1953-1954
13. *Etude (Study) No. 1*, 1953
14. *The Tunnel*, 1954
15. *To Brooklyn*, 1953-1954
16. *Etude (Study)*, 1954
17. *Souvenir d'Haïti*, 1953-1954
18. *Elevator*, 1953
19. *Snow Seen from Within*, 1954. Coll. Mr. and Mrs. Philippe Thoby-Marcelin
20. *Street Scene*, 1953
21. *Uptown*, 1954
22. *Interior*

July 14 - August 16, 1954

JOSE LUIS CUEVAS: DRAWINGS

During the last few years, a group of artists has grown up in Mexico taking as an approach to their work the conscious analysis and interpretation of reality, with an avoidance of political themes.

José Luis Cuevas has established a reputation as a leading figure of the new trend, despite his youth and the fact that he is known only from a pair of one-man shows in Mérida and Mexico City and participation in a scant number of group exhibitions. Aside from the attention accorded him by critics, his success stems from the interest of private collectors in Mexico—among others the well-known Dr. Alvar Carrillo Gil—who from the first have acquired a large part of his output.

Cuevas was born in 1933 in Mexico City. He is entirely self-taught, having started to draw at the age of twelve. Three years later, he began to work with oil, a medium which he now seldom uses. Instead, he works mainly in ink, either with brush or with pen, and occasionally in watercolor. The feeling of his production, therefore, is entirely structural, such as can be rendered in black and white. Mexican expressionism has provided him with a mode for manifesting a romantic-adolescent attitude toward life—in its saddest and most sordid aspects—together with that morbid interest in death which has been one of the most characteristic elements in Mexican art since pre-Columbian times. Cuevas depicts mankind at its lowest social levels, or as seen in its irrational aspects. He has produced a highly emotional series of drawings, of convulsionary and hallucinating effect, suggestive of the eerie late manner of Goya and of the brutal, sarcastic early productions of Orozco. The main interest of Cuevas's drawings and watercolors resides in the fact that they are direct interpretations of real human beings. Not sketches or preliminary studies, they are finished and definitive analytical portraits, made in the immediate presence of the sitter. In the particular case of the insane, Cuevas sought and obtained permission to work inside an asylum in Mexico City, a very sizable output resulting thereby.

In connection with his first one-man show held at the Prisse Gallery in Mexico City in 1953, the critic Margarita Nelken wrote: "His figures form a vibrant slice of life." The Cuban painter Felipe Orlando declared: "José Luis Cuevas's vision is not confined to the superficially picturesque, but penetrates to the very marrow."

Although works by Cuevas have figured in various group exhibitions in the United States, the present exhibit at the Pan American Union is his first one-man show in this country.

CATALOGUE

1. *El parto (Childbirth)*
2. *Partera (Midwife)*
3. *El bebé (Baby)*
4. *Tres niños (Three Children)*
5. *Niñita (Little Girl)*
6. *Niña paralítica (Paralytic Girl)*
7. *Adolescente (Adolescent)*
8. *Mujeres (Women)*
9. *Ramera (Woman of the Street)*[1]
10. *Mujeres del siglo XX (Women of the Twentieth Century)*
11. *Prostituta (Woman)*[1]
12-24. *Retratos del natural en el manicomio (Real Life Studies from the Insane Asylum)*
25. *Adivinadora (Fortune Teller)*
26. *Carnicero (Butcher)*
27. *Monja (Nun)*
28. *Moribundo (Near Death)*
29. *Cadaver I*
30. *Cadaver II*
31. *Cadaver III*

Watercolor Drawings

32. *Adolescente (Adolescent)*
33. *Ramera (Woman)*[1]
34. *Interior*
35. *Niñas (Girls)*
36. *Mujer del siglo XX (Woman of the Twentieth Century)*
37. *Las iniciadas (The Initiates)*
38. *Mujer contrahecha (Deformed Woman)*
39. *En la carpa (Under the Tent)*

August 17 - September 16, 1954

IVAN SERPA: COLLAGE AND PAINTING

Ivan Serpa was born in Rio de Janeiro in 1923. He studied there under Axel Leskoscheck and received awards at several local and national salons. His first one-man show took place in 1951, at the Brazilian-American Institute in Rio, and works by him were included in the two international biennials of São Paulo, winning various prizes. Among other group shows in which he has participated are the Brazilian exhibits in Lausanne, Switzerland, the Venice Biennial of 1952, and this year's Pan American exhibit in Caracas.

Serpa reflects the non-objective, constructivist trend that, principally under the influence of the Swiss concrete movement, has developed recently in the work of several modern artists of Brazil. In addition to his work in oil, Serpa has been experimenting with a new method of collage. Paper of different colors is cut, mainly in geometric

[1] Literal translation of nos. 9 and 33 is "Whore;" of no. 11 is "Prostitute." —*Ed.*

shapes, and the pieces overlapped. They are then laminated by a process involving the use of cellulose, compressed at a carefully determined temperature. Interesting textures and shades are produced, resulting from the contrast between the transparency and opaqueness of the silk paper employed. This new technique of collage makes Serpa's work more resistant to changes in weather, maintaining the stability of the composition.

The notable critic Mário Pedrosa, in discussing this new method, commented:

> By his discovery, this young Brazilian artist has given us a broad, yet precise, perception of color as a purely physical element—of color as light. At the same time, he has enriched our aesthetic acquaintance with a new experience, typical of our age: that of colors in themselves, freed of their immemorial association with objects, finding support only in abstract arrangements of geometrical planes, regular or irregular, transparent or opaque, void of any objective significance. This vision of the interplay of colors in purely imaginary space opens up to the spectator a new dimension of reality. This is the secret of all true art.

The present exhibit consists for the most part of examples of this medium discovered by the artist. It is being presented as the first step in an interchange between the Museum of Modern Art of Rio de Janeiro, where the artist teaches, and the Pan American Union. It represents the first exhibit of any of Serpa's work in the United States, and has been made possible through the generous cooperation of the Moore-McCormack Lines, which provided the transportation.

CATALOGUE

Paintings

1. *Collage a Compressão (Compressed Collage) No. 9*, 37 x 29 cm.
2. *Collage a Compressão (Compressed Collage) No. 13*, 38 x 27 cm.
3. *Collage a Compressão (Compressed Collage) No. 14*, 41 x 35 cm.
4. *Collage a Compressão (Compressed Collage) No. 16*, 44 x 33 cm.
5. *Collage a Compressão (Compressed Collage) No. 17*, 46 x 34 cm.
6. *Collage a Compressão (Compressed Collage) No. 18*, 46 x 36 cm.
7. *Collage a Compressão (Compressed Collage) No. 26*, 47 x 36 cm.
8. *Collage a Compressão (Compressed Collage) No. 36*, 46 x 33 cm.
9. *Collage a Compressão (Compressed Collage) No. 37*, 47 x 34 cm.
10. *Collage a Compressão (Compressed Collage) No. 39*, 30 x 22 cm.
11. *Collage a Compressão (Compressed Collage) No. 40*, 47 x 34 cm.
12. *Collage a Compressão (Compressed Collage) No. 41*, 47 x 34 cm.
13. *Collage a Compressão (Compressed Collage) No. 42*, 46 x 33 cm.
14. *Collage a Compressão (Compressed Collage) No. 43*, 46 x 33 cm.
15. *Collage a Compressão (Compressed Collage) No. 46*, 47 x 34 cm.
16. *Collage a Compressão (Compressed Collage) No. 49*, 47 x 34 cm.
17. *Collage a Compressão (Compressed Collage) No. 51*, 46 x 33 cm.
18. *Desenho (Drawing)*, gouache, 36 x 36 cm.
19. *Composition No. 96*, oil, 36 x 36 cm.
20. *Composition No. 97*, oil, 70 x 70 cm.

September 17 - October 6, 1954

MUNDY OF CHILE: OILS AND DRAWINGS

A descendant of Britons, Clarence Mundy was born in Valparaíso, Chile, in 1920. He studied at the School of Fine Arts of the University of Chile, in Santiago, under the painters Jorge Caballero, Pedro Reszka, and Gregorio de la Fuente; and after graduation he was appointed assistant professor of the preparatory courses offered by that institution. His work was exhibited at the National Salon in Santiago in 1946 and 1947, winning prizes. Mundy also held one-man shows at the Ministry of Education in Santiago from 1944 to 1947, at the Galería Pacífico in Buenos Aires in 1948, and at the Chilean-American Institute in Santiago in 1949 and 1951.

The critic Ana Helfant said of Mundy in the newspaper *La Nación*:

> He shows that he is a good observer. He captures the moment with a great sense of humor. Each and every drawing is marked by a touch of irony.

And the painter Sergio Montecino wrote the following:

> I feel that, in his preoccupation with commenting upon man in his daily habits and those relations which constitute life in society, Mundy displays a sufficient degree of spiritual insight to be truly interesting, and this keeps him from falling into artful caricature or trivial observation.

Mundy has been a cartoonist for the magazine *Política y Espíritu*, and alternates in his production between illustration, humorous drawing, and painting in the traditional manner. Examples of all these types are presented in this exhibit, which is the first one-man show of Mundy's work to be held in the United States.

CATALOGUE

Oils

1. *Milka*, 1952
2. *Zorka*, 1952
3. *Sergio*, 1954
4. *Cayetano*, 1945
5. *Crítico (Critic)*, 1951
6. *Flores (Flowers)*, 1952
7. *Naturaleza muerta (Still Life)*, 1952
8. *Autorretrato (Self-Portrait)*, 1949
9. *Mañana en el parque (Morning in the Park)*, 1952
10. *Muchacho (Youngster)*, 1952
11. *Gala (Gala Occasion)*, 1954
12. *Retrato (Portrait)*, 1952
13. *Estudiante (Student)*, 1949
14. *Percherones (Percherons)*, 1952
15. *Premios de lotería (Lottery Prizes)*, 1954
16. *Profetas callejeros (Roaming Prophets)*, 1954
17. *Extenuación (Exhausted)*, 1949
18. *Quietud (Repose)*, 1949
19. *Margarita*, 1954
20. *Jaime*, 1954
21. *Virginia*, 1954

Drawings

22. *Carmen*, 1952
23. *Bob*, 1952
24. *Eileen*, 1950
25. *Waco*, 1950
26. *Gremialista (Union Man Speaker)*, 1949
27. *Comité Investigador (House Committee)*, 1954
28. *Chismería (Gossiping)*, 1949
29. *Vieja chocha (Grandmother's Favorites)*,[1] 1949
30. *Mujer de circo (Circus Woman)*, 1949
31. *Verano en Nueva York (Summer in New York)*, 1953
32. *Muralista (Muralist)*, 1949
33. *Diputado (Congressman)*, 1950
34. *Pintor abatido (Discouraged Artist)*, 1949
35. *Jackie*, 1952

October 7 - 30, 1954

BIRDS OF ARGENTINA BY SALVADOR MAGNO

For many years the Argentine-born artist Salvador Magno has specialized in paintings of great usefulness to science, ornithology being his main interest. He has worked for the National Museum of Natural History of Buenos Aires and has illustrated several books related to birds of Argentina. He is a member of the Ornithological Society of Buenos Aires.

This exhibit, which opened early this year at the American Natural History Museum in New York, aroused great interest among specialists and, according to Dr. Robert Cushman Murphy, Chairman of the Department of Birds of that institution:

> These paintings are of high order—simple, faithful, and strikingly decorative. They would do credit to the foremost contemporary portrayers of birds in the United States. Some of them suggest the style and smartness of Audubon.

Thanks to the Traveling Exhibition Service of the Smithsonian Institution, this collection of unique watercolors is here presented for the first time in the Washington area. Also, with the cooperation of Dr. Herbert Friedmann of the same institution, we are enlarging the scope of this exhibit with some original mounted examples of the birds depicted, selected from the ample ornithological collection of the Smithsonian Museum. Through the courtesy of Dr. William Mann, Director of the National Zoological Park, the crested screamer bird is being displayed for comparison with Magno's watercolor.

CATALOGUE

Watercolors

1. *Pelzeln's Yellow Finch* (Sicalis flaveola pelzelni)

[1] Literal translation is "Senile Woman." —*Ed.*

2. *Spectacled Tyrant* (Hymenops perspicillata)
3. *Crested Screamer* (Cariama cristata)
4. *Jacana* (Jacana spinosa)
5. *Common Miner* (Geositta cunicularia)
6. *Yellow Cardinal* (Gubernatrix cristata)
7. *Yellow-Billed Teal* (Nettion Blavirostre)
8. *Green Paroquet* (Myiopsitta monacha)
9. *Condor* (Vultur gryphus)
10. *Toco Toucan* (Ramphastos toco)
11. *Crested Grebe* (Colymbus occipitalis)
12. *South American Stilt* (Himantopus himantopus melanurus)
13. *Brown-Rumped Marsh Bird* (Pseudoleistes virescens)
14. *Great Horned Owl* (Bubo virginianus)
15. *Many-Colored Tyrant* (Tachuris rubrigastra)
16. *Brazilian Cormorant* (Phalacrocorax brasilianus)
17. *Fire-Crowned Tyrant* (Machetornis rixosa)
18. *American Egret* (Casmerodius albus egretta)
19. *White-Faced Glossy Ibis* (Plegadis chihi)
20. *Nacunda Nighthawk* (Podager macunda nacunda)
21. *Rufous-Backed Ground-Tyrant* (Lessonia rufa)
22. *Southern Caracará* (Polyborus plancus)
23. *Chilean Flamingo* (Phoenicopterus ruber chilensis)
24. *Chiloé Widgeon* (Anas sibilatrix)
25. *Green Kingfisher* (Chloroceryle americana)
26. *Asarás Black Cacique* (Archiplanus solitarius)

November 9 - December 6, 1954

VELASQUEZ OF HONDURAS

Since there is no specific term for the self-taught artist who neither follows academic tradition nor participates in new developments in art, the most commonly used adjective has been that of "primitive." This term links the artist with the remote tradition of spontaneous, direct, instinctive painting, which has been cultivated from the earliest phases of art history to the present day by men and women the world over who consider art as a side-line in earning a living, but have a deep and passionate feeling for it. In the current exhibition we present one of these primitive painters, the Honduran J. Antonio Velásquez. However, rather than a one-man show of different examples of a certain skill for painting, this exhibition can be considered as the multiple portrait of a small village called San Antonio de Oriente, which years ago was a silver-mine center, located in the pine hills of Honduras. Velásquez has lived in this town, with his wife and six children, for more than twenty years and in painting has taken a most honest and direct approach, analyzing all the elements in the landscape—almost counting the cobblestones in the road.

Velásquez was born in the village of Caridad in 1906. He has practiced a number of trades: was a telegraph operator for years and now is the barber of the Pan American Agricultural School near Tegucigalpa. Paintings that he took with him there attracted the attention of different visitors who purchased them and started to spread the fame of Velásquez in the United States and other countries.

The painter began to practice his art at an early age, producing drawings and compositions on paper. It was not until 1933 that he started to work in oil, later in commercial enamel, constantly depicting the different aspects of his

beloved town of San Antonio de Oriente. His art appears there in processional banners and altar decorations and in simple commercial lettering. His expression, rather than being childish or imaginatively amorphous, takes the form of a minute detailing of reality. He uses the smallest of brush strokes to obtain nuances, shades, and a bizarre richness of green.

In spite of the fact that his paintings are represented in several collections in this country, thanks to the efforts of Dr. Wilson Popenoe, Director of the Agricultural School, who for years encouraged the artist and helped him to sell his work to many North American collectors, this is Velásquez's first one-man show in the United States. He has presented his work in Tegucigalpa, the Honduran capital, and in 1949 one of his paintings represented his country in the Inter-American show which was circulated in this hemisphere by the Pan American Union. The artist exhibited in the first Hispanic-American Biennial in Madrid in 1951, and he obtained a prize in the Hallmark contest for Christmas cards. The artist had never traveled out of his country before the present occasion; his trip has been made possible by the generous help of the President of Honduras, Dr. Juan Manuel Gálvez.

CATALOGUE

Paintings

1. *Autorretrato (Self-Portrait)*
2. *Catedral de Tegucigalpa y la estatua de Francisco Morazán (Central Park of Tegucigalpa)*
3. *Catedral de Tegucigalpa y la estatua de Francisco Morazán (South side of the Cathedral of Honduras)*
4. *Catedral de Gracias (Cathedral of Gracias)*
5. *Catedral de Comayagua, antigua capital de Honduras (Cathedral of Comayagua)*
6. *Santuario Nacional de Suyapa (Sanctuary of the Virgin of Suyapa)*
7. *Una carretera de Honduras (Stretch of Highway in Honduras)*
8. *Escuela Agrícola Panamericana (The Pan American Agricultural School)*
9. *Vista de San Antonio de Oriente (View of San Antonio de Oriente)*
10-25. *San Antonio de Oriente (Details of San Antonio de Oriente)*

December 8 - 27, 1954

ARTURO REQUE MERUVIA OF BOLIVIA

Arturo Reque Meruvia was born in Cochabamba, Bolivia, in 1906. After going through primary and secondary schools in that city, he started his artistic career as a professor of drawing in 1924. Two years later he went to Buenos Aires where he studied in the National School of Fine Arts until 1929. He then went to Spain where he has lived to the present time, making only a few brief trips to Bolivia. He has executed murals and has held one-man shows in both Spain and Bolivia. Although Reque Meruvia follows the Indianist trend of contemporary art prevalent in the highlands of South America, he has also succeeded in the historical genre and has devoted a good deal of time to the graphic arts.

In this exhibition, which is the first one-man show of the artist in the United States, Reque Meruvia is presenting only scenes, types, and landscapes of his native Bolivia. The Spanish critic J. Camon Aznar of *ABC* of Madrid, said in 1953: "In Reque Meruvia's work we perceive the grandeur of Bolivia where the thickness of the jungle permits an unusual interplay of light and a richness of green." The Bolivian critic Rigoberto Villarroel Claure said in his book *Arte Contemporáneo*: "Reque Meruvia's work is decisive and solid."

CATALOGUE

1. *In the Bolivian Tin Mines*, 250 x 202 cm.
2. *Miner*, 100 x 70 cm.
3. *Catholic Indian*, 100 x 70 cm.
4. *Cholas of the Valley*, 70 x 60 cm.
5. *Indian, Llama, and Mountain*, 70 x 60 cm.
6. *The Sling*, 70 x 60 cm.
7. *Love with Music*, 70 x 60 cm.
8. *Drums and Flutes*, 70 x 60 cm.
9. *Chola[1] Selling Flowers*, 70 x 60 cm.
10. *Praying to God*, 70 x 60 cm.
11. *The Devil Dance*, 70 x 60 cm.
12. *Masks*, 70 x 60 cm.
13. *Sicus of the High Plains*, 70 x 60 cm.
14. *Little Indians of Choqueyapu*, 70 x 60 cm.
15. *Lake Titicaca*, 70 x 60 cm.
16. *Friends*, 70 x 60 cm.
17. *Puña*, 70 x 60 cm.
18. *Quechua Indian of Potosí*, 70 x 60 cm.
19. *Indian Festival*, 55 x 45 cm.
20. *Flute*, 55 x 45 cm.
21. *The Siringa*, 55 x 45 cm.
22. *Jungle*, 55 x 45 cm.
23. *Palm Tree*, 55 x 45 cm.
24. *Botacú*, 55 x 45 cm.
25. *Jungle of Pando Region*, 55 x 45 cm.
26. *Jungle of the Beni Region*, 55 x 45 cm.
27. *Nature*, 200 x 150 cm.

[1] A *chola* is a woman of Indian and white ancestry. —*Ed.*

YEAR 1955

January 18 - February 14, 1955

ALEJANDRO OBREGON OF COLOMBIA

The personality of Alejandro Obregón stands out as a renovator in the panorama of contemporary art of Colombia. Although generally accepted in the highest intellectual circles, the painter was regarded until very recently as a controversial figure, not only because of the nature of his work but also because of his activities as director of the School of Fine Arts in Bogotá. Through a strict discipline based entirely on the tradition of the great masters, he has achieved a progressive direction in his art which has been a new point of departure for some younger artists in Colombia.

Obregón was born in 1920 in Barcelona, Spain, of a Colombian father and a Spanish mother and has always been a Colombian citizen. He studied in Spain and later in the United States where he attended the school of the Museum of Fine Arts in Boston from 1937 to 1941 and studied under Karl Zerbe. He returned to Spain and then to Colombia where he held various posts until 1949, at which time he went to France and settled down for an extended period in the Romanesque town of Alba.

Besides directing the School of Fine Arts for several years, Obregón executed murals in various Colombian cities and held several one-man shows in that country, in Spain, and last summer in the Galerie Creuze in Paris. The critic Pierre Descargues commented on this occasion: "How gifted Obregón is and how his paintings gladden through their interplay of color, their transparency, and their richness!" The critic Alain Borne stated: "Lasting is the fascination of this unique and rare work of a man resolved to show us what he is like, but not resigned to appear on only one path and in only one color." The critic of the magazine *Arts* wrote: "Obregón is a disciplined baroque painter who seeks an exact expression of his personality."

Obregón decided before he returned to Colombia to visit the United States once more, and we therefore have this opportunity to present his first one-man show in this country.

CATALOGUE

Paintings

1. *Primavera (Spring)*, 1954
2. *Still Life*, 1954
3. *Three Cups, Grey*, 1953
4. *Birds in Cage*, 1954
5. *Three Cups, Yellow*, 1953
6. *Three Cups, Blue*, 1953
7. *Easter Sunday*, 1954
8. *Souvenir of Venice*, 1954
9. *Still Life with Cat*, 1954
10. *Flower with Pigeon*, 1954
11. *Primavera (Spring) II*, 1954

12. *The Mistral*, 1953
13. *Pigeons in Venice*, 1954
14. *Composition, Dog, and Bicycle*, 1953
15. *Descent from the Cross*, 1952
16. *Phantoms of Mont-Saint-Michel*, 1954
17. *Red Still Life*, 1954
18. *Unicorn*, 1953
19. *Small Interior*, 1953
20. *Shangurru*, 1953
21. *The Rain*, 1953
22. *Two Houses*, 1952
23. *Miniature*, 1954
24. *The Bull*, 1952
25. *Arm of Christ*, 1954
26. *Two Cups*, 1954
27. *Poisson d'Avril (April Fish)*, 1954
28. *Still Life in Whites*, 1954
29. *The Fish*, 1954
30. *Masks*, 1953
31. *Meteors and Volcanoes*, 1954
32. *Cat and Bird's Nest*, 1954
33. *Sacramental Apple*, 1953
34. *Birds' Cemetery*, 1953
35. *Tropical Flower*, 1954

January 28, 1955[1]

SPECIAL EXHIBITION OF PAINTINGS BY LOIS MAILOU PIERRE-NOEL IN HONOR OF THE PRESIDENT OF HAITI AND MADAME MAGLOIRE

On the occasion of the visit of the President of Haiti and Madame Magloire to the United States, the Ambassador Representative of Haiti on the Council of the Organization of American States and Madame Love Léger have organized a special exhibition of paintings by Lois Mailou Pierre-Noël to be presented at the Pan American Union during the stay of the President in Washington.

Lois Mailou Pierre-Noël was born in Boston. She studied there and later at the Académie Julian in Paris. Former head of the Art Department at the Palmer Memorial Institute in Sedalia, North Carolina, she is at present a professor in the Department of Art of Howard University, Washington, D.C. The artist has won several awards and has exhibited in France and in the United States. Her work is included in public and private collections in the United States and Haiti.

As part of the ceremonies honoring the distinguished visitors from Haiti, the President and Madame Magloire will officially accept the portraits that Mrs. Pierre-Noël painted of them during her last trip to Haiti.

[1] No information on the closing date of this show is available. —*Ed*.

CATALOGUE

Oils

1. *Son Excellence Général Paul E. Magloire, Président d'Haïti (His Excellency General Paul E. Magloire, President of Haiti)*
2. *Madame Paul E. Magloire*
3. *Jeune mère Haïtienne (Young Haitian Mother)*
4. *La Saline*
5. *Jeune marchande (Young Vendor)*
6. *Fleurs de La Découverte (Flowers of La Découverte)*
7. *Marché de Kenscoff (Market at Kenscoff)*
8. *Maison d'été du Président Magloire (Summer House of President Magloire)*, La Boule
9. *Marché Vallières (Market Vallières)*
10. *Barques de pêcheurs (Fishing Boats)*, Port-au-Prince
11. *Bamboche sous la tonnelle, (Party under the Gazebo)*, Forêt des Pins
12. *St. Pierre de Pétionville*
13. *Jenty*, Grand Goave
14. *Milot*
15. *La Citadelle du Roi Christophe (La Citadelle of King Christophe)*
16. *Carriès*
17. *Jour de marché (Market Day)*, Kenscoff
18. *Place du Carfour-Raymond (Square of Carfour-Raymond)*
19. *Cité Magloire*
20. *Dance folklorique (Folkloric Dance)*
21. *Paysan (Peasant)*

Watercolors

22. *Quartier au Fort National (Neighborhood at the National Fort)*
23. *Vendeuses de Pétionville (Vendors of Pétionville)*
24. *Jeune vendeuse (Young Vendor)*
25. *Vieux quartier (Old Quarter)*, Port-au-Prince
26. *Coin de marché à Kenscoff (Market Scene at Kenscoff)*
27. *Caille paille (Hut)*, Carriès
28. *Grosse roche*, St. Marc
29. *Martissant*
30. *Miragoane*
31. *Benisois, Lucien-Louis et Fortuna*

February 16 - March 15, 1955

MATTA OF CHILE: OILS AND DRAWINGS

Roberto Matta Echaurren is a Latin American artist of international reputation. He has been associated with the surrealist movement almost from the beginning of his career, and his work has been singled out for praise in exhibitions devoted both to surrealism in particular and to modern art in general. His name and examples of his work appear in many books and articles in which discussion is made of the important trends in contemporary art during the last three decades.

In the opinion of James Thrall Soby, one of the most serious art critics and scholars in the United States today, Matta is "the latest, perhaps for a time the last, important painter of the surrealist movement. . . . His energy and pictorial imagination seems boundless, and for so young a man he has already produced a remarkable body of work. . . . We may well ask what other artist of his generation has come so far and so boldly on the road which the surrealists rediscovered twenty-odd years ago."

Matta was born in Santiago, Chile, in 1912 and graduated as an architect from the National University in 1931. He then worked in France as an assistant to the famous architect Le Corbusier from 1934 to 1935, and joined the surrealists in Paris in 1937, immediately achieving a prominent position among them. During these years he traveled extensively throughout Europe. He first came to the United States in 1939, and soon received favorable reviews and sold works to important museums and private collectors. In the period between his first one-man show at the Julien Levy Gallery in New York in 1940 and his most recent, held last month at Sidney Janis Gallery in the same city, he presented works regularly every year at important galleries in Manhattan and other cities in the United States. For the last four years Matta has been living alternately in Rome and in Paris, where he has also held one-man shows. He visited his native country during the middle of 1954 and exhibited at the National Museum of Fine Arts in Santiago.

In this exhibit, which is Matta's first one-man show in the Washington area, we are presenting a limited group of huge canvases corresponding to the artist's latest period. All the works, with the exception of the two drawings produced twelve years ago, were executed in 1953 and 1954 and are presented here through the courtesy of Matta's sole agent in the United States, Sidney Janis Gallery, 15 East 57th Street, New York City.

CATALOGUE

Oils

1. *And of the World*, 1953, 47 x 68"
2. *The Dawn Donor*, 1954, 81 x 121"
3. *The Thanks-Giver*, 1954, 82 x 120"
4. *Link of Contradiction*, 1954, 31 x 40"
5. *The Kissproof World*, 1954, 44 x 57"
6. *Sand Witch*, 1954, 81 x 82"
7. *Morningness*, 1953, 47 1/2 x 68 3/4"
8. *I Am the Door*, 1954, 45 x 56"
9. *Arms Opened Like Open Eyes*, 1953, 82 x 120"
10. *Let's Phosphoresce No. 1*, 36 x 47"

Drawings

11. *Polygamy of Space*, 1942, 22 1/2 x 28 1/2"
12. *Study*, 1942, 22 1/2 x 28 1/2"

March 16 - April 11, 1955

MANUEL RENDON OF ECUADOR

The figure of Manuel Rendón stands in almost complete isolation in the panorama of contemporary art in Ecuador. During the last fourteen years an Indianist trend in painting, sculpture, and the graphic arts has developed in that country, stemming from the Indianism originated by contemporary artists of Mexico and Peru. Unlike these, Rendón

has tried to interpret national subject matters in a more intellectual and international manner, and recently this has led him to a non-objective mode of expression, which nonetheless reflects the brilliant light and tropical flavor of his native country.

Manuel Rendón was born in Paris in 1894, the son of the then Ecuadorian Minister to France. He was educated in that country and attended the free classes in drawing at the Grande Chaumière. Aside from this training, the artist considers himself self-taught. Beginning in 1916, he presented works in Paris salons and in 1920 he visited Ecuador for the first time. He continued to reside in France—though he made two more visits to his fatherland—and eventually succeeded in holding one-man shows at the Zborowsky and Léonce Rosenberg Galleries. He exhibited at the latter until 1937, when he returned to Ecuador to spend ten years painting in the isolated mountain city of Cuenca. During this period he participated in group shows in Guayaquil and Quito and won a number of awards. In 1947 he returned to Paris, where he held one-man shows in 1949 and 1951 at the Art du Faubourg and Ariel Galleries, respectively. Rendón then again returned to Ecuador and now maintains residence in Guayaquil and the Galápagos Islands. Last year he held one-man shows in Guayaquil and Quito, under the auspices of the Casa de la Cultura Ecuatoriana (House of Ecuadorian Culture).

Examples of Rendón's works are to be found in the Museum of Modern Art in Paris, the Grenoble Museum, and the San Francisco Museum of Art.

In a monograph devoted to him published in Paris by the Editions Grizard, the critic Robert Vrinat commented:

> The originality of Rendón's palette and color construction are as important as his sense of design and composition. Both are of the same nature, emerge from the same spirit, and lead to the same end.

The artist, now on his way to France, has stopped in Washington to present his first one-man show in the United States at the Pan American Union. Upon this occasion he is exhibiting only works produced in Ecuador during the last two years.

CATALOGUE

Paintings

1. *El neófito (The Neophyte)*, 61 x 46 cm.
2. *Sombras y luces (Lights and Shadows)*, 61 x 46 cm.
3. *Florecimiento (The Flowering)*, 61 x 46 cm.
4. *Serenidad (Serenity)*, 61 x 46 cm.
5. *La escala (The Ladder)*, 46 x 38 cm.
6. *Los pájaros (Birds)*, 73 x 60 cm.
7. *Inocencia (Innocence)*, 73 x 54 cm.
8. *El alba (Dawn)*, 73 x 54 cm.
9. *Las algas (Algae)*, 73 x 54 cm.
10. *Dispersión (Dispersion)*, 73 x 54 cm.
11. *Desvanecimiento (Fainting)*, 65 x 54 cm.
12. *Ruptura (Fracture)*, 100 x 73 cm.
13. *El brote (The Bud)*, 100 x 73 cm.
14. *La caída (The Fall)*, 100 x 73 cm.
15. *El principio (The Beginning)*, 92 x 73 cm.
16. *Fiat Lux*, 92 x 73 cm.
17. *El enjambre (The Swarm)*, 92 x 73 cm.
18. *El puerto (The Port)*, 92 x 73 cm.

177
19. *Atraimientos (Attractions)*, 92 x 73 cm.
20. *El desarrollo (The Unfolding)*, 81 x 65 cm.
21. *Conjunción (Union)* 81 x 61 cm.
22. *Apariencias (Appearances)*, 81 x 65 cm.
23. *Elevación (Elevation)*, 130 x 97 cm.
24. *Contrapunto (Harmony)*, 117 x 89 cm.
25. *Desenvolvimiento (Development)*, 117 x 85 cm.
26. *El huevo de oro (The Golden Egg)*[1]
27. *Sacrifice*[1]
28. *Attributes*[1]
29. *The Arrows*[1]

April 12 - May 3, 1955

ART OF THE AMERICAS IN CELEBRATION OF PAN AMERICAN WEEK

In honor of Pan American Week, presentation is being made, for the first time in the Pan American Union, of a group of paintings from the collection of the Fine Arts Department of the International Business Machines Corporation. They represent a number of the American nations and are shown through the courtesy of Mr. Thomas J. Watson. Mr. Watson started the collection about fifteen years ago, with works from each of the seventy-nine countries in which IBM field offices are maintained.

The collection has since been enlarged to the point that it now numbers several thousand pieces, including not only painting and sculpture, but also the popular, graphic, and applied arts. Many of the items are from Latin American countries, and the present group has been selected from among the best of these with a view to illustrating the various trends in different periods of the artistic development in our hemisphere.

CATALOGUE

Painting and Sculpture

Antonio Berni (Argentina)
1. *Woman of the Red Sweater*, oil

Emilio Pettoruti (Argentina)
2. *Ultima serenata (Last Serenade)*, 1937, oil

José Fioravanti (Argentina)
3. *Simón Bolívar*, bronze

Marina Núñez del Prado (Bolivia)
4. *Danza de cholas (Dance of Cholas)*,[2] wood

[1] Also exhibited but not included in the original catalogue. —*Ed.*

[2] A *chola* is a woman of Indian and white ancestry. —*Ed.*

Emiliano Di Cavalcanti (Brazil)
 5. *Carnaval (Carnival)*, oil

Roberto Burle Marx (Brazil)
 6. *Suburban Symphony*, oil

Gregorio Vásquez de Arce (Colombia, 18th century)
 7. *Santiago at Battle of Clavijo*, oil

Samuel Román Rojas (Chile)
 8. *Chilean Girl*, bronze

Francisco Zúñiga (Costa Rica)
 9. *Head of Indian*, stone

Nicolás de la Escalera (Cuba, 18th century)
 10. *Virgen del Rosario (Virgin of the Rosary)*, oil

Amelia Peláez (Cuba)
 11. *Marpacífico (Hibiscus)*, 1943, oil on canvas, 45 1/2 x 35"

Bernardo Rodríguez (Ecuador, 18th century)
 12. *La Sagrada Familia (The Sacred Family)*, oil

Eduardo Kingman (Ecuador)
 13. *Air Raid*, oil

Rufino Tamayo (Mexico)
 14. *El flautista (The Flute Player)*, 1944, oil on canvas, 114.4 x 94.5 cm.

David Alfaro Siqueiros (Mexico)
 15. *Sunrise of Mexico*, oil

Jaime Bestard (Paraguay)
 16. *La procesión (The Procession)*, oil

Artist Unknown (Cuzco school, Peru, 18th century)
 17. *Virgin Surrounded by Angels*, oil

Pedro Figari (Uruguay)
 18. *Colonial Dance*, oil

Héctor Poleo (Venezuela)
 19. *Familia andina (Andean Family)*, 1944, oil on canvas, 27 1/2 x 23"

Philip Guston (United States)
 20. *Sentimental Moment*, oil

Childe Hassam (United States)
 21. *Across the Avenue in Sunlight*, oil

BIOGRAPHICAL NOTES[1]

BERNI, Antonio. Painter, draftsman, printmaker, born in Rosario, Argentina, 1905. Studied in Rosario, 1916; Madrid, 1925; under André Lhote and Othon Friesz, Paris, 1926, on a fellowship awarded by the Jockey Club of Rosario and the Santa Fe Province governor. Traveled in Europe returning to Argentina in 1930. Was president of the Sociedad Argentina de Artistas Plásticos; professor of drawing, Escuela Nacional de Bellas Artes, 1935-45; and stage designer for the Teatro del Pueblo, all in Buenos Aires. Worked with Siqueiros and in 1943 went to Chile as part of the Argentine group forming Siqueiro's Comité Continental de Arte para la Victoria. Traveled to the Pacific Coast, 1946, and since 1947 has lived for long periods in Santiago del Estero in Argentina among cotton harvesters and woodcutters. Has held individual exhibitions since 1921 in Rosario, Buenos Aires, Montevideo, Madrid, and Paris. Participated in national and international exhibitions in Montevideo, San Francisco, New York, and Paris. Since 1925 has won many awards, including first prizes at the Salón de Artes Decorativas (1937), Salón Nacional (1937, 1940), and the Grand Prize, Salón Nacional, 1943.

BESTARD, Jaime. Painter, draftsman, sculptor, writer, born in Asunción, 1892, where he studied under Pablo Alborno and Juan Samudio. Lived in Paris, 1922-1933. In Asunción founded, with Julián de la Herrería, the Salón de Primavera (1934) and is also a founding member of the Centro de Artistas Plásticos, 1952. Held individual exhibitions in Asunción and Buenos Aires. Participated in national salons and international shows, including the Salon des Indépendents, Paris, 1929-1933; *Latin American Exhibition of Fine and Applied Art*, Riverside Museum, New York, 1939; and the São Paulo Biennial, 1955.

ESCALERA, José Nicolás de la. Cuban painter, 1734-1804. Executed mural and ceiling decorations in churches and convents in Cuba, where many of his paintings were in private and public collections.

FIORAVANTI, José. Sculptor, born in Buenos Aires, 1896. Studied at the Escuela Superior de Bellas Artes and is a member of the Academia Nacional de Bellas Artes. Lived and worked in different European cities, 1924-27, and in Paris, 1929-35. In Buenos Aires he is a professor at the Escuela Superior de Bellas Artes. His individual exhibitions include the Museo de Arte Moderno, Madrid, 1924, Musée du Jeu de Paume, Paris, 1935, and other museums and galleries in Buenos Aires and Paris. Participated in national and international group exhibitions and executed numerous monuments in Buenos Aires and Rosario. Was awarded several first prizes in Buenos Aires and the Grand National Prize at the National Salon, 1936.

NUÑEZ DEL PRADO, Marina. Sculptress, born in La Paz, 1910. Studied at the Academia de Bellas Artes, La Paz, 1927-30. Traveled in the United States under a Latin American Fellowship granted by the American Association of University Women, 1940-41, remaining in the United States until 1948. In 1941 received the Honorary Degree of Master of Humane Letters from the Russell Sage College, New York, and an exhibition of her sculptures circulated in the main United States museums and institutions, including the Pan American Union. Held individual exhibitions in Latin America, the United States, and Europe, including museums in Rio de Janeiro and São Paulo (1951), and the Petit Palais, Paris (1953). Since 1930 has participated in numerous national and international exhibitions, and the biennials in São Paulo and Madrid in 1951, and in Venice in 1952. Was awarded numerous prizes, among them gold medals in La Paz (1930 and 1950), Caracas (1934), Buenos Aires (1936), Berlin (1938), National Association of Women Artists, New York (1946). In 1954 the Bolivian government granted her El Cóndor de los Andes decoration.

PETTORUTI, Emilio. Painter, draftsman, born in La Plata, Argentina, 1892. Lived, worked, and studied in Italy in 1913-21, and in Germany, Austria, and Paris in 1921-24, taking active part in ultramodern groups. Back in Argentina, introduced the modern art tendencies in his country and was director of the Museo de Bellas Artes of La Plata, 1930-47. Went back to Europe in 1952 and took up residence in Paris where he now lives. Held individual

[1] Not included in the original catalogue. See Index of Artists for reference on those not listed here. —*Ed.*

exhibitions in Latin America, Europe, and the United States, including the Museo de Bellas Artes, Buenos Aires, 1938; the San Francisco Museum of Art and other museums in the United States, 1942-43; Museu de Arte Moderna, São Paulo, 1949; Museo Nacional de Bellas Artes, Santiago de Chile, 1950. Participated in national salons and international shows in Italy, France, and the United States.

RODRIGUEZ, Bernardo. Ecuadorian painter, active at the end of the eighteenth century and beginning of the nineteenth century. Painted many portraits and executed several works at the cathedral in Quito.

ROMAN ROJAS, Samuel. Sculptor, born in Rancagua, Chile, 1907. Moved to Santiago in 1924 and entered the Academia de Bellas Artes. Under a Humboldt Fellowship, went to Germany and traveled in Europe, 1937-39. His work has been shown in Chile and abroad, and his sculptures in stone, granite, marble, iron, bronze, cement, plaster, terra-cotta, and wood can be found in parks and public and private buildings in Chile. Won several awards, including Honor Prize at the International Exposition of Applied Arts, Germany, 1938.

VASQUEZ DE ARCE Y CEBALLOS, Gregorio. Painter, draftsman, born in Bogotá, 1638. Died in the same city, 1711. Studied in the workshop of Baltasar de Figueroa, 1653. Best known and most successful artist of his time, produced over 500 paintings between 1657 and 1711 for churches, convents, and private residences of the area. The Museo de Arte Colonial in Bogotá keeps in its collection 105 sepia and black ink on paper drawings, as well as numerous paintings.

May 5 - June 3, 1955

JORGE LARCO OF ARGENTINA

Jorge Larco is one of the best-known artists of the group which began opening up new directions in Argentina more than thirty years ago. He stands as a competent watercolorist with a wide reputation not only in his own country but also abroad.

Larco was born in Buenos Aires in 1897 and was taken to Madrid when he was six years old. He lived there until 1917, except for a period in 1912 and 1913 when he made a trip to his native country and Mexico. In Madrid he studied under Alejandro Ferrant and Julio Romero de Torres, and attended the Royal Academy of San Fernando. He exhibited in Spain and worked as an illustrator for several important magazines there. After his return to Argentina his work appeared regularly, from 1918 on, at the National Salon in Buenos Aires, where Larco won different awards, especially for his accomplishments in watercolor. Nevertheless, he continued to travel from time to time to Europe, Uruguay, and Brazil. In Argentina he has been a professor of drawing and decorative arts at two different official schools, and for a long time he was an illustrator for the popular magazines *Caras y Caretas*, *El Hogar*, and *Mundo Argentino*. In 1946 he made another trip to Spain, where he exhibited in the Museum of Modern Art of Madrid. He also held one-man shows in various Argentine galleries from 1927 to 1947.

For the last year the artist has been residing in Mexico City, where the Proteo Gallery presented his work in an extensive exhibition held last January and February. Part of this same exhibit is being shown at the Pan American Union as Larco's first one-man show in the United States.

Works by Jorge Larco can be found in the collections of the National Museum of Fine Arts and the Museum of La Boca, both in Buenos Aires; in the Museum of Modern Art in Madrid; in the IBM collection in New York; and also in the local museums of Eva Perón, Rosario, Santa Fe, San Juan, Corrientes, Mendoza, and Tandil in Argentina.

CATALOGUE

Oils

1. *Torerillo (Little Bullfighter)*, 1947
2. *Estudio (Study)*, 1947
3. *La cañada*, Córdoba, 1950
4. *Potrero de Garay (Pasture Land of Garay)*, Córdoba, 1950
5. *El vallecito (The Little Valley)*, Córdoba, 1951
6. *Santa Teresa*, Córdoba, 1952
7. *El Niño Dios Church*, Córdoba, 1952
8. *Los dos ranchos (Two Huts)*, Córdoba, 1953
9. *Sarah and Sari*, 1954

Watercolors

10. *La estancia (The Ranch)*, Buenos Aires, 1935
11. *El limonar (Lemon Grove)*, Argentine Delta, 1940
12. *La zanja en el naranjal (Ditch in the Orange Grove)*, Argentine Delta, 1940
13. *Hibiscus*, Brazil, 1944
14. *Cementerio (Cemetery)*, Canavieiras, Brazil, 1944
15. *Lidio*, Canavieiras, Brazil, 1945
16. *Los novios (Bridal Couple)*, Canavieiras, Brazil, 1945
17. *Escorial*, Madrid, 1946
18. *La pirca (Stone Wall)*, Córdoba, 1947
19. *Paisaje de Cruz Chica (Cruz Chica Landscape)*, Córdoba, 1947
20. *Río de los Reartes (Reartes River)*, Córdoba, 1948
21. *Amanecer (Dawn)*, Córdoba, 1949
22. *Desnudo (Nude)*, 1950
23. *La canasta de frutas (Fruit Basket)*, 1953
24. *Bock y granadas (Stein and Pomegranates)*, 1953
25. *Tomates (Tomatoes)*, 1953
26. *La raja de zapallo (Slice of Squash)*, 1953
27. *La raja de sandía (Slice of Watermelon)*, 1953
28. *Mal tiempo (Bad Weather)*, Córdoba, 1953
29. *El estanque (Pool)*, Córdoba, 1953
30. *Ana María*, 1953
31. *Ajos y morteros (Garlic and Mortar)*, 1954
32. *Río de los Reartes (Reartes River)*, Córdoba, 1954
33. *Pontalba Apartments*, New Orleans, 1954

June 6 - July 5, 1955

OSWALDO GUAYASAMIN OF ECUADOR

The wide public acclaim won by the Mexican muralists of the 1920s, with their emphasis on national, and more particularly Indian themes, led artists in a number of other Latin American countries with large autochthonous populations to adopt a similar trend, emphasizing the indigenous element. The treatment was for the most part realistic, often with dramatic overtones. The three countries which have generally maintained this Indianist

movement in art are Peru, Bolivia, and Ecuador.

Recognized as the foremost exponent of the nationalist trend in the last-mentioned country, Oswaldo Guayasamín has been highly praised by intellectuals there who find in Indianism the only possible course for the development of modern art. He has been promoted especially by the Casa de la Cultura Ecuatoriana in Quito, which has commissioned murals from him, has had his works exhibited abroad, and has published articles and books on him and his work.

Guayasamín was born in Quito in 1919, and studied there at the National School of Fine Arts. He left Ecuador for the first time in 1943, at the invitation of the United States Department of State, to visit museums in this country. On that occasion he held a one-man show in New York at the Mortimer Brandt Gallery. In 1945 he traveled in Peru, Chile, Argentina, and Bolivia, exhibiting in their respective capitals. Later he journeyed through Mexico, Guatemala, Colombia, and Panama.

In the latter part of 1953 he went to Caracas, Venezuela, where the Museum of Fine Arts presented a vast exhibit of more than one hundred of his works, entitled by the artist *Huacayñan (The Way of Tears)*. This had been shown the year before at the Colonial Museum in Quito. Due to lack of space in our gallery, we can present here only a fraction of the exhibit, featuring some of the more significant of the paintings.

Guayasamín is represented in the collections of the Museum of Modern Art in New York, the San Francisco Museum of Art, the Art Institute of Chicago, the Museum of the University of Cincinnati, the Pinacoteca Municipal of Lima, the Casa de la Cultura Ecuatoriana of Quito, and many private collections in the United States, Latin America, and Europe. The present exhibit constitutes his first one-man show in Washington.

CATALOGUE

1. *La muerte (Death)*, triptych: *Silencio (Silence), Ataúd blanco (The White Coffin), Meditación (Meditation)*
2. *La angustia (Anguish)*, triptych: *Desolación (Desolation), Desesperación (Despair), Resignación (Resignation)*
3. *El páramo*, triptych: *Helada (The Frost), La montaña (The Mountain), Viento (The Wind)*
4. *Quito*
5. *Los prisioneros (The Prisoners)*
6. *Origen (Origin)*
7. *Mendigo (The Beggar)*
8. *La corrida (The Bullfight)*
9. *Madre y niño (Mother and Child)*
10. *Cabeza de indio (Indian)*
11. *Cabeza de india (Indian Woman)*
12. *Resurrección (Resurrection)*
13. *Autorretrato (Self-Portrait)*
14. *Mural: Ecuador*
15. *Riña de gallos (Cock Fight)*

July 6 - August 6, 1955

ENRIQUE ECHEVERRIA OF MEXICO

A year ago the Pan American Union held for the first time a one-man show of drawings by José Luis Cuevas, and this year it is presenting Enrique Echeverría, a member of the Proteo Gallery group to which Cuevas belongs. This group takes as an approach to its work the conscious analysis and interpretation of reality, with an avoidance of

political themes.

Echeverría was born in Mexico in 1923. He started to paint at an early age, later was a pupil of the Spanish painter Arturo Souto, and then studied at the Esmeralda School of Fine Arts in Mexico City. His work was included in several group shows. In 1952 he went to Europe and for a year visited England, Spain, France, and Italy. In 1954 the Galería Proteo of Mexico City held his first one-man show.

There are no literary implications in Echeverría's interpretation of reality; he takes, rather, a simple and direct approach to domestic scenes and people of his native country. He, like other members of his group, delights in showing plain, inconspicuous folk taken from daily life. There is no political symbolism or allegoric intention in his portraits of the poor or in the humble scenes of Mexico he selects as subject matter, but there is an interest in achieving pure pictorial values with a national theme.

The current exhibit represents the artist's second one-man show and the first presentation of his work in the United States.

CATALOGUE

Paintings

1. *Paisaje urbano (City Scene)*
2. *Los cirqueros (Circus People)*
3. *La pollera (Chicken Vendor)*
4. *El carnicero (Butcher) No. 1*
5. *Novia juchiteca (Juchitec Bride)*
6. *Paisaje de la Ciudad de México (Scene in Mexico City)*
7. *Muros (Walls)*
8. *Paisaje con figuras (Landscape with Figures)*
9. *Paisaje (Landscape)*
10. *La bailarina (The Dancer)*
11. *Las recogedoras de leña (Wood Gatherers)*
12. *Niña en rojo (Girl in Red)*
13. *El carnicero (Butcher) No. 2*
14. *La cocinera (Cook)*
15. *Los pulqueros (Pulque Drinkers)*
16. *El taco (Man Eating a Taco)*
17. *Paisaje en verde (Houses in Green)*
18. *El pensador (The Thinker)*

Drawings[1]

July 6 - August 6, 1955

IRMA DIAZ OF MEXICO

Limitations of space at the Pan American Union make extensive exhibitions of sculpture impractical. Beginning with

[1] Titles are unavailable. —*Ed.*

the present show, however, a few selected pieces by a practicing artist will be presented from time to time, in conjunction with the exhibits of paintings.

Irma Díaz is a native of Durango, Mexico. In addition to attending the School of Painting and Sculpture and the Polytechnic Institute in Mexico City, she studied at the Art Institute of Chicago and Alfred University in the United States. She has taught in the public schools of Hartford, Connecticut, and at Hull House in Chicago. Díaz has frequently taken part in group shows in the United States and Mexico, and examples of her work are to be found in private collections throughout the Americas. This is the first presentation of her sculpture in Washington.

CATALOGUE

Sculpture

1. *Reclining Woman*, bronze
2. *Indian Girl*, bronze
3. *Child*, bronze
4. *María*, terra-cotta
5. *Paloma*, terra-cotta
6. *Iraida*, terra-cotta

August 10 - September 9, 1955

LUCE CARPI TURNIER OF HAITI

Among the modern, independent artists, following neither primitive nor academic trends, who first received recognition in Haiti some ten years ago through the efforts of the Centre d'Art in Port-au-Prince, Luce Turnier has been prominent since the beginning as the possessor of one of the most clearly defined and original personalities in the group.

Carpi Turnier was born in 1924 in Jacmel, a port on the southern peninsula, and began to paint at an early age. Toward the end of 1944 she enrolled in the classes conducted by the U.S. painter DeWitt Peters at the newly organized Centre d'Art. She participated in its group shows and later became a member of the faculty. In 1948 Carpi Turnier received a grant from the Rockefeller Foundation for study at the Art Students League in New York, where she worked with Morris Kantor and Harry Sternberg until the following year. Examples of her work were included in a group show of Haitian painters held at the Jacques Seligman Gallery in the same city.

In 1951 the artist received a scholarship from the French government, followed by one from her own country, which enabled her to remain in France until 1953, devoting all her time to painting. Her work appeared in group exhibitions in Paris, and she also held an individual show there. Later Carpi Turnier traveled in Germany, exhibiting in Hamburg, Bonn, and Bremen. She recently married Cioni Carpi, who is both a painter and a stage comedian. Although works by her have figured in several shows in the Washington area, this is her first individual exhibit in the United States.

CATALOGUE

Paintings

1. *Ma fille (My Daughter)*
2. *Le tuberculeux (Tuberculosis)*

3. *Mendiante (Beggar)*
4. *La vieille (Old Woman)*
5. *Concierge (Building Superintendent)*
6. *Ma chambre d'hôpital (My Hospital Room)*
7. *Le vieux (Old Man)*
8. *Mon atelier (My Studio)*
9. *Mon atelier (My Studio)*
10. *Bouteille (Bottle)*
11. *Le pavillon (Pavilion)*
12. *Paysage (Landscape)*
13. *Mangini*
14. *Le poêle (Stove)*
15. *Toit rouge (Red Roof)*
16. *Débardeurs (Dockers)*
17. *Chardons (Thistles)*
18. *Fleurs blanches (White Flowers)*
19. *Etudes (Studies)*
20. *Etudes (Studies)*
21. *Portrait d'Eva Thoby-Marcelin (Portrait of Eva Thoby-Marcelin)*

22-30. Drawings[1]

September 12 - 28, 1955

TWO ENGRAVERS OF BRAZIL: FAYGA OSTROWER, ARTHUR LUIZ PIZA

Accompanying the trend toward total abstraction in painting and sculpture, the graphic arts in Brazil have likewise developed along non-figurative lines, exploring new forms and techniques. This exhibition presents the work of two young artists who have emerged in recent years as clearly defined personalities in the realm of printmaking.

Fayga Ostrower was born in Lodz, Poland, in 1920, but emigrated to Brazil some twenty years ago and has been a Brazilian citizen since 1940. It was in that year that her work first began to appear in group shows. She studied at the Getúlio Vargas Foundation in Rio de Janeiro, and held individual exhibits in São Paulo at the Museum of Modern Art, and in Rio at the Ministry of Education, the Brazilian Press Association, and the local Museum of Modern Art. She currently teaches art at the last mentioned institution. Prints by her have been included in group shows of Brazilian artists in Chile, Ecuador, Japan, France, Switzerland, and the Scandinavian countries.

In addition to her work as an engraver, Ostrower has designed textiles and jewelry and has included examples thereof in most of her exhibits. She has also done illustrations for books.

Last year Ostrower obtained a Fulbright Fellowship for study in the United States. She enrolled at Atelier 17 and the Brooklyn Museum Art School, where she has been learning new techniques in etching, aquatint, and woodcut. Examples of work done in New York and textiles which she designed formed an individual exhibit at the Contemporaries Gallery during the month of May and now constitute her presentation at the Pan American Union.

Arthur Luiz Piza was born in São Paulo, Brazil, in 1928. He studied with the painter Antônio Gomide and held his

[1] Titles are unavailable. —*Ed.*

first one-man show in his native city at the Brazilian Architectural Institute. After 1951 he moved to Paris, where he joined the atelier of the printmaker Johnny Friedlaender, perfecting his knowledge of etching, burin engraving, and aquatint. While in Paris he participated in the May Salon of 1953, and held one-man shows of his prints at the Galerie Saint Placide and the Librairie Française. He exhibited in Switzerland in 1954 at the art museums of Bern, Geneva, and Zurich. After his study with Friedlaender, Piza returned to Brazil, where he participated in group shows and executed a fresco for the church at Juliápolis in the State of São Paulo. He is now again living in Paris.

Piza works chiefly in free forms, which the Brazilian novelist and physician José Geraldo Vieira has compared to the "anatomy of microscopic cells, neurons, or transversal fissures in the veins." This presentation at the Pan American Union constitutes the first showing of Piza's prints in the United States.

CATALOGUE

Fayga Ostrower

Etchings

1. *Pendular*
2. *A Drift*
3. *Late Noon*
4. *Wing of Plane*
5. *Fleeting Mood*
6. *Sidereal Antenna*
7. *Immersion*
8. *Crack*

Aquatints

9. *Coalfield*
10. *Serenity*
11. *Sand Pattern*
12. *Suspension*
13. *Perpetual Silhouettes*

Woodcuts

14. *Bulwarks*
15. *Fragments of Wrecked Ship*

Arthur Luiz Piza

Etchings

1. *Shaped Like a Woman*
2. *Lobster Woman*
3. *Mating*
4. *Metamorphosis*
5. *Polliwog*
6. *Bite*
7. *Rag-Eater*
8. *Chlorophyll*

9. *Voluptuous Diagram*
10. *Petrified Specimen*
11. *Eyry*
12. *Auricular Portion*
13. *Three Figures*
14. *Fungus in Love*

Aquatints

15. *Bird*
16. *Conception*
17. *Howling Mask*
18. *Medusa*
19. *Larvae*
20. *Flowering Embryo*
21. *Bag*
22. *Hippogriff Playing*
23. *Figure*
24. *Cellule*
25. *Cosmos*
26. *Fetus*
27. *Skinned Rooster*

October 6 - 22, 1955

ENRIQUE CAMINO BRENT OF PERU

The work of Enrique Camino Brent is already known in artistic circles of the United States. Since 1938 he has participated in group exhibitions of Latin American art, of which the most important was the 1940 Golden Gate International Exposition in San Francisco.

Camino Brent was born in Lima, Peru, in 1909 and attended the National School of Fine Arts there from 1922 to 1932. He has traveled extensively in his native country, as well as in Bolivia and Argentina, in search of subject matter for his work which, during the last twenty years, has followed the Indianist trend prevalent in contemporary Peruvian art. As a pupil of José Sabogal, the leader of the group, he has developed a personality of his own and is considered one of the foremost figures in the Indianist movement. The artist came to this country in 1946, at the invitation of the Department of State, and later held a successful one-man show in Ciudad Trujillo, Dominican Republic. He has also held one-man shows in Lima, Peru; Buenos Aires and La Plata, Argentina; and La Paz, Bolivia. His work is represented in the collections of IBM, San Francisco Museum of Art, and the Fine Art Museums of Buenos Aires and La Plata.

Camino Brent is at present traveling and painting in Spain and Italy. The present exhibition is his first one-man show in the Washington area.

CATALOGUE

Paintings

1. *Balcones rojos (Red Balconies)*, Cuzco

2. *El mercado en Chachapoyas (Market in Chachapoyas)*
3. *Varayok, Lake Titicaca*, Puno
4. *La escalera roja (The Red Staircase)*, Cuzco
5. *Balcón de Chachapoyas (Balcony in Chachapoyas)*
6. *Viejas de Arequipa (Old Women of Arequipa)*
7. *Procesión india (Indian Procession)*, Cuzco
8. *Patio azul (Blue Patio)*, Chachapoyas
9. *El sermón (The Sermon)*, Cuzco
10. *La casa de los Pizarro (House of the Pizarros)*, Cuzco
11. *Balsas pesqueras (Rafts)*, Lake Titicaca
12. *Cúpula de Chiguata (Cupola of Chiguata)*, Arequipa
13. *Cúpulas de Arequipa (Cupolas of Arequipa)*
14. *Escalera de la casa cural (Stairway of a Priest's House)*, Chachapoyas
15. *Tambo de cobre (Copper Deposits)*, Arequipa
16. *Puertas azules (Blue Doors)*, Arequipa
17. *Belfries*. Loaned by His Excellency Don Fernando Berckemeyer, Ambassador of Peru

November 16 - December 17, 1955

EUDORO SILVERA OF PANAMA

Though the development of his artistic personality is a matter of only the last five years, Eudoro Silvera is today considered one of the foremost painters of his native Panama. Born in 1917 in the city of David, in the Province of Chiriquí, he studied at the National School of Fine Arts in the capital with the impressionist painter Roberto Lewis. During nine years of residence in the United States, Silvera attended art classes in New York at the Cooper Union, working under Morris Kantor and Peppino Mangravite. At the same time he studied at the Juilliard School of Music.

In the mid-1940s Silvera figured in a group exhibition at the Corcoran Gallery in Washington and he held a one-man show at the Artist's Gallery in New York in 1947. That same year one of his works was included in an exhibit of *Contemporary Religious Painting in America* at Oberlin College in Ohio. One-man shows of his compositions were given in Panama City in 1951, 1953, and 1954.

Silvera earns his living both as an illustrator and as a musician. He has written and illustrated a book for children. While one of his oils appeared in the exhibition of contemporary Panamanian painting held at the Pan American Union late in 1953, the present exhibit is his first one-man show in the Washington area.

This exhibition was brought to this country through the courtesy of the Otis McAllister Agency of Panama.

CATALOGUE

Oils

1. *San Francisco (Saint Francis)*
2. *Profeta (Prophet)*
3. *Pescadores (Fishermen)*
4. *Tamboreros (Drummers)*
5. *Figura a caballo (Figure on Horseback)*
6. *Cabeza reclinada (Reclined Head)*

7. *Naturaleza muerta con hojas (Still Life with Leaves)*
8. *Figura (Figure)*
9. *Bodegón con nabos (Still Life with Turnips)*
10. *Gallo (Cock)*
11. *Figura de uniforme (Figure in Uniform)*
12. *Friso (Frieze)*
13. *Figura (Figure)*
14. *Figura reclinada (Reclined Figure)*
15. *Cabeza (Head)*
16. *Bodegón con copa (Still Life with Cup)*
17. *Bodegón con botella y vasos (Still Life with Bottle and Glasses)*
18. *Desnudo sentado (Seated Nude)*
19. *Bodegón con jarras (Still Life with Pitchers)*
20. *Peces (Fish)*

Gouaches

21. *Cristo cualquiera (Any Christ)*
22. *Dos figuras (Two Figures)*
23. *Acordeonista (Accordion Player)*
24. *Mujer ante el espejo (Woman in Front of Mirror)*
25. *Mujer con instrumento (Woman with Instrument)*
26. *General típico (Typical General)*

December 19, 1955 - January 14, 1956

ARTISTS OF THE UNITED STATES IN LATIN AMERICA II

This is the second exhibition the Pan American Union has held on this subject. Its purpose is not only to include artists of the United States in its program of art shows but also to stimulate those North American painters and sculptors who travel in this hemisphere and find a source of inspiration for their work in Latin America.

As before, Mexico continues to be the most popular center of production, but other countries are likewise represented. Also, as in the case of the previous exhibition, no limitation has been established as to tendencies, which vary from realistic to non-objective interpretations. This is a selection of statements of the creative spirit, attempting to interpret a different milieu. All, moreover, are evidence of the desire for understanding among peoples, an achievement that can be realized first of all through art.

For this occasion only we are including a view of the Pan American Union building, executed by a Washington artist, as it is a symbol of the unity of the Americas.

CATALOGUE

Painting, Drawing, and Sculpture

Jane Orcutt Blatter
1. *View of Quito*, Ecuador, oil
2. *Ecuadorian People*, Ecuador, oil

Robert C. Ellis
 3. *Cloth Market*, Mexico, oil, 23 3/4 x 30"
 4. *Grief,* Mexico, oil, 24 x 48"
 5. *Multitude in the Valley of Decision*, Mexico, casein, 36 x 48"
 6. *Desert in the Night*, Mexico, casein, 11 x 30"

Cynthia Green
 7. *Three Sisters*, Brazil, oil
 8. *Students in the Café do Zequinha*, Brazil, oil. Loaned by the Charles Barzansky Galleries, New York

Samuel Herman
 9. *View of San Miguel de Allende*, Mexico, oil
10. *Portrait of Camilo López*, Mexico, oil

Dorothy Hood
11. *Homage to Xochitl*, Mexico, ink drawing, 17 1/4 x 22 1/4"
12. *Bull and Sun Images*, Mexico, ink drawing, 17 1/4 x 22 1/4"

Walter Kamys
13. *Chichén-Itzá*, Mexico, oil, 39" x 43" (with frame). Loaned by the Bertha Schaefer Gallery, New York

Theodora Kane
14. *Hillside above Caracas*, Venezuela, duco, 20 x 24"
15. *Hill in San Francisco*, Venezuela, watercolor, 24 x 30" (with frame)

Frank W. Kent
16. *Market Day in Toluca*, Mexico, oil, 28 x 36"

Sheldon Kirby
17. *Boatyard*, Peru, oil, 36 x 48"

Babette Kornblith
18. *El Campanino*, Costa Rica, watercolor, 26 x 40"

Charles Johnson Post
19. *Field Dressing Stations, San Juan Hill, July 1, 1898*, Cuba, watercolor, 28 x 21" (with frame)

David Ramsey
20. *Drawing*, Mexico, ink

Thea Ramsey
21. *Christ*, Mexico, enamel on copper
22. *Virgin*, Mexico, drawing

Ruth Perkins Safford
23. *Hall of Flags, Pan American Union*, Washington, D.C., gouache

Millard Sheets
24. *Hills of Pátzcuaro*, Mexico, watercolor, 31 x 39" (with frame). Loaned by the Dalzell Hatfield Galleries, Los
 Angeles

Anne Truitt
25. *Maya Woman*, Mexico, terra-cotta

YEAR 1956

January 20 - February 16, 1956

EDGAR NEGRET OF COLOMBIA: SCULPTURES

The figure of Edgar Negret looms forth as one of the most significant and interesting personalities in the panorama of contemporary Latin American sculpture. Departing from his early, thorough training in realism, Negret has, in maturing, acquired a rigorous discipline and a form of expression without parallel or counterpart in Latin America—one which the critic of *Arts* magazine in New York recently qualified as the "symbol of an age."

Negret was born in Popayán, Colombia, in 1920. While still very young he attended the Academy of Fine Arts in Cali, and his realistic portraits of Walt Whitman and Gabriela Mistral, produced under the influence of training he received there, elicited wide acclaim. Beginning in 1945, he won a number of important prizes in various local and national exhibits.

However, while still in his native country, Negret became interested in free forms and new materials, and his compositions began to reflect the influence of Henry Moore, Jacques Lipschitz, and Alexander Calder, whose works he knew through reproductions. Finally, in 1949 he decided to come to the United States, where he started serious work in metals at the Sculpture Center (formerly the Clay Club) in New York. In 1953 the artist went to Madrid where he held one-man shows at the Museum of Contemporary Art and at the Buchholz Gallery; later he retired for two years to the island of Mallorca, where he has produced most of the compositions included in the present exhibition.

Negret returned to the United States last year, and the Peridot Gallery again presented his work. His imaginative output of pipes cut, welded, and painted in suggestive forms, with a definite poetical feeling, attracted much attention from the Manhattan critics. Stewart Preston said in the *New York Times*:

> The utterly geometrical bias of this work does not mask Negret's real feeling for shapes and their combinations. Significant form is not limited to studio litter, and Negret is inspired by machinery.

A reviewer in the *New York Herald Tribune* stated that he considered Negret's sculptures "original and unfailingly interesting in shape, and each work makes an oddly forceful presence, sometimes barbaric, sometimes playful, but always emotional in impact."

This exhibit is the first presentation of the artist's work in the Washington area.

CATALOGUE

Sculptures

1. *La Anunciación (Annunciation)*, 1947, bronze
2. *Walt Whitman*, 1945, bronze
3. *Muchacho en la ventana (Boy in the Window)*, 1946, bronze
4. *Ascensión, huella de Cristo (Ascension, Christ's Footprint)*, 1948, plaster of Paris

5. *Rostro de Cristo (Christ's Face)*, 1950, iron
6. *Ascensión, huella de Cristo (Ascension, Christ's Footprint)*, 1949, iron
7. *Gato (Cat)*, 1949, iron
8. *Arlequín (Harlequin)*, 1950, German silver
9. *Vaso con una flor (Vase with Flower)*, 1950, steel
10. *Telaraña (Cobweb)*, 1950, steel
11. *Mano de Prometeo (Prometheus' Hand)*, 1949, terra-cotta
12. *Angel*, 1949, terra-cotta
13. *Paloma (Dove)*, 1949, terra-cotta
14. *Dirección sur (Facing South)*, 1952, plaster of Paris
15. *Aparato mágico (Magic Apparatus) No. 2*, 1954, polychrome iron
16. *Columna conmemorativa de masacre (Massacre Commemorative Column)*, 1953, plaster of Paris
17. *Máscara (Mask)*, 1955, polychrome iron
18. *El escudo (Shield)*, 1955, polychrome iron
19. *Aparato mágico (Magic Apparatus) No. 3*, 1954, polychrome iron
20. *Arquitectura submarina (Underwater Architecture)*, 1954, polychrome iron

January 25 - February 15, 1956

CHILEAN ART EXHIBIT

The Institute of Plastic Arts of the University of Chile in Santiago has arranged a large exhibition of paintings, sculptures, and engravings to be shown in the United States under the auspices of the government of Chile. Due to lack of space, the number of works has been reduced but examples of the work of each of the artists selected by the Institute have been included, thereby providing a complete panorama of contemporary Chilean art. A similar show will be on display during the month of March in the building of the Carnegie Endowment for International Peace in New York City.

CATALOGUE

Oils

Agustín Abarca
 1. *Laguna de invierno (Lake in Winter)*

Graciela Aranís
 2. *Verano en Meudon (Summer in Meudon)*

Héctor Banderas
 3. *Verano (Summer)*

Marco Bontá
 4. *La quema de Judas (The Burning of Judas)*

Pablo Burchard
 5. *Paisaje (Landscape)*

Jorge Caballero
 6. *Puerto (Seaport)*

Héctor Cáceres
7. *Juana*

Isaías Cabezón
8. *Palma de Mallorca*

José Caracci
9. *Autorretrato (Self-Portrait)*

Ana Cortés
10. *Mercado callejero (Street Market)*

Ximena Cristi
11. *Naturaleza muerta (Still Life)*

Gregorio de la Fuente
12. *Autorretrato (Self-Portrait)*

Eduardo Donoso
13. *Esperando el paso de la procesión (Waiting for the Procession)*

Augusto Eguiluz
14. *Interior*

Jorge Elliott
15. *Bosque natural del sur de Chile (Southern Chilean Forest)*

Pascual Gambino
16. *Retrato del pintor Pedro Reszka (Portrait of the Painter Pedro Reszka)*

Laureano Guevara
17. *Dunas (Dunes)*

Juan Francisco González
18. *Mercedes Robles*

Arturo Gordon
19. *La riña (The Brawl)*

Roberto Humeres
20. *Niña del abanico (Girl with Fan)*

Jorge Letelier
21. *Paisaje (Landscape)*

Sergio Montecino
22. *Los dos hermanos (Two Brothers)*

Olga Morel
23. *Bellavista al atardecer (Bellavista at Dusk)*

Carlos Ossandón
24. *Autorretrato (Self-Portrait)*

Carlos Pedraza
25. *Naturaleza muerta (Still Life)*

Tole Peralta
26. *Mujeres con la botella de la pasión (Women Holding Bottles)*

Matilde Pérez
27. *Navidad criolla (Chilean Christmas)*

José Perotti
28. *La lectura (Reading)*

Maruja Pinedo
29. *Vendedora de pájaros (Woman Selling Birds)*

Exequiel Plaza
30. *Pintor bohemio (Bohemian Painter)*

Aída Poblete
31. *Alicia (Alice)*

Israel Roa
32. *Siempreviva (Immortelle)*

Laura Rodig
33. *Mariscadores de Chiloé (Shellfish Gatherers in Chiloé)*

Raúl Santelices
34. *Silvia (Sylvia)*

Arturo Valenzuela
35. *Escena de Angelmó (Boats at Angelmó)*

Alberto Valenzuela Llanos
36. *Rocas en el barranco (Rocks)*

Ramón Vergara
37. *Composición (Composition) No. 8*

Prints

Marco Bontá
38. *Santiago antiguo (Old Santiago)*

Dister Busser
39. *La crucifixión (Crucifixion)*

Jorge Cruzat
40. *La caza (The Hunt)*

Ana Cortés
41. *Navidad (Christmas)*

Julio Escamez
42. *En el río (By The River)*

Graciela Fuenzalida
43. *Niñas de Chile (Chilean Girls)*

René Gallinato
44. *Pájaros (Birds)*

Lily Garafulic
45. *Autorretrato (Self-Portrait)*

Carlos Hermosilla
46. *Maternidad (Maternity)*

Pedro Lobos
47. *Eva (Eve)*

Draco Maturana
48. *Mujer (Woman)*

Francisco Otta
49. *Desnudo (Nude)*

Francisco Parada
50. *Composición (Composition)*

Héctor Pino
51. *Las tres Pascualas (The Three Pascualas)*

Francisco Quintero
52. *Composición (Composition)*

Ciro Silva
53. *Callejón de Valparaíso (Street in Valparaíso)*

Viterbo Sepúlveda
54. *Composición (Composition)*

Fernando Saragoni
55. *Calle colonial (Colonial Street)*

Walter Solón
56. *Funeral en el altiplano (Funeral in the Highlands)*

Sculptures

Lily Garafulic
57. *El profeta (The Prophet)*, marble
58. *Niobe*, marble
59. *Venus*, marble

Alberto López Ruz
60. *Viejita sentada (Old Woman in a Chair)*, terra-cotta

Germán Montero
61. *Moisés (Moses)*, ceramic

José Perotti Ronzoni
62. *Teresa Tello*, bronze
63. *Violeta Acosta*, bronze

Laura Rodig
64. *Mapuche (Mapuche Indian)*, bronze

Benito Román
65. *Guacolda*, terra-cotta
66. *Fresia*, terra-cotta
67. *Pillán*, terra-cotta

Héctor Román
68. *Angel*, stone
69. *Maternidad (Maternity)*, stone
70. *Maternidad (Maternity)*, stone

BIOGRAPHICAL NOTES[1]

ABARCA, Agustín. Painter, born in Talca, Chile, 1882. Died in Santiago, 1953, where he lived since 1904. Studied at the Academia de Bellas Artes, under Pedro Lira, and at the Escuela de Bellas Artes, under Fernando Alvarez de Sotomayor and Alberto Valenzuela Llanos. Exhibited, since 1907, in individual and group exhibitions in Chile and abroad, including the Pittsburgh International, Pennsylvania, 1935; *Latin American Exhibition of Fine and Applied Art*, Riverside Museum, New York, 1939; and the Golden Gate International Exposition, San Francisco, 1940. Won several awards such as the First Prize for Drawing, Santiago, 1907.

ARANIS, Graciela. Painter, draftsman, born in Chile, 1905. Studied at the Escuela de Bellas Artes of Santiago, 1921. Under a scholarship, went to Paris on a study trip, 1927. Since 1923 has held individual exhibitions in Chile and participated in group shows, including the *Inter-American Exhibition of Chilean Painting*, circulating in the Americas in 1937-39; São Paulo Biennial, 1953. Won First Prize for Drawing, Viña del Mar, 1939, among other awards.

BANDERAS, Héctor. Painter, illustrator, born in Santiago, 1903. Studied at the Escuela de Bellas Artes in Santiago, and in France and Germany under a Chilean government fellowship, 1929-31. Is a professor of decorative art and ceramics, Escuela de Artes Aplicadas, Santiago. His work has been exhibited in Chile and abroad, including

[1] Not included in the original catalogue. See Index of Artists for reference on those not listed here. —*Ed.*

the *Latin American Exhibition of Fine and Applied Art*, Riverside Museum, New York, 1939; Golden Gate International Exposition, San Francisco, 1940. Was awarded several prizes such as the First Prize, National Salon, 1933.

BONTA, Marco A. Painter, draftsman, printmaker, art critic, born in Santiago, 1898, where he studied at the Academia Nacional de Bellas Artes. Traveled and studied in Europe, 1927-31, under a scholarship granted by the Chilean Ministry of Education. Since 1931 has been a professor at the Graphic Arts Section of the Escuela de Artes Aplicadas. Hired by the Venezuelan government to create the courses of Applied Arts in Caracas, 1938, he stayed there until 1945, when he returned to Santiago and has been president of the Asociación de Pintores y Escultores; co-founder and first director of the Instituto de Extensión de Artes Plásticas of the University of Chile, Santiago; co-founder and first director of the Museo de Arte Contemporáneo, Santiago, 1947. Wrote extensively on Chilean art. Since 1923 has exhibited in individual and group exhibitions in Chile, Brazil, Colombia, France, Peru, the United States, and Venezuela, including the *First Exhibition of Latin American Artists*, Paris. Was awarded several first prizes at national salons and the First Prize and Bronze Medal at the International Exposition of Seville, Spain, 1929.

BURCHARD EGGELING, Pablo. Painter, architect, born in Santiago, 1875, where he studied at the School of Architecture and Escuela de Bellas Artes. Held individual exhibitions in Chile, including the Museo Nacional de Bellas Artes of Santiago, and in Europe. Participated in many group exhibitions, such as the *Latin American Exhibition of Fine and Applied Art*, Riverside Museum, New York in 1939 and the Golden Gate International Exposition, San Francisco, 1940. Won numerous first and honor prizes and in 1944 was the first Chilean painter to receive the highest award in Chile, the Premio Nacional de Arte.

CABALLERO, Jorge. Painter, born in Santiago, 1902, where he studied at the Escuela de Bellas Artes. In 1927-31 worked under André Lhote in Paris, later becoming his assistant. Exhibited in Chile and abroad, including the *Pan American Exposition*, Los Angeles, 1925; Salon d'Automne, Salon des Indépendants, and *Latin American Artists*, Paris; Pittsburgh International, Pennsylvania, 1935; *Inter-American Exhibition of Chilean Painting*, circulating in the Americas 1937-39; *Latin American Exhibition of Fine and Applied Art*, Riverside Museum, New York, 1939; Golden Gate International Exposition, San Francisco, 1940. Won many awards including first prizes at national salons.

CABEZON, Isaías. Painter, born in Salamanca, Chile, 1893. Studied in Santiago and Europe, under a Chilean government fellowship granted in 1928. Lived in Berlin and Paris. Exhibited in Chile, Berlin, Paris, and the United States, including the Golden Gate International Exposition, San Francisco, 1940. Was awarded several prizes in national salons, including a First Prize, 1942.

CACERES, Héctor. Painter, draftsman, born in Valparaíso, Chile, 1900. Studied at the Escuela de Bellas Artes of Santiago, 1927; Kunstgewerbe und Handwerkerschule, Berlin; and Académie Colarossi, Paris, under a Chilean government fellowship 1929-30. Since 1939 has held individual exhibitions in Chile. Participated in numerous group exhibitions, including *Latin American Exhibition of Fine and Applied Art*, Riverside Museum, New York, 1939; the Golden Gate International Exposition, San Francisco, 1940; *Chilean Painting*, circulating in the United States, 1942; *Contemporary Chilean Art*, Rio de Janeiro and Montevideo, 1944; Biennial of Madrid, 1951; and Biennial of São Paulo in 1951 and 1953. Was awarded numerous prizes in Chile, including the Prize of Honor, National Salon, 1943.

CARACCI, José. Painter, draftsman, born in Frascati, Italy, 1887. Studied in Santiago de Chile at the Catholic University with Pedro Lira, 1902-07; Escuela de Bellas Artes with Fernando Alvarez de Sotomayor, 1908-13; later, with Alberto Valenzuela Llanos and Juan Francisco González. Graduated as professor of drawing in 1913, and since has been a professor of drawing in different institutions in Santiago. Exhibited in Latin America, Europe, and the United States, including international exhibitions in San Francisco, 1915, 1939; *Pan American Exposition*, Los Angeles, 1925; *Latin American Exhibition of Fine and Applied Art*, Riverside Museum, New York, 1939; São Paulo

Biennial, 1951. Has received numerous prizes in national exhibitions, including Gold Medal, 1921, 1930, 1940; and in international shows in Quito (Silver Medal, 1909), Buenos Aires (Bronze Medal, 1910, 1940), and Seville, Spain (Bronze Medal, 1929).

CORTES, Ana. Painter, draftsman, printmaker, born in Santiago, 1906. Studied at the Escuela de Bellas Artes in Santiago, under Juan Francisco González and Richon Brunet; Académie de la Grande Chaumière under André Lhote, through a Chilean government fellowship, 1928; and under Boris Grigoriev. Traveled several times in Europe and the United States. Held many individual exhibitions and participated in numerous group shows, including, since 1927, national and Parisian salons; Chilean art exhibitions in Buenos Aires (1941) and the United States (1939, 1942); Latin American exhibitions in New York (1942) and London (1944); and São Paulo Biennial (1951). Since 1928 has won many prizes in national salons, including medals and first prizes, the most recent one in 1952.

CRISTI, Ximena. Painter, draftsman, printmaker, born in Rancagua, Chile, 1920. Studied painting and drawing at the Escuela de Bellas Artes in Santiago, 1939-45. Under an Italian government scholarship studied at the Academy of Fine Arts in Rome, 1950-52. Traveled in France and Spain. Since 1948 has held individual exhibitions in Santiago. Participated in national and international exhibitions. Won several prizes in national salons.

CRUZAT, Jorge. Painter, printmaker, born in Chile. Studied at the Escuela de Artes Aplicadas of Santiago, 1934-38. Exhibited in Chile and abroad, including the *Inter-American Exhibition of Chilean Painting*, circulating in the Americas, 1937-39.

DONOSO, Eduardo. Painter, born in Santiago, 1902. Studied in Paris at the Ecole des Beaux-Arts, 1920-23, and Academy of Louis F. Biloul, 1924-32. Traveled in Europe and the United States. Belongs to the *Grupo de los Independientes*. Held individual exhibitions in Paris and Santiago. Since 1924 has participated in many national and international exhibitions, including Parisian salons since 1928; international expositions in Seville (1929), and Barcelona (1932), Brussels (1935); *Inter-American Exhibition of Chilean Painting*, circulating in the Americas, 1937-39; and in Buenos Aires and Bogotá.

EGUILUZ, Augusto. Painter, born in Santiago, 1893. Studied with Albert Gilbert, London, 1911-13; Arturo Gordon, Santiago; at the Escuela de Bellas Artes, with Juan Francisco González, Santiago; and at the Académie de la Grande Chaumière, Paris, under a Chilean government fellowship. Belongs to the *Grupo de Montparnasse*. Traveled in Europe. Since 1927 has held individual exhibitions in Chile. Since 1926 has participated in many group exhibitions in Chile and abroad, including the *Latin American Exhibition of Fine and Applied Art*, Riverside Museum, 1939; the Golden Gate International Exposition, San Francisco, 1940; *Chilean Painting*, circulating the United States, 1942; Madrid and São Paulo biennials, 1951. Has won several prizes since 1928, including first prizes (1939) and the Prize of Honor (1948) in national salons in Santiago and Viña del Mar.

ESCAMEZ, Julio. Painter, muralist, draftsman, printmaker, born in Antihuala, Chile, 1926. At the age of sixteen, started his career as an assistant muralist to Gregorio de la Fuente for the fresco painting at the railroad station in Concepción. Studied mural painting, Escuela de Bellas Artes, with Laureano Guevara. Traveled to Italy and lived in Florence. In 1953 became professor of graphic arts and mural painting in Concepción (Chile), where he painted other murals. Exhibited in Chile and abroad, including the São Paulo Biennial, 1955.

FUENTE, Gregorio de la. Painter, muralist, born in Santiago, 1910, where he studied at the Escuela de Bellas Artes and worked as an assistant to Laureano Guevara, 1937. Worked under David Alfaro Siqueiros in the mural at Chillán. Study trips to France (1955) and Brazil (1955) under different scholarships. Executed a 270 square meter mural at the railroad station, Concepción (Chile), 1943-46. Exhibited in Chile, the United States, and the São Paulo Biennial, 1951. Was awarded several prizes in national salons (1939, 1940, 1941).

FUENZALIDA, Graciela. Sculptress, printmaker, draftsman, born in Concepción, Chile, 1916. Studied at the

Escuela de Bellas Artes and at the Universidad de Chile in Santiago. Was awarded several prizes in national salons, including First Medal, 1943 and 1954.

GALLINATO, René. Graphic artist, born in Chile. Studied at the Escuela de Bellas Artes, Santiago. Participated in several group exhibitions in Chile and abroad.

GAMBINO, Pascual. Painter, draftsman, born in Montevideo, 1891. Took up residence in Chile and studied with Nicanor González Méndez. Held individual exhibitions in Chile and Argentina. Participated in Chilean national salons winning a Medal of Honor, 1940.

GONZALEZ, Juan Francisco. Painter, born in Santiago, 1853. Died in Melipilla, Chile, 1933. Studied at the Academia de Pintura and under Juan Kirchbach and Juan Mochi in Santiago. Traveled in Latin America, Europe, and Morocco. Was a professor of drawing in Valparaíso and Santiago. Exhibited in Chile winning the Prize of Honor of the National Salon of 1898, among others.

GORDON VARGAS, Arturo. Painter, illustrator, born in Valparaíso, 1883. Died in 1944. Studied architecture; entered the Academia de Bellas Artes, 1904, where one of his teachers was Pedro Lira; also studied with Fernando Alvarez de Sotomayor, 1908-11. Belongs to the *Grupo de Montparnasse*. Illustrated magazines and books. Since 1908 exhibited in national salons winning several prizes, including First Medal, 1921. Was also awarded a prize at the *Centennial Exhibition*, Buenos Aires, 1910. Decorated with Laureano Guevara the Chilean Pavilion at the International Exposition of Seville, 1929, where he also exhibited.

GUEVARA, Laureano. Painter, muralist, draftsman, born in Molina, Chile, 1889. Studied at the Escuela de Bellas Artes, Santiago; Académie de la Grande Chaumière, Paris; and the Royal Academy of Fine Arts, Copenhagen, under a government of Chile fellowship, 1924-1928. Member of the *Grupo de Montparnasse*, held individual exhibitions in Chile and participated in international exhibitions, including the *Latin American Exhibition of Fine and Applied Art*, Riverside Museum, New York, 1939; Golden Gate International Exhibition, San Francisco, 1940. Decorated with Arturo Gordon the Chilean Pavilion at the International Exposition of Seville, 1929, winning a Gold Medal. Was awarded first prizes and gold medals in national salons, including First Prize for Mural Painting, Art Salon of the Quadricentennial of the City of Santiago de Chile, 1941.

HERMOSILLA, Carlos. Painter, draftsman, printmaker, born in Valparaíso, 1905. Studied at the Escuela de Artes Aplicadas and Escuela de Bellas Artes, Santiago. Since 1939 has been a professor of printing and sketching, Escuela de Bellas Artes, Viña del Mar. Exhibited in Chile, the United States, and other countries, including the *Inter-American Exhibition of Chilean Painting*, circulating in the Americas in 1937-39, and the 1951 São Paulo Biennial. Was awarded first prizes and gold medals in the national salons of 1937, 1938, and 1939 and Gold Medal at the *Exhibition of Chilean Artists*, Buenos Aires, 1942.

HUMERES, Roberto. Painter, architect, born in San Felipe, Chile, 1903. Studied at the Escuela de Bellas Artes and Universidad de Chile of Santiago, and in Europe under a Chilean government fellowship (1928), working and traveling for six years. Also attended urban studies courses at the Sorbonne. Exhibited in national and Parisian salons; Pittsburgh International, Pennsylvania 1935; *Latin American Exhibition of Fine and Applied Art*, Riverside Museum, New York, 1939; Golden Gate International Exposition, San Francisco, 1940, among others. Won several national prizes, including First Medal (1936), Gold Medal (Valparaíso, 1936), and First Prize in the Art Salon of the Quadricentennial of the City of Santiago de Chile, 1941.

LETELIER, Jorge. Painter, born Antofagasta, Chile, 1887. Studied at the Escuela de Bellas Artes in Santiago, and in France and Spain. Exhibited in Chile and abroad, including the International Exposition in Seville, 1929; Pittsburgh International, Pennsylvania, 1935; *Inter-American Exhibition of Chilean Painting*, circulating in the Americas, 1937-39. Was awarded several prizes in national salons.

LOBOS, Pedro. Painter, draftsman, printmaker, musician, born in Putaendo, Chile, 1918. Studied at the Escuela de Artes Aplicadas of Santiago. Exhibited in Chile, Argentina, and the United States. Was awarded several prizes in national salons, including First Prize for Drawing, 1945.

LOPEZ RUZ, Alberto. Clay sculptor, draftsman, born in Chile. Participated in several national salons.

MATURANA, Draco. Painter, printmaker, engineer, born in Chile. Studied painting, Escuela de Bellas Artes, Santiago, 1942-47; printmaking, Escuela de Artes Aplicadas, during six years; and in 1955 at the S.W. Hayter's Atelier 17 in Paris, under a French scholarship. Held individual exhibitions in Chile. Participated in national salons and the 1953 São Paulo Biennial.

MONTERO, Germán. Sculptor, ceramist, born in Chile. Held individual exhibitions in Santiago. Participated in several national salons.

MOREL, Olga. Painter, born in Chile. Studied at the Escuela de Bellas Artes, Santiago. Held individual exhibitions in Santiago and other cities in Chile. Participated in group exhibitions in Chile, Colombia, Venezuela, Spain, and the United States. Was awarded First Prize for Painting, National Salon, Santiago, 1955, among other awards.

OSSANDON, Carlos. Painter, writer, art critic, born in Santiago, 1900. Studied with Pedro Reszka. Traveled in Europe. Writes on a variety of art subjects in *El Imparcial* and *El Diario Ilustrado* and published several books, including a monograph, *Alfredo Valenzuela Puelma*, Santiago, 1934. Exhibited in Chile and abroad, including the *Inter-American Exhibition of Chilean Painting*, circulating the Americas, 1937-39; *Latin American Exhibition of Fine and Applied Art*, Riverside Museum, New York, 1939. Was awarded prizes in national salons.

PARADA, Francisco. Painter, printmaker, architect, born in Chile, 1910. Studied in Santiago at the Escuela de Artes Aplicadas and with Marco Bontá. Professor of graphic arts in Santiago, where he held one individual exhibition. Participated in national and international group shows, including the São Paulo Biennial, 1951. Was awarded prizes in national salons.

PEDRAZA, Carlos. Painter, born in Taltal, Chile, 1913. Studied at the Escuela de Bellas Artes, Santiago. Held individual exhibitions in Chile. Participated in national and international group shows, including the São Paulo Biennial, 1951. Won several awards in national salons in Santiago, including First Prize for Painting in 1941 and the Prize of Honor in 1949.

PERALTA, Tole. Painter, born in Chile, 1920. Studied at the Escuela de Bellas Artes and also with John Duguid in Valparaíso, London, and Paris. Exhibited in Chile.

PEROTTI, José. Painter, printmaker, sculptor, ceramist, born in Santiago, 1898, where he studied sculpture at the Escuela de Bellas Artes. Through a Chilean government scholarship also studied at the Escuela de Bellas Artes in Madrid, under Romero de Torres, Sorolla, and Miguel Blay, 1920; and under Bourdelle in Paris. Through a Humboldt fellowship took courses in painting, sculpture, and applied arts in Germany for two years. Belongs to the *Grupo de Montparnasse*. Was a professor of sculpture at the Escuela de Bellas Artes in 1927 and since 1929, and for many years, directed the Escuela de Artes Aplicadas. Exhibited in national and international group shows such as the *Inter-American Exhibition of Chilean Painting*, circulating in the Americas in 1937-39. Won several national awards, including First Prize for Sculpture in 1919 and the National Prize for the Arts in 1953.

PINEDO, Maruja. Painter, draftsman, born in Iquique, Chile, 1907. Studied at the Escuela de Bellas Artes of Santiago, and painting, drawing, and composition at the Ozenfant Academy, New York. Traveled in South and North America, the Caribbean, and Europe. Held individual exhibitions in Chile, Buenos Aires (1948), Rio de Janeiro (1950), Lima (1951), and New York (1952). Participated in national and international group shows. Since 1939 has won several prizes and medals in national salons, including First Prize, International Salon, Valparaíso.

PINO, Héctor. Draftsman, printmaker, born in Chile. Studied at the Escuela de Artes Aplicadas in Santiago, under the direction of Marco A. Bontá. Participated in group exhibitions in Chile.

PLAZA, Exequiel. Painter, born in Chile, 1892. Died in 1947. Studied in Santiago at the Escuela de Bellas Artes and under Fernando Alvarez de Sotomayor. Exhibited in national salons where he won the Prize of Honor in 1924.

POBLETE, Aída. Painter, born in Temuco, Chile, 1916. Studied in Santiago at the Escuela de Bellas Artes under Pablo Burchard. Exhibited in group and individual exhibitions in Chile and the United States. Won several awards in Chile.

RODIG, Laura. Sculptress, painter, printmaker, born in Chile, 1901. Studied at the Escuela de Bellas Artes, Santiago; and with André Lhote in Paris, through a Chilean government scholarship, 1928. Taught art to Indian children in Chile (1918-26) and Mexico (1932-37). Traveled in Europe and the United States. Exhibited in Chile, Mexico, the United States, Spain, and France (including Parisian salons); *Latin American Exhibition of Fine and Applied Art*, Riverside Museum, New York, 1939. Since 1914 has won several first prizes in Chile and Gold Medal, *International Exhibition*, Seville, 1929.

ROMAN, Benito. Ceramist, sculptor, born in Rancagua, Chile, 1915. Studied at the Escuela de Artes Aplicadas of Santiago. Since 1945 has been a professor of ceramics at the Escuela de Bellas Artes, Viña del Mar. Participated and won first prizes in national salons.

ROMAN, Héctor. Ceramist, sculptor, born in Chile. Participated in several national salons winning First Prize, Viña del Mar, 1939.

SANTELICES, Raúl. Painter, born in Chile, 1916. Studied at the Escuela de Bellas Artes of Santiago, under Augusto Eguiluz, 1935; with Cândido Portinari, Rio de Janeiro, 1944. Held individual exhibitions in Chile and abroad, including the Museu Nacional de Belas Artes, Rio de Janeiro, 1944. Participated in national and international shows in Chile and in the São Paulo Biennial, 1953. Has won several prizes in national salons since 1936, when he was awarded a fellowship to study at the Universidad de Chile, and in 1945 was awarded the First Prize for Painting.

SARAGONI, Fernando. Printmaker, born in Chile. Studied at the Escuela de Artes Aplicadas in Santiago.

SEPULVEDA, Viterbo. Graphic artist, ceramist, born in Chile, 1926. Studied at the Escuela de Artes Aplicadas, Santiago. Held individual exhibitions in Santiago. Participated in group exhibitions in Chile, Peru, and Germany.

SILVA, Ciro. Printmaker, born in Chile. Participated in national salons, winning an award in 1945.

SOLON, Walter. Painter, muralist, printmaker, born in Sucre, Bolivia, 1925. Studied at the Escuela de Bellas Artes, La Paz, 1939; Escuela de Artes Aplicadas, Santiago, 1944-50. Executed the mural *Bolivia* at the Palacio de Bellas Artes in Santiago, and a fresco at the University of Chuquisaca (Bolivia), 1951. Organized the first School of Muralists in Sucre (Bolivia, 1950). Held individual exhibitions in Bolivia and Chile. Won First Prize for Printmaking, National Salon, Santiago, 1947.

VALENZUELA LLANOS, Alberto. Painter, born in San Fernando, Chile, 1869. Died in Santiago, 1925. Studied at the Escuela de Bellas Artes of Santiago, with Cosme San Martín and Pedro Lira; in Paris in 1901, under a Chilean government scholarship; and later attended the Académie Julian in that same city. Exhibited in national and Parisian salons. Won several national awards (including the Prize of Honor, 1903), international prizes in Paris, and the Gold Medal, Centennial Exhibition, Buenos Aires, 1910.

VALENZUELA, Arturo. Painter, born in Antofagasta, Chile, 1900. Studied at the Escuela de Bellas Artes and

Instituto Pedagógico, graduating as a professor of drawing. Exhibited in Chile, Spain, and the United States, including the Golden Gate International Exposition, San Francisco, 1940, and the São Paulo Biennial of 1951. Won several awards, including First Prize, National Salon, Santiago, 1941.

February 21 - March 17, 1956

VICENTE MARTIN OF URUGUAY: OILS

Art in Uruguay has always been international in flavor, and at various periods the country has produced figures whose fame extended far beyond the national borders. Among these, during the nineteenth century, one must mention Juan Manuel Blanes and, at the beginning of the twentieth, Rafael Barradas, followed a little later by the intimate Pedro Figari. These last two depicted life in colonial Montevideo in paintings which were widely acclaimed in Europe.

At the same time, Joaquín Torres-García was striving to integrate the rigid, geometrical principles of pre-Columbian American art with the tenets of the constructivist school. In this effort he was successful and today, seven years after his death, he is considered one of the most important personalities in Latin American art. In an attempt to perpetuate his aesthetic theories, he established in Montevideo a workshop which is still active in the promotion of constructivism throughout the La Plata region.

Vicente Martín, after a short period of apprenticeship at the Fine Arts Circle in Montevideo, entered the Torres-García Workshop and was trained by its founder to translate reality into a new language of forms. However, Martín's independent viewpoint impelled him to abandon the rigid orthodoxy of the master's principles and work out a mode of expression of his own. Martín nevertheless admits his debt to Torres-García for broadening his field of artistic vision.

Vicente Martín was born in Montevideo in 1911. He has traveled in Europe, visiting both London and Paris; in the latter city he attended the art courses of Othon Friesz and those given at the Grande Chaumière. He was at one time curator of the National Museum of Fine Arts in Montevideo, and at present he is a professor of drawing and painting at the National School of Fine Arts. He has held several one-man shows in his native country, and works by him have been included in the Uruguayan selection at the three biennials in Sao Paulo, Brazil. He exhibited in Paris in 1947, in Quito in 1955, and in Buenos Aires in 1948 and 1956. His work is to be found in the national and municipal museums of fine arts in Montevideo, in the Museum of Modern Art in Santiago de Chile and in São Paulo, and in private collections in both Europe and the New World. This is the artist's first one-man show in the United States.

CATALOGUE

Oils on Paper

1. *Cabeza de india (Head of an Indian Woman)*
2. *La mujer del collar (Woman with Necklace)*
3. *Paisaje (Landscape)*
4. *El niño loco (Mad Boy)*
5. *Gallo de riña (Fighting Cock)*
6. *Torso*
7. *Bailarina (Ballerina)*
8. *La mujer del collar (Woman with Neck Ornament)*
9. *Charrúa (Charruan)*

10. *Pez (Fish)*
11. *Serenata (Serenade)*
12. *Dolor (Pain)*
13. *Paisaje con sol (Landscape with Sun)*
14. *Countenance*[1]
15. *Niña en camisa (Girl in Chemise)*
16. *Pájaro en la noche (Bird at Night)*
17. *Gallo asustado (Frightened Rooster)*
18. *Cabeza (Girl's Head)*
19. *Cabeza de guerrero (Head of a Warrior)*
20. *Desnudo (Nude)*
21. *Personage*[1]
22. *Cabeza de negra (Head of a Negro Woman)*
23. *Cabeza (Head)*
24. *Campesinos (Country People)*
25. *Niña con jaula (Girl with Cage)*
26. *Cabeza (Woman's Head)*
27. *Figura (Figure)*
28. *Virgen niña (The Virgin Mary as a Child)*
29. *Face*[1]
30. *Visage*[1]

March 21 - April 10, 1956

LITURGICAL ART FROM CANADA

Canada is the only nation in this hemisphere that does not belong to the Organization of American States. Nevertheless, since our plan of exhibits is to give a complete panorama of art in the Americas and to represent each country at least once, we are exhibiting for the first time the works by a group of our northern neighbors. It is particularly fitting that this show should coincide with Holy Week, since the works composing it originated with Le Retable, an association of French-Canadian artists from the Province of Quebec who are primarily interested in religious art.

Le Retable was formed in 1946. Its members include Father Wilfrid Corbeil, painter, sculptor, and architect; Father André Lecoutey, painter and sculptor; Sylvia Daoust, sculptress; Gilles Beaugrand, goldsmith; Bertrand Vanasse, ceramist; Maurice Raymond, painter; and Marius Plamondon, artist in stained glass and sculptor.

Everything relating to the liturgy of the church and within the realm of the plastic arts is of interest to Le Retable. The talents of the group enable its members to meet needs in all fields, from architecture, painting, sculpture, and the designing and execution of stained glass windows, to work in gold, silver, wrought iron and ceramics, and the production of vestments, linens, and furniture.

In the service of God, no work is of minor importance: even the humblest article becomes worthy of aesthetic treatment. With this thought in mind, the artists and craftsmen of Le Retable aim at unity of conception and a harmony among the finished objects as each takes its place in the general fabric of the end product, the church.

[1] In the Spanish list used during this exhibition, all these titles appeared as *Cabeza* (Head). —*Ed.*

CATALOGUE

Father Max Boucher
 1. *Head of Christ*, stone
 2. *Madonna*, wood

Father Wilfrid Corbeil
 3. *Crucifixion*, wood
 4. *Candlestick*, gold and crystal, executed by Gilles Beaugrand

Sylvia Daoust
 5. *Joan of Arc*, wood

Marcel Dupond
 6. *Assumption*, painting

Loise Gadbois
 7. *Annunciation*, painting

Louis Grypinich
 8. *Missal*, enamel

Yvan Landry
 9. *Madonna*, ceramic

Father André Lecoutey
10. *Visitation*, painting

Les Ateliers Saint-Viateur
11. *Saint Viateur*, iron and brass

Marius Plamondon
12. *The Way of the Cross*, two panels

Maurice Raymond
13. *Christ*, painting
14. *Annunciation*, painting

René Thibault
15. *Figures*, ceramic

16. *Chalice*, collective work: design, Father Corbeil; enamel, M. Dupond; ivory, Charuet; execution, Les Ateliers
 Saint-Viateur

Models

17. *Indian Church*
18. *Christmas Crib*

Textile

19. *Liturgical Vestments*, home spun

Photos and plans[1]

[1] Titles are unavailable. —*Ed.*

April 12 - May 19, 1956

ZAÑARTU OF CHILE: OILS AND ENGRAVINGS

Enrique Zañartu is representative of an increasing trend among Latin American artists toward self-expression in international idiom. Producing work which is displayed on terms of equality with that of the leading creative artists of New York and Paris today, he has met with favorable critical reception wherever he has exhibited.

Though born in Paris in 1921, Zañartu is a citizen of Chile, being the son of Chilean parents who took him back to their native land when he was still very young. He began his artistic education in 1944 as a student of engraving in S.W. Hayter's Atelier 17 in New York. In 1946 he went to Cuba, where he took up painting. Later he returned to New York, and in 1949 he journeyed to Paris, where he has lived ever since. There he held one-man shows at the Galerie Creuze in 1950, and at the Galerie du Dragon in 1955. He presented individual exhibits in Germany at the Springer Gallery in Berlin in 1952, and at the Frank Gallery in Frankfurt. His work has been included in numerous group shows both in Europe and in the United States.

Examples of Zañartu's work can be found in the Museum of Modern Art of New York, in the Stedelijk Museum of Amsterdam, the Museum of Jerusalem, the Museum of Wuppertal (Germany), the National Museum of Fine Arts in Santiago de Chile, and in numerous private collections in Europe and North and South America. In 1955 he was commissioned to illustrate two books of French poetry, *Mythologie du Vent* by Jacques Charpier, and *Les Indes* by Edouard Glissant.

In connection with his last exhibit in Paris, the critic Yvonne Hagen said that the painting of Zañartu "has to do with broken-off elements; paths that stop and become soft, woody corners, or skidding skies in whites, jumping across the canvas in roaring movement, back again to deep silent areas." The critic Alain Jouffroy stated that Zañartu is "among the younger painters, one of the most representative of the modern spirit. His work has reached a point of exceptional balance." Still another critic, Luce Hoctin, described Zañartu's latest work as "rigorously even, and yet poetic—these two characteristics making his work among the most refined of our day." The Greek-American writer Nicolas Calas said that Zañartu's work "is a cosmos of line, color, plane, and pattern to which man has entrance."

The Maskin Gallery in New York is currently presenting examples of his work in conjunction with that of Matta, Dubuffet, and Giacometti. The exhibit at the Pan American Union is the first one-man show of Zañartu's art in the Washington area.

CATALOGUE

Oils

1. *Origins*, 1953
2. *Under the Grass*, 1953
3. *Siege II*, 1954
4. *Enraged Excursionist*, 1953
5. *Sower*, 1954
6. *Prisoners*, 1954
7. *Vagabonding*, 1954
8. *The Traveller and His Shadow*, 1955
9. *Displacement*, 1955
10. *Beachcomber III*, 1955
11. *Beachcomber II*, 1955
12. *Landscape*, 1955

13. *Forester*, 1955
14. *Couple No. 1*, 1955
15. *Couple No. 2*, 1955
16. *Landscape with Mountain*, 1955
17. *Players*, 1955
18. *By the Water*, 1955
19. *Landscape with Bird*, 1955
20. *On the Beach*, 1954
21. *In the Bullfight*, 1954
22. *The Sixth Day*, 1955
23. *Painting*, 1955
24. *Painting*, 1955

Engravings[1]

25. *Siege*
26. *Landscape*
27. *The Flame No. 1*
28. *The Cold Sun Image*
29. *The Flame No. 2*
30. *Cold Landscape*

April 27 - May 31, 1956

VENEZUELAN BIRDS BY KATHLEEN DEERY DE PHELPS
An Exhibition of Watercolors Sponsored by the Creole Petroleum Corporation

Kathleen Deery de Phelps (Mrs. William H. Phelps, Jr.), whose beautiful paintings are now first shown in North America, belongs to a distinguished Venezuelan family. Her father-in-law, dean of Venezuelan naturalists, is founder of the leading Museum of Ornithology in that country and the sponsor of numerous educational enterprises concerned with the nation's natural history. Her husband is also a distinguished ornithologist, explorer, geographer, and conservationist.

Mrs. Phelps has become a figure in the ornithological world in her own right. An Australian by birth, she is now a Venezuelan. With her husband she has carried on ornithological research in the remotest parts of the country, where her interests have also led her to make important botanical collections.

These sixty-four lovely paintings are the first major representation of Venezuelan birds. They have style and grace and charm. Faithful and accurate, they were chosen by the artist to represent a cross section of the bird families found throughout the country. They give an excellent impression of the variety and exotic quality of Venezuelan bird life, and are a testimonial to Phelps's talent and observation.

The Creole Petroleum Corporation is to be congratulated for publishing her charming book, *Aves venezolanas*, and for sponsoring this exhibition with the National Audubon Society.

I hope that in the future Mrs. Phelps will continue to expand her splendid dossier of Venezuelan birds. —*S. Dillon*

[1] Also exhibited but not included in the original catalogue. —*Ed.*

Ripley

CATALOGUE

1. *Corocoro (Scarlet Ibis), Eudocimus rubra*
2. *Güirirí (Black-Bellied Tree Duck), Dendrocygna autumnalis*
3. *Gavilán primito (Eastern Sparrow Hawk), Falco sparverius*
4. *Gallineta azul (Purple Gallinule), Porphyrula martinica*
5. *Gallito de agua (American Jacana), Jacana spinoza*
6. *Alcaravancito (Pied Plover), Hoploxypterus cayanus*
 Playero corredor (Thick-Billed Plover), Charadrius wilsonia
7. *Guaraguanare (Laughing Gull), Larus atricilla*
8. *Maraquita (Inca Dove), Scardafella squammata*
 Tortolita (Common Ground Dove), Columbigallina passerina
9. *Calzoncito (Black-Headed Caique), Pionites melanocephala*
10. *Loro real (Yellow-Headed Parrot), Amazona ochrocephala*
11. *Garrapatero (Smooth-Billed Ani), Crotophaga ani*
12. *Juan gil (Striped Cuckoo), Tapera naevia*
13. *Lechuza de campanario (Barn Owl), Tyto alba*
14. *Aguaitacamino (Pauraque), Nyctidromus albicollis*
15. *Vencejo grande (White-Collared Swift), Streptoprocne zonaris*
16. *Limpiacasa (Salle's Hermit), Phaethornis augusti*
 Tucuso (Gould's Violet-Ear), Colibri coruscans
17. *Rabo de machete (Blue-Tailed Sylph), Aglaiocercus kingi*
 Topacio (Crimson Topaz), Topaza pella
18. *Tucuso montañero (Collared Trogon), Trogon colaris*
19. *Martín pescador (Amazon Kingfisher), Chloroceryle amazona*
20. *Pájaro león (Blue-Crowned Motmot), Momotus momota*
21. *Tucuso de montaña (Rufous-Tailed Jacamar), Galbula ruficauda*
22. *Aguantapiedras (Two-Banded Puffbird), Hypnelus bicinctus*
23. *Pico de frasco (Groove-Billed Toucanet), Aulacorhynchus sulcatus*
 Piapoco (Sulphur and White Breasted Toucan), Ramphastos vitellinus
24. *Carpintero real (Black and White Woodpecker), Phloeoceastes melanoleucus*
25. *Pico de garfio (Red-Billed Sickle-Bill), Campylorhamphus trochilirostris*
26. *Tin (Handsome Fruit-Eater), Pipreola formosa*
27. *Gallito de rocas (Cock of the Rock), Rupicola rupicola*
28. *Saltarín cabecidorado (Golden-Headed Manakin), Pipra erythrocephala*
 Tintoro de lomo azul (Blue-Backed Manakin), Chiroxiphia pareola
 Saltarín cola de hilo (Cirrhate Manakin), Teleonema filicauda
29. *Duende (White-Headed Marsh-Tyrant), Arundinicola leucocephala*
 Sangre de toro (Vermilion Flycatcher), Pyrocephalus rubinus
30. *Tijereta (Fork-Tailed Flycatcher), Muscivora tyrannus*
31. *Pico chato (Yellow-Crested Flat-Bill), Platyrinchus mystaceus*
 Titirijí (Gray-Backed Tody-Tyrant), Todirostrum cinereum
 Atrapamoscas pigmeo (Pygmy Tyrant), Myiornis ecaudatus
32. *Golondrina azul (Blue and White Swallow), Atticora cyanoleuca*
 Golondrina de agua (White-Winged Swallow), Iridoprocne albiventer
33. *Piarro (Violaceus Jay), Cyanocorax violaceus*
34. *Querrequerre (Green Jay), Cyanocorax incas*
35. *Chocorocoy (Orinoco Banded Wren), Campylorhynchus nuchalis*
36. *Cucarachero pechicastaño (Rufous-Breasted Wren), Thryothorus rutilus*

Cucarachero (Southern House Wren), Troglodytes musculus
37. *Paraulata llanera (Tropical Mockingbird), Mimus gilvus*
38. *Paraulata de agua (Black-Capped Mockingbird), Donacobius atricapillus*
39. *Ojo de candil (Bare-Eyed Thrush), Turdus nudigenis*
40. *Sirirí (Rufous-Browed Pepper Shrike), Cyclarhis gujanensis*
 Sirirí real (White-Eared Greenlet), Smaragdolanius leucotis
41. *Payador (Cabanis' Diglossa), Diglossa baritula*
 Miellero verde (Green Honeycreeper), Chlorophanes spiza
42. *Tucuso de montaña (Red-Legged Honeycreeper), Cyanerpes cyaneus*
 Copeicillo violáceo (Purple Honeycreeper), Cyanerpes caeruleus
43. *Mielero turquesa (Blue Dacnis), Dacnis cayana*
 Reinita (Bananaquit), Coereba flaveola
 Reinita negra (Black Bananaquit), Coereba flaveola
44. *Reinita montañera (Olive-Backed Warbler), Parula pitiayumi*
 Canario de mangle (Golden Warbler), Dendroica petechia
 Coronita (Collared Redstart), Myioborus miniatus
45. *Arrendajo (Yellow-Rumped Cacique), Cacicus cela*
46. *Mirlo (Shiny Cowbird), Molothrus bonariensis*
47. *Gonzalito (Yellow Oriole), Icterus nigrogluaris*
48. *Turpial (Troupial), Icterus icterus*
49. *Maicero (Black and Yellow Oriole), Gymnomystax mexicanus*
50. *Turpial de agua (Yellow-Headed Marsh Bird), Agelaius icterocephalus*
51. *Tordo (Red-Breasted Blackbird), Leistes militaris*
52. *Perdigón (Common Meadowlark), Sturnella magna*
53. *Azulejo golondrina (Swallow Tanager), Tersina viridis*
 Verdín (Blue-Rumped Chlorophonia), Clorophonia cyanea
54. *Corona azul (Black-Throated Euphonia), Tanagra musica*
 Curruñatá azulejo (Orange-Bellied Euphonia), Tanagra xanthogaster
 Saucito (Yellow-Bellied Euphonia), Tanagra trinitatis
55. *Siete colores (Paradise Tanager), Tangara chilensis*
 Verdín (Speckled Tanager), Tangara Chrysophrys
56. *Cabeza de lacre (Bay-Headed Tanager), Tangara gyrola*
 Monjita (Rufous-Crowned Tanager), Tangara cayana
57. *Azulejo (Blue-Gray Tanager), Thraupis virens*
 Azulejo montañero (Golden-Vented Tanager), Thraupis cyanocephala
58. *Pico de plata (Silver-Beaked Tanager), Ramphocelus carbo*
 Candelo (Hepatic Tanager), Piranga flava
59. *Moriche Blanco (Magpie Tanager), Cissopis leveriana*
60. *Paraulata ajicera (Grayish Saltator), Saltator coerulescens*
61. *Cardenalito (Red Siskin), Spinus cucullatus*
 Bandera alemana (Black-Eared Cardinal), Coccopsis gularis
62. *Cardenal Coriano (Vermilion Cardinal), Richmondena phoenicea*
63. *Canario de tejado (Saffron Finch), Sicalis flaveola*
 Oficialito (Pileated Finch), Coryphospingus pileatus
 Correporsuelo (Rufous-Collared Sparrow), Zonotrichia capensis
64. *Sabanero coludo (Wedge-Tailed Ground Finch), Emberizoïdes herbicola*

May 21 - June 19, 1956

HUGO CONSUEGRA OF CUBA

The consecration of the modern group of painters of Cuba after 1940, in their own country and abroad, created a new interest in progressive art among the young students, and about 1950 a new group was formed called The Eleven, which included painters and sculptors under thirty years old. This group mainly followed a non-objective trend in contrast to the idealistic, poetical, and highly colored interpretation of reality assumed by the previous generation. One of the most outstanding and definite personalities in the group of The Eleven has been Hugo Consuegra, born in Havana in 1929, formerly a pupil at San Alejandro Academy and also an architect graduated from Havana's University last year.

Although Consuegra as an architect follows a rigid mathematical discipline, adapting his creations to a rigorous geometrical feeling, as a painter he lets his imagination flow in free forms and attains best advantage of the accidental in elaborate shapes and surprising textures. Although he has held only one one-man show, in Havana's Lyceum in 1953, his work has been included in many groups of Cuban paintings, such as in New York in the Galería Sudamericana at the end of 1955, and in Houston in the Museum of Fine Arts this year. On the occasion of the presentation of the former group, the critic Carlyle Burrows of the *New York Herald Tribune* said: "The paintings by Hugo Consuegra are abstract, with an arrestingly fluent, dreamlike substance." The artist has also been included in group shows in various parts of the island of Cuba.

Consuegra is already represented in several important collections in Cuba and abroad. This is his second one-man show and his first solo presentation in the United States.

We wish to express our appreciation to the following Washington collectors who have loaned their drawings by Consuegra for this exhibit: Mr. and Mrs. H. Gates Lloyd, Mr. Aurelio Giroud, Mrs. Mortimer Lebowitz, Miss Doris Mills, Mr. Celestino Sanudo, Miss Angela Soler, and Mr. and Mrs. George Wheeler.

CATALOGUE

Oils

 1. *En contra nuestra (Against Ourselves)*, 40 x 50"
 2. *Noche de guerra (Night of War)*, 40 x 50"
 3. *Estar ausente (Absent)*, 40 x 50"
 4. *Despertar (Awakening)*, 40 x 50"
 5. *Africa de frente (Looking at Africa)*, 40 x 50"
 6. *Caza mayor (Big Game Hunt)*, 40 x 50"
 7. *Octubre (October)*, 40 x 50"
 8. *Montescos y Capuletos (The Montagues and Capulets)*, 40 x 50"
 9. *La tarde vencida (Vanquished Afternoon)*, 25 x 40"
 10. *El dolor nocturno (Night Pain)*, 25 x 40"
 11. *Los bordes del éxito (Bordering Success)*, 25 x 40"
 12. *La venganza (Vengeance)*, 50 x 80"
13-14. *Collage*[1]
15-16. *Drawing*[1]

[1] Titles are unavailable. —*Ed.*

June 20 - July 9, 1956

AMANDA DE LEON OF VENEZUELA

The daughter of the Spanish portrait painter Rafael Andrade, Amanda de León was born in Spain in 1908 but was brought up in, and is a citizen of, Venezuela. Several years ago she went to live in New York where she began depicting scenes and memories of the South American country in which she was reared.

A self-taught artist, Amanda de León paints as a primitive with a graceful, feminine touch and a colorful palette. She has held various one-man shows at the Carlebach Gallery in New York which is representing her works in the United States, and in 1951 she exhibited at the Galerie Weil in Paris. The magazine *Arts* commented on this latter exhibit: "She charms us with her quality of color, her sincere naiveté, and her sense of humor."

Last year the Fine Arts Publishers of New York edited a monograph on the artist with color reproductions of her paintings and an introduction by the critic Duncan P. Osborne. Of her Mr. Osborne says: "She combines the fantastic with the real, the creative with the ornamental, resulting in decorative designs of a happy conception and rich imaginative value."

Miss de León's works are represented in some twenty museums and public collections in the United States, as well as in museums in France, Italy, England, Spain, Switzerland, Brazil, Ireland, India, Austria, Japan, Germany, and Canada.

CATALOGUE

Paintings

1. *The Cloud of Locusts*
2. *Sentinel*
3. *The Serenaders*
4. *Boulangerie (Bakery)*
5. *The Holy Family*
6. *Scene of Venice*
7. *In the Cornfield*
8. *The Friar*
9. *Flower Factory*
10. *Scene from the Ballet "Capricho Español"*
11. *Santa Claus*
12. *Farm Scene*
13. *Voyagers*
14. *Boy with Dogs*
15. *Hacienda*
16. *In the Seminary*
17. *Immigrants*
18. *Fourth of July*
19. *Woman Washing*

July 10 - August 7, 1956

JOSE ECHAVE OF URUGUAY

José Echave is outstanding among young Uruguayan artists of promise for the highly disciplined work which he has accomplished during the course of his short career. A self-taught painter, he was born in the Department of Salto, Uruguay, in 1921 and presented his first one-man show in the provincial capital at the age of twenty-four. His work has been included in group shows in Ecuador, Argentina, Switzerland, and the Netherlands, as well as in his native Uruguay. He held an individual exhibit at the Vert Galant Gallery in the capital, Montevideo, in 1954. A number of awards has been accorded him at the Uruguayan national salons.

Following a representative trend, Echave depicts Uruguayan life and types, especially those of the back country. As a sideline to his painting, during the last few years he has been working as a stage and costume designer for the Municipal Theater and other dramatic enterprises in Montevideo.

Examples of Echave's work are to be found in the Municipal Museum of Montevideo, Salto, Colonia, and San José, all in Uruguay, as well as in the country's National Museum of Fine Arts. He is represented in private collections in Uruguay and Argentina, and he has executed four murals in tempera and fresco in the city of Salto.

This exhibit at the Pan American Union is the first presentation of Echave's art in the United States.

CATALOGUE

Oils

1. *Trampero (Trapper)*, 100 x 80 1/2 cm.
2. *Vendedor de pájaros (Bird Vendor)*, 100 x 81 cm.
3. *Niños y trampas (Children and Cages)*, 100 x 81 cm.
4. *Mesa en el monte (Still Life)*, 100 x 81 cm.
5. *Carnaval del cerro (Carnival in the Hills)*, 94 x 74 cm.
6. *Guarases (Foxes)*, 97 x 65 cm.
7. *El niño de las caretas (Boy with Masks)*, 97 x 65 cm.
8. *Doma (Horse Breaking)*, 97 x 65 cm.
9. *Máscaros (Costumed Men)*, 97 x 65 cm.
10. *Jacú muerta (Dead Bird)*, 80 x 66 cm.
11. *Riña de teros (Birds Fighting)*, 80 x 66 cm.
12. *Pájaros del estero (Inlet with Birds)*, 80 x 60 cm.
13. *Three Men,*[1] 80 x 60 cm.
14. *Viejo paisano (Old Man)*, 71 x 56 cm.
15. *Sartas (Catch of Fish)*, 80 x 45 cm.
16. *Vendedor de caretas (Mask Vendor)*, 80 x 45 cm.
17. *Murguista (Masked Man)*, 60 x 50 cm.
18. *Carguero (Pack Horse)*, 60 x 50 cm.
19. *Caballos (Horses)*, 60 x 50 cm.
20. *Potrillos blancos (White Colts)*, 60 x 50 cm.

[1] In the Spanish list used during this exhibition, this title appears as *Gente del corso* (Carnival People). —*Ed.*

Temperas

21. *Caballería de barro (Cavalry in Clay)*, 43 x 32 cm.
22. *Contrabandista (Smuggler)*, 43 x 32 cm.
23. *Lavandera (Washerwoman)*, 43 x 32 cm.
24. *Bombisto (Carnival Time)*, 43 x 32 cm.
25. *Zorro y teros (Fox and Birds)*, 43 x 32 cm.
26. *Lavanderas del río (Washerwomen of the River)*, 46 x 32 cm.
27. *Petizos (Ponies)*, 46 x 32 cm.
28. *Muñecas de bananal (Dolls)*, 43 x 32 cm.
29. *Gurí (Young Boy on Horseback)*, 43 x 32 cm.
30. *Pajareros (Birdcatchers)*, 46 x 32 cm.

August 9 - September 10, 1956

TWO ARTISTS FROM MEXICO: FERNANDO BELAIN, GELES CABRERA

Continuing its program for acquainting the public with the work of young creative artists of Latin America, the Pan American Union presents at this time a joint exhibition of two Mexicans of the rising generation. Unrelated in school, trend, or group, they are alike in banning political content from their work—in seeking to express national tradition without adopting nationalistic platforms.

Fernando Belain was born in Mexico City in 1921. He attended the Philadelphia School of Industrial Art from 1939 to 1943. In the latter year he joined the United States Army and was attached to its Special Services until 1946. While stationed in Germany, he executed a stage design in Bad Kissingen and there exhibited some of his work. His first one-man show took place in Mexico City in 1948 at the Mexican-American Cultural Institute, and he has taken part in group exhibits at Mexico City College, where he teaches art history and applied arts. He was recently appointed director of applied arts at the Design and Decoration Center in the Mexican capital. In addition to his army services overseas, Belain has traveled widely in Europe, Africa, and the Americas. His works figure in a number of important private collections in the United States, France, and Latin America. This is his first public presentation in the United States.

Geles Cabrera was born in Mexico City in 1928. She studied at the Academy of San Carlos there, and later took courses in sculpture at the Academy of San Alejandro in Havana, in which city she resided during 1948 and 1949. She participated in two group shows in the Cuban capital, at one of which she received an award. She has held several individual exhibits, the first in 1949 at the Mont Orendain Gallery in Mexico City, and two others at the Gallery of Modern Art in the same city in 1950 and 1952. Geles Cabrera has frequently figured in Mexican group shows, and one of her works was recently included in the *Gulf Caribbean Art Exhibition*, which was held at the Museum of Fine Arts of Houston and is now being circulated among other museums of the United States. Sculptures by her are to be found in the Museum of Fine Arts of Mexico City and in several private collections of her own country and the United States. This is her first exhibit in this country.

CATALOGUE

Fernando Belain

Oils on Canvas

1. *Huida a Egipto (Flight into Egypt)*, 130 x 88 cm.

2. *Huida a Egipto (Flight into Egypt)*, 61 1/2 x 46 1/2 cm.
3. *Madonna*, 61 1/2 x 46 1/2 cm.
4. *Paisaje (Landscape)*, 32 x 61 cm.
5. *Mujer (Woman)*, 61 x 61 cm.
6. *Pastores (Shepherds)*, 110 x 92 cm.
7. *Paisaje (Landscape)*, 100 x 76 cm.
8. *Naturaleza muerta (Still Life)*, 100 x 75 cm.
9. *Paisaje (Landscape)*, 100 x 91 1/2 cm.
10. *Nacimiento (Birth)*, 130 x 100 cm.
11. *Mujer con mandolina (Woman with Mandolin)*, 130 x 100 cm.
12. *Cristo (Christ)*, 130 x 100 cm.
13. *Asís (Assisi)*, 130 x 88 cm.
14. *Cristo (Christ)*, 130 x 165 cm.

Oils on Paper

15. *El Rey (The King)*, 65 x 50 cm.
16. *Flautista (Flutist)*, 65 x 50 cm.
17. *Fumadores de opio (Opium Smokers)*, 65 x 50 cm.
18. *Sueños (Dreams)*, 65 x 50 cm.
19. *Sueños (Dreams)*, 65 x 50 cm.
20. *Dolor (Pain)*, 65 x 50 cm.
21. *Adolescente (Adolescent)*, 65 x 50 cm.
22. *Colgado (Hanging)*, 65 x 50 cm.
23. *Estudio y modelo (Study and Model)*, 65 x 50 cm.
24. *Pareja (Couple)*, 65 x 50 cm.
25. *Fantasía (Fantasy)*, 65 x 50 cm.
26. *Mujer (Woman)*, 32 1/2 x 51 cm.
27. *Mercado (Market)*, 32 1/2 x 50 cm.
28. *Amazona (Amazon)*, 33 x 50 cm.
29. *Mujer orando (Woman Praying)*, 21 x 34 cm.
30. *Mujer con gallo (Woman and Cock)*, 38 x 50 cm.

Geles Cabrera

Sculptures

1. *Pareja (Couple)*, stone, 60 x 30 cm.
2. *Hombres luchando (Men Fighting)*, 18 1/2 x 33 cm.
3. *Estudio de movimiento (Study of Movement)*, 41 x 30 cm.
4. *Mujer yacente (Recumbent Woman)*, 15 x 43 cm.
5. *Relieve de niña (Girl Relief)*, 33 x 26 cm.
6. *Bailarina (Ballerina)*, 33 x 19 cm.
7. *Torso*, 29 x 12 cm.
8. *Maternidad (Maternity)*, 24 x 21 cm.
9. *Niña con muñeca (Girl with Doll)*, 22 x 14 cm.
10. *Figura sedente (Seated Figure)*, 25 x 15 cm.
11. *Mujer (Woman)*, 42 x 28 cm.
12. *Mujer sentada (Seated Woman)*, 41 x 23 cm.
13. *Reposo (Repose)*, 13 x 12 cm.

August 28 - October 4, 1956

NACHO LOPEZ, PHOTOGRAPHER OF MEXICO

Only a country with a certain degree of maturity can appreciate an attempt to investigate marked contrast in its living conditions from an artistic point of view. First among the American nations, Mexico has set an example in this line, not only in the realm of literature and the graphic and plastic arts, but also in the field of cinematography. A centuries-old melting pot of Spanish and Indian cultures, Mexico is a land of vigorous life. Its artists probe the lower depths, seeking to derive from the intense vitality of the masses an aesthetic essence which will impart character and meaning to their work.

The press photographer Nacho López is representative of those Mexican artists who endeavor to express a message in terms of the adverse and the negative. Although he employs a different medium, one which always retains the intrinsic values of photography as an art, quite independent of pictorial qualities, he nevertheless pursues substantially the same aim as his fellow countrymen José Guadalupe Posada, in engravings, José Clemente Orozco, in murals, and José Luis Cuevas, in drawings.

Nacho López was born in Tampico in 1925. By the age of fourteen he was already an outstanding amateur photographer, and he had founded a club for other enthusiasts in Mérida, Yucatán. In 1946 he went to Mexico City and began to work as a graphic reporter for two different magazines there; later he became the laboratory man and general assistant to Víctor de Palma, *Life* correspondent in Mexico. After a short period as a commercial photographer, he became camera assistant to Kenneth Richter, a specialist in documentaries, and at the same time he studied cinematographic techniques with Manuel Alvarez Bravo and Ricardo Razetti at the Mexican Academy of Motion Picture Arts.

In 1948 he himself gave a course in the techniques of photography in Caracas, at the School of Journalism of the Central University of Venezuela. López has been a graphic reporter for such well-known magazines as *Así*, *Mañana*, *Hoy*, and *Siempre*, and has served as correspondent for the United States picture agency Black Star. His assignments have taken him to all parts of his own country and to several nations in Central and South America.

This exhibit consists of ten series, each with a general title, no names being assigned to the individual prints composing the group. Save for the experimental sequence *Proportion in Motion* devoted to the art of the dance, each represents a deeply penetrating and profoundly human approach to the daily life of Mexico, the work of a wandering reporter who observes the humble aspects of everyday existence with an inquisitive and imaginative eye, revealing aesthetic values which otherwise pass unperceived.

This exhibition was originally presented in Mexico City in November of 1955 at the Salón de la Plástica Mexicana, a gallery belonging to the National Institute of Fine Arts. It is through the courtesy of that gallery that the Pan American Union is able to offer this, the first showing of López's work in the United States.

The master of Mexican photographers, Manuel Alvarez Bravo, stated in his preface to the catalog which accompanied the exhibit in Mexico City:

> López treats his photographs not as mere items for mass reproduction but as objects which can be admired for their intrinsic qualities as finished works of photography, for the harmony of their tonal values, for their spatial composition, for the subject matter or lack thereof, and for the human reaction captured.

In July of this year López completed his work as cameraman of the documental motion picture *Nuevos horizontes* (New Horizons) for the Instituto Nacional Indigenista of Mexico. At present he is collecting photographic material for a book he is preparing entitled "El mundo indígena" (The World of the Indians).

CATALOGUE

Photographs

1. *Día de fiesta (Fiesta)*
2. *Dimensión en movimiento (Proportion in Motion)*
3. *Yo también he sido niño bueno (Once Upon a Time . . .)*[1]
4. *Sólo los pobres van al infierno (Hell Is for the Poor)*
5. *Lo sagrado y lo mágico (Presence of the Unseen)*[1]
6. *La muerte es una siesta (Death Is a Siesta)*
7. *Ventanas (Windows on Life)*
8. *El sabor de las cosas simples (The Magic of the Commonplace)*
9. *Trabajo sin sueños (The Shadow of Toil)*[1]
10. *Módulos y temperaturas (Counterpoint)*[1]

September 11 - October 8, 1956

EDUARDO RAMIREZ OF COLOMBIA: PAINTINGS

Among young Colombian artists of the avant-garde, Eduardo Ramírez Villamizar, together with the sculptor Edgar Negret, represents the non-objective trend. Clean, meticulous, geometric forms characterize his art—an art which is the product of tireless, conscientious study and rigorous training, an art which has won for him a place of first rank in Colombia today.

Ramírez was born in Pamplona, Colombia, in 1923. He studied at the School of Architecture of the National University and at the School of Fine Arts, both in Bogotá. Later he became a professor of painting and sculpture at the School of Ceramics in the same city.

Ramírez held his first one-man show at the Society of Engineers in Bogotá a decade ago. Later his work appeared in group shows both in the capital and in other cities of Colombia. In 1949 he figured in a joint exhibition with his fellow countrymen Edgar Negret and Enrique Grau at the New School for Social Research in New York. In 1950 Ramírez traveled to Paris and held an individual exhibit at the Arnaud Gallery. Two years later he returned to Colombia and presented works characteristic of his new, abstract mode of expression in a one-man show at the National Library in Bogotá. It was at this time that he initiated his work in the field of sculpture. In 1955 he executed his first mural, non-objective in character, for the offices of the Bavaria Brewing Company in Bogotá. In that same year he returned to Europe and traveled through France and Italy until this last spring, when he went to New York and there created most of the paintings in the present exhibit.

This is Ramírez's first one-man show in Washington. Examples of his work, however, were included in a group exhibition of modern Colombian painters at the Pan American Union in 1949. One of his paintings and one of his aluminum sculptures are currently featured in the Colombian section of the *Gulf Caribbean Art Exhibition* organized by the Houston Museum of Fine Arts, which is being circulated to museums throughout the United States.

[1] Literal translations of these titles are: no. 3, "I Have Also Been a Good Boy;" no. 5, "The Sacred and the Magic;" no. 9, "Dreamless Work;" no. 10, "Modules and Temperatures." —*Ed.*

CATALOGUE

Paintings

1. *Un vaso azul (Blue Glass)*, 1953
2. *Paisaje lunar (Lunar Landscape)*
3. *Nocturno (Nocturne)*
4. *Composición para mural (Composition for a Mural)*
5. *Ventana azul (Blue Window)*
6. *Composición dorada (Composition in Gold)*
7. *Rojo y amarillos (Red and Yellows)*
8. *Composición lunar (Lunar Composition)*
9. *Composición con grises (Composition in Grey)*
10. *Nudo negro-azul (Knot in Black and Blue)*
11. *Composición con triángulos (Composition in Triangles)*
12. *Dibujo sobre un fondo (Design Against a Background)*
13. *Cuasi simétrico (Almost Symmetrical)*
14. *Máscara blanca y negra (Black and White Mask)*
15. *Tensión horizontal (Horizontal Tension)*
16. *Recuerdo maya (Mayan Reminiscence)*
17. *Díptico (Diptych)*
18. *Fondo ocre (On an Ocher Background)*
19. *Collage paisaje (Landscape Collage)*
20. *Collage circular (Circular Collage)*

October 10 - November 5, 1956

RENE PORTOCARRERO AND RAUL MILIAN OF CUBA

Born in Havana in 1912, taking up painting at an early age, but remaining entirely self-taught, René Portocarrero is an outstanding figure in the generation which initiated the modern art movement in Cuba. His early career was largely devoted to a baroque rendition, in flowing lines, of national subjects with particular emphasis upon colonial interiors, old patios in Havana suburbs, and the stained glass windows which were a common feature of Cuban houses built around the turn of the century. More recently, he has turned to a poetic interpretation of reality in which characters and personages of fantasy may also appear.

Portocarrero has executed several murals in Cuba as well as stage and costume designs for plays and ballets. He has participated in all modern Cuban shows presented abroad—in Argentina, France, Guatemala, Haiti, Mexico, Russia, Sweden, and the United States. One-man exhibits of his work took place at the Julian Levy Gallery in New York in 1945, and in Guatemala City in 1947. His work has figured in the three biennials of São Paulo, Brazil. It is represented in more than ten United States museums, including the San Francisco Museum of Art and the Museum of Modern Art of New York, and it is included in the collections of the Museum of Modern Art of Rio de Janeiro, Casa de la Cultura Ecuatoriana of Guayaquil, and the two principal museums of Santiago, Chile. The Broadway producer Joshua Logan is the owner of a large number of Portocarreros, and others belong to Hollywood artists James Stewart, Henry Fonda, José Ferrer, and Margaret Sullavan. Currently examples of his work are to be found in three group exhibits in the United States: the *Gulf Caribbean Art Exhibition* of Houston; *Cuban Painting Today*, organized by the American Federation of Art; and a Cuban group show at the Roland de Aenlle Gallery in New York.

Like Portocarrero with whom he has long been associated, Raúl Milián is a native of Havana. Both in years and in artistic experience he is somewhat the former's junior: he was born in 1914 and made his debut in Cuban art only six years ago. A student of philosophy, Milián at first produced a series of highly intricate drawings of a non-objective nature. Later he began to depict human forms in an austere, expressionistic fashion. Individual exhibits of his work were held in 1953 at the Robert Hull Fleming Museum in Burlington, Vermont, and at the Picture Loan Society of Toronto, Canada, and last year at the University of Havana. He figured in the three São Paulo biennials, and examples of his production are to be found in the same museums as those of Portocarrero.

This exhibit has been made possible chiefly through the collaboration of Mr. Joseph Cantor of Indianapolis, Indiana, a collector who not only owns a large number of works by both artists, but also has generously presented others to museums in the United States and Latin America. The Pan American Union also expresses its thanks to other collectors who have lent pictures for this exhibit, which is the first showing of the work of Portocarrero and Milián in the Washington area.

The following have loaned works for the exhibit: Mr. Joseph Cantor, Indianapolis, no. 1-8 and 15-26; the Museum of Contemporary Art, Santiago, Chile, no. 9 and 26; the Museum of Fine Arts, Santiago, Chile, no. 10 and 25; Miss Angela Soler, Washington, D.C., no. 12 and 34; Dr. Aurelio Giroud, Washington, D.C., no. 13; Dr. and Mrs. Joaquín Fermoselle Bacardí, Washington, D.C., no. 14; Lt. and Mrs. Roberto Corredera, Silver Spring, Maryland, no. 33.

CATALOGUE

René Portocarrero

Oils

1. *Composition in Red, White and Blue*
2. *The City*
3. *Figure in Rose*

Temperas

4. *Study in Red*
5. *The Fans*
6. *Opal Fantasy*
7. *Imperial Purple*
8. *The Forge*
9. *Marine Signals*
10. *Future of the Rose*
11. *Promenade*
12. *Head of Woman*
13. *Witch*
14. *Witch*

Drawings

15. *Marine*
16. *King*
17. *Queen*

Raúl Milián

Ink Drawings

18. *Composition No. 43*
19. *Composition No. 37*
20. *Composition No. 34*
21. *Composition No. 47*
22. *Composition No. 30*
23. *Composition No. 40*
24. *Composition No. 32*
25. *Composition No. 35*
26. *Composition No. 44*
27. *Man in Red*
28. *Blue Face*
29. *Man with Helmet*
30. *The Couple*
31. *The Oracle*
32. *Man in Gray*
33. *Composition in Red*
34. *Composition in Ocher*

November 14 - December 11, 1956

FIFTEEN PAINTERS OF CHILE

From January 25th to February 15th of this year, the Pan American Union presented in the corridor of its main building an exhibition of paintings, sculptures, and graphic arts organized by the Institute of Plastic Arts of the University of Chile. Since the Institute's selection was made chiefly from the works of artists who had won prizes at the national salons over a period of years, the exhibit reflected mainly the cautious, conservative trend followed by a number of very distinguished contemporary Chilean artists.

As a complement to that exhibit, the Department of Culture of the Ministry of Education of Chile has organized the present show in representation of the more advanced tendencies current in the country's painting today. Research and exploration of new fields are characteristic of the work of the avant-garde. Far from speaking a single language, the members thereof take a variety of approaches ranging from poetic realism to abstraction, thereby imparting an international flavor to contemporary artistic production in the southern republic.

With the exception of the painters Nemesio Antúnez and Pablo Burchard, Jr., who have held one-man shows at the Pan American Union, the artists now presented are being exhibited in Washington, D.C. for the first time. Grateful acknowledgement is made to the Department of Culture of the Chilean Ministry of Education for its cooperation without which this exhibition would not have been possible.

CATALOGUE

Oils

Nemesio Antúnez
 1. *Civic Center*
 2. *Table*

3. *Bicycles*

Pablo Burchard, Jr.
4. *Neighborhood*
5. *The Lamp*

Pedro Burchard
6. *Composition*
7. *Composition*

Isi Cori
8. *Representation*
9. *Nudes*

Gabriela Garfias
10. *Mulata Macumba*

Byron Gigoux
11. *On a Sunday*
12. *Fishing Schooner*

Emilio Hermansen
13. *Highlands*
14. *The Fair*

Raimundo Infante
15. *Composition in Space*
16. *Earthly Composition*

Ricardo Irarrázaval
17. *Maternity*
18. *Nature*

Juana Lecaros
19. *Musicians*
20. *In the Days of the Gramophone*

Magdalena Lozano
21. *Phantom Musicians*
22. *Crystal*

Alfonso Luco
23. *The Supper*
24. *Watermelons*

Fernando Marcos
25. *Rapa Nui*

Carmen Silva
26. *Interior*
27. *City*

Mónica Soler Vicens
28. *Essential Forms*
29. *Luminous Triangle*

BIOGRAPHICAL NOTES[1]

BURCHARD, Pedro. Painter, architect, born in Santiago, 1922. Although he is one of the main representatives of abstract painting in Chile, has not held individual exhibitions or participated in official salons. Exhibited only in the Winter Salon of Santiago in 1955 and 1956.

CORI, Isi. Painter, born in Chile, 1898. Started painting in 1946. Held six individual exhibitions in Santiago and was awarded two first medals in national salons.

GARFIAS, Gabriela. Painter, born in Santiago, 1921. Studied at the Escuela Nacional de Bellas Artes of the same city, and in Rio de Janeiro under a Brazilian government fellowship, 1948. Has exhibited in national salons and group exhibitions abroad. Has been awarded several prizes in Chile.

GIGOUX, Byron. Painter, journalist, writer, born in Caldera, Chile, 1900. A self-taught painter, he is also the editor of two major newspapers in Santiago since 1913 and published short stories and a novel *El cerro de los Yales*. Inspired by the work of Cézanne, Van Gogh, and Bonnard at the beginning of his career, developed a personal style that enabled him to become an important representative of the Chilean avant-garde. To the present, did not exhibit in Chile.

HERMANSEN, Emilio. Painter, born in Santiago, 1919. Considers himself a self-taught artist and is the director of the Art Gallery of the British-Chilean Institute. Held individual exhibitions in Santiago.

INFANTE, Raimundo. Painter, architect, born in Santiago, 1928. Traveled in Europe in 1949 and 1951-52, in Venezuela in 1953, and Central America and the Caribbean in 1954. Is a well-known soccer player of the Catholic University team. Held individual exhibitions and participated in group shows in Chile.

LOZANO, Magdalena. Painter, born in Madrid, Spain, 1913. Studied at the Escuela de Bellas Artes and with Pedro Reszka, Santiago. Held one individual exhibition, Santiago, 1954. Has never participated in group exhibitions. Lives in Santiago.

LUCO, Alfonso. Painter, born in Santiago, 1925. Graduated as an architect from the Catholic University of Santiago. Under different scholarships studied art in the United States (1948-52) and in Spain (1953). Held individual exhibitions in the United States, Chile, and Spain. Participated in group exhibitions in Santiago and Buenos Aires.

MARCOS, Fernando. Painter, muralist, born in Valparaíso, Chile, 1919. Studied at the Escuela de Bellas Artes and Escuela de Artes Aplicadas of Santiago, and under a Mexican fellowship also studied for two year at the Escuela de Pintura y Escultura of Mexico City. Executed two murals in Chile. Exhibited in Chile, Mexico, Argentina.

SOLER VICENS, Mónica. Painter, born in Concepción, Chile, 1926. Studied under Emilio Pettoruti, and in the Pettoruti Workshop in Argentina, 1947-1953. Traveled in Europe, 1956. Held an individual exhibition in Buenos Aires, 1953. Participated in salons and group exhibitions in Buenos Aires and Santiago.

[1] Not included in the original catalogue. See Index of Artists for reference on those not included here. —*Ed.*

November 23, 1956 - January 5, 1957

ALOISIO MAGALHÃES OF BRAZIL

Aloisio Magalhães appears as one of the most interesting personalities in the modern art movement of northeastern Brazil, a region whose luminous colors find reflection in his impressionist style, tending toward abstraction.

Born in Recife in 1927, Magalhães was for many years entirely self-taught as a painter. In 1951, however, he received a scholarship from the French government which enabled him to stay in Paris until 1953. There he attended the S.W. Hayter's Atelier 17. He has participated in group shows in Recife and in Bahia, and examples of his work were included in the last two São Paulo biennials. His first one-man show took place in the last mentioned city at the Museum of Modern Art, in November 1954, and a month later the same exhibit was repeated at the Ministry of Education in Rio de Janeiro. In 1956 he held a second individual exhibition at the São Paulo Museum of Modern Art, and another one at Atelier 415 in Recife.

In the foreword to the catalogue of his first one-man show in São Paulo, the critic Ariano Saussuna stated:

> Recife and its environs now have an artist of their own, to paint the tile roofs, the expanses of water, the palm trees, and those suddenly encountered, out-of-the-way streets that recall small towns of the back country or that attest, rather, to the survival of the small town in the dynamic, beloved metropolis of the Northeast.

Magalhães came to the United States recently under the auspices of the National Educational Exchange Service. The current exhibit is the first presentation of his work in this country.

CATALOGUE

Oils

1. *Coqueiros (Coconut Palms)*
2. *Folhagem (Foliage)*
3. *Porto de pescadores (Fishing Port)*
4. *Mocambos (Huts)*
5. *Cidade verde (Green City)*
6. *Próximo ao mar (Near the Sea)*
7. *Botafogo*
8. *Paisagem verde (Green Landscape)*
9. *Cidade e campo (Town and Country)*
10. *Bananeiras (Banana Plants)*
11. *A cidade (The City)*
12. *Começo de verão (Early Summer)*
13. *Paisagem azul (Blue Landscape)*
14. *Olinda*
15. *Recife, ceu amarelo (Recife, Yellow Sky)*
16. *Olinda II*
17. *Porto (Harbor)*
18. *High Noon*
19. *Grande vista da cidade (General View of the City)*
20. *Paisagem (Landscape)*

Gouaches, Drawings, and Other Media

21. *As árvores (Trees)*
22. *Peixe na praia (Fish on the Beach)*
23. *Chuva especial (Special Rain)*
24. *Chuva especial (Special Rain) II*
25. *Vegetação tropical (Tropical Vegetation)*
26. *Mangue (Mangrove Swamp)*
27. *Cidade particular (Private City)*

December 12, 1956 - January 8, 1957

IGNACIO GOMEZ JARAMILLO OF COLOMBIA

Ignacio Gómez Jaramillo has for some time been one of the most active modern Colombian artists, among whom he has acquired a reputation of certain distinction. He was born in 1910 in the city of Medellín, whose School of Fine Arts he later attended. In 1929 he went to Spain to continue his studies in painting and two years later he transferred to Paris. Since that period he has traveled extensively both in Europe and in this hemisphere. In 1936 Gómez Jaramillo made a visit to Mexico, where he executed murals for a school in the capital. The following year he came to the United States to exhibit at the Delphic Studios in New York. The author of a number of murals in his native Colombia, he served as director of the School of Fine Arts of Bogotá from 1940 to 1944.

Gómez Jaramillo recently held a one-man show in Caracas. This exhibit constitutes his first individual presentation in the Washington area.

CATALOGUE

Oils

1. *Rue Saint Rustique*, 1931
2. *Desnudos (Nudes)*, 1937
3. *San Sebastián (Saint Sebastian in the Trenches)*, 1952
4. *Retrato del Doctor C.U.P. (Portrait of Doctor C.U.P.)*, 1950
5. *Vendedora de pescado (Woman Selling Fish)*, 1954
6. *Un grito en la selva (A Cry in the Wilderness)*, 1954
7. *Maternidad mediterránea (Mediterranean Motherhood)*, 1954
8. *Paisaje (Landscape)*, 1954
9. *El estudiante (Student)*, 1954
10. *Pescados (Fish)*, 1954
11. *El éxodo (The Exodus)*, 1954
12. *El toro y las palomas (Bull and Doves)*, 1954
13. *El payaso (Clown)*, 1954
14. *Mujer y máscara (Woman and Mask)*, 1956
15. *Composición (Composition)*, 1956
16. *El tiple del pueblo ("Tiple" of the Village)*,[1] 1956
17. *Naturaleza muerta (Still Life)*, 1956

[1] Literal translation of *tiple* is treble. —*Ed.*

18. *Naturaleza muerta (Still Life)*, 1956
19. *Cabeza de Cristo (Head of Christ)*, 1956
20. *Maternidad indígena (Indian Mother)*, 1956
21. *Autorretrato (Self-Portrait)*, 1956

Drawings

22. *Dibujo (Drawing for a Fresco)*, 1954
23. *Dibujo (Drawing for a Fresco)*, 1954

Monotype

24. *Cristo (Christ)*, 1956

YEAR 1957

January 14 - February 15, 1957

SARAH GRILO AND FERNANDEZ MURO OF ARGENTINA

A large portion of the younger generation of Argentine artists has turned to the non-objective as a mode of expression, producing works characterized by clean, rigidly geometric designs. Among the more important exponents of this tendency are José Antonio Fernández Muro and Sarah Grilo, who in private life are husband and wife.

José Antonio Fernández Muro was born in Madrid, Spain, in 1920, but for the last ten years he has been an Argentine citizen. A self-taught artist, he began to paint in the dramatic style of Spanish realism, but subsequently abandoned it for abstraction. Compositions by him are to be found in the Stedelijk Museum of Amsterdam and the Fine Arts Museum of Santa Fe, Argentina, as well as in a number of private collections in America and Europe. He has held several shows in Buenos Aires, and his work has been included in Argentine group exhibits in Brazil, France, India, Italy, the Netherlands, and Venezuela. One of his compositions figured in the contemporary section of the exhibition of Argentine artists presented last year at the National Gallery in Washington, D.C.

Sarah Grilo was born in Buenos Aires in 1920. Like her husband, she is a self-trained artist. Like him, also, she is represented in the collection of the Stedelijk Museum of Amsterdam and was included in the recent National Gallery exhibit. She held individual exhibitions in Madrid in 1949 and in Buenos Aires in 1950, 1952, 1954, and 1955, and she has been presented in Brazil and the Netherlands. In addition to her work in the Stedelijk Museum, her compositions figure in the Municipal Museum of Córdoba, Argentina, and in many private collections in her native country.

This is the first time that either artist has had an individual presentation in the United States.

CATALOGUE

Paintings

Sarah Grilo

1. *Pintura (Painting) 52-7*, 65 x 81 cm.
2. *Pintura (Painting) 53-4*, 65 x 81 cm.
3. *Tema sobre rojo (Motif on Red)*, 100 x 81 cm.
4. *Tema sobre amarillo (Motif on Yellow)*, 100 x 81 cm.
5. *Tema sobre fondo blanco (Motif on White Background)*, 116 x 90 cm.
6. *Tema en grises (Motif in Greys)*, 81 x 54 cm.
7. *Entre dos círculos (Between Two Circles)*, 61 x 50 cm.
8. *Tema en azules (Motif in Blues) No. 5*, 81 x 65 cm.
9. *Pequeño círculo celeste (Small Azure Circle)*, 61 x 50 cm.
10. *Tema sobre azul (Motif on Blue)*, 100 x 81 cm.
11. *Tema en violeta (Motif in Violet)*, 81 x 54 cm.

12. *Tema simple (Simple Motif)*, 81 x 65 cm.
13. *Composición (Composition), 56-2*, 100 x 81 cm.
14. *Horizontales (Horizontals)*, 116 x 91 cm.

Antonio Fernández Muro

1. *Tema sobre blanco (Motif on White)*, 81 x 65 cm.
2. *Tema sobre violeta (Motif on Violet)*, 100 x 50 cm.
3. *Progression of a Form*
4. *Circle*
5. *Pintura (Painting)*
6. *Parallel Bands*
7. *Horizontal and Vertical Rectangles.* Lent by Col. Jacobo Soifer
8. *Pintura (Painting) 6-54.* Lent by Col. Alberto Gainza Castro
9. *Pintura (Painting) 6-56*
10. *Triangles*

February 6 - 24, 1957

FINE ART OF THE CARIBBEAN[1]

An exhibit of one hundred and twenty-nine pieces judged as outstanding work of contemporary artists in the Caribbean. Sponsored by the Alcoa Steamship Company.

In 1954 the Alcoa Steamship Company launched a Caribbean-wide fine art contest encompassing the Leeward and Windward Islands, Barbados, Trinidad, Jamaica, British West Indies, the French West Indies, the Netherlands Antilles, Virgin Islands, Haiti, the Dominican Republic, Puerto Rico, Venezuela, British Guiana, and Suriname. The purpose was to bring together for the first time native fine art truly representative of the entire Caribbean area. To accomplish this, the contest was rigidly restricted to native-born citizens of each area, and to others who had been residents for a minimum of fifteen years. Ten thousand dollars in prizes were offered to the winners.

By the late spring of 1955 the contestants had submitted 1,283 entries. Regional judgings were then held at fourteen key points within the Caribbean, with local academicians, museum curators, and critics serving on the judging committees. The local selections that resulted were next brought to New York and in September 1955 were displayed for grand and first prize awards at the National Academy of Design, New York City. The judges for these awards were: Hyatt Mayor, Curator of Prints, Metropolitan Museum of Art; John J. Gordon, Curator, Brooklyn Museum of Art; Vernon C. Porter, Director, National Academy of Design.

The judges awarded three grand prizes, fourteen regional first prizes, and forty honorable mentions. Grand and first prize awards and honorable mentions are noted where applicable on the pages of this program.

[1] Only a selected portion of this exhibition was presented at the Pan American Union. Since no information is available on which artists actually exhibited at the Pan American Union, the catalogue used in the original exhibition is reproduced here in its entirety.—*Ed.*

CATALOGUE

Barbados

Robert J. MacLeod
 2. *Martin's Bay*, Barbados
 3. *Red Fish*

Golde M. White
 4. *Study of Two Children*

Therold Barnes
 5. *Fisherman's Child*

Briggs A. Clarke
 6. *The Belle Plantation*, Barbados

Ivan Payne
 7. *Queen Street*, Speightstown. Regional First Prize

Harold C. Connell
 8. *Tropical Flowers*

Hubert Brathwaite
 9. *Scenery, Labour Day Celebrations*. Honorable Mention

British Guiana

Alma Taharally
 11. *Santapee Band*

Florence Cavigioli
 12. *Steel Band Parade*. Honorable Mention

Alvin Bowman
 13. *Fishday, Urquart Stelling*

Albert de Freitas
 14. *Life on a Mission*

Vivian Antrobus
 15. *Bathing Betty*

R.G. Sharples
 16. *Georgetown Gateway*. Honorable Mention

Joseph B. Smith
 17. *The Old Farmer*

Basil Angold Thompson
 18. *Portrait of Agatha*

Morris Mann
19. *Diamond Country Amatuk*

Patrick Barrington
20. *Coconut Water Vendor*. Regional First Prize

Dominican Republic

Liliana García Cambier
21. *Meditación (Meditation)*
22. *Mestiza*. Honorable Mention

Ricardo Velázquez L.
23. *Vendedoras (Vendors)*

Virginia Simón
24. *Cordillera (Mountains)*. Honorable Mention

Eduardo Martínez D' Ubago
25. *Cargadora de frutas (Carrying Fruits)*
26. *Pescador (Fisherman)*

Paul Giudicelli
27. *Máscara (Masks)*
28. *Hombre y tambor (Man and Drum)*. Regional First Prize

Juan Plutarco Andújar
29. *Pescadores (Fishermen)*
30. *Vendedoras de frutas (Fruit Vendors)*

French West Indies

Martinique

Raymond Honorien
31. *Paysage (Landscape)*. Honorable Mention
32. *Marché à la campagne*

Jeanne Labautière
33. *Paysage aux bambous (Landscape with Bamboos)*

Claudine Marie-Claire
34. *Les beaux Dimanches (Beautiful Sundays)*

Ginette Mangallon
35. *Case de pêcheurs (Fisherman Cabin)*. Regional First Prize

Germain Tiquant
36. *Un Dimanche à Case-Pilote (Sunday at Case-Pilote)*. Honorable Mention

Guadeloupe

Jacques Malespine
 37. *Titine au bain (Titine Bathing)*
 38. *Jeune créole (Young Creole)*

Solange Pettrelluzz-Questel
 39. *Madoudou*. Honorable Mention
 40. *Rite*

Haiti

Antonio Joseph
 42. *Fruit merchant*. Honorable Mention

André Normil
 43. *Basse-cour (Farmyard)*. Honorable Mention

Fernand Pierre
 44. *Vieilles maisons (Old Houses)*. Honorable Mention

Castera Bazile
 45. *Caribbean Distractions*. First Grand Prize and Regional First Prize

Enguerrand Gourgue
 46. *Paysage (Landscape)*. Honorable Mention

Wilson Bigaud
 47. *Marché (Market)*. Honorable Mention

Maurice Borno
 48. *Buveurs (Drinkers)*

Adam Léontus
 50. *Cérémonie (Ceremony)*

Jamaica

Ralph Campbell
 51. *Paradise Street*

Whitney Miller
 52. *John Canoe Entering City*. Honorable Mention

Rhoda Jackson
 53. *On a Country Road*

Gaston Tabois
 54. *Peasants Life*. Honorable Mention

Carl Abrahams
55. *The Calypso Band*. Regional First Prize

Gloria Escoffery
56. *Village Scene*. Honorable Mention

Cleveland Morgan
57. *Father and Child*

Albert Huie
58. *Crop Time*. Honorable Mention

Leonard Morris
59. *Country Dance*. Honorable Mention

Ana Hendricks
60. *Pocomania*. Honorable Mention

Leeward Islands

Antigua

E.T. Henry
61. *Port James*
62. *Lord Nelson's Club*. Honorable Mention
63. *Five Islands*

A.G. Prince
64. *St. John's Harbour*

Kendrick Tully
65. *Church Street*. Honorable Mention

Walter A. Pratt
66. *Life by the Blue*

St. Kitts

Franklin Browne
67. *Mending Nets*

Cynric Griffith
68. *The Vendor*
69. *Sugar Cane Cutters*. Honorable Mention

Nevis

Eva Wilkin
70. *Cotton Picking Time in Nevis*. Regional First Prize

Netherlands West Indies

Curaçao

Ronald Yang
71. *Impression of Coney Island in Curaçao.* Honorable Mention

Elmar E. de Windt
72. *Simadan*

Rudolf V. Marchena
73. *Sebastopolstraat by Moonlight.* Honorable Mention

Lucila Engels
74. *Sunny Boy.* Honorable Mention
75. *Rhythm on the Land*

Alberto Badaracco
76. *The Colorful Harbour*

Aruba

Leo Kuiperi
77. *Dande*
78. *Dera Gai*

John C. Lampe
79. *Fruit Market at Sea Side.* Regional First Prize
80. *Lend View of an Arubian Landscape through a Window*

Puerto Rico

Fernando M. Monserrate
81. *Street Scene*, Catano

Alfonso Arana
83. *La Parva (Holy Family at Rest).* Honorable Mention

Eduardo Vera Cortés
84. *Vida de perros (Dogs' Life).* Second Grand Prize and Regional First Prize

Manuel Hernández Acevedo
85. *Paisaje de Loiza (Loiza Landscape).* Honorable Mention

Samuel Sánchez
88. *Despedida de duelo (Mourning Farewell)*
89. *Una voz conocida (A Known Voice)*

Bart Mayol
90. *Serenade*

Suriname

D.C. Geijskes
91. *Bushnegro Village Langa*

Erwin de Vries
92. *Vrouw Met Meloen (Woman with Watermelon)*
93. *Vrouw Met Stier (Woman with Ox)*. Honorable Mention

Stuart Robles de Medina
94. *De Groei, Voorst Suriname (The Growth, Representing Surinam)*. Regional First Prize

Soekimin Sastro
95. *Sorguliet*

Stanley Brown
96. *Vrouwen in Rouwkledy (Women in Mourning)*

Antoon W. Van Vliet
97. *Wientie Dansie (Voodoo Dance)*

A. Th. Favery
98. *Zandafgraving (Sand Pit)*

Trinidad

Alfredo Codallo
99. *Bataille Bois*

Joseph Cromwell
100. *Maracas Bay*. Honorable Mention
101. *Bel Air Dancers at Evening*
102. *Steel Band*. Regional First Prize

Sybil Richardson
103. *Caribbean Rhythm*

Wilson Minshall
104. *Crab and Callaloo*

Noel Vaucrosson
105. *Spiritual Baptist Gathering*

Jeanette Pollard
106. *Village Scene*

Nina G. Lamming
107. *Mangoes*

Carlisle Fenwick Chang
108. *Bongoe Dancers*. Honorable Mention

U.S. Virgin Islands

St. Thomas

Aline M. Kean
109. *Three Eras*

Enid Kimmel
110. *Seaside, French Village*
111. *Sentinel*
112. *Native Kitchen*

Marie Moore
113. *St. Thomas Waterfront*. Regional First Prize

Albert E. Daniel
114. *Fond Recollections*. Honorable Mention
115. *The Coal Wharf Gang Driver*

Alfred Lockhart
116. *Waterfront and Pier*

St. Croix

Sasha Manson
117. *Bandstand*. Honorable Mention

Ruth M. Gregory
118. *Old Sunday Market Street, Christiansted*

Venezuela

Saúl Padilla
119. *Cachicamo*

Juvenal Ravelo
120. *Calle de Barquisimeto (Street of Barquisimeto)*

Crisójeno Araujo
125. *Ranchos campesinos (Peasant Huts)*

René Croes Michelena
126. *Diablos de Yare*. Honorable Mention

Manuel Vicente Gómez
127. *Barrio de Caracas (District in Caracas)*. Honorable Mention
128. *Juego de bolas criollas (Creole Bowling Game)*

Windward Islands

St. Lucia

E. L. Cozier
129. *Drying Sails, Soufrière*

Lily A. Auguste
130. *The Ship*

Dunstan St. Omer
131. *Sea at Dauphin*. Honorable Mention

Harold F.C. Simmons
132. *Sunday Morning, Canaries*

Joseph Gaston de Brettes
133. *Bram*. Third Grand Prize and Regional First Prize

Grenada

Rosemary Charles
134. *The Green Bridge*. Honorable Mention

George N. Hayling
135. *Where Fisher Folk Live*

Dominica

Stephen Haweis
136. *Balisier with Fang Carving*. Honorable Mention

Francis Anthony Toulon
137. *Carib*. Honorable Mention

St. Vincent

Owen Douglas Brisbane, Jr.
138. *Carnival's Happy Wanderers*. Honorable Mention

BIOGRAPHICAL NOTES[1]

ABRAHAMS, Carl. Painter, draftsman, born in St. Andrew, Jamaica, 1913. Self-taught, started his career in 1938 as cartoonist for Jamaican newspapers. After three years service in the British Royal Air Force in World War II, returned to Jamaica and devoted to painting. One of the pioneers of Jamaican art, has exhibited in group and one-man shows in Jamaica and abroad. Was awarded several prizes for his paintings.

ARAUJO, Crisójeno. Painter, born in El Tocuyo, Venezuela. Participated in official salons and other Venezuelan

[1] Not included in the original catalogue. See Index of Artists for reference on those not listed here. —*Ed.*

group exhibitions.

BAZILE, Castera. Painter, muralist, born in Jacmel, Haiti, 1923. Self-taught artist, joined the Centre d'Art and since 1945 has been a full-time artist. Executed three murals at the Holy Trinity Cathedral, 1950 and 1951. Participated in the exhibitions of the Centre d'Art in Haiti and abroad.

BIGAUD, Wilson. Painter, muralist, born in Port-au-Prince, Haiti, 1931. Self-taught artist, executed one mural painting at the Holy Trinity Cathedral in Port-au-Prince, 1950-51. Joined the Centre d'Art in 1946, participating in its exhibitions in Haiti and abroad.

CHANG, Carlisle Fenwick. Painter, muralist, photographer, set and costume designer, dancer, born in St. John, Trinidad, 1921. Studied at the Central School of Arts and Crafts, London, under a British Council Art Scholarship, 1950; under an Italian government scholarship studied ceramics in Faenza (Italy), 1953. Executed murals at Piarco Airport and the Port-of-Spain Town Hall. Exhibited in Trinidad, the Caribbean region, and England. Has received several awards for his paintings.

CLARKE, Briggs A. Painter, draftsman, born in Barbados, 1905. Self-taught as an artist, has been an art teacher at Harrison's College since 1945. Founding member of Barbados Arts and Craft Society, 1944. Exhibited in Barbados and the Caribbean area.

ENGELS, Lucila (Lucila Engels-Boskaljon). Painter, sculptress, born in Curaçao, Netherlands Antilles, 1920. Started painting in 1942. Member of the Netherlands Federation of Painters, 1949, has exhibited since 1948 in Amsterdam, including the Stedelijk Museum, 1952, 1954; Curaçao, 1950-52; Museo de Bellas Artes, Caracas, 1955; and the São Paulo Biennial, 1955. In 1952, at an exhibition held at the Amsterdam Stedelijk Museum, one of her works was declared Painting of the Week, and works by her were published in the book *Cats*, Amsterdam, 1954.

ESCOFFERY, Gloria. Painter, art teacher, journalist, born in Jamaica, 1923. Obtained a B.A. degree at McGill University in Canada. Also studied at Slade School of Art in London. Has regularly exhibited in Jamaica and abroad.

GARCIA CAMBIER, Liliana. Painter, born in Dominican Republic, 1929. Graduated from the Escuela Nacional de Bellas Artes where she now teaches. Has exhibited in the Dominican Republic and abroad, including biennials in the Dominican Republic (1952-56), Madrid (1953), and São Paulo (1955).

GIUDICELLI, Paul. Painter, draftsman, ceramist, muralist, born in San Pedro de Macorís, Dominican Republic, 1921. Graduated from the Escuela Nacional de Bellas Artes, 1951. Also studied philosophy, Universidad Autónoma, Santo Domingo. Held his first one-man show at the Galería Nacional de Bellas Artes, 1953. Participated in national and international group exhibitions, including biennials in São Paulo (1951 and 1955), the Dominican Republic (1954, 1956), and Barcelona (Spain, 1955). Has been awarded several prizes since 1951.

GOMEZ, Manuel Vicente. Painter, born in Puerto Nutrias, State of Barinas, Venezuela, 1918. Studied in Caracas at the Academia de Bellas Artes, 1934-35, and Escuela de Artes Plásticas y Artes Aplicadas, under Antonio E. Monsanto, Marcos Castillo, and Armando Lira. Held individual exhibitions at the Museo de Bellas Artes, Caracas, 1949 and Ateneo de Valencia (Venezuela), 1954. Has participated in national group exhibitions since 1940. Won, among other awards, First Prize for Students, Official Salon, Museo de Bellas Artes, Caracas, 1940; Honorable Mention, *International Exhibition of Valencia* (Venezuela), 1955.

GOURGUE, Enguerrand. Painter, draftsman, born in Port-au-Prince, Haiti, 1930. Self-taught artist, joined the Centre d'Art in 1947. Started drawing and painting at an early age and at seventeen participated in an exhibition at the Museum of Modern Art, New York. Also participated in the São Paulo Biennial, 1951.

HUIE, Albert. Painter, art teacher, born in Falmouth, Jamaica, 1920. While studying at Ontario College of Art in Toronto, was awarded the British Council Art Scholarship in 1947, to study in Camberwell School of Art in London, specializing in research of old and modern techniques. Held one-man shows in Jamaica, giving the largest one-man exhibition in Kingston, 1943. Participated in group exhibits in Jamaica and abroad. Won the Award of Merit, *All Jamaica Art Exhibition*, 1938; two first prizes at the *Police Art Contest*, 1939, when he was also recommended for one of the first prizes at the New York World's Fair; an international award, Spanish American Biennial, Havana, 1954. This same year his work was selected for a presentation to HRH Princess Margaret.

JACKSON, Rhoda. Painter, muralist, textile designer, born in Gilnock Hall, St. Elizabeth, Jamaica. Studied at the Reading University Art School in England. Returned to Jamaica in 1936 where she paints and teaches art in schools. Was one of the first mural painters in Jamaica. Has exhibited in Europe and the Caribbean area, as well as in regular shows in Jamaica.

LEONTUS, Adam. Painter, born in Port-au-Prince, Haiti, 1928. Self-taught as an artist, joined the Centre d'Art in 1944 participating in its exhibitions in Haiti and abroad.

MARTINEZ D' UBAGO, Eduardo. Painter, muralist, stage designer, born in Pamplona, Spain. Graduated from the Escuela Nacional de Bellas Artes, Santo Domingo, 1952. Executed murals in private residences, the Hospital Santo Socorro, and the Feria de la Paz y Confraternidad del Mundo Libre. Exhibited in the Dominican Republic and abroad, including biennials in Santo Domingo (1954 and 1956), Barcelona (Spain, 1955), and São Paulo (1955). Won four stage design contests, Teatro Escuela de Arte Nacional, Santo Domingo. Has lived in the Dominican Republic since 1940.

MILLER, Whitney. Painter, draftsman, sculptor, born in St. Elizabeth, Jamaica, 1930. Self-taught as an artist, has participated in national group exhibitions.

MORGAN, Cleveland. Painter, sculptor, born in St. Elizabeth, Jamaica, 1934. Served as a mechanic apprentice before joining the Jamaica School of Arts and Crafts. Has exhibited in Jamaica and abroad.

MORRIS, Leonard. Painter, born Kingston, Jamaica. Was a member of the art classes at the Junior Center of the Institute of Jamaica and a student of the Jamaica School of Art and Crafts. Has exhibited in one-man and group shows in Jamaica and abroad.

PIERRE, Fernand. Painter, born in Port-au-Prince, Haiti, 1922. A self-taught artist, participated in group exhibitions in Haiti and abroad.

PLUTARCO ANDUJAR, Juan. Painter, muralist, born in Monte Cristi, Dominican Republic, 1931. Presently, is studying under a scholarship at the Escuela Nacional de Bellas Artes in Santo Domingo. Executed murals in private residences, Santo Domingo. Has participated in national group exhibitions winning several prizes.

RAVELO, Juvenal. Painter, born in Caripito, State of Monagas, Venezuela, 1931. Studied at the Escuela de Artes Plásticas of Caracas and Barquisimeto. At present is an art teacher. Has participated in art salons in Venezuela and was awarded a prize in 1956.

ROBLES DE MEDINA, Stuart. Painter, born in Suriname, 1930. Participated in group exhibitions in Suriname and Trinidad.

VRIES, Erwin de. Painter, born in Suriname, 1929. Held individual exhibitions in Paramaribo, 1948; Den Haag (Netherlands), 1952; National Museum, Curaçao, 1954; Houston (Texas), 1955; Amsterdam, 1956.

WINDT, Elmar Egidio de. Artist born in Curaçao, Netherlands Antilles, 1927. At an early age started outdoor

sketching and drawing. In 1952 met Joannes Pandellis who guided and trained him. Participated in regional group exhibitions.

WHITE, Golde M. Painter, born in Barbados, 1890. Studied art in London. Co-founder of the British Guiana Art and Craft Society, 1931, and the Barbados Art and Craft Society, 1944. Exhibited in Barbados and the Caribbean area.

February 14 - March 21, 1957

ARTISTS OF NICARAGUA

Some ten years ago the painter Rodrigo Peñalba returned to his native Nicaragua after a prolonged absence in the United States, Mexico, and various countries of Europe, chiefly Italy. Soon after his arrival he was appointed director of the National School of Fine Arts in Managua, an institution that had been in a state of semi-stagnation. Peñalba's first move was to revitalize study methods and attempt to draw to the school all potential artists with some degree of talent, imagination, and ambition. As Peñalba dealt only with problems of technique and imposed no specific mode of expression upon his pupils, improvement was evident after even a few courses. For the first time small collections of Nicaraguan art were sent abroad to figure in international exhibitions such as the Second Biennial in São Paulo, Brazil, and the First Biennial in Madrid, Spain. Last year the Visual Arts Section of the Pan American Union selected a number of artists from the group centering on Peñalba to represent Nicaragua in the *Gulf Caribbean Art Exhibition* organized for presentation at the Museum of Fine Arts of Houston and now circulating among other institutions in this country.

All the artists who are now making their Washington debut are still associated with the School of Fine Arts of Managua, although they have completed their courses of study. They represent a variety of styles, stimulated, rather than restricted, by Peñalba as director and teacher. Among the trends illustrated are the expressionism of Omar d' León; the primitivism of Asilia Guillén; the subtle, lyrical approach of Armando Morales, a prize-winner in several international exhibitions; and the ingenious simplifications of the poet-sculptor Ernesto Cardenal.

CATALOGUE

Oils

Asilia Guillén
1. *El Río Coco (Coco River)*, 1953, 10 1/2 x 26"
2. *El Puerto de Moyogalpa (Port of Moyogalpa)*, 1953, 10 1/2 x 25"
3. *Tempestad (Tempest)*, 1953, 20 x 16"
4. *Lago de Nicaragua (Lake of Nicaragua)*, 1955, 21 x 15". Lent by Mrs. Alma de Arana Valle, Nicaragua
5. *Lincoln*, 1954, 24 x 20"
6. *La quema de Granada por las tropas norteamericanas (Granada Fire)*, 1957

Omar d'León
7. *Canasteras (Basket Makers) No. 1*, 1956
8. *Canasteras (Basket Makers) No. 2*, 1956
9. *Canasteras (Basket Makers) No. 3*, 1956, 36 x 25"
10. *Flautista (Flutist) No. 27*, 1956, 37 x 29 1/2"
11. *Naturaleza muerta (Still Life)*, 1955, 20 1/2 x 6 3/4"
12. *Naturaleza muerta (Still Life)*, 1955, 20 3/4 x 6 1/2
13. *Naturaleza muerta (Still Life)*, 1955, 20 1/2 x 6 1/4"

Armando Morales
14. *Barcos abandonados (Abandoned Boats)*, 1956, 28 x 40"
15. *Estampida (Stampede)*, 1956, 28 x 40"
16. *Selva (Forest) I*, 1956, 28 x 24 1/2"
17. *Selva (Forest) II*, 1956, 28 x 40"
18. *Llano (Plains)*, 1956, 28 x 40"
19. *Muchacha con pesadillas (Girl with Nightmares)*, 1956, 28 1/2 x 59 1/2"
20. *Arbol-espanto (Tree-Spook)*, 1956, 23 x 51 1/2"
21. *Después de la quema (After the Fire)*, 1956, 28 x 49"
22. *Lancha cargada (Loaded Launch)*, 1957

Rodrigo Peñalba
23. *Ultima Cena (Last Supper)*, 1956, 33 1/4 x 53 1/2"
24. *Lavanderas (Washerwomen)*, 1956, 48 x 33 1/2"
25. *Descendimiento (Descent)*, 1952, 35 x 26"
26. *Crucifixión (Crucifixion)*, 1952, 35 x 26". Lent by Mr. Enrique Palazio, Nicaragua
27. *Durmientes (Sleepers)*, 1954, 31 1/2 x 24"
28. *Maternidad (Maternity)*, 1955, 17 3/4 x 15"

Fernando Saravia
29. *Crepúsculo (Twilight)*, 1955, 40 1/2 x 23"
30. *Eclipse*, 1955, 34 x 29"

Sculptures

Ernesto Cardenal
31. *Agouti*,[1] 1956, polychrome plaster. Lent by the School of Fine Arts, Managua
32. *Iguana*, 1956, polychrome plaster. Lent by the School of Fine Arts, Managua
33. *Madona y niño (Madonna and Child)*, 1956, plaster. Lent by the School of Fine Arts, Managua
34. *Torso*, 1956, plaster. Lent by Mr. Jaime Villa, Nicaragua

Fernando Saravia
35. *Maternidad (Maternity)*, 1956, stone
36. *Pájaro (Bird)*, 1956, artificial stone

ABOUT THE ARTISTS

CARDENAL, Ernesto. Poet and sculptor born in Granada, 1925. Graduated with a degree in Philosophy and Letters from the University of Mexico; post-graduate studies at Columbia University, New York. Has published poetic works and essays on poetry.

GUILLEN, Asilia. Painter born in Granada, 1887. Has attended the School of Fine Arts since 1951. Professional embroiderer.

LEON, Omar d'. Painter and draftsman born in Managua, 1929. Attended the School of Fine Arts from 1948 to 1953.

[1] In the list of works sent by the artists for this exhibition, this title appears as *Chancho de monte* or "Wild Hog." —*Ed*.

MORALES, Armando. Painter, draftsman, and printmaker born in Granada, 1927. Attended the School of Fine Arts sporadically from 1941 to 1945, steadily from 1948 to 1953. Special awards: Second Biennial of Madrid, 1953; *Gulf Caribbean Art Exhibition* of Houston, 1956; and *Science and Art Contest*, Guatemala, 1956.

PEÑALBA, Rodrigo. Painter born in León, 1908. Beginning in 1926, studied at the Chicago Academy of Fine Arts, the Academy of Fine Arts of San Carlos in Mexico City, and the San Fernando Academy of Fine Arts, Madrid. Graduated in 1941 from the Royal Academy of Fine Arts, Rome. Lived in Italy until 1947. One-man shows: San Marco Gallery, Rome, 1945; Marquié Gallery, New York, 1947; Pan American Union, Washington, D.C., 1947; Newcomb-Macklin Gallery, New York, 1949. Has participated in numerous group shows in Europe, Latin America, and the United States.

SARAVIA, Fernando. Sculptor and painter born in Managua, 1922. Attended the School of Fine Arts between 1941 and 1948.

March 2 - April 4, 1957

ARTISTS OF PUERTO RICO

During the past decade, a modern art movement has gradually been developing in the island of Puerto Rico. The painters and sculptors participating in the movement, though for the most part trained in art schools of the United States, have nevertheless maintained a definitely Latin mode of expression. Their first joint efforts, around 1951, focused upon an art center in San Juan. Although the center enjoyed but a brief existence, a number of artists were left with a common desire and intent to depict the life and customs of their native island. Many are represented in the collections of the Museum of Anthropology, History, and Art of the University of Puerto Rico; they exhibit constantly at the Ateneo in San Juan and at other cultural institutions of the island.

This exhibit, a limited selection from a more numerous group of works displayed at the Riverside Museum in New York two months ago, exemplifies the more advanced trends in Puerto Rican art. The current show is sponsored by the Institute of Puerto Rican Culture of San Juan and the Riverside Museum which organized the original exhibition. Thanks are expressed to both institutions and to the Office of the Commonwealth of Puerto Rico in Washington, D.C., for rendering possible this first presentation of Puerto Rican art in the capital area.

CATALOGUE

Olga Albizu
1. *Composition in Black*

Alfonso Arana
2. *Landscape*

Solange Arana
3. *Landscape*

Félix Bonilla Norat
4. *Landscape*

Andrés Bueso
5. *San José Housing Project*

Luis Germán Cajigas
6. *San José Street*. Coll. Mr. and Mrs. Luis Muñoz-Lee

Manuel Hernández Acevedo
7. *Picking Coffee*

Lorenzo Homar
8. *Le-Lo-Lai*. Coll. University of Puerto Rico
9. *Acrobats*

Epifanio Irizarry
10. *Phantoms in the Night*

Carlos Marichal
11. *House in Yauco*

José R. Oliver
12. *New Year's Eve*. Coll. Governor and Mrs. Luis Muñoz-Marín

Francisco Palacios
13. *Marionette*

Carlos Raquel Rivera
14. *Intimacy*

Julio Rosado del Valle
15. *Portrait of a Young Man*. Coll. Mr. Aníbal Otero
16. *Amazon*

Samuel Sánchez
17. *Day of Innocents*. Coll. Mr. and Mrs. Clarence Senior

Rafael Tufiño
18. *Goyita, Portrait of My Mother*. Coll. University of Puerto Rico
19. *The Slums of La Perla*. Coll. Dr. Fernando M. Monserrate

José A. Torres Martinó
20. *House and Trees*. Coll. Dr. Fernando M. Monserrate

Eduardo Vera
21. *The Fruit Vendors*

BIOGRAPHICAL NOTES[1]

ARANA, Alfonso. Painter, draftsman, graphic artist, born in New York, 1927. Moved to Puerto Rico at the age of four. Studied at the Art Department, American University, Washington, D.C., under a Puerto Rican scholarship; with Spanish artist José Bardasano, México City, for five years; at the Ecole des Beaux-Arts, Paris, graduating four years later. Exhibited in Paris, 1950; Mexico City, Chihuahua, Puerto Rico, and the Third Hispanic American

[1] Not included in the original catalogue. See Index of Artists for reference on those not listed here. —*Ed.*

Biennial, Barcelona (Spain), 1955.

BONILLA NORAT, Félix. Painter, graphic artist, born in Cayey, Puerto Rico, 1912. Studied at the Boston Child-Walker School of Fine Arts; Ernest Thurn Summer School of Fine Arts, Gloucester, Massachusetts; Academia de San Fernando, Madrid, 1936; and in Paris and Florence under a Puerto Rican scholarship. Served in the U.S. Army, 1941-1945, and became officer of monuments and fine arts in the occupied regions in Europe, 1945. Founded a serigraphy workshop, New York, 1946. Returned to Puerto Rico in 1948 and worked with Irene Delano at the Graphic Arts Workshop in the production of posters. Co-founded Studio 17, the Puerto Rican Art Center, and the Association Pro-School of Plastic Arts. Since 1956 has been a professor at the University of Puerto Rico. Exhibited in New York and Puerto Rico; Salon des Tuileries, 1938, and Salon des Indépendants, 1956, both in Paris; and the Third Hispanic American, Barcelona (Spain), 1955.

BUESO, Andrés. Graphic artist, born in Mexico, of Spanish parents. Co-founded Studio 17 and the Puerto Rican Art Center, 1950; is a professor of serigraphy, Graphic Arts Department, Division of Community Education, San Juan. Exhibited in Puerto Rico and New York. Lives in Puerto Rico.

CAJIGAS, Luis Germán. Painter, muralist, graphic artist, born in Quebradillas, Puerto Rico, 1934. Studied with Félix Bonilla, Lorenzo Homar, and others at the Graphic Arts Department, Division of Community Education, San Juan, where he now works; and with painter Fran Cervoni. In 1956 painted a mural at the Iglesia de Guadalupe. Since 1955 has exhibited in Puerto Rico, Jamaica, and Mexico.

HERNANDEZ ACEVEDO, Manuel. Painter, graphic artist, born in Aguas Buenas, Puerto Rico, 1921. A shoemaker and mender before he started working under Irene Delano and later under Lorenzo Homar and Rafael Tufiño at the Graphic Arts Department of San Juan, where he now works. Published with other Puerto Rican artists some portfolios of prints, including *Estampas de San Juan*, 1954. Participated in various group exhibitions in Puerto Rico and Jamaica. Was awarded the Prize for Printmaking, Ateneo Puertorriqueño, San Juan, 1956.

HOMAR, Lorenzo. Painter, draftsman, graphic artist, jewelry and stage designer, born in Puerto de Tierra, Puerto Rico, 1913. Studied at the Pratt Institute and the Brooklyn Art Institute with Rufino Tamayo, Arthur Osver, and Gabor Peterdi, New York. Worked as a vaudeville acrobat, engraver, and jewelry designer at House of Cartier, New York, 1940-50, with a four-year lapse, when he fought in World War II, serving with the U.S. Army, South Pacific, 1942-45. Co-founded the Puerto Rican Art Center, 1950. Since 1952 has been the director of the Graphic Arts Department, Division of Community Education, San Juan. Illustrated several books and published with other Puerto Rican artists some portfolios of prints, including *Estampas de Puerto Rico*, 1951. Held individual exhibitions in Puerto Rico and the United States, including the Brooklyn Museum, New York, 1949, and the Library of Congress, Washington, D.C., 1954-57. Participated in group exhibitions in Puerto Rico and the United States. Was awarded the Guggenheim Fellowship, 1956.

IRIZARRY, Epifanio. Painter, graphic artist, born in Ponce, Puerto Rico, 1915. Studied in Ponce; in Germany while serving with the U.S. Army; and at the Art Students' League, New York, 1950-53. Also studied mural painting and worked for a while as restorer at the Ringling Museum of Art, Sarasota, Florida. At present works with the Graphic Arts Department, San Juan. Exhibited in Puerto Rico and abroad, including the Third Hispanic American Biennial, Barcelona (Spain), 1955. Won several awards in Puerto Rico and a Guggemheim Fellowship.

MARICHAL, Carlos. Painter, draftsman, graphic artist, stage and costume designer, born in Tenerife, Canary Islands, 1923. Studied at the Royal Academy in Brussels, and in Spain, France, and Mexico. Invited by the University of Puerto Rico, moved to the island, 1947, and is a faculty member as well as the technical director of the University Theatre. Illustrated several books and other publications. Exhibited in Puerto Rico and Mexico.

OLIVER, José R. Painter, muralist, sculptor, born in Arecibo, Puerto Rico, 1901. At an early age, went to Barcelona (Spain), where he obtained a Ph. D. in chemistry and also studied drawing, painting, and sculpture under

Félix Mestres, Juan Antonio Perera, and other Spanish artists. Lived in Madrid and Paris. Returned to Puerto Rico in 1936 and abandoned his art career. Around 1950 he associated with the Puerto Rican Art Center and resumed his artistic activities. Executed several murals in private and public buildings in Puerto Rico. Exhibited in Barcelona (Spain) and Puerto Rico, where he was awarded several prizes.

PALACIOS, Francisco. Painter, graphic artist, born in Guayana, Puerto Rico, 1915. Studied printmaking in New York. Worked under Irene Delano at the Graphic Arts Workshop in the production of posters. Published with other Puerto Rican artists some portfolios of prints, including *Estampas de San Juan*, 1954. Exhibited in Puerto Rico.

RIVERA, Carlos Raquel. Painter, graphic artist, born in Yauco, Puerto Rico, 1923. Studied at the Art Academy of Santurce, under the direction of Edna Coll; Art Students League, New York, 1949; Juan Rosado's Workshop, Puerta de Tierra, 1951. Co-founded the Puerto Rican Art Center, 1950. Works with the Graphic Departr ;nt, Division of Community Education, San Juan. Illustrated several books and with other Puerto Rican artists published portfolios of prints, including *Estampas de San Juan*, 1954. Exhibited in Puerto Rico, Mexico, Jamaica, Spain. Won First Prize for Engraving, San Juan Christmas Festival, 1953.

SANCHEZ, Samuel. Painter, graphic artist, born in Corozal, Puerto Rico, 1929. Studied at the Puerto Rican Art Center, 1940-51. Since 1950 has held individual exhibitions in Puerto Rico and Venice. Was awarded several prizes, including First Award, Coffee Festival, San Juan, 1943.

TORRES MARTINO, José A. Painter, graphic artist, novelist, born in Ponce, Puerto Rico, 1916. Studied drawing with Horacio Cataign, Ponce; Pratt Institute and New School for Social Research, New York; and under a scholarship at the Academy of Fine Arts, Florence (Italy), 1948. Co-founded the Puerto Rican Art Center, San Juan, 1950. Was awarded Prize for Painting, Ateneo de Puerto Rico, 1953.

TUFIÑO, Rafael. Painter, graphic artist, born in New York, 1922. Moved to Puerto Rico at the age of ten. Worked at Juan Rosado's Workshop; later studied with the Spanish painter Felipe Sánchez; under a Guggenheim Fellowship also studied painting and engraving with Chávez Morado, Castro Pacheco, and others at the Academia de San Carlos, Mexico, 1947. During World War II served with the U.S. Army, and some of his sketches appeared in the *Yank Magazine* in Panama. Co-founded the Puerto Rican Art Center, 1950. Since that year works with the Graphic Arts Department, Division of Community Education, San Juan. Exhibited in Puerto Rico.

VERA, Eduardo. Painter, graphic artist, wood carver, born in Utuado, Puerto Rico, 1926. Studied serigraphy at the Graphic Arts Workshop with Irene Delano, Félix Bonilla, and Julio Rosado del Valle, San Juan. Works at the Graphic Arts Department, San Juan. With other Puerto Rican artists published some portfolios of prints, including *Estampas de San Juan*, 1954. Participated in several exhibitions in Puerto Rico and Jamaica. Won several awards in Puerto Rico and the Second Grand Prize at the *Caribbean Art Contest*, Alcoa Steamship Company, New York, 1955.

March 25 - April 10, 1957

PORTRAITS BY SANGRONIZ OF CHILE

This select group of paintings by the Chilean artist Luis Alberto de Sangroniz is being exhibited under the sponsorship of His Excellency, Alberto Sepúlveda Contreras, Ambassador of Chile to the Organization of American States. It marks a temporary interruption in the Pan American Union's program for presenting new trends in Latin American art, offering by way of contrast a traditional approach to portraiture.

As an academic, a member of the Royal Academy of Fine Arts of San Luis (Zaragoza, Spain), Sangroniz enjoyed a great reputation in Spanish high society of the 1920s. Since his sitters were in large measure members of the nobility and included the last Spanish monarch and members of his family, Sangroniz has often been called "the painter of kings and princes." Then as now, Sangroniz's approach consisted in concentrating on the most attractive aspects of his subjects and treating them with a smooth, decorative technique that has made him a favorite illustrator for magazine covers in South America.

Sangroniz was born in Santiago, Chile, in 1896 and considers himself self-taught. In addition to his long sojourn in Spain where he held several one-man shows, he has lived and exhibited in Paris, London, Lima, and Santiago. Recently he has been residing in Buenos Aires.

CATALOGUE

Portraits

1. *Mrs. Van Benson*
2. *Mrs. Trina Díaz*
3. *Mr. Martin Fabry*
4. *Mrs. Grace Cornell de Graff*
5. *Mr. Kurt Graff*
6. *Mrs. Edmund M. R. Gray*
7. *Mrs. R. O. D. Hopkins*
8. *Elisa de Lacayo's Family*
9. *Mrs. Margarita de Landajo*
10. *Mrs. Mireya Kulczewsky de Larrain*
11. *Mrs. Raquel Layon de Maza*
12. *Miss Priscilla Mead Boyer*
13. *Miss Paloma Muse Sangroniz*
14. *Mrs. Lillian O'Donnell*
15. *Miss Marisa Rubio*
16. *Mrs. Mercedes Ponce de León de Sangroniz*
17. *Mrs. Teresa Cáraves de Sepúlveda*
18. *Mrs. Luise Bernstorff Schoenboyer*
19. *Miss Joanne Spiller*
20. *Mrs. Robert A. Suczek*
21. *Mrs. Frank Varga*
22. *Mrs. Dolf A. Widmann*

April 17 - May 15, 1957

FERNANDO BOTERO OF COLOMBIA

Fernando Botero is representative of the progressive trend recently adopted by Colombian artists of the younger generation, among whom he holds a place of first rank by reason of the monumental quality of his forms and his bold use of color.

Botero was born in 1932 in Medellín, Colombia, where he began to paint while still attending high school. He later moved to Bogotá. There he held one-man shows in 1951, 1952, and 1955. He has won several awards in group shows in Colombia and was similarly recognized at the Biennial in Barcelona (Spain), two years ago. He was

represented in the *Gulf Caribbean Art Exhibition* presented at the Museum of Fine Arts of Houston and elsewhere in this country in 1956.

Botero has combined his interest in creative art with an interest in its applications in the fields of stage design and illustration. For the past year he has been living in Mexico City, where he produced most of the works now presented in this, his first one-man show in the United States.

CATALOGUE

Oils

1. *Afternoon*
2. *Sentimental Experience*
3. *Light of the Six Hundred*
4. *Men and Table*
5. *Yellow*
6. *Flower and Fruit*
7. *Summer*
8. *At Three Thirty*
9. *Boy*
10. *Life*
11. *Still Life*
12. *Almayer's Chair*
13. *Man with Two Roosters*
14. *Black Cup*
15. *Figure and Space*
16. *Waiting*

Gouaches

17. *Natural Flowers*
18. *Nude*
19. *Composition of Pineapples and Cups*
20. *Black, Rose and White*

Monotypes and Drawings

21. *White Rooster*
22. *Fish and Cup*
23. *Flowers*
24. *Vase*
25. *Girasoles (Sunflowers)*
26. *Flowers on White*
27. *Lion by the Window*
28. *Head*
29. *Still Life*
30. *Still Life*
31. *Woman and Dog*

May 21 - June 19, 1957

JULIA DIAZ AND RAUL ELAS OF EL SALVADOR

The modern art movement in El Salvador bears a close relationship to the private art school established there some ten years ago by the Spanish painter Valero Lecha. From this still active center has come a number of artists who have imparted new directions to painting and sculpture in their Central American republic. Among the outstanding figures to emerge from Valero Lecha's school are Julia Díaz and Raúl Elas, who for the first time are exhibiting a considerable number of their works in this country.

Julia Díaz was born in Cojutepeque, El Salvador, in 1917. Receiving a scholarship from the government of the country to study in Europe, she visited most of the major cities there and attended several free academies in Paris. Later she received a scholarship from the Institute of Hispanic Culture to study for six months in Madrid. Since returning to her native country, she has exhibited there, winning a number of awards. Examples of her work appear in the National Museum of El Salvador and in private collections in that country, France, and the United States. She has participated in group shows in the two countries last mentioned and in Spain and various parts of Latin America. She is currently professor of painting in the Department of Plastic Arts of the Salvadoran Ministry of Culture.

In reviewing an exhibition presented by Julia Díaz upon her return from Europe three years ago, the writer Trigueros de León characterized her work as "the product of a proven vocation, enriched by training and personal experience."

Raúl Elas Reyes was born in San Salvador in 1918. After graduation from the Valero Lecha Academy, he went to Mexico to attend the School of Book Arts. Obtaining a scholarship from the Salvadoran Ministry of Culture in 1949, Elas studied in France and Spain until 1952. He attended the National School of Fine Arts in Paris, and held one-man shows at the Buchholz Gallery in Madrid in 1952 and at the Maison de l'Amérique Latine and the Galerie de Seine in Paris in 1953. He held other individual exhibits in San Salvador in 1954 and 1955, and his work appeared in the First Hispanic American Biennial of Madrid in 1951, the exhibit of Latin American Painters in Paris in 1950, and the *Gulf Caribbean Art Exhibition*, Houston, 1956. Elas is represented in the National Museum of El Salvador, in the National Library of Guatemala, and in private collections in Spain and throughout Latin America. He is at present art director of the Salvadoran National Tourist Commission, for which he has executed a mural.

The Paris daily *Combat* discovered "a certain *élan vital*" in his compositions, and the critic of *France-Amérique Latine* stated: "The work of Elas possesses unquestionable qualities. It is full of tropical exuberance and poetic feeling and shows a masterly use of color."

CATALOGUE

Julia Díaz

Oils and Temperas

1. *Head*
2. *Study No. 1*
3. *Study No. 2*
4. *Composition*
5. *Maternity*
6. *Figure*
7. *Self-Portrait*
8. *Study in Blue*

9. *Children*
10. *Study in Grey*
11. *Composition*
12. *Landscape*
13. *San Salvador*
14. *Street Urchin*
15. *Young Girl*

Raúl Elas

Oils

1. *La selva (Forest) No. 1*
2. *Lomas (Hills), 1950*
3. *La selva (Forest) No. 2*
4. *Mujeres en la playa (Women at the Beach)*
5. *Kites*
6. *El sol (Sun)*
7. *Mexican Twilight*
8. *Night in San Salvador*
9. *Night in Madrid*
10. *Mountains*
11. *Red Nets*
12. *Nocturno de puerto (Seaport at Night)*
13. *Paisaje de verano (Summer Landscape)*
14. *Night*
15. *Paisaje de verano (Summer Landscape) No. 2*
16. *Interior gótico (Gothic Interior), 1952*
17. *Hills No. 2*, watercolor and tempera
18. *Industrial Area*
19. *Pareja (Couple)*

May 21 - June 30, 1957

ENAMELS BY HUGO MARIN OF CHILE

Although Hugo Marín is a painter of some standing, his efforts during the last few years have been directed toward the field of applied arts, more especially to work in enamel, for which he has achieved a name of distinction in his native country.

Marín was born in Santiago de Chile in 1930 and attended the School of Applied Arts there for some years. In 1951 he won a scholarship from the government of Italy and another the following year from the government of France for study in those countries. He held one-man shows in Santiago in 1949 and 1952; he exhibited at the Galería Xagra in Madrid, 1952; he participated in the Salon des Artistes Décorateurs in Paris, 1953 and 1954; he presented his work at the Club des Quatre Vents, Paris, 1953; and in Pforzheim (Germany), 1953; in Geneva and Lucerne (Switzerland), 1954 and 1955; and in Brussels (Belgium), 1954. Last year Marín held a one-man show at the University of Chile in Santiago. He has done book illustration in France, and his work can be found in the Museum of Modern Art of Paris and Santiago de Chile, in the Museum of Art and History of Geneva, and in several private collections in Europe and Chile.

This is the artist's first individual presentation in the United States.

CATALOGUE

Enamels

 1. *Bliss*
 2. *The Executed*
 3. *Slaughter of the Holy Innocents*
 4. *The Cemetery*
 5. *Musician and Children*
 6. *The Bathers*
 7-8. *Crucifixion No. 1 and 2*
 9. *Child with Kite*
 10. *Seated Child*
 11-12. *Christ Descended from the Cross, No. 1 and 2*
 13-14. *Nativity, No. 1 and 2*
 15-16. *The Harbour No. 1 and 2*
 17-19. *Children Playing No. 1, 2, and 3*
 20. *The Millers*
 21. *Dance*
 22. *Resurrection*
 23. *Figures*
 24. *Women with Watermelons*
 25-26. *Mother and Child No. 1 and 2*
 27-28. *A Child No. 1 and 2*
 29. *An Indian*
 30. *Musicians*
 31. *Man with a Peacock*
 32. *On the Waterfront*
 33. *Figure with a Dove*
 34-39. *Landscape, No. 1, 2, 3, 4, 5, and 6*
 40. *Altar* (10 pieces)

June 21 - July 15, 1957

THREE PAINTERS OF PERU

The three painters here presented belong to a generation of Peruvian artists who are now in their forties or fifties. Although representing a variety of trends, they are alike in rejecting the precepts of the Indianist school that preceded them, with its emphasis upon description and motifs taken from folklore. Their interest is in forms and tonal effects rather than in direct representation, even when they take as a theme the Peruvian landscape or a scene of everyday life.

Alberto Dávila was born in Trujillo, Peru, in 1912 and studied at the National School of Fine Arts in Lima, where he is at present a teacher. He has participated in Peruvian group shows in Mexico, Canada, Cuba, and Venezuela, and at the Second São Paulo Biennial. He has held one-man shows in Lima every year since 1953. The recipient of various awards at the national salons, he won the National Prize for Painting in 1953.

Sérvulo Gutiérrez, born in Ica, Peru, in 1914, is a self-taught artist. Alternating between painting and prize fighting, he definitely abandoned the ring in 1938, when he went to Paris to devote his time to painting and, for a brief period, to sculpture. He has also traveled and painted in Argentina. Gutiérrez has participated in group shows of Peruvian painting abroad and in his native land, and has held a number of one-man exhibits in Lima. In a recent interview the artist stated: "In my painting reality is shown as I conceive and feel it, and the variations from the objective which my art exhibits are not studied."

Born in Switzerland in 1901 and now a Peruvian citizen, Enrique Kleiser has lived in his adopted country for the last twenty-five years, and it was there that he started to paint and take part in exhibitions. He has exhibited in Chile and Brazil, and held his first one-man show in the United States two years ago, at the Norfolk Museum in Virginia.

CATALOGUE

Oils

Sérvulo Gutiérrez

1. *Paisaje (Landscape)*
2. *La chola*[1]
3. *Cabeza (Head)*
4. *Crepúsculo en Ica (Twilight in Ica)*
5. *Cabeza con pelo rojo (Red Hair)*
6. *La Archirana*
7. *El árbol de cristal (Crystal Tree)*
8. *Still Life*
9. *Figura en una procesión (Procession)*

Alberto Dávila

1. *Symphony in Blue*
2. *Woman and Boats*
3. *Woman and Child*
4. *Composition*
5. *Still Life*
6. *Shrine and Bull*
7. *Shrine*
8. *Huanchaqueras*
9. *Women of Santa Rosa*
10. *Weaving Nets*

Enrique Kleiser

1. *Composition*
2. *Large Composition*
3. *Composition*
4. *Painting*
5. *Color in Space*

[1] *Chola* is a woman of Indian and white ancestry. —*Ed.*

July 16 - August 19, 1957

MARIA LUISA OF BOLIVIA: PAINTINGS

At the end of last year, a painting by María Luisa de Pacheco was included in a Latin American group show presented by the Institute of Contemporary Arts at its headquarters in the Corcoran Gallery. This was the first appearance of Sra. de Pacheco's work in Washington, and the current show is her first individual exhibit in the capital area.

Born in La Paz, Bolivia, in 1919, Sra. de Pacheco studied both at the Academy of Fine Arts in that city and under her fellow countryman Cecilio Guzmán de Rojas. Later, during a sojourn in Spain, she enrolled in the Royal Academy of San Fernando and in the private workshop of the Madrid artist Daniel Vásquez Díaz.

In addition to those she has presented in her native country, Sra. de Pacheco has held individual exhibitions in Madrid (1951), Santiago de Chile (1953), Buenos Aires (1954), and New York (1956). The last-mentioned, held at the Galería Sudamericana, was her first in the United States. She has participated in group shows in Bolivia, Cuba, Spain, and Venezuela, and has been featured in the Bolivian section of all three São Paulo Biennials.

She has won several first prizes, national and international; and her work is to be found in the collections of the Museums of Modern Art in Rio de Janeiro and São Paulo, the Municipal Museum of Contemporary Art of La Paz, and the National Museum of Fine Arts of Buenos Aires.

In addition to serving as an illustrator for the Bolivian daily *La Razón* and the Spanish magazines *Mundo Hispánico* and *Cuadernos Hispanoamericanos*, Sra. de Pacheco has taught at the Academy of Fine Arts in La Paz since 1951. She has traveled extensively in Europe and South America, and has recently opened a studio in New York.

The Chilean critic Víctor Carvacho has praised "her outstanding three-dimensional sense of form," and his Argentine colleague Manuel Mújica Laínez found in her painting "dramatic and poetic suggestion." Dore Ashton of the *New York Times* wrote recently: "Certain of the paintings in which she depicts cloaked figures closed in on themselves have a mysterious aura, while others, particularly her drawings, are firm, sinuous works, using contrast of hot colors with cool."

CATALOGUE

Oils

1. *Composición con figuras (Composition with Figures)*
2. *Palliris (Women Miners)*
3. *The Earth*
4. *Idolos (Idols)*
5. *Desnudo (Nude)*
6. *Woman Combing Her Hair*
7. *Twilight*
8. *Paisaje del altiplano (Altiplano Landscape)*
9. *Musicians*
10. *Idolos pre-colombinos (Pre-Columbian Idols)*
11. *Aymará Amulets*
12. *Woman*
13. *Figure*
14. *Two Women*
15. *Ciudad colonial (Colonial Town)*

16. *Wall Street*
17. *Procession*
18. *Figure in Violet*
19. *Ritual Dance*
20. *Tihuanacu*
21. *Andean Women*
22. *Reclining Figure*
23. *Estudio (Study)*
24. *Natives*
25. *Isolation*

Drawings[1]

August 7 - September 18, 1957

IVO BABAROVIC OF CHILE

A new name in Chilean art is that of Ivo Babarovic. Though born in Buenos Aires in 1924, he has lived in Chile since the age of two. In 1947 he attended the School of Fine Arts of the National University, and two years later he joined the workshop of Gregorio de la Fuente. Meanwhile he was studying to be a civil engineer, receiving his degree in 1951. In that same year he began to participate in group shows in Santiago. Between 1953 and 1956 his work figured in official salons held in that city and in Viña del Mar. In 1956 his first one-man show took place at the Chilean-British Cultural Institute in Santiago. From this last-mentioned exhibit came a number of the pictures included in this, the first individual presentation of Babarovic's work in the United States.

CATALOGUE

Oils

1. *Estufa y jarro azul (Stove and Blue Jug)*, 1956
2. *El botijo (The Spanish Jar)*, 1956
3. *Las hermanas (Sisters)*, 1956
4. *Mujer recostada (Reclining Woman)*, 1956
5. *Mesa con frutas (Table with Fruit)*, 1956
6. *Mujer peinándose (Woman Combing Her Hair)*, 1956
7. *Dos mujeres (Two Women)*, 1957
8. *Interior y naturaleza muerta (Interior and Still Life) I*, 1957
9. *Interior y naturaleza muerta (Interior and Still Life) II*, 1957
10. *Muchacha comiendo un fruto (Girl Eating Fruit)*, 1957
11. *Mujer sentada (Seated Woman)*, 1957
12. *Naturaleza muerta (Still Life)*, 1957

[1] Titles are unavailable. —*Ed*.

August 20 - September 11, 1957

LEOPOLDO NOVOA OF URUGUAY

Although born in Spain in 1919, Leopoldo Nóvoa is a lifelong citizen of Uruguay. Self-taught, he acknowledges the influence of the Uruguayan master Joaquín Torres-García, whose example gave the initial impulse to Nóvoa's own artistic career. Nevertheless, Nóvoa neither knew Torres-García personally nor joined the workshop established by that constructivist painter in Montevideo.

Nóvoa resides in Buenos Aires, where he held one-man shows at the Krayd Gallery in 1955 and the Van Riel Gallery in 1956; however, he frequently commutes across the Plata River to paint and present individual exhibits in his own country. Oils by him were shown in Buenos Aires at the Velázquez Gallery in 1953 and the Viau Gallery in 1954. In 1956 they were exhibited at Cantegrill in Punta del Este, Uruguay. An exhibit of Nóvoa's drawings had been held the previous year at the Sáenz Peña Gallery in La Plata, Argentina; others took place in 1956 at the Antígona Gallery in Buenos Aires and the Windsor Gallery in Montevideo. The floating exhibition of Argentine art sent around the world on the liner Yapeyú included one of his works.

Nóvoa is represented in the National Museum of Fine Arts of Buenos Aires and a number of private collections in Argentina and Uruguay. Reviewing his last show in the Argentine capital, the daily *La Nación* declared: "Leopoldo Nóvoa is a highly gifted artist. Working in pure colors, he achieves rich contrasts, and has created a joyous mode of painting."

CATALOGUE

Oils

1. *La cola del kerosene (Kerosene Line)*
2. *El Río de la Plata (Plata River)*
3. *Naturaleza con cebollas (Still Life with Onions)*
4. *Paisaje del Este (Landscape) No. 1*
5. *Limón y copa (Lemon and Cup)*
6. *Paisaje del Este (Landscape) No. 2*
7. *Bosque de Punta Ballena (Woods at Punta Ballena)*
8. *Paisaje del Este (Landscape) No. 3*
9. *El carro de la fruta (Fruit Cart)*
10. *El molinillo de café (Coffee Mill)*
11. *Paisaje del Este (Landscape) No. 4*
12. *Bañistas de día (Swimming by Day)*
13. *Muchacha en la ventana (Girl at the Window)*
14. *El hombre de Buenos Aires (Man of Buenos Aires)*
15. *Bañista de noche (Swimming at Night)*
16. *Mujer con verduras (Woman with Vegetables)*
17. *Campesino (Farmer)*
18. *Cosechando papas (Harvesting Potatoes)*
19. *Muchacha en la ventana (Girl at the Window)*
20. *Paisaje del Este (Landscape) No. 5*
21. *Dunas y pinos (Sand Dunes with Pines)*
22. *La barra del Arroyo Solís (Sand Bar of Solís Stream)*
23. *Inmigrantes (Immigrants) No. 1*
24. *Inmigrantes (Immigrants) No. 2*
25. *La vendedora de pescado (Woman Selling Fish)*

Engravings

26. *Naturaleza con tomate (Still Life with Tomato)*
27. *Gallina y gallo (Hen and Rooster)*
28. *Bañistas de Carrasco (Bathers at Carrasco)*
29. *Gaviota y lancha (Sea Gull and Boat)*
30. *Fuente con merluza (Fish)*
31. *Campesino en domingo (Farmer on a Sunday)*
32. *Paisaje nocturno del Este (Landscape at Night)*

September 12 - October 17, 1957

ANTONIO PRADO OF BRAZIL

An architect as well as a painter, Antônio Prado is an exponent of the most advanced trends in modern Brazilian art.

Born in Vitória, in the State of Espírito Santo, in 1927, Prado attended the National School of Fine Arts in Rio de Janeiro for a year, and thereafter was enrolled for two years in the National School of Architecture. He served for a time on the faculty of the latter institution as professor of design. He is currently engaged in architectural practice in Miami, Florida, where he has taken up residence.

Prado's work as a painter has been shown at the national salons in Rio de Janeiro and at salons in São Paulo and Bahia. Compositions by him were included in the Second and Third São Paulo Biennial, and in the 1955 Biennial in Barcelona (Spain).

Carlos Fléxa Ribeiro, art critic and professor of art history at the University of Brazil, writing of Antônio Prado, speaks of his "discipline and restraint" as a follower of the non-objective trend:

> In many respects his painting shows as it were a deliberate relinquishment, an intentional renunciation of plastic values. From his economy of resources there results a type of painting that is clean in texture and clear in composition, making an immediate visual impact. His work is brilliant in conception and shows a strongly personal character in its execution. . . . Antônio Prado may be classed among those modern painters who have already achieved recognition in Brazil, and of whose creative talent much is still to be expected.

This is Prado's first one-man show in the United States.

CATALOGUE

Paintings, 1957

1. *Ritmo (Rhythm) No. 1*, 24 x 30"
2. *Ritmo (Rhythm) No. 2*, 24 x 30"
3. *Ritmo (Rhythm) No. 3*, 24 x 30"
4. *Cordas (Cords)*, 24 x 24"
5. *Contraste (Contrast)*, 24 x 20"
6. *Composição (Composition) No. 6*, 25 x 30"
7. *Preto e branco (Black and White)*, 24 x 20"

8. *Composição (Composition) No. 8*, 24 x 30"
9. *Abstração (Abstraction) No. 8*, 30 x 24"
10. *Cinza e branco (Grey and White)*, 30 x 25"
11. *Azul e branco (Blue and White)*, 30 x 25"
12. *Linhas (Lines)*, 30 x 25"
13. *Abstração (Abstraction) No. 5*, 30 x 40"
14. *Forma (Form)*, 30 x 40"
15. *Movimento (Movement) No. 1*, 30 x 40"
16. *Movimento (Movement) No. 2*, 20 x 24"
17. *Abstração (Abstraction) No. 4*, 30 x 40"
18. *Forma (Form) No. 1*, 30 x 40"
19. *Forma (Form) No. 2*, 30 x 40"
20. *Abstração (Abstraction) No. 6*, 24 x 30"

Gouaches, 1957

1-10. *Desenho abstrato (Abstract Design)*

September 20 - October 20, 1957

ARCHITECTURE IN VENEZUELA
An Exhibition Sponsored by the Venezuelan Society of Architects and the Creole Petroleum Corporation

EXHIBITION COMMITTEE

Cipriano Domínguez, President, Venezuelan Society of Architects
Luis Ramírez, Architect
Mateo Manaure, Designer
Paolo Gasparini, Photographer

HONORARY COMMITTEE

From Venezuela

Moisés F. Benacerraf
Guido Bermúdez B.
Carlos A. Brando
Diego Carbonell
Oscar Carpio
Miguel Casas Armengol
Julián Ferris
Ernesto Fuenmayor
José Miguel Galia
Carlos Guinand Baldó
José Hoffmann
Pedro Lluberes D.
Leopoldo Martínez Olavarría
Willy Ossott
Alejandro Pietri Pietri

Jorge Romero Gutiérrez
Tomás José Sanabria
Guillermo A. Suárez
Juan Andrés Villanueva
Gustavo Wallis

From the United States

Pietro Belluschi
Leon Chatelain, Jr.
R. Buckminster Fuller
Philip C. Johnson
Ludwig Mies Van Der Rohe
Richard J. Neutra
Eero Saarinen
José Luis Sert
Edward D. Stone
William W. Wurster

ARCHITECTS REPRESENTED

Moisés F. Benacerraf, Venezuelan, Yale University
Guido Bermúdez B., Venezuelan, Universidad Central, Caracas
Carlos A. Brando, Venezuelan, Universidad Central, Caracas
Ramón Burgos, Chilean, Universidad Católica, Santiago de Chile
Diego Carbonell, Venezuelan, Massachusetts Institute of Technology, Cambridge
Oscar Carpio, Venezuelan, Universidad Central, Caracas
Miguel Casas Armengol, Venezuelan, Universidad Nacional de Colombia, Bogotá
Miguel Salvador Díaz, Venezuelan, Universidad Central, Caracas
Cipriano Domínguez, Venezuelan, Universidad Central, Caracas
Carlos Dupuy, Venezuelan, Universidad Nacional de Colombia, Bogotá
Simón Fernández, Venezuelan, Universidad Central, Caracas
Julián Ferris, Venezuelan, Syracuse University, Syracuse, New York and Universidad Central, Caracas
José Miguel Galia, Uruguayan, Architecture School of Montevideo, Universidad Central, Caracas
Carlos Guinand Baldó, Venezuelan, Universidad Central, Caracas
José Hoffmann, Venezuelan, Universidad Central, Caracas
Juan Hurtado Manrique, Venezuelan, Universidad Central, Caracas
Pedro Lluberes D., Venezuelan, Universidad Central, Caracas
José Manuel Mijares, Venezuelan, Universidad Central, Caracas
Alejandro Pietri Pietri, Venezuelan, Universidad Central, Caracas
Jorge Romero Gutiérrez, Venezuelan, Universidad Central, Caracas
Tomás José Sanabria, Venezuelan, Universidad Central, Caracas
Guillermo A. Suárez, Venezuelan, Universidad Nacional de Colombia, Bogotá
Juan Andrés Vegas, Venezuelan, Massachusetts Institute of Technology, Cambridge and Universidad Central, Caracas
Martín Vegas, Venezuelan, Illinois Institute of Technology, Chicago, Universidad Central, Caracas
Carlos Raúl Villanueva, Venezuelan, Ecole des Beaux-Arts, Paris

Other Architects Represented

Dirk Bornhorst

Emile Vestuti
Pedro Neuberger
Julio C. Volante

INTRODUCTION

Architecture, which has a promising future in Venezuela, is currently undergoing accelerated development there. Without wishing to compare itself to its great neighbors—Brazil, for instance—Venezuela desires its architecture to be recognized and placed with that of those countries avoiding the beaten path, wanting to express the feeling of our times.

Venezuela's simple but magnificent colonial architecture flourished in the eighteenth century when, unfortunately, perishable materials such as adobe and mud were utilized. However, all the modern techniques employing iron and concrete are currently being used, retaining at the same time the logical, rational expression evinced in the constructions of the past century.

Venezuela, a vast and immensely rich country, lent itself to planned architectural development. Therefore, the City Planning Commission was created, a dependency of the national government, working through the Ministry of Public Works. Its main function is to study regional planning and to control rural and urban developments.

Caracas, the capital city, is strategically located in the center of Venezuela and is directly connected to the rest of the world by the port of La Guaira, the airports of Maiquetía and Maracay and, by land, to the Pan American Highway.

Eastern Venezuela, the shores of Lake Maracaibo, the mountainous region of the Andes, the Caracas central section, and all the regions along the great Orinoco River were considered geographically and economically as the most suitable for regional planning development.

With regard to Caracas, the project of joining the La Guaira superhighway to those of the eastern valley will greatly increase the flow of traffic. In addition, the completion of the great Simón Bolívar Center will serve to give air to the old part of the city and provide Caracas with large parking lots and bus depots.

Concrete, the most important material utilized in architecture, has enabled us to create new forms—technically very interesting. Interior space is given special consideration in our current projects, since this is where men think, love, and relax. We are giving concentrated study to this particular phase in order to attain true architectural expression. The brilliancy of colors contributes another special characteristic to the makeup of our young architecture.

The Mediterranean influence, so evident in Venezuelan architecture, and buildings with porches, porch roofs or awnings, so wisely arranged to take full advantage of climate and light, are very significant and amply justify the confidence and enthusiasm of our young architects. —*Carlos Raúl Villanueva*

AN APPRECIATION

Intercultural events are the events which mold and move the world. We must be deeply grateful to the Sociedad Venezolana de Arquitectos for collecting and presenting to a broad public the architecture produced in their beautiful and truly amazing country.

Architecture, always expressive of the civilization from which it springs, is, in Venezuela especially, expressing one of the miracles of our time: the unprecedented resourcefulness and vigor of a fast developing region which, in little more than a decade, has become the modern prototype of man's progress and potentials in an age of science and prolific engineering.

There, a population at large is affected by the impressive clusters of public housing of the Banco Obrero on the hills of Caracas, the workers housing units at Lake Maracaibo and in the Orinoco Valley, the unusual Centro Simón Bolívar, the Institutes of Education and Research, the comfort of strikingly situated new hotels on the mountains and at the littoral, modern office buildings in the cities and sugar-mills in the countryside. It is a vast new world that has been unfolding without pause.

When I myself, in 1923, reached the shores of this Western Hemisphere, it was not a new world of novel form. The prevalent thinking was conventional, indeed to many it seemed hopelessly so, and pioneering in design was ridiculed for decades to come. My Venezuelan colleagues of today will hardly be able to gauge my loneliness in those days, or the rarity of finding a receptive client.

More than thirty years ago I wrote and illustrated a book to which I gave the title *How America Builds*. By America I meant the world between Atlantic and Pacific, the world which has absorbed immigration of people and ideas from all around the globe, a world predicated on modern means of production and ingenuity. I predicted that the new materials and constructions which serve us, the new fuels which propel our transportation, distribution and all our humming wheels, would make this mighty continent a seedbed of new form, a vast exhibition of design skill, operating under new circumstances.

Venezuela has taken a leading place in this experimental adventure. A short time ago it would have been best characterized by the lyrical, old world charm of small town plazas. Now all this seems reversed. Side by side with regional and city planners, well endowed by the administration of Venezuela, architects have served government, industry, commerce, and cultural pursuits with a promptness, a grasp of the moment, a presence of mind, perhaps unparalleled anywhere else.

The shapes man has thus added so fast to the lovely scene of Venezuelan nature, from the islands off the shore and the seacoast to the high mountainous elevations and to the tropical river valley of the interior, are shapes of man's new environment.

The design of environment arranges the impacts on our own so ancient organic being, basically unchanged in a hundred thousand years. Design places powerful stimuli around us, but, easily enough, also features which may fatigue and irritate.

In the speed and haste of our technological civilization, the architect has a social responsibility which he never in the past had wielded to a comparable degree. He can subtly help and harm life processes. He must hold and keep human values foremost in his artistic consciousness and before his conscience. Architects and planners are indeed a powerful instrument toward the happy survival of mankind, and in Venezuela they have courageously taken the initiative in actions which are in many ways exemplary to the rest of the world, whose interest they command.

We, in the distance, appreciate the helpfulness of the Creole Petroleum Corporation, one of the industrial leaders of a fabulous country, in bringing before our eyes a true intercultural event like this magnificent showing of work to which the architects of Venezuela have given their untiring efforts and talents. —*Richard J. Neutra*

CATALOGUE

Panels

Photos on the following panels are courtesy of the Hamilton Wright Organization Inc.: 6, 10, 24, 26, 38 (upper right), 39, 40 (lower right), 54.

1. Colonial Architecture: *Church El Calvario*, Carora: *Residence La Casa del Sol*, Coro; *Cathedral*, Guanare; *Church Santa Barbara*, Cabudare; *Detail, Santa Bárbara*

54. *Regional Plan of Margarita Island*, by Office of City Planning, and *Hotel Porlamar*, by Martín Vegas and José Miguel Galia
55. *Venezuelan Pavilion for International Exposition*, Santo Domingo, Dominican Republic, 1955, by Alejandro Pietri Pietri
56. *Venezuelan Cactus*

Stereos

1. *Gran Avenida Building*, Caracas, by Carlos Guinand Baldó and Moisés F. Benacerraf
2-3. *Maripérez Cable Car Terminal*, Caracas, by Alejandro Pietri Pietri
4. *Centro Simón Bolívar*, looking down from 30th-story penthouse, Caracas, by Cipriano Domínguez
5. *Library at University City*, by Carlos Raúl Villanueva. *Mural*, by Mateo Manaure
6. *Covered Walk*, University City, Caracas
7. *Aluminum Screen*, by Victor Vasarely; *Mural*, by Pascual Navarro at University City
8. *Mural*, by Fernand Léger at University City
9. *Mural*, by Mateo Manaure; *Sculpture*, by Balthazar Lobo at University City
10. *Sculpture*, by Henri Laurens, *Mural* by Fernand Léger at University City
11. *Mural*, by Pascual Navarro, at University City
12. *Detail of Mural*, by Pascual Navarro, at University City
13. *Library and Small Auditorium* at University City, by Carlos Raúl Villanueva
14. *Sculpture*, by Jean Arp and *Mural*, by Mateo Manaure, at University City
15. *Engineering and Architecture School*, University City, by Carlos Raúl Villanueva

Transparencies

1. *Church Santo Domingo*, Mérida
2. *Church El Calvario*, Carora
3. *Hotel Alto Llano*, Barinas, by Oscar Carpio and Guillermo A. Suárez
4. *Hotel Prado del Río*, Mérida, by Tomás José Sanabria and Julio C. Volante
5. *School of Architecture*, University City, by Carlos Raúl Villanueva
6. *Mobile*, by Alexander Calder, School of Architecture
7. *Mural*, by Pascual Navarro, at covered plaza, University City
8. *Aluminum Screen*, by Víctor Vasarely; *Mural*, by Mateo Manaure, at University City
9. *Sculpture*, by Jean Arp; *Mural*, by Mateo Manaure, at University City
10. *Mural*, by Fernand Léger, at University City
11. *Building Housing Air Conditioning Equipment* at University City; *Mural*, by Victor Vasarely; and *Sculpture*, by Antoine Pevsner
12. *Stained Glass Window*, by Fernand Léger, in University City Library
13. *Mural*, by Mateo Manaure, at University City
14. *Sculpture*, by Henri Laurens; *Mural*, by Fernand Léger, at University City
15. *Mural*, by Mateo Manaure, at University City
16. *Simón Bolívar Housing Development*, Caracas, 1956, by Carlos Raúl Villanueva and José Manuel Mijares
17. *Gil Fortoul Housing Development*, Barquisimeto, by José Manuel Mijares
18. *School of Petroleum Engineering*, University of Zulia, Maracaibo, by Carlos Raúl Villanueva
19. *School of Petroleum Engineering*, University of Zulia, Maracaibo, by Carlos Raúl Villanueva
20. *Zapara Housing Development*, Maracaibo, by José Hoffmann

BIOGRAPHICAL NOTES[1]

BENACERRAF, Moisés F. Architect, born in Caracas, 1924. Studied at Yale University, 1942-47, under Herberd Read, Elia Kazan, and others. Founded with Carlos Guinand Baldó the architecture firm Guinand y Benacerraf, Caracas, 1947, introducing modern architectural concepts in constructions such as the Gran Avenida Building, Caracas, 1952, and the Banco Unión, Sucursal del Este, Sabana Grande, 1953. In 1950 founded, with Francisco Carrillo Batalla and Carlos Guinand Baldó, Planificación y Vivienda, one of the first private urban planning offices in Venezuela, where city plans were drafted for Puerto Ordaz, Ciudad Piar, Shell Company of Venezuela Refinery of Punta Cardón (a project translated into more than ten languages), 1950-54.

BERMUDEZ BRICEÑO, Guido. Architect, born in Maracaibo, 1925. Studied at the Universidad Central de Venezuela, Caracas, 1946-51. Before graduation, started working as draftsman in the Banco Obrero where, following Le Corbusier's principles of high-rise living and under the guidance of Architect Carlos Raúl Villanueva, developed his thesis Conjunto Multifamiliar Cerro Grande, built in 1954. Planned many other urban developments such as the Conjunto Multifamiliar Piloto, Caracas, 1951, and Centro Comercial Jacinto Lara, Barquisimeto, 1954. Since that year he has been a member of the Taller de Arquitectura del Banco Obrero, first governmental institution for urban development, and since 1956 he has been teaching architectural design at the School of Architecture and Urban Studies in Caracas.

DOMINGUEZ, Cipriano. Civil engineer, architect, born in Caracas, 1904. Graduated as a civil engineer and doctor in physics and mathematics from the Universidad Central de Venezuela, Caracas, 1928. Also studied in Paris, 1930-33, at the Ecole Spéciale d'Architecture, doing internships at the studio of Le Corbusier whose principles he introduced in Venezuela and applied them in one of his more important projects, the towers of the Centro Simón Bolívar, 1948. Worked for the Ministry of Public Works, Caracas, 1934-45, and designed public buildings in different Venezuelan cities, including the Instituto Pedagógico and the Liceo Fermín Toro, Caracas, 1936. In 1945 co-founded the Venezuelan Society of Architects and the Architecture Division of the School of Engineering, Universidad Central de Venezuela, where he was a professor of architectural composition, 1945-50. Member of the Venezuelan delegation to the Pan American Congress of Architects in Lima (1947), Havana (1950), Mexico (1952) and Caracas (1955). During this time he was also the director of the National Committee for Urban Projects in Caracas.

FERRIS, Julián. Architect, born in Caracas, 1921. Graduated from the University of Oklahoma as an architectural engineer, 1945, and from Syracuse University as an architect, 1947. Returning to Caracas in 1948, co-founded in 1953 the School of Architecture and Urban Studies of the Universidad Central de Venezuela, where he is presently teaching while also working as an architect. His more important projects include Edificio de Apartamentos Laguna Beach, Tanaguarena; Urbanización Chuao, Caracas; and others.

GALIA, José Miguel. Architect, born in Montevideo, Uruguay, 1919. Graduated from the School of Architecture, University of Montevideo, 1944. Completed two graduate courses in architectural design and composition, winning the Carre Prize in both, 1945 and 1946. As a professor, helped structure the curriculum of the School of Architecture and Urban Studies where he has been a founding professor since 1953. As a professional, founded with Martín Vegas the architecture firm Vegas y Galia, Caracas, 1950, of significant achievements in the Venezuelan modern architectural movement, such as the buildings El Municipal, 1951; Casa Monagas in Las Acacias, 1952; Tabare in San Bernardino, 1953; Polar, Teatro del Este, and Anglo-Ven Sales in Bello Monte, 1955, all of them in Caracas. Won several distinctions, including Silver Medal, Seventh Pan American Congress of Architects, Lima, 1947. Lives in Caracas since 1948.

HURTADO MANRIQUE, Juan. Engineer, architect, born in Caracas, 1837, where he died in 1896. Studied at the

[1] Not included in the original catalogue. See Index of Artists for reference on those not listed here. —*Ed.*

university in Caracas. Worked as an engineer in hydraulic and agricultural projects. Fought in the Federal War obtaining the rank of General. Probably lived in Europe for some years before working as an architect for the Guzmán Blanco government. Occupied high positions in architectural related jobs, such as director of City Buildings and Urban Embellishment, 1883; minister of public works, 1887 and 1894; professor of architecture, Academy of Fine Arts, 1887-1891. Wrote two essays on architecture, 1894-96. An admirer of French architecture, his projects were drafted in the neo-classic, neo-baroque and neo-Gothic styles. His more important accomplishments include the north façade of the Central University of Venezuela, and the National Museum, 1873-75; several churches such as the Santa Teresa Church and the Masonic Temple, 1877; the bridges on the Catuche and Caraota Canyons, 1880-1883; and San Jacinto Market, 1885-90.

NAVARRO, Pascual. Painter, draftsman, born in Caracas, 1923. Since 1934 studied at the Academia de Bellas Artes and at the Escuela de Artes Plásticas y Aplicadas, 1941-45, both in Caracas. Lived for some time in Macuto with Armando Reverón. Through a Venezuelan scholarship granted in 1947, went to Paris where he attended Dewasne's Abstract Art Workshop, studied under André Lhote and with Alejandro Otero and Mateo Manaure; co-founded the Venezuelan group *Los Disidentes*, 1950. Executed three abstract murals at the Ciudad Universitaria, Caracas, 1953. Held an exhibition with Mateo Manaure at the Museo de Bellas Artes of Caracas in 1947; one-man shows at Galerie Arnaud, Paris, 1952; and Galería Clam, Madrid, 1955. Participated in the Salon des Réalités Nouvelles, Paris, 1951-54. Was awarded several prizes in different Venezuelan salons, including Premio Federico Brandt, Caracas, 1947; Premio Antonio Esteban Frías, Caracas, 1949; and the Grand Prize for Venezuelan Painters, International Exposition, Valencia (Venezuela), 1955. Has lived in Paris since 1947.

PIETRI PIETRI, Alejandro. Architect, born in Caracas, 1924. Studied at the School of Architecture and Urban Studies, Universidad Central de Venezuela, Caracas, 1950-55, where his professors were José Miguel Galia, Jorge Romero Gutiérrez, Juan Andrés Vegas, and Carlos Raúl Villanueva. Among his more important projects are the Venezuelan Pavilion at the International Exposition in Bogotá and in Santo Domingo, and the Maripérez Cable Car Terminal, 1955-56.

SANABRIA ESCOBAR, Tomás José. Architect, born in Caracas, 1922. Graduated as a civil engineer from the Universidad Central de Venezuela, Caracas, 1945; and obtained a Master Degree in architecture from the Graduate School of Design, Harvard University, Cambridge, 1947. Since then he has worked as an independent architect, while also teaching at the Universidad Central de Venezuela in Caracas. There, in 1948, was assigned founding director of the Department of Architectural Composition. Since 1954 he is the director of the Department of Architecture at the School of Architecture. Co-founded with Diego Carbonell the firm Carbonell y Sanabria Arquitectos (1949-53), where, among others, the plans were drafted for La Electricidad de Caracas located in San Bernardino (1951). His more important projects include the Fábrica de Azucar, El Palmar, San Mateo; Aragua (1956); Hotel Humboldt, Pico Avila, Caracas; and Hotel Prado del Río Mérida (1957). Was decorated with the Order Francisco de Miranda, 1957.

VEGAS PACHECO, Martín. Architect, born in Caracas, 1926. Graduated with a Bachelor of Science in architecture from the Illinois Institute of Technology, Chicago, 1949, having been a student of Ludwig Mies van der Rohe. Also studied at the Universidad Central de Venezuela, Caracas. Founded with José Miguel Galia the architecture firm Vegas y Galia in Caracas in 1950. This enterprise excelled for its innovative architectural concepts in the construction of buildings such as the Edificio Municipal (1951), Casa Monagas in Las Acacias (1952), Edificio Tabare in San Bernardino (1953), and the Edificio Polar and the Teatro del Este (1955), all of them in Caracas.

VILLANUEVA, Carlos Raúl. Architect, born in London, 1900. Studied in the architecture studio of Gabriel Héraud and graduated as an architect from the Ecole Supérieure des Beaux-Arts in Paris. One of the most creative architects in Venezuela, has worked independently and since 1945 for the Banco Obrero. His projects include the Hotel Jardín (1929) and the Plaza de Toros (1931), both in Maracay; and in Caracas, Galería de Arte Nacional (1934), Escuela Gran Colombia (1934), Urbanización El Silencio (1941), and Edificios Multifamiliares Cerro Piloto (1954), in

collaboration with Guido Bermúdez, Carlos Brando, and Juan Centella. In 1942 he started to draft the Ciudad Universitaria in Caracas, with a very free interpretation of space and integrating the work of internationally prominent artists. Among other distinctions, was awarded the Grand Prize at the International Exposition of Paris in 1937, for the design of the Venezuelan Pavilion done in collaboration with Luis Malaussena. Has lived in Caracas since 1928.

October 22 - November 15, 1957

ALFREDO BIGATTI OF ARGENTINA: DRAWINGS AND MONOTYPES

One of the countries of this hemisphere in which there has been a steady development in sculpture is Argentina, and one of the most important artists of his generation, outstanding as a forerunner of modern Argentine sculpture, is Alfredo Bigatti.

Born in Buenos Aires in 1898, Bigatti studied at the National Academy of Fine Arts there and between 1923 and 1924 carried out postgraduate studies in the workshop of the great French sculptor Antoine Bourdelle in Paris. For seven years the artist traveled extensively in Europe and participated in numerous international exhibitions, among them the one in Paris in 1937 and the one in San Francisco in 1939, and for both executed reliefs for the Argentine pavilions. He won the Special National Award for Sculpture in Buenos Aires in 1935 and the Grand Prize for Sculpture in the International Exhibition of Paris in 1937. A member of the National Academy of Fine Arts, Bigatti is a professor of sculpture in the School of Fine Arts in Buenos Aires and exhibits frequently there. One of his latest works is the *Monument to the Flag* erected in Rosario, Argentina, in 1947.

As a member of the group of artists in Argentina who reacted against academic formula in the early 1920s, Bigatti has evolved progressively from the neo-classical conceptions received from Bourdelle into a more expressive and simplified, austere sense of form which links his work with contemporary Italian sculpture. Due to transportation difficulties, we are unable to present actual examples of the artist's sculpture and can only present them through photographs. However, the drawings and monotypes which comprise his part of this exhibition closely follow the trend of his present three-dimensional work and give a complete idea of his creative power. This is the artist's first one-man exhibition in the United States.

CATALOGUE

Drawings

 1. *Desnudo (Nude)*
 2. *El auriga (Coachman)*

Monotypes

 3. *Toilette*
 4. *Joven y caballo (Boy and Horse)*
5-7. *Adán y Eva (Adam and Eve)*, tryptic
 8. *El jinete (Horseman)*
 9. *El origen (Origin)*
 10. *Cosmos*
 11. *Jinete y caballos (Horseman with Horses)*
 12. *En la playa (At the Beach)*
 13. *Mujeres (Women)*

14. *Desnudo (Nude)*
15. *Caballo (Horse)*
16. *La partida (Departure)*

October 22 - November 15, 1957

RAQUEL FORNER OF ARGENTINA

Argentina was one of the first countries in this hemisphere to accept the new directions in art emanating from post-impressionism. Soon after World War I a group of Argentine painters and sculptors went to Europe, settling mainly in France where they were placed in contact with fauvism, cubism, surrealism, etc. Composed of some twelve outstanding personalities, this group has always considered Raquel Forner the most important woman painter of her generation.

Miss Forner was born in Buenos Aires in 1902 and studied at the National Academy of Fine Arts. Between 1929 and 1930 she went to Europe for the first time, enrolled in the workshop of the painter Emile Othon Friesz, participated in the Salon of the Tuileries and later in the International Exposition of Paris in 1937, where she won a gold medal. Invited two years earlier to participate in the Carnegie International of Pittsburgh, she was included in Latin American shows in New York and in San Francisco in 1939. In addition to having participated in many national salons in Argentina in which she received numerous awards, the artist has held various individual exhibits in Buenos Aires in the Bonino Gallery, the official representative of her work in Argentina. Last year she won the Grand Prize of the National Salon of Buenos Aires. She is represented in the collections of the Museum of Modern Art of New York; Municipal Museum, Montevideo; National Museum of Fine Arts, Buenos Aires; and in several other Argentine museums. In private life Raquel Forner is the wife of sculptor Alfredo Bigatti, whose graphic work is being displayed jointly with hers in this, her first solo show in the United States.

Departing from an allegorical surrealism in which the artist narrated intricate subject matters with competent craftsmanship, she has developed in the last few years work of absolute maturity, of suggestive content mainly based upon pure plastic expression, using all the resources of a painter of exceptional imagination who attains quality above all.

CATALOGUE

Oils

1. *Apocalipsis (Apocalypse)*, 1955
2. *Principio (Beginning)*, 1957
3. *Fin (End)*, 1957
4. *Punto cero (Zero Point)*, 1956
5. *Cementerio marino (Marine Cemetery)*, 1957
6. *El sueño (The Dream)*, 1956
7. *La red (The Net)*, 1957
8. *La espera (Waiting)*, 1956
9. *Las copas (Cups)*, 1957
10. *Las lunas (Moons)*, 1957
11. *El destino (Destiny)*, 1954
12. *La quimera (Chimera)*, 1954
13. *Toro en rojo (Red Bull)*, 1954
14. *Nocturno (Nocturne)*, 1955

Drawings[1]

15. *The Call*, drawing
16. *Sketch for the Net*
17. *Nocturne*
18. *Cycle*
19. *Sketch for Marine Cemetery*
20. *The Embrace*
21. *The Mirror*
22. *The Dream*
23. *Sketch for Net II*
24. *Fallen Beast*
25. *Nightmare*
26. *Night*

Monotype

27. *Interlunio*

November 19 - December 11, 1957

HUMBERTO JAIMES SANCHEZ OF VENEZUELA

Non-objective art is of recent development in Venezuela. It was toward 1947 that Alejandro Otero and Mateo Manaure, then scholarship students in Paris, began to pioneer in the field. Joined by others, both painters and sculptors, they now constitute a group of about ten artists experimenting with different media and seeking to express themselves in geometric forms. Much of their work has been ancillary to architecture: the murals commissioned for buildings in the modern style have provided a demand and insured a certain measure of acceptance for the new art.

A leading figure among the abstractionists is Humberto Jaimes Sánchez, born in San Cristóbal, Venezuela, in 1930. Jaimes went to Caracas to study at the School of Plastic Arts and at different times taught art and served as a stage designer in the same city. In 1954 he received a scholarship for study in Europe, where he spent three years working in Rome and Paris.

Jaimes's one individual exhibit took place at the Free Workshop in Caracas in 1949, but his work has been included in many group shows in Venezuela. Abroad he has figured in the *Gulf Caribbean Art Exhibition* in Houston, in an exhibit of six Venezuelan painters organized by the Pan American Union and the Smithsonian Institution in 1954, in the Second São Paulo Biennial of 1953, and in the *International Exposition of Contemporary Art* held in Paris in 1955. He received awards at the Venezuelan salons in 1952 and 1953, and compositions of his form part of private collections both in his own country and in France.

The French critic Gaston Diehl wrote of Jaimes's work:

> The rudimentary figures looming out of primal night have for him but the value of allusive symbols. In building them into plastic shapes he displays the surest of structural logic and a

[1] Also exhibited but not included in the original catalogue. —*Ed.*

concern for the lyric effects of colors. His work arouses lively interest by reason of its emotional density and the forcefulness with which it conveys human feeling.

This is the first individual exhibit of Jaimes's work in the United States.

CATALOGUE

Oils

1. *Andes*
2. *Barlovento*
3. *Nativity*
4. *Ritual*
5. *Aleluya (Hallelujah)*
6. *Dancers*
7. *Devils on Strike*
8. *Oración (Prayer)*
9. *Devilment*
10. *Piachería*
11. *Curse*
12. *Budding Moon*
13. *Fractured Time*
14. *Personaje (Personage)*
15. *Rituals*
16. *Domingo de Ramos (Palm Sunday)*
17. *Saint John's Day*
18. *Ritual Group*
19. *Fiancée*

Gouaches

20. *The Jazz Age*
21. *Enchantment*

Collages

22. *Germination and Miracle*
23. *Dolls*
24. *Saintliness*

Oils[1]

25. *Earthly Symbol*
26. *The Bicycle*
27. *Tumbler*
28. *Painting for a Little Girl*
29. *Amoureux*
30. *East Light*

[1] Also exhibited but not listed in the original catalogue. —*Ed.*

31. *Wind*
32. *Mediodía (Noon)*
33. *Dance*
34. *Come and Go*
35. *River Gnome*
36. *Double Icon*

Scratchboard

37. *Crescent Moon*

November 19 - December 17, 1957

CARICATURES AND CARTOONS FROM CUBA

This exhibit was organized in Havana by the Cuban Association of Caricaturists. For more than fifteen years now that society has counted among its members cartoonists and caricature artists from publications throughout the island. The Association holds an annual salon of humorous art in Havana, and sponsors group exhibitions in other parts of the country. This is the first show which it has presented outside Cuba. It was aided in the arrangements by the Cuban National Institute of Culture, for whose cooperation appreciation is here expressed.

CATALOGUE

Caricatures and Cartoons

Enrique Arias
 1. *Alicia Alonso*

Luis Castillo
 2. *Caída (Fall)*
 3. *Sueño (Dream)*

Juan David
 4. *Ernest Hemingway*
 5. *Igor Stravinsky*

José L. Díaz de Villegas
6-8. *Dibujo humorístico (Drawing)*
Silvio Fontanillas
 9. *Competencia (Competing)*

Lázaro Fresquet
 10. *Sans paroles*
 11. *Hi-Fidelity*
 12. *Telephonic Beginning*

David García
 13. *Ambiente (Environment)*

Alfonso Luaces
14. *Airmail*
15. *El cowboy se divierte (Cowboy at Play)*

Conrado Massaguer
16. *Mr. Hoover*

Carlos Mestre
17. *Ike*
18. *Spruille Braden*

Nico (Antonio Mariño)
19. *Afinidad (Affinity)*

Niko (Nicolás Luhrsen)
20. *Tentación (Temptation)*
21. *El domador revisa el motor (Lion Tamer Inspecting Motor)*
22. *El periodista Herbert Matthews (Newspaperman Herbert Matthews)*

René de la Nuez
23. *Busto italiano (Italian Bust)*
24. *Sin palabras (Without Words)*

Pecruz (José A. Cruz)
25. *Olimpiada (Olympics)*

Gilberto Pérez
26. *Adlai Stevenson*

José Luis Posada
27. *El pacifista (The Pacifist)*

Antonio Rubio
28. *Eleanor Roosevelt*
29. *Injerto (Inbreeding)*

Humberto Valdés
30. *Romeo y Julieta (Romeo and Juliet)*

Carlos Vidal
31. *Drawing*
32. *Sic transit gloria mundi*

Luis F. Wilson
33. *Pesca submarina (Underwater Fishing)*

Silvio Fontanillas
34. *Competencia (Competing)*

BIOGRAPHICAL NOTES[1]

ARIAS, Enrique. Painter, draftsman, caricaturist, musician in the Philharmonic Orchestra of Havana, born in Havana, 1918. Studied under García Cabrera and at the Academy of San Alejandro, Havana. Held one individual exhibition, Havana, 1951. Participated in the Salón de Humoristas and the Second Hispanic American Biennial of Art, Havana, 1954. Was awarded two prizes.

CASTILLO, Luis. Graphic artist, caricaturist, cartoonist, born in Cuba, 1935. Has worked for several newspapers and at present for *Bohemia*. Does animated films. Exhibited in the Salón de Humoristas and other group shows in Havana. Was awarded two prizes for his commercial drawings.

DAVID, Juan. Draftsman, caricaturist, born in Cienfuegos, Cuba, 1911. Has worked for the main newspapers and magazines of Havana as political caricaturist and at the United Nations, New York, 1948 and 1949. Since 1929 has held individual exhibitions in Cuba and the United Nations, 1949. Was awarded First Prize at the Salón de Humoristas of Havana in 1937, 1938 and 1939, and at the *Contest of War Posters*, Havana, 1942. His drawings have been reproduced in publications in Argentina, Mexico, Spain, and the United States.

DIAZ DE VILLEGAS, José Luis. Draftsman, caricaturist, cartoonist, civil engineer, born in Cuba, 1925. Held one individual exhibition and participated in group shows in Cuba. Was awarded two prizes at the Salón de Humoristas of Havana.

FONTANILLAS, Silvio. Caricaturist, born in Cuba, 1913. Founder of the weekly magazine *Zig Zag* of Havana. Has worked for many Cuban magazines and newspapers and directed some weekly humorous magazines. Exhibited in the Salón de Humoristas, winning several awards.

FRESQUET, Lázaro. Painter, draftsman, caricaturist, cartoonist, stage designer, writer, born in Cuba, 1931. Worked for advertising agencies, magazines, and publishing houses; did film animation and stage designs. At present is the art director of the magazine *Teleprograma*, and of the Advertising and Film Company Ostap. Has exhibited in the Salón de Humoristas since 1951, winning one prize.

GARCIA, David. Caricaturist, born in Cuba, 1921. Art director of Aguila Publicitaria. Exhibited in the Salón de Humoristas and other group shows in Cuba.

LUACES VILLAURRUTIA, Alfonso. Caricaturist, born in Camagüey, Cuba, 1922. Studied at Georgia Military College, but is self-taught as an artist. Works for several magazines and newspapers. Exhibited in the Salón de Humoristas, and the Second Hispanic American Biennial of Art, Havana, 1954. Was awarded several prizes for his caricatures.

MASSAGUER, Conrado. Caricaturist, painter, born in Cárdenas, Cuba, 1889. Studied at the Military Academy, New York, graduating as a lieutenant; self-taught as an artist. Worked for many magazines and newspapers in Cuba and the United States, including *Journal, Life, World, Vanity Fair*. Founded the magazines *Gráfico* (1913) and *Social* (1916), both in Havana. Co-founded the Salón de Bellas Artes and the Salón de Humoristas, 1939. Illustrated many books and published *Guignol* in 1924, a book with forty caricatures. Since 1911 has exhibited in Paris (1929), New York (1930), and Cuba. Was awarded many prizes and honors in the United States and Cuba.

MESTRE, Carlos. Caricaturist, born in Cuba, 1918. Worked for nearly all the Cuban newspapers and magazines. Does commercial drawings and is the director of the magazine *The Dinners' Club* of Cuba. Held four individual exhibitions, Havana. Since 1939 has participated in every Salón de Humoristas as well as other salons and group

[1] Not included in the original catalogue. —*Ed.*

exhibitions in Cuba. Was awarded numerous prizes for caricature.

ÑICO (Antonio Mariño Souto). Draftsman, caricaturist, born in Cuba, 1936. Works for several magazines. Exhibited in one Salón de Humoristas.

NIKO (Nicolás Luhrsen). Caricaturist, cartoonist, born in Havana, 1916. Self-taught as an artist. Worked for nearly all the Cuban magazines and newspapers. Art director for several advertising agencies. One of the three caricaturists who created the first sound animated cartoon in Cuba, held one individual exhibition and participated in Cuban salons and group exhibits, including the Second Hispanic American Biennial of Art, Havana, 1954.

NUEZ, René de la. Caricaturist, born in Cuba, 1938. Self-taught as an artist. Works for several magazines and newspapers. Participated in one Salón de Humoristas and in other group exhibitions in Havana. Was awarded a prize for caricature.

PECRUZ (José A. Cruz). Caricaturist born in Cuba, 1937. Self-taught as an artist. Works for the weekly magazine *Zig Zag*, is chief coordinator of the column "Humorismo criollo" in *Bohemia* and a radio commentator. Exhibited in one Salón de Humoristas.

PEREZ, Gilberto. Caricaturist, born in Cuba, 1943. Self-taught as an artist, he is still studying at the secondary school. Collaborating caricaturist in *Zig Zag*, has participated twice in the Salón de Humoristas and was awarded the Second Prize for Caricature in 1956.

POSADA, José Luis. Caricaturist, born in Villaviciosa, Cuba, 1929. Self-taught as an artist, exhibited in group shows and the Second Hispanic American Biennial of Art, Havana, 1954. Won a prize at the Salón de Humoristas.

RUBIO, Antonio. Caricaturist, painter, born in Cuba, 1921. Self-taught as an artist, worked for nearly all the Cuban newspapers and magazines. Is the art director of an advertising agency. Participated in many salons and group exhibitions in Havana. Won nine prizes at the Salón de Humoristas and four in different poster contests.

VALDES, Humberto. Caricaturist, born in San Nicolás de Bari, Cuba, 1923. Studied with Aparicio and Hurtado de Mendoza. Works for *El Tiempo, Bohemia*, and *Zig Zag*. Held individual exhibitions in Havana and Güines. Participated in the Salón de Humoristas and several other group exhibitions in Cuba. Was awarded several prizes, including one at the Second Hispanic American Biennial of Art, Havana, 1954.

VIDAL, Carlos. Draftsman, caricaturist, born in Cuba, 1920. Studied at the Escuela de Bellas Artes, Havana. Lived in New York working as caricaturist and draftsman when he was seventeen. Has worked for many magazines and newspapers in Havana. At present works for *Información* and is a collaborating caricaturist for *Bohemia*. He is also a commercial graphic artist and a professor of drawing at the American Academy and the Escuela Profesional de Periodismo. Won five prizes in the Salón de Humoristas and four in different poster contests.

WILSON VALERA, Luis F. Caricaturist, born in Cuba, 1931. Studied for two years at the Medical School. Collaborating caricaturist in *Bohemia* and *Zig Zag*. Won several prizes at the Salón de Humoristas in Guantánamo and two prizes at carnival poster contests in Oriente.

December 19, 1957 - January 13, 1958

VICTOR CARVACHO OF CHILE

Both as a painter and as a critic, Víctor Carvacho is an exponent of the most advanced trends in Chilean art. First

in the column which he wrote for the magazine *Pro-Arte* from 1948 to 1951, and since then in the pages of the newspaper *El Debate*, Carvacho has constantly combatted academic restraint, championing the cause of artistic freedom.

Born in Santiago in 1916, Carvacho studied at the University of Chile from 1935 to 1938. He held one-man shows at the Galería del Pacífico in Santiago in 1947, 1948, and 1950 and at the Chilean-British Cultural Institute in the same city in 1947. Exhibitions of his work have been held outside Chile at the Institute of Architects in Rio de Janeiro (1949) and at the Renaissance Society of the University of Chicago (1957). The artist has taken part in group shows both in his own country and in Argentina and Brazil.

Carvacho currently teaches art under the auspices of the Chilean Ministry of Education, and has come to this country at the invitation of the International Exchange Service of the U.S. Department of State. This exhibition at the Pan American Union is the first presentation of his work in the Washington area.

CATALOGUE

Oils

1. *Carnaval selva (Sylvan Carnival)*, Rio de Janeiro, 1949
2. *Carnaval delirio (Gay Carnival)*, Rio de Janeiro, 1949
3. *Mujeres orquídeas (Lavender Women)*,[1] Rio de Janeiro, 1949
4. *Homenaje a Rio (Homage to Rio)*, Rio de Janeiro, 1949
5. *Paisaje (Landscape)*, Santiago, Chile, 1950
6. *Salto chileno (Waterfall)*, Santiago, Chile, 1957
7. *Atajada (Rodeo)*, Santiago, Chile, 1957
8. *Faena volante (Flying Wonder)*, Santiago, Chile, 1957
9. *Cactus*, Santiago, Chile, 1957
10. *La aurora (Dawn)*, Santiago, Chile, 1957
11. *Náufrago (Shipwreck)*, Santiago, Chile, 1957
12. *El traje indonesio (Indonesian Dress)*, Chicago, 1957
13. *Siesta*, Chicago, United States, 1957

December 23, 1957 - January 20, 1958

CARLOS PAEZ VILARO OF URUGUAY

Born in Montevideo in 1923, Carlos Páez Vilaró entered upon a professional career in drawing and magazine illustration at the age of ten. Self-taught not only in that field but in those of music and literature as well, he has led a highly varied artistic existence. Employing Negro rhythms, he has composed popular songs of the type known in the Plata River countries as *candombes*; he has written a very considerable body of verse, as yet unpublished; he has drawn up the outline of a ballet; he has designed a stage production; and he has done sketches for theatrical costumes.

For the last twelve years the whole of Páez Vilaró's artistic production has been based on Negro themes. In this respect, he has followed the example of the Uruguayan master Pedro Figari, who likewise depicted the life of the decreasing Negro population of the cities of the Plata River.

[1] Literal translation of this title is "Orchid Women." —*Ed.*

Páez Vilaró has traveled extensively in Argentina, Brazil, and Chile. He has held thirteen one-man shows in his native Uruguay and has participated in group exhibitions with examples of his work in oil, drawing, watercolor, and ceramics. He has had two individual exhibits in Buenos Aires, the first at the Wildenstein Gallery in 1955, the second at the Aquelarre Gallery in 1956. In the latter year, works by Páez Vilaró were also exhibited in the Portuguese African colony of Angola, by the local museum, and in the cities of Luanda and Nova Lisboa.

This is the first presentation of Páez Vilaró's art in the United States.

CATALOGUE

Paintings

1. *Scooter*
2. *Fisherwoman*
3. *Orphanage*
4. *Soup*
5. *The Wake*
6. *Pregnant Women*
7. *Jazz*
8. *Lovers*
9. *Man Lying Down*
10. *Nursemaid*
11. *Walk in the Park*
12. *Owl No. 1*
13. *Fishbowl*
14. *Fruit Vendor*
15. *Laundress*
16. *Lullaby*
17. *Waiter*
18. *Man and Still Life*
19. *Sweethearts*
20. *Owl No. 2*
21. *Drinking Mate*
22. *Women of Bahia*
23. *Drum Session*
24. *Women Workers*
25. *Head No. 1*
26. *Puppets*
27. *Head No. 2*
28. *Boatman*
29. *Still Life*

YEAR 1958

January 23 - February 18, 1958

ALDEMIR MARTINS OF BRAZIL

Drawing has always provided a favorite vehicle of expression for Latin American artists. It is, moreover, seriously cultivated as an instrument for work in painting or sculpture. Many prominent Latin American painters began their careers in the field of drawing, later abandoning it, save for incidental use in connection with their pictorial production. The case of Aldemir Martins is rather different: he initially sought expression in drawing; then he turned from it to painting; finally, he gave up the latter, reverting to drawing as his sole medium.

Martins was born in Ingazeiras, in the State of Ceará, Brazil, in 1922. Although he began to practice design at an early age, he did not initiate regular production until his period of military service, in the years 1942-45, when he taught drawing, designed aerial maps, and founded a group of artists in Ceará. At the same time he began a career as an illustrator for newspapers and magazines of the region, and his work was exhibited in local group shows. Upon his discharge from the army in 1945, Martins went to Rio de Janeiro, where he participated in a number of exhibitions. The following year he moved to São Paulo, which has been his place of residence ever since. Immediately after his arrival there he held his first one-man show at the local Institute of Architects. In 1950 Martins, who had been alternating between painting and drawing, decided to devote all of his efforts to the latter field, thereby unifying his artistic personality. While he has traveled throughout Brazil in search of subjects, he continues to derive the themes with which he has won a reputation as one of the outstanding younger artists of his country from his native Northeast.

Aldemir Martins has participated in numerous group shows in Brazil and in all four São Paulo biennials. At each of the latter he won awards, including a First Prize for Drawing in 1955. He has, moreover, worked in other aspects of the graphic arts, contributing prints as well as drawings to group shows of Brazilian art in Bolivia, Chile, Czechoslovakia, Japan, Mexico, Peru, Switzerland, and the United States. At the last Venice Biennial, in 1956, he won the International First Prize for Drawing. Martins held a one-man show at the Friends of Art Gallery in Montevideo in 1956, and in the same year he appeared in a joint exhibit with his fellow countryman Lívio Abramo at the Caetani Palace in Rome. He has held a number of highly successful individual exhibits in Brazil, and his show at the Bonino Gallery in Buenos Aires last year was a complete sellout.

Examples of Martins's work are to be found in the Museum of Modern Art of Rio de Janeiro, São Paulo, and New York; in the Museum of Bahia (Brazil); in the National Museum of Fine Arts in Buenos Aires, Rio de Janeiro, and Warsaw; in the State Museum of São Paulo; and in the Municipal Building of Montevideo. Martins is also represented in numerous private collections in his own country, Europe, and the United States.

Writing of the artist, the critic Marc Berkowitz sums up his motifs: scenes of the harsh, cruel life in the backlands of his native state; the bloodthirsty but dignified figures of the *cangaceiros*, the lacemakers, often of a statuesque beauty; the shimmering elegance of fantastic fish; and, in Martin's most recent work, birds and cats. The birds are imaginary ones, living in a tropical forest of the artist's own creation; nevertheless, as Berkowitz says, they are "the very quintessence of birds and of the tropics." The cats, heraldic and at times Mephistophelian in air, likewise pertain to the realm of fantasy; nevertheless, they are expressive of "the very souls of cats."

This is the first individual presentation of Aldemir Martins's work in this country.

CATALOGUE

Drawings

1. *Seated Woman*
2. *Blue Fish*
3. *Man of Ceará*
4. *Iridescent Fish No. 1*
5. *Iridescent Fish No. 2*
6. *Figure*
7. *Green Fish*
8. *Red Fish*
9. *Yellow Fish*
10. *Accordionist*
11. *Bird*
12. *Round Cat*
13. *Blue Cat*
14. *Bird*
15. *Black and Grey Bird*
16. *Rooster No. 1*
17. *Rooster No. 2*
18. *Rooster No. 3*
19. *Rooster No. 4*
20. *Mar e jangada (Sea and Raft)*
21. *Esperando a jangada (Waiting for the Raft)*
22. *Cangaceiro à espreita (Cangaceiro in Ambush)*
23. *Cangaceiro No. 1*
24. *Cangaceiro No. 2*
25. *Cangaceiro No. 3*
26. *Paisagem com carnaúba (Wax Palm in Landscape)*
27. *Pássaro enverganhado (Shy Bird)*
28. *Holiday Bird*
29. *A Patola*
30. *Rendeira (Lacemaker) No. 1*
31. *Rendeira (Lacemaker) No. 2*

32-33. *Printed Textile*

34. *Guinea Hen,* silkscreen

January 23 - February 18, 1958

THE PROPHETS BY ALEIJADINHO PHOTOGRAPHED BY HANS MANN

The eighteenth century marks the dawn of Latin American culture, particularly in the field of the fine arts. It was at that time that European and native elements began to fuse, resulting in the first artistic works to possess a recognizable "American" flavor. The characteristic is to be noted in the paintings produced by the schools of Cuzco

and Mexico, in the carved images of the school of Quito, and in the baroque architecture and sculpture of Brazil.

Among the artists who arose during the 1700s, Antônio Francisco Lisboa (c. 1730-1814) stands out as one of the greatest creative personalities ever to be revealed in this hemisphere.

The son of a Portuguese carpenter and a Negro slave, he produced for the churches that were reared in the gold-mining towns of his native Minas Gerais sculptures which, as perfect examples of the work of the period, are worthy of inclusion in any history of art. These sculptures, generally integrated with architecture, another field in which he demonstrated special talent, are scattered in small towns such as Ouro Preto, Sabará, and São João del-Rei. The culminating examples, however, are to be found at Congonhas do Campo, in the figures of the prophets adorning the monumental staircase before the Church of Bom Jesus de Matosinhos, and in the Scenes of the Passion in the adjacent garden.

Legend has been mixed with fact as regards Lisboa's life. It has never been determined where he studied, though it is known that he began work with his father as a carpenter's apprentice. After the age of forty-five he fell victim to a disease which, though evidencing all the symptoms of leprosy, has not been definitely established as such. To its maiming effects he owes the nickname of Aleijadinho, or little cripple, by which he is generally known. From the time of its first manifestations, the artist began to live in isolation and sought to avoid being seen by others, concealing his appearance under voluminous cloaks and broad-brimmed hats. He worked for the most part at night, and when construction necessitated his being out of doors, he shielded himself with a tent.

Though Aleijadinho never traveled outside Minas, European influences have left noticeable marks upon his work. The Gothic sculptures of northern Europe, the baroque carvings of southern Germany, Michelangelo's *Moses*, Bernini's draperies—all have their reminiscences in Aleijadinho's art. This phenomenon has been attributed to the wide dissemination during the eighteenth century of prints depicting artistic masterpieces. In assimilating these influences, however, Aleijadinho gave to his work a highly personal, often tortured, and deeply moving expression. The prophets at Congonhas furnish the best example of this manner. Since they date from a period in which Aleijadinho's affliction was most intense, they were carved in soapstone, a relatively soft medium, requiring a lesser degree of effort from his crippled hands. The friability of the material, which can be etched with a fingernail, has condemned the figures to eventual decomposition, through exposure to the elements and the vandalism of visitors without respect for master works of American art.

The pictures presented in this exhibit were taken several years ago by Hans Mann, a German photographer who specializes in recording sculpture and architecture. Taken from all possible angles, both in order to reveal the vigor of Aleijadinho's conception and to help visitors to Congonhas to a better appreciation of the statues, they constitute the most complete document of the artist's work there to date.

The remarkable enlargements from Mr. Mann's negatives were produced by the firm of Franke and Heidecke of Braunschweig, Germany, manufacturers of the Rolleiflex and Rolleicord cameras with which the pictures were taken. We avail ourselves of this opportunity to express our appreciation to both Mr. Mann and Franke and Heidecke, whose generous cooperation has made the exhibition possible.

After the showing at the Pan American Union, the pictures will be available for display elsewhere in the United States.

CATALOGUE

Photographs

 1-2. *Calle del pueblo Congonhas do Campo (Street of Congonhas do Campo)*
 3. *Vista panorámica del Valle de Congonhas do Campo (Valley of Congonhas do Campo)*

4-5. *Iglesia Bom Jesus de Matosinhos en Congonhas do Campo (Bom Jesus de Matosinhos Church)*
6-9. *Grupo de profetas en el atrio (Group of Prophets)*
 10. *Baruch*
 11. *Baruch Closeup*
 12. *Baruch*
13-16. *Joel*
17-18. *Ezekiel*
19-21. *Jonah*
22-26. *Jonah Closeups*
 27. *Group of Prophets*
 28. *Baruch's Head*
29-31. *Jeremiah*
32-34. *Hosea*
 35. *Hosea's Head*
 36. *Grupo de profetas (Group of Prophets)*
37-39. *Habakkuk*
40-41. *Obadiah*
 42. *Nahum*
 43. *Amos*
 44. *Fachada de Bom Jesus de Matosinhos (Façade of Bom Jesus de Matosinhos Church)*
 45. *Grupo de profetas (Group of Prophets)*
 46. *Jeremiah*
47-48. *Hosea*

March 14 - April 11, 1958

PAINTINGS AND DRAWINGS BY ENRIQUE GRAU OF COLOMBIA

During the last ten years, modern painting has achieved maturity in Colombia. Characterized by richness of color, imaginative treatment of subject matter, and strict discipline, it has won wide international recognition. Outstanding among the dozen or more important creators composing the vanguard is the figure of Enrique Grau Araujo. Tireless in artistic labors, he is remarkable for the constant evolution to be noted in his work.

Grau was born in 1920 in the coastal city of Cartagena, and it was there that he first began to paint. Later he moved to Bogotá and in 1940 he won a scholarship from the Colombian government to study in the United States. He remained in this country until 1943, working at the Art Students League with Harry Sternberg, Morris Kantor, and George Grosz. Upon his return to Colombia, he held several one-man shows in the capital and other cities of that country and taught for several years at the National School of Fine Arts in Bogotá. At the same time he rendered service as a draftsman to the National Census Bureau. In 1953 Grau went to Mexico, where contact with the artists of that country led him to develop from a soft, synthetic realism to works characterized by massive forms of monumental intent. He has since taken a variety of directions: one manner is reminiscent of the evocative style of Rufino Tamayo; another resembles the poetic, imaginative luminosity of his fellow countryman Alejandro Obregón. During 1956 Grau visited Europe, particularly Italy, where he studied the Renaissance masters. From them he absorbed something of the spirit of classicism, evident in the clarity and the static placidity of his recent canvases. It is to be noted that, in assimilating characteristics from other artists and other periods, Grau always expresses himself in thoroughly modern idiom, in a plastic language all his own. In addition to his activity in painting, he has engaged in book illustration and stage design.

Grau has participated in thirty-six group exhibitions, both in his native country and abroad. Among those of the

latter variety are the Venice Biennial of 1950; the *International Exhibition of Valencia* in Venezuela, 1955; the *Gulf Caribbean Art Exhibition* of the Museum of Fine Arts, Houston, 1955; and the Fourth São Paulo Biennial, 1957. A one-man show of his works was presented in 1956 at the L'Asterisco Gallery in Rome. National recognition of his work came last fall, when he received the First Prize for Painting at the Tenth National Salon of Colombian Artists in Bogotá.

Since 1942, when Grau was included in a Pan American group show in New York, his work has been exhibited on a number of occasions in this country. In 1943 it was presented in New York at the Argent Galleries, the American Institute of Decorators, and the ACA Gallery, and in Memphis, Tennessee, at the Brooks Art Gallery. In 1950 a large selection of his paintings was on view at the New School for Social Research in New York, in an exhibit which also included works by Grau's fellow Colombians Eduardo Ramírez and Edgar Negret. His first one-man show in the United States took place last month at the Roland de Aenlle Gallery in New York.

This is the first individual presentation of Grau's work in the Washington area.

CATALOGUE

Oils

1. *Magic Table*
2. *Objects under Eclipse*
3. *Victorian Table*
4. *The Dream*
5. *Still Life with Figure*
6. *Elegy to a Martyr*
7. *Still Life in Red*
8. *Figure in Interior*
9. *The Mirror*
10. *Figure and Construction*

Drawings[1]

March 14 - April 11, 1958

ENGRAVINGS BY GUILLERMO SILVA OF COLOMBIA

An experimentalist among modern Colombian painters, Guillermo Silva is best known for his work in the fields of engraving and stained glass. His prints, of a small and intimate nature, reminiscent of the poetic world of Paul Klee, have appeared in numerous exhibitions both in his native country and abroad, including the Fourth São Paulo Biennial, 1957.

Guillermo Silva Santamaría was born in 1921 in the city of Bogotá, where he studied at Pierre Daguet's workshop. In 1948 he came to the United States to visit museums and engage in painting. Later in the same year he went to France, and there he enrolled in Jean Crotti's workshop to learn the techniques of making stained glass. In 1950 he was appointed professor of drawing at the Fine Arts School of Bogotá, but the following year he returned to Europe, staying through 1952. Peru was the object of a visit in 1953. In 1955 Silva went to Mexico, where he now

[1] Titles are unavailable. —*Ed.*

resides, to study the technique of engraving at the Fine Arts School in the capital. He held one-man shows at the Proteo and Excélsior galleries in the same city in 1955 and 1956, and he currently teaches etching and design at the Ibero-American University and stained glass techniques at the Esmeralda School of Fine Arts.

Silva held his first one-man show in the United States in 1957 at the Martin Schweig Gallery in Saint Louis. This exhibit was later repeated at the New School for Social Research in New York. In 1958 examples of Silva's work were included in the Seventh Salon of Graphic Arts of the Museum of Portland, Oregon. A month ago a one-man show of his prints was held at the Guatemalan School of Fine Arts in Guatemala City. This is the first individual presentation of his work in the Washington area.

CATALOGUE

Oils on Canvas

1. *Vendedor de pájaros (Bird Vendor) No. 1*, 50 x 100 cm.
2. *Vendedor de pájaros (Bird Vendor) No. 2*, 80 x 110 cm.
3. *El cilindrero (Organ Grinder)*, 50 x 110 cm.
4. *Salón de belleza (Beauty Parlor)*, 80 x 110 cm.
5. *Red de pájaros (Birds)*
6. *Teléfonos públicos (Public Telephones)*, 70 x 110 cm.

Prints

7. *La niña del jardín (Girl in Garden)*, drypoint
8. *Leyenda china (Chinese Legend)*, drypoint
9. *Complicaciones (Complications)*, etching
10. *Arca de Noé pequeña (Small Noah's Ark)*, etching
11. *Arca de Noé grande (Large Noah's Ark)*, etching
12. *Torre de Babel (Tower of Babel)*, drypoint
13. *Barcos (Boats)*, etching
14. *Puerto (Port)*, burin engraving
15. *Peces (Fish)*, drypoint
16. *Barco (Boat)*, soft technique
17. *Pescador con red (Fisherman with Net)*, drypoint
18. *Pajarero (Bird Dealer)*, drypoint
19. *Red de pájaros (Birds) No. 1*, etching
20. *Red de pájaros (Birds) No. 2*, drypoint
21. *Pátzcuaro*, drypoint
22. *Condominio (Cooperative Dwelling)*, drypoint
23. *Salón de belleza (Beauty Parlor)*, drypoint
24. *Composición aérea (Aerial Composition)*, etching
25. *Sueños de infancia (Childhood Dreams)*, drypoint
26. *Ciudad con niebla (City under Fog)*, drypoint
27. *Amanecer (Dawn)*, drypoint
28. *La muerte del caballero azul (Death of the Blue Cavalier)*, drypoint
29. *Playa (Beach)*, drypoint
30. *La niña del estanque (Girl by Pond)*, burin engraving
31. *Red (Net)*, drypoint

April 15 - May 14, 1958

OSWALDO VIGAS OF VENEZUELA: PAINTINGS

Continuing its program of introducing to the Washington area young Latin American exponents of new directions in painting and sculpture, the Pan American Union now presents an outstanding figure in the non-objective movement which has recently developed in Venezuelan art.

Oswaldo Vigas was born in Valencia, Venezuela, in 1926. In 1939 he enrolled in the local school of fine arts and in 1946 he moved to Caracas, where he entered the Medical School of the Central University of Venezuela. This marks the beginning of what one might term a dual personality: as a physician, Vigas specializes in pediatrics; as a painter, he explores a new world of forms. Without neglect of his scientific profession, Vigas devotes a very considerable amount of time to painting, which he treats not as a sideline or a hobby but with the same serious sense of responsibility with which he practices medicine. In 1952 he went to France on a scholarship and studied art at the Sorbonne while serving an internship in a Paris hospital.

Vigas held his first one-man show in his native Valencia in 1942. Individual exhibits of his work were presented in Caracas in 1952, 1954, and 1957: the first was held at the Museum of Fine Arts, the others at other galleries. Abroad Vigas held one-man exhibitions at the Galerie La Roue in Paris in 1956 and at the Museum of Modern Art in Madrid in 1957. A controversial situation arose in connection with the latter when the catalog was suppressed by the Spanish censors because of a democratic declaration by the artist contained therein.

Vigas has participated in group shows in Paris since 1953; he took part in the São Paulo biennials of 1953 and 1955 and in the Venice Biennial of 1954. He has exhibited in Switzerland and in various French provincial centers. A few of his works were included in a Venezuelan group show at the Pan American Union in 1954; others figured in the *Gulf Caribbean Art Exhibition* held at the Museum of Fine Arts, Houston, in 1956, at which Vigas won a special award. Recognition of his dual professional capacities was accorded him last October in Caracas, when he received First Prize at the First Physicians' Salon of Plastic Arts.

This is the first individual presentation of the work of Oswaldo Vigas in the United States.

CATALOGUE

Oils

1. *Nacimiento de un personaje (Birth of Personage)*, 1954, 146 x 114 cm.
2. *Anunciación (Annunciation)*, 1954, 130 x 79 cm.
3. *Primeros personajes (Leading Personages)*, 1954, 130 x 97 cm.
4. *Guayana: selva (Guayana Forest)*, 1954, 195 x 130 cm.
5. *Guayana: encuentro (Guayana Meeting)*, 1954, 195 x 130 cm.
6. *Nacimiento vegetal (Sprouting Vegetables)*, 1954, 118 x 240 cm.
7. *Presencia (Presence)*, 1954, 65 x 54 cm.
8. *Iniciación (Initiation)*, 1954, 65 x 50 cm.
9. *Regreso (Return)*, 1954, 61 x 50 cm.
10. *Simbiosis (Symbiosis)*, 1954, 73 x 60 cm.
11. *Portal*, 1954, 130 x 197 cm.
12. *Objeto salvaje (Wild Object)*, 1955, 146 x 114 cm.
13. *Perfil (Profile)*, 1954, 81 x 65 cm.
14. *Objeto paisaje (Landscape)*, 1955, 65 x 92 cm.
15. *Objeto negro (Study in Black) No. 1*, 1956, 146 x 114 cm.
16. *Objeto negro (Study in Black) No. 2*, 1956, 130 x 97 cm.

17. *Objeto negro (Study in Black) No. 3*, 1956, 145 x 89 cm.
18. *Gran signo (Imposing Symbol)*, 1956, 80 x 80 cm.
19. *Amanecer (Dawn)*, 1954, 81 x 54 cm.
20. *Objeto en sombra (Shadows)*, 1955, 81 x 65 cm.
21. *Otra especie (Separate Species)*, 1956, 92 x 73 cm.
22. *Construcción en ocre (Design in Ochre)*, 1956, 92 x 73 cm.
23. *Construcción en rojo (Design in Red)*, 1956, 73 x 60 cm.
24. *Formas selváticas (Forest Forms)*, 1956, 92 x 73 cm.
25. *Construcción violeta (Study in Violet)*, 1957, 92 x 80 cm.
26. *Objeto crepuscular (Twilight)*, 1954, 61 x 50 cm.
27. *Objeto verde (Study in Green)*, 1955, 73 x 60 cm.

May 15 - June 16, 1958

OILS AND DRAWINGS BY JORGE CAMACHO OF CUBA

The youngest artist that has appeared in the panorama of modern painting in Cuba is Jorge Camacho. Born in 1934 in Havana, Camacho became interested at an early age in literature. Later he turned his attention to painting. Although he considers himself self-taught, he has nevertheless received the encouragement of such prominent Cuban painters as Cundo Bermúdez and Mario Carreño, who detected a genuine talent in the young painter.

Camacho finished high school and entered Havana University in 1952 to study law, but two years later he abandoned these studies to devote all his time to painting. After participating in numerous group shows in Cuba, he held his first one-man show in the Galería Cubana in Havana in 1955. For this exhibition Mario Carreño appraised his paintings as follows:

> There is a marked American accent in his work, if we interpret American art as that derived from the pre-Columbian plastic art of the continent. The different, remote Indian cultures, from the Tiahuanacan, the Incan, the Mayan, and the Aztec up to our Taíno idols, offer a firm basis which permits us to talk of a magnificent "American art."

As a result of his interest in pre-Hispanic cultures, the young artist visited Mexico in 1954 and in 1957.

Camacho received an Honorary Award in the last National Salon held in Havana late in 1956; last year he participated in the Fourth Biennial of São Paulo, Brazil, and held his second one-man show in Havana's Lyceum.

This is the first individual presentation of Camacho's work in the United States.

CATALOGUE

Oils

1. *The Hunt*
2. *Mask*
3. *Figure on Horseback*
4. *Dios invocando la luna (God Contemplating the Moon)*[1]

[1] Literal English translation of this title is "God Invoking the Moon." —*Ed.*

5. *Bird Hunter*
6. *La hechicera (The Sorceress)*. Lent by Dr. Aurelio Giroud
7. *Pájaro agresivo (Aggressive Bird)*
8. *La huida mágica (Magic Flight)*
9. *Figura a horcajadas (Reclining Figure)*
10. *El entierro (The Burial)*
11. *Agonía de un ciudadano (Agony of a Citizen)*
12. *Personaje misterioso (Mysterious Personage)*. Coll. Mr. & Mrs. William Rivera
13. *Fusilamiento 1957 (Shooting in 1957)*. Coll. Pan American Union
14. *El triunfo de la muerte (The Triumph of Death)*
15. *Old Construction*
16. *The Great Dictator*
17. *The Wedding*
18. *Annunciation of Myself*

Drawings[1]

May 15 - June 16, 1958

HUGO RODRIGUEZ OF CUBA

Hugo Rodríguez is an artist whose career developed between Cuba and the United States. Born in Havana in 1929, he attended the National School of Fine Arts from 1944 to 1946, and during the latter year received a scholarship from the Society of Arts and Crafts in Detroit which enabled him to remain there for six years. Specializing during this period in window displays and commercial art, as a sideline the artist started to create in the plastic arts and tried different media such as tile, scratchboard, oil and others. Although he returned to Havana in 1952, he was back in Detroit in 1954, where he is settled as the proprietor of the Gallery Four.

Rodríguez has won several awards for his exhibits in Detroit. His work is to be found in private collections in Ohio and New York as well as in the Detroit Institute of Arts and the Cranbrook Institute of Art. He continues to be a Cuban citizen.

This is the artist's first one-man show in the Washington area.

CATALOGUE

Watercolors

1. *Prometheus*, 1958
2. *Inner Forces No. 2*, 1958
3. *Ornothogulum alba*, 1958
4. *Abejas (Bees)*, 1957
5. *Westwind*, 1958. Coll. Mr. & Mrs. Morris Evans
6. *Pastoral*, 1958. Coll. Mr. & Mrs. M. Baumgartner
7. *Cohetes (Fireworks)*, 1956
8. *Cyclamen alba*, 1957. Coll. Mr. & Mrs. Jack Mennenberg

[1] Titles are unavailable. —*Ed.*

Ink and Scratchboards

9. *Rose Shell*, 1956
10. *Sunflowers*, 1956
11. *Clivia*, 1956
12. *Agave (Seedpod)*, 1956. Coll. Mr. & Mrs. Theodore Schatz
13. *Arum gigantica*, 1957
14. *Beach House*, 1957
15. *Hastatum rubra*, 1956
16. *St. Francis*, 1955. Private Collection
17. *Echeveria purpura*, 1957. Coll. Mr. & Mrs. Jack Beckwith
18. *Eucalyptus*, 1956
19. *Cedar of Labanon Fruits*, 1956. Coll. Mr. & Mrs. Anthony Chiodo
20. *Rosetta*, 1957

June 17 - July 15, 1958

THE CUZCO SCHOOL OF PAINTING. A SELECTION

At the time of the conquest of Peru by the Spaniards, Cuzco, lying in the heart of the Andes, was the capital of the Inca empire. For many years thereafter, it continued to be the most important and most populous city under the Spanish crown in South America.

Few cities in America show such a perfect blending of pre-Columbian culture and the Spanish way of life. Today Inca cobblestones still pave many of the narrow streets of Cuzco. The houses the Spaniards built for themselves after 1533 often incorporated existing Inca stone work, combining the austerity and simplicity of Indian construction with the flamboyant spirit of the European architecture of the period. In this great center, surrounded by great agricultural and mineral wealth, many churches were built, and of course they required decoration in both sculpture and painting.

Since the Spanish crown sent to America mainly soldiers and churchmen, never outstanding artists or architects, or even artisans, not only the erection of military and civil structures but also the construction and decoration of the churches had to be entrusted to native craftsmen. Some members of the religious orders were minor painters, and a few laymen who were artists went to Peru, among them the son of the Spanish master Murillo. Mexico in the north and Cuzco in the south provided paintings not only for their own churches, but also for those of the respective vice-royalty, no matter how distant. Painting in Cuzco started to flourish in the second half of the sixteenth century, and it declined only after independence had been won in the early 1800s. Its sphere of influence reached other important cultural centers and subsidiary schools were established in Potosí and Quito. The Cuzco school of painting left its imprint as far north as the Venezuelan Andes and as far south as Chile and Argentina.

More isolated than the Mexican school, the Cuzco school became more provincial and acquired a more indigenous flavor. There have been a few attempts to trace the origins, influences, and styles of the few masters known by name, or to identify their works by their technique, but most of the research to date has been in the historical field. The magnificent output of more than two full centuries is still awaiting aesthetic appraisal. For 200 years, during which production was intensive, the Cuzco painters had as models copies of well-known European paintings, originals by minor artists, and engravings of both. For us today, however, the main interest of this school lies in its limitations and the freedom with which the native hands overcome them—their lack of skill in copying perspective, their inability to produce foreshortening or render chiaroscuro using the technique of the old masters. In depicting subject matter, they seemed to retrogress from Renaissance art to medieval concepts. The copies

executed by the Indians from works by Italian, Spanish, and North European masters were, therefore, characterized by rigidity and a flat use of space, and these defects were compensated for by an instinctive sense of color and ornamentation. The work of the Cuzco school is characterized by a rich and imaginative love of decoration, a clever use of gold leaf, and the addition of multiple floral motifs. In some instances, a subject that had become outmoded or whose rendition was forbidden by the Catholic Church was still being produced by the Cuzco painters. An example in this exhibit is the representation of the Holy Trinity by three figures having identical faces of Christ, a treatment of the subject that had been proscribed.

Because of the abundance of gold and precious woods, a parallel craft was developed—marquetry and cabinetwork—and out of this grew a special interest in frames for the paintings. In some instances the frame acquired such an architectural importance that painting became only incidental and was reduced to a fourth or a fifth of the whole area. Many of the paintings that served as part of minor altars in homes of the rich were completely dwarfed by the intricate filigree frames, round or square, in which they were set.

This small selection of paintings of the Cuzco school, which gives an insight into one of the most interesting cultural expressions of this hemisphere and have never been shown in this country before, is being presented through the courtesy of a dealer who recently brought them to the United States. To this group we have added a few pieces that already were in Washington collections. We should like to express our thanks and appreciation to all the lenders who have made possible this first attempt to give a comprehensive exhibit of paintings of the Cuzco school at the Pan American Union.

CATALOGUE

Paintings

1. *The Holy Trinity*
2. *Virgin of the Rosary*
3. *Virgin of Mercy*
4. *Virgin of Chapi*
5. *Our Lord of the Earthquakes*
6. *Virgin of the Rosary with Two Saints*
7. *Virgin of the Rosary*
8. *The Holy Family*
9. *The Holy Trinity*
10. *The Calvary*
11. *Adoration of the Magi*
12. *Saint Francis*. Loaned by Mr. Manuel E. Ramírez, Washington, D.C.
13. *Adoration of the Christ Child*. Loaned by Mr. Manuel E. Ramírez, Washington, D.C.
14. *The Healing*. Loaned by Mr. Manuel E. Ramírez, Washington, D.C.
15. *Archangel*. Loaned by Mr. Manuel E. Ramírez, Washington, D.C.
16. *Saint John the Baptist and The Christ Child*. Loaned by Mr. Manuel E. Ramírez, Washington, D.C.
17. *Saint Francis*. Loaned by Mr. Manuel E. Ramírez, Washington, D.C.
18. *The Annunciation*. Loaned by Mr. Manuel E. Ramírez, Washington, D.C.
19. *The Immaculate Conception*
20. *The Virgin*
21. *La Virgen de la leche (Nursing Virgin)*
22. *Saint Cajetan*. Private collection, Washington, D.C.
23. *Saint Michael*, Loaned by Mrs. Esther N. de Calvo, Washington, D.C.

July 17 - August 14, 1958

SZALAY OF ARGENTINA: INK DRAWINGS

Few artists are known exclusively for their work in the field of monochrome drawing. Many painters, sculptors, and engravers practice drawing as a sideline—some very successfully—but rare is the individual for whom it is the sole medium of plastic expression. Until recently Latin America provided but two notable examples: José Luis Cuevas of Mexico and Aldemir Martins of Brazil. Now an artist worthy to rank with them has begun to make his presence felt in Argentina.

Lajos Szalay was born in Hungary in 1909. He attended the School for Advanced Study of the Fine Arts in his native Budapest between 1927 and 1935, and in 1930 he traveled to France for a year of training abroad. He returned to France after World War II and took up residence there; later, however, he moved to the New World. For the last ten years Szalay has been living in Argentina, and he is now a citizen of that country. In 1948 he was the recipient of a UNESCO scholarship.

Szalay has illustrated six books: three in Budapest, between 1941 and 1945, and three in his adopted country, between 1949 and 1957. While a professor at the Argentine University of Tucumán, he participated in local exhibitions. This is the first presentation of the art of Lajos Szalay in the United States, where previously he had been known only as an illustrator of books and magazines.

The subject matter of Szalay's drawing is highly dramatic: frequent motifs are the tragedy and horror of war and the desperate brutalities of totalitarianism. The artist has acquired admirable fluency in the handling of his medium: his line, though exquisite, is possessed of great vigor, and the economy of means employed in expressing his ideas is characteristic of drawing at its best.

In evaluating Szalay's work the Argentine critic Jorge Romero Brest, at present director of the National Museum of Fine Arts in Buenos Aires, said:

> I believe the secret charm is in the subtle technique of the joinings, not only in the ingenious arabesques that unnoticed join the figures, but in the relations between the planes that break up the original shape provoking new spacial dynamic structures. In these cases—the best in my opinion—space masters discreetly behind the entanglement of encountered, superposed lines or behind the clearness of lines that limit nothing, at times giving these shapes, almost empty of significant contents, force of transparency.

CATALOGUE

Ink Drawings

1. *Pescadores (Fishermen)*
2. *El pescado (Fish)*
3. *Odysseus*
4. *Primavera (Spring)*
5. *Centauro (Centaur)*
6. *Dos hombres (Two Men)*
7. *Tres figuras (Three Figures)*
8. *Tristeza (Sadness)*
9. *Figuras (Figures)*
10. *La madre (Mother)*
11. *La familia (Family)*

12. *La pareja (Couple)*
13. *Desnudos (Nudes)*
14. *Modelo (Model)*
15. *Mujer sentada (Seated Woman)*
16-20. *Caballo (Horse)*
21. *Jinete (Horseman)*
22. *El circo (Circus)*
23. *Lucha (Fight)*
24. *Quadriga*
25. *El hijo pródigo (Prodigal Son)*
26. *San Francisco (Saint Francis)*
27. *Ecce homo*
28. *Daniel y los leones (Daniel and the Lions)*
29. *El sacrificio de Isaac (Sacrifice of Isaac)*
30. *Jesús y San Pedro (Jesus and Saint Peter)*
31-32. *El sueño de San José (Saint Joseph's Dream)*
33. *La paz (Peace)*
34. *Consummatum est*
35-38. *San Juan y Herodes (Saint John and Herod)*
39. *La despedida (Leavetaking)*
40-45. *La tragedia húngara (Hungarian Tragedy)*

September 19 - October 13, 1958

GILBERTO ACEVES NAVARRO OF MEXICO

In contrast with the social realism of older Mexican artists, there is a tendency among the most recent generation—that which has not yet attained the age of thirty—to transmute national themes into forms which are either highly intricate or greatly simplified in nature. Among those exploring new modes of expression for Mexican painting along intellectual but nonetheless sensitive lines, we find the figure of Gilberto Aceves Navarro.

Born in Mexico City in 1931, he studied there at the School of Painting and Sculpture of the National Institute of Fine Arts, from which he graduated four years ago. In 1956 he became director of the School of Painting in Acapulco, and last year he was appointed to a professorship of art at the Women's College of Mexico City, where he currently teaches. Works by Aceves Navarro are to be found in the Museum of Modern Art of São Paulo (Brazil), in the National Museum of Mexico, and in many private collections north and south of the Río Grande. He has participated in several group exhibits in his native country and held one-man shows in the capital in 1955, 1956, and 1958. The last two were presented at the Salon of Mexican Plastic Art, which is sponsored by the National Institute of Fine Arts. On the occasion of his most recent exhibition in Mexico, the critic Margarita Nelken described Aceves Navarro's work as "indisputably and profoundly Mexican in expression."

This is the first individual exhibit by Aceves Navarro in the United States.

CATALOGUE

Oils

1. *Stooped Man*
2. *Woman Lying Down*

 3. *Seated Figure*
 4. *Woman Leaning Over*
 5. *Strange Head*
 6. *The Philosopher*
 7. *Woman with New Coiffure*
 8. *The Beast*
 9. *Man with Arms Crossed*
10. *Smiling Face*

Drawings[1]

October 16 - November 16, 1958

RUGS OF ECUADOR DESIGNED BY DR. ISIDORO KAPLAN

For the second time the Pan American Union is presenting an exhibition illustrative of the high level of achievement in textiles attained in Ecuador. The current display consists exclusively of wool rugs woven by female artisans under the direction of Dr. Isidoro Kaplan, who provides the designs and indicates the colors. The patterns are generally based on pre-Columbian Indian motifs or on prehistoric drawings of Old World origin.

Dr. Kaplan was born in Latvia in 1898 but has lived in Quito since 1937. By profession he is a physician, specializing in radiology; his hobbies, however, are photography and art in general.

According to Dr. Kaplan, the rugs are woven on wooden looms, of which he has two or three girls working at each. The double warp, of the best cotton thread, is of his own manufacture, and two weft threads are employed. The pile is of common, local wool; each pile consists of four yarn threads, chiefly of blended colors. The Gordian or Turkish knot is used, each knot having eight ends. Dr. Kaplan dyes the wools personally, employing coloring matter resistant to water and light.

This group of rugs has previously been shown only in Ecuador and Peru; the exhibition at the Pan American Union is its first appearance in the United States.

CATALOGUE

Wood Rugs

 1. *Bison from Altamira*, cave painting from northern Spain
 2. *The Seven Branches*
 3. *Hunting Scene*, cave painting from eastern Spain
 4. *Catfish*, pottery decoration, Nasca style, ancient Peru
 5. *Red Cats*, Indian dish decoration, ancient Ecuador
 6. *Mochica Messengers*, pottery decoration, ancient Peru
 7. *Pumas*, Inca textile design
 8. *Jellyfish*, taken from nature
 9. *Pelicans*, Manta style, ancient Ecuador
10. *Frigate Birds*, skies of Ecuadorian coast

[1] Titles are unavailable. —*Ed*.

11. *Nasca Warrior*, pottery decoration, ancient Peru
12. *Carchi Cubism*, dish decoration, ancient Ecuador
13. *Panzaleo Pattern*, pottery decoration, ancient Ecuador
14. *Carchi Dish*, Indian abstraction, ancient Ecuador
15. *Carchi Dish with Cross*, Indian abstraction, ancient Ecuador
16. *Chimeras*, Manta style, ancient Ecuador
17. *Basutoland Hunters*, rock painting, South African Stone Age
18. *Deer Hunting*, cave painting, Valltorta Gorge, eastern Spain
19. *Stone Age Life*, cave painting from Cogul, eastern Spain

October 16 - November 17, 1958

CARYBE OF BRAZIL

Carybé is the name by which the art world knows Héctor Bernabó. Born in Lanús, in the Province of Buenos Aires in Argentina, the artist-to-be spent his boyhood in Rome. Travel then took him to Brazil, where he stayed for several years, and to other South American countries. In 1950 he returned to Brazil and established himself in the picturesque old colonial city of Salvador, better known by the name of the state of which it is the capital, Bahia. He acquired the citizenship of his new residence and is considered one of the foremost artists of the Brazilian Northeast.

Although perhaps best known for his drawings, Carybé has executed several murals in Brazil, principally in the State of Bahia. He has held many one-man shows in Buenos Aires, Rio de Janeiro, São Paulo, Salvador, and Recife. He exhibited at the Bodley Gallery in New York last year, and again a few months ago. Although his work has previously figured in group shows in Washington, this is Carybé's first individual presentation in this area.

EXHIBITION LIST[1]

Oils

1. *Beach*
2. *Musicians*
3. *Corn in Season*
4. *Fighting Rooster*

Watercolors

5. *Women*
6. *Roundup*
7. *Changó*

Gouaches

8. *Voodoo Figure II*
9-11. *Ritual Dance I, II, III*
12. *Indians*

[1] Not included in the original catalogue. —*Ed*.

13. *Rafts*
14. *Heat*
15. *Circus*
16. *Fishermen*
17. *Women of Bahia*

Ink Drawings

18. *Twins*
19. *Woman Standing*
20. *Pigs*
21. *Voodoo Figure I*
22. *School of Dance*
23. *Mother and Son*
24. *St. George and the Dragon*
25. *Oxun*
26. *Warriors*

Textile

27-28. *Indian Woman I, II*, executed by Gina Prado

Photographs of Murals Executed in Bahia

1. *Cidade do Salvador Building*
2. *Castro Alves Building*
3. *Liga Brasileira de Asistencia Building*
4. *Cidade de Ilheus Building*
5. *Residence of Mr. Manuel Cintra Monteiro*
6. *Carneiro Ribeiro School*
7. *Business Club*
8-9. *School of Corta Braço Section*, details
10. *Catarina Paraguasú Building*
11. *Banco Português do Brasil*
12. *Delta Building*
13-15. *Conference Hall of Correia Ribeiro Company*
16. *Hall of the Cinema Guarani*

November 18 - December 15, 1958

ARMANDO VILLEGAS OF PERU

Armando Villegas belongs to the group of young Peruvian artists that has turned its back upon the Indian themes cultivated by painters of an earlier generation. He was born in Pomabamba, Peru, in 1926. Seven years ago the Colombian government awarded him a fellowship to study in Bogotá and he thereupon settled in that city, marrying the ceramist Alicia Tafur, with whom he shares the current exhibition.

Villegas has participated in a number of the Colombian national salons, receiving several awards. His work has appeared in the Colombian or Peruvian sections of a number of international exhibitions, such as the Fourth São

Paulo Biennial in 1957, and the Inter-American Biennial, Mexico City, 1958. He figured in a traveling exhibit of Peruvian painting presented in Sweden and other Scandinavian countries in 1957, and his work was included in group exhibitions in Argentina in 1952, and at the Petit Palais, Paris, 1958. He has held one-man shows in Bogotá and Medellín, Colombia; in Lima, Perú; and at the National Museum of Fine Arts in Caracas, Venezuela. This is the first individual presentation of his work in the United States.

CATALOGUE

Oils

1. *Ocre y rojo (Ochre and Red)*, 1955
2. *Ave (Bird)*, 1956
3. *Filigrana (Filigree)*, 1957
4. *Noctámbulo (Night Owl)*, 1957
5. *Equilibrio (Equilibrium)*, 1958
6. *Positivo y negativo (Positive and Negative)*, 1958
7. *Overtura (Overture)*, oil and caseine, 1958
8. *Vigía (Vigil)*, 1958
9. *Alambrico (Composition) No. 1*, 1957
10. *Ocre-negro-azul (Ochre-Black-Blue)*, 1957
11. *Construcción (Construction)*, 1958
12. *Verticales en blanco (Verticals in While)*, 1958
13. *Panorama eléctrico (Electric Panorama)*, 1958
14. *Fantasía (Phantasy) No. 1*, 1958
15. *Fantasía (Phantasy) No. 2*, 1958
16. *Ancestro (Ancestor)*, 1958
17. *Trofeos (Trophies)*, 1957
18. *Toten (Totem)*, 1958
19. *Otoñal (Autumnal)*, 1957
20. *Composición en rojo y negro (Composition in Red and Black)*, 1958
21. *Composición en gris (Composition in Grey)*, 1958
22. *Rombo (Rhombus)*, 1958

November 18 - December 15, 1958

ALICIA TAFUR OF COLOMBIA: SCULPTURES AND CERAMICS

Ceramic art has been widely cultivated in Colombia in recent years. Among its practitioners is the young Alicia Tafur, who studied both at the Ceramic Workshop of the Department of Cundinamarca, and under Alberto Arboleda, a Colombian ceramist of international reputation. Upon graduation from the Ceramic Workshop Miss Tafur began to teach and in 1953 she won her first award. Far from confining her efforts to decorative objects of a utilitarian nature, she has sought to develop her medium along other lines, even attempting pure sculpture. The year 1956 saw individual presentations of her work in Bogotá and Medellín. In addition, she has taken part in group shows in her own country and in the *Gulf Caribbean Art Exhibition* organized by the Museum of Fine Arts, Houston, in the same year.

Alicia Tafur was born in Cali, Colombia, in 1934 and is now married to the Peruvian painter Armando Villegas, who shares this exhibition with her. This is the first occasion on which her work has been presented in the Washington area.

CATALOGUE

Sculptures

 1. *Fragilidad (Fragility)*, steel
 2. *Forma (Form)*, steel
 3. *Reminiscencia chibcha (Chibcha Reminiscence)*, bronze
 4-5. *Simétrico (Symmetrical) No. 1 and 2*, bronze
 6. *Forma en blanco (Form in White)*, terra-cotta
 7. *Silencio (Silence)*, terra-cotta
 8. *Líneas nuestras (Our Lines)*, terra-cotta
 9. *Configuración (Configuration)*, terra-cotta
 10. *Simétrico (Symmetry)*, terra-cotta

Ceramics

 11. *Luna en ocre y azul (Moon in Ochre and Blue)*
 12. *Evocación (Evocation)*
13-19. *Botellas con remembranzas (Bottles with Remembrances) No. 1, 2, 3, 4, 5, 6, and 7*
 20. *Femineidad (Femininity)*
 21. *Anfora (Amphora)*
22-24. *Plato (Plate) No. 1, 2, and 3*
25-26. *Platos (Plates) No. 1 and 2*
 27. *Máscara en rojo y blanco (Mask in Red and White)*
 28. *Fitomorfo (Vegetable Form)*
 29. *Máscara en ocre (Mask in Ochre)*
 30. *Figura mítica (Mythical Figure)*

December 16, 1958 - January 7, 1959

MODERN CERAMICS FROM LATIN AMERICA[1]

The art of ceramics is one of the oldest arts in Latin America. Its tradition dates from pre-Hispanic times and has suffered in certain periods through lack of interest or excessive industrial competition. Nevertheless, people have continued the practice of baking and decorating clay in each country with greater or less intensity. Therefore, for centuries popular arts have been the mainstay of the tradition of ceramics, and in recent years this ancient art has been resumed by artisans and professional artists. In the present exhibition we intend to group examples by ceramists of five countries, featuring the important contribution made by Yugoslav-born professor, Sime Pelicaric, to this art from his workshop in Buenos Aires.

This exhibition has been made possible through the efforts of the enthusiastic admirer of ceramics, Miss Teresa Palacios of Chile, whom we thank for her considerable energy in organizing and assembling this show, which is the first of its kind to be presented in the Pan American Union.

[1] The list of works exhibited is unavailable. —*Ed.*

ABOUT THE ARTISTS

MOTTA, Helou. Ceramist, sculptress, born in São Paulo, Brazil, 1925. There she studied ceramics until 1951, when she went to Italy and studied in Faenza. Studied also in Rome. Held a one-man show in the Museum of Modern Art of São Paulo, 1953, where she is a professor of ceramics. Exhibited also in Buenos Aires in 1956.

PAEZ VILARO, Carlos. Painter and ceramist born in Montevideo, Uruguay, 1923. As a painter, he has exhibited in Europe, Africa, and Latin America, and recently in a one-man show in the Pan American Union. As a ceramist, he has his own workshop in Montevideo and has exhibited in Santiago de Chile, Buenos Aires, and Montevideo. He is the director of the Workshop of the Artisans of Uruguay.

PELICARIC, Sime. Lawyer, diplomat, and ceramist born in Brac Island, Yugoslavia, 1915. Studied ceramics in Italy and sculpture in Yugoslavia with Ivan Mestrovic. Settled ten years ago in Argentina, where he is a citizen. Held one-man shows in Santiago, Chile; Lima, Peru; and Buenos Aires, Argentina, where he is represented by the Galería Bonino.

TAFUR, Alicia. Ceramist born in Cali, Colombia, 1934. Has studied in the Workshop of the Department of Cundinamarca and under Alberto Arboleda, Colombian ceramist. Participated in group shows in Colombia and in the United States. Held a one-man show in the Pan American Union a month ago.

YRARRAZAVAL, Ricardo. Painter and ceramist born in Santiago, Chile, 1931. Studied in Canada and traveled extensively in Europe. Has studied in New York under André Racz; at the School of Fine Arts, Rome; and at the Académie Julian in Paris. Started working in ceramics in Santiago in 1954. Exhibited his paintings and ceramics in Santiago de Chile. Participated in a group show of Chilean artists held in the Pan American Union in 1956.

YEAR 1959

CABRERA MORENO OF CUBA

After the emergence of the first generation of modern artists in Cuba during the late 1930s, there was a period of lull without any new additions to the group. The first attempts to follow the modern trends started among graduates of the National Academy of Fine Arts about a decade later. Among the new names to be added by 1948 to the group of Cuban painters of the avant-garde was Servando Cabrera Moreno, who was abandoning a sort of meticulous idealistic rendering of reality, especially in the field of portraiture, for a more elaborate conception in which he was approaching new trends for his art, after years of hard discipline in the Academy.

Servando Cabrera Moreno, who is presenting his first one-man show in the United States at this time, was born in Havana in 1923. There he attended the Academy, of which he is a graduate. Later he went to New York and enrolled in the Arts Students League. He also traveled in Mexico and Guatemala and finally went to Europe. In Spain he was associated, six years ago, with new artists like Tapies, Saura, and Oteiza, who were also driving Spanish contemporary art into a new plastic direction. Cabrera Moreno exhibited in group shows and held a solo presentation at Madrid's Clan Gallery in the fall of 1952. Two years later, in Paris, he was presented in the La Roue Gallery. In 1956 the National Institute of Culture in his native city held a one-man show of his work. Here his new approach to art was presented, that one which the painter was developing during his European sojourn which took him, apart from residence in Spain and France, to Germany, Portugal, Switzerland, Greece, Sweden, Denmark, Holland, Belgium, England, and Italy, as well as Morocco.

Servando Cabrera Moreno has participated in numerous group shows in Cuba and the United States, and his work has been included in important group exhibitions in Venezuela, France, and Spain. His paintings have been among the Cuban selections sent to several biennial exhibits, including the Twenty-sixth in Venice, the Fourth in São Paulo and the First in Mexico City. His most recent one-man show was held at Havana's Lyceum early last year.

CATALOGUE

Oils

1. *The Visit*
2. *Full Moon Panorama*
3. *Mother and Child*
4. *Sunday Woman*
5. *Siesta*
6. *Street Call Vending*
7. *Musicians*
8. *Unknown Face*
9. *Sunrise*
10. *Cutting Cane*
11. *The Interpreter*
12. *Las Damas de Buenavista (Ladies From Buenavista)*

13. *Portrait*

Gouaches

14. *La luna en el parque (Moon on the Park)*
15. *Espejo (Mirror)*
16. *Festín (Feast)*
17. *Girl from Marianao*
18. *Offering*
19. *Noon*
20. *The Wait*
21. *Saturday Afternoon*
22. *Interior*
23. *Duo*

January 12 - February 5, 1959

MARIA BONOMI OF BRAZIL

Among Latin American countries, Brazil stands out in the field of modern engraving for the quality and boldness of its practitioners. Maria Bonomi belongs to the youngest generation of engravers which is bringing so much recognition abroad to contemporary Brazilian art.

Maria Bonomi is a citizen of Brazil born in Meina, Italy, in 1935. She has lived in São Paulo since childhood and there started her graphic and art studies, first under the direction of Lasar Segall and subsequently under Yolanda Mohalyi, Karl Plattner, and Lívio Abramo. In 1952 she went to Italy, studying under Enrico Prampolini and Emilio Vedova. At present she is in New York enrolled in the Art Department of Columbia University, working under the guidance of Hans Muller. At the same time she is studying graphic art at the Pratt Institute, under Seong Moy.

Miss Bonomi has participated in numerous group exhibitions in Brazil, particularly in the Third São Paulo Biennial, as well as in New York. She has also held one-man shows at the Museum of Modern Art of São Paulo in 1956, and last November made her first solo presentation in the United States at the Roland de Aenlle Gallery in New York. In connection with this last show, the *New York Times* art critic, Dore Ashton, praised the work of Miss Bonomi as follows:

> She is inventive. In the woodcut the invention of symbols to correspond to three-dimensional delineation is essential. Miss Bonomi can twist her knife, scrape and incise with agility, and knows the value of variation.

This is the first presentation of the work of Maria Bonomi in Washington, D.C.

CATALOGUE

Woodcuts

1. *Stillness in Motion*
2. *White Night*
3. *Wandering Night*
4. *Patterns of Night*

5. *Drowned Shadow*
6. *Foreboding*
7. *Thoughts*
8. *Restrained Joy*
9. *Light over Shadows*
10. *Spanning Lights*
11. *Light Refraction*
12. *Search of Light*
13. *Prism*
14. *Noise*
15. *Fallen Rhythms*
16. *Drum Beat*
17. *Emotion*
18. *City in Bloom*
19. *Downtown*
20. *Superimposed Cities*
21. *Parade*
22. *Hour Escape*
23. *Wings*
24. *Soaring Aloft*
25. *Spring*
26. *Split Force*
27. *Crystal Thought*
28. *Affirmation*
29. *High Water*
30. *Lost Ropes*
31. *Evasion to New Patterns*
32. *Oblivion*

Wood Engravings

33. *Interwoven Impressions*
34. *Speculation*
35. *Dream*
36. *Interlude*
37. *Lamp Over Silence*
38. *Light Rebound*
39. *Restrained Hope*
40. *Entangled Evaluation*
41. *Reinforcement*
42. *Brink of Power*
43. *Magnitude*

February 6 - March 1, 1959

ABULARACH OF GUATEMALA

Among the new generation of Guatemalan artists, Rodolfo Abularach has emerged as one maintaining close contact with the trends of modern art started in that country by Carlos Mérida, who linked modern expression with the

ancient Mayan heritage. Abularach has followed the same path, developing his own mode of expression through an extremely refined technique, especially in the medium of drawing, which constitutes this exhibition.

Rodolfo Abularach was born in Guatemala City in 1933 and enrolled in the School of Engineering of the National University in that capital. After only one year he decided to abandon his scientific studies in order to devote all his time to painting. In 1953 he went to California, where he enrolled in the School of Art at the Pasadena City College. Later that year he went to Mexico, where he continued his art studies. After two years, between 1955 and 1957, he worked as a draftsman for the Ministry of Education of Guatemala as well as for the National Museum of Archaeology. In the latter year he was appointed professor of drawing and painting in the National School of Fine Arts in Guatemala City, and early in 1959 he obtained a scholarship from the Guatemalan government to study in the United States. Since then he has taken post-graduate courses in graphic arts at the Arts Students League, and has also received a grant from the Department of State to visit museums in the United States. Abularach has held one-man shows in Guatemala City in 1947, 1954, and 1957. He has also been included in group shows of Latin American art in Mexico, Guatemala, and in the United States. His work is represented in both the National Museum of Art of Guatemala and the National Collection of Fine Arts of La Paz, Bolivia, and the Museum of Modern Art of New York has just acquired one of his drawings.

This present exhibit constitutes his first one-man show in the United States.

CATALOGUE

Drawings

1. *Head*
2. *Promenade*
3. *Flight of Anguish*. Coll. Mr. and Mrs. Robert Randall
4. *Moles*
5. *Fugitive from a Mayan Lintel*
6. *Beast of Tikal I*
7. *Menagerie in Uaxactún*
8. *Figure from a Stela*
9. *Beast of Tikal II*
10. *Reclined Musician*
11. *Mineral God*
12. *Maximon*
13. *Couple from Zaculeu*
14. *Birds Nesting*
15. *Deidad (Deity)*
16. *The Queen*
17. *The Birth of a Stela*
18. *The Realm of the God*
19. *Cosmogony*
20. *Bats*. Lent by Miss Betty Wilson
21. *A Head For Ixtab*. Lent by The Museum of Modern Art, New York

March 2 - 17, 1959

IBERE CAMARGO OF BRAZIL

An outstanding personality in the generation of Brazilian artists now approaching maturity is that of Iberê Camargo. In the past twenty years, during which modern trends have dominated the fields of painting and sculpture in Brazil,

Camargo's work has figured prominently in nearly all the important shows sent to represent the country abroad.

Iberê Camargo was born in Restinga Sêca, in the State of Rio Grande do Sul, in 1914—the year after the first exhibition of painting in the modern manner was held in Brazil. He began his training at the School of Arts and Crafts of the city of Santa Maria. He continued there, with a two-year interruption, until 1942 when he received a scholarship to study in Rio de Janeiro. There he enrolled at the National School of Fine Arts, but after a short period of academic training he left to work under the direction of his fellow countryman, the painter Alberto da Veiga Guignard.

Since 1943 Camargo has exhibited regularly in national and state salons. Among awards which he has received was the Travel Prize of the National Salon of 1947. This permitted him to tour Europe. In Rome he frequented the studios of the painter Giorgio de Chirico and the sculptor Carlos Petrucci, and in Paris he studied under André Lhote.

This is the first presentation of the works of Iberê Camargo in the Washington area.

CATALOGUE

Oils

1. *Painel com garrafas (Panel with Bottles)*, 1957, 150 x 93 cm.
2. *Painel com garrafas e objetos (Panel with Bottles and Objects)*, 1958, 150 x 93 cm.
3. *Garrafas (Bottles)*, 1957, 199 x 65 cm.
4. *Carretéis (Bobbin)*, 1958, 92 x 65 cm.
5. *Manequim (Mannequin)*, 1957-58, 116 x 73 cm.
6. *Mesa (Table)*, 1957, 92 x 65 cm.
7. *Porta (Door)*, 1957, 100 x 65 cm.
8. *Paisagem com poste (Landscape with Post)*, 1956, 81 x 65 cm.
9. *Natureza morta (Still Life)*, 1957, 81 x 65 cm.
10. *Natureza morta com garrafas (Still Life with Bottles)*, 1957, 81 x 65 cm.
11. *Natureza morta com frigideira (Still Life with Ice Box)*, 1957, 81 x 65 cm.
12. *Fachada (Façade)*, 1957, 81 x 65 cm.
13. *Muro (Wall)*, 1957, 81 x 65 cm.
14. *Poços de Caldas*, 1956, 65 x 54 cm.
15. *Rua (Street)*, 1956, 65 x 54 cm.
16. *Casas (Houses)*, 1956, 65 x 54 cm.
17. *Morros (Walls)*, 1955, 65 x 54 cm.
18. *Paisagem (Landscape)*, 1956, 65 x 54 cm.
19. *Interior*, 1955, 47 x 38 cm.
20. *Abóbora (Gourd)*, 1958, 100 x 62 cm.

Engravings[1]

[1] Titles are unavailable. —*Ed.*

March 18 - April 13, 1959

JOAQUIN CHIÑAS OF MEXICO

With the exhibition here presented by the Pan American Union Joaquín Chiñas is making but his second formal appearance in the world of art. Possessed of no academic training, he has nonetheless developed a realistic style, serene, solid, and plain, that is thoroughly in keeping with the Mexican creative tradition. The sense of massiveness and monumentality characteristic of much of the best in Mexican art likewise marks the compositions of this young unknown.

Chiñas was born in Tehuantepec, in the State of Oaxaca, in 1923, but for the past two years he has lived in Tijuana, Baja California, near the American border. He has held such varied jobs as those of seaman, gardener, and carpenter. Two years ago he began to devote a large measure of time to art. While he has visited museums in his native Mexico, he has had no teachers. His inspiration has been furnished by the Mexican people, whom he seeks to depict in his monochromes.

In October 1958 works by Chiñas appeared in an exhibition in the city of San Diego, where they attracted the attention of the Honorable Bob Wilson, United States Representative for California. It is through the latter's kind assistance that the Pan American Union is able to present the first one-man show of a new figure, now taking his place in the ranks of contemporary Mexican artists.

CATALOGUE

Drawings

1. *Girl's Face*
2. *The Family*
3. *Woman*
4. *Farmer*
5. *Child*
6. *Woman*
7. *Old Woman*
8. *Man from the South*
9. *Indian*
10. *María*
11. *Woman from the South*
12. *Smiling Girl*
13. *Girl from Tehuantepec*

March 18 - April 13, 1959

ALBERTO GIRONELLA OF MEXICO

A leading figure in the group of Mexican artists who have achieved celebrity in the past decade is that of the painter Alberto Gironella.

Born in Mexico City in 1929, Gironella, though self-taught, has striven since the beginning of his artistic career to follow the path marked out by the Spanish school, and more particularly the example of José Gutiérrez Solana, with his paintings of "Black Spain." Although he never strays far from Mexican themes, Gironella has adopted the

crude approach to reality characteristic of the Spanish master, executing his canvases, however, with broader brush strokes and a more synthetic rendition of forms than are to be noted in Gutiérrez Solana's work.

Gironella held his first one-man show in an antique shop in the city of Guanajuato in 1953; the only other one to date took place at the Proteo Gallery in Mexico City in 1957. The artist has participated in numerous group exhibitions in Mexico, Venezuela, France, Italy, Israel, and the United States. Examples of his work are to be found in the Museum of Modern Art in Tel Aviv and in private collections in the United States, Mexico, and other countries of Latin America. Gironella has illustrated books and he was one of the founders of the Prisse and Proteo galleries.

In connection with his Mexico City show in 1957, the critic Raúl Flores Guerrero wrote:

> While he was once a draftsman of delicate line, his recent pictorial tendency has been to the use of bold, aggressive strokes of black. These are not outlines in the naturalistic manner; they are, rather, an announcement of later brush strokes, a forecast of the final structure of his works. One might say that they are preliminary sketches of the pictures to come. It is this which endows them with so high a degree of expressiveness.

This is the first individual presentation of the artist's work in the United States.

CATALOGUE

Oils

1. *Section of Birds, No. 1*
2. *Section of Birds, No. 2*
3. *Useless War Equipment*
4. *El glotón (The Glutton)*
5. *New Orleans*
6. *Kiki*
7. *The Blonde*
8. *Bourgeois Drama*
9. *Metamorphosis of the Queen No. 1*
10. *Metamorphosis of the Queen No. 2*
11. *Sophy, the Bearded Woman No. 1*
12. *Sophy, the Bearded Woman No. 2*
13. *Sophy, the Bearded Woman No. 3*
14. *Spring No. 1*
15. *Spring No. 1*
16. *The Toast*
17. *Head of an Old Man*

Drawings[1]

[1] Titles are unavailable. —*Ed.*

April 13 - May 10, 1959

CONTEMPORARY DRAWINGS FROM LATIN AMERICA

For many years, both in Latin America and in the world at large, drawing was considered a mere preliminary step to what was held to make a real picture, namely, painting. This idea has gradually lost ground, and today there is a large number of artists who have chosen drawing as their sole means of expression and whose works possess a complexity and depth formerly thought to be attributes of painting alone. In contemporary Latin American art drawing is increasingly practiced and accepted as an end in itself.

The present exhibit of works by artists from eleven countries represents the leading trends taken by this branch of art in Latin America today. The selection was made by Mr. José Gómez Sicre, Chief of the Visual Arts Section of the Pan American Union, and Mrs. Annemarie H. Pope, Chief of the Traveling Exhibitions Service of the Smithsonian Institution. After the presentation here, the exhibit will be circulated, under the auspices of the Smithsonian, to museums and other cultural organizations throughout the United States.

CATALOGUE

Rodolfo Abularach (Guatemala)
 1. *Birds in Flight*, ink

Enrique Arnal (Bolivia)
 2. *Toy Bull*, ink

Cundo Bermúdez (Cuba)
 3. *Después de la función (After the Performance)*, pencil

José Y. Bermúdez (Cuba)
 4. *Dibujo (Drawing) No. 7*, Ink and quill pen

Roberto Burle Marx (Brazil)
 5. *Forms*, ink and felt pen

Servando Cabrera Moreno (Cuba)
 6. *Visit in the Afternoon*, ink

Mario Carreño (Cuba)
 7. *Meridian*, ink

Carybé (Brazil)
 8. *Burros*, wash-ink

Juan Carlos Castagnino (Argentina)
 9. *Caballos (Horses)*, wash-ink

Hugo Consuegra (Cuba)
10. *Bridge to Despair*, wash-ink

José Luis Cuevas (Mexico)
11. *Funerales de un dictador (Funeral of a Dictator)*, inks and gouache

Raquel Forner (Argentina)
12. *Shadows*, wash-ink

Alberto Gironella (Mexico)
13. *Owls*, wash-ink

Marcelo Grassmann (Brazil)
14. *The Taming of the Beast*, ink

Enrique Grau (Colombia)
15. *Composition*, ink

Wifredo Lam (Cuba)
16. *Deities*, wash-ink

Fernando Lemos (Brazil)
17. *In Spite of Rain*, ink

María Luisa (Bolivia)
18. *Torso*, ink and gouache

Luis Martínez Pedro (Cuba)
19. *Forms*, silver point

Aldemir Martins (Brazil)
20. *Woman*, ink

Roberto Matta (Chile)
21. *Philanthropic Hangmen*, pencil

Alejandro Obregón (Colombia)
22. *Composition*, ink

Ciro Oduber (Panama)
23. *Fruit Vendor*, ink

Amelia Peláez (Cuba)
24. *Girls in a Garden*, ink

Eduardo Ramírez (Colombia)
25. *Slabs*, charcoal

Kasuya Sakai (Argentina)
26. *Whirling Forms*, ink and gouache

Luis Seoane (Argentina)
27. *Standing Woman*, wash-ink

Carmen Silva (Chile)
28. *Lavatorio (The Lavatory)*, pencil

Fernando de Szyszlo (Peru)
29. *Adagio*, wash-ink and charcoal

Rufino Tamayo (Mexico)
30. *Woman*, ink

Clorindo Testa (Argentina)
31. *Forms in Black*, printing ink

Leopoldo Torres Agüero (Argentina)
32. *City Dwelling*, wash-ink

Oswaldo Vigas (Venezuela)
33. *Monolithic Flower*, ink

Enrique Zañartu (Chile)
34. *Forms*, wash-ink and charcoal

BIOGRAPHICAL NOTES[1]

LEMOS, Fernando. Painter, draftsman, printmaker, illustrator, photographer, poet, born in Lisbon, Portugal, 1926. Studied at the Escola Industrial Antônio Arroio. Co-founder of Galeria Março, Lisbon. Published a poetry book, *Teclado universal*, Lisbon, 1953. Since that year, did illustrations for magazines and books, including *Vôo sem pássaro dentro*, by Adolfo Casais Monteiro, São Paulo, 1954. Decorated, with other artists, the exhibition *History of São Paulo* (1954), commemorating the fourth centennial of that city, and the Bahia Stand of the Brazilian Pavilion at the United States World Trade Fair, New York, 1957. Held individual exhibitions of painting, drawings, and photographs in Lisbon and other cities in Brazil, including the Museum of Modern Art of São Paulo (1953 and 1954) and of Rio de Janeiro (1953). Participated in national salons and international shows, including the biennials of São Paulo (1953-57) and Paris (1959), and the Fourth International Art Exhibition, Japan, 1957. Was awarded an Acquisition Prize (1953) and the Award for Best National Draftsman (1957) at the Second and Fourth São Paulo biennials, among other prizes. Lives in Brazil since 1953.

SEOANE, Luis. Painter, muralist, draftsman, graphic artist, lawyer, born in Buenos Aires, 1910. Raised and educated in Galicia (Spain), attended Law School, Universidad de Santiago de Compostela. Returned to Argentina in 1936 and since 1938 has been very active as an illustrator and graphic artist, publishing books and albums of drawing and prints. His *Homenaje a la Torre de Hércules* (1945) was selected by the Graphic Arts Institute and the Pierpont Morgan Library, New York, as one of the best books of drawings published between 1935-1945. Also published three books of poems, one of short stories, and two plays. Executed numerous murals mainly in Buenos Aires, such as the big mural at the Teatro Municipal General San Martín. Held individual exhibitions of painting in Buenos Aires, Montevideo, London, and New York; and of prints and drawings in Buenos Aires, Lima, Caracas, São Paulo, and Bahia. Participated in numerous national and international exhibitions, including *Argentine Art* in Washington, D.C. and other United States cities (1956), and La Paz and Lima (1958); biennials of Venice (1956), Mexico and Cincinnati (Ohio) (1958), and São Paulo (1959); and the International Exposition of Brussels (1958).

SILVA, Carmen. Painter, draftsman, printmaker, born in Santiago de Chile, 1930. Studied drawing with André Racz and Nemesio Antúnez, New York; and graphic arts in Paris in 1954-1955, and with Enrique Zañartu, also in Paris, 1958. Since 1955 held individual exhibitions in Santiago and participated in numerous national and

[1] Not included in the original catalogue. See Index of Artists for reference on those not listed here. —*Ed.*

international shows, including the biennials of São Paulo (1957) and Mexico City (1958), and the Guggenheim International Award, New York, 1958.

TESTA, Clorindo. Painter, muralist, draftsman, architect, born in Naples, Italy, 1923. Graduated as an architect from the National University, Buenos Aires. Traveled in Spain and Italy, 1949-1951. Has held individual exhibitions in Buenos Aires since 1952. Participated in Argentine group exhibits in Rio de Janeiro and Amsterdam, 1953; Washington, D.C., 1955; and the Venice Biennial, 1956. Was awarded an Honor Diploma, International Exposition, Brussels (1958), and First Prize for Argentina, International Exposition, Punta del Este (Uruguay), 1959. Has lived in Argentina since 1924 and is an Argentine citizen.

April 21 - May 11, 1959

ANTONIO HENRIQUE OF BRAZIL

A new contributor to the development of the graphic arts in Brazil is Antônio Henrique Amaral, who is making his debut in the United States with this exhibit at the Pan American Union.

The artist was born in São Paulo in 1935 and studied for about a year under the direction of the celebrated engraver Lívio Abramo at the workshop maintained by that city's Museum of Modern Art. During 1958 that museum presented a one-man show of works by Antônio Henrique, which was exhibited later in the same year at the Chilean-British Cultural Institute in Santiago, Chile. In January 1959 he enjoyed another exhibit in Chile, this time at the University of Concepción. Antônio Henrique has participated in several group shows in Brazil, at which he won various awards. His work is to be found in numerous private collections in Argentina, Brazil, and Chile.

In presenting the artist during the exhibition in Santiago, the Chilean painter and critic Víctor Carvacho said:

> The forms created by Antônio Henrique reveal the extravert side of the Brazilian soul. His work overflows with flora and fauna in constant metamorphosis, proliferating in that tropical light which clothes all living things with splendor.

CATALOGUE

Linoleum Cuts

1. *Homem e mulher (Man and Woman)*, 1957
2. *Cavalo (Horse)*
3. *Movimento (Movement)*
4. *Figures in the Moonlight*
5. *Mulatas (Mulatto Woman)*
6. *Arvore (Tree)*
7. *Samba*
8. *Negra (Negro Woman)*
9. *Fusão (Fusion)*, 1957
10. *People*
11. *Distorção (Distortion)*, 1958
12. *Girl*, woodcut
13. *Quarrel*
14. *Antagonism*
15. *Negras (Negro Women)*

16. *Inlaid Figure*
17. *Solitude*
18. *Negra (Negro Woman) No. 2*
19. *Black and White*
20. *Woman and Eyes*
21. *Woman No. 3*
22. *Mulher em preto (Woman in Black)*, 1958
23. *Nocturne*
24. *People*
25. *On the Head*

May 13 - June 14, 1959

ELSA GRAMCKO OF VENEZUELA

With this exhibit of compositions by Elsa Gramcko, for the first time an artist is making an individual debut at the Pan American Union. About four years ago, when the chief of the Visual Arts Section was in Caracas selecting works for the *Gulf Caribbean Art Exhibition* to be held in Houston, the painter Alejandro Otero took him to the studio of a young woman who had been producing quietly under Otero's direction, without evidencing any interest in displaying her output. To her great surprise, after an inspection of her accumulated works, she was invited to participate in the Houston show. Since she had never exhibited before, she agreed that her first individual presentation should take place at the Pan American Union under its auspices. Her promise is now fulfilled.

Gramcko was born in Puerto Cabello, Venezuela, in 1925. She attended the School of Fine Arts in Caracas for a brief period, during which she also studied philosophy at the National University. When Alejandro Otero saw the paintings she was turning out as a hobby, he was much impressed and encouraged her to continue in the abstract line she had taken as her medium of expression. Her work, international in flavor, tends toward the geometrical. Forms are neatly conceived, with a delicate, feminine touch.

Group shows, in addition to the Houston exhibition, in which Gramcko has participated are the three official salons held in Caracas since 1957, the First Salon of Abstract Venezuelan Art, Caracas, 1957, and the exhibit presented in the Venezuelan Pavilion at the International Exposition in Brussels, 1958.

CATALOGUE

Oils

1. *Composition I*
2. *Composition II*
3. *Composition III*
4. *Composition IV*
5. *Composition V*
6. *Composition VI*
7. *Composition VII*
8. *Composition VIII*
9. *Composition IX*
10. *Composition X*
11. *Composition XI*
12. *Composition VII*

May 13 - June 14, 1959

ANGEL HURTADO OF VENEZUELA

An outstanding personality in the abstract trend which has evidenced itself in Venezuelan art during the past decade is that of Angel Hurtado. He was born in 1927 in El Tocuyo, in the State of Lara, and it was there that he attended primary and secondary school. Later he moved to Caracas, where he studied for four years at the National School of Plastic Arts. During that period he participated in all the national salons and in all the important group exhibits which took place in Venezuela. In addition, he held two one-man shows, the first in El Tocuyo in 1945 and the second in Barquisimeto the following year. In 1954 Hurtado left for Europe and settled in Paris, where he continued painting and also experimented with creative cinematography, serving as director of photography for four short art films.

Hurtado has traveled in Belgium, England, Germany, the Netherlands, Spain, and Scandinavia. Last year he went to Switzerland, Italy, and Greece. It was on that journey that he prepared most of the compositions included in this show, the first individual presentation of his work in the United States, where he had previously been known only through his participation in the *Gulf Caribbean Art Exhibit*, Houston, 1956. In Paris he has taken part in a number of group shows: Salon des Réalités Nouvelles, Salon de Mai, and Galerie Cimaise de Paris. His works have also been included in the Venezuelan Section of the Venice and São Paulo biennials.

Upon the occasion of the last Venice Biennial, the French critic André Kuenzi wrote of Hurtado's paintings that they are "vigorous and strongly rhythmic, genuinely pictorial, and possessed of great poetic intensity."

CATALOGUE

Oils

1. *Bajo el signo de Escorpión (Under the Sign of Scorpio)*, 130 x 81 cm.
2. *Bajo el signo de Cáncer (Under the Sign of Cancer)*, 130 x 81 cm.
3. *El centro de la noche (Deepest Night)*, 100 x 73 cm.
4. *Noche descarnada (Black of Night)*, 65 x 46 cm.
5. *Luz negra (Black Light)*, 61 x 50 cm.
6. *Ritmos nocturnos (Nocturnal Rhythms)*, 65 x 54 cm.
7. *Interior cósmico (Cosmic Interior)*, 65 x 54 cm.
8. *Núcleo (Nucleus)*, 40 x 80 cm.
9. *Música roja (Red Music)*, 92 x 65 cm.
10. *Forma nocturna (Nocturnal Form)*, 92 x 60 cm.
11. *Penumbra*, 81 x 54 cm.
12. *Orbita (Orbit)*, 73 x 60 cm.
13. *Regiones de luz (Regions of Light)*, 92 x 60 cm.
14. *Silencio (Silence)*, 81 x 54 cm.
15. *Vértigo (Vertigo)*, 73 x 50 cm.
16. *Meteoros (Meteors)*, 92 x 65 cm.
17. *Pulso de la sombra (Pulse of the Shadow)*, 92 x 65 cm.
18. *Astrología (Astrology)*, 80 x 80 cm.
19. *El poder de la noche (Power of the Night)*, 116 x 81 cm.
20. *Ventana a la luna (Widow to the Moon)*, 46 x 38 cm.
21. *Fin de otoño (End of Autumn)*, 130 x 89 cm.
22. *Presagio (Omen)*, 116 x 89 cm.
23. *Espacios limitados (Limited Spaces)*, 80 x 40 cm.
24. *Azul (Blue)*, 35 x 22 cm.

25. *Gris (Grey)*, 35 x 22 cm.
26. *Signo (Sign)*, 65 x 54 cm.
27. *Eclipse*, 65 x 54 cm.
28. *Eclosión (Blossoming)*
29. *Formas en equilibrio (Forms in Equilibrium) No. 1*, 116 x 89 cm.
30. *Formas en equilibrio (Forms in Equilibrium) No. 2*, 116 x 89 cm.
31. *Primavera (Spring)*, 130 x 89 cm.
32. *Verano (Summer)*, 130 x 89 cm.

Pastels

33. *Signo de lo desconocido (Sign of the Unknown)*
34. *Signo de lo absoluto (Sign of the Absolute)*
35. *Signo de tensión (Sign of Tension)*

June 16 - July 13, 1959

MARIA MORENO KIERNAN OF ARGENTINA: ENGRAVINGS

María Moreno Kiernan was born in 1914 in La Plata, Argentina. After study at the School of Fine Arts of the University of La Plata and at the University of Cuyo, she became professor of plastic arts at the School of Fine Arts in Buenos Aires. In addition, she serves as an illustrator on the staff of the Museum of Natural Sciences in La Plata. She has submitted works at numerous salons in Argentina and has won several awards.

Moreno Kiernan is currently in the United States under the auspices of the Museum of Natural Sciences of La Plata. Taking advantage of her presence in New York, the Galería Sudamericana held an individual exhibition of her work in that city two months ago. It is that exhibit which is now repeated at the Pan American Union.

CATALOGUE

Woodcuts

1. *El afilador (The Sharpener)*
2. *Vendedores de pájaros (Bird Vendors)*
3. *Vendedora de aves (Bird Vendor)*
4. *El permiso (The Permit)*
5. *Comparsa (Carnival)*
6. *Pájaro (Bird)*
7. *Pájaros (Birds) No. 1*
8. *La Virgen y el Niño (Virgin and the Child) No. 1*
9. *Peces (Fish)*
10. *Pájaros (Birds) No. 2*
11. *Sagrada Familia (Holy Family)*
12. *La Virgen y el Niño (Virgin and the Child) No. 2*
13. *La florista (Florist)*
14. *Naturaleza muerta (Still Life)*

Lithographs

15. *Pájaros en la red (Birds in the Net) No. 1*
16. *Pájaros en la red (Birds in the Net) No. 2*

June 16 - July 13, 1959

JOAQUIN ROCA REY OF PERU

Joaquín Roca Rey is the outstanding personality in contemporary Peruvian sculpture. In that medium he represents the revolt of the current generation against the slavishly descriptive art of Indian inspiration which prevailed in his native country and its neighbors during the decade of the 1930s.

Roca Rey was born in Lima in 1923. He attended the National School of Fine Arts in that city; he also studied under the celebrated Spanish sculptors Victorio Macho and Jorge de Oteiza. His first one-man show took place in Lima in 1948, and there he exhibited again in 1952, 1954, and 1959. Abroad, individual presentations of his work were given in 1951 at the Breteau Gallery in Paris and the Biosca Gallery in Madrid. In the same year he exhibited together with his fellow sculptor and compatriot Jorge Piqueras at the Galleria dello Zodiaco in Rome. On that occasion the prominent Italian art critic Lionello Venturi said of Roca Rey that "he has a deep and rigorously plastic sense of creation." In 1956 and 1957 joint exhibits of his work and that of the Peruvian painter Fernando de Szyszlo took place at the Museum of Modern Art in Rio de Janeiro and in São Paulo, and at the Galería Sudamericana in New York City. In connection with the last-mentioned presentation, the magazine *Art News* said of the sculptor that he evidenced a "sophisticated vocabulary and wide range of accomplishment." Joaquín Roca Rey has participated in numerous group shows in Peru, Europe, and the United States, and in the two São Paulo biennials. In 1955, in collaboration with the Peruvian architect Pardo de Zela, Roca Rey won an international competition for the design of a monument to the late President Remón of Panama, recently erected in the capital of that republic.

This is Joaquín Roca Rey's first one-man show in Washington, which has been made possible through the cooperation of the Cultural Office of the Peruvian Ministry of Foreign Affairs and of Aerolíneas Peruanas, S.A.

CATALOGUE

Sculpture

1-3. *Ritmo en tres (Rhythm in Three)*, bronze, 195 x 123 x 36 cm.
 4. *Flautista (Flutist)*, bronze, 105 x 62 x 63 cm.
 5. *Pez (Fish)*, aluminum, 30 cm. (height)
 6. *Abrazo (Embrace)*, bronze, 28 x 14 cm.
 7. *A las Américas (To the Americas)*, bronze, 53 x 34 1/2 cm.
 8. *Figura en el espacio (Figure in Space)*, bronze, 28 cm. (height)
 9. *Castillos en el aire (Castles in the Air)*, iron, 122 x 26 x 26 cm.
10. *Prisionero político desconocido (Unknown Political Prisoner)*, bronze, 31 x 26 x 17 cm.
11. *Composición (Composition)*, aluminum, 27 (height)
12. *Maternidad (Maternity)*, aluminum, 26 cm. (height)
13. *Calidoscópico (Kaleidoscope)*, copper (relief), 100 x 54 1/2 x 5 cm.
14. *Hierro en primavera (Iron in the Spring)*, iron, 93 x 41 x 40 cm.
15. *Homenaje a Thor Heyerdahl (Homage to Thor Heyerdahl)*, iron, 20 cm. (height)
16. *Homenaje a los mochicas (Homage to the Mochicas)*, aluminum, 40 cm. (height)
17. *Estola funeraria (Funeral Plaque)*,[1] iron, 111 1/2 x 51 x 46 1/2 cm.
18. *Trilogía (Trilogy)*, steel, 113 x 43 x 58 cm.
19. *Jeremías (Jeremiah)*, bronze, 56 x 37 x 20 cm.
20. *Monumento al Tumi (Monument to the Tumi)*, bronze, 57 cm. (height)

[1] Literal translation of this title is "Funerary Stole." —*Ed.*

21. *Puerta a Oriente (Door to the Orient)*, bronzed iron, 41 cm. (height)
22. *Exodo (Exodus)*, bronze, 37 cm. (height)
23. *Complemento arquitectónico (Architectural Complement)*, aluminum, 25 cm. (height)
24. *Escultura constructivista (Constructivist Sculpture)*, bronze, 35 x 60 cm.
25. *Cazadora de mariposas (Butterfly Catcher)*, aluminum, 75 cm. (height)

July 14 - August 12, 1959

MIGUEL DIOMEDE OF ARGENTINA: PAINTINGS

In regard to technique in its traditional sense and for sheer craftsmanship, Argentina has long held front rank in Latin American art. Although the principal influences on painting and sculpture have been European—more particularly French and Italian—in origin, recent generations have endeavored to give their compositions a more characteristically Argentine flavor, seeking inspiration in national sources. The current exhibition of the Pan American Union presents the work of an artist firmly rooted in the European past, whose quiet, intimate manner avoids academic routine without exploring any of the bolder trends of contemporary art, an artist whose search is for purely pictorial values, without literary overtones.

Miguel Diomede was born in Buenos Aires in 1902. He describes himself as self-taught. Long ignored, it was only in 1941, when he held his first one-man show in Avellaneda, that he began to win a measure of recognition. Other individual exhibitions took place in Buenos Aires at the Rose Marie, Plástica, and Bonino galleries, in 1945, 1951, and 1952, respectively. Since 1944 Diomede has participated in a succession of salons, winning a number of awards. Last year Jorge Romero Brest, the new director of the Museum of Fine Arts in the Argentine capital, invited him to present a retrospective exhibition of his production; this served to affirm the artist's position as one of the outstanding painters of his generation. In presenting this show, Romero Brest declared:

> Diomede's work defies classification. He fits into no category; he escapes even from the widely
> accepted distinction whereby artists are divided into the two opposing camps of figurative painters
> and abstractionists. The reason for this lies in the fact that, like all true artists, Diomede is bound
> not by the spell of the external world but by that of the world within himself.

Diomede is represented in several Argentine collections, including that of the National Museum of Fine Arts. The current presentation of his work is the first of any kind to take place in the United States.

CATALOGUE

Oils

1. *Durazno con uvas (Peach with Grape)*, 1956, 27 x 19 cm.
2. *Plato con fruta (Plate with Fruit)*, 1953, 23 x 33 cm.
3. *Plato con durazno (Plate with Peach)*, 1954, 27 x 19 cm.
4. *Cabeza (Head) No. 1*, 1938, 30 x 24 cm.
5. *Duraznos (Peaches)*, 1945, 28 x 23 cm.
6. *Pescados (Fish) No. 1*, 1957, 35 x 27 cm.
7. *Figure (Figure)*, 1938, 32 x 26 cm.
8. *Duraznos y bananas (Peaches and Bananas)*, 1957, 36 x 29 cm.
9. *Plato y frutas (Plate and Fruits)*, 1952, 37 x 28 cm.
10. *Rodeo*, 1949, 38 x 32 cm.
11. *Paisaje (Landscape)*, 1955, 33 x 31 cm.

12. *Naturaleza muerta (Still Life)*, 1958, 41 x 27 cm.
13. *Cabeza (Head) No. 2*, 1957, 46 x 33 cm.
14. *Pescados (Fish) No. 2*, 1947, 50 x 30 cm.
15. *Ada*, 1956, 76 x 50 cm.
16. *Autorretrato (Self-Portrait)*, 1955, 62 x 51 cm.
17. *Mujer con violetas (Woman with Violets)*, 1955, 65 x 54 cm.
18. *Renzi*, 1946, 65 x 49 cm.
19. *Flores (Flowers)*, 1952, 37 x 29 cm.
20. *Desnudo (Nude)*, 1957, 33 x 19 cm.

August 13 - September 6, 1959

EDUARDO MOLL OF PERU: PAINTINGS

Eduardo Moll belongs to the group of young artists who have turned away from the Indianist tendency that for many years dominated Peruvian art. His work is clearly rooted in expressionism, at first figurative, now non-objective.

Born in Leipzig, Germany, in 1929, Moll has lived in Peru since childhood and is a citizen of that country. While studying chemical engineering at the University of San Marcos in Lima, he took courses at the National School of Fine Arts. He later continued his art studies in France and Germany. Since 1951 his work has appeared in group exhibitions in Peru, Chile, Brazil, and France. His first one-man show at Lima's Galería Roma, in 1951, was followed by six others in Peru. Last year his engravings were exhibited at the Museum of Colonial Art in Quito, Ecuador.

Moll founded and now teaches at an art school for prisoners at the Lima Penitentiary, and he is art critic of the daily *La Crónica*.

CATALOGUE

Oils

1. *Círculos en movimiento (Circles in Movement)*
2. *Negro sobre azul (Black on Blue)*
3. *Composición en grises (Composition in Grey)*
4. *Gris sobre negro (Grey on Black)*
5. *Circle in Darkness*
6. *Composición en negro (Composition in Black)*
7. *Círculo sobre violeta (Circle on Violet)*
8. *Contrapunto de movimientos (Counterpoint of Motion)*
9. *Negro sobre gris (Black on Grey)*
10. *Composición sobre rojo (Composition on Red)*
11. *Negro sobre rojo (Black on Red)*
12. *Counterpoint Staccato*
13. *Vibraciones sobre grises (Vibrations on Grey)*
14. *Movimiento en azul (Motion on Blue)*
15. *Negro sobre blanco (Black on White)*
16. *Movimiento ascendente (Ascending Motion)*
17. *Composición (Composition)*
18. *Composición (Composition)*

YEAR 1960

March 2 - 20, 1960

LILIA CARRILLO AND MANUEL FELGUEREZ OF MEXICO

After an interruption of more than seven months in its program of periodic exhibitions, the Pan American Union is opening to the public a remodeled gallery, which possesses the advantages of air conditioning and modern lighting. To reinitiate our activities we have decided upon a joint exhibition by two Mexican artists who attempt that which has seldom been seen in Mexican art since the Conquest: the embodiment of a pre-Columbian tradition in a non-representational style. Lilia Carrillo and Manuel Felguérez belong to that new generation which, although it includes figurative artists, turns its back on social realism or any form of programmatic or ideological art.

Manuel Felguérez was born in Mexico City in 1928. He began to study sculpture there at the age of twenty, when he enrolled in the National School of Plastic Arts. In 1949 he went to Paris, where he attended classes at the Grande Chaumière, studying under the sculptor Ossip Zadkine. He returned to Paris for a year in 1954 upon the receipt of a scholarship from the French government. Again he studied under Zadkine, but this time at the Académie Colarossi.

It was in 1957 that Felguérez turned his efforts to painting. Without abandoning sculpture completely, he began to exhibit regularly works in two dimensions. He has held one-man shows at the Franco-Mexican Cultural Institute in Mexico City, 1954; the Maison du Mexique, Paris, 1955; and the Souza Gallery, Mexico City, 1959.

Felguérez has participated in group shows in Paris, Munich, Barcelona, Geneva, Jerusalem, Boston (Massachusetts), St. Louis (Missouri), Fort Worth (Texas), and Mexico City. His sculpture has been included in several group exhibits at the Bertha Shaeffer Gallery in New York. Examples of his work are to be found in the Museum of Modern Art in Mexico, the National Museum of Israel in Jerusalem, and the Weiner Collection in Fort Worth, as well as in several private collections in the United States, Mexico, and France.

The Souza Gallery is the exclusive representative in Mexico for the works of Carrillo and Felguérez. Both are now presenting their works in the Washington area for the first time.

Lilia Carrillo was born in Mexico City in 1929. She studied at the National School of Painting and Sculpture from 1948 to 1952. Two years after graduating, she received from the government of France a scholarship which afforded her the opportunity to live in Paris, where between 1954 and 1955 she spent her time painting and attending classes at the Grande Chaumière. Upon returning from France, Carrillo was appointed to a professorship at the National Institute of Fine Arts and later she became a tapestry designer at the Center for Applied Arts.

Carrillo has held individual exhibitions at the Maison du Mexique in Paris in 1955 and at the Souza Gallery in Mexico City in 1957. Her work has been included in group shows in Paris, Jerusalem, St. Louis (Missouri), San Antonio (Texas), New York, and Mexico City. She is represented in the collections of the Museum of Modern Art of Israel in Tel Aviv, the Museum of Modern Art in Mexico City, and in numerous private collections.

CATALOGUE

Paintings

Lilia Carrillo

1. *Umbral del crepúsculo (Threshold of Dusk)*, 90 x 60 cm. Coll. Josefina Vicens
2. *Mediodía (Midday)*, 86 x 72 cm. Coll. Josefina Vicens
3. *La ciudad de Andrómeda (The City of Andromeda)*, 100 x 80 cm. Coll. Socorro García
4. *Imagen recobrada (Recovered Image)*, 50 x 60 cm. Coll. Dolores Feliu
5. *La ventana (The Window)*, 63 x 45 cm. Coll. Josefina Vicens
6. *Los caballos y la noche (Horses and the Night)*, 52 x 19 cm.
7. *Presagio (Omen)*, 60 x 50 cm.
8. *El desayuno del Dr. Atl (The Breakfast of Dr. Atl)*, 100 x 50 cm.
9. *Espacio luminoso (Luminous Space)*, 130 x 50 cm.
10. *La lucha con el ángel (War with the Angel)*, 100 x 70 cm.
11. *Homenaje a Watteau (Homage to Watteau)*, 100 x 60 cm.
12. *Júbilo neutro (Neutral Merriment)*, 70 x 90 cm.
13. *El fin (The End)*, 53 x 28 cm.
14. *La vigilia de Caronte (The Vigil of Caronte)*, 200 x 80 cm.
15. *Voyage*, gouache, 50 x 32 cm.

Manuel Felguérez

1. *Pintura (Painting)* 8-1959, 45 x 35 cm.
2. *Pintura (Painting)* 10-1959, 51 x 40 cm.
3. *Pintura (Painting)* 12-1959, 80 x 50 cm.
4. *Pintura (Painting)* 15-1959, 90 x 60 cm.
5. *Pintura (Painting)* 16-1959, 80 x 70 cm.
6. *Pintura (Painting)* 18-1959, 60 x 50 cm.
7. *Pintura (Painting)* 19-1959, 80 x 70 cm.
8. *Pintura (Painting)* 20-1959, 100 x 80 cm.
9. *Pintura (Painting)* 21-1959, 100 x 80 cm.
10. *Pintura (Painting)* 22-1959, 110 x 80 cm.
11. *Pintura (Painting)* 23-1959, 160 x 110 cm.
12. *Pintura (Painting)* 1-1960, 100 x 70 cm.
13. *Pintura (Painting)* 2-1960, 100 x 80 cm.
14. *Pintura (Painting)* 3-1960, 100 x 60 cm.
15. *Escultura (Sculpture)*, bronze, 80 cm.

March 18 - April 10, 1960

CONTEMPORARY GRAPHIC ARTS OF BRAZIL

The sudden appearance of modern Brazilian architecture, in 1940, surprised everyone since the movement surged in a perfectly mature state, with a sure foot and characteristics of its own, as if a tropical occurrence. A similar phenomenon is occurring in Brazilian engraving. Without any tradition to justify it, during the last twenty years we have seen the development of a large group of artists who, with excellent results, have dedicated themselves exclusively to engraving in which they find their only and most satisfactory means of expression.

Oswaldo Goeldi and Lívio Abramo are the deans and pioneers of the entire movement. Both continue untiringly working and teaching, and few are those who do not owe them, directly or indirectly, something of their artistic formation. Thus, all the earlier Brazilian engravers instruct and prepare the new generation of artists with great promise. In the instance of Fayga Ostrower, whose work is daily becoming purer, her creation has attained such quality that it merited the Grand International Prize for Engraving in the last Biennial of Venice.

Other artists, less known but of exceptional interest, such as Edith Behring, Rossini Perez, and Maria Bonomi are successfully directing important workshops of engraving in Rio and São Paulo, renovating the technique and awakening new talents.

The Brazilian engravers are now well known and were well received in Europe, where they have been systematically exhibiting since 1950 in the biennials of Venice, Lugano, and Lublin, in great retrospectives such as that of Geneva which took place in 1955, and in private museums and galleries of the Continent.

In the United States of America these engravers are known individually. Works of artists such as Fayga Ostrower, Iberê Camargo, and Maria Bonomi receive favorable criticisms and reach great acceptance in the artistic circles.

There was lacking, however, a group presentation of the sort by which the North American public and critics might have the opportunity to see the diverse aspects which characterize Brazilian engraving today.

In the selection now on exhibition we have tried to reunite all, or practically all, of the most significant names of Brazilian engraving, who are represented by works chosen from their most recent production. It is, then, a picture which strives to be faithful to the present state of Brazilian engraving. This presentation to the North American public and collectors is made possible through the generous aid and interest of the Pan American Union, General Secretariat of the Organization of American States, and the Smithsonian Institution. —*Wladimir Murtinho*, Director of the Cultural Division, Ministry of Foreign Affairs of Brazil.

CATALOGUE

Lívio Abramo
 1. *Macumba*, woodcut
 2. *Paraguay*, woodcut

Edith Behring
 3. *Engraving No. 1*, aquatint and drypoint
 4. *Engraving No. 2*, etching and aquatint
 5. *Engraving No. 3*, etching and aquatint

Vera Bocayuva Mindlin
 6. *Parrot*, drypoint and aquatint
 7. *Orchestra*, drypoint and aquatint

Mário Augusto de Berrêdo Carneiro
 8. *Table*, aquatint
 9. *Urban Landscape*, aquatint

Maria Bonomi
10. *Dialogue*, woodcut
11. *Engraving No. 2*, woodcut

Iberê Camargo
12. *Fruits and Spools*, aquatint
13. *Three Spools*, relief and aquatint
14. *Spools*, aquatint

João Luiz Chaves
15. *Engraving No. 1*, etching
16. *Engraving No. 2*, etching
17. *Engraving No. 3*, etching

Oswaldo Goeldi
18. *Cutting Block*, woodcut
19. *Bird of Storm*, woodcut
20. *Still Life*, woodcut

Antônio Henrique
21. *Horse*, woodcut
22. *Three Women*, woodcut

Roberto De Lamônica
23. *Engraving No. 1*, aquatint
24. *Engraving No. 2*, aquatint
25. *Engraving No. 3*, aquatint

Anna Letycia
26. *Bird No. 1*, aquatint
27. *Bird No. 2*, aquatint
28. *Bird No. 3*, aquatint

Fayga Ostrower
29. *Engraving No. 1*, woodcut
30. *Engraving No. 2*, aquatint
31. *Engraving No. 3*, aquatint

Lygia Pape
32. *Engraving No. 1*, wood engraving
33. *Engraving No. 2*, wood engraving

Rossini Perez
34. *Engraving No. 15*, etching and aquatint
35. *Engraving No. 16*, etching and aquatint
36. *Engraving No. 17*, etching and aquatint

Arthur Luiz Piza
37. *Transparency*, aquatint
38. *Expulsion*, engraving and aquatint
39. *Engraving No. 17*, aquatint

Isabel Pons
40. *Poblete*, mixed media
41. *My Love*, mixed media

ABOUT THE ARTISTS

ABRAMO, Lívio. Was born in São Paulo in 1903. He has participated in numerous international exhibitions. Recipient of the First National Prize for Engraving at the São Paulo Biennial in 1952.

ANNA LETYCIA. Was born in 1929 in Rio de Janeiro. She studied engraving with Iberê Camargo and lithography with Darel. Her works have been seen in numerous shows in Brazil as well as in other countries throughout the world. She has received various prizes.

ANTONIO HENRIQUE. Was born in São Paulo in 1935. He studied under Lívio Abramo. He has held several one-man shows and has participated in numerous group shows in Brazil, where he has received various awards.

BEHRING, Edith. Was born in Rio de Janeiro in 1916. She studied with Portinari, Leskoschek, and Friedlaender. The French government awarded her a scholarship for four years of study in Europe. She has held several individual shows and participated in group shows in this hemisphere and in Europe.

BOCAYUVA MINDLIN, Vera. Was born in Rio de Janeiro in 1920. She studied engraving under Goeldi, Jean Pons, and Iberê Camargo. She has exhibited in this hemisphere and in Europe both individually and in group shows.

BONOMI, Maria. Was born in Italy in 1935. She adopted Brazilian citizenship in 1944 when she moved to Brazil. She has studied in Europe, the United States, and Brazil. Her works have been in several group shows throughout the world, and she has held numerous individual shows in Brazil and the United States.

CAMARGO, Iberê. Was born in Rio Grande do Sul in 1914. He studied engraving in Rome with Carlo Alberto Petrucci. He has held several one-man shows in this hemisphere and has participated in diverse exhibitions of Brazilian art outside of his native country. At present he is a professor of engraving at the Municipal Institute of Fine Arts of Rio de Janeiro.

CARNEIRO, Mário Augusto de Berrêdo. Was born in Brazil in 1930. He studied architecture at the National School of Architecture and engraving under Iberê Camargo and Johnny Friedlaender.

CHAVES, João Luiz. Was born in São Paulo in 1921. He studied engraving in São Paulo and in Paris. Chaves has participated in group shows in Europe and the Western Hemisphere and has held one-man shows in Paris, São Paulo, and cities in Holland.

GOELDI, Oswaldo. Was born in Rio de Janeiro in 1895. He has held individual shows in Rio and in Europe and has participated in several group exhibits throughout the world. At the First Biennial of São Paulo he was awarded the Grand Prize for Engraving.

LAMONICA, Roberto De. Was born in Mato Grosso in 1933. He has studied with Renina Katz, Poty, Darel, Orlando da Silva, and Friedlaender. His one-man shows have been held in Rio de Janeiro and São Paulo, and he has participated in various group shows both in Brazil and in other countries. He is the recipient of several awards.

OSTROWER, Fayga. Was born in Poland in 1920. She studied with Santa Rosa, Carlos Oswald, and Axel Leskoschek. She has participated in many international exhibitions in Brazil and in Brazilian exhibitions throughout the world.

PAPE, Lygia. Was born in Nova Friburgo in 1929. She belongs to the neo-concrete vanguard group of painters, engravers, sculptors, and poets. Her works have been seen in several international and national group shows, at which she has obtained various awards.

PEREZ, Rossini. Was born in Rio Grande do Norte in 1932. He studied art at the Brazilian Association of Design and the Museum of Modern Art of Rio. He has done illustrations for various periodicals in Rio and São Paulo. Perez has held several one-man shows in South America and has participated in national and international group shows.

PIZA, Arthur Luiz. Was born in São Paulo in 1928. He has studied with Gomide and Friedlaender. Piza was a participant in group shows throughout the world and has held one-man shows both nationally and internationally.

PONS, Isabel. Was born in Spain, she is a naturalized Brazilian. She has had long experience with wood engraving and has recently turned her interest to woodcutting. Her works have been seen in the São Paulo biennials.

April 13 - May 10, 1960

ROSER MUNTAÑOLA: OILS. CIRO ODUBER: DRAWINGS

Great progress is to be noted in the development of the arts in Panama during the past decade, particularly in the fields of architecture and painting. In 1953 the Pan American Union presented a group exhibition of ten contemporary Panamanians. This was well received; the work of Eudoro Silvera, Roser Muntañola, and Ciro Oduber being judged outstanding for the freshness and directness of the artists' approach. In view of this success, in 1955 Silvera was given a one-man show at the Union. Now Roser Muntañola and Ciro Oduber, who in private life are husband and wife, are being accorded a joint exhibition, restricted to the media in which they respectively excel—Oduber in drawing, and Muntañola in painting.

Roser Muntañola was born in 1928 in Barcelona, Spain, but for several years now she has been a citizen of Panama. At the age of nine she was taken to Argentina, and from 1941 to 1950 she studied at the three national art schools in Buenos Aires with a year off in 1948-49 for a course at the National School of Fine Arts in Barcelona. The winner of scholarships from the Argentine and Spanish governments, she has held individual exhibitions at the National Library of Panama, 1951; the Vaireda Gallery in Barcelona, 1953; the National Museum of Panama, 1959; and the Panamanian-United States Association, 1960. Examples of her work are to be found in the National Museum of Panama and in many private collections in Argentina, Panama, and Spain.

Ciro Oduber was born in 1921 in Panama. After studying there with the painters Roberto Lewis and Humberto Ivaldy, he traveled to Argentina to take courses at the National School for Advanced Study in Art. He held one-man shows in Buenos Aires at the Kraft Gallery in 1949 and the House of Mendoza in 1950, and in Panama at the University of Panama in 1951, the National Library in 1952, the National Museum in 1959, and the Panamanian-United States Association in 1960. In 1959 he participated in the Inter-American Exhibition in Cartagena, Colombia, where he was awarded a Purchase Prize. He is now represented in the Museum of Modern Art of the last mentioned city, in the National Museum in Panama, and in many private collections in Argentina, Brazil, Chile, Panama, Puerto Rico, Spain, and the United States.

This is the first extensive exhibit of the works of either artist in the United States.

CATALOGUE

Roser Muntañola

Oils

1. *Imágenes (Images)*

2. *Gusto a sandía (Watermelon Taste)*
3. *Cometas (Kites)*
4. *Lunas de piedra (Moons of Stone)*
5. *Sandías (Watermelons)*
6. *Juegos de niños (Children's Games)*
7. *Eva (Eve)*
8. *Madre (Mother)*
9. *Ronda y luna (Moon and Promenade)*
10. *Diablitos (Little Devils)*
11. *Maternidad (Maternity)*

Ciro Oduber

Drawings

1-14. *Viacrucis (The Way of the Cross)*
15. *Limpiabotas (Shoeshine Boy)*
16. *Vendedor de pescado (Fish Vendor)*
17. *Barredor de calles (Street Cleaner)*
18. *Billeteras (Lottery Seller)*
19. *Freidora de tortillas (Frying Tortillas)*
20. *Cargadoras de agua (Water Carriers)*
21. *Cuidador de gallos (Rooster Breeder)*
22. *Caballitos (Ponies)*
23. *Pollera (Typical Costume)*
24. *Montuno (Bushman)*
25. *India en hamaca (Indian Woman in a Hammock)*
26. *Mujer en hamaca (Woman in a Hammock)*
27. *Carbonero (Coal Vendor)*
28. *Periodiquero (Newsboy)*
29. *Vendedor de sandía (Watermelon Vendor)*
30. *India kuna (Kuna Indian Woman)*
31. *Indio kuna (Kuna Indian Man)*
32. *Jinete (Rider)*
33. *Cristo (Christ)*
34. *Cristo (Christ)*
35. *Altar, la vida (Altar, the Life)*
36. *Calle prohibida (Forbidden Street)*

April 18 - May 8, 1960

MEXICAN PAINTINGS

It has been several years since the Pan American Union last had the opportunity to present a group exhibit of Mexican paintings. Recently, however, the chairman of the Council of the Organization of American States, Ambassador Vicente Sánchez Gavita of Mexico, succeeded in bringing to Washington the notable collection belonging to his friend Agustín Velázquez Chávez, and at the same time the Ambassador of Mexico to the United States, Antonio Carrillo Flores, graciously made available for public presentation a group of important works in his possession. To these the Pan American Union has been able to add not only items from its permanent collection

and from private collections, but also one lent by the Phillips Gallery of Washington and two, never before shown in this city, from the Museum of Modern Art in New York.

To all those whose loans have made this exhibition possible the Pan American Union expresses its most sincere appreciation.

CATALOGUE

Paintings

Abraham Angel
1. *Los enamorados (The Sweethearts)*, oil. Coll. Ambassador Carrillo Flores

Anonymous, nineteenth century
2. *El árbol de la noche triste (The Tree of the Sad Night)*, oil. Coll. Sr. Agustín Velázquez Chávez

Dr. Atl
3. *Paisaje del Valle de México (Landscape of the Valley of Mexico)*, resins. Coll. Sr. Agustín Velázquez Chávez
4. *El Valle de México (The Valley of Mexico)*, resins. Coll. Ambassador Carrillo Flores

Lilia Carrillo
5. *Espacio luminoso (Luminous Space)*, oil. Coll. of the artist

José Castillo
6. *Niño con tuna (Child with Prickly Pear)*, oil. Coll. Sr. Agustín Velázquez Chávez

Joaquín Clausell
7. *Canal de Santa Anita (Santa Anita Canal)*, oil. Coll. Sr. Agustín Velázquez Chávez
8. *Seascape*, oil. Coll. Sr. Agustín Velázquez Chávez

José Luis Cuevas
9. De la serie *Funerales de un dictador: La viuda* (From the Series *Funeral of a Dictator: The Widow*), ink drawing. Coll. Pan American Union

Manuel Felguérez
10. *Pintura (Painting) No. 19*, oil. Coll. Pan American Union

Alberto Gironella
11. *El glotón (The Glutton)*, oil. Coll. Pan American Union

Guillermo Gómez Mayorga
12. *El Popocatépetl desde Atlisco (Popocatépetl Volcano Seen from Atlisco)*, oil. Coll. Sr. Agustín Velázquez Chávez

Jesús Guerrero Galván
13. *Niño con sandía (Child with Watermelon)*, gouache. Coll. Ambassador Carrillo Flores
14. *Retrato de Amelia (Portrait of Amelia)*, pencil. Coll. Sr. Agustín Velázquez Chávez
15. *El Maestro Velázquez Andrade (The Teacher Velázquez Andrade)*, oil. Coll. Sr. Agustín Velazquez Chávez

María Izquierdo
16. *Taverna (Alehouse)*, oil. Coll. Ambassador Carrillo Flores

Guillermo Meza
17. *Hilandera (Spinner)*, oil. Coll. Ambassador Carrillo Flores

José Clemente Orozco
18. *Zapatistas*, oil. Coll. The Museum of Modern Art, New York

Máximo Pacheco
19. *Water Girl*, oil. Coll. Sr. Agustín Velázquez Chávez

Eduardo Prunés
20. *El Lago de Chalco (Chalco Lake)*, oil. Coll. Sr. Agustín Velázquez Chávez

Diego Rivera
21. *Retrato familiar (Family Portrait)*, oil and encaustic. Coll. Sr. Agustín Velázquez Chávez
22. *Russian Children Playing in the Snow*, oil. Extended loan of Miss Evelyn Murray, Washington, D.C.
23. *La toma de Veracruz (The Capture of Veracruz)*, ink drawing. Coll. Sr. Agustín Velázquez Chávez
24. *El regreso de dos revolucionarios (Homecoming of Two Revolutionaries)*, watercolor. Coll. Minister Enrique Dardo Cúneo

David Alfaro Siqueiros
25. *Cabeza de mujer (Woman's Head)*, duco. Coll. Ambassador Carillo Flores

Rufino Tamayo
26. *Animales (Animals)*, oil. Coll. The Museum of Modern Art, New York
27. *Carnaval (Carnival)*, oil. Coll. The Phillips Gallery, Washington, D.C.
28. *Frutera (Fruit Vendors)*, watercolor. Coll. Ambassador Carrillo Flores

José María Velasco
29. *El Molino del Rey*, drawing. Coll. Sr. Agustín Velázquez Chávez
30. *El Valle de México (The Valley of Mexico)*, oil. Coll. Sr. Agustín Velázquez Chávez

BIOGRAPHICAL NOTES[1]

ANGEL, Abraham. Painter, draftsman, born in Mineral del Oro, Chihuahua, 1905. Started painting in 1922 on his own. Later attended the workshop of Manuel Rodríguez Lozano. Died in Mexico City, 1924, at the age of nineteen, leaving a small but charming production of Mexican rural scenes, now in the hands of very few collectors.

Dr. ATL (Gerardo Murillo). Painter, draftsman, writer, volcanologist, born in Guadalajara, 1875. Studied at the Escuela de Bellas Artes, Mexico City; in Paris and Italy, where he received a Ph.D. in philosophy and law. In 1911-14 studied volcanology in Italy. As a politician has been an important and active member of the revolution; as an art historian has published a six volume work on the churches of Mexico and a monograph on its popular arts; as a scientist published monographs on the Mexican volcanoes Popocatépetl and Paricutín; as a writer published several novels, many short stories, and poetry. As an artist he is the father of the modern art movement in Mexico and executed an amazing number of works in oil, charcoal, pastel, and *acqua-resina* (Atl-colors), a technique invented by him. Held many individual exhibitions in Mexico, at the Palacio de Bellas Artes (1944) and the Museo Nacional de Artes Plásticas (1948), among others. Participated in group exhibitions in Paris, Rome, and in the United States, including *Latin American Exhibition of Fine and Applied Art*, Riverside Museum, New York, 1939; the Golden Gate International Exposition, San Francisco, 1940, *Modern Mexican Painters*, Institute of Modern Art,

[1] Not included in the original catalogue. See Index of Artist for reference on those not listed here. —*Ed.*

traveling in the United States, 1941-42.

CLAUSELL, Joaquín. Painter, born in Campeche, 1866. Died in Lagunas de Zempoala, 1935, Was a self-taught artist. Moved to Mexico City, 1886, where he graduated as a lawyer. Went to Europe, 1892-93, where he became interested in the impressionist movement and in painting, motivated by his friendship with Dr. Atl. Was director of the Escuela de Pintura al Aire Libre, Ixtacalco. Produced a large number of landscapes, many of them exhibited at the Palacio de Bellas Artes, Mexico City, 1945. Participated in international shows, including the Golden Gate International Exposition, San Francisco, 1940.

GOMEZ MAYORGA, Guillermo. Painter, muralist, born in Puebla, 1890. Studied in Mexico, France, and Italy. Painted murals in Mexico. Was awarded several prizes in Mexico and Europe.

GUERRERO GALVAN, Jesús. Painter, muralist, draftsman, printmaker, born in Tonalá, 1910. Went to the United States at a young age and studied at the School of Plastic Arts, San Antonio, Texas. Returned to Guadalajara in 1922. Studied with the painter José Vizcarra and joined the *Grupo sin Número y sin Nombre*. Moved to Mexico City in 1930, where he painted murals in several schools of the metropolitan area, as well as in Morelia. In 1942, through a grant of the Coordinator of Inter-American Affairs, he was an artist in residence and a professor of painting at the School of Fine Arts, University of New Mexico in Albuquerque, where he also painted a mural. Held individual exhibitions in Mexico and the United States. Participated in national and international group exhibitions, including *Twenty Centuries of Mexican Art*, Museum of Modern Art, New York, 1940 and *Modern Mexican Painters*, Institute of Modern Art of Boston, traveling in the United States, 1941-42.

IZQUIERDO, María. Painter, draftman, born in San Juan de los Lagos, 1907. Died in Mexico City, 1955. Studied painting under Germán Gedovius and drawing with Garduño, Academia de San Carlos, 1928-29. Held individual exhibitions in Mexico City, New York, Buffalo, Hollywood, San Francisco, Paris, London, Santiago de Chile, Viña del Mar, and Bombay. Participated in many national and international exhibitions including *Latin American Exhibition of Fine Arts*, Riverside Museum, New York, 1939; the Golden Gate International Exposition, San Francisco, 1940; and *Modern Mexican Painters*, Institute of Modern Art of Boston, traveling in the United States, 1941-42.

MEZA, Guillermo. Painter, draftsman, born in Mexico City, 1917. Self-taught as a painter, except for courses taken at a night art school for laborers at the age of fifteen. In 1937 one of his teachers, Balmori, took him to Morelia as his assistant, becoming a teacher of drawing. Returned to Mexico City in 1938 and, sponsored by Diego Rivera and Inés Amor, started holding individual exhibitions in 1940. Others followed in Mexico City and Boston. Participated in group exhibitions in Mexico and abroad, including the Golden Gate International Exposition, San Francisco, 1940; *Modern Mexican Painters*, Institute of Modern Art of Boston, traveling in the United States, 1941-42; *Mexican Art*, National Institute of Fine Arts of Paris, traveling in Europe, 1952.

PACHECO, Máximo. Painter, muralist, draftsman, born Huichapán, 1905. Studied at the Academia de Bellas Artes of Mexico City, 1918-21, under Ramón Alva de la Canal and Fermín Revueltas. With Orozco, Rivera, Siqueiros, and others, founded the Sindicato de Pintores y Escultores, initiating the muralist movement with some frescoes at the National Preparatory School of Mexico City. Worked under Revueltas and later under Diego Rivera in the murals of the Secretariat of Education of Mexico City, as well as in those executed in Chapingo. In 1926 started working on his own, painting frescoes in several schools. Held his first individual exhibition in Mexico City in 1926. Participated in many group exhibitions, including the Golden Gate International Exposition, San Francisco, 1940, and those organized by the American Federation of Arts, the College Arts Association, and the Mexican Art Gallery in the United States. Was awarded several first prizes for poster designs, 1931-36. His last important mural was executed at the Escuela Nacional de Maestros, 1938, when he had to abandon painting for health reasons.

SIQUEIROS, David Alfaro. Painter, muralist, draftsman, printmaker, born in Chihuahua, 1896. Studied at Academia de Bellas Artes, Mexico City, 1911-13; Escuela de Pintura al Aire Libre, Santa Anita, 1913. In 1911

engaged in politics and art-related activities, and since 1924 has devoted much time in working for the Communist Party. Arrested in 1930, was confined to the city of Taxco in 1931, and was expatriated for some years. Fought in the Mexican Revolutionary Army, 1914-1918, and in the Spanish Republican Army, 1938-39; organized syndicates and founded several magazines and newspapers; attended syndicalist congresses in Moscow, South America, and the United States. Founding member of the muralist movement in Mexico, was the author of its Manifesto, 1922. That same year started his first mural at the Escuela Nacional Preparatoria. Thereafter executed many others in Mexico, the United States, Argentina, Chile, and Cuba. Founded an experimental workshop in New York in 1936-38, where new techniques were explored. Held individual exhibitions in Mexico, Montevideo, Buenos Aires, and New York. Participated in international exhibitions, including Pittsburgh International, Pennsylvania, 1935; *Latin American Exhibition of Fine Arts*, Riverside Museum, New York, 1939; Golden Gate International Exposition, San Francisco, 1940; at the Art Institute of Chicago in 1944 and the San Francisco Museum of Art in 1945. Was awarded several prizes, including the Prize for Foreign Artists, Venice Biennial, 1950.

VELASCO, José María. Painter, draftsman, lithographer, born in Tematzcalzingo, 1840. Died in Mexico City, 1912, where he had lived since the age of six. Studied landscape painting at the Academia de San Fernando, Madrid, 1858-68, with the Italian painter Eugenio Landesio and the Spanish painter Pelegrín Clavé, among others. Visited Philadelphia (1876), Chicago (1893), and Paris (1889), as well as England, Germany, Italy, and Spain. Was professor of landscape perspective, Academia de San Carlos, Mexico City, 1868-1902, when a heart attack forced him to give up painting and classes. Did a large number of lithographs. Published *Flora de los alrededores del Valle de México*, illustrated with hand colored lithographs. Exhibited in Mexico and at international shows, including the Universal Exposition of Paris, 1889, where he exhibited sixty-eight paintings and served as head of the Mexican delegation. Since 1860—when he received a pension to continue studying—has won many distinctions, including awards from the President of Mexico (1862-64) and the Emperor Maximilian (1865); prizes at the Philadelphia Centennial Exhibition (1876), World's Fair of Chicago (1893), and a decoration from the Emperor of Austria.

May 11 - 29, 1960

THREE WOMEN PAINTERS OF COLOMBIA:
JUDITH MARQUEZ, CECILIA PORRAS, AND LUCY TEJADA

Technical competence, seriousness of purpose, and a continuing aesthetic tradition have, in general, been distinguishing features of the work of Colombian artists. Among them there had been no women until the last two decades. Although relative newcomers, the female practitioners who have appeared have maintained the high standards of quality in painting, sculpture, and the graphic arts, which their male counterparts had established in earlier years.

The current exhibition contains work by women from three different regions of Colombia, who have followed widely divergent paths of expression. All are artists of established reputation in their own country, but this is the first extensive presentation of the work of any of them in the United States.

Judith Márquez, born in Manizales in 1929, studied at the National University of Colombia in Bogotá and at the University of Tennessee in Knoxville. She has participated in group shows not only in her own country but in the Dominican Republic and Venezuela as well, winning several awards. Works by her have been shown at the Barcelona Biennial, 1955; the Mexico City Biennial, 1958; and the Venice Biennial, 1958. She has held individual exhibits in Bogotá in 1955 and 1957, in Medellín in 1956, and in Manizales in 1957.

Lucy Tejada, was born in Pereira in 1924. She studied in Bogotá at the National University and at the School of Fine Arts. Awarded prizes at a number of group shows, she has had individual exhibitions of her work in Bogotá in 1952, 1956, and 1958, and in Cali and Madrid in 1956. In private life she is the wife of the Colombian painter

Antonio Valencia, with whom she has traveled extensively in France, Italy, and Spain.

Cecilia Porras was born in Cartagena in 1920, but studied at the School of Fine Arts in Bogotá and is now a member of its faculty. Individual presentations of her work took place in Medellín, 1950; Cartagena, 1951; Barranquilla, 1952; and Bogotá, 1955 and 1956. She has participated in numerous group shows in Colombia since 1949, and works by her were included in the 1955 Barcelona Biennial and the 1956 *Gulf Caribbean Art Exhibition* presented at the Museum of Fine Arts, Houston. She has been the recipient of numerous awards at shows and in competitions in her own country.

CATALOGUE

Oils

Judith Márquez
 1. *Formas rítmicas (Rhythmic Forms) No. 1*, 1960
 2. *Horizontal azul-naranja (Blue-Orange Horizontal)*, 1959
 3. *Planos rítmicos (Rhythmic Planes)*, 1960
 4. *Planos en rojo (Planes in Red)*, 1960
 5. *Formas rítmicas (Rhythmic Forms) No. 2*, 1960
 6. De la serie *Paisajes tropicales No. 1* (From the Series *Tropical Landscapes No. 1)*, 1959
 7. De la serie *Paisajes tropicales* (From the Series *Tropical Landscapes) No. 2*, 1960
 8. *Contrapunto (Counterpoint) No. 1*, 1960
 9. *Contrapunto (Counterpoint) No. 2*, 1960
 10. *Horizontal rojo-gris (Red-Gray Horizontal)*, 1960

Lucy Tejada
 1. *Mujeres en el crepúsculo (Women in the Twilight)*, 1960, oil on canvas, 22 x 63"
 2. *Mujeres y la luna (Women and the Moon)*, 1960, oil on canvas, 22 x 63 1/2"
 3. *Coloquio (Colloquy)*, 1960, oil on canvas, 31 1/2 x 39"
 4. *La ventaja (The Advantage)*, 1959, oil on canvas, 21 1/2 x 29 1/2"
 5. *Bodegón de las semillas (Still Life with Seeds)*, 1959, oil on canvas, 21 1/2 x 29 1/2"
 6. *Mujer y naranja (Woman and Orange)*, 1960, oil on Bristol board, 24 x 24"
 7. *El vaso azul (The Blue Vase)*, oil on Bristol board, 24 x 24"
8-11. *Pájaro herido (Wounded Bird) No. 1, No. 2, No. 3, No. 4*, 1960, oil on Bristol board, 13 x 27"

Cecilia Porras
 1. *Paisaje para un niño (Landscape for a Child)*
 2. *Brujerías (Witchcraft)*
 3. *Isla Maparapa (Maparapa Island)*
 4. *Un tren para Mateo (A Train for Mateo)*
 5. *Estructura para un pájaro (Structure for a Bird)*
 6. *Viento sur (South Wind)*
 7. *Pájaro mecánico (Mechanical Bird)*
 8. *Child's Head*
 9. *Tren nocturno (Night Train)*

May 31 - June 14, 1960

SEVENTEEN PAINTERS OF ARGENTINA

As part of the commemoration of the 150th anniversary of the revolution which established Argentina as an

independent nation, the Museum of Modern Art of Buenos Aires, with the assistance of the Department of Cultural Relations of the Argentine Ministry of Foreign Affairs, has prepared a group show of Argentine paintings for circulation in the United States. This small but representative exhibition was organized by Mrs. Marta A. de Estrín as a cross section of artistic trends in recent decades. It includes works by men and women born at the turn of the century and by others in their twenties—forerunners of modern tendencies, such as Castagnino, Gómez Cornet, and Del Prete, and the most recent personalities to appear: Pucciarelli, Polesello, and Chab. All demonstrate that interest in moving toward unexplored fields which is one of the principal characteristics of art in Argentina today.

Appreciation is expressed to the Central Institute of Cultural Relations of Israel for Latin America, which has facilitated the presentation of this exhibition in the United States.

CATALOGUE

Oils

Carlos Alonso
 1. *Figure*

Luis Barragán
 2. *Landscape*
 3. *Dance Mood*

Juan Batlle Planas
 4. *Mother and Child*
 5. *Figura (Figure)*

Juan Carlos Castagnino
 6. *Guitar Player*
 7. *Motherhood*, drawing
 8. *Horses*, drawing

Luis Centurión
 9. *Birdcage*
10. *Still Life*

Víctor Chab
11. *Painting No. 5*
12. *Painting No. 8*

Vicente Forte
13. *Composition Nº 1*
14. *Composition Nº 2*

Ramón Gómez Cornet
15. *Child*
16.. *Maid*

Rómulo Macció
17. *Composition I*
18. *Composition II*

Martha Peluffo
19. *Tangle*
20. *Vertical*

Rogelio Polesello
21. *Concrete I*
22. *Concrete II*

Leopoldo Presas
23. *Mother and Child*
24. *Figures*

Mario Pucciarelli
25. *Abstraction Nº 2*
26. *Untitled*

Francisca Ramos de los Reyes
27. *Abstraction I*
28. *Abstraction II*

Raúl Soldi
29. *The Mother*
30. *Landscape with Car*

Roberto J. Viola
31. *Abstract I*
32. *Abstract II*

Juan Del Prete
33. *Abstraction II*
34. *Abstraction IV*

BIOGRAPHICAL NOTES[1]

ALONSO, Carlos. Painter, draftsman, printmaker, illustrator, born in Tunuyán, 1929. Studied painting at the Universidad Nacional de Cuyo with Ramón Gómez Cornet, and Universidad de Tucumán with Lino Spilimbergo. Traveled in Europe on a study tour sponsored by Galería Viau, 1954. Won the contest of Editorial Emecé, to illustrate the second part of *Don Quijote de la Mancha*, Buenos Aires, 1957—first part was illustrated by Dalí. Also illustrated *Martín Fierro* for the same publishing house, 1960, among many other publications. Held individual exhibitions in Buenos Aires, Madrid, Paris. Since 1952 has participated in many national and international group exhibitions, including the Second Inter-American Biennial, Mexico City, 1960.

BARRAGAN, Luis. Painter, born in Buenos Aires, 1914. Studied at the Escuela Superior de Bellas Artes. Traveled in the Patagonia in 1936 and visited Europe three times. Co-founder of the group *Orion* and *Grupo de los Veinte* (Twenty Painters and Sculptors), widely exhibited with both. Since 1943 has held individual exhibitions in Argentina. Since 1939 has participated in national and international shows, including India, 1953; the Biennial of São Paulo, 1953, 1954, and 1959; Biennial of Havana, 1954; Washington, D.C., 1956; Dallas, 1960; and Mexico City, 1958. Was awarded many prizes, including first and acquisition prizes in Buenos Aires, and First Prize, First

[1] Not included in the original catalogue. See Index of Artists for reference on those not listed here. —*Ed.*

Pan American Exhibition, Punta del Este (Uruguay), 1959.

BATLLE PLANAS, Juan. Painter, muralist, draftsman, printmaker, illustator, stage designer, born in Terrella de Montgri, Spain, 1911. Entered the Industrial School of Buenos Aires, 1924, dropping out shortly after. An expert in education and the Gestalt theory, has been the director of the Instituto de Investigaciones de la Forma, professor of psychology of form and color, and other related subjects; author of a test based on the reactions developed by geometrical shapes, and of several articles on the same subject. He also illustrated several poetry books and published some portfolios of his engravings; was the stage designer for plays by Jean Anouilh and Igor Stravinsky, among others; executed a number of murals in private and public buildings in Buenos Aires. Since 1934 has held about forty-five individual exhibitions in Argentina—including the Museo Nacional de Bellas Artes, Buenos Aires, 1959)—and in Montevideo, Asunción, Washington, D.C., and Rome. Participated in more than 240 national and international group shows. In 1960 the Academia Nacional de Bellas Artes awarded him with the Premio Palanza. Lives in Argentina since 1913.

CASTAGNINO, Juan Carlos. Painter, draftsman, muralist, illustrator, architect, born in Mar del Plata, 1908. Studied in Buenos Aires at the Escuela Superior de Bellas Artes with Carlos Ripamonte and Alfredo Torcelli, and under Lino Spilimbergo, Bernardo Victorica, and Ramón Gómez Cornet; and in Paris under an Argentine scholarship, 1938-39. Traveled in Europe, 1939, 1949, and 1952. In 1934 worked with David Alfaro Siqueiros on a mural in Buenos Aires, where he later executed others, as well as in Mar del Plata and in Uruguay. Illustrated several books. Exhibited in national and international group shows in Paris, Washington, D.C., Lima, Warsaw, San Francisco, Melbourne, Tokyo, Bucharest, Leningrad, Moscow, New York, and the Biennial of Mexico, 1960. Was awarded several prizes in Buenos Aires national salons, including First Prize for Painting, 1948; First Prize for Drawing, 1957; and the Grand Prize of Honor for Painting, 1959. Also won a Medal of Honor, International Exposition, Brussels, 1958.

CENTURION, Luis. Painter, draftsman, born in Entre Ríos, 1922. Studied in several private academies. Since 1940 has collaborated with several avant-garde groups. Member of *Grupo de los Veinte* (Twenty Painters and Sculptors), 1952-57. Traveled in South America. Since 1947 has held individual exhibitions in Buenos Aires. Participated in national salons and international group shows, including the São Paulo Biennial, 1957; *Pan American Exhibition*, Punta del Este (Uruguay), 1959; and in Argentine group shows in Lima, New York, San Francisco, Melbourne, Tokyo, among others.

GOMEZ CORNET, Ramón. Painter, draftsman, printmaker, born in Santiago del Estero, 1898. Studied at the Academia Provincial de Bellas Artes, Córdoba; Académie Ronsom, Paris; and Arts Studio, Barcelona (Spain). Lived and traveled in Europe, 1915-21, where he returned several times. Founded the Museo Provincial de Bellas Artes, Santiago del Estero. Since 1921 has held individual exhibitions in Buenos Aires and in New York (1942). Participated in national salons (1917-46) and group exhibitions abroad. Was awarded Silver Medal, International Exposition, Paris, 1937; Grand Acquisition Prize, National Salon, Buenos Aires, 1946; and First Prize, Salon of Santa Fe, 1950, among many other awards.

PELUFFO, Martha. Painter, born in Buenos Aires, 1931. Member of the groups *Siete Pintores Abstractos* (1957), and *Phases* (since 1958), has participated in all their exhibitions. Since 1952 has held individual exhibitions in Buenos Aires and Córdoba. Participated in Argentine group shows at the Museum of Modern Art in Montevideo, Mexico, and Rio de Janeiro; and in Tokyo, New York, and Panama. Was awarded prizes in Buenos Aires.

PRETE, Juan Del. Painter, sculptor, born in Vasto, Italy, 1897. Moved to Argentina in 1909, becoming an Argentine citizen, 1929. Attended for a short time the Academia Perugino and the Mutualidad de Estudiantes de Bellas Artes, Buenos Aires, but considers himself mainly a self-taught artist. Under a fellowship granted by the Friends of the Arts Association, lived in Paris in 1929-33, joining the groups of the *Surindépendants* (1931), and *Abstraction-Création-Art Non-Figuratif'* (1932). Participated in the exhibitions of both groups in Paris. Returned to Europe, 1953 and 1954. Since 1926 has held individual exhibitions in Buenos Aires, including the first non-

figurative exhibit in Argentina, 1933, and a retrospective at the Museo de Artes Plásticas, 1951; and in Montevideo, Paris, Genoa, Milan, and the São Paulo Museum of Art in 1953. Participated in numerous national and international shows such as the biennials of Venice (1952 and 1958), São Paulo (1953, 1957, and 1959—(special room) and Mexico (1958); *Pan American Exposition*, Punta del Este (Uruguay), 1959. Won numerous awards in national salons and international shows, including Gold Medal, International Exposition, Paris, 1937; Premio Palanza, granted by the Academia Nacional de Bellas Artes, Buenos Aires, 1958; Grand Prize for Foreign Artists, International Exposition, Brussels, 1958.

RAMOS DE LOS REYES, Francisca. Painter, draftsman, printmaker, born in Buenos Aires, 1925, where she studied at the Escuela Superior de Bellas Artes in 1947-50, and attended courses of mural painting in 1951. Traveled in Europe, 1952-53, visiting Italy, France, and Spain. Lived and worked for six months in Barcelona (Spain). Since 1954 has held individual exhibitions in Buenos Aires. Participated in group exhibitions in Barcelona; Pan American Exposition in Pôrto Alegre (1958), and Punta del Este and New York (1959); Argentine group shows in New York, Washington, D.C., Panama, and Caracas. Was awarded a prize in Barcelona, 1954.

SOLDI, Raúl. Painter, muralist, draftsman, printmaker, illustrator, movie and theatre set designer, born in Buenos Aires, 1905. Studied at the Academia Nacional de Bellas Artes of Buenos Aires and at the Brera Royal Academy of Milan. Traveled in Europe, 1921-33, living and working in Germany and Italy, where he was a member of the groups *Avanguardia Artistica* and *Il Milione* in Milan. Under a fellowship of the Comisión Nacional de Cultura remained two years in the United States studying set design, and for many years was a set designer for Argentina Sono Film and the Teatro Colón; illustrated, *Veinte poemas de amor y una canción desesperada* by Pablo Neruada, among others; executed murals in Buenos Aires. Since 1934 has held individual exhibitions in Argentina and abroad, including Paris. Participated in national and international group shows, including the First Quadrennial, Rome, 1931; International Engraving Exhibition, Florence, 1932; at the Museum of Modern Art, New York, 1943; the Biennial of São Paulo, 1957; and the Inter-American Biennial of Mexico City (special room), 1960. Won numerous first prizes in Argentina, including the Premio Palanza, awarded by the Academia Nacional de Bellas Artes, 1952. His international prizes include First Prize, Trieste, 1931; and gold medals at International Exposition of Paris (1937), and Golden Gate International Exposition, San Francisco (1940).

June 15 - July 10, 1960

ANTONIO TORIBIO OF THE DOMINICAN REPUBLIC: SCULPTURE

An outstanding personality in the movement toward new modes of expression which has developed in the art of the Dominican Republic over the last twelve years is that of Antonio Toribio, the first sculptor to take the path of abstraction. Working principally in iron and wood, he has given to his compositions a tropically baroque character.

Toribio was born in Villa Trinitaria, Dominican Republic, in 1931. He studied at the National School of Fine Arts in the capital and graduated in 1949. In 1954 and 1955 he executed a variety of works for the Fair of Peace and Progress held in Ciudad Trujillo. Between 1951 and 1959 he held five one-man shows in his native country and participated in a number of group exhibitions, winning awards at several of them. Since his coming to the United States in 1959, he has taken part in various group presentations and he recently held a very successful individual show at the Fulton Gallery in New York.

Commenting on that exhibit, Bennett Schiff, the critic of the *New York Post*, wrote:

> Toribio, who carves in wood and welds in iron, is one of the cleanest and most refreshing sculptors to have come along in some time. Throughout his work there is a consistency of precise, disciplined and ordered thinking, a subtle regard for organic construction, although his work is

abstract, and a handling of his materials that is entirely admirable.

The magazine *Art News*, reviewing the same show, declared:

> He works with assurance in bas-reliefs and standing forms of mahogany, the surfaces of which are as elegantly chaste as their contrapuntal relationships are held in poise.

CATALOGUE

Sculpture

1. *Figure*, wood, 1958
2. *Head*, wood, 1958
3. *Figure*, wood, 1958
4. *Animal*, iron, 1959
5. *Head*, iron, 1959
6. *Figure*, iron, 1959
7. *Fish*, iron, 1959
8. *Figure*, iron, 1959
9. *Figure*, iron, 1959
10. *Relief*, wood, 1958

Drawings (all executed in 1960)

1. *Detalle (Detail)*, plamoink, 48 x 48"
2. *Elementos (Elements)*, plamoink, 48 x 48"
3. *Composición (Composition)*, plamoink, 48 x 48"
4. *Figura (Figure)*, plamoink, 48 x 48"
5. *Detalle (Detail)*, gouache and ink, 35 x 35"
6. *Composición (Composition)*, gouache and ink, 35 x 35"
7. *Figuras (Figures)*, gouache and ink, 35 x 35"
8. *Cabezas (Heads)*, gouache and ink, 35 x 35"
9-12. *Proyecto (Project)*, ink, 20 x 16"

June 21 - July 10, 1960

3,000 YEARS OF COLOMBIAN ART[1]

Press Release No. 53060, Pan American Union, Washington, D.C., June 13, 1960. The Pan American Union's Hall of the Americas is being converted into a giant art gallery for displaying the most complete collection of art ever

[1] This exhibition consisted of more than 500 pre-Columbian and colonial objects as well as contemporary works selected from the exhibit *3,500 Years of Colombian Art*, previously shown at the Lowe Art Museum, Coral Gables, Florida, under the sponsorship of the International Petroleum Corporation of Colombia (INTERCOL). For that event an illustrated book, *Arte colombiano*, was published with texts by Luis Alberto Acuña, Graciliano Arcila Vélez, Enzo Carli, Luis Duque Gómez, Casimiro Eiger, Walter Engel, Gregorio Hernández de Alba, Edith Jiménez Muñoz, Gerardo Reichel-Dolmatoff, and Marta Traba. No catalogue for this exhibition at the Pan American Union is available. The exhibition list given here is based on the Pan American Union Press Release No. 53060 of June 13, 1969 and other references consulted. It includes only the contemporary works exhibited and may contain involuntary errors and omissions. In 1962, with some minor changes, this exhibit was circulated in Europe. —*Ed.*

to reach this country from South America. Titled *3,000 Years of Colombian Art*, the collection literally encompasses the art history of Colombia from pre-historic times to the present.

Hundreds of art objects, many of them vividly colored ceramics, have been gathered from some ten major Indian civilizations which flourished and disappeared before the coming of the Spaniards. Perhaps the most striking and original of these were produced by the Quimbayas peoples, including single and double bowls on which painted or sculptured animal figures are decorated in black, red, and white.

The pre-Columbian ceramists of the Pacific coast culture of Tumaco were also masters of naturalistic human and animal forms. They molded small clay caricature figures, or expressions of magic ideas, and exaltations of motherhood. This culture reveals a mastery of flat surfaces, figure distortion, and movement.

Among the other cultures represented in the collection are the Chibchas peoples of the highlands, who produced remarkable ceremonial effigy urns; the San Agustín culture of southern Colombia, notable for large-size statuary; and the nearby culture of Tierradentro, renowned for its ornamented caves and statuary carved from rock.

Work in gold and other precious metals reached a high perfection among several pre-Hispanic groups. These peoples were masters in handling alloys, working in gold leaf, and casting by the "lost wax" process. On view at the exhibit will be gold nose rings, crowns, pendants, and masks in hammered designs. Heavier cast gold objects have also been found in the Quimbayas area, while work in filigree and gold thread come from the Chibchas zone.

More than a year was required to collect these rare pieces of pre-Columbian art from every part of Colombia.

A large section of the Pan American Union's forthcoming exhibit will be devoted to colonial statuary, painting, furniture, and work in gold and silver.

Some twenty contemporary Colombian painters and sculptors are represented in the exhibit. Colombia's modern art movement began in the second decade of this century and was strongly influenced by Mexican mural painting. Included are: Gómez Jaramillo, Gonzalo Ariza, Alipio Jaramillo, Luis Alberto Acuña, Pedro Nel Gómez, Marco Ospina, Alejandro Obregón (generally regarded as Colombia's foremost modern painter), Eduardo Ramírez Villamizar, Guillermo Wiedemann, and Fernando Botero.

Other Colombian painters included in the exhibit are Enrique Grau, Armando Villegas, Lucy Tejada, Cecilia Porras, Judith Márquez, and others.

EXHIBITION LIST

Contemporary Painters and Sculptors

Luis Alberto Acuña
 1. *Retrato de la esposa del artista (Portrait of the Artist's Wife)*, 1929, oil on wood, 88 x 65 cm.
 2. *Tañedor de flauta (Flute Player)*, 1947, oil on wood, 50 x 35 cm.
 3. *La tribu fantasma (The Ghost Tribe)*, 1957, 90 x 70 cm.

Alberto Arboleda[1]

Gonzalo Ariza
 1. *Amanecer (Dawn)*, 5'10" x 2'4"

[1] Titles of the works exhibited are unavailable. —*Ed.*

 2. *Bogotá*, 5" x 2'4"
 3. *Mañana temprano (Early Tomorrow)*, 5'10" x 4'8"

Fernando Botero
 1. *Mona Lisa de doce años (Mona Lisa at the Age of Twelve)*, oil, 197 x 211 cm.
 2. *La tarde (The Afternoon)*, oil, 175 x 130 cm.
 3. *Bodegón en rojo y azul (Still Life in Red and Blue)*, 129 x 185 cm.

Ignacio Gómez Jaramillo
 1. *La mesa de los niños (The Children's Table)*, 1959, oil, 3'1" x 1'1/2"
 2. *Cosas simples (Simple Things)*, 1957, 2'1" x 2'8"
 3. *Objetivos fragmentados (Fragmented Objectives)*, 1957, oil, 2'1" x 2'8"

Enrique Grau
 1. *Mujer con sombrero (Woman with Hat)*, 1960, oil, 3'4" x 2'10"
 2. *Tres mujeres (Three Women)*, 1955, oil, 3'4" x 3'10"
 3. *Muchacho con máscara (Boy with Mask)*, 1960, oil, 5'5" x 2'6"

Alipio Jaramillo Giraldo
 1. *Lavadoras (Washerwomen)*, oil, 90 x 120 cm.
 2. *El platanal (Banana Plantation)*, oil, 90 x 120 cm.
 3. *La cosecha (The Harvest)*, oil, 90 x 120 cm.

Luciano Jaramillo
 1. *Naturaleza muerta (Still Life)*, oil

Judith Márquez
 1. *Horizontal amarillo (Horizontal Yellow)*, 1959, oil, 1'10" x 6'
 2. De la serie *Paisajes, montañas y arboles* (From the Series *Landscapes, Mountains and Trees)*, 1960, oil,
 2'7" x 4'9"

Alfonso Mateus[1]

Edgar Negret[1]

Alejandro Obregón
 1. *Cotopaxi*, oil on canvas, 4'4" x 5'6"
 2. *Nacimiento de los Andes (Birth of the Andes)*, oil on canvas, 4'4" x 5'6"

Pedro Nel Gómez
1-2. *Watercolors*
3-5. *Cardboards for a Fresco*

Marco Ospina[1]

Roberto Pizano
1-2. Oils[1]

[1] Titles of the works exhibited are unavailable. —*Ed.*

Cecilia Porras
 1. *Monte rojo (Red Woods)*, oil on canvas, 53 x 38"
 2. *Ciudad antigua (Ancient City)*, oil on canvas, 53 x 31"
 3. *Juguete (Toy)*, oil on canvas, 40 x 32"

Eduardo Ramírez Villamizar
 1. *Figura abstracta (Abstract Figure)*, oil

Juan Antonio Roda
 1. *Baltazar (Baltasar) No. 1*, 1959, oil, 4'4" x 2'10"
 2. *Baltazar (Baltasar) No. 2*, 1959, oil, 4'4" x 2'10"
 3. *Enero (January)*, 1960, oil, 4'4" x 2'
 4. *Familia de pescadores (A Family of Fishermen)*, 1957, oil and tempera on cardboard, 2'5" x 3'5"

Héctor Rojas Herazo
 1. *Nocturno de carnaval (Carnival Nocturne)*, 4'9" x 3'4"
 2. *Bestia mitológica azuzada por un duende de maíz (Mythological Beast Instigated by a Corn Elf)*, 4'9" x 3'1"
 3. *Espantapájaros imprecando a la lluvia (Scarecrow Imprecating the Rain)*, 3'11" x 4'8"

Otto Sabogal
 1. *Figuras (Figures)*, cement, 3'8" x 2'2" x 1'9"

Andrés de Santamaría
 1. *Gallardías (Gallantry)*, 60 x 50 cm. Coll. Mrs. Sofía Urrutia
 2. *Retrato de campesina belga (Portrait of a Belgium Peasant Woman)*, 74 x 61 cm. Coll. Mrs. Elvira de Nieto

Lucy Tejada
1-3. Oils[1]

Armando Villegas
 1. *Azul violeta verdeluz (Blue-Violet-Green)*, 1958, oil, 4'2" x 3'7"
 2. *Superficies en blanco (White Areas) No. 2*, 1959, oil, 4'2" x 3'7"
 3. *Retrato de la esposa del pintor (Portrait of the Painter's Wife)*, 1959, oil, 1'8" x 4'3"

Guillermo Wiedemann
 1. *Dos mujeres (Two Women)*, 1955, oil, 2'3" x 3'3"
 2. *Mujer en el mercado (Woman in the Market)*, 1958, oil, 2'7" x 3'3"
 3. *Formas (Forms)*, 1959, oil, 2'7" x 3'3"
 4. *Fantasía (Fantasy)*, 1959, oil, 2'2" x 2'8"

BIOGRAPHICAL NOTES[1]

ARBOLEDA, Alberto. Sculptor, ceramist, born in Popayán, 1926. Studied at the Escuela de Cerámica, Universidad del Cauca, 1943-45; and with Edgar Negret and Jorge de Oteiza. Traveled in Europe and lived in Paris and Denmark. Since 1947 has held individual exhibitions in Bogotá and Rome. Participated in the First Caribbean Biennial in 1956, among other national and international group shows.

ARIZA, Gonzalo. Painter, draftsman, printmaker, art critic, born in Bogotá, 1912. Studied at the Escuela de Bellas

[1] See Index of Artists for reference on those not listed here. —*Ed.*

Artes, Bogotá; at the Koto Kogei Gakko, Tokyo, on a Japanese government fellowship, 1936-37, and under the Japanese artists Maeda and Foujita. Lived in Japan as Secretary to the Colombian Embassy, Tokyo, 1955-57. Illustrated several books; translated into Spanish the book *Japanese Popular Art* by Soetsu Yanagi, 1936-37; wrote and published several articles and essays on Colombian art. Since 1940 has held individual exhibitions in Bogotá and Tokyo and participated in many national salons, where he was awarded a prize, 1946. Also participated in the First Hispanic American Biennial, Madrid, 1951.

JARAMILLO, Alipio. Painter, muralist, draftsman, printmaker, born in Manizales, Colombia, 1913. Studied at the Escuela de Bellas Artes, Bogotá, 1937-40. Traveled in South America and lived in Chile, 1941-43, where he worked under David Alfaro Siqueiros at the mural in Chillán (1941), and painted other murals there and in Santiago de Chile, including the fourteen murals at the Ministry of Education. In 1944 executed with Alfredo Guido two murals at the Escuela de Bellas Artes, Buenos Aires. Returned to Bogotá in 1946. At present lives in Manizales where he teaches at the Escuela de Bellas Artes. Held individual exhibitions in Bogotá and Rio de Janeiro. Since 1939 has participated in national salons and other group exhibitions in Colombia. Won several prizes in Bogotá and Santiago de Chile.

NEL GOMEZ, Pedro. Painter, muralist, born in Anorí, Colombia, 1899. Studied drawing and painting in Medellín, 1912-20, where he also studied civil engineering and architecture at the Escuela Nacional de Minas, graduating many years later (1939). Lived in Florence where he also studied architecture at the Architecture Academy, and painting with Felice Careno and Charamonti, 1925-30. Was the director of the Institute of Fine Arts; founder and dean of the School of Architecture at the National School of Minas, Medellín, 1957. Executed numerous murals in Bogotá, Medellín, and Antioquia, including the ten monumental frescos at the Palacio Municipal in Medellín, covering 300 square meters, 1934-39. Since 1924 has held individual exhibitions in Bogotá, Medellín, and Caracas. Participated in national salons and other group exhibitions in Colombia and abroad, including the International Exposition, Florence, 1928. Won several prizes in Colombia.

OSPINA, Marco. Painter, muralist, born in Bogotá, 1912. Studied at the Escuela de Bellas Artes, Bogotá, 1930-40. Professor of theory of art at the Escuela de Bellas Artes (1945-64), and of drawing at the University of Bogotá (1956-58). Executed murals in the Iglesia de Fátima, Bogotá, 1954. Held individual exhibitions in Colombia. Participated in national and international group exhibitions, including the Third Hispanic American Biennial, Barcelona (Spain), 1955. Was awarded several prizes in Colombia.

PIZANO, Roberto. Painter, born in Bogotá, 1896. Died in Usaquén, 1929. Studied drawing at the Escuela de Bellas Artes, Bogotá; Academia de San Fernando, Madrid, 1917-20, with Joaquín Sorolla, José Moreno Carbonero, Luis Menéndez Pidal and others; with Fernando Alvarez de Sotomayor, Madrid, 1923; in several studios and academies, Paris, 1923. Traveled in Spain, France, and Italy in 1920 and 1923, and in England and northern Europe in 1927. In Bogotá he was appointed professor (1921) and director (1927) at the Escuela de Bellas Artes, where he founded the Museum of Art Reproductions. Published a book on the Colombian painter *Gregorio Vásquez Arce y Ceballos*, Paris, 1926. Since 1923 has exhibited at the Salon des Indépendants of Paris and other group exhibitions in France and Colombia. Was awarded several prizes, including Honor Diploma, International Exposition, Bordeaux (France), 1927.

RODA, Juan Antonio. Painter, muralist, draftsman, graphic artist, born in Valencia, Spain, 1921. Studied painting at the Escuela de Artes y Oficios and Escuela Massona, with José Obiola, Barcelona (Spain); Ecole des Beaux-Arts, Paris, 1950, under a French scholarship. Lived in Paris, 1950-55. Since 1959 has been a professor of drawing at the School of Architecture of the National University, and director of the Fine Arts School of the University of the Andes, Bogotá. Since 1946 has held individual exhibitions in Barcelona (Spain), Paris, Bogotá, and New York. Participated in national salons and international group exhibitions, including at the Museum of Modern Art, The Hague, 1952; Second Hispanic American Biennial of Art, Havana, 1954. Won several awards, including First Prize, *Artistas Españoles Residentes en París*, Paris, 1954; Hispanic American Biennial, Barcelona (Spain), 1955. Has lived in Bogotá since 1955.

ROJAS, Héctor. Painter, poet, writer, born in Tolú, 1921. Self-taught as an artist. Published several poetry books in Colombia. Since 1947 has held individual exhibitions in Bogotá.

SABOGAL, Otto. Sculptor, born in Calarcá, 1935. Studied at the Escuela de Bellas Artes, Bogotá, 1956-59. Participated in national and international exhibitions, including the First Paris Biennial of Young Artists, 1959.

SANTAMARIA, Andrés de. Painter, born in Bogotá, 1860. Died in Brussels, 1945. Went to England at the age of two and studied at the Ecole des Beaux-Arts in Paris under the direction of Ferdinand Humbert and Henri Gervex. Lived in Bogotá, 1893-97 and 1904-11, when he was the dean of the Escuela de Bellas Artes, professor of painting and sculpture, and founder of the Escuela Profesional de Artes Decorativas e Industriales. lived in Brussels since 1900. Exhibited in Bogotá, Brussels, Paris, London.

July 12 - 31, 1960

MARCELO GRASSMANN OF BRAZIL: DRAWINGS AND PRINTS

Drawing and engraving are practiced in Brazil as ends in themselves, rather than as preparatory steps toward painting. A high degree of maturity has been achieved in both, with the result that Brazilians have won important awards in these media in a number of international competitions. An outstanding figure among these artists who have renounced color, preferring the pen and the burin to the brush, is that of Marcelo Grassmann.

Grassmann's creations closely resemble the fantasies conceived by sixteenth-century Flemish artists. His is a world of hallucination and strife, peopled by witches, warriors, and strange beasts, depicted with fluid lines in a highly individual style marked by exuberant tropical imagination. His dream realm does not show the literary influences characterizing the works of the surrealists, but displays rather a purely plastic power of invention.

Grassmann was born in São Paulo, Brazil, in 1925. He holds that he is self-taught. At the First National Salon of Modern Art, Rio de Janeiro, 1954-1955, he won as a prize a trip to Europe. In the national category at the São Paulo Biennial he received the First Prize for Engraving in 1954 and the First Prize for Drawing in 1959. He obtained the Drawing Award at the First Paris Biennial, 1959, and a Special Prize for Sacred Art at the Venice Biennial of 1958. Examples of his work are to be found in the Museum of Modern Art of Rio de Janeiro, São Paulo, and Buenos Aires; in the Dallas Museum of Fine Arts; at the Pan American Union; and in many private collections in Brazil, France, and the United States.

Grassmann has spent the last few months in Europe, as a result of the award he received at the Paris Biennial, traveling in France, Italy, and Switzerland. In May of this year he held an extensive one-man show at the San Fedele Cultural Center in Milan. The current exhibit at the Pan American Union is the first individual presentation of his work in the United States.

CATALOGUE

Drawings

1. *Mermaid I*
2. *The Anatomist*
3. *The Performers*
4. *Parasites*
5. *Mermaid II*
6. *The Rider I*

7. *Promenade*
8. *Don Quixote*
9. *Dancers*
10. *Fishers*
11. *Astronomer*
12. *Cats I*
13. *The Great Ball*
14. *Luncheon*
15. *Fish Eater*
16. *The Knight*
17. *Gargoyle*
18. *Cats II*
19. *Struggle of Monsters*
20. *St. George*
21. *Don Quixote and Sancho*
22. *The Rider II*
23. *Midwife*
24. *Bureaucrat*
25. *Dead Animal*
26. *Childbirth*
27. *The Lovers*
28. *Fisher*

Lithographs

29. *Harpies I*
30. *Harpies II*
31. *Menagerie*
32. *The Dead One*
33. *Animals*

Woodcuts

34. *The Fight*
35. *Pageant*

August 1 - 22, 1960

MARCELO BONEVARDI AND FERNANDO MAZA OF ARGENTINA: PAINTINGS

This exhibition comprises the work of two Argentine artists who belong to the new generation which is engaged in non-objective art. Both are presently in the United States under scholarships: Marcelo Bonevardi, on a grant from the John Simon Guggenheim Memorial Foundation, and Fernando Maza, a holder of an Organization of American States fellowship. They are both studying and working in New York. All the works being shown at the Pan American Union were produced in that city as a result of the artists' reaction to the prevalent directions of art in the United States today.

Marcelo Bonevardi was born in Buenos Aires in 1929 and, although he studied architecture at the National University of Córdoba in Argentina, he considers himself a self-taught painter. He first received a scholarship from

the Guggenheim Memorial Foundation in 1958, and this grant was renewed in 1960. Bonevardi has participated in group shows in Argentina and the United States, winning several prizes. He has held one-man shows in the Antígona Gallery, Buenos Aires, 1957; the O Gallery, Buenos Aires, 1956; the Gallery 4, Detroit, 1959; and the Radio Nacional de Córdoba, 1958. His work is represented in the Ministry of Public Works in Buenos Aires, the Kaiser Industry Gallery in Córdoba, and several museums in his native country.

Fernando Maza was born in Buenos Aires in 1936. He considers himself self-taught. He has participated in several group shows in his country and won a number of awards. His first one-man show was held in the Rubbers Gallery, Buenos Aires, 1959. This year his works were presented individually in the Latow Gallery in New York. Maza is represented in the collection of the Museum of Modern Art in Buenos Aires.

This is the first presentation of either artist's work in the Washington area.

CATALOGUE

Oils

Marcelo Bonevardi

1. *Painting 22*, 1959
2. *Painting 24*, 1959
3. *Painting 26*, 1959
4. *Painting 31*, 1959
5. *Painting 32*, 1959
6. *Painting 33*, 1959
7. *Painting 36*, 1959
8. *Painting 41*, 1960
9. *Painting 46*, 1960
10. *Painting A*, 1960
11. *Painting B*, 1960
12. *Painting C*, 1960
13. *Painting D*, 1960
14. *Painting E*, 1960

Fernando Maza

Oils, 1960

1. *Painting Elusive*
2. *Composition*
3. *Cry*
4. *Message*
5. *Infinitude*
6. *No Turn*
7. *God's Command*
8. *Cryptic Orders*
9. *No Man Lands*
10. *Return from the Void*
11. *Fall into Hope*

Prints[1]

[1] Titles are unavailable. —*Ed*.

August 25 - September 13, 1960

VIRGINIA DE VERA OF CHILE: PAINTINGS

Virginia de Vera, who was born in Santiago, Chile, in 1930, belongs to the younger generation of Chilean artists who have followed the abstract trend. In 1951 she studied art for one term at the Catholic University of Chile. From 1952 to 1955 she was enrolled in the School of Fine Arts of the National University and later studied with the well-known Chilean painter Nemesio Antúnez in the School of Applied Arts.

Although Vera has been absent from Chile for some time, she has demonstrated a sincere interest in continuing her art studies and activities. On coming to the United States in 1956, she studied at the University of Utah. Married to a Chilean physician in residence in a Canadian hospital, she has been active in the art centers of Montreal during the last two years. She held one-man shows at the University of Montreal and at the Museum of Fine Arts in 1958 and 1960, respectively. She has also had solo shows at the Municipal Library in Salt Lake City in 1957, and at the Sudamericana Gallery in New York, 1959.

This is the first presentation of Virginia de Vera's work in the Washington area.

CATALOGUE

Oils

 1-8. *The Way of the Cross*
9-11. *Parabolic Rhythms*

Caseins

12. *Duo for Flute and Violin*
13. *Bird of Night*
14. *Solid Smoke*
15. *Ballerina*
16. *Water Bird*
17. *Wooden Bird*
18. *Sea Flower*
19. *Lute Player*
20. *South American Madonna*
21. *Variation No. 1*

September 15 - October 5, 1960

GEORGES LIAUTAUD OF HAITI: SCULPTURES

The artistic heritage of America incorporates not only aboriginal and European strains, but also an important legacy from Africa. In areas in which the Negro population is of significant proportions, the art resulting from the fusion of the African with either or both of the other ethnic elements is a hybrid product marked by flavor, rhythm, and a strong feeling for color.

The work of Georges Liautaud is a specific example of the incorporation of African forms into the artistic expression of our hemisphere. Unlike the compositions produced in Paris at the turn of the century, when motifs

from African sculpture were grafted onto modern painting, Liautaud's creations bear no mark of French intellectualism. They are, rather, a direct transplanting of Africa into America. Although sometimes regarded as a craftsman in the folk tradition, Liautaud should be considered a serious artist, whose work compares favorably with that of a number of recognized sophisticates.

Liautaud was born in 1899 in the town of Croix-des-Bouquets, Haiti, and it was there that he received his primary education and studied mechanics. Later he took up the blacksmith's craft and, over the years, he hammered out at his forge agricultural implements, branding irons, and crosses for the cemetery of his native village. In his hands, the crosses became genuine works of art, combining, in a curious example of religious syncretism, the Christian symbol with motifs characteristic of voodoo rites. In 1953 one of these crosses came to the attention of DeWitt Peters, the founder and director of the Centre d'Art in Port-au-Prince, who invited Liautaud to create works of purely artistic significance. In his compositions Liautaud makes use of iron (generally from empty gasoline drums) and, occasionally, tin sheets. He cuts, grates, or perforates the pieces, combining them to form flat, two-dimensional creatures of fancy—strange beasts, mermaids, and the like. When, however, he turns to three-dimensional sculpture, the subject matter is generally Catholic.

In 1955 the chief of the Visual Arts Division of the Pan American Union was introduced to the work of Liautaud and invited the artist to participate in the *Gulf Caribbean Art Exhibition*, which was being prepared for presentation at the Museum of Fine Arts, Houston. In 1958, at his suggestion, Liautaud was asked to participate in the Carnegie International at Pittsburgh, contributing a *Crucifixion* recognized as being of great artistic significance. In 1959 sculpture of Liautaud was presented in the Pan American Union section of the Fifth Biennial in São Paulo.

The first public display of Liautaud's work in the United States occurred this year at the Nessler Gallery in New York. The current exhibition is composed largely of the works shown in New York and at the São Paulo Biennial, and includes loans from private collectors in the United States. This is the first presentation of Liautaud's sculpture in the Washington area.

CATALOGUE

Iron Sculpture

1. *Volupia*
2. *Sirène (Mermaid)* I
3. *Mask*
4. *Young Girl*
5. *Bird*
6. *Personage.* Coll. Mr. James E. Scott, Washington, D.C.
7. *Crucifixion.* Coll. Pan American Union
8. *Animal*
9. *Three Snakes*
10. *Lamentation.* Coll. Reverend R.C. Hunsicker, New York
11. *Deity.* Coll. Mrs. José Y. Bermúdez, Oakton, Virginia
12. *Sirène (Mermaid) II.* Private collection, Washington, D.C.
13. *Ungan.* Coll. Mr. H. Marc Moyens, Alexandria, Virginia
14. *Croix (Cross)*
15. *Sirène (Mermaid) III*
16. *Bird Woman with Three Heads*[1]
17. *Woman with Three Heads*[1]

[1] Also exhibited but not included in the original catalogue. —*Ed.*

18. Pair of Vendors[1]
19. *Devil*[1]
20. *Six Women*[1]
21. *Crucifixion*[1]
22. *Adam and Eve*[1]

October 2 - 24, 1960

RICARDO GRAU OF PERU: OILS[2]

Among Peruvian painters, Ricardo Grau is unusual in having evidenced close ties with European tradition ever since the beginning of his artistic career, although the brilliance of his palette at times suggests the colors used by the Indians of his country in their dress and objects of daily use. He was born in Bordeaux, France, in 1908, of Peruvian parents; he attended schools in Belgium, and from 1924 to 1936 he studied in Paris, where he was a pupil of Othon Friesz, André Favory, André Lhote, and Fernand Léger. Since 1940 he has taught at the National School of Fine Arts in Lima, and from his workshop have come several promising young Peruvian painters.

Grau exhibited in a number of French salons between 1930 and 1937, and he has held one-man shows in Brussels, Paris, and Lima. The one presented in 1959 at the Institute of Contemporary Art in the last mentioned city was particularly successful, and it is from that show that most of the works here exhibited were taken. Last year, moreover, Grau participated in the Fifth São Paulo Biennial and in the Dallas Museum of Fine Arts exhibition *South American Art Today*. Examples of his work have figured in group shows throughout the Americas.

This is Grau's first individual appearance in the United States.

CATALOGUE

Oils

1. *Composition No. 1*
2. *Composition No. 2*
3. *Painting No. 1*
4. *Painting No. 2*
5. *Painting No. 3*
6. *Composition No. 3*
7. *Composition No. 4*
8. *Composition No. 5*
9. *Composition No. 6*
10. *Painting No. 4*
11. *Painting No. 5*

[1] Also exhibited but not included in the original catalogue. *—Ed.*

[2] This exhibition was cancelled. *—Ed.*

October 24 - November 13, 1960

MARIO PUCCIARELLI OF ARGENTINA: OILS

Abstract art is by no means a novelty in Argentina. As early as 1913 Emilio Pettoruti began experimenting in that direction; and, if the artists who came to maturity between the two world wars followed the line of figurative expressionism, the generation which emerged at the conclusion of the second conflict took up a sharply geometric non-objective trend.

As a reaction to the rigidity of this tendency, there has recently developed among a group of younger artists the international movement called informalism, which abhors strict technical canons and allows the elements in the picture to flow in free forms throughout the canvas and beyond, in an open form of composition which rejects even the limitations of a frame. The medium used is generally a thick impasto of sand, asphalt, cement, or, occasionally, other materials, employed to provide tactile appeal. The color is often indefinite; the tendency is to the somberly neutral, the dexterity of the artist being demonstrated by the use of different tones in subtle modulations and nuances.

This rather general description of informalism can specifically be applied to the work of Mario Pucciarelli, who stands out as the somewhat theoretical leader of the movement in Argentina. A self-taught artist, born in Buenos Aires in 1928, Pucciarelli took up painting some years ago but did not gain recognition until 1957, when he received an important prize at the Salon of Engravers and Watercolor Artists. In the brief span of years since, he has accumulated half a dozen other major awards, the most recent of them resulting from a competition organized by the Torcuato Di Tella Foundation of Buenos Aires, in which the noted Italian critic Lionello Venturi served as judge.

Pucciarelli has taken part in group shows in Montevideo, Buenos Aires, New York, Rome, Tokyo, and Paris, and participated in the Dallas Museum of Fine Arts' exhibition *South American Art Today*. His first one-man show took place in Buenos Aires at the Galatea Gallery in 1958; this was followed by one at the Pizarro Gallery, 1959, likewise in the Argentine capital, and by one at the Zaffaroni Gallery in Montevideo in 1959. This exhibition, sponsored by the Cultural Department of the Argentine Ministry of Education, is his first individual presentation in the United States.

CATALOGUE

Oils

1. *Variedad serial (Variation of Textures)*, 1957
2. *Male and Female*, 1957
3. *Exaltación textural (Exaltation of Texture)*, 1957
4. *Estructura sensible (Sensible Structure)*, 1957
5. *Serie anímica (Subjective Series)*, 1958
6. *Contrapunto en la serie (Counterpoint)*, 1958
7. *On a Lavender Ground*, 1958. Coll. Mr. James E. Scott, Washington, D.C.
8. *Serie sensible (Sensible Sequence)*, 1958
9. *Expresión sensible (Sensorial Expression)*, 1959
10. *Phenomenal Development*, 1959
11. *Acontecimiento en el espacio (Incident in Space)*, 1960
12. *Sensación de la voluntad compositiva (Perception of the Will of Composition)*, 1960
13. *Actividad sensible (Dynamic Touch)*, 1960
14. *Aleph*, 1960
15. *Mediator Dei*, 1960

16. *Lanier Place*, 1960
17. *Tierra del Fuego*, 1960
18. *Composition*, 1960[1]
19. *Díptico (Diptych)*, 1960[1]

November 16 - December 6, 1960

JAN SCHREUDER OF ECUADOR: COLLAGES

In this exhibition Jan Schreuder, founder and, for more than seven years, director of the Ecuadorian Art Center, demonstrates his latest experiments in the plastic arts. After strict and disciplined training in painting, he has set out on a new path, seeking new horizons, new effects, new appeals to touch as well as sight, through the juxtaposition of such varied materials as cloth, bark, and sand with oils. Unlike that of most of the followers of this trend, Schreuder's use of color shows subtle tonal interplay.

An Ecuadorian citizen, Schreuder was born in The Hague, Netherlands, in 1904, and attended the Academy of Fine Arts in that city. Deeply interested in the art of the Americas, he spent several years in Venezuela and later visited Guatemala, where he became fascinated with pre-Columbian art. In 1938 he went to Ecuador, where, except for occasional trips to Europe and the United States, he has since remained. He has held one-man shows in The Hague, Stockholm, Paris, Guatemala City, Quito, New York, and San Francisco, and in other United States cities, and his works have been included in such group shows as the Carnegie International of 1952 and the São Paulo Biennial of 1957. This is the first showing of Mr. Schreuder's works in Washington.

Through the Art Center in Quito, Schreuder has directed numerous projects for the Ecuadorian government and for the United Nations; his promotion of the use of native designs in tapestry and carpet-making merits special mention. He has also given art instruction to Ecuadorian children and peasants, some of whose works, including murals, have been shown at the United Nations headquarters in New York City, and in several other countries.

CATALOGUE[2]

1-13. Oil and collage in different materials, 1960
 14. Construction in metal, 1960

December 9, 1960 - January 8, 1961

SCULPTURES BY NOEMI GERSTEIN
AND PAINTINGS BY FRANCO DI SEGNI OF ARGENTINA

Resuming a practice of occasionally presenting jointly artists who are in private life husband and wife, the Pan American Union is pleased to introduce at this time to the Washington public the Argentine couple, Noemí Gerstein and Franco Di Segni.

[1] Also exhibited but not included in the original catalogue. —*Ed*.

[2] Titles are unavailable. —*Ed*.

Noemi Gerstein was born in Buenos Aires in 1910. After studying at a number of private workshops in her native city, she travelled to France where she attended classes at the Grande Chaumière in Paris and worked under the direction of the celebrated sculptor Zadkine. Since 1948 individual exhibitions of her compositions have been held in galleries and museums both in Argentina and abroad, the most recent having taken place at the Roland de Aenlle Gallery in New York a few weeks ago. She has also participated in group shows in Argentina, in the Mexican and Venetian biennials, and in the exhibit held in connection with the Brussels World's Fair.

Franco Di Segni was born in Rome in 1910, but he has lived in Argentina since 1939 and has been a citizen of that country since 1942. He has specialized in the psychology of art, a subject on which he has written several books and lectured in Argentina and Europe. As a practicing artist, he considers himself self-taught. He has held eight one-man shows in Argentina and has taken part in numerous group exhibitions both there and in other countries.

This is the first presentation of either artist in the Washington area.

CATALOGUE

Noemí Gerstein

Sculptures

1. *El centinela (The Sentinel) I*, iron
2. *Rey Lear (King Lear)*, 1960, iron, 90 cm. (height)
3. *De las profundidades (Out of the Depth)*, 1960, iron, 65 cm. (height)
4. *El mago (The Magician)*, latten silver
5. *La niña (Young Girl)*, 1959-60, latten silver
6. *Someone*, iron
7. *Contrapunto (Counterpoint)*, 1957, brass, 50 cm. (height)
8. *El centinela (The Sentinel)*, 1956-57, brass
9. *Orpheus*, brass
10. *Puzzle I*, 1958, brass
11. *Puzzle II*, 1958, brass
12. *Small Relief*, brass
13. *Diálogo (Dialogue)*, 1956, alabaster, 30 cm. (height)[1]
14. *Totem*, 1958, iron, 220 cm. (height)[1]

Franco Di Segni

Paintings

1. *Ensueño (Reverie)*, 1957, 70 x 90 cm.
2. *Diálogo (Dialogue)*, 1957, 70 x 90 cm.
3. *Reunión (Reunion)*, 1959, 70 x 100 cm.
4. *Idolo (Idol)*, 1959, 105 x 30 cm.
5. *Destrucción (Destruction)*, 1957, 35 x 80 cm.
6. *Scherzo*, 1959, 80 x 35 cm.
7. *Personaje (Personage)*, 1956, 80 x 35 cm.
8. *Aparición (Apparition)*, 1956, 70 x 55 cm.
9. *Forma rara (Strange Form)*, 1957, 70 x 40 cm.

[1] Also exhibited but not included in the original catalogue. —*Ed.*

10. *Animo (Fortitude)*, 1959, 80 x 35 cm.
11. *Domingo triste (Blue Sunday)*, 1960, 90 x 35 cm.
12. *Casi nada (Almost Nothing)*, 1959, 70 x 55 cm.
13. *Tierra (Earth)*, 1956, 70 x 65 cm.
14. *Duda (Doubt)*, 1957, 35 x 70 cm.

December 25, 1960

RAICES DE LA PAZ (ROOTS OF PEACE): MURAL BY CARLOS PAEZ VILARO. INAUGURATION

The mural was executed in oil on one of the walls of the tunnel connecting the Main Building of the Pan American Union with the Administration Building. It was carried out at the initiative of the Visual Arts Division and is the work of the Uruguayan painter Carlos Páez Vilaró, who lent services without remuneration of any sort.

The mural is 525 feet long. In the twenty-eight days it took to paint it, 700 pounds of pigment, 150 gallons of solvent, and 300 brushes were used. All the materials employed were the gift of the Uruguayan paint-manufacturing firm I.N.C.A.

Art students from the University of Maryland and the Corcoran Gallery School collaborated with the painter Páez Vilaró in executing the work. This is perhaps the first occasion in which team-work was thus employed on a large scale in mixing paints and applying them rapidly to backgrounds and other color zones. The most faithful and efficient of the assistants were Pedro Proenza, León Dediot, and José Luis Zayas of Cuba, and José Varnadore of the United States.

This mural was begun on the fourteenth of November, one thousand nine hundred and sixty, and was inaugurated on the twentieth of December of the same year, Doctor José A. Mora being Secretary General of the Organization of American States.

The Uruguayan painter Carlos Páez Vilaró was born in Montevideo in 1923. He enjoys a well-earned international reputation, particularly as a muralist, having executed a number of works of this type in his native city. He is at present a member of the Directing Council of the Museum of Modern Art of Montevideo and director of the Uruguayan Craftsmen's Workshop. He has dedicated his mural *Roots of Peace* to the memory of his father, Dr. Miguel A. Páez Formoso, a former professor at the University of the Republic of Uruguay and a distinguished figure in the Pan American movement.

RAICES DE LA PAZ (ROOTS OF PEACE)

The central idea of the mural expressed in its title *Roots of Peace* has been developed in ten large tonal areas. No clear line of demarcation separates one from the other, both in order to preserve dramatic continuity and to suggest to the viewer the spiritual unity that joins together the peoples of the Americas without suppressing any of the shades of difference that distinguish one from another.

As an ensemble, the mural is the graphic statement of a Pan American program for ensuring peace and harmony throughout the Western Hemisphere. The aspiration to achieve the fruits of peace, repeatedly symbolized by the image of a fish, is the dominant note in the elaborate allegory of the mural.

The artist's imagination conceives the tunnel as a vast furrow in which colors, scattered like seeds, spring up in the form of trees whose boughs intertwine, forming a dense thicket. Upon these fancifully conceived branches, there

bloom as it were faces schematically rendered. According to the theme developed in each section, objects of the most highly varied character appear, now as fruits, now as flowers.

DESCRIPTION OF THE TONAL AREAS (following the numeration appearing in the frieze of the mural)

Sector No. 1: Technical Cooperation

The figures in this sector exchange symbols of their respective activities, thereby expressing the idea of effective technical assistance for the mutual benefit of the members of the American community. Whether it be the specialist in agriculture (represented by a rake), or the biologist (indicated by a microscope), the technicians of the Hemisphere must place their knowledge at the service of all the countries, without distinction.

Sector No. 2: Racial Tolerance

Marked by the varied color of the faces, the races of America appear grafted upon a single trunk. One and the same life-giving lymph circulates through these "flowers of tolerance." True brotherhood, based on Christian ideals of understanding, broad-mindedness, and magnanimity, frustrates every attempt at isolation. This the artist has symbolized by intertwining the figures, which shower gifts of all sorts on one another. A significant detail to be noted is supplied by two representatives of different races eating from the same plate.

Sector No. 3: Mutual Assistance and Closely Knit Markets

This sector begins with the "plant of cooperation," rich in fruits symbolizing the generous aid of one country to another in time of disaster (medicine, food, housing, etc.). Next is represented the flow of trade along multiple lines of communication, both national and international. Producers of coffee, wool, timber, sugar, and leather exchange or sell their goods in markets which are knit ever more closely together.

Sector No. 4: Physical Development

The development of the human physique is basic to the achievement of the Hemisphere's goals. Strong, healthy young people—exemplars of the sound mind in a sound body—can be formed only through a systematic pursuit of sports, under the stimulus of frequent tournaments and international competitions. Thirty-three graphic variations suggest to the imagination the gamut of athletic games, from Swedish gymnastics to soccer.

Sector No. 5: Common Ideals

An America that is united by indissoluble bonds presupposes a common attitude in regard to its historic calling and general agreement upon a series of questions fundamental to the development of its political life. First place among those principles that constitute the essence of American social thought must be assigned to the democratic organization of the state. The fifth sector of the mural is devoted to this common spiritual denominator of the American peoples, and the figures consequently appear hand in hand, linked by the firm bonds of common ideological beliefs.

Sector No. 6: Preservation of Folk Craft

America is one, but in the midst of diversity. It must preserve all that is peculiar to, or characteristic of, its various regions. The folk craft of each country and province must be not merely respected but protected and fostered, in order that the genuine and spontaneous expressions of the popular soul be neither lost nor disfigured. In the development of this theme, Páez Vilaró has given free rein to his imagination, depicting in original fashion the multitude of musical instruments and objects of popular art that compose the traditional folk craft of the Americas.

Sector No. 7: Cultural Exchange and the Encouragement of the Arts

Drama, ballet, painting, sculpture, ceramics, architecture, and music require government support and stimulus if talent is to realize its possibilities and full expression is to be given to intellectual and artistic creative powers. This is perhaps the most complex section of the mural, and the one most difficult of interpretation, since Páez Vilaró has sought to manifest in visible form, through color and linear rhythm, the fertile imagination of American genius and the variety of its aesthetic expression. It is, however, one of the most original in concept of the various sections, and one of the richest in movement.

Sector No. 8: Exploitation of Natural Resources and Industrial Development

Exploiting to a maximum the natural resources of America is one of the goals of its people in their economic progress. The spiritual and material peace of the Hemisphere must be based upon labor and upon the diversification of the means of production, for these are the sources of wealth and well-being. This sector begins at a niche in a wall where the artist has made amusing use of a water tank to emphasize the idea of machinery, as it were by a sculptural collage. The rest of the section develops the idea of industrial progress in a dynamic graphic fantasy, in which frequent symbolic use is made of the wheel and the gear. One may note also the curious representations of aspects of America's mineral production, ranging from precious stones to an oil well, the latter serving to mark the end of this sector.

Sector No. 9: Child-Welfare Services and the Eradication of Ignorance

This sector is dedicated to the family and more particularly to the child. The future citizen of the Americas must have watchful protection from cradle days. Here many arms are extended to offer him physical and intellectual assistance. Since the worst enemy of youth is ignorance, figures suggesting books, pens, and other teaching materials abound in this sector. The nucleus of the family, formed by the father and mother, occupies the center of the sector, and from it there extends a long branch budding with offspring. Attention is called to the figure of a bird in flight supported by two arms extending from the upper edge of the mural. This represents the idea of an abandoned child receiving the anonymous but effective protection of public welfare services.

Sector No. 10: Respect for Liberties

The last of the tonal areas of the mural is dedicated to individual liberties, the enjoyment of which is essential to human dignity. All the figures in this sequence have taken on the schematic appearance of a fish which, as was said before, symbolized for the artist the central idea of peace. One can easily make out the figure representing popular suffrage, whose one arm casts its ballot, while the other repels all forces of compulsion which seek to exert an influence upon its conscience. Other liberties appear in turn—freedom of assembly, of speech, of religion; the right to work and to engage in private enterprise. Last of all comes freedom of movement, symbolized by the wheel.

YEAR 1961

January 9 - 31, 1961

ALBERTO DUTARY OF PANAMA: OILS AND DRAWINGS

It is curious to note the appearance in recent years, in widely separated parts of the world, of artists who, singly or in groups, are seeking to reincorporate subject matter into painting. This movement is not so much an international reaction against the generally prevailing non-objective trend as a natural development for artists who have acquired complete freedom in the handling of media through their search for abstract forms, textural effects, and bold concepts.

This has been the case with Alberto Dutary of Panama. A representative of the most recent artistic generation to appear in that country, Dutary spent a period of apprenticeship in Spain, after which he entered upon the practice of his profession, following at first the non-objective tendency. Gradually, however, he began to introduce recognizable subject matter into his compositions, more particularly figures of people. The works resulting from this new approach to painting, with its emphasis on the human element, are highly complex—at times even cryptic—for the artist aims to describe the world in the light of the knowledge he has achieved by experimenting in the poetic chaos of abstract art.

Dutary was born in Panama City in 1932. He attended the National School of Fine Arts there during 1950 and 1951. He later went to Madrid, where he enrolled in the Academy of San Fernando and subsequently worked at the National School of Graphic Arts. Upon his return to Panama in 1958, he was appointed to teach painting in the Canal Zone. Dutary has participated in several group shows in Spain; he represented Panama at the First Salon in Barranquilla, Colombia, in 1959; and one of his paintings was included in the important exhibition *U.S. Collects Pan American Art* staged at the Chicago Art Institute. His first one-man show took place at the Sala Seral in Madrid in 1957 and was circulated through a number of northern Spanish cities in the following year. His first individual exhibition in Panama took place at the Chamber of Commerce in 1958. The following year the National University presented his work and in 1960 another exhibition was held at the National Museum.

The current presentation is Dutary's first one-man show in the United States.

CATALOGUE

Oils

1. *Comparsa (Carnival)*
2. *Figura de día (Figure by Day)*
3. *Ghost*
4. *Expectation*
5. *Imagen (Image)*
6. *The Beach*
7. *Reefs*
8. *Group at Sunset*
9. *Burning*

10. *Composición (Composition)*
11. *Pareja (Couple)*
12. *Happiness*

Drawings[1]

February 1 - 22, 1961

MARYSOLE WORNER OF MEXICO: OILS

Among Mexican painters of the new generation, Marysole Worner Baz has shown herself heir to the legacy of realism transmitted by the Mexican school of the 1920s—a realism which has become less nationalistic in its expression.

Worner was born in Mexico City in 1936. She began painting when very young and has never had academic training. In 1957, however, she received from the French Institute for Latin America a scholarship which enabled her to spend a year painting in Paris and visiting art centers in other European cities. Beginning in 1955, she has held a series of individual exhibitions in Mexico, and her work has been included in group shows not only in that country but also in Canada, France, and the United States.

Since 1958 Worner's compositions have been exhibited by the Galería Proteo of Mexico City and New York, her exclusive agent. Appreciation is expressed to that gallery for its cooperation in preparing the current exhibition, which is the first to present Worner's work in the Washington area.

CATALOGUE

Oils on Masonite

1. *Unidad (Unity)*
2. *Alto en el camino (Pause in the Road)*
3. *La cama (The Bed) No. 5*
4. *En marcha (On the March)*
5. *El café (The Coffee)*
6. *Autorretrato (Self-Portrait)*
7. *Cancioneras (Songstresses)*
8. *Tamaleras (Tamale Vendors)*
9. *Ronda de niñas (Girls Playing)*
10. *Tortillería (Tortilla Factory)*
11. *La familia (The Family)*
12. *Niña sola (Lonely Girl)*
13. *Curandera (Witch Doctor)*
14. *Afanadoras (Humble Task)*
15. *Grito ahogado (Muffled Scream)*
16. *Dos mundos (Two Worlds)*
17. *Recreo (Recess)*
18. *Los aros (The Rings)*

[1] Titles are unavailable. —*Ed.*

19. *Humanidad (Humanity)*
20. *Res vidae*
21. *Pleito de perros (Dog Fight)*
22. *Mañana (Tomorrow)*
23. *Juegos (Games)*
24. *Los olvidados (The Forgotten Ones)*, oil on canvas

February 23 - March 16, 1961

DAVID MANZUR OF COLOMBIA

The initial impulse to the development of Colombian art as we know it today—fresh, imaginative, and colorful—was given by a group composed of Alejandro Obregón, Enrique Grau, Guillermo Wiedemann, Eduardo Ramírez, and Armando Villegas. More recently a still younger generation has arisen. Their work, characterized by great spontaneity, combines a poetic transfiguration of reality with solidly grounded knowledge of the basic principles of art. Perhaps the most mature of the younger personalities is that of David Manzur; certainly he ranks among the most interesting creative figures in contemporary Colombian art.

Manzur was born in Neira, Colombia, in 1929. Although he was attracted to painting when still very young, his first creative experiences were gained in the theater, as a stage designer and an actor. A few years ago Manzur played the male lead in the first full-length feature film to be produced in Colombia. He also worked in radio and television. Later, abandoning the stage and the screen, he began to devote entirely to painting. At different periods he studied at the Claret School of Drawing at Las Palmas in the Canary Islands, at the Art Students League in New York, and at the School of Fine Arts in Bogotá. He was recently appointed professor of drawing, color, and fresco at the University of the Andes in the last mentioned city.

Among Manzur's most important works is a mural which he executed for the Arlequín Theater in Bogotá in 1958. Since 1953 he has held eight one-man shows in his native land. He participated in the Mexico and Venice biennials of 1958 and has taken part in many group shows in Colombia, Canada, and the United States. At the Eleventh Salon of Colombian Art (Bogotá, 1958) he received the Second Prize for Painting.

On the occasion of the one-man show he held at the Sociedad Económica de Amigos del País in the Colombian capital in 1959, the Bogotá critic Walter Engel characterized Manzur's development as "intelligent, disciplined, and persistent." Most of the compositions in tempera and oil here presented come from that exhibition. This is the first presentation of David Manzur's work in the Washington area.

CATALOGUE

Paintings

 1. *Temas del mar (The Sea) No. 2*, oil
2-4. *Flor de hierro (Flower of Iron), Panel I, II, and III*, triptych, tempera
 5. *Elementos para un ángel (Elements That Constitute an Angel) No. 8*, oil
 6. *Peces a la luz (Fish under Light)*, oil
 7. *Bodegón (Still Life)*, oil
8-11. *Flor de mar (Flower from the Sea) A, B, C, D*, tempera
 12. *Bodegón sobre oro (Still Life on a Gold Background)*, oil
 13. *Peces (Fish)*, oil
 14. *Bodegón en ocre (Still Life in Ocher)*, oil

15. *Peces muertos (Dead Fish)*, oil
16. *Bodegón en blanco y negro (Still Life in Black and White)*, tempera
17. *Flor nocturna (Night Flower)*, tempera
18. *Bodegón gris (Still Life in Grey)*, tempera
19. *Laúd rojo (Red Lute)*, tempera
20. *Temas del mar (The Sea) No. 3*, oil
21. *Composición azul (Composition in Blue)*, oil
22. *Acuario (Aquarium)*, oil

March 17 - April 12, 1961

MARIA HELENA ANDRES OF BRAZIL: PASTELS

Maria Helena Andrés is among Brazilian artists following the abstract trend in painting. Born in the city of Belo Horizonte in 1922, she received her first training at the local art school from the celebrated Alberto da Veiga Guignard. Later she studied in Rio de Janeiro with Carlos Chambelland. Individual exhibitions of her work were presented in Belo Horizonte in 1953, 1954, 1955, and 1959; at the Brazilian-American Cultural Institute of Rio in 1954; and at the Piccola Gallery in the same city last year. Andrés participated in four of the São Paulo Biennials as well as in numerous salons held throughout Brazil, at which she received several awards. Compositions by her have been included in group shows of Brazilian painting which have circulated in Spanish America and Europe, and examples of her work are to be found in the National Museum of Fine Arts in Rio and in many private collections in her native country. She has taught at the School of Fine Arts in Belo Horizonte, and this year she came to the United States on a museum tour at the invitation of the Department of State. This is the first individual presentation of Andrés's work in the United States.

CATALOGUE

Pastels

1. *Movement*
2. *Clouds*
3. *Explosion*
4. *Port Streets*
5. *Protection*
6. *Storm*
7. *Ocean Forms*
8. *Departure*
9. *The Wind*
10. *High Noon*
11. *Nocturnal Landscape*

March 17 - April 12, 1961

ALFREDO DA SILVA OF BOLIVIA: PAINTINGS

Two widely differing trends characterize present-day Bolivian art. One takes native themes for its subject matter, with special emphasis on the life of the mine workers. The other is non-objective, although some of its expressions

are at times reminiscent of the art of this Andean republic's remote past, as represented, for example, by the abstract treatment of stone in the Tiahuanacan culture.

Alfredo Da Silva is a follower of the second trend. His compositions suggest mineral forms, slabs of stone, or ancient monoliths, rendered with a sensitive feeling for color.

Da Silva was born in the colonial mining town of Potosí in 1936. Despite brief training at the local art academy and a short course in drawing at the University of Córdoba (Argentina) in 1957, he considers himself self-taught. After winning awards in Potosí in 1954 and a Special Prize at the Municipal Salon in La Paz in 1956, he went on to win the highest distinction for a foreign artist at the National Salon in Buenos Aires in 1959. He held a one-man show at the Galería H in Buenos Aires in 1958, and he has participated in numerous salons and group exhibits not only in Argentina, where he now resides, but also in Brazil, Chile, Uruguay, and his native Bolivia. Examples of his painting are in the Potosí Museum, the Museum of Modern Art in Buenos Aires, and private collections in France, Lebanon, the United States, and various countries of Latin America. This is the first public presentation of the work of Da Silva in the United States.

CATALOGUE

Oils on Paper

1. *Cosmos andino (Andean Cosmos)*
2. *Enigma*
3. *Sugerencia (Suggestion)*
4. *Forma (Form) A*
5. *Composición (Composition) I*
6. *Pintura (Painting) I*
7. *Forma cósmica (Cosmic Form)*
8. *Prehistoria (Pre-History)*
9. *Contraste (Contrast)*
10. *Blanco y negro (Black and White)*
11. *Sensación (Sensation)*
12. *Siena (Sienna)*
13. *Ocres (Ocher)*
14. *Pintura (Painting) II*
15. *Tensión (Stress)*
16. *Equilibrio (Equilibrium)*
17. *Transparencia (Transparency)*
18. *Quietud (Calm)*
19. *Composición (Composition) II*
20. *Pintura (Painting) III*
21. *Forma (Form) B*

April 4 - 19, 1961

THE COLOMBO PRESS OF ARGENTINA:
A SELECTION OF FIRST AND DE LUXE EDITIONS[1]

Extending its program of exhibits of art of the Americas to a new field, the Pan American Union presents for the first time a selection of examples of book illustration, taken from the publications of the Colombo Press of

[1] The list of works exhibited is unavailable. —*Ed.*

Argentina.

There have long been printers in Latin America who have devoted time and skill to the production of deluxe editions, sometimes of but six or ten copies, signed and numbered, for the delight of bibliophiles. Argentina has the greatest tradition in this line, and among contributors thereto a place of distinction is held by the Colombo Press. Books bearing its colophon are veritable jewels of the printer's craft: masterly use of type (carefully chosen as to face and hand set), tonal variations in inks, a skillful disposition of open spaces (in the form of wide margins and blank pages), and illustration by outstanding engravers make of a utilitarian object a true work of art.

Founded by Francisco Colombo (1878-1953), the Press had its beginnings as a small printery in the little town of San Antonio de Areco. To this provincial establishment, starting in 1922, fell the honor of bringing out the first editions of a then unknown author, Ricardo Güiraldes. After the success, in 1926, of Güiraldes's *Don Segundo Sombra*—long since recognized as a modern classic—Colombo moved his shop to Buenos Aires. There he began to issue important editions of national, Latin American, and European authors, engaging as illustrators prominent Argentine painters, sculptors, and engravers, such as Emilio Centurión, Lino E. Spilimbergo, Héctor Basaldúa, Juan Batlle Planas, Leopoldo Presas, Raúl Soldi, Norah Borges, Rodolfo Castagna, Hemilce Saforcada, Leopoldo Torres Agüero, Armando Sica, Luis Noé, Rómulo Macció, and others. Upon the death of the founder, his sons Osvaldo and Ismael took over the business, continuing his tradition of fine book-making of high artistic quality.

A comprehensive view of the output of the Colombo Press is provided by the current exhibit, which is presented under the auspices of the government of the Argentine Republic.

BIOGRAPHICAL NOTES[1]

CENTURION, Emilio. Painter, muralist, illustrator, born in Buenos Aires, 1894. Studied under Gino Moretti, Buenos Aires, 1910-12. Visited France, Spain, and Italy. Very active as an art teacher since 1920 and in other art related activities, executed several murals in Buenos Aires and has participated in many group shows, including the National Salon since 1911. Held individual exhibitions at the Museum of Fine Art in Santa Fe (1937), in La Plata (1945), and the Galería Bonino of Buenos Aires (1954), among others. His more important awards include First Prize (1920) and Grand Acquisition Prize (1935), both from the National Salon in Buenos Aires.

SPILIMBERGO, Lino Eneas. Painter, muralist, printmaker, illustrator, born in Buenos Aires, 1896. Graduated as a professor of drawing from the Academia Nacional de Bellas Artes, Buenos Aires, 1917. Studied in Paris with André Lhote. Traveled in Germany, France, Italy, 1925-28. Taught drawing in different art schools and directed the Instituto Superior de Artes, Universidad Nacional de Tucumán (Argentina). Member of the National Academy of Fine Arts since 1956, exhibited extensively in his country and abroad. Won numerous prizes, including First Prize for Painting, National Salon, Buenos Aires, 1933; Grand Prize, International Exposition, Paris, 1937.

TORRES AGÜERO, Leopoldo. Painter, muralist, draftsman, illustrator, born in Buenos Aires, 1924. Studied at the Escuela Nacional de Bellas Artes, Buenos Aires, and in Paris. Traveled in Europe, 1950-51. Illustrated, among others, the collection of short stories by Monteiro Lobato, Buenos Aires. Executed several murals in Argentina. Since 1949 has held individual exhibitions in Buenos Aires and at the Museo de Arte Moderno, Montevideo, 1959. Participated in national and international group shows, including the International Biennial of Color Lithography, Cincinnati, 1957; *International Exhibition of Modern Art*, Buenos Aires, 1960. Was awarded First Prize, Sociedad de Acuarelistas y Grabadores, Buenos Aires, 1956.

[1] Not included in the original catalogue. See Index of Artists for reference on those not listed here. —*Ed.*

April 12 - May 10, 1961

JAPANESE ARTISTS OF THE AMERICAS.
A SELECTION OF PAINTINGS BY KUBOTTA, PERU; MABE, BRAZIL; NISHIZAWA, MEXICO; OKADA, UNITED STATES; SAKAI, ARGENTINA

This exhibition comprises examples of the work of five artists who, though born in Japan, have been living and producing on American soil for some years. Unrelated and painting in widely separated areas of the hemisphere, they nevertheless evidence a common cultural heritage, adapted in differing ways to the varying environment of the lands of their adoption.

It is only fitting that, as part of the commemoration of Pan American Week, there should be presented at the headquarters of the Organization of American States an exhibition indicative of the hospitality with which our hemisphere has received men of other continents, and the ideas and experience which they represent. America is not only a racial but a cultural melting pot, to which all nationalities and civilizations have made contributions. Here men have been able to create free from dictates or interference of any kind; here artistic traditions of the most varied provenance have found fertile ground for new development.

It is fitting also that evidence be presented that contemporary art of the Americas is not, as many biased critics have claimed, derived solely and directly from the school of Paris. In addition to its indigenous and Western European heritage, the New World has at different times and in different ways received legacies from Eastern Europe as well as from Asia and Africa.

All the painters here presented have achieved eminence in the countries of their residence. To the art of those countries they have contributed a new accent—one which in the middle of the last century was introduced to Europe by artists, generally French, who took it directly from its sources in the Orient. The Japanese who have come to the New World have enriched artistic production here by their highly refined plastic sensitivity. Their open form of composition, the asymmetrical organization of their paintings, the calligraphic quality of their brushwork, their sense of space are invaluable contributions to contemporary Latin American art. That art, following dictates of no single school or cultural tradition, is representative, in its freedom of expression, of the essential liberty of the peoples of the Western Hemisphere and clear evidence of the universal quality of the civilization which here has come into being.

We wish to acknowledge the invaluable aid of the following institutions, without whose help it would have been impossible to assemble this exhibit: Escuela Nacional de Bellas Artes, Lima; Galería Sistina, São Paulo; Galería Proteo, Mexico City; the Phillips Collection, Washington, D.C.; Galería Bonino, Buenos Aires and Rio de Janeiro.

CATALOGUE

Paintings

Arturo Kubotta (Peru)
 1. *Cemetery*
 2. *Blue Symphony*
 3. *Golden Section*
 4. *Nature*

Manabu Mabe (Brazil)
 1. *Bustacro*
 2. *Homage to Snow*
 3. *White Work*

4. *Voices*
5. *Autumn*

Luis Nishizawa (Mexico)
1. *Fruit*
2. *Warrior*
3. *Stela*
4. *Goats*
5. *Relief*

Kenzo Okada (United States)
1. *Footsteps*
2. *Banner*

Kazuya Sakai (Argentina)
1. *Yin*
2. *Ugetsu*
3. *Oni*
4. *Composition Number Five*

ABOUT THE ARTISTS

KUBOTTA, Arturo. Born in Lima in 1932 of a Japanese father and Peruvian mother. Studied at the National School of Fine Arts, where he obtained several awards. Has exhibited only in group shows in Peru. Kubotta is representative of the new generation of Peruvian artists.

MABE, Manabu. Born in Kumamoto, Japan, in 1924. Settled in Brazil in 1934. Brazilian citizen. Self-taught, started to paint fifteen years ago and has held one-man shows in Rio de Janeiro, São Paulo, and Rome. Received awards at the Salon of Modern Art in São Paulo in 1959, and won the First National Prize for Painting at the Fifth Biennial of São Paulo in 1959. He was awarded Special Prize at the First Youth Biennial of Paris in 1959 and the Fifth Prize at the Thirtieth Biennial of Venice in 1960. Mabe's work is represented in the collections of the Dallas Museum of Fine Arts and the Museum of Modern Art in São Paulo.

NISHIZAWA, Luis. Born in San Mateo, Mexico, 1920, of a Japanese father and Mexican mother. Studied at the National Academy, Mexico City. Has executed murals and obtained the Second Prize at the National Salon and at the Second Inter-American Biennial in Mexico in 1959. In 1961 he was awarded the First Prize in the National Salon for Landscape. His work is represented in the Museum of Modern Art in Mexico City.

OKADA, Kenzo. Born in Yokohama, Japan, 1902. Studied at the Fine Arts University in Tokyo. Study trip to Paris, 1924-27. Returned to Japan to teach. Has lived in New York since 1950. Obtained awards in the Biennial of Venice (1958) and of São Paulo (1957). Participated in group shows at the Chicago Art Institute (1957) and Carnegie Annual (1955), among others. His work is represented in the collections of the Art Institute of Chicago; the Metropolitan Museum of Art, the Museum of Modern Art, the Whitney Museum for American Art, the Guggenheim Museum, the Brooklyn Museum, all in New York City; and art museums in Baltimore, Boston, San Francisco, Santa Barbara, Yale University, and the Phillips Collection of Washington, D.C., from which two paintings were included in this exhibition.

SAKAI, Kazuya. Born in Buenos Aires in 1927 of Japanese parents. Educated in Japan. Self-taught painter. Taught at the University of Tucumán, Argentina. Held one-man shows in Buenos Aires, Rio de Janeiro, and São Paulo. Obtained a prize at the Argentine Pavilion of the Brussels World's Fair in 1958.

April 13 - May 28, 1961

TWO PHOTOGRAPHIC ESSAYS BY ALFREDO TESTONI OF URUGUAY

An outstanding name in Latin American photography is that of the Uruguayan Alfredo Testoni, who is making his debut in the United States at the Pan American Union in two separate exhibits to be presented consecutively.

The first of these exhibits, entitled *Children at School*, was entered in a contest on that topic for press photographers in Montevideo. It consists of ten candid-camera exposures, taken with a Rolleiflex, equipped with a normal lens, while a kindergarten teacher was telling the tale of *Little Red Riding Hood* to her small charges. Each picture corresponds to a different moment in the story and reflects its emotional impact on the hearers, who were so completely absorbed in the narration as to remain oblivious to the presence of the photographer. The result is a revealing study in child psychology, remarkable for its freshness and innocent sincerity.

The second exhibit, entitled *Walls*, displays an entirely different facet of Testoni's art. Static and analytic, it is a study in textural relationships, the examples being provided by walls photographed during Testoni's travels in such widely separated lands as France, Germany, Greece, Iran, Italy, Lebanon, and Sweden. Testoni's approach resembles the informalism of certain painters of the younger generation. Surface effects and accidents are given aesthetic value by the photographer's keen eye and his skill in cropping and in enlarging details. He imparts to a fragment the importance of the whole, or, rather, he endows it with a significance which the whole itself often does not possess.

Testoni was born in Montevideo in 1919. He began his professional career working for the newspaper *El Pueblo* in 1930. Later he set up in business for himself, doing publicity photography. In 1950 he joined the staff of *El Debate*, as acting chief of photography for that paper; this permitted him to travel throughout Latin America and Europe. Currently he works for the dailies *La Mañana* and *El Diario*, and is the photographic correspondent in Uruguay for the magazines *Life* and *Time*. He has held four one-man shows in Montevideo and has won awards at contests in Argentina, Spain, and his native Uruguay. Examples of his work have been reproduced in publications of Czechoslovakia, Germany, Italy, Spain, and the United States.

CATALOGUE

Photographs

April 13 to 30

Serie *La escuela y el niño: Caperusita Roja* (Series *Children at School: Little Red Riding Hood*)

1. *Había una vez una niña... (Once upon a time there was a little girl . . .)*
2. *...a las flores y a los pájaros (. . . to the flowers and the birds)*
3. *Era tan buena como bella (She was as good as she was beautiful)*
4. *—Tu abuelita está enferma (—Your grannie is sick)*
5. *—¡No te detengas Caperucita Roja! (—Don't stop anywhere along the way!)*
6. *... pero el lobo estaba allí, oculto, esperándola (. . . but the wolf was hidden, waiting)*
7. *Vestido con las ropas de la abuela, se acostó (Dressed in the grandmother's clothes, the wolf got in bed)*
8. *—Son para acariciarte mejor, hija mía (—The better to caress you with, my dear)*
9. *...y gruñendo se echó sobre la niña devorándola (. . . and growling, he leaped at Little Red Riding Hood)*
10. *Caperucita volvió a reír, dichosa como antes (Red Riding Hood left her grandmother's house laughing, and lived happily ever after)*

May 1 to 28

Serie *Muros* (*Walls* Series)

1. *Montmartre*, Paris
2. *Detritus*, Paris
3. *Desierto decorado (Decorated Desert)*, Persepolis
4. *Collage Mural*, Iran
5. *Tiempo torrencial (Rainy Season)*, Athens
6. *Resistencia final (Final Resistance) No. 2*, Munich
7. *Escenario para el misterio (Scene for Mystery)*, Stockholm
8. *Antiguas huellas (Ancient Prints)*, Rome
9. *Resistencia final (Final Resistance) No. 1*, Munich
10. *Paisaje de la eternidad (Landscape of Eternity)*, Baalbek
11. *Piedra y hierro (Stone and Iron)*, Florence

April 19 - May 15, 1961

JOAQUIN TORRES-GARCIA (1874-1949) OF URUGUAY

A few days before his death in 1949, Joaquín Torres-García dispatched, at the request of the then Section of Visual Arts, a selection of compositions by himself and by artists associated with his workshop in Montevideo, for presentation in Washington. Held posthumously, the exhibition attracted such favorable attention that ever since the Pan American Union has been desirous of devoting a one-man show to the work of an Uruguayan who ranks not only as a forerunner of contemporary trends in Latin America but also as a painter of world-wide recognition.

Torres-García was born in Montevideo in 1874. At the age of seventeen he went to Spain and settled in Barcelona, where he established contact with local avant-garde artists, among them Pablo Picasso. At different times Torres-García lived in France as well as Spain and, largely through the group known as *Cercle et Carré*, he became associated with the international movement known as constructivism, then in its early stages. This brought him into close contact with Van Doesburg and Mondrian.

Torres-García adopted the principle of organizing the picture within a framework of vertical and horizontal rigidity. He never, however, abandoned the symbolic representation of objects of nature. While other constructivists plunged boldly into the realm of non-figurative painting, Torres-García continued to use the representational element, albeit in a highly cryptic fashion, producing as it were plastic hieroglyphics. In these he sought to incorporate the spirit of ancient forms taken from pre-Columbian art—a world in which another great master of our time, Paul Klee, was also seeking inspiration.

Torres-García returned to Montevideo after 1934, and there he began an apostolic existence, devoted to the dissemination of his ideals. He founded a workshop, which was attended not only by his own two sons but also by a number of other young Uruguayan artists, whose endeavor brought them well-earned recognition. A man of conviction, Torres-García was often involved in polemics, defending his theories. He wrote books and gave more than five hundred lectures seeking to win disciples. He advocated an "art of the Americas" for the world, expressed in an international language of permanent values. As the French critic Jean Cassou said:

> He was the right man to speak to his countrymen in a language they could understand: his experience had brought him back to first principles, the natural point of departure for his continent, which now suddenly, directly, enthusiastically, with clear and candid purity, opened

itself to an immense future.

As a special tribute to a master who engaged until his death in championing a great cause, the Pan American Union has made available, by exception, the space normally occupied by its permanent collection, in order to permit the showing of the most significant compositions of Torres-García that it has been possible to assemble in the United States. The exhibition has been made possible through the cooperation of Miss Rose Fried, the owner of a New York gallery bearing her name, which is the exclusive agent for the work of Torres-García. After the presentation in Washington, the exhibit will be circulated to a limited number of museums in the United States and in Europe, under the sponsorship of the Traveling Exhibition Service of the Smithsonian Institution. Appreciation is here expressed both to the Smithsonian and to Miss Fried for the assistance they have so generously lent in connection with this presentation.

CATALOGUE

Paintings

1. *Construcción (Construction)*
2. *Objeto a cinco tonos sobre fondo blanco (Five Toned Object on a White Background)*
3. *Construcción (Construction)*
4. *Construcción (Construction)*
5. *Construcción en blanco (Construction in White)*
6. *Constructivo en cinco tonos con hombre universal en rojo (Construction in Five Tones with Universal Man in Red)*
7. *Composición (Composition)*
8. *Estructura constructiva con línea blanca (Constructive Structure with white Lines)*
9. *Construcción (Construction)*
10. *Grafismo indoamericano (American Indian Graphic)*
11. *Construcción (Construction)*
12. *Construcción (Construction)*
13. *Pescado constructivo (Constructivist Fish)*
14. *Construction in Five Tones*
15. *Structured Forms With Reliefs in White*
16. *Constructivo a doble línea con tierra sombra (Double Line Construction from the Earth to the Shadows)*
17. *Construcción (Construction)*
18. *City with a Constructivist Port and Bridge*
19. *Arte constructivo (Constructivist Art)*
20. *Construcción (Construction)*
21. *Composición universal (Universal Composition)*
22. *Reminiscent Constructions*
23. *Construcción (Construction)*
24. *Figura (Figure)*

May 11 - June 4, 1961

RODOLFO MISHAAN OF GUATEMALA: PAINTINGS

Rodolfo Mishaan, who is here presented to the Washington public for the first time, is a personality new to contemporary Guatemalan art. Like others of his countrymen who have exhibited at the Pan American Union—Roberto Ossaye, Roberto González Goyri, and Rodolfo Abularach—Mishaan began his studies at the

National School of Fine Arts in Guatemala City and spent the major portion of his period of apprenticeship in the United States.

Mishaan was born in Guatemala City in 1924. He came to the United States twelve years ago and enrolled in the Art Department of Syracuse University, where he devoted several years primarily to the study of textile design. Upon leaving Syracuse, Mishaan went to New York City, where he took special art courses at the Art Students League, the New School for Social Research, and Columbia University.

Mishaan has participated in several group exhibitions in this country and in Guatemala. His first one-man show took place at the Galería Sudamericana in New York last year. Examples of his work are to be found in numerous private collections of the United States. In the field of applied art, he has served as a designer for several firms of the textile industry. Mishaan's style has evolved from a free interpretation of pre-Columbian Indian symbols to a more abstract mode of expression, exemplified by the works in the present exhibition.

CATALOGUE

Oils on Canvas

1. *Life Force*, 50 x 60"
2. *Cosmos*, 24 x 36"
3. *The Edge*, 22 x 28"
4. *Penumbra (Twilight)*, 24 x 36"
5. *Ignea* (Igneous), 22 x 28"
6. *Ancestral*, 22 x 28"
7. *Prenatal*, 24 x 36"
8. *Surreal*, 24 x 36"
9. *Toltec*, 24 x 36"
10. *Lunar*, 28 x 36"
11. *Handel*, 24 x 36"
12. *Arrival*, 24 x 36"
13. *Natura*, 24 x 36"
14. *Ascension*
15. *Orpheus*
16. *Euridice*
17. *Presumption*
18. *Saudade*

June 5 - 27, 1961

JORGE DAMIANI OF URUGUAY: PAINTINGS

Jorge Damiani belongs to a young generation of artists who, after evolving from a figurative to a non-objective approach in painting, have recently made a subtle return toward nature, without, however, losing contact with abstraction.

Damiani was born in Genoa, Italy, in 1931. His parents were citizens of Uruguay, who later took him back to their native land. He became interested in art while a high-school student and at first worked independently as a self-taught painter. In 1951, however, he traveled to Italy to study for two years at the celebrated Brera Academy in Milan. Returning to Uruguay, he worked intensively, painting and exhibiting, until 1959 when he received a

fellowship from the John Simon Guggenheim Foundation to further his career in the United States. Since the beginning of 1960 Damiani has been residing in New York City, where earlier this year he held a one-man show at the Roland de Aenlle Gallery. He has participated in numerous group exhibits in Italy, the United States, and Uruguay, and in the Fourth São Paulo Biennial.

Examples of his work are to be found in the Museum of Modern Art of New York, in the Dallas Museum of Fine Arts, and in numerous private collections in the United States, Uruguay, and other parts of Latin America.

CATALOGUE

Oil, Paper, and Sand on Canvas

1. *Osamenta (Bones) I*, 50 x 40"
2. *Osamenta (Bones) II*, 50 x 35"
3. *Reptil (Reptile)*, 50 x 34"
4. *Nido (Nest)*, 24 x 40"
5. *Camoatí*, 24 x 34"
6. *Metamorfosis (Metamorphosis)*, 33 x 24"
7. *Fósil* (Fossil), 33 x 44"
8-11. *Cuadro (Composition) I, II, III, IV*, 43 x 33"
12. *Cuadro (Composition) V*, 33 x 43"

Oil on Canvas

13-17. *Boceto para cuadro (Sketchs for a Composition) I, II, III, IV, V*, 11 x 8"

June 28 - July 23, 1961

OMAR RAYO OF COLOMBIA: PAINTINGS

Omar Rayo was born in Roldanillo, Colombia, in 1928. At the age of nineteen he began his artistic career in Bogotá, as a cartoonist and illustrator for various newspapers and magazines. Between 1948 and 1954 he exhibited the productions stemming from this period of apprenticeship, after which he began to turn more toward painting and to work which had no connection with the field of illustration. In 1954 he began an extensive tour of Latin America, giving one-man shows that year in Quito and Guayaquil; in Lima, Arequipa, and Cuzco in 1955; in La Paz and São Paulo in the same year; in Rio de Janeiro and Montevideo in 1956; and in Buenos Aires, Montevideo, and Santiago de Chile in 1957. In 1958 he returned to Colombia, where he gave five individual exhibits—two in Bogotá and one each in Cali, Medellín, and Barranquilla. In 1959 Rayo obtained a fellowship from the Organization of American States that enabled him to pursue his career in Mexico City, where he presented five one-man shows, in addition to one in the city of Monterrey. Omar Rayo has taken part in many group exhibitions throughout Latin America and has obtained numerous awards in a variety of countries. Examples of his work are to be found in the Museum of Modern Art of New York, the Brooklyn Museum, the New York Public Library, the National Museum of Bogotá, the Museum of Modern Art of Mexico City, and other important collections, including that of the Luis A. Arango Library in Bogotá.

This is the first presentation of Omar Rayo's work in the Washington area.

CATALOGUE

Oils on Canvas

1. *Coloquio rojo-negro-blanco (Red, Black, White Colloquial)*, 40 x 34"
2. *Coloquio azul-rojo-negro (Blue, Red, Black Colloquial)*, 32 x 32"
3. *Ultimas luces en New York (Last Lights in New York)*, 31 x 30"
4. *Elementos para una bacanal (Elements for a Bacchanalia)*, 35 x 34"
5. *Ala para Hela (Wing for Hela)*, 34 x 34"
6. *Ojo negro (Dark Eyes)*, 35 x 30"
7. *Boceto para hacer una luna (Sketch of a Moon)*, 35 x 34"
8. *Ojo azul (Blue Eye)*, 32 x 23"
9. *Ruinas de un templo blanco (Ruins of a White Temple)*, 32 x 23"
10. *Luz íntima (Intimate Light)*, 32 x 22"
11. *Forma de eclipse (Form in Eclipse)*, 32 x 32"
12. *Composición en emergencia (Composition in Emergency)*, 32 x 23"
13. *Bodegón vertical (Vertical Still Life)*, 27 1/2 x 39"
14. *Gran jarra vieja (A Large Old Jug)*, 27 1/2 x 24"
15. *Jarra blanca (White Jug)*, 24 x 22"
16. *Signos para un alfabeto (Signs for an Alphabet) No. 3*, 35 x 24"
17. *Signos para un alfabeto (Signs for an Alphabet) No. 4*, 30 x 25"
18. *Signos para un alfabeto (Signs for an Alphabet) No. 5*, 35 x 30"
19. *Signos para un alfabeto (Signs for an Alphabet) No. 6*, 32 x 32"
20. *Signos para un alfabeto (Signs for an Alphabet) No. 7*, 32 x 30"

21-30. Intaglios[1]

June 28 - July 23, 1961

GINA PRADO OF BRAZIL: TAPESTRIES

Born in the city of Vitória, in the State of Espírito Santo, Brazil, Gina Prado has been a resident of Washington since 1957. Attendance at classes in museum organization offered by the Museum of National History of Rio de Janeiro awakened in her an interest in tapestry. After her marriage in 1952 to the Brazilian painter and architect Antônio Prado, she began to weave tapestries following designs created by her husband and by other artists with whom they were acquainted. The present exhibition displays examples stemming from this collaboration.

Prado has participated in numerous group shows in Brazil, Mexico, and the United States, winning Special Award at the 1959 Annual Area Show sponsored by the Corcoran Gallery of Art.

CATALOGUE

Tapestries

1. *Cat*, designed by Marcelo Grassmann
2. *Dancers*, designed by Antônio Prado

[1] Titles are unavailable. —*Ed.*

3. *Tree*, designed by Antônio Prado
4. *Butcher*, designed by José Luis Cuevas
5. *Trio*, designed by Armando Villegas
6. *Composition*, designed by Antônio Prado
7. *India I*, designed by Carybé
8. *India III*, designed by Carybé
9. *Drama in the Sky*, designed by Manabu Mabe
10. *Autumn*, designed by Antônio Prado

July 24 - August 16, 1961

ENRIQUE CASTRO-CID OF CHILE: PAINTINGS

The newest figure to emerge in the panorama of abstract art in Chile is that of Enrique Castro-Cid, who is here presented in his first one-man show in the United States.

Castro-Cid was born in Santiago in 1937, and enrolled in the Fine Arts School of the Chilean capital at an early age. In the first group show in which he took part—the National Salon of 1959—his entry was distinguished with a prize. Thereafter, examples of his work were included in all group exhibits held in Santiago, and he was invited to participate in special shows organized for presentation in Japan and Venezuela in 1960. That same year saw his first individual exhibition in his native city.

Castro-Cid is now in the United States, following a brief sojourn in Mexico, where he journeyed on a scholarship. He initiated his activities on the North American art scene by participating in a group show at the Galería Sudamericana in New York two months ago.

The artist interprets the works presented now in the Pan American Union as the results of his "search into the mysterious structures of significant expression in nature."

CATALOGUE

Paintings

1. *Natural Speed*
2. *Metapsychosis*
3. *Reincarnation*
4. *Ligaments*
5. *Dead People*
6. *Skinless*
7. *Eschatological*
8. *Stone Woman*
9. *Abyssal Form*
10. *Joint*

Drawings and Temperas[1]

[1] Titles are unavailable. —*Ed.*

July 24 - September 7, 1961

MASKS BY HECTOR UBERTALLI

Masks are as old as humanity and as universal as the world itself. The Argentine artist Héctor Ubertalli has devoted himself to continuing the tradition of mask-making. Working with a technique and materials which he has devised, he attempts to reconstruct, through his art, the features of important historical personalities, or to create images for mythical or symbolic ideas.

Ubertalli was born in Buenos Aires in 1928. He studied at the National Academy of Fine Arts in that capital, specializing in sculpture. Later, Argentine creator of masks Félix Aranguren accepted him as a pupil.

Ubertalli has devoted his talent almost entirely to the use of the theater. His masks have been frequently seen in Argentine productions of the classics, in ballet, and many other productions of the modern stage. He has exhibited his works since 1949 in almost every South American capital, as well as in Paris, Genoa, and Cairo. In May of this year the Ligoa Duncan Galleries of New York presented a one-man show of Ubertalli's masks, from which a special selection has been made for presentation at the Pan American Union.

CATALOGUE

Masks

1. *San Francisco de Asís (Saint Francis of Assisi)*
2. *Isabel de Inglaterra (Elizabeth of England)*
3. *María Estuardo (Mary Stuart)*
4. *Juana de Arco (Joan of Arc)*
5. *Japonesa (Japanese)*
6. *Tibetano (Tibetan)*
7. *Mujer hindú (Hindu Woman)*
8. *Africa*
9. *Medusa*
10. *Neptuno (Neptune)*
11. *Antígona (Antigone)*
12. *Titania*
13. *Oberon*
14. *Teatro griego (Greek Theatre) No. 1*
15. *Teatro griego (Greek Theatre) No. 2*
16. *Ballet*
17. *Abstracto turquesa (Turquoise Abstract)*
18. *Abstracto violeta (Violet Abstract)*

August 17 - September 7, 1961

MARUJA ROLANDO OF VENEZUELA: PAINTINGS

Contrary to the prevalent geometrical trend in the modern painting of Venezuela, an important group of artists has appeared which follows an informalist direction—the new approach to abstract art and romantic vision—in opposition to the classical spirit proposed by the geometrical trend. Open compositions, prominent surfaces of a constant interplay of texture, and mysterious highlights on dark colors are the main characteristics of the informalists.

Maruja Rolando has been associated with that group for the last two years and has exhibited with them in Venezuela and Havana. In the spring of this year Miss Rolando held a joint exhibit with the informalist Venezuelan painter J. M. Cruxent at the Center of Fine Arts and Letters in the city of Maracaibo.

Rolando was born in Barcelona, Venezuela, in 1923 and started to take private art lessons in her native country along with her regular education. She later came to the United States and enrolled in the Boston Museum School of Art, where she was a pupil of David Aronson and Karl Zerbe. Upon her return to Venezuela she became very active in her field, and since 1954 has contributed to group exhibits. Her works are included in many private collections in Venezuela and the United States, and this exhibition constitutes the first presentation of Maruja Rolando in the United States.

CATALOGUE

Paintings

1. *Yo habitaré mi nombre (I Will Inhabit My Name)*, 1960, 80 x 45 cm.
2. *Maliconia*, 1960-61, 80 x 80 cm.
3. *De espanto y brinco (Of Fear and Jump)*, 1960, 100 x 150 cm.
4. *Ambix*, 1960, 100 x 150 cm.
5. *Somos una generación sin despedida (We are a Generation without Farewell)*, 100 x 150 cm.
6. *Hermético (Hermetic)*, 1960, 100 x 150 cm.
7. *Gaspard de la Nuit (Gaspard of the Night)*, 1960, 100 x 150 cm.
8. *Maldoror*, 1960, 100 x 150 cm.
9. *Desplazado (Displaced)*, 100 x 150 cm.
10. *The Grasshopper Feared to Misplace His Forces*,[1] 1960, 90 x 130 cm.
11. *Ilusión de una metamorfosis (Illusion of a Metamorphosis)*, 1961, 140 x 160 cm.
12. *Forget-Me-Not*,[1] 1960
13. *Disonancia sentimental (Sentimental Dissonance)*
14. *Amoidena*
15. *Vuelo sideral (Sidereal Flight)*, 140 x 160 cm.
16. *Muaco*, 140 x 160 cm.
17. *Kledelina*, 1960
18. *Wakalina*

September 8 - 24, 1961

HILDA LOPEZ: STREETS AND INLETS OF MONTEVIDEO, OILS

Another young personality from South America comes forward with a message of figurative art enriched by the experience of the prevalent trend of non-objectivism. Hilda López was born in Montevideo in 1922. For some time she studied painting there under Manuel Rosa, Vicente Martín, and Lino Dinetto, and engraving under Guillermo Rodríguez. In spite of being a disciplined artist of a certain degree of maturity, she refused to exhibit anywhere during her years of apprenticeship and started only two years ago, participating in local salons. Finally, in July 1960, at the insistence of the owner of the Zaffaroni Gallery in Montevideo, she agreed to be presented in a one-man show which was warmly received. On that occasion the chief of the Division of Visual Arts of the Pan

[1] In the catalogue of this artist's exhibition at the Museo de Bellas Artes, Caracas, 1960, title no. 10 appears as *The Grace Hoper Feared to Mixplace His Fauces*; no. 12 appears as *Forget-Me-Knot*. —*Ed.*

American Union happened to be in the capital of Uruguay, and invited the artist for this first presentation of her work outside of her native country. The exhibit consists only of two series: *Streets* and *Inlets of Montevideo*, treated in a flat, two-dimensional way, letting the abstract organization of the picture prevail.

CATALOGUE

Oil on canvas

Serie *Calles de Montevideo (Streets of Montevideo* Series)

1. *No. 1*, 1959, 116 x 89 cm.
2. *No. 2*, 1959, 116 x 81 cm.
3. *No. 3*, 1960, 80 x 61 cm. Coll. Mr. Fernando García Esteban, Montevideo
4. *No. 4*, 1960, 105 x 72 cm.
5. *No. 5*, 1960, 105 x 72 cm.
6. *No. 6*, 1960, 120 x 72 cm.
7. *No. 7*, 1960, 134 x 81 cm.
8. *No. 8*, 1960, 116 x 81 cm.
9. *No. 9*, 1960, 120 x 72 cm. Coll. Mr. Alberto Angenscheidt, Montevideo
10. *No. 10*, 1960, 116 x 81 cm. Coll. Mrs. Hilda Slowak, Montevideo
11. *No. 11*, 1960, 146 x 89 cm.
12. *No. 12*, 1960, 146 x 89 cm.

Serie *Puertos de Montevideo (Inlets of Montevideo* Series)

13. *No. 1*, 1959, 102 x 81 cm.
14. *No. 2*, 1959, 103 x 83 cm.
15. *No. 3*, 1959, 105 x 72 cm.
16. *No. 4*, 1960, 116 x 81 cm.
17. *No. 5*, 1960, 100 x 81 cm. Coll. Mr. Alberto Angenscheidt, Montevideo
18. *No. 6*, 1960, 116 x 81 cm.
19. *No. 7*, 1960, 146 x 89 cm.
20. *Pintura (Composition) No. 1*, 1960, 150 x 100 cm.

September 19 - October 13, 1961

ROBERTO DE LAMONICA OF BRAZIL: ENGRAVINGS

During the last ten years the graphic arts in Brazil have attained an extraordinary degree of maturity in technical creativeness and artistic significance. A group of engravers has emerged and won a solid prestige for Brazil as well as many awards in international contests. Among the most outstanding personalities to appear during the last few years in the group of artists devoted to graphic work is Roberto De Lamônica, born in 1933 in the State of Mato Grosso. He moved to São Paulo and enrolled in the School of Fine Arts in that city, where he specialized in the graphic arts from the beginning. In 1957 he obtained a special award, which consisted of a trip to China, in the salon known as *Para Todos*.

On that same trip he also visited Italy, Switzerland, and the Soviet Union, as well as some countries in the Soviet bloc. He has also traveled throughout South America. He has shown his work individually in several museums and galleries in Brazil and has obtained numerous awards in contests and group shows. In Rio de Janeiro he has also

attended the famous workshop of the Museum of Modern Art and taken special courses under the French engraver Friedlaender. He has also participated in biennials and international shows in Lugano (Switzerland), Carrara (Italy), Israel, Venezuela, Cincinnati (Ohio), Lisbon, Mexico City, and Amsterdam. His last one-man show was held in the Institute of Contemporary Art in Lima, Peru. His work is represented in museums of The Hague (Holland), La Paz (Bolivia), and Belo Horizonte (Brazil). The Brazilian critic Marc Berkowitz has stated that De Lamônica is "able to select a special technique to suit each of his works because of his wide knowledge of the graphic arts."

CATALOGUE

1-15. Engravings[1]

September 25 - October 17, 1961

GUILLERMO TRUJILLO OF PANAMA: PAINTINGS

A new approach to the pre-Hispanic tradition is presented in this exhibition of the work of Guillermo Trujillo of Panama. This painter, who has been searching into the mysterious forms of the aboriginal art of Central America, has incorporated it into the spirit of today's art. Hieratic and solemn figures of the pre-Hispanic heritage are treated with freedom and looseness of abstract art in a very eloquent and significant unity of expression.

Guillermo Trujillo was born in Horconcitos, a town in the Province of Chiriquí, Panama, in 1927. He studied in his native town and continued his high school and university training in the capital of Panama from 1941 until 1953, when he graduated as an architect from the University of Panama. He was granted a scholarship given by the Institute of Hispanic Culture in Madrid, where he studied landscape design and ceramics. He also attended painting courses at the San Fernando School of Fine Arts in the capital of Spain, where he remained until 1958. Trujillo has held seven one-man shows in Panama City, Caracas, and Madrid between 1953 and 1960. He has won numerous awards in international exhibitions, not only for painting but also as an architect specializing in landscape design. He has also participated in the Third Hispanic American Biennial in Madrid, in the Second Mexican Biennial, and the Fifth São Paulo Biennial where he obtained an Honorary Award. Apart from his work as an architect and a professor of architecture at the University of Panama, Trujillo as a painter has executed several murals in his native country in public and private buildings. This is the first one-man show of Guillermo Trujillo in the United States, where his work has never been presented before.

CATALOGUE

Oils, 1960 and 1961

1. *Elegía al sol (Elegy to the Sun)*
2. *La ofrenda (The Offering)*
3. *Figuras en la playa (Figures on the Beach)*
4. *Cazador de recuerdos (Hunter of Memories)*
5. *Final del día (End of the Day)*
6. *Seres acaparando la luz (Light Hoarders)*
7. *Idilio (Idyll)*
8. *Sueño de una noche de verano (Summer Night's Dream)*
9. *Ritual*

[1] Titles are unavailable. —*Ed.*

10. *Hacia la ciudad (Toward the City)*
11. *Imagen interrumpiendo el paisaje (Image Obstacle in a Landscape)*
12. *Espíritu del fuego (Spirit of Fire)*
13. *Mujeres invocando la lluvia (Women in a Rain Ceremony)*
14. *Adán y Eva (Adam and Eve)*
15. *Invitación a la noche (Invitation to the Night)*
16. *Soledad (Loneliness)*
17. *Exodo (Exodus)*
18. *Figuras, recuerdos... (Figures and Memories)*
19. *Seres de la noche (Night Figures)*
20. *Fiesta del toro (Ceremony of the Bull)*

October 17 - November 6, 1961

ROGELIO POLESELLO OF ARGENTINA: OILS AND MONOTYPES

In its presentations of Argentine art, the Pan American Union has exhibited, in turn, the works of various generations, with the aim of providing a view of the chronological development of trends in a country which is a focal point of artistic activity in Latin America. It now introduces the youngest personality to have emerged there, Rogelio Polesello, born in Buenos Aires in 1939. Polesello began his training early and graduated from the National School of Visual Arts when only nineteen. In 1959 he obtained a prize offered by the Losada publishing house to young artists of talent, and the following year he received a similar award from a Buenos Aires society whose name indicates its aim: *Ver y Estimar* (To See and Appreciate).

Polesello has been an active participant in group shows in his own country during the last three years. His work was included in the *South American Art Today* exhibit organized by the Dallas Museum of Fine Arts (1959), which later circulated to other institutions, and it has figured in other exhibitions held in Lima, Mexico City, Rio de Janeiro, and various cities of the United States. Polesello has had one-man shows in Buenos Aires at the Peuser Gallery (1959), the Pizarro Gallery (1960), and the Lirolay Gallery (1961). This is his first individual presentation in the United States.

Young as he is, Polesello has not only created a reputation in the commercial field as a layout and poster designer of unusual interest, but also won recognition as one of the most promising creative artists in Argentina today. He began his production along geometric lines, and, with certain variations, this has remained as his characteristic mode of expression. Nevertheless, in a search for new and unusual values, Polesello takes a subjective approach to his material. The use of circles, a vibrant repetition of design, and subtle modulations of color enable his work to escape the frigidity of pure geometry. With his feeling for color and his imaginative resources, Polesello appears as one of the brightest talents in the young artistic generation of Latin America.

CATALOGUE

Oils, 1960 and 1961

1. *Storm*
2. *Orange on Vermillion*
3. *Black*
4. *Ocher*
5. *Orange Variations*
6. *Orange on Magenta*

7. *Earth of America*
8. *White Square*
9. *Red, White, and Blue*
10. *Red on Blue and Blue on Red*
11. *Composition of 1958*
12. *Pampeano*
13. *Italic*

Monotypes,[1] 1958

November 8 - 27, 1961

GUILLERMO WIEDEMANN OF COLOMBIA: OILS AND WATERCOLORS

Guillermo Wiedemann was born in Munich, Germany, in 1905. He has resided in Colombia since 1939 and for the past sixteen years he has been a Colombian citizen. Moreover, although he began his professional training in his native city, the most important developments in his artistic career have taken place in the country of his adoption. Upon arrival there, he became greatly interested in Colombian scenes and folklore and devoted a large part of his output to depictions of local types. Later, in his search for a personal style, he began to abandon contact with nature, treating his subjects in an increasingly abstract fashion, until he achieved the complete non-objectivity which currently characterizes his work.

Wiedemann has had six one-man shows in Colombia and has participated in numerous salons and other exhibitions there, winning several awards. In 1946 he had individual exhibits at the Carstairs Gallery in New York and the museums of San Francisco and Pasadena in California. In 1950 the Hielscher Gallery made an extensive presentation of his work in Munich. Wiedemann has also taken part in the São Paulo, Venice, and Mexico City biennials and in other important international shows. This is the first exhibit of his paintings to take place in the Washington area.

CATALOGUE

Oils

1. *Fantasía (Fantasy)*
2. *Ritmo (Rhythm)*
3. *Signo (Signal)*
4. *Formas (Forms)*
5. *Metamorfosis (Metamorphosis)*
6. *Composición (Composition)*
7. *Subir (Ascension)*
8. *Rojo (Red)*
9. *Círculo (Circle)*
10. *Sombras (Shadows)*

Watercolors

11. *Líneas y colores (Lines and Colors)*

[1] Titles are unavailable. —*Ed.*

12. *Formas (Forms)*
13. *Composición (Composition)*
14. *Formas sobre fondo rosado (Forms on Red Background)*[1]
15. *En la sombra (In the Shade)*
16. *Formas y colores (Forms and Colors)*
17. *Rayos (Rays)*
18. *Pintura roja (Red)*
19. *Ritmos (Rhythms)*
20. *Sombras (Shadows)*
21. *Allegro*
22. *Vuelo (Flight)*
23. *Juego (Play)*
24. *Diálogo (Dialogue)*
25. *Crepúsculo (Twilight)*
26. *Fuga (Fugue)*
27. *Cuento (Story)*
28. *Sin título (Untitled)*
29. *Concentración (Concentration)*
30. *Sueño (Dream)*
31. *Grises (Graces)*[1]
32. *Movimiento lento (Slow Motion)*
33. *Contraste (Contrast)*

November 28 - December 14, 1961

JORGE PAEZ OF URUGUAY: OILS

A personality newly emergent upon the artistic scene in Uruguay is that of Jorge Páez, born in Montevideo in 1921.

Páez claims to be self-taught, but in 1948 he frequented the workshop of the well-known Uruguayan painter Vicente Martín and a decade later, after a period in which he all but abandoned painting, he enrolled in the classes of Lino Dinetto, an Italian artist then resident in Montevideo. In the last few years he has actively engaged not only in artistic creation but also in promoting exhibitions, founding galleries, and writing art criticism for the Uruguayan press.

Páez has participated in salons in his native country since 1957, and in Uruguayan group shows in Buenos Aires and São Paulo. He was represented in the *South American Art Today* exhibit at the Dallas Museum in 1959, and in July of this year he had his first one-man show at the Pizarro Gallery in Buenos Aires. Upon this last mentioned occasion, Hugo Parpagnoli, the art critic of *La Prensa*, described Páez's paintings as "alive, of mobile quality, and communicative."

This is the first presentation of the work of Jorge Páez in the Washington area.

[1] Literal translation of No. 14 is "Forms on Pink Background" and of No. 31 is "Grays." —*Ed.*

CATALOGUE

Oils on Canvas

1. *Cabeza cósmica (Cosmic Head)*, 81 x 100 cm.
2. *Humanidad (Humanity)*, 50 x 70 cm.
3. *Hombre (Man)*, 80 x 100 cm.
4. *Visión de playa (Vision of the Beach)*, 100 x 75 cm.
5. *Hombre (Man)*, 80 x 100 cm.
6. *Cosmos I*, 75 x 100 cm.
7. *Paisaje (Journey)*, 80 x 100 cm.
8. *Playa de astros (Celestial Bodies)*, 100 x 80 cm.
9. *Playa de flores (Flowers)*, 100 x 80 cm.
10. *Cosmos II*, 82 x 100 cm.
11. *Niña (Little Girl)*, 60 x 83 cm.
12. *Naturaleza (Nature)*, 81 x 60 cm.
13. *Cosmos III*, 60 x 81 cm.
14. *Criatura y mundo (Creature and World)*, 61 x 50 cm.

December 4, 1961 - January 15, 1962

ANA MARIA MONCALVO OF ARGENTINA: ENGRAVINGS

Ana María Moncalvo was born in Buenos Aires in 1921. She studied at the Ernesto de la Cárcova Art School where she acquired a degree in engraving. She began exhibiting in 1941 at the official art salons and in 1945 was awarded the Mitre Prize for her engravings.

Moncalvo has traveled extensively in South America, Europe, and North Africa.

Her recent exhibitions have been at the Galería Galatea and Galería Heroica in Buenos Aires and in La Paz, Bolivia, and Madrid, Spain.

In 1959 she was awarded the First Prize of Honor at the Salón de Córdoba and again that year the Second Prize in the Bienal del Magisterio. In 1960 she was awarded the Acquisition Prize at the Salón de Mar del Plata. This is the first exhibit of Moncalvo's work in the Washington area.

CATALOGUE

1-15. Engravings[1]

[1] Titles are unavailable. —*Ed.*

December 15, 1961 - January 8, 1962

YOUNG PERUVIAN ARTISTS: OILS

A new generation of artists has emerged in Peru in recent years, constituted for the most part by graduates of the National School of Fine Arts in Lima. While they have taken a variety of directions in their work, the general trend may be said to be toward abstraction.

The current exhibition puts on view for the first time in the United States compositions by some of these young Peruvians who are just initiating their professional careers. It was assembled by the Association of Students and Graduates of the Lima School of Fine Arts, and appreciation is here expressed to the director of the School, Juan Manuel Ugarte Eléspuru, for his cooperation in making this presentation possible.

CATALOGUE

Oils

Alfredo Ayzanoa
 1. *Personaje mítico (Mythological Personage)*, 70 x 100 cm.
 2. *Pintura (Painting) No. 1*, 89 x 116 cm.

Alfredo Basurco
 3. *Abstracción (Abstraction) No. 1*, 46 x 123 cm.

Miguel Angel Cuadros
 4. *Areas azules (Blue Zones)*, 116 x 81 cm.
 5. *Zona en transformación (Transparent Zones)*,[1] 89 x 116 cm.

Enrique Galdós
 6. *Serranas (Women of the Highlands)*, 120 x 85 cm.
 7. *Bodegón (Still Life)*, 85 x 66 cm.

Dante Gavidia
 8. *Cosmic Nature*, 90 x 116 cm.
 9. *Ovidean Constellation*, 69 x 64 cm.

Arturo Kubotta
10. *Sinfonía azul (Blue Symphony)*, 54 x 65 cm.
11. *Fuerza atávica (Atavic Force)*, 54 x 116 cm.
12. *Necrópolis (Necropolis)*, 45 x 100 cm.

José Milner
13. *Pintura (Painting) No. 3*, 64 x 94 cm.
14. *Ancestro (Ancestor) No. 3*, 50 1/2 x 65 cm.

Alberto Quintanilla
15. *Charango y pájaro (The Charango and Bird)*, 65 x 81 cm.
16. *Perritos (Little Dogs)*, 67 x 58 cm.

[1] Literal translation of this title is "Zone in Transformation." —*Ed*.

17. *Perro y luna (Dog and Moon)*, 120 x 85 cm.
18. *Bodegón (Still Life)*, 66 x 54 cm.

Alberto Ramos
19. *Mujer con abanico (Woman with Fan)*, 81 x 65 cm.
20. *Casas (Houses)*, 81 x 65 cm.
21. *Figuras (Figures)*, 101 x 54 cm.

Oswaldo Sagástegui
22. *Pintura (Painting) No. 1*, 81 x 65 cm.
23. *Pintura (Painting) No. 2*, 150 x 70 cm.

Tilsa Tsuchiya
24. *Gatos (Cats)*, 74 x 61 cm.
25. *Mujer con sandía (Woman)*,[1] 81 x 64 cm.

BIOGRAPHICAL NOTES[2]

AYZANOA, Alfredo. Painter, born in Tarma, Peru, 1932. Studied at the Escuela Nacional de Bellas Artes, graduating with Gold Medal, Lima, 1960. Held individual exhibitions in Lima. Participated in group exhibitions including biennials in Paris (1959) and São Paulo (1961).

BASURCO, Alfredo (Alfredo González Basurco). Painter, printmaker, born in Arequipa, Peru, 1926. Graduated from the Escuela de Bellas Artes with Gold Medal, Lima, 1959. Was awarded a scholarship to study in France. Won First National Prize for Painting, Lima, 1959, and Honorable Mention for Print, Second Inter-American Biennial of Painting and Printmaking, Mexico, 1960.

CUADROS, Miguel Angel. Painter, draftsman, born in Lima, 1928. Graduated from the Escuela Nacional de Bellas Artes with honors, Lima, 1956. Held individual exhibitions in Lima, including the Instituto de Arte Contemporáneo, 1960-61. Participated in national group exhibitions and international shows, including the Sixth São Paulo Biennial, 1961.

GALDOS RIVAS, Enrique. Painter, draftsman, graphic artist, born in Lima, 1933. Graduated from the Escuela Nacional de Bellas Artes with Gold Medal, Lima, 1959. Traveled to Brazil under a Brazilian scholarship. Held individual exhibitions in Lima and Rio de Janeiro. Participated in national and international shows, including the Biennial of Paris (1959 and 1961) and of São Paulo (1961). Was awarded several prizes, including the First National Prize, Fomento a la Cultura, Lima, 1960.

GAVIDIA CAMPOS, Dante. Painter, draftsman, printmaker, graphic artist, born in Lima, 1927. Studied at the Escuela Nacional de Bellas Artes in Lima, receiving a Diploma of Honor for Drawing, 1951, and graduating with Silver Medal, 1959. Created a comic strip, *Tradiciones de Don Ricardo Palma*, in the newspaper *El Comercio*, and is an illustrator in other newspapers. Participated in several Peruvian group shows. Was awarded First Prize, Congreso de Empleados del Perú, Lima, 1952.

QUINTANILLA, Alberto. Painter, born in Cuzco, Peru, 1934. Graduated from the Escuela Nacional de Bellas Artes with Gold Medal, Lima, 1959. Traveled to Paris under a French scholarship. Held individual exhibitions in

[1] Literal translation of this title is "Woman with Watermelon." —*Ed.*

[2] Not included in the original catalogue. See Index of Artists for reference on those not listed here. —*Ed.*

Lima. Participated in national group exhibitions and the First Biennale de la Jeunesse, Paris, 1959.

RAMOS MINAYA, Alberto. Painter, born in Arequipa, Peru, 1930. Graduated from the Escuela Nacional de Bellas Artes with Diploma of Honor and Silver Medal, Lima, 1961. Participated in several group exhibitions in Lima.

SAGASTEGUI, Oswaldo. Painter, born in Huánuco, Peru, 1936. Graduated with Gold Medal from the Escuela Nacional de Bellas Artes, Lima, 1959. Exhibited in Peru.

TSUCHIYA, Tilsa. Painter, born in Supe, Peru, 1936. Graduated from the Escuela de Bellas Artes with Gold Medal, Lima, 1959. Participated in national group exhibitions and the First Biennale de la Jeunesse, Paris, 1959.

YEAR 1962

January 9 - 28, 1962

FLORENCIO GARAVAGLIA OF ARGENTINA: OILS

Despite a professional career extending back for a very considerable number of years, Florencio Garavaglia may be viewed as representative of the younger generation of Argentine artists, since he is a leading advocate of the movement prevalent among them: informalism. Its practitioners, abhorring strict technical canons, allow the elements in a picture to flow freely throughout the canvas and beyond, in an open form of composition which rejects even the limitations of a frame. The medium used is generally a thick impasto of sand, asphalt, or cement—occasionally other materials—employed to provide tactile appeal. Color is indefinite; the tendency is to the somberly neutral, the dexterity of the artist being demonstrated by subtle nuances and modulation of tones.

Garavaglia was born in Buenos Aires in 1916 and studied at the Higher School of Fine Arts in that city. From 1942 to 1947 he traveled throughout Latin America, exhibiting his work in a number of countries. He has had one-man shows in Buenos Aires since 1951, and examples of his work have been included in the more important group exhibitions held in Argentina during the last twelve years. A particularly significant exhibit of his work was given at the Casa Veltri Gallery in Buenos Aires early in 1951.

In addition to his activity as a practicing artist, Garavaglia has been commissioned by the Ministry of Education of Argentina to lecture and organize exhibitions for presentation in the provinces.

This is the first exhibit of Garavaglia's work to be shown in the United States.

CATALOGUE

Oils on Canvas, 1960 and 1961

 1-3. *Pintura (Painting)*, 45 x 100 cm.
 4-5. *Pintura (Painting)*, 55 x 100 cm.
 6-8. *Pintura (Painting)*, 70 x 100 cm.
 9-14. *Pintura (Painting)*, 55 x 125 cm.
15-19. *Pintura (Painting)*, 70 x 125 cm.
20-23. *Pintura (Painting)*, 70 x 150 cm.

January 29 - February 14, 1962

RUGS DESIGNED BY ARTISTS OF THE AMERICAS AND EXECUTED, INTERPRETED, AND SUPERVISED BY GLORIA FINN OF THE UNITED STATES

The technique of the hooked rug, in which virgin wool is worked with a punch needle into a linen base stretched upon a frame, is widely practiced as a folk craft, but has rarely attained the artistic level here exhibited in the compositions of Gloria Finn.

A native New Yorker, Finn took up the craft as a hobby in 1952 and, though self-taught, rapidly achieved great technical proficiency, employing as many as fifteen or twenty different colors in her rugs, in a variety of textures and reliefs. Having a great interest in modern painting, Finn early in her career asked United States artists of her acquaintance to design for her. The resulting rugs were so maturely professional that she was soon invited to exhibit at institutions such as the Borgenicht Gallery in New York (1954), the Baltimore Museum of Art (1955), and the De Cordova Museum in Massachusetts (1955). Later a show of her work was circulated in the United States under the auspices of the American Federation of Arts. The E. I. du Pont de Nemours Company of Wilmington, Delaware, next commissioned Finn to prepare special designs for an exhibit which was circulated by the Smithsonian Institution, and the United States Information Agency requested her to provide examples of her work for a show that has been extensively displayed abroad and is still on exhibition.

Becoming interested in new trends in art in the Americas, Finn traveled to Mexico and Cuba in 1957 and, as a result of the impressions she received there, she has from time to time requested abstractionists who have exhibited at the Pan American Union to prepare designs which she has later executed at her Washington studio.

More recently Finn has enlarged the scope of her activity by giving instruction in her craft to underprivileged girls of the southern Italian village of Sermoneta. Under her expert guidance, the girls have created rugs for this and other exhibitions. Those here on view were first displayed at Gallery 88 in Rome four months ago.

It is only fitting that they now be shown at the institution which provided the environment for the development of Finn's art, the Pan American Union.

CATALOGUE

Rugs designed by:

 1. José Bermúdez, Cuba
 2. Roberto Burle Marx, Brazil
 3. Mario Carreño, Cuba
 4. Robert Goodnough, United States
 5. Luis Martínez Pedro, Cuba
 6. Carlos Mérida, Guatemala
 7. Hans Moller, United States
 8. Alejandro Otero, Venezuela
 9. María Luisa Pacheco, Bolivia
10. Amelia Peláez, Cuba
11. Eduardo Ramírez, Colombia
12. Manuel Rendón, Ecuador
13. Humberto Jaimes, Venezuela

BIOGRAPHICAL NOTES[1]

BERMUDEZ, José Y. Painter, sculptor, draftsman, born in Havana, 1922. Studied under Roberto Diago in Havanna (1952-53) and at the Bell School, Washington, D.C. (1961). Exhibited in Cuba and the United States, including the Martha Jackson Gallery of Art, Washington, D.C (1961). Was awarded a prize for painting in Havana (1953).

[1] Not included in the original catalogue. See Index of Artists for reference on those not listed here.—*Ed.*

February 15 - March 5, 1962

MANUEL JIMENEZ OF PERU: OILS, DRAWINGS, COLLAGES, AND GOUACHES

As a complement to the exhibit of young Peruvian artists presented recently at the Pan American Union, this exhibition features the work of another newcomer to the professional painting in Peru. Manuel Jiménez Sologuren was born in Lima in 1935. A born artist he has shown his inclination toward painting since early childhood. He attended the School of Fine Arts in Lima between 1952 and 1953, at which time his formal training ended and he began earning his livelihood as a commercial artist. Three years ago Jiménez abandoned this sideline completely and devoted his talent to purely creative painting. He held a one-man show in Lima early in 1961 in the Art Center, and his work was included in a group show titled *Treasures from Peru*, organized by the Peruvian government and sent to Mexico and Japan in 1960. Jiménez's work is represented in private collections in Lima, Buenos Aires, and New York.

Attracted by the vigor of the new American painting, the young Peruvian artist last year came to the United States and presently resides in New York City, where most of the work included in this exhibition, which is his first one-man show in the United States, has been produced.

CATALOGUE

Oils

1. *Amarillo en movimiento (Yellow in Movement)*, 1960, oil on canvas, 51 1/2 x 65 1/2"
2. *Ascendente (Ascendant)*, 1960, oil on canvas, 59 x 77"
3. *Blue Square*, 1961-1962, oil on canvas, 50 x 40"
4. *Bull*, 1961, oil on canvas, 50 x 56"
5. *Catarata (Cataract)*, 1960, oil on masonite, 48 x 63"
6. *Chosica*, 1960, oil on masonite, 48 x 45"
7. *Door to a Little Temple*, 1961, oil on cardboard, 9 x 13 1/2"
8. *Encounter*, 1961, oil on cardboard, 8 1/2 x 9 1/2"
9. *Falling Bird*, 1962, oil on canvas, 58 x 50"
10. *For Gregory Corso*, 1961, oil on canvas, 60 x 50 1/2"
11. *Green Lake*, 1961, oil on canvas, 48 x 40"
12. *Knight*, 1961, oil on cardboard, 19 1/2 x 30"
13. *Mask*, 1961, oil on cardboard, 40 x 30"
14. *River*, 1961, oil on canvas, 54 x 54"
15. *Reverse*, 1961, oil on canvas, 51 x 70"
16. *Show Window on 3rd. Avenue*, 1961, oil on canvas, 40 x 30"
17. *Untitled Composition*, 1960, oil on canvas, 65 1/2 x 56 1/2"
18. *Untitled Composition*, 1961, oil on cardboard, 29 x 21"

Drawings, Collages, and Gouaches

19. *After the Tide*, 1961, ink on paper
20. *Backyard Flower*, 1961, ink on paper
21. *Black Bone*, 1961, ink on paper
22. *Idol*, 1961-62, colored ink, watercolors and oil
23. *Pour Csopi*, 1961, collage
24. *Saturday Rain*, 1961, colored ink, watercolors and gouache
25. *The Bridge*, 1961, collage
26. *They All Think about the White Line*, 1961, collage
27. *Under the Wheel*, 1961, collage
28. *Water Sounds*, 1961, watercolors and gouache
29. *Windmill*, 1961, ink drawing

February 15 - March 12, 1962

DRAWINGS BY LUCIEN PRICE
AND SCULPTURES BY PHILIPPE STERLIN OF HAITI

Several friends of the artist Lucien Price have brought to Washington drawings that the artist executed before 1951, the year in which he was interned in a mental asylum in Haiti, where he remains. He has not produced any work since then.

Price was born in Port-au-Prince, Haiti, in 1914. He studied in his native city and in Paris. When the Art Center in Port-au-Prince was founded, he was assigned as professor of drawing. There he held his first one-man show in 1947. His drawings have also been included in numerous group shows of Haitian art both in his native country and France, Germany, Mexico, and the United States.

Also shown with this exhibition are three wooden sculptures by a fellow-Haitian, Philippe Sterlin, through whose cooperation the showing of the works of Lucien Price was made possible.

CATALOGUE

Lucien Price

Drawings

1. *Champ de Cannes*
2. *Flowers*
3. *Formes (Forms)*
4. *Spirit*
5. *Woman*
6. *Acrobat with His Hands Cut Off*
7. *Market Woman with Luminous Hands*
8. *Coffee Carrier*
9. *Without Breeches*
10. *Study of a Peasant Dance*
11. *Chrysalides*
12. *Chant d'Afrique (Song of Africa)*
13. *Self-Portrait* (the only self-portrait of Lucien Price who was born on Christmas Eve)

Philippe Sterlin

Sculptures

1. *Aida Woedo*, October 1960
2. *Narcisse*, November 1960
3. *Dieu Tombe (God Falls)*, December 1960

March 12 - 22, 1962

VICENTE FORTE OF ARGENTINA: OILS

An outstanding personality in the generation of Argentine artists now in their late forties or early fifties is that of

Vicente Forte. Born in 1912 in Lanús, a suburb of Buenos Aires, he studied at a cooperative art school in the nearby capital. Developing into a theoretician of painting, Forte wrote a number of texts, lectured extensively throughout his country, and in 1935 was appointed professor at the National Academy of Fine Arts. In 1938 he adhered to the group known as *Orión*, which gathered together nearly all the important painters and sculptors of his generation. During the years from 1943 to 1946, he studied with the great Argentine cubist Emilio Pettoruti. Forte absorbed the sobriety of palette and clarity of form which mark Pettoruti's style but developed these characteristics along highly personal lines. In 1948 he held his first one-man show at the Van Riel Gallery in Buenos Aires. A year later he went to Europe for the first time. Upon his return, he began to receive important awards at salons and group shows—due recognition of the leading position he had achieved in Argentine painting. In 1961 Forte journeyed to Brazil, presenting exhibits of his compositions at the Museum of Modern Art in São Paulo and the Barcinski Gallery in Rio de Janeiro. He also exhibited in Buenos Aires at the Rubbers Gallery, which is the exclusive representative for his work.

The current presentation is Forte's first one-man show in the United States.

CATALOGUE

Oils

1. *Lámpara y fuente (Lamp and Fountain)*
2. *Frutera y pescado (Bowl of Fruit with Fish)*
3. *Pájaro y jaula (Bird and Cage)*
4. *Jaula y fuente (Cage and Fountain)*
5. *Las garrafas (Carafes)*
6. *Table with vase*
7. *Mesa con jaula (Table with Cage)*
8. *Mesa de pescados (Table with Fish)*
9. *La lámpara (The Lamp)*
10. *Naturaleza muerta (Still Life)*
11. *Mesa vertical (Vertical Table)*
12. *Vertical*
13. *Mesa con objetos (Table with Objects)*
14. *El violón (The Bass Viol)*
15. *The Bucket*
16. *El pájaro (The Bird)*
17. *Objetos (Objects)*
18. *Fuente y mesa (Fountain and Table)*
19. *Horizontal*
20. *Trucha (Trout)*

March 23 - April 12, 1962

ARMANDO MORALES OF NICARAGUA: OILS

Five years ago the Pan American Union presented a group show of contemporary Nicaraguan art which attracted wide attention. The figure of greatest significance to emerge from that exhibition was that of Armando Morales, both because of the intrinsically high quality of his work and because of the strikingly individual personality which it revealed.

Morales was born in 1927 in Granada, Nicaragua. His education at the local Jesuit school was along rigid, humanistic lines. Although Morales was interested in painting from his youth, his professional training did not begin until 1950, at the Managua School of Fine Arts. There, under the guidance of its director, the painter Rodrigo Peñalba, he started to develop his ability to work with a large palette and soon demonstrated a capacity for handling vibrant, vigorous colors with chromatic subtlety and in a distinctively individual style.

Since 1953 he has participated in group exhibitions throughout the hemisphere, receiving prizes at the Second Biennial of Spanish American Art in Havana (1954) and at the *Gulf Caribbean Art Exhibition* of Houston (1956). In 1956 Morales obtained the main award in a Central American art contest held in Guatemala. In 1959 he was awarded the prize for the Best Latin American Painter at the Fifth São Paulo Biennial. Three years ago he received a two year fellowship from the John Simon Guggenheim Memorial Foundation for study at the Pratt Graphic Art Center. During the current year Morales has held one-man shows at the Jerrold Morris Gallery in Toronto and at the Angeleski Gallery in New York. His last presentation in a group show was in the exhibition *Latin America - New Departures*, organized by the Institute of Contemporary Arts.

Examples of Morales's work are to be found in the Museum of Modern Art of New York, the Museum of Fine Arts of Houston, the Museum of Modern Art of São Paulo, the Museum of Inter-American Art in Cartagena (Colombia), and the Institute of Contemporary Art in Boston. He is also represented in many private collections in the United States, Canada, and Latin America. This is Armando Morales's first one-man show in Washington.

COMMENTARIES

The painting of Armando Morales is the plastic expression of equilibrium between a feverish artistic passion and a disciplined technical control. . . .

Accordingly, though from Nicaragua, his work is unmistakably within the great Spanish tradition. The literary associations are Calderón, Lope de Vega, Teresa de Avila, Unamuno, Pío Baroja, and, above all, García Lorca. The pictorial associations are Velázquez, Goya, El Greco, Picasso, Gris, the New Spanish school

"A statement, I think, should not be uttered in a rough or immodest way . . . ," Morales has written. "In the last steps of making a painting I do not emphasize or add things; instead, I hide and cover them up. My painting is the result of a purifying work in search of sobriety and austerity." —*Emilio del Junco*, President, Jerrold Morris International Gallery Ldt., Toronto, Canada.

Morales is an engaging if stern young painter who in spite of his prolonged stay in New York City has maintained an almost haughty independence from local currents. His form-language is based on curvilinear constructions utilizing a subdued and sombre monochrome. . . . Subject, theme, idea, and form are fused into a unity that is rich in metaphysical content. Death is ever present. That death, of Spanish-Indian origin, breaks out in the painter's content and form, in his writing and his conversation. —*Thomas M. Messer*, Director, The Guggenheim Museum, New York.

CATALOGUE

Oil on Canvas

1. *Guerrillero muerto (Dead Warrior) VIII*, 1962, 64 3/4 x 40"
2. *Requiem II*, 1962, 64 3/4 x 40"
3. *Guerrillero muerto (Dead Warrior) IX*, 1962, 64 3/4 x 40"
4. *Naturaleza muerta (Still Life)*, 1962, 25 x 40"
5. *Figura sentada (Seated Figure)*, 1961, 25 x 40"
6. *Hombre sentado (Seated Man)*, 1962, 25 x 40"

7. *Prostituta muerta (Dead Prostitute)*, 1962, 25 x 40"
8. *Estudio de cráneo quemado (Study of a Burned Skull)*, 1961, 20 x 32"

Oils on Cardboard

9. *Tauromaquia (Bullfighting) II*, 1960, 19 1/2 x 23 1/2"
10. *Tauromaquia (Bullfighting) VII*, 1960, 16 x 20"
11. *Tauromaquia (Bullfighting) VIII*, 1960, 16 x 20"
12. *Sol muerto (Dead Sun)*, 1960, 16 x 20"
13. *Pirañomaquia I*, 1960, 16 x 20"
14. *Requiem I*, 1961, 16 x 20"
15. *Guitarra nocturna (Nocturnal Guitar)*, 1960, 16 x 20"
16. *Sirena fluvial (Fluvial Siren)*, 1960, 16 x 20"
17. *Guitarra (Guitar)*, 1960, 16 x 20"
18. *Manaus nocturno (Nocturnal Manaus)*, 1960, 16 x 20"
19. *Responsos (Litany)*, 1960, 13 x 20"
20. *Seascape*[1]
21. *Requiem III*[1]
22. *Guerrillero (Warrior)*[1]
23. *Skull*[1]

April 3 - May 3, 1962

BRAZILIAN WOODCUTS FROM THE STATE OF RIO GRANDE DO SUL[2]

Press Release No. 44, Brazilian Embassy, Washington, D.C., March 28, 1962. President João Goulart of Brazil shall open an exhibit of Brazilian woodcuts from the State of Rio Grande do Sul during his official visit to the Pan American Union, on April 3, 1962. After addressing the Council of the Organization of American States, President Goulart will review the works presented by several artists from his home State of Rio Grande do Sul.

This exhibit has been organized by the Brazilian Embassy in Washington, in combination with the Brazilian Delegation to the OAS and the Visual Arts Department of that organization. It is a selection of valuable woodcuts by artists Vasco Prado, Zoravia Bettiol, Danubio Vilamil Gonçalves, Ediria Carneiro, Joel Amaral, Francisco Riopardense de Macedo, and Francisco Stockinger.

Vasco Prado was born in Uruguaiana in 1914 and was a student of Fernand Léger in Paris. He participated in exhibits of Brazilian engravers in New York, Paris, Lisbon, Moscow, Peking, Prague, Montevideo, and Viña del Mar (Chile). Prado has won several prizes in Brazil and abroad and is also active and well known as a sculptor.

Zorávia Bettiol was born in Pôrto Alegre in 1935. A pupil of Prado, she has also exhibited with success in Brazil and Uruguay. She was awarded several state prizes and also works with tapestry.

Danubio Gonçalves was born in Bagé in 1925 and has participated in many exhibits in South America. He has won several prizes, including a travel prize, achieved through his valuable work in engraving. He has been active in mosaics too.

[1] Not included in the original catalogue but also exhibited. —*Ed.*

[2] The list of works exhibited is unavailable. —*Ed.*

Ediria Carneiro is a native of Bahia, but she has been living in Pôrto Alegre for a long time. She studied with Santa Rosa and Goeldi and has participated with success in several national exhibits.

Joel Amaral, born in Livramento in 1918, came to Pôrto Alegre in 1949. He has paintings in several museums in Brazil as a result of the many medals and prizes won at national and Latin American exhibits.

Francisco de Macedo was born in Pôrto Alegre in 1921 and is also a civil engineer and professor at the University of Rio Grande do Sul. He won several prizes and is the author of a book on Rembrandt, which received an award.

Francisco Stockinger, who was born in Austria in 1919, came to Brazil at the age of three. He studied in Rio and obtained several medals at the National Salon of Fine Arts for his sculptures. In 1955 he moved to Pôrto Alegre and has been devoting his attention to wood engraving.

All of the artists whose work is on the present exhibit are from what is known as the school of Pôrto Alegre, the capital of the southern most state of Brazil. Notice in particular the egrets of Prado and Stockinger, the coal mining series of Gonçalves, and the gauchos of Bettiol. It is hoped that this selective exhibit, which will have the honor to be opened by President Goulart, will provide a source of inspiration to American art lovers and contribute to a better artistic understanding between our two peoples.

April 13 - May 6, 1962

NEO-FIGURATIVE PAINTING IN LATIN AMERICA: OILS

Among the interpretations given to the abstract tendency in art by its champions and its foes alike is that it represents an escape from reality. The artist sets forth in search of the undiscovered realm that lies within him or, in revulsion or indifference, rejects his surroundings, seeking to become the god of a world of his own creation. Whatever view one may take in their regard, non-objective painters and sculptors have flourished in the last decade and a half, and even their detractors admit that through total abstraction the artist has achieved a new freedom in the handling of media and in the concept of composition.

Of late, the human figure has begun to return from the banishment to which it had been consigned. There were always, of course, artists who remained untouched by non-objective tendencies continuing to take recognizable reality as their point of departure, but now everywhere there are appearing others who, while taking advantage of the technical freedoms of the abstractionists, nonetheless seek expression through the human form. Among them, for examples, is the French painter Jean Dubuffet, with his excursions into what his compatriots call *l'art brut*. A large number has also emerged in the United States. Their work, profoundly expressionistic in tone, generally evidences the anguish, doubt, or horror which they see as besetting the men of our time. By comparison, previous experiments in expressionism, such as those made in Germany in the early years of this century, or the work of Chaim Soutine, seem milder, maintaining a certain balance among forms, and avoiding thereby the brutal distortion that leads to total disintegration. Among the various groups in the United States, special emphasis should be given to the so-called schools of Chicago and California, and certain compositions of the New Yorker Willem de Kooning are milestones of great significance.

At the same time that the tendency has flourished in the United States, followers of some standing have also appeared in Latin America. Mexico is the forerunner in this regard, offering the example of certain phases of the work of Tamayo and Orozco, not to speak of José Luis Cuevas, one of the most influential neo-figurative artists in the hemisphere.

The current exhibition offers a drawing by Cuevas with the preparatory studies which provide a valuable insight

into his creative processes. It also includes works by leading painters of Argentina, Colombia, Nicaragua, and Panama, all of whom, in treating the human figure, envelope it in the uncertainty or despair which they find characteristic of our age. The exhibit does not pretend to be comprehensive: it aims merely to call attention to the trend by displaying examples from the work of artists now active in Latin America. Considerations of space motivated the exclusion of artists from north of the Rio Grande, as at least a dozen thereof would have to appear if coverage were to be in any degree representative.

This is the first time that any of the works here exhibited have been on view in the United States.

CATALOGUE

Paintings and Drawings

Rómulo Macció (Argentina)
 1. *Quartet*, oil on canvas

Carolina Muchnik (Argentina)
 2. *Figures*, oil on canvas

Luis Felipe Noé (Argentina)
 3. *Chacota* (Racket), oil on canvas

Jorge de la Vega (Argentina)
 4. *Adam and Cain*, oil on canvas

Fernando Botero (Colombia)
 5. *Bishop*, oil on canvas

Carlos Granada (Colombia)
 6. *Women with Flower*, oil on canvas

José Luis Cuevas (Mexico)
 7. *Reclining Nude*, ink drawing on canvas with oil additions
 8. *Sketches for the Reclining Nude*, ink drawing on paper

Armando Morales (Nicaragua)
 9. *Guerrillero muerto (Dead Guerrillero)*, oil on canvas. Coll. Mr. Ramón Osuna, Washington, D.C.

Alberto Dutary (Panama)
10. *Totem Game*, oil on canvas

Guillermo Trujillo (Panama)
11. *Soledad (Loneliness)*, oil on canvas

BIOGRAPHICAL NOTES[1]

MUCHNIK, Carolina. Painter, born in Gualeguaychú, Entre Ríos, Argentina. Studied in Europe, where she associated with several art groups. Held individual exhibitions in Paris, Brussels, and Buenos Aires. Participated

[1] Not included in the original catalogue. See Index of Artists for reference on those not listed here. —*Ed.*

in national and international group shows, including *Muestra Internacional de Arte Moderno* in 1960 and *Otra Figuración* in 1961, both in Buenos Aires, and at the Museu de Arte Moderna, Rio de Janeiro, 1961.

NOE, Luis Felipe. Painter, draftsman, born in Buenos Aires, 1933. Studied under Horacio Butler, 1952. Was granted a French scholarship to live and paint in Paris, 1961. Was art critic for the newspaper *El Mundo*, 1956. Founding member of the group *Nueva Figuración*, participated in all its exhibitions (1961-65) held in Buenos Aires, Montevideo, and the Museu de Arte Moderna, Rio de Janeiro. Exhibited individually in Buenos Aires. Participated in Argentine group shows held at the Museo de Arte Moderno in Mexico City and the Instituto de Arte Contemporáneo of Lima, 1960; Institute of Contemporary Art in London and Museu de Arte Moderna of Rio de Janeiro, 1961. His participation in international shows include *Exposición Internacional de Arte Moderno*, Buenos Aires, 1960; Paris Biennial, 1961; and *Latin American Art* in Paris, 1962. Won an award at the annual Premio Ver y Estimar salon, Buenos Aires, 1961.

May 10 - June 3, 1962

MANABU MABE OF BRAZIL: OILS

The artistic career of Manabu Mabe has been meteoric in its rapidity and brilliance. Four years ago he was virtually unknown, but 1959, as *Time* put it, was the year of Manabu Mabe. In the course of a few months he received the principal award at the São Paulo Salon of Contemporary Art, the First Prize for a Brazilian Painter at the Fifth São Paulo Biennial, and the Braun Award for the best painter in oils at the First Paris Biennial. Since that time he has continued to garner honors and has secured an international reputation as one of the most important younger painters of today.

Mabe was born in Kumamoto, Japan, in 1924. He began the study of painting at primary school in his native country, but the financial situation of his family forced him to abandon his classes. In 1934 the family emigrated to Brazil, finding work on the coffee plantations of the State of São Paulo. In his spare time Mabe practiced painting and the art of calligraphy. He established a small home industry, producing hand-painted neckties, doilies, and napkins, which he sold to department stores in São Paulo or hawked in person on the streets of that city.

Mabe figured in the group show *Japanese Artists of the Americas* held at the Pan American Union last year, but this is the first individual presentation of his work in the United States.

CATALOGUE

1-15. Oils[1]

June 12 - 26, 1962

CARLOS GRANADA OF COLOMBIA: OILS AND DRAWINGS

Carlos Granada was born in Hondo, Colombia, in 1933 and is representative of the new generation of artists of that country. He studied at both the School of Fine Arts of Bogotá, Colombia, and of Madrid, Spain, where he consequently participated in numerous group shows obtaining special awards. In 1958 he was represented in the

[1] Titles are unavailable. —*Ed*.

Biennial of Venice.

Granada has held one-man shows in Bogotá, Rome, and Madrid. A painting by him was included in the exhibition at the Pan American Union last month, *Neo-Figurative Painting in Latin America*, however, this constitutes his first one-man show in the United States.

CATALOGUE

Oils

1. *Flores azules para una muerta (Blue Flowers for a Dead Woman)*
2. *Variación sobre un tema de Goya (Variation of a Goya Subject)*
3. *Segunda transformación (Second Transfiguration)*
4. *Flores para un niño blanco (Flowers for a Child in White)*
5. *Crimen pasional (Crime of Passion)*
6. *Muerte y transfiguración de Pedrito Chamorro (The Death and Transfiguration of Pedrito Chamorro)*
7. *El paso de la laguna Estigia (Crossing Lake Estigia)*
8. *La masacre de los inocentes (The Massacre of the Innocents)*
9. *Trágica muerte de Concepción (The Tragic Death of Conception)*
10. *A la memoria de Gregorio—Kafka: La Metamorfosis (In Memory of Gregory—Kafka: The Metamorphosis)*

Drawings

11. *Juegos de amor y de azar (Gambling with Love and Hazard)*
12. *Masacre, Sevilla, 19 de julio de 1936 (Massacre, Seville, 19 July 1936)*
13. *Masacre, Pamplona, 22 de julio de 1936 (Massacre, Pamplona, 22 July 1936)*
14. *Hacinamiento de los justos (Mass Burial of Honest Men)*
15. *Parto póstumo de Segunda (The Posthumous Birth of Segunda)*
16. *Variación sobre el amor (Variation about Love)*
17. *Juego de azar (Hazardous Game)*
18. *Fusilamiento (Firing Squad Execution) No. 1*
19. *Fusilamiento (Firing Squad Execution) No. 2*

June 19 - August 1, 1962

MI PUEBLO, PHOTOGRAPHS BY MANUEL CARRILLO OF MEXICO[1]

Press Release No. E-441/62, Pan American Union, Washington, D.C., June 17, 1962. A collection of eighty photographic studies in black and white by the Mexican photographer Manuel Carrillo will be exhibited in the Visual Arts Gallery of the Pan American Union. . . .

The eighty photos in the current exhibit known as *Mi Pueblo* (My People) are character studies of Indian Mexico. Most of the settings are laid in small towns and country classrooms. They depict the life of the Mexican peasant and his family.

Manuel Carrillo was born in 1906 in Mexico City. He has had several exhibits in the United States, the most recent

[1] The catalogue of this exhibition and the titles of the photographs exhibited are unavailable. —*Ed.*

of which was at the Enoch Pratt Public Library in Baltimore, Maryland. In 1960 some 50,000 persons viewed his exhibit at the downtown Public Library in Chicago.

Carrillo is the general agent for the Illinois Central Railroad in Mexico City and became interested in photography as a hobby ten years ago.

June 29 - July 19, 1962

ASILIA GUILLEN OF NICARAGUA: OILS

Primitive artists have been of frequent occurrence in the cultural history of Latin America since the earliest colonial days. Upon occasion, examples of their production have figured in exhibits at the Pan American Union. The paintings of Asilia Guillén, however, are here presented less as an illustration of primitive tendencies than as genuinely aesthetic expressions by a Central American housewife, molded by provincial tradition, but free and spontaneous in her work which evidences a true appreciation of beauty.

Doña Asilia Guillén was born in 1887 in Granada, Nicaragua. Like all girls of her class in that city, still strongly colonial in its atmosphere, she took courses in painting, music, and embroidery to improve her chances for marriage. It was the last mentioned of these arts which she adopted as her own and which she practiced all but exclusively until ten years ago. At that time the poet Enrique Fernández Morales suggested that she paint the extraordinary compositions that she had been creating with needle and thread. Asilia Guillén took up the challenge. Her first painting was shown to Rodrigo Peñalba, Director of the National School of Fine Arts in Managua, who at once invited her to come to that institution and engage in serious study. As a mature woman, Doña Asilia was reluctant to sit in classes with adolescents. She decided therefore to work at home and to check her progress periodically with Peñalba. Soon she began to win recognition throughout her country, and five years ago she was one of the artists included in a Nicaraguan group show at the Pan American Union.

Asilia Guillén participated in the Mexican Inter-American Biennial, and examples of her work were included in exhibitions of primitive paintings held last year in Knokke, Belgium, and in Baden-Baden and other German cities. Her paintings have been acquired by numerous private individuals and figure in important collections both in Latin America and in the United States. In addition, her compositions have been reproduced in European books and magazines. She is considered one of the outstanding primitive painters of Latin America by reason of the imagination she displays and of the highly personal character of her brush work, which to some degree recalls the stitches of her embroidery. The current show is her first individual exhibition anywhere.

CATALOGUE

Oils

1. *Desesperación (Despair)*, 21 x 13"
2. *Isletas de Granada (Isles of Granada)*, 21 x 27"
3. *Victor Hugo en su inspiración (Inspiration of Victor Hugo)*, 19 x 25"
4. *Iglesia antigua de Guadalupe (Old Church in Guadalupe)*, 20 x 26"
5. *Milagro de Granada (Miracle of Granada)*, 19 x 27"
6. *Volcán Ometepe (Ometepe Volcano)*, 20 x 33"
7. *Entrega del territorio norte de Nicaragua (Cession of the Northern Territory of Nicaragua)*, 20 x 33"
8. *Región norte de Nicaragua (Northern Region of Nicaragua)*, 25 x 38"
9. *Rafaela Herrera defendiendo el castillo contra los piratas (Rafaela Herrera Defends the Castle against the Pirates)*, 1962, 25 x 38"

10. *Mis amigos, los poetas (My Friends, the Poets)*, 25 x 31"
11. *Indios (Indians)*, 20 x 17"
12. *Río Coco (River Coco)*, 27 x 11"
13. *Managua*, 18 x 23"
14. *Miseria (Misery)*, 16 x 20"
15. *Quijotería nicaragüense (Nicaraguan Quixotism)*, 17 x 18"
16. *Laguna de Masaya (Masaya Lagoon)*, 17 x 15"
17. *Laguna de Apoyo (Apoyo Lagoon)*, 17 x 14"
18. *Isla del Maíz (Maiz Island)*, 21 x 34"

July 25 - August 19, 1962

ANIBAL VILLACIS OF ECUADOR: PAINTINGS

Until the last five years or so, the artistic development of Ecuador was hampered by a predominance of conventional attitudes toward painting, sentimentality of manner, and native Indian subject matter which resulted in little more than the production of souvenirs for the tourist trade. Of late, however, a generation of young artists has risen in revolt against the former order. Prominent among its members is the figure of Aníbal Villacís.

Villacís was born in Ambato in 1927. Having been attracted to the plastic arts since childhood, in 1953 he succeeded in obtaining a scholarship from the Ecuadorian government for study abroad. The following year he was awarded another by the Institute of Hispanic Culture in Madrid. These permitted him to attend courses at the National School of Fine Arts in the Spanish capital and to travel extensively in Europe.

Villacís has had one-man shows in Caracas (1951), Madrid (1954), Bogotá (1956), and Rio de Janeiro (1958), in addition to ones in the Ecuadorian cities of Ambato, Guayaquil, and Quito. He has obtained numerous awards at salons in his native country, in which National Museum his work is represented. His compositions are also to be found in the Bogotá National Museum and in many private collections in the United States and Latin America.

In a recent interview, Villacís defined his painting—of which the human form is a constant motif—as expressionist in character. He went on to declare that his intention is to create compositions which, though American in their essence, nevertheless convey a message of universal significance. His work evidences an interest in pre-Columbian design and is marked by great economy of color, tending at times toward monochrome.

The present exhibition constitutes Villacís's first one-man show in the United States.

CATALOGUE

Oils

1. *Horizontal Forms*
2. *Flor de piedra (Stone Flower)*
3. *Tonal Clay*
4. *Image of Time*
5. *The Big Question*
6. *Scripture of the Ages*
7. *Moon Texture*
8. *Shyri*
9. *To Paccha Affectionately*

10. *Portrait of a Negro Child*
11. *Congruence in Red*
12. *Filigree*
13. *White Transparencies*
14. *Símbolos (Symbols)*
15-24. Drawings, watercolors, and sketches[1]

August 20 - September 10, 1962

RODOLFO OPAZO OF CHILE: OILS AND ENGRAVINGS

Rodolfo Opazo is one of the outstanding personalities to appear in Chilean art during the last five years. He was born in Santiago in 1935 and there attended the National School of Fine Arts. In 1957 the Institute of Hispanic Culture awarded him a scholarship to study in Spain, where he spent a year before returning to Chile. His work has been exhibited at national salons since 1956 and at group shows in Lima, Peru, and Dallas, Texas. He was included in the Chilean sections of the Fifth and Sixth São Paulo Biennial, and has won prizes for his paintings both in his native country and abroad. Opazo has also distinguished himself as an engraver, exhibiting works in Argentina, Peru, and the United States.

Paintings by Opazo are to be found in the Dallas Museum of Fine Arts and the Museum of Contemporary Art of Santiago, while engravings by him appear in the collections of various Chilean museums and in those of the Metropolitan Museum and the Museum of Modern Art in New York.

Opazo received a fellowship from the Organization of American States to perfect his techniques in engraving at the Pratt Institute in New York, and his first one-man show was held in that city this year at the Galería Sudamericana. The current exhibition is his first in the Washington area.

CATALOGUE

Oils

1. *Los Duques de Alba (The Duke and Duchess of Alba)*
2. *Torso*
3. *La vaca sagrada (The Sacred Cow)*
4. *Figuras en la playa (Figures on the Beach)*
5. *El mutilado (Mutilated Person)*
6. *Figura soñando (Sleeping Figure)*[2]
7. *Señora durmiendo (Woman Sleeping)*
8. *Pintura (Painting)*
9. *Mujer oliendo flor del árbol de dos cabezas (Woman Smelling Flowers from the Tree of Two Heads)*
10. *Pintura con sol azul (Painting with Blue Sun)*
11. *El Cardenal (The Cardinal)*
12. *Cabeza (Head) I*
13. *Cabeza (Head) II*

[1] Titles are unavailable. —*Ed.*

[2] Literal translation of this title is "Dreaming Figure." —*Ed.*

14. *Cíclope (Cyclope)*

Engravings

1. *Mr. Peter*
2. *The Sleeping Beauty*
3. *The Wounded Lady*
4. *The Watchtower*
5. *Nocturnal Horse*

September 10 - October 7, 1962

ALFREDO HALEGUA OF URUGUAY: SCULPTURES

Alfredo Halegua was born in Montevideo, Uruguay, in 1930. He studied with the sculptor Edmundo Prati at the School of Plastic Arts in his native city, graduating in 1951. As early as 1947 he had participated in various national salons and group shows, obtaining several awards. In 1959 Halegua was awarded a scholarship to study at Rinehart School of Sculpture in Baltimore, and he has since been living in that area. In addition to the practice of his art, he has written several articles and lectured on the subject.

His work is represented in the National Museum of Fine Arts of Montevideo, the Municipal Museum of Salto, and many private collections in Uruguay, Brazil, Italy, and the United States.

This is Halegua's first one-man show in this country.

CATALOGUE

Sculptures

1. *Auschwitz*, wood, 68 x 50"
2. *Reclining Figure*, elm wood, 49 x 25"
3. *Torso*, elm wood, 50 x 21"
4. *Warrior with Helmet*, polychrome wood, 45 x 17 1/2"
5. *Portrait of Mrs. Jacqueline Kennedy*, elm wood, 29 x 17"
6. *The Prophet*, wood, 30 x 22"
7. *The Shadow's Machine*, wood, 63 x 15"
8. *Bird*, wood, 25 x 40"
9. *Animal Form*, bronze, 27 1/4 x 12"
10. *Adam*, wood, 50 x 30"
11. *Three Spaces*, wood, 35 x 20"
12. *Underwater Form*, wood, 27 x 17"
13. *Compensating Shapes*, 37 x 16"
14. *Miss Universe*, wood, 34 x 17 1/2"
15. *Orpheus*, bronze, 42 x 34"
16. *The Crown*, polychrome wood, 67 x 23"

October 8 - 25, 1962

LEONEL GONGORA OF COLOMBIA: DRAWINGS

Leonel Góngora is representative of the trend current among Latin American artists toward a revived interest in the human form—a trend which provided the theme of the group show *Neo-Figurative Art in Latin America*, recently presented at the Pan American Union.

Góngora was born in Cartago, Colombia, in 1932. After study at the National School of Fine Arts in Bogotá, he came to the United States on a scholarship from Washington University in Saint Louis. This was followed by a similar award from the University of Syracuse.

Góngora has participated in group exhibitions in the United States and Canada and several one-man shows of his work have been held in Saint Louis. His most recent individual exhibit took place early this year at the Israeli Institute in Mexico City, where he is presently residing. In addition to his painting, he has illustrated several books and articles for a number of publications.

This is the first presentation of Góngora's work in the Washington area.

CATALOGUE

Drawings

1. *Depende del cristal con que se mire (It Depends on the Mirror in Which you Gaze)*, 12 x 28 cm.
2. *Interior*, 12 x 28 cm.
3. *Trio*, 12 x 28 cm.
4. *Una actitud desconcertante (A Disconcerting Attitude)*, 12 x 28 cm.
5. *Dos (Two)*, 12 x 28 cm.
6. *A media luz (In the Semi-Dark)*, 12 x 28 cm.
7. *Perro sí come perro (Dog Eats Dog)*, 24 x 32 cm.
8. *Hay días en que somos tan lúbricos, tan lúbricos (There are Days I Love You More)*, 31 x 24 cm.
9. *Secreto entre familia (Family Secret)*, 25 x 32 cm.
10. *Se ven lo mismo que ayer (They Look the Same as Yesterday)*, 32 x 23 cm.
11. *Escena nocturna (Nocturnal Scene)*, 32 x 23 cm.
12. *Su ahijado (Your Godchild)*, 27 x 37 cm.
13. *La caída (The Fall)*, 32 x 38 cm.
14. *El hueco (The Hole)*, 32 x 38 cm.
15. *Viajeros (Travelers)*, 32 x 38 cm.
16. *Danza (Dance)*, 32 x 38 cm.
17. *Minuet*, 32 x 38 cm.
18. *Adelante (Go Ahead)*, 32 x 38 cm.
19. *Un hombre (A Man)*, 37 x 44 cm.
20. *Romanticismo (Romanticism)*, 37 x 44 cm.
21. *Fuego (Fire)*, 37 x 44 cm.
22. *Cain*, 37 x 44 cm.

October 8 - 25, 1962

JOSE MANUEL SCHMILL OF MEXICO: DRAWINGS

Among the new directions characterizing contemporary art is one leading from the purely abstract to a reevaluation of the human form. This trend formed the subject of an exhibition recently presented at the Pan American Union,

entitled *Neo-Figurative Art in Latin America.*

A rising figure among young Mexican artists who have taken the neo-figurative direction is José Manuel Schmill. His approach is via the fantastic, his work being marked by an eerie distortion of forms.

Schmill was born in Mexico City in 1924. He is in large measure self-taught, although he did receive informal instruction for a short period. He has participated in group exhibits both in his native country and throughout Latin America. His first one-man show took place in the Mexican capital in 1956 and has been followed by five others in the same city. The current exhibition marks the first presentation of his work in the United States.

CATALOGUE

Drawings

1. *El paseo (The Walk)*
2. *El lémur (The Lemur)*
3. *Nihilistas (Nihilists)*
4. *Estoicos (Stoics)*
5. *El profeta (The Prophet)*
6. *El viento (The Wind)*
7. *Derruido (Demolished)*
8. *El apestado (The Pestilent)*
9. *Hombre (Man)*
10. *Dama en reparación (Lady in Atonement)*
11. *Enanos (Dwarfs)*
12. *Vegetal femenino (She-Vegetable)*
13. *Estudio para "Los Jinetes del Apocalipsis" (Study for "The Horsemen of the Apocalypse")*
14. *El sombrero de fieltro (The Felt Hat)*
15. *El extranjero (The Stranger)*
16. *La ternerita (The Calf)*
17. *Rasputin*
18. *La notable hermafrodita (The Notable Hermaphrodite)*
19. *El amante (The Lover)*
20. *El dandy (The Dandy)*
21. *Mesalina (Messalina)*
22. *El centurión (The Centurion)*
23. *Dama (Woman)*
24. *Odalisca (Odalisque)*
25. *Espectro (Spectre)*
26. *Estudios de animales (Animal Studies)*
27. *Escena circense (Circus Scene)*
28. *Espantajo (Scarecrow)*
29. *Estudio para "La muerte" (Study for "The Death")*
30. *El vidente (The Seer)*
31. *El epicúreo (The Epicurean)*
32. *Vieja dama (Old Woman)*
33. *El orador (The Orator)*
34. *Atleta (The Athlete)*
35. *Cabeza (Head)*
36. *Ave del paraíso (Bird of Paradise)*
37. *Tres camaradas (Three Comrades)*

38. *Gárgola*
39. *El buen juez (The Good Judge)*
40. *Fábula (Fable)*
41. *El incubo (Incubus)*
42. *Reyes y sacerdotes (Kings and Priests)*
43. *El enano (The Dwarf)*
44. *Gog y Magog (Gog and Magog)*
45. *Triste historia (Sad Story)*
46. *El niño (The Child)*
47. *Cortesanas de Sodoma y Gomorra (Courtesans of Sodom and Gomorrah)*
48. *Pájaros errantes (Wandering Birds)*
49. *Figuras de danza (Dancing Figures)*
50. *Muerte y bufón (Death and the Clown)*
51. *El rey "M" (King "M")*
52. *Víctima y verdugo (Victim and Executioner)*
53. *El olvido (Forgotten)*
54. *Nos observan (We Are Being Observed)*
55. *Caballero andante (Walking Gentleman) I*
56. *Caballero andante (Walking Gentleman) II*
57. *La angustia (Anguish)*
58. *Flora*
59. *Saltimbanquis (The Tumblers)*
60. *Mujer ideal (Ideal Woman)*
61. *Derruido (Destroyed)*
62. *El tatuado (The Tatooed Man)*
63. *Cuatro cabezas (Four Heads)*
64. *El jorobado (The Hunchback)*
65. *Retrato (Portrait)*
66. *Retrato (Portrait)*

October 25 - November 17, 1962

DRAWINGS BY ROBERTO CABRERA
AND PAINTINGS BY MARCO AUGUSTO QUIROA
OF GUATEMALA

At the beginning of this century, when Carlos Mérida and Carlos Valenti emerged as forerunners of modern art in Guatemala, they started a curious pattern. Two artists have appeared simultaneously every three or four years since, working in different media—painting, sculpture, engraving, and drawing. Recently two new names have been added to the increasing group of modern artists originating in that beautiful Central American country. For the first time in the United States, the Pan American Union presents paintings by Marco Augusto Quiroa and drawings by Roberto Cabrera. Both artists are contemporaries and follow more or less an identical path. Therefore, it is fitting that these exhibitions be presented together.

Quiroa was born in Chicacao, Guatemala, in 1937. He attended the National School of Plastic Arts from 1953 to 1960, where, in addition to his studies, he was active in artist and student associations. Upon completion of his studies he obtained a scholarship for a brief sojourn in Mexico. Last year he obtained the top award in the Central American Contest held in San Salvador, and this year he has been the recipient of several prizes in the Carlos

Valenti National Contest. Quiroa's paintings, which are based almost entirely on the search for pre-Columbian forms adapted to modern expression, are represented in several private collections in his native country as well as in the National Museum of Guatemala and of El Salvador. He has had several one-man shows in his native country since 1958 as well as one in Mexico City in 1960. Quiroa has also participated in numerous group shows in Guatemala and Mexico and in the two Paris biennials.

Cabrera was born in Guatemala City in 1939 and also attended the National School of Plastic Arts. He has been, as Quiroa, active in artist and student associations. He has traveled in Mexico and Central America and has been included in several group shows in Guatemala and Mexico since 1960, where he has received various prizes. His participation in the Carlos Valenti National Contest, held two months ago in the capital of Guatemala, brought him his most recent award. Cabrera is also a notable painter and graphic artist although this presentation is limited to drawing, the medium in which he transmits his interest in cryptic Mayan forms.

CATALOGUE

Roberto Cabrera

Drawings

1. *Cualquier día (Any Day)*
2. *La bajada (The Descent)*
3. *Figura de verano (Summer Figure)*
4. *El que cuenta los días (He Who Counts the Days)*
5. *Gran devorador de lunas (Great Devourer of Moons)*
6. *El quemador de montes (The Arsonist)*
7. *Las dos hijas (Two Daughters)*
8. *Cazador de espejos (Hunter of Mirrors)*
9. *El Siete Flores (The Man Called "Seven Flowers")*
10. *Cabeza perforada (Perforated Head)*
11. *Puente roto (Broken Bridge)*
12. *Constructor de dientes (Constructor of Teeth)*
13. *Muro de recuerdos (The Wall of Memory)*
14. *Paisaje con perro (Landscape with Dog)*
15. *La Llenadora (The Fulfiller)*
16. *Operador de vientos (Operator of the Wind Machine)*
17. *La entrada (The Entrance)*
18. *Nubes, montes y suspiros (Clouds, Hills, and Sighs)*
19. *La caña (The Sugar Cane)*
20. *Paisaje de jueves (Thursday's Landscape)*
21. *Las puertas en el polvo (Doors in the Dust)*
22. *Figura tragacuentos (Storyteller)*[1]
23. *Mujer de los días cortos (Woman of the Short Days)*
24. *El encuentro (The Meeting)*

Marco Augusto Quiroa

Oils on Canvas

1. *Situación violenta (Violent Situation)*

[1] Literal translation of this title is "Story-Devouring Figure." —*Ed.*

2. *La máquina del amor (The Love Machine)*, oil on masonite
3. *Aves (Birds)*
4. *Pájaros perseguidos (Pursued Birds)*
5. *El pastor (The Shepherd)*
6. *La tenta, juego infantil (Child's Game)*
7. *La despedida del pescador (Farewell of the Fisherman)*
8. *El suicida (The Suicide)*
9. *El desayuno (The Breakfast)*
10. *El glotón (The Glutton)*
11. *El festín del pelícano (The Feast of the Pelican)*
12. *Rosario Icaza en el cine (Rosario Icaza in the Movies)*
13. *Maternidad (Maternity)*
14. *El enano (The Dwarf)*

November 21, 1962 - January 7, 1963

NEW DIRECTIONS OF ART FROM SOUTH AMERICA: PAINTINGS FROM ARGENTINA, CHILE, BRAZIL, AND URUGUAY

Sponsored by *Show* Magazine and Kaiser Industries Corporation

Events in recent days have made us all aware of our ignorance of the southern half of this hemisphere. Now, out of a crisis, we are forced to learn. And we quickly realize that it is not enough to grasp some basic statistics. What we need is a comprehension of different cultures.

The paintings in this show represent the best of four great South American countries: Argentina, Brazil, Chile, and Uruguay. They have been chosen from the First South American Art Biennial held this year in Córdoba, Argentina, and sponsored by Industrias Kaiser Argentina (IKA). The competition was judged by experts from each country and two international authorities, Sir Herbert Read and José Gómez-Sicre, Director of the Visual Arts Section of the Pan American Union.

From this exhibition, one can begin to sense the prodigious variety and talent to be found in South America. Unfortunately, because of geography, communications, apathy, and ignorance, not much of this has been recognized in the United States.

For *Show* Magazine, the exhibit adds another dimension to its November issue, devoted to the contemporary arts of South America.

For Kaiser, it is another example of how the company allies itself with the culture of any foreign country in which it does business.

The American Federation of Arts and the Pan American Union have generously furnished exhibition space for this collection which will later travel throughout the United States.

We are all convinced of the surprise and pleasure this show will render those thousands of people who have never seen South American paintings before. And we are equally certain that from this pleasurable process, there will evolve a slightly better sense of half our hemisphere.

CATALOGUE

Paintings

Ernesto Farina (Argentina)
1. *Yuyal (Weeds)*, 1960, 80 x 95 cm.
2. *Yuyal (Weeds) I*, 1962, 130 x 165 cm.

José Antonio Fernández Muro (Argentina)
3. *Ovalo encendido (Burning Coal)*,[1] 1962, 130 x 162 cm.
4. *Gran círculo (Big Circle)*, 1962, 114 x 146 cm.
5. *Resquicio (Slit)*, 1962, 146 x 162 cm.

Raquel Forner (Argentina)
6. *Los que vieron la luna (Those Who Saw the Moon) I*, 1962, 160 x 130 cm.
7. *Los que vieron la luna (Those Who Saw the Moon) II*, 1962, 160 x 120 cm.
8. *El astronauta (The Astronaut)*, 1962, 200 x 130 cm.

Leónidas Gambartes (Argentina)
9. *Personajes (Personages)*, 1962, 80 x 120 cm.
10. *Mito arcaico (Archaic Myth)*, 1959, 62 x 99 cm.

Alfio Grifasi (Argentina)
11. *Puesto del noroeste (Outpost in the Northwest)*, 1961, 120 x 160 cm.
12. *Entierro del angelito (Burial of a Little Angel)*, 1959, 120 x 80 cm.

Rómulo Macció (Argentina)
13. *Sueño o muerte (Dream or Death)*, 1962, 130 x 200 cm.
14. *Hombre (Man)*, 1962, 130 x 200 cm.
15. *Espejo (Mirror)*, 1962, 120 x 135 cm.

Leopoldo Presas (Argentina)
16. *Descendimiento (Descent)*, 1962, 195 x 120 cm.
17. *Crucifixión (Crucifixion)*, 1962, 130 x 190 cm.

Antonio Seguí (Argentina)
18. *Estudio de un paisaje americano (Study for an American Landscape)*, 1962, 100 x 200 cm.
19. *De Tikal con sol (Tikal with Sun)*, 1962, 210 x 130 cm.
20. *Para una zoología americana (For an American Zoology)*, 1962, 130 x 190 cm.

Roberto Viola (Argentina)
21. *Las Tablas de la Ley (Tables of the Law)*, 1962, 140 x 190 cm.
22. *Los elementos (The Elements)*, 1962, 100 x 170 cm.

Danilo Di Prete (Brazil)
23. *Pintura (Painting) II*, 137 x 84 cm.
24. *Pintura (Painting) III*, 120 x 120 cm. Lent by the Caraffa Museum

[1] Literal translation of this title is "Burning Oval." —*Ed.*

Manabu Mabe (Brazil)
25. *Pintura I, pardo (Painting I, Grey)*, 1961, 100 x 150 cm.
26. *Pintura II, branco (Painting II, White)*, 1961, 130 x 129 cm.
27. *A estrada (The Road)*, 1961, 130 x 110 cm.

Yolanda Mohalyi (Brazil)
28. *Composição (Composition) AX*, 1962, 132 x 220 cm.
29. *Composição (Composition) CH*, 1962, 150 x 130 cm.

Ivan Serpa (Brazil)
30. *Animal*, 1962, 120 x 120 cm.
31. *Gênese (Genesis)*, 155 x 125 cm.

Nemesio Antúnez (Chile)
32. *Cordillera adentro (Amit the Mountains)*, 1962, 98 x 130 cm.
33. *Río andino (Andean River)*, 1962, 121 x 121 cm.

Ernesto Barreda (Chile)
34. *Postigo (Shutter)*, 1961, 91 x 72 cm.
35. *Mampara (Screen)*, 1961, 91 x 91 cm.
36. *Puerta (Door)*, 1961, 170 x 100 cm.

José Gamarra (Uruguay)
37. *Pintura (Painting) I*, 1962, 130 x 100 cm.
38. *Pintura (Painting) II*, 1962, 130 x 100 cm.
39. *Pintura (Painting) III*, 1962, 130 x 100 cm.

Vicente Martín (Uruguay)
40. *Paisaje (Landscape) I*, 1962, 136 x 96 cm.
41. *Paisaje (Landscape) II*, 1962, 136 x 96 cm.

Jorge Páez (Uruguay)
42. *Altamira dos (Altamira Two)*, 1962, 130 x 162 cm.
43. *Idolitos (Small Idols)*, 1962, 80 x 117 cm.

Américo Spósito (Uruguay)
44. *Olimar VI*, 1962, 130 x 160 cm.
45. *Olimar VII*, 1962, 130 x 160 cm.

ABOUT THE ARTISTS

ANTUNEZ, Nemesio. Born in Santiago de Chile in 1918. Studied architecture at Columbia University and later at the S. W. Hayter Engraving Workshop in New York. Has held shows in New York, Paris, Lima, Rio de Janeiro, Buenos Aires, and Santiago de Chile. Is now director of the Museum of Contemporary Art in Santiago.

BARREDA, Ernesto. Born in Paris in 1927. Self-taught. In 1962 won Second Prize at the First Córdoba Art Biennial in Argentina. Has held one-man shows in Santiago, Buenos Aires, and New York. Shows regularly in the latter city.

FARINA, Ernesto. Born in Córdoba, Argentina, in 1912. Studied in his native city and in Italy. In 1933 exhibited for the first time in the National Salon and since that time has participated in local, national, and international group

shows. Competed for the Palanza Prize in 1951, 1960, and 1961 and for the Acquarone and Werthein Prizes in 1961. Exhibited in the São Paulo and Venice biennials, the Brussels World's Fair, and in group exhibitions in Santiago de Chile, Lima, and Montevideo. Has had many one-man shows. In 1960 received First Prize at the Third Industrias Kaiser Argentina (IKA) Salon.

FERNANDEZ MURO, José Antonio. Born in Madrid in 1920, moved to Argentina in 1938. Has traveled to Paris and Madrid and holds a UNESCO scholarship to study museum administration in Europe and in the United States. At present he is in New York. Has held many one-man shows in Buenos Aires galleries and has participated in many group shows in important European capitals, in the United States, and in Brazil. In 1960 received a Guggenheim award. His work is in museums of Buenos Aires, New York, and Amsterdam, and in private collections in Argentina and abroad.

FORNER, Raquel. Born in Buenos Aires in 1902, studied in the National Academy of Fine Arts. Has made various trips through Europe and America. During first trip to Paris attended the courses given by Othon Friesz. Has had one-man shows in Montevideo, Rome, Washington, New York, Rio de Janeiro, and Buenos Aires. Has also participated in important group shows in various European and American countries, being the featured artist at the Sixth São Paulo Biennial. Was awarded Gold Medal at the Paris International Exposition in 1937, the Palanza Prize of Buenos Aires in 1948, the Grand Award of Honor from the National Salon of Fine Arts in 1955, the Press Award of the First Inter-American Biennial of Mexico in 1958, and the Grand Prize of the First American Art Biennial sponsored by IKA in Córdoba, Argentina, in 1962. Her work is found in museums of New York, Montevideo, Buenos Aires, Córdoba, Santa Fe, Rosario, San Juan, among others.

GAMARRA, José. Born in Tacuarembó, Uruguay, in 1934, studied with Vicente Martín and, on a scholarship granted by the government of Brazil, with Iberê Camargo and Friedlaender in Rio de Janeiro. Active in Uruguayan and international shows, he has received various prizes. His work is found in the National Museum of Fine Arts, Blanes Museum, and Municipal Museum in Uruguay, and in private collections in Uruguay, Brazil, and Europe.

GAMBARTES, Leónidas. Born in Rosario, Santa Fe, Argentina, in 1909, is self-taught. Has had one-man shows in Buenos Aires galleries and has frequently competed in national salons, where he has won major prizes. Has been invited to exhibit in private shows and obtained the First Prize in 1959 at the Second IKA Salon. His work has been studied by Roger Plá, Córdova Iturburu, Mujica Láinez, Payró, and others, and a film has been made on his art entitled *Gambartes*, produced by the National Commission of Painting.

GRIFASI, Alfio. Born in 1927 in the Province of Salta, northern Argentina. Later moved to Córdoba and took courses in the School of Fine Arts of the National University, graduating with the degree of Professor of Design and Painting. Had individual showings in the Province of Tucumán as well as in Córdoba and Buenos Aires. As a member of the *Group of Modern Painters* of Córdoba, he exhibited in that city as well as in Buenos Aires, Tucumán, Rosario, Santa Fe, and Panama City. Participated in officially and privately sponsored exhibitions. In 1959 won the Second Prize of the Second IKA Salon and in 1961 obtained top prizes in this same contest. Besides the IKA Art Collection his works hang at the provincial museums of Córdoba, Tucumán, and Santa Fe.

MABE, Manabu. Born in Kumamoto, Japan, in 1924. Went to Brazil in 1934, worked in rice fields, then painted and sold neckties in the streets of São Paulo. First show in 1951. A few years later obtained Brazilian citizenship. In 1959 received the Leirner Prize for Contemporary Art, the São Paulo State Government Award in the Salon Paulista, the Prize for the Best Brazilian Painter at the São Paulo Biennial, and the International Painting Prize in the Paris Biennial. In 1960 won the Fiat Prize at the Venice Biennial and in 1962 First Prize at the First American Art Biennial of Córdoba. Has held many one-man shows in Brazil and abroad.

MACCIO, Rómulo. Born in Buenos Aires in 1931, is self-taught. Has participated in many group shows in Buenos Aires, Mexico City, New York, and other cities. In 1959 exhibited in the De Ridder Salon; in 1960 in the *Phases Group* exhibition in Uruguay, in the *150 Years of Argentine Art* show, in the Ver y Estimar Salon and in the Pipino

y Márquez Biennial, all in Buenos Aires; in 1961 at the São Paulo Biennial; and in 1962 at the Venice Biennial. Was awarded the Chantal Prize and the De Ridder Award in 1959, and the Acquisition Award of the Torcuato Di Tella Foundation in 1961. In 1962 won a scholarship from the National Art Fund and is presently living in Paris.

MARTIN, Vicente. Born in 1911 in Montevideo, studied with Guillermo Laborde and Joaquín Torres-García in Montevideo, and attended the Académie de la Grande Chaumière and the Othon Friesz Studio courses in Paris. Taught at the National School of Fine Arts. Participated in the Inter-American Biennial in Mexico City (1958), Venice Biennial (1960), and São Paulo Biennial. In 1956 showed in Washington, D.C., at the invitation of the Pan American Union. In that same year the National Committee of Fine Arts presented a representative group of his paintings. Has shown in Uruguayan salons since 1936, receiving the National Grand Prize, and showed in the *Punta del Este International Exhibition*, where he won First Prize, both in 1959. Received Honorable Mention from the Inter-American Biennial of Mexico City in 1960. His work is found in the Museum of Contemporary Art in Chile, Museum of Modern Art in Rio de Janeiro, and in the São Paulo Museum of Modern Art.

MOHALYI, Yolanda. Born in Hungary in 1909, studied at the Royal Academy of Fine Arts in Budapest. Moved to Brazil in 1931, where she began to show frequently in the São Paulo Salon, winning Gold Medal in 1937. First individual show in 1946. In 1960 received the Leirner Prize for Contemporary Art.

PAEZ, Jorge. Born in 1921 in Montevideo, is self-taught. Worked in the studios of Vicente Martín and Lino Dinetto. Traveled to Europe several times, meeting leading artists, the primary factors in his training. Was a member of the Uruguayan committees for several shows and international biennials. Participated in exhibits in Dallas, Buenos Aires, the *Punta del Este International Exhibition* (1959), and in many group shows in Uruguay. In 1961 held a one-man show in Buenos Aires and at the Pan American Union in Washington, D.C. His work is found in São Paulo and Buenos Aires museums and in private collections in Munich, Amsterdam, Dallas, Washington, Rio de Janeiro, and Uruguay.

PRESAS, Leopoldo. Born in Buenos Aires in 1915, first studied painting in 1932. In 1939 participated in the opening show of the *Orión* group and had his first one-man show in Buenos Aires in 1946. Since then has exhibited in all Argentine salons, receiving important awards. In 1959 he received the Grand Award of Honor from the National Salon. Held various one-man shows throughout Argentina and in New York. Participated in the biennial of São Paulo and of Venice.

PRETE, Danilo Di. Born in Italy in 1911, held his first one-man show in Lucca. Belonged to the group under Viani's leadership at the Viani School, participating in various shows in Florence, Naples, Milan, among others. Exhibited at the Quadrennial of Rome and the biennials of Venice and of São Paulo. In the First São Paulo Biennial received First Prize for Painting. Has held one-man shows in many European cities.

SEGUI, Antonio. Born in Córdoba, Argentina, in 1934, studied painting and sculpture briefly in Argentina, France, and Spain. In 1957 showed for the first time in Córdoba. Then held twenty-three one-man shows in almost all countries of Latin America and participated in many group shows in museums and galleries in New York, San Francisco, Rio de Janeiro, and Pôrto Alegre. In 1961 competed in the art salons Ver y Estimar, Di Tella, Acquarone, Salón de los Críticos, Werthein (where he received Second Prize), and Argentine Automobile Club (where he won First Prize). Has also received awards in Córdoba and Tucumán, 1958; International Salon of Mexico, 1960; First IKA Salon, 1958, among others. His work is found in the museums of Córdoba, Tucumán, Buenos Aires, Mexico City, Guatemala City, Lima, Quito, Tokyo, and others.

SERPA, Ivan. Born in Rio de Janeiro in 1923, was a pupil of Leskoschek. First individual show in 1947. Was named Best Young Brazilian Painter at the First São Paulo Biennial in 1951. That same year joined the avant-garde group *Frente*. In 1957 obtained a scholarship from the Salon of Modern Art to travel in Europe. Has participated in many group shows abroad, including three Venice biennials. Has also held several one-man shows.

SPOSITO, Américo. Born in Montevideo in 1924, studied in the Fine Arts Circle and in the Torres-García Workshop. Has participated in many art salons in Uruguay, receiving one Special Mention and the Campomar Prize. Obtained First Prize from the Salon Sureño de Pintura in 1956, and the Blanes Prize in 1961, sponsored by the Banco República del Uruguay. In 1955 received the Prize Arno in the Third São Paulo Biennial.

VIOLA, Roberto. Born in 1907 in Santa Fe, Argentina, studied in the Córdoba School of Fine Arts. Won a scholarship in competition in that province and traveled throughout Italy, Belgium, France, and Spain from 1932 to 1935. Has exhibited his work in many one-man shows and in the Biennial of São Paulo, the Spanish American Biennial of Cuba and the Punta del Este Biennial, winning awards. Participated in the Werthein and Acquarone competitions. In 1958 received First Prize from the IKA Salon and in 1961 First Prize of the Córdoba Salon.

November 28 - December 17, 1962

SERGIO CASTILLO OF CHILE: SCULPTURES

Sergio Castillo was born in Santiago, Chile, in 1925. Prior to enrolling at the Julian Academy in Paris in 1948, he had received no previous art training. Later, on his return to Chile in 1952, he attended the National School of Fine Arts, where he completed four years of study. Traveling frequently in Europe and the United States made him receptive to the abstract trends in Latin American sculpture.

Castillo has held one-man shows at the Feluca Gallery in Rome (1957), the Galería Sudamericana in New York City (1958 and 1962), and the Institute of Contemporary Arts in Lima (1959). He has participated in numerous group exhibitions in Chile and held a one-man show in Santiago in 1958. Participation in international shows has brought him numerous important awards in Rome and Paris as well as in his native country. His work is represented in museums in Chile and Venezuela and in private collections in Europe, the United States, and Latin America. This is Sergio Castillo's first one-man show in the Washington area.

CATALOGUE

Sculptures
1. *Templo al sol (Temple to the Sun)*, 70 x 20 x 20 cm.
2. *Templo a la luna (Temple to the Moon)*, 70 x 20 x 20 cm.
3. *Templo al aire (Temple to the Air)*, 70 x 20 x 20 cm.
4. *Templo a la lluvia (Temple to the Rain)*, 80 x 20 x 20 cm.
5. *Homenaje al rayo (Homage to Lightning)*, 80 x 20 x 20 cm.
6. *Ancestro araucano (Araucan Ancestor)*, 150 x 30 x 30 cm.
7. *Manu-Tara*, 120 x 30 x 30 cm.
8. *Toro (Bull)*, 90 x 70 x 30 cm.
9. *Miura*, 80 x 70 x 30 cm.
10. *Gallo (Rooster)*, 50 x 20 x 20 cm.
11. *Homenaje a la tierra (Homage to the Earth)*, 40 x 20 x 20 cm.

Wall Reliefs

12-16. *Composición mural (Composition) No. 1, No. 2, No. 3, No. 4, No. 5*

December 18, 1962 - January 13, 1963

LUIZ DE CARVALHO OF BRAZIL: PAINTINGS

Luiz Woods de Carvalho was born in 1935 in Belo Horizonte, the capital of the Brazilian State of Minas Gerais. Between 1954 and 1957 he studied at the School of Fine Arts in that city under the late Alberto da Veiga Guignard, one of the forerunners of the modern art movement in Brazil. In 1959 Carvalho went to Rio de Janeiro, where for a short period he studied lithography, the silkscreen process, and advertising art.

In 1958, while serving as director of the Visual Aids Program in the United States Information Office in Belo Horizonte, Carvalho exhibited some of his compositions at a local salon. Two years later he came to the United States and held a one-man show at the Brazilian Center in New York City. At that time his work, based on elements of Brazilian folklore, was marked by flat patterns and vivid coloring. After two years in Manhattan, he continues to manifest a characteristically Brazilian interest in color, but he has advanced to an abstract type of composition, painting in a dynamic manner acquired since leaving his native country. This exhibition at the Pan American Union is the first to present Carvalho's work in the Washington area.

CATALOGUE

Paintings

1. *A Exú (To the Devil)*
2. *A Ogum (To Ogum)*
3. *A Omulu (To Omulu)*
4. *A Yemanjá (To Yemanjá)*
5. *A Yarassu (To Yarassu)*
6. *A São Jorge Guerreiro (To Saint Jorge Guerreiro)*
7. *A Cosme e Damião (To Cosme and Damião)*
8. *A Umbanda (To Umbanda)*
9. *A Momo (To Momo)*
10. *Oração à Virgem (Prayer to the Virgin)*
11. *Promessa (Offering)*
12. *Prece (Prayer)*
13. *Orixá*
14. *Vudu (Woodoo)*
15. *Fetiche (Fetish)*
16. *Macumba*
17. *Barraco*
18. *Sebastião*
19. *Bahia*
20. *Xingú*
21. *Rio*
22. *Tico-Tico*
23. *Sambalanço*

YEAR 1963

January 15 - February 4, 1963

AMADO ALDARACA OF MEXICO: PAINTINGS

Amado Aldaraca was born in Orizaba, Mexico, in 1934. After a brief period of study in the Mexican capital, he came to the United States five years ago, taking up residence in New York City, where he joined the Art Students League. In 1959 he enrolled in the Contemporaries Graphic Center and last year in the New School for Social Research. He is currently engaged in commercial art and illustration in Manhattan.

This exhibition at the Pan American Union constitutes the first public presentation of Aldaraca's work.

CATALOGUE

Paintings

1. *Transformación (Decay)*, 52 x 42"
2. *El velorio (The Wake)*, 44 x 34"
3. *Templo (Temple)*, 60 x 50"
4. *Aspas*, 46 x 38"
5. *Pantano (Marsh)*, 50 x 36"
6. *Musgo (Moss)*, 29 x 25"
7. *Cubo (Cube)*, 30 x 20"
8. *Pintura negra (Black Painting)*, 30 x 20"
9. *Paisaje con nieve (Snow Landscape)*, 26 x 21"
10. *Estable (Stable)*, 29 x 20"
11. *Tauro (Taurus)*, 25 x 16"
12. *Cenizas (Ash)*, 38 x 23"
13. *Máscara (Mask)*, 50 x 42"
14. *Corteza (Bark)*, 36 x 24"
15. *La rueda (The Wheel)*, 20 x 20"
16. *Emblema (Emblem)*, 30 x 30"
17. *Entrada (Entrance)*, 27 x 27"
18. *El espejo (Mirror)*, 46 x 38"
19. *Tiempo (Time)*, 27 x 26"
20. *Sequoia (Redwoods)*, 42 x 34"

February 7 - 26, 1963

ALFREDO SINCLAIR OF PANAMA: PAINTINGS

Like other exponents of modern art in Panama, Alfredo Sinclair passed from a representational to a non-objective

manner, only to return to the figurative, which is his current style of expression.

Sinclair was born in Panama City in 1915. For a number of years he was a student in the workshop of Humberto Ivaldi, one of the forerunners of modern art on the isthmus. After Ivaldi's death, in 1944, Sinclair studied by himself until 1948, when he enrolled in the School of Fine Arts of Buenos Aires. During the ensuing period of apprenticeship in Argentina he won several awards.

Sinclair held a one-man show at the Antú Gallery in Buenos Aires in 1950, followed by others in his native country at the National Museum (1959), the Hotel Tívoli (1960), and the Press Club and Cultural Library (1962). He has participated in salons and contests in Panama, winning a number of prizes; he has taken part in group exhibitions in Costa Rica; he obtained various awards in the cultural contest sponsored by the government of El Salvador in 1961; and compositions by him have been included in the Panamanian sections of the biennials in Mexico, Spain, and Brazil.

While examples of Sinclair's work figured in the group show of Panamanian artists held at the Pan American Union in 1953, this is the first individual presentation of his work in the United States.

CATALOGUE

1. *Elementos en tonos cálidos (Elements in Warm Tones)*
2. *Cabeza de santo (Head of a Saint)*
3. *Composición en fríos y cálidos (Composition in Warm and Cold Tones)*
4. *Paisaje en rosa (Landscape in Rose)*
5. *Muralla (Wall)*
6. *Bodegón con sandía (Still Life with Watermelon)*
7. *La ciudad (The City)*
8. *Gioconda*
9. *Bodegón azul (Blue Still Life)*
10. *Elementos dispersos (Scattered Elements)*
11. *Pájaro azul (Blue Bird)*
12. *Flores verdes (Green Flowers)*
13. *Mujer sentada (Seated Woman)*
14. *Frutas y flores (Fruits and Flowers)*
15. *Botellas y frutas (Bottles and Fruits)*
16. *El frutero (The Fruit Basket)*
17. *La cena (The Dinner)*
18. *Tapete azul (Blue Covering)*

February 27 - March 18, 1963

ANATOL WLADYSLAW OF BRAZIL: RECENT DRAWINGS

Anatol Wladyslaw was born in Poland in 1913, but has long been a naturalized citizen of Brazil. An engineer by profession, he has had a distinguished career as an artist, participating in many group exhibitions and holding one-man shows in São Paulo, Rio de Janeiro, Mexico City, and New York. The most notable recognition of his achievements thus far has consisted in the First Prize for Drawing awarded him by the Brazilian section of the Sixth São Paulo Biennial.

This is the first presentation of Wladyslaw's work in Washington.

CATALOGUE

1-25. Drawings, ink on paper[1]

February 27 - March 18, 1963

MANE BERNARDO OF ARGENTINA: RECENT PAINTINGS

Mane Bernardo has practiced a variety of forms of artistic expression: painting, sculpture, stage design, and puppetry. The last mentioned field, which permitted her to combine several of her talents, occupied her for many years, during which she designed both figures and scenery for a marionette theater in Buenos Aires, in addition to serving as puppeteer.

Born in the Argentine capital in 1913, Bernardo studied at the National School of Fine Arts there and also in the city of La Plata. Her participation in group shows in her native country, Europe, and the United States has won her numerous awards. The works presented on this occasion have never before been exhibited in this country. They provide examples of her explorations in the realm of abstract painting during recent years.

CATALOGUE

Paintings: Petroleum, Chlorox, Aniline, Inks, Oil Bases, Textures

Serie *Trayectoria de la forma (Trajectory of the Form* Series)

1. *Estructura de la forma (Structure of the Form)*
2. *La forma que sueña (The Form That Sleeps)*[2]
3. *Forma + Forma (Form + Form)*
4. *Forma, color y forma (Form, Color, and Form)*
5. *El cielo y la forma (The Sky and the Form)*
6. *Espacio y forma (Space and Form)*
7. *Llevando una forma (Carrying a Form)*
8. *La forma azul (The Blue Form)*
9. *Forma sin forma (Form without Form)*
10. *Forma de textura (Textural Form I)*[2]
11. *Textura de forma (Textural Form II)*[2]
12. *La forma en el universo (The Form in the Universe)*

March 19 - April 8, 1963

ARTURO KUBOTTA OF PERU: PAINTINGS AND LITHOGRAPHS

Arturo Kubotta is one of a number of emerging personalities in the panorama of Latin American art whom the Pan

[1] Titles are unavailable. —*Ed.*

[2] Literal translations of these titles are: no. 2, "Dreaming Form;" no. 10, "Form of Texture;" no. 11, "Texture of Form." —*Ed.*

American Union can claim to have encouraged at the start of their professional careers. Compositions by him were included in two group presentations at the Pan American Union gallery, *Japanese Painters of the Americas*, and *Young Peruvian Artists*, both in 1961. The exceedingly favorable reception accorded his work by critics and public alike resulted in the offering of a one-man show, Kubotta's first anywhere.

The artist was born in Lima, Peru, in 1932, of a Japanese father and a Peruvian mother. He enrolled in the city's School of Fine Arts in 1953, and from 1957 to 1959 he enjoyed a special merit scholarship. Even before his graduation in 1960 he had participated in local group shows and won several awards. Last year Kubotta came to the United States at the invitation of the State Department, with a Fulbright scholarship, as a consequence of which he has been pursuing advanced studies in graphic arts at the Chicago Art Institute for the past several months. Lithographs executed during this period are included in the present exhibition.

Examples of Kubotta's work have figured not only in Peruvian salons, but in group shows in Mexico, in the São Paulo and Paris biennials, and in traveling exhibitions organized and sponsored by the Pan American Union. His paintings are to be found in private collections in Brazil, Japan, Peru, the United States, and Venezuela.

CATALOGUE

Oils on Canvas

1. *Endlessly Spacious*, 1962, 26 1/2 x 81 1/2 cm. Coll.Pan American Union
2. *Beyond the Mind*
3. *Homage over Death Itself*
4. *Every Minute Zen*
5. *Intihuatana*
6. *Enlightened Nature*
7. *The Silent Temple*
8. *Abstract Painting*, oil on board
9. *Abstract Forms*, oil on board
10. *Zen*
11. *Painting 1963 No. I*
12. *Painting 1963 No. II*
13. *Nothing and Everything*
14. *Marcahuamachuco*
15. *Fuerza atávica (Atavic Force)*, 54 x 116 cm.
16. *The Third Eye*. Coll. Mr. and Mrs. Mackenzie Gordon
17. *Trilobite*. Coll. Dr. and Mrs. Bernardo Bermúdez
18. *Cosmic Stratum*. Coll. Dr. James E. Scott

Lithographs

19. *Machu-Picchu*
20. *Composición lítica (Lithic Composition)*
21. *Chancay*
22. *Espeleología* (Speleology)
23. *Chavín de Huántar*
24. *No Water, No Moon*
25. *Erosion*
26. *Amorphous Forms*

April 2 - 30, 1963

ANDEAN HANDICRAFTS BY ANDEA OF BOLIVIA, UNDER THE DIRECTION OF MME. ELENA ELESKA[1]

The present exhibition of textile products originated in the workshops of an unusual enterprise which, owing to its location in the highlands of Bolivia, has been given the name Andea.

Andea was founded and is still directed by Elena Eleska, a United States citizen of Austrian origin, who has had a versatile career as a painter, designer, and anthropologist. Prior to embarking upon this current venture, she had traveled throughout Asia as the art director of a celebrated two-year caravan that retraced the journeys of Marco Polo. She first visited Bolivia fourteen years ago. Some three years later she acquired an old abandoned farmhouse on the outskirts of Cochabamba and remodeled it, employing indigenous materials and the skills of native craftsmen. In producing the textiles needed for furnishing, she gathered a group of competent spinners and weavers to work the local llama, alpaca, and sheep wool into upholstery, curtains, and bedspreads. This was the start of Andea.

The enterprise now possesses complete facilities, employing more than 500 people, and receives assistance from the United States Agency for International Development (USAID). Manufactures include rugs, blankets, sweaters, and stoles. While control of quality is carefully maintained, production has currently reached sufficient volume for Andea to enter the export market.

We wish to express our thanks to Andea for assembling this interesting exhibition and to Panagra Airlines for the courtesy extended in the transport of the items.

April 15 - 28, 1963

PRIMITIVE ARTISTS OF THE AMERICAS IN CELEBRATION OF PAN AMERICAN WEEK 1963

A selection of the work of primitive artists—humble, often anonymous artisans in paint, metal, and wood—produced at varying periods in the history of the New World, is presented in celebration of Pan American Week 1963, and to provide a perspective of one of the oldest, strongest, and liveliest of our artistic traditions.

What we know today as primitive art is as old as the first inhabitants of the Americas. The Aztecs and the Mayas, as is witnessed by the codices they have left, produced simple graphic depictions, characterized by the directness of approach and of appeal typical of naive art. The Europeans who came to mingle with the aborigines instinctively sought to translate American nature in Old World plastic terms. Still later, the Africans appeared, bringing a strong preference for brilliant color.

For all of these, our ancestors' painting was from the beginning a natural mode of expression. Colors were applied to objects of daily use—jugs and bowls—for decorative purposes, and to boards, canvas, or tin with a view to artistic creation for its own sake. Painting also served as a magic element in religious rites; it recorded public calamities and military triumphs; it celebrated Catholic saints and aboriginal deities; it registered pride of ownership of rural properties or pure-bred stock. Votive offering, portraiture, landscape, and magic symbolism in the naive vein appeared almost simultaneously on American shores and have resisted the impact of time, academic teaching, and the sophistication of civilization.

[1] The list of works exhibited is unavailable. —*Ed.*

The present group of paintings and sculpture comprises ritual effigies, portraits, depictions of historical events, and representations of everyday objects and scenes. They stem from many regions and cultures; they are the product of mingling of bloods and of ethnic traditions. Many of the artists of bygone days devoted full time to their craft. Those of the present, however, gain their livelihood in highly varied fashions. They number a barber, a blacksmith, an embroiderer, and a diver. Each, whatever his period or profession, shows an individual attitude toward life in his instinctive creations. All, however, bear evidence to a striving for artistic expressions that transcends time and place, uniting peoples throughout our hemisphere.

Grateful acknowledgement is made to the following institutions and individuals, without whose cooperation this exhibition would have been impossible: the Minister of Foreign Affairs of Venezuela and Mrs. Marcos Falcón Briceño; Collection of Edgar William and Bernice Chrysler Garbisch, courtesy of National Gallery of Art, Washington, D.C.; The Phillips Collection, Washington, D.C.; Collection of the Museum of Fine Arts, Caracas, Venezuela, courtesy of Mr. Raúl Nass; Collection of Mr. Ramón G. Osuna, Washington, D.C.; Collection of Mr. and Mrs. Newton Steers, Washington, D.C.; Albert Loeb Gallery, New York City.

CATALOGUE

Paintings

Anonymous (Bolivia)
 1. *Ex-Voto*, seventeenth century, oil on wood, 17 x 10 1/2". Private collection, Washington, D.C.

Anonymous (Ecuador)
 2. *Boy with Bird*, early nineteenth century, oil on canvas, Quito school. Private collection, Washington, D.C.

Anonymous (Colombia)
 3. *Simón Bolívar*, about 1820, oil on canvas, 30 1/2 x 23".
 Coll. Minister of Foreign Affairs of Venezuela and Mrs. Falcón Briceño, Washington, D.C.

Anonymous (Colombia)
 4. *Lake Scene*, nineteenth century, tempera on silk, probably convent work, 13 x 18".
 Private collection, Washington, D.C.

Anonymous (Guatemala)
 5. *El 21 de Diciembre del Año 1891 (21st of December of the Year 1891)*, ex-voto, 1892, 14 x 17".
 Coll. Mr. Ramón G. Osuna, Washington, D.C.

Anonymous (Mexico)
 6. *Maravillosa curación de dispepsia (Marvelous Dyspepsia Cure)*, ex-voto, 1844, 10 x 14", oil on tin.
 Private collection, Washington, D.C.

Anonymous (United States)
 7. *Still Life with Rose*, nineteenth century, 20 x 25".
 Coll. Mr. and Mrs. Jeremiah A. O'Leary, Jr., Alexandria, Virginia

Gabriel Alix (Haiti, 1930)
 8. *La ville (The City) II*, oil on cardboard, 20 x 24". Coll. Mr. James E. Scott, Washington, D.C.

Montas Antoine (Haiti, 1926)
 9. *The Two Houses*, about 1954, oil on cardboard, 18 x 26". Coll. Mr. Ramón G. Osuna, Washington, D.C.

John Bradley (United States, active 1836-47)
10. *Emma Homan*, 1843-44, 34 x 27 1/8". Coll. Edgar William and Bernice Chrysler Garbisch, New York

E. Bustamante (Cuba, twentieth century)
11. *Still Life*, about 1941, oil on cardboard, 16 x 20". Private collection, Washington, D.C.

Feliciano Carvallo (Venezuela, 1920)
12. *Still Life*, 1949, oil on canvas, 29 x 34". Private collection, Washington, D.C.

J. Chiappini (Haiti, 1922)
13. *Portrait de Toussaint L'Ouverture (Portrait of Toussaint L'Ouverture)*, oil on wood, 21 x 12 1/2".
 Private collection, Washington, D.C.

Casimiro Domingo (Argentina, 1900)
14. *Apparitions*, oil on cardboard. Coll. Mr. and Mrs. Newton Steers, Washington, D.C.

Préfète Duffaut (Haiti, 1923)
15. *Jacmel, City and Coastal Scene*, 1952, oil on masonite, 16 x 24".
 Coll. Mr. Ramón G. Osuna, Washington, D.C.

G. Gasomer (United States, 1811-1861)
16. *The Barth Children*, 1851, oil on canvas, 36 1/4 x 26".
 Coll. Edgar William and Bernice Chrysler Garbisch, New York

Asilia Guillén (Nicaragua, 1887)
17. *Héroes y artistas vienen a la Unión Panamericana para ser consagrados (Heroes and Artists Come to the Pan American Union to Be Consecrated)*, 1962, oil on canvas, 20 x 24". Coll. Pan American Union

Edward Hicks (United States, 1780-1849)
18. *The Peaceable Kingdom*, 1846, oil on canvas, 24 x 31 3/4". The Phillips Collection, Washington, D.C.

Charles Hofman (United States, active 1872-1878)
19. *View of the Schuylkill County Almshouse Property*, 1876, oil on canvas.
 Coll. Edgar William and Bernice Chrysler Garbisch, New York

Hector Hyppolite (Haiti, 1894-1948)
20. *Personnage du Voodoo (Personage of Voodoo)*, 1946, oil on cardboard.
 Coll. Mr. Ramón G. Osuna, Washington, D.C.

John Kane (United States, 1860-1934)
21. *Across the Strip*, 1929, oil on canvas, 32 1/4 x 34 1/4". The Phillips Collection, Washington, D.C.

Noé León (Colombia, 1907)
22. *Peláez Hermanos, Building in Barranquilla*, 1962, oil on cardboard, 28 x 39".
 Private collection, Washington, D.C.

Georges Liautaud (Haiti, 1899)
23. *Sirène (Mermaid)*, iron sculpture. Private collection, Washington, D.C.

Víctor Millán (Venezuela, 1919)
24. *Carnaval en Oriente (Carnival in Oriente)*, 1954, oil on canvas, 21 x 27".
 Coll. Mr. Ramón G. Osuna, Washington, D.C.

Rafael Moreno (Cuba, 1887-1955)
25. *Morón Sugar Mill*, 1947, oil on canvas, 44 x 76". Courtesy Albert Loeb Gallery, New York City

Philomé Obin (Haiti, 1892)
26. *Toussaint L'Ouverture reçoit une lettre du Consul (Toussaint L'Ouverture Receives a Letter from the Consul)*,
 1945, oil on wood, 23 x 17". Private collection, Washington, D.C.

Louverture Poisson (Haiti, 1914)
27. *Adam et Eve: le péché éternel (Adam and Eve: The Original Sin)*, 1945, oil on wood, 12 x 16".
 Private collection, Washington, D.C.

Heitor dos Prazeres (Brazil, 1902)
28. *Samba*, 1949, oil on canvas, 20 x 24". Coll. Museum of Fine Arts, Caracas, Venezuela,
 extended loan from Raúl Nass

João Real (Brazil)
29. *Yemanya*, 1956, oil on canvas, 16 x 12". Private collection, Washington, D.C.

Gaston Tabois (Jamaica, 1931)
30. *Landscape in Jamaica*, 1956, oil on cardboard, 16 x 12".
 Coll. Minister of Foreign Affairs and Mrs. Falcón Briceño, Washington, D.C.

F. Trejo (El Salvador)
31. *Tuberculosis*, ex-voto, 1938, oil on cardboard and collage, 15 x 18 1/2". Private collection, Washington, D.C.

José Antonio Velásquez (Honduras, 1906)
32. *Vista de San Antonio de Oriente (View of San Antonio de Oriente)*, 1956, oil on canvas, 22 x 28 1/2".
 Private collection, Washington, D.C.

BIOGRAPHICAL NOTES[1]

ALIX, Gabriel. Painter, born in Haiti, 1930. Worked at the Centre d'Art, Port-au-Prince. Exhibited in New York; Washington, D.C.; Illinois State Museum; *Exposición Panamericana de Pintura Moderna*, Museo de Bellas Artes, Caracas, 1948; *Thirty-two Artists of the Americas*, touring Latin American countries, OAS, 1949; Musée d'Art Moderne, Paris; Amsterdam; First Inter-American Biennial of Painting and Print, Mexico, 1958.

ANTOINE, Montas. Painter, born in Léogane, Haiti, 1926. Joined the Centre d'Art, 1950. Participated in the exhibitions organized by the Centre d'Art in Haiti and abroad, including the United States.

BUSTAMANTE, E. Contemporary painter born in Cuba. Exhibited in Cuba and abroad, including *Naive Art of the World*, circulating in museums in Baden-Baden, Frankfurt, and Hannover, all in Germany, 1961.

CHIAPPINI, Jean. Painter, born in Dajabón, Dominican Republic, 1922. Moved to Cap-Haïtien where he met Michelet Giordani, under whose guidance started painting. Participated in the exhibition *Naive Art of the World* that circulated in German museums in Baden-Baden, Frankfurt, and Hannover, 1961.

DOMINGO, Casimiro. Painter, born in Spain, 1882. A shoemaker since the age of ten, took up residence in Argentina in 1923. Started painting as a self-taught artist at the age of fifty-three (1935). Held individual exhibitions in Buenos Aires. Participated in the exhibition *Les peintres naïfs du douanier Rousseau à nos jours*, Brussels, 1958, and in Paris.

DUFFAUT, Préfète. Painter, muralist, poet, born in Jacmel, Haiti, 1923. By the age of twelve, worked as a shipwright. In the 1950s associated with the Centre d'Art. Decorated the walls of the church in La Gonâve and painted two murals at the Holy Trinity Cathedral, Port-au-Prince. Held individual exhibitions at the Centre d'Art, Port-au-Prince, and participated in the shows organized by this Center in Haiti and abroad, including the United States. Also exhibited at the First Inter-American Biennial of Painting and Print, Mexico, 1958, and *Naive Art of the World*, circulating in German museums in Baden-Baden, Frankfurt, and Hannover, 1961.

[1] Not included in the original catalogue. See Index of Artists for reference on those not listed here. —*Ed.*

HYPPOLITE, Hector. Painter, born on Saint Marc, Haiti, 1894. Died in Port-au-Prince, 1948. Apprentice to shoemaker at age of twelve, Voodoo priest, house painter, and furniture decorator, wandered through Africa and America. Founded the group *Primitive Painters* in Haiti. Joined the Centre d'Art of Port-au Prince in 1945. Achieved world recognition thanks to André Breton, who wrote about him and exhibited his paintings in surrealist exhibitions in Europe. His work was also included at the UNESCO *Exposition Internationale d'Art Moderne*, Musée d'Art Moderne, Paris, 1946; First Inter-American Biennial of Painting and Print, Mexico, 1958; *Naive Art of the World*, circulating in German museums in Baden-Baden, Frankfurt, and Hannover, 1961.

MORENO, Rafael. Painter, muralist, born in Alajar, Spain, 1887. Died in Cuba, 1955. Before he turned to painting, was a bricklayer, farm laborer, apprentice to bull-fighter, proprietor of a grocery store and a shooting gallery. In 1930 began to paint murals in bars and cabarets of La Playa (Cuba). Soon after, was "discovered" by two French art dealers. Held individual exhibitions in Havana. Participated in group exhibitions in Cuba and abroad, including *Modern Cuban Painters* at the Museum of Modern Art of New York (1944) and *Six Latin American Painters* in 1946, both circulating in the United States, and *Naive Art of the World*, circulating in German museums in Baden-Baden, Frankfurt, and Hannover, 1961.

OBIN, Philomé. Painter, born in Bas Limbé, Haiti, 1892. Worked as barber, coffee merchant, and clerk in the Cap-Haïtien Finance Department; became the head of the Cap-Haïtien branch of the Centre d'Art; and founded his own School of Painting. Executed a group of heraldic paintings for the Masonic Lodge at Limonae. Exhibited in the United States; in France, including the UNESCO *Exposition Internationale d'Art Moderne*, Musée d'Art Moderne, Paris, 1946; Germany; Holland; *Exposición Panamericana de Pintura Moderna*, Museo de Bellas Artes, Caracas, 1948; *32 Artists of the Americas*, touring Latin American countries, OAS, 1949; First Inter-American Biennial of Painting and Print, Mexico, 1958; and *Naive Art of the World*, circulating in German museums in Baden-Baden, Frankfurt, and Hannover, 1961.

POISSON, Louverture. Painter, born in Cayes, Haiti, 1914. Before beginning to paint, worked as a salesman in an import-export house of Cayes. Moved to Port-au-Prince, 1945, and joined the Centre d'Art. Exhibited in Washington, D.C., New York, and other cities in the United States; the UNESCO *Exposition Internationale d'Art Moderne*, Musée d'Art Moderne, Paris, 1946; *Exposición Panamericana de Pintura Moderna*, Museo de Bellas Artes, Caracas, 1948; First and Second Inter-American Biennial of Painting and Print, 1958 and 1960; *Naive Art of the World*, circulating in German museums in Baden-Baden, Frankfurt, and Hannover, 1961.

PRAZERES, Heitor dos. Painter, born in Rio de Janeiro, 1902. A well-known composer of Brazilian sambas, received First Prize for his samba *Mulher de Malandro* at the Carnival of 1932. Started painting in 1937, after the death of his wife. Held individual exhibitions in Rio de Janeiro. Participated in Brazilian exhibitions in Paris, various cities in Switzerland, London, Buenos Aires, New York; Biennial of São Paulo (1951 and 1953), Biennial of Barcelona (Spain, 1955), and Biennial of Venice (1956). Was awarded a prize at the First São Paulo Biennial, 1951.

REAL, João. Contemporary painter born in Brazil. Exhibited in Brazil and abroad, including *Naive Art of the World*, a traveling exhibition shown at the Staatliche Kunsthalle Baden-Baden, the Historisches Museum, Frankfurt, and the Kunstverein, Hannover, all in Germany, 1961.

TABOIS, Gaston. Painter, born in Trout Hall, Clarendon, Jamaica, 1931. Studied at the College of Arts, Sciences and Technology in Kingston and Dillard University of New Orleans. Self-taught as an artist, started painting in 1951. Exhibited in Jamaica and the United States, including the Museum of Fine Arts, Houston, 1956.

May 1 - 28, 1963

RODRIGUEZ CANDHALES OF URUGUAY: DRAWINGS

The artist known as Dándolo Rodríguez Candhales, whose real family name is Hordeñana, was born in Montevideo, Uruguay, in 1917. He began to paint at an early age, working with the Italian teacher Casandro. In 1947 he received a scholarship that took him to Italy. From that country he went on to France, where he devoted time in Paris to an intensive study of the varying values of shadows, and then to Spain, where his drawings took on the light and movement that have become their distinguishing characteristics. Among the portraits he did of European personalities, he attaches particular importance to those of Chancellor Konrad Adenauer and the late Pope Pius XII.

Candhales was awarded Gold Medal as the outstanding painter in Naples in 1948. The same year his works were exhibited not only in that city but also in Rome and in Cannes. In the New World they have been presented, among other cities, in Montevideo, 1945, 1950, and 1957; Rio de Janeiro, 1955; Santiago (Chile), 1958; Lima, 1961; and Cali (Colombia), 1961.

The Peruvian critic Fernando de la Presa has written:

> Candhales is a truly original artist resembling no other. His quick sketches of scenes in cafés may occasionally recall Toulouse Lautrec, but to his rapid strokes and sensation of movement he imparts a poetic, dreamlike quality, distorting the reality of the scenes he depicts in order to heighten the message they convey.

This is the first exhibition of Candhales's work in the Washington area.

CATALOGUE

1-24. Drawings, 1954-61[1]

May 1 - 20, 1963

FEDERICO MARTINO OF ARGENTINA: RECENT PAINTINGS

For some time now, the Argentine painter Federico Martino has been one of the champions of a new trend known as *tiempismo* (time-ism), which stresses the value of time rather than that of space. For Martino, a painting should convey a sense of continuity, deriving not from movement but from the infinite progression of lines from the beginning of the composition to the end. The picture thus represents a fragment of time; it provides a point of departure for the eye to continue the artist's conception beyond the confines of the frame. Recently Martino has modified his basic pattern, breaking the lines with subtle chromatic touches. The result suggests a fragment of a universal wall of harmonious color.

Martino was born in Buenos Aires in 1930. He enrolled in the National School of Fine Arts in 1943 and graduated seven years later. Shortly afterwards he was appointed to teach art history at the same institution. In 1957 he received an invitation to visit France from the government of that country, and he took advantage of the opportunity to travel to other parts of Europe—Belgium, the Netherlands and, in particular, Scandinavia.

[1] Titles are unavailable. —*Ed*.

Martino has had one-man shows in Buenos Aires at the Rubbers Gallery in 1959 and 1960 and at the Van Riel Gallery in 1960, and in Miami at the Museum of Modern Art in 1963. Examples of his work have been included in Argentine group shows sent to England, Mexico, and Uruguay, as well as in the Mexico, São Paulo, and Venice biennials. Currently compositions by him are to be seen at an important exhibition in Barranquilla, Colombia.

Martino is the recipient of a fellowship from the Organization of American States, under which he has been doing postgraduate work at the Corcoran School of Art. The current show is the first presentation of his painting in the Washington area. —*J.G-S.*

CATALOGUE

Paintings

1. *Folk,* 70 x 120 cm.
2. *Marvelous*
3. *H.N.*, 80 x 150 cm.
4. *Don*
5. *Miedo (Fear)*
6. *Washington*, 70 x 70 cm.
7. *Viva Pepe*
8. *Ecce Homo*, 50 x 100 cm.
9. *¡Que mueran Dalí y Picasso! (Down with Dalí and Picasso!)*, 70 x 120 cm.
10. *Noé* (Noah)
11. *Male*
12. *Female*
13. *What?!*, 22 x 70 cm.
14. *Ra . . .*
15. *En la lucha (The Fight Continues)*, 27 x 80 cm.
16. *Corcoran*
17. *Basta (Enough)*, 25 x 65 cm.
18. *Lanier Place*
19. *Martino 63*, 100 x 110 cm.
20. *Pigs*
21. *16th Street*
22. *America*
23. *Argentina*, 30 x 64 cm.
24. *Tiempismo*
25. *OEA*, 15 x 30 cm.
26. *NN*, 30 x 150 cm.
27. *Lincoln*, 25 x 70 cm.
28. *Paris is a Myth*, 85 x 110 cm.
29. *I Was Also a Public Employee*

May 21 - June 11, 1963

ALBERTO BRANDT OF VENEZUELA

Alberto Brandt was born in Caracas, Venezuela, in 1924. At a very early age he began the study of the piano, first at the National Conservatory in his native city and later at the Hamburg conservatory. At different times he

numbered among his teachers the distinguished Chilean artists Rosita Renard and Arnaldo Tapia Caballero and the world-renowned Walter Gieseking. It was not until 1957 that Brandt embarked upon a career in the plastic arts, taking up painting. As had been the case with music, he quickly attained a remarkable level of maturity. Within the year he held his first one-man show at the Centro Profesional del Este in Caracas. A second individual exhibition was presented in 1958 at the Norte-Sur Gallery in the same city; it was followed by others at the Valerie Schmidt Gallery of Paris in 1961, Windsor Gallery of Barcelona (Spain) in 1962, and at the Sala Mendoza of Caracas in 1963. Brandt has participated in group shows in France, Italy, Spain, and Venezuela. In the last named country he won the First Prize at the D'Ampaire Salon in Maracaibo, 1960. Examples of his work are to be found in private collections in Belgium and France, and in the Museum of Modern Art of Caracas.

The distinction conferred upon his work by rigorous discipline has been duly noted by critics. Commenting upon the compositions presented at the Valerie Schmidt Gallery, the writer for the Paris journal *Arts* said:

> The soft, luminous fluorescent canvases of the young Venezuelan informalist Alberto Brandt are broken at occasional intervals by vibrant jets of darker hue. His palette is a subtle one, of delicate nuances.

The present show comprises compositions executed in Paris and Caracas between 1958 and 1963. Brandt follows the informalist trend; he terms his abstractions "cosmic." Their highly original titles betray his underlying sense of humor. This is the first time that his works are shown in the United States.

CATALOGUE

Paintings, 1958-1963[1]

1. *Tres impúdicos ante el Cabildo (Three Impudent Persons Before the Courts)*
2. *Ataúlfo deposita un papiro místico en el National City Bank (Ataulphus Deposits a Mystic Papyrus in the National City Bank*
3. *Escandalosa abdicación de Urbano VII (The Scandalous Abdication of Urban VII)*
4. *El matrimonio místico de Santa Catalina (The Mystic Marriage of Saint Catherine)*
5. *Grupo de zagaletones atacando a un coleóptero (Group of Tomboys Attacking a Coleopteran)*
6. *La adoración de los arbustos eidolónicos (The Adoration of the Eidolonic Bushes)*
7. *El laberinto hidrocálico (The Hydrocalyc Maze)*
8. *De cómo Ataúlfo fue lanzado en persecución de unas enaguas (Why Ataulphus Was Urged to Persecute Skirts)*
9. *Expectativa ante la llegada del cadáver de San Ildefonso (Expectation on the Arrival of the Body of Saint Ildefonso)*
10. *Teresa de la Parra recibe al Embajador de Eritrea (Teresa de la Parra Receives the Emperor of Eritrea)*[2]
11. *Audición de Heliogábalo con un onóvalo (Heliogabalus Playing the Onovalus)*
12. *Tres pretendientes al trono de Siracusa y masacre (Three Pretenders to the Throne of Syracuse and Massacre)*
13. *Desprestigio de la inversión al sur de Tapipa (Discredit of Investment South of Tapipa)*
14. *Paseo erótico de un iconoclasta por San Agustín del Sur (Erotic Promenade of an Iconoclast throughout San Agustin del Sur)*
15. *Regocijo necrófilo en las faldas de Cabo Codera (Necrophilic Satisfaction in the Outskirts of Codera Cape)*
16. *Mutación mimética de las paralaxias axiales (Mimetic Mutation of the Axial Parallaxias)*
17. *First Interplanetary Trip of a Visigothic King*
18. *Pipino el Breve no era muy fotogénico (Pepin the Short Was Not Too Photogenic)*

[1] Many of the Spanish terms used in these titles were created by the artist. —*Ed.*

[2] Literal translation of this title is "Teresa de la Parra Receives the Ambassador of Eritrea." —*Ed.*

19. *The Inter-Lobster is Transformed into Little Red Riding Hood*
20. *Lady Catherine De Burr Circumcises the Last Plantagenet*
21. *Astrology for Insects*
22. *Antinoe Never Committed Suicide*
23. *Capricornians in the Search for Sears Roebuck & Co.*
24. *Cleopatra Assaulted at West Central Park*
25. *All the Emeralds Were False and Expendable*
26. *Once Upon a Time It Is the End*
27. *Castiglione Decides to Try Baseball*
28. *Hadrian Never Abolished the Tyranny of Popcorn*
29. *Doña Urraca and Don Sancho Advocate Birth Control*

June 11 - July 1, 1963

JORGE DE LA VEGA OF ARGENTINA: OILS

In celebration of Pan American Week 1962, the Pan American Union presented a group exhibition entitled *Neo-Figurative Painting in Latin America*. Commenting on the movement in question, the catalogue of the show stated:

> Of late, the human figure has begun to return from the banishment to which it had been consigned. There were always, of course, artists who remained untouched by non-objective tendencies, continuing to take recognizable reality as their point of departure, but now everywhere there are appearing others who, while taking advantage of the technical freedoms of the abstractionist, nonetheless seek expression through the human form.

Among the artists presented was Jorge de la Vega, a leading exponent of the neo-figurative trend in Argentina, in which country it has been taking shape for several years. He was born in Buenos Aires in 1930 and studied architecture at that city's university. However, shortly before graduation, he abandoned his projected career in order to devote full time to painting, which had previously been only an avocation.

Although de la Vega is considered an autodidact, he has taught composition at the Manuel Belgrano School of Fine Arts in the Argentine capital and is a professor of art appreciation at the School of Architecture of the University of Buenos Aires. In 1962 the National Fund for the Arts awarded him a fellowship which permitted him to spend a year in Europe, chiefly in France, but with excursions to Belgium, Germany, Italy, the Netherlands, Spain, Switzerland, and the United Kingdom.

Works by de la Vega are to be found in several Argentine institutions, among them the Buenos Aires Museum of Modern Art. They have been presented in national and international salons and in Argentine exhibits in Madrid, New York, Paris, and Rio de Janeiro. The artist has held one-man shows in Buenos Aires at the Municipal Gallery (1951), the Plastic Gallery (1952), and the Lirolay Gallery (1961). He has also appeared in group exhibitions with the co-founders of the movement known as *Otra Figuración* (Another Figuration). Numbered among these are Rómulo Macció and Luis Felipe Noé, both of whom were included in the 1962 show at the Pan American Union and will receive individual presentations there at a later date.

This is the first exhibition dedicated to the compositions of Jorge de la Vega to be offered in the United States.

CATALOGUE

Oils on Canvas

1. *Desnudo (Nude)*, 1960, 100 x 120 cm.
2. *Pez doméstico (Domestic Fish)*, 1960, 90 x 130 cm.
3. *Las formas de la respiración (Forms of Respiration)*, 1961, 130 x 162 cm.
4. *Ritos (Rites)*, 1961, 114 x 146 cm.
5. *Asfixia por ascensión rápida (Breathless Because of Rapid Ascension)*, 1962, 116 x 89 cm.
6. *Derviche*, 1961, 97 x 146 cm.
7. *Pantagra*, 1962, 116 x 89 cm.
8. *Bohemio Hi-Fi (Hi-Fi Bohemian)*, 1962, 116 x 89 cm.
9. *Cabeza (Head)*, 1962, 40 x 50 cm.
10. *Signo (Sign)*, 1962, 60 x 50 cm.
11. *Dos cabezas (Two Heads)*, 1962, 70 x 50 cm.
12. *La tierra (The Earth)*, 1962, 70 x 50 cm.
13. *La bestia y la bestia (The Beast and The Beast)*, 1962, 70 x 60 cm.

Oils on Canvas and Collage

14. *Danza de la montaña (Mountain Dance)*, 1963, 195 x 130 cm.
15. *Zoo íntimo (Intimate Zoo)*, 1963, 195 x 130 cm.
16. *Ruido de mar (Sound of the Ocean)*, 1963, 162 x 130 cm.
17. *Ruido de bosque (Sound of the Forest)*, 1963, 162 x 130 cm.
18. *Un día, la aventura (One Day, the Adventure)*, 1963, 140 x 100 cm.
19. *Pastoral*, 1963, 130 x 97 cm.
20. *Gato en el espejo (Cat in the Mirror)*, 1963, 130 x 81 cm.

July 8, 1963

PHOTOGRAPHS OF BRAZIL BY DAVID ZINGG. ORIGINAL SCULPTURES BY LYGIA CLARK, MARIO CRAVO, AGNALDO DOS SANTOS, AND GIULIANO VANGI[1]

BIOGRAPHICAL NOTE

CLARK, Lygia. Sculptress, painter, born in Belo Horizonte, Brazil, 1920. Studied under Roberto Burle Marx, Rio de Janeiro, 1947; with Arpad Szannes, Dobrinsky, and Fernand Léger, Paris, 1948-50. Was an instructor, Institute for the Deaf and Dumb, Rio de Janeiro, 1950-55; and a founding member of the *Grupo Neoconcreto*, 1959. Since 1952 has held individual exhibitions in Paris, Rio de Janeiro, and New York. Participated in the Biennial of São Paulo (1953, 1955, 1957, and 1959), and of Venice (1960 and 1962); *Arte Neoconcreta*, Museu de Arte Moderna of Rio de Janeiro and São Paulo, 1960; and in Paris, Montevideo, New York, Buenos Aires, Washington, D.C. Was awarded several prizes in Brazil, including the National Prize for Sculpture, Sixth São Paulo Biennial (1961) and was acclaimed by the critics the "artistic revelation of the year," Rio de Janeiro, 1962.

[1] No catalogue is available for this exhibition. —*Ed.*

CRAVO, Mário. Sculptor, painter, draftsman, printmaker, born in Salvador, Bahia, Brazil, 1923. Studied with Pedro Ferreira, Bahia; Humberto Cozzo, Rio de Janeiro; School of Fine Arts, Syracuse University, under Ivan Mestrovic, 1947. Traveled in the United States, Canada, and Mexico. Teaches printmaking at the Escola de Belas Artes, University of Bahia. Did an album of prints for the Museu de Arte, São Paulo, 1950, and in 1951 another album with his color prints was published in Bahia, *Seis profetas do Aleijadinho*, with an introduction by Wilson Rocha. Held individual exhibitions in Bahia, New York, the Museu de Arte de São Paulo (1950), and the Museu de Arte Moderna of Rio de Janeiro (1959). Participated in many group exhibits in Brazil and Europe, including the biennials of São Paulo (1951 and 1955-61), Venice (1952 and 1960), and Tokyo (1957); Salon de Mai in Paris (1954), Kunsthalle in Berne (1954) and Musée d'Art Moderne in Paris (1960). Was awarded several prizes in Bahia, at the Biennial of São Paulo, in Rio de Janeiro, and the First Prize for Sculpture at the 1955 Salão Paulista de Arte Moderna.

SANTOS, Agnaldo Manoel dos. Sculptor, born in Bahia, Brazil, 1926. Died in 1962. Was a self-taught artist. Held individual exhibitions in Bahia and Rio de Janeiro. Participated in several group exhibits, including *Artists of Bahia*, Museu de Arte Moderna, São Paulo, 1956.

VANGI, Giuliano. Sculptor, born in Barberino di Mugello, Florence, Italy, 1931. Studied at the Institute of Art and at the Accademia, Florence. Executed a sculpture for the Customs Palace, Ancona (Italy), 1956. Held individual exhibitions in São Paulo and Rio de Janeiro. Participated in several Brazilian group exhibitions, including the São Paulo Biennial, 1961. Was awarded First Prize for Sculpture, Art Salon, Curitiba, 1961. Lives in São Paulo since 1959.

July 16 - August 22, 1963

THE ARTIST AS PRINTMAKER I: JOSE LUIS CUEVAS OF MEXICO

With this exhibition, the Print Gallery of the Pan American Union embarks upon a new series, featuring the etchings, engravings, woodcuts, and lithographs of artists whose work in other media has previously been on view in the Main Gallery.

For initial presentation it offers a panorama of the activity as a printmaker of José Luis Cuevas—from etchings and woodcuts done in 1947, when he was but fourteen years old, to the lithographs of his portfolio *Cuevas on Cuevas; Recollections of Childhood*, recently issued in a deluxe, limited edition by the Kanthos Press, to wide critical acclaim.

Cuevas (born in Mexico City in 1933) provides perhaps the sole example in contemporary Latin America of an artistically precocious youth who has developed over the years into a strong, clearly defined, creative personality. His style and subject matter have been copied—closely, or with varying degrees of modification—by other artists, not only in Mexico and the United States, but in lands as far distant as Italy and India.

Although he had previously participated in two or three minor exhibitions, it was not until his one-man show at the Pan American Union in 1954, featuring drawings of inmates of an insane asylum, that Cuevas won international renown. Since that time, whether in individual or group exhibitions, his work has been presented in major cities of Canada, France, Italy, and the United States, and in most of the capitals of Latin America. Examples are to be found in some twenty museums, including ten in the United States. Cuevas has received two major international awards: First Prize for Drawing at the Fifth São Paulo Biennial, and a similar distinction at the Seventh Exhibition of Artists in Black and White held in Lugano, Switzerland.

This retrospective exhibit permits a clear view of the development of Cuevas's style over the past decade and a half.

That style, which had its origins in the traditions of the Mexican school, showed in its early stages a strong influence of José Clemente Orozco and—as regards technique—Leopoldo Méndez. Gradually, and without ever abandoning its Mexican accent, Cuevas's manner progressed toward a more universal type of expression. A good example of this evolution is furnished by his interpretation of the *Christ Child* as painted by Mantegna, a study which represents a turning point in his production. Cuevas has since developed a mode of expression peculiarly his own, with his own repertory of forms. He preserves the atmosphere of violence and horror he obtained initially by a direct approach to nature, but his treatment is now more intellectual and in consequence more profound. The degree of maturity he has achieved is clearly evidenced by the series of prints he has done for art books.

Cuevas's first venture into this field took place in 1959, with *The World of Kafka and Cuevas*, published by the Falcon Press. This work, which met with a highly favorable critical reception, made no attempt to illustrate Kafka's texts. It sought rather to interpret, in lines and forms, the cryptic message of the tormented Czech visionary. The artist's treatment of his own childhood memories, in *Cuevas on Cuevas*, is similar: in no way subordinate to the text, the accompanying lithographs are nonetheless in close harmony with its spirit. The balance thus achieved contributes in no small measure to making of the album a masterpiece of graphic art. —*J.G-S.*

CATALOGUE

Prints

1. *The Embrace*, 1947, drypoint, 6 x 4". Sole copy extant. Coll. Mexico City College
2. *Woman with a Lamp*, 1947, etching, 8 x 5 1/4". Made for an illustration, sole copy extant. Coll. Mexico City College
3. *Seated Child*, 1947, aquatint, 5 x 4". Sole copy extant. Mexico City College
4. *Illustration*, 1947, mezzotint, 5 x 4 3/4". Four copies, dated, signed, unnumbered. Coll. Mexico City College
5. *Illustration*, 1947, drypoint, 4 x 3 1/4. Sole copy extant. Coll. Mexico City College
6. *Myth*, 1948, drypoint, 6 1/2 x 4 1/2". Seven copies, signed, unnumbered. Coll. Mr. Guillermo Silva, Mexico City
7. *Portrait of Mireya*, 1948, etching, 9 x 5". Inscription: "1948 Cuevas." Unnumbered. Coll. Mexico City College
8. *After the War*, 1950, linoleum, 13 1/2 x 7 3/4". Inscription: "cn." Unnumbered. Artist's studio
9. *Paz (Peace)*, 1950, linoleum, 13 1/2 x 10". Inscription: "Paz." Unnumbered. Artist's studio
10. *Demon*, 1953, drypoint, 9 1/2 x 5 1/2". Sole copy extant. Coll. Mr. Guillermo Silva, Mexico City
11. *Woman of New York*, 1954, lithograph, two colors, 9 x 13 1/2". Ten copies, signed, numbered. Coll. Geo Miller Workshop, New York City
12. *Poster for an Exhibition*, 1956, lithograph, 15 x 11. Inscription: "J.L. Cuevas EXPOSICION 56 26." Eight copies, signed, numbered. Coll. Mr. André Vanderbroeck, Mexico City
13. *Homage to Picasso's Circus People*, 1956, lithograph, 12 1/2 x 10". Inscription: "Oct 26 56." Eight copies, signed, numbered. Coll. Mr. Andre Vanderbroeck, Mexico City
14. *Coney Island, Today*, 1956, lithograph, 12 x 10 1/2". Inscription: "26 oct 56 today." Four copies, signed, numbered. Coll. Mr. André Vanderbroeck, Mexico City
15. *Today*, 1956, lithograph, 10 1/2 x 14". Inscription: "26 oct 56 Hoy." Six copies, signed, numbered. Coll. Mr. André Vanderbroeck, Mexico City
16. *Sketch for a Crucifixion*, 1956, lithograph, 12 1/2 x 16". Inscription: "litografía oct 20." Four copies, second state. Coll. Mr. André Vanderbroeck, Mexico City
17. *Contortionist*, 1956, lithograph, 12 x 10". Inscription: "26 oct 56." Nine copies, first state, signed, numbered. Coll. Mr. André Vanderbroeck, Mexico City
18. *Cretinismo (Cretinism)*, 1956, lithograph, 19 x 24". Inscription: "Cuevas 26 Oct 56 ¡Cretinismo!" Artist's proof, first state. Coll. Mr. André Vanderbroeck, Mexico City
19. *Niño de Mantegna (Interpretation of Mantegna's Christ Child)*, 1957, lithograph, two colors, 19 x 14". Inscription: "Niño de Mantegna 26 feb 1957 New York." Fifteen copies, signed, numbered. Coll. Geo Miller Workshop, New York City

20. *Autorretrato (Self-portrait)*, 1958, woodcut, 12 x 7". Signed, numbered (some with variations in ink and double printing). Artist's studio

21. *Self-portrait after Rembrandt*, 1962, lithograph, 12 x 15 1/6". Inscription: "Self-Portrait after Rembrandt 12 9 62." Artist's proof. Coll. Kanthos Press, Los Angeles

22. *Two Heads*, 1962, lithograph, 13 x 19". Lengthy text inscription. Third state. Artist's proof. Coll. Kanthos Press, Los Angeles

23. *Two Heads*, 1962, lithograph, 15 x 22 1/4". Lengthy text inscription. Second state, artist's proof. Coll. Kanthos Press, Los Angeles

24. *Crouching Figure*, 1962, lithograph, 16 x 22". Inscription: "8 9 62." Artist's proof, first state. Coll. Kanthos Press, Los Angeles

25. *Crouching Figure*, 1962, lithograph, 16 x 22". Artist's proof, second state. Coll. Kanthos Press, Los Angeles

26. *Portrait of the Artist as a Young Man*, 1962, lithograph, 19 3/4 x 12 7/8". Inscription: "Cuevas by Cuevas, portrait as a young man, 28 ago. 1962 Cuevas." Artist's proof, second state. Coll. Kanthos Press, Los Angeles

27. *Portrait of the Artist as a Young Man*, 1962, lithograph, 12 x 15 1/2". Inscription: "Cuevas by Cuevas, portrait of the artist as a young man, 28 ago. 1962 Cuevas." Artist's proof, second state. Coll. Kanthos Press, Los Angeles

28. *Portrait of the Artist as a Young Man*, 1962, lithograph. Inscription: "Portrait of the artist as a young man, 28 ago." Artist's proof, third state. Coll. Kanthos Press, Los Angeles

29. *Mireya*, 1962, lithograph with crayon, 10 x 6 1/4". Experimental lithograph with color crayon, sole copy extant. Coll. Kanthos Press, Los Angeles

30. *Mireya*, 1962, lithograph with crayon, 10 x 6 1/4". Inscription: "cambiar de posición la figura." Experimental color lithograph with crayon, sole copy extant. Coll. Kanthos Press, Los Angeles

31. *Two Medallion Heads*, 1962, lithograph, 12 1/2 x 17". Inscription: "Cuevas" (signed on reverse of the stone). Artist's proof, first state. Coll. Kanthos Press, Los Angeles

32. *The Butcher*, 1962, lithograph, 22 x 30". Inscription: "Cuevas 1-X-62." Twenty copies, signed, numbered. Coll. Kanthos Press, Los Angeles

33. *The Leap*, 1962, lithograph, 6 1/4 x 12". Five copies, signed, numbered. Coll. Kanthos Press, Los Angeles

34. *Yo viejo Cuevas (Myself as an Old Man)*, 1962, lithograph, 8 3/4 x 6 3/4". Inscription: "Yo Viejo Cuevas." Ten copies, signed, numbered. Coll. Kanthos Press, Los Angeles

35. *Yo viejo Cuevas (Myself as an Old Man)*, 1962, variation, with two old commercial lithographs, 7 1/2 x 10 1/2". Inscription: "Yo Viejo Cuevas." Artist's proof. Coll. Kanthos Press, Los Angeles

The Worlds of Kafka and Cuevas, edited and designed by Louis R. Glessmann and Eugene Feldman. Texts by Franz Kafka, Max Brod and Rollo May. Introduction by José Gómez-Sicre. Philadelphia: Falcon Press, 1959. 36 pp., illustrated.

Recollections of Childhood, a portfolio of twelve original lithographs, one hundred copies, signed, numbered. Autobiographic text by José Luis Cuevas. Lithographs executed by Joe Funck. Los Angeles: The Kanthos Press, 1962.

July 22 - August 13, 1963

MANUEL HERNANDEZ OF COLOMBIA: OILS

A new personality emerges in the contemporary art of Colombia and is making a debut in the United States with this one-man show.

Manuel Hernández was born in Bogotá in 1928. He studied at the Academy of Fine Arts in that capital and later completed post graduate studies in Santiago de Chile and Rome, Italy, where he remained until early this year.

Hernández has held the following one-man shows: at the Pacífico Gallery, Santiago, Chile, 1951; El Callejón Gallery, 1955 and 1958; the Gallery of Luis Angel Arango Library, 1960; and the Gallery of the National Library, 1962, all in Bogotá, Colombia.

He has also participated in numerous group shows, among them the Hispanic-American Biennial in Barcelona, Spain, 1955; the Guggenheim International Award Show in Paris, 1956; the Venice Biennial and the Mexico City Biennial, 1958; *Group of Latin American Artists* in the Gallery Numero in Rome, 1962; and a group show of Colombian artists held in Miami at the beginning of this year. Hernández has also obtained awards in national contests in 1955 and 1961.

His work is represented in several museums of Colombia and abroad. At present the artist is residing in New York on a sabbatical from the Fine Arts Academy of the University of Tolima, Colombia, where he is a professor of art.

CATALOGUE

Oils

1. *Elementos para una naturaleza muerta (Elements for a Still Life)*, 30 x 24"
2. *Formas hacia un centro (Center Bound Forms)*, 32 x 24"
3. *Formas en movimiento (Forms in Movement)*, 24 x 20"
4. *Medio día sobre el muro (Noon Sun on the Wall)*, 24 x 24"
5. *Elementos para un jardín (Elements for a Garden)*, 48 x 36"
6. *Variación de superficies (Variation of Surfaces)*, 14 x 16"
7. *Superficie en rojo y azul (Surface in Red and Blue)*, 18 x 14"
8. *Formas en verde transparente (Transparent Green Forms)*, 36 x 28"
9. *Base para una forma (Basis for a Form)*, 36 x 28"
10. *Forma suspendida (Suspended Form)*, 36 x 28"
11. *Elementos para un sistema (Elements for a System)*, 36 x 28"
12. *Formas superpuestas (Overlapping Forms)*, 36 x 28"
13. *Motivo volátil en ocre y azul (Volatile Motive in Ocher and Blue)*, 20 x 16"
14. *Elementos rítmicos (Rhythmic Elements)*, 36 x 50"
15. *Gran forma inclinada (Great Inclined Form)*, 50 x 36"
16. *Motivo exterior (Exterior Motive)*, 50 x 36"
17. *Ritmo imaginario (Imaginary Rhythm)*, 50 x 36"
18. *Motivo floral (Floral Motive)*, 50 x 36"
19. *Movimiento dirigido (Directed Movement)*, 50 x 36"
20. *Elementos hacia una gran forma (Elements Bound toward a Great Form)*, 50 x 36"
21. *Motivo hacia la luz (Motivation Toward Light)*, 50 x 36"
22. *Figuración sobre el trópico (Tropical Figuration)*, 50 x 36"
23. *Imagen vegetal (Vegetable Image)*, 50 x 36"
24. *Formas de un cometa roto (Forms from a Disintegrated Comet)*, 30 x 40"
25. *Motivo sobre un río (River Theme)*, 34 x 42"
26. *Elementos sobre el muro (Elements on a Wall)*, 34 x 42"
27. *Base para formas superpuestas (Basis for Overlapping Forms)*, 28 x 36"
28. *Naturaleza muerta con acento rojo (Still Life with Red Accent)*, 22 x 30"

August 15 - September 1, 1963

VENEZUELAN POTTERY: THE ARTISTS, THEIR POTTERY

CATALOGUE

Eduardo Gregorio
 1-4. *Bottle*
 5. *Flower Pot*
 6-7. *Bottle*

Cristina Merchán
 8. *Rag Animal*
 9. *Ocean Cube*
 10. *Rag Animal*
 11. *Water Bottle*
 12. *Flower Pot*
 13. *Bowl*
 14. *Flower Pot*

Luisa and Gonzalo Palacios
 15. *Jar*
 16. *Bottle*
 17-20. *Bowl*
 21. *Flower Pot*

Seka
 22-28. *Ceramic Form*

Tecla Tofano
 29. *Bowl*
 30-34. *Flower Pot*
 35. *Bowl*

María Luisa de Tovar
 36. *Canaima 1*
 37. *Canaima 2*
 38. *Yellow*
 39. *Caroni*
 40. *Chamotte*
 41. *Blue Stain*
 42. *La bandera (The Flag)*

Thekla and Gottfried Zielke

 43-44. *Flower Pot*
 45-46. *Jar*
 47-48. *Flower Pot*
 49. *Jar*

ABOUT THE ARTISTS

GREGORIO, Eduardo. Born in Spain, 1904. Group Shows: Official Annual Plastic Arts Salon, Caracas, since 1959; Arts of Fire, Fundación Mendoza, Caracas, 1960; International Ceramics Praha 62, Prague, 1962; *International Ceramics Exhibition*, Art Museum, Buenos Aires, 1962; Museum of Contemporary Crafts, New York, 1963. Awards: Applied Arts Award, Official Annual Salon, Caracas, 1962.

MERCHAN, Cristina. Born in Venezuela, 1927. Individual Show: Caracas Art Museum, January 1963. Group Shows: Free Art Workshop, Plastic Arts School, Caracas, 1956; Official Annual Plastic Arts Salon, Caracas, since 1957; Arts of Fire, Fundación Mendoza, Caracas, 1958 and 1960; International Exposition, Brussels, 1958; *International Ceramics Exhibition*, Art Museum, Buenos Aires, 1962; Museum of Contemporary Crafts, New York, 1963. Awards: Applied Arts Award, Official Annual Salon, Caracas, 1957; Silver Medal, *International Ceramics Exhibition*, Buenos Aires, 1962.

PALACIOS, Luisa and Gonzalo. Born in Venezuela, 1923 and 1916. Group Shows: Official Annual Plastics Art Salon, Caracas, since 1959; Arts of Fire, Fundación Mendoza, Caracas, 1957 and 1958; International Exposition, Brussels, 1958; Galería El Muro, Caracas, 1962; *International Ceramics Exhibition*, Art Museum, Buenos Aires, 1962; Museum of Contemporary Crafts, New York, 1963. Awards: Applied Arts Award, Official Annual Salon, Caracas, 1960.

SEKA (Seka Severin de Tudja). Born in Yugoslavia, 1923. Individual Shows: Librairie Espagnole, Paris, 1959; Caracas Art Museum, 1962. Group Shows: Official Annual Plastic Arts Salon, Caracas, since 1955; Arts of Fire, Fundación Mendoza, Caracas, 1957, 1958, and 1960; Galería El Muro, Caracas, 1962; Museum of Contemporary Crafts, New York, 1963. Awards: Applied Arts Award, Official Annual Salon, Caracas, 1955; Gold Medal, International Exhibition Praha 62, Prague, 1962; First Individual Prize, Gold Medal, *International Ceramics Exhibition*, Art Museum, Buenos Aires, 1962.

TOFANO, Tecla. Born in Italy, 1927. Individual Show: Caracas Art Museum, 1960. Group Shows: Free Art Workshop, Plastic Arts School, Caracas, 1956; Official Annual Plastic Arts Salon, Caracas, since 1957; Arts of Fire, Fundación Mendoza, Caracas, 1958, 1960; International Exposition, Brussels, 1958; Galería El Muro, Caracas, 1962; Museum of Contemporary Crafts, New York, 1963. Awards: Applied Arts Award, Official Annual Salon, Caracas, 1958; Silver Medal, International Ceramics Praha 62, Prague, 1962; Second Individual Price, Gold Medal, *International Ceramics Exhibition*, Art Museum, Buenos Aires, 1962.

TOVAR, María Luisa de. Born in Venezuela, 1902. Individual Show: Venezuelan-North American Cultural Center, Caracas, 1948. Group Shows: Official Annual Plastic Arts Salon, Caracas, since 1942; Arts of Fire, Fundación Mendoza, Caracas, 1957, 1958, and 1960; Galería El Muro, Caracas, 1962; *International Ceramics Exhibition*, Art Museum, Buenos Aires, 1962; Museum of Contemporary Crafts, New York, 1963. Awards: Applied Arts Award, Official Annual Salon, Caracas, 1946; Applied Arts Award, Annual Salon, Culture Center, Maracay (Venezuela), 1961; Gold Medal, International Ceramics Praha 62, Prague, 1962.

ZIELKE, Thekla and Gottfried. Born in Germany, 1928 and 1929. Individual Shows: Caracas Art Museum, 1960 and 1962. Group Shows: Official Annual Plastic Arts Salon, Caracas, since 1960; Museum of Contemporary Crafts, New York, 1963. Awards: Applied Arts Award, Official Annual Salon, Caracas, 1960; Silver Medal, International Ceramics Praha 62, Prague, 1962; Silver Medal, *International Ceramics Exhibition*, Art Museum, Buenos Aires, 1962.

September 3 - 22, 1963

FREDA OF BRAZIL: MOSAICS

The artist known as Freda was born in the northern Brazilian city of Fortaleza, but underwent a long period of professional training in Europe. She is a graduate of the Academy of Fine Arts of Ravenna, Italy, where she specialized in mosaic. In addition, she studied ceramics at the National Art Institute of Faenza and the University of Bologna, graphic representation at the University of Rome, and printmaking and tapestry-weaving at the Technical Institute of Stuttgart. Returning to Brazil, she organized the teaching of mosaic at the National School of Fine Arts, of whose committee on industrial arts she is a member, and at the National Institute of Pedagogical Studies. In addition, she has organized, and participated in, two seminars on art education for children and has lectured on mosaic and architecture at the School of Architecture of Recife.

Although Freda's earliest interest had been tapestry-weaving, it was in Ravenna, with its splendid examples of Byzantine mosaic, that she found her true medium of expression. While respecting tradition, she has avoided sterile repetition, seeking to impart a modern spirit to the art, and employing such novel materials as bone and bits of porcelain in addition to the usual glass and stone. The critic Marc Berkowitz has said of her compositions that she has achieved a "harmony of imagination, form, color, and material resulting in a true work of art."

Freda has exhibited in the European cities of Rome, Ravenna, Florence, Fribourg, and Faenza, and in the Brazilian ones of Rio de Janeiro, São Paulo, Teresópolis, and Recife. Examples of her work are to be found not only in her native land but in Argentina, Germany, Great Britain, Italy, Mexico, and Norway. This is the first presentation of her mosaics in the Washington area.

CATALOGUE

Mosaics

1. *Acordes em vernelho e azul (Red and Blue Harmonies)*, 1963, 30 x 90 cm.

Série do Mar (Series of the Sea)

2. *Composição (Composition) No. 1*, 1962, 50 x 80 cm.
3. *Composição (Composition) No. 2*, 1962, 50 x 80 cm.
4. *Composição (Composition) No. 3*, 1962, 25 x 120 cm.
5. *Composição (Composition) No. 4*, 1962, 25 x 65 cm.
6. *Forma vegetal (Vegetable Form)*, 1961, 50 x 100 cm.
7. *Forma em movimento (Form in Movement)*, 1963, 35 x 90 cm.
8. *Criptogámicas em fuga (Cryptogamia in Fugue)*, 1961, 25 x 65"
9. *Charybdea murrayana*, 1961, 25 x 65 cm.
10. *Espirais marinhas (Sea Spirals)*, 1963, 25 x 90 cm.
11. *Outono mineral (Mineral Autumn)*, 1961, 25 x 100 cm.
12. *Flor metálica (Metalic Flower)*, 1961, 25 x 100 cm.
13. *Rio: Caminho das Paineiras (Rio I)*, 1959, 50 x 80 cm.
14. *Rio: Estrada das Furnas (Rio II)*, 1959, 50 x 80 cm.
15. *Forma verde em transformação (Green Form in Transformation)*, 1962, 50 x 85 cm.
16. *Nascimento espacial (Spatial Birth)*, 1959, 50 x 75 cm.
17. *Escaravelho lunar (Scarab of the Moon)*, 1962, 50 x 80 cm.
18. *Jangadas em mar calmo (Rafts in the Calm Sea)*, 1960, 50 x 100 cm.
19. *Florinigro verde (Green Vegetation)*, 1960, 25 x 90 cm.
20. *A morte do veado (The Death of the Deer)*, 1961, 50 x 100 cm.

21. *Sons em vermelho e preto (Sounds in Red and Black)*, 1962, 80 x 130 cm.
22. *Paisagem espacial (Scenery in Space)*, 1963, 80 x 130 cm.
23. *Flamingo guerreiro (Flamingo Warrior)*, 1962, 25 x 90 cm.
24. *O vôo do flamingo (The Flight of the Flamingo)*, 1962, 25 x 90 cm.
25. *O repouso do flamingo (The Repose of the Flamingo)*, 1962, 25 x 90 cm.
26. *Variações em topázios e cobalto (Variations in Cobalt and Topaz)*, 1963, 25 x 75 cm.
27. *Variações em topázios e ametistas (Variations in Topaz and Amethyst)*, 1963, 25 x 90 cm.
28. *Forma quente (The Hot Mold)*, 1962, 50 x 80 cm.
29. *Variações em vidro e metal (Variations in Metal and Glass)*, 1963, 25 x 65 cm.
30. *Acrópole submersa (The Submerged Acropolis)*, 1962, 50 x 90 cm.

September 4 - 31, 1963

MARIO PARIENTE AMARO OF URUGUAY: OILS, GOUACHES, AND DRAWINGS

Mario Pariente Amaro was born in Montevideo, Uruguay, in 1915. As a child he received instruction in literature and aesthetics from his father, the distinguished teacher, Don Andrés R. Pariente.

From his early youth he followed his natural inclination toward drawing and although he attended art school briefly he may be considered a self-taught painter.

Pariente Amaro has participated in many group shows in his native country. He has also held one-man shows in the capital, Montevideo, and in Buenos Aires, Argentina.

This is the first presentation of Pariente Amaro's work in Washington.

EXHIBITION LIST[1]

Oils, Gouaches, and Drawings

1. *Blanco sutil sobre negro (Subtle White on Black)*
2. *Estática y dinámica (Static and Dynamics)*, tempera and ink
3. *Ictiólogo con peces (Ichthyologist with Fish)*
4. *Rojo estático y negro dinámico (Static Red and Dynamic Black)*
5. *Amorfismo (Amorphous)*
6. *Marina (Seascape)*
7. *El caballero y el monstruo (Cavalier and Monster)*
8. *España, caballeros (Spain, Cavaliers)*
9. *De la serie de los fantasmas: El encuentro o el descanso (From The Ghosts Series: Encounter or Rest)*
10. *Evocación antidiluviana (Pre-Diluvial Reminiscence)*
11. *Gallo rojo al amanecer (Red Rooster at Dawn)*
12. *La sequía (The Drought)*
13. *Evocación persa (Persian Evocation)*
14. *Evocación dantesca (Dantesque Evocation)*
15. *Evocación griega (Greek Evocation)*
16. *La fortaleza grande (Big Fortress)*

[1] This list of works exhibited was not included in the original catalogue and may be incomplete. —*Ed.*

17. *Rojo sobre rojo y negro (Red on Red and Black)*
18. *Negro sobre amarillo (Black on Yellow) No. I*
19. *Negro sobre amarillo (Black on Yellow) No. II*
20. *Danza del rojo y el negro (Red and Black Dance)*

September 24 - October 10, 1963

ALFONSO MATEUS OF COLOMBIA: OILS

The career of the Colombian painter Alfonso Mateus is largely European: for almost a decade he has been living and working in Munich and, save for presentation in his native land, his compositions have been exhibited only in the countries of the Old World.

Mateus was born in Bogotá in 1927 and received training at the local School of Fine Arts. In 1956, having been awarded a scholarship for study abroad, he elected to work at the Munich Academy of Fine Arts under Franz Nagel. In 1959 the German government presented him with a further fellowship, enabling him to continue his training for an additional two years. Since 1960 he has been teaching at the Academy.

In recent years, Mateus has followed the abstract expressionist trend, employing a palette of well-controlled neutral tones. Examples of his work are to be found in many private collections in Germany and Colombia, as well as in the Graphic Arts Gallery of Munich and the Luis Angel Arango Library in Bogotá. In November 1962, on the occasion of a brief visit of the artist to his native city, his compositions were put on view at the National Library. A selection was also included in the important exhibition *3000 Years of Colombian Art*, which toured six major European cities the same year.

Appreciation is here expressed to Pan American World Airways, which generously brought these works to Washington for the first presentation of the art of Alfonso Mateus in the United States.

CATALOGUE

Oil and Casein

1-17. *Untitled*

Watercolors and Drawings

18-23. *Untitled*, 50 x 70 cm.

October 1 - 27, 1963

PEDRO FRIEDEBERG OF MEXICO: DRAWINGS

The representative of a fantastic, imaginative trend bordering on surrealism, Pedro Friedeberg is a new personality on the scene of Mexican art. Born in Italy in 1937, Friedeberg was brought at a very early age to Mexico, of which country he is now a citizen. He took courses in architecture at the Ibero-American University in Mexico City, and later was a pupil of the German-Mexican painter and sculptor Mathias Goeritz.

Friedeberg's ink drawings, in which straight lines and hard edges mingle with a superabundance of arabesques, constitute a highly individual approach to surrealism. His depictions, though showing a relation to pop art, evidence a less direct vision of reality, being more intellectual and elaborate in conception than the work of the new hyper-objective school.

In Mexico City Friedeberg has had one-man shows at the Diana Gallery (1959), the Proteo Gallery (1960), and the Petroleum-Workers Club (1961). The Carstairs Gallery presented his work in New York in 1961; the Villa Bloc exhibited it in Paris in 1962. During the current year, Friedeberg has had individual exhibitions in Lisbon and Munich. Examples of his work are to be found in many private collections in Mexico and in the United States.

The noted French surrealist poet André Breton has declared that Friedeberg's compositions are among the most fully accomplished works in the surrealist manner. The painter Leonora Carrington, herself a distinguished cultivator of that manner, has acclaimed Friedeberg with enthusiasm, declaring that the exhibition she had viewed, "gave me delight, a rare sensation for me when faced with the artistic production of modern man."

This is the first presentation of Friedeberg's work in the Washington area.

CATALOGUE

Drawings

1. *The Origin of Marmalade*
2. *The Ping-Pong Hall of Fame*
3. *The Birthday of an Irresponsible Aviatrix*
4. *The Desegregated Finishing School for Taxidermists' Daughters*
5. *The Jail for Butterfly Hunters*
6. *The Laboratories of Applied Stupidity*
7. *Project for the Central Offices of the National Institutes of Pain and Pleasure*
8. *Project for the Pavilion of Canine Phrenology at the World's Fair*
9. *Project for the House of a Retired Philatelist*
10. *Project for the House of Edward James Esq.*
11. *Project for the Hospital for Workers of the United Fruit Company*
12. *Some of the Medals Distributed at the Seventh Congress of Papaya Eaters*
13. *Three Priestesses of the Order of the Hexagonal Orange*
14. *An Uncensored Scene from the Atharva-Veda*
15. *A Leak in the Blood Bank*
16. *A Mask for a Disappointed Pediatrician*
17. *Ornithodelphia, the City of Bird Lovers*, 1963, ink on paper, 15 1/2 x 10 1/4"
18. *Prolegomena and Paralipomena*

Also presented in this exhibition is an example of the Friedeberg chair and clock.

October 11 - November 3, 1963

STEFAN STROCEN OF ARGENTINA: PAINTINGS

Stefan Strocen, described by the Argentine critic Córdova Iturburu as "a sort of abstract expressionist who makes highly intelligent use of the principal resources of informalism," was born in Buenos Aires in 1930.

He graduated in 1950 from the National School of Fine Arts, where he taught drawing and engraving until 1955. While still a student he won First Prize in the latter medium from the San Martín Gallery of Buenos Aires. Other prizes followed, among them a grant for study abroad from the Argentine National Fund for the Arts which permitted him to pursue his career in Paris from 1959 to 1961.

While in Europe Strocen held one-man shows in Brussels, Madrid, and Paris. Back in his native country in 1962, he presented his work at the Rioboo Gallery in Buenos Aires, the Museum of Modern Art in La Plata, and the Elía Institute in San Miguel. Immediately prior to the current exhibit at the Pan American Union, which is Strocen's first in the Washington area, he had a show at the Galerie Internationale in New York. Upon that occasion the critic of the *New York Times*, Brian O'Doherty, wrote:

> These paintings are most concerned with creating a textural screen on which to project sensitivity. The results, consistently rich and warm, have frequent moments of delight.

Examples of Strocen's work are to be found in the Museum of Modern Art of Buenos Aires, the Museum of Fine Arts of Córdoba (Argentina), and several other institutions, in addition to numerous private collections in Europe and the Americas.

CATALOGUES

Oils

1. *Paisaje azul (Blue Landscape)*
2. *El rapto (The Kidnap)*
3. *Liberación (Liberation)*
4. *Hail the Fatherland*
5. *Madre tierra (Motherland)*
6. *Primavera (Spring)*
7. *El prisionero (The Prisoner)*
8. *Urutaú (The Bird That Cries)*
9. *Viracocha*
10. *Fetiche (Fetish)*
11. *Idolo desgarrado (Broken Idol)*
12. *Figura aprisionada (Imprisoned Figure)*
13. *Ekeko*
14. *Ritual Image*
15. *Laceration*
16. *Stratus Colloguy*
17. *Animal Ceremony*
18. *Medium*
19. *Ave tierra (Lonesome Bird)*
20. *Hallucination*
21. *Strange Flight*
22. *Animal Eclipse*
23. *Telluric Awakening*
24. *Apetito lunar (Lunar Quest)*
25. *Cacique*

Lithographs[1]

[1] Titles are unavailable. —*Ed.*

October 28 - November 25, 1963

ARTISTS OF LATIN AMERICA: PHOTOGRAPHS BY MORTON BEEBE[1]

November 5 - 25, 1963

CESAR VALENCIA OF ECUADOR

During the last few years, the Ecuadorian artist César Valencia has devoted his interest to encaustic and by further developing this medium has given a specific resistance to the softness of wax. By his deft use of this material he obtains extraordinary results in controlled accidents of color and composition. This also gives the abstract informalist a new vehicle for expressing textures and surfaces with great distinction.

Valencia was born in Quito, Ecuador, in 1918. He attended the Academy of Fine Arts there beginning as a student of architecture, later transferring his interest only to painting. After leaving the Academy, he became a reporter for the Quito newspaper *El Comercio*, for which he also was art critic over an eight-year period.

In 1943 he traveled to the Galápagos Islands, an Ecuadorian territory, and for several months he remained in that remote area of the Pacific Ocean painting and recording nature in detail through his work. As a result of these efforts he obtained in 1944 the Mariano Aguilera Award, which is the highest honor given to an artist in Ecuador. A year later he was appointed cultural attaché and has since served in his country's embassy in Chile, Bolivia, Peru, and Argentina, where he has not only shown his work but has organized exhibitions of Ecuadorian painting.

Last year, after Valencia exhibited at the North Gallery and the Museum of Modern Art in Buenos Aires, the art critic for *La Prensa*, Ernesto Ramallo, commented: "The works reveal a mature and straightforward nature expressed in the most difficult medium of encaustic."

This is the first presentation of Valencia's work in the United States.

CATALOGUE

1-20. Oil[2]

November 26 - December 12, 1963

MARIA THEREZA NEGREIROS OF COLOMBIA AND BRAZIL: PAINTINGS AND DRAWINGS

Although Maria Thereza Negreiros is a Brazilian citizen by birth and graduated from the National School of Fine Arts of Rio de Janeiro, she began her professional career in Colombia and is now considered one of the outstanding

[1]This exhibition consisted of photographs of Latin American artists taken by the United States photographer Morton Beebe. It was previously shown at the Oakland Museum of Art, the Kaiser Center, and the Stanford University. No catalogue is available. —*Ed*.

[2] Titles are unavailable. —*Ed*.

young talents in the modern art of that country.

Negreiros was born in Amazonas, Brazil, in 1930. She moved to Colombia in 1954 and has produced most of her major work in the coastal city of Cali, where she now lives. Her participation in several group shows earned for her the Grand Prize in the First National Festival of Art in Cali (1961) and the National Salon of Bogotá (1962). Examples of her work were included in the important Colombian exhibition *3,000 Years of Colombian Art*, that traveled throughout Europe last year under the auspices of the Colombian government and International Petroleum Company (Esso Standard Oil) and are presently representing her adopted country at the Seventh São Paulo Biennial.

The artist has held one-man shows in the gallery of the Luis Angel Arango Library in Bogotá in 1961 and at the Museum of Modern Art of Bogotá this year. Walter Engel, critic for *El Espectador*, commented on the occasion of the latter exhibition: "When Maria Thereza Negreiros joined the art circles of Bogotá her expression was lyrical; today her painting is epic—strong and transcending." The art critic of *La Nueva Prensa*, Marta Traba, found her work "refined, original, nonconforming, tenacious, and free from the limitations of abstract expression."

This is the first presentation of Maria Thereza Negreiros's work in the United States.

CATALOGUE

Drawings

1. *Cipós (Pillar) No. 1*
2. *Cipós (Pillar) No. 2*
3. *Genesis No. 1*
4. *Genesis No. 2*
5. *Genesis No. 3*

Paintings

6. *Genesis No. 4*
7. *Genesis No. 5*
8. *Genesis No. 6*
9. *Genesis No. 7*
10. *Genesis No. 8*
11. *Genesis No. 9*
12. *Genesis No. 11*
13. *Genesis No. 13*
14. *Genesis No. 14*
15. *Genesis No. 15*
16. *Genesis No. 16*
17. *Genesis No. 18*

December 12, 1963 - January 8, 1964

OSCAR CAPRISTO OF ARGENTINA: OILS

Among the chief forerunners of modern Latin American art has been the Argentine master Emilio Pettoruti. In his studio many of the most important present-day Argentine painters have acquired the essentials of an austere style, geometric in its foundation, typical of the cubist discipline which he follows and imparts.

Outstanding among Pettoruti's pupils is Oscar Capristo, who now exhibits a manner of his own, characterized by hard-edged effects obtained through careful control of color. The first impression which his work conveys to the spectator's eye is of a spotless surface on which, in an airless space, a constellation of geometric forms engages in an interplay of vibrant color.

Capristo was born in Buenos Aires in 1921. He began his study of the graphic arts at the People's University of La Boca and the Manual Belgrano National Preparatory School of Fine Arts, and for a time he frequented the workshop of the engraver Fernando López Anaya. His definitive training in painting, however, came from his work with Pettoruti, as the result of an award from the Ernesto Santamarina Foundation in 1945. In addition to easel painting, he has executed murals (some in mosaic) and has engaged in stage design, book illustration, lecturing, and teaching. He is currently professor of painting in the Fine Arts School of the city of Mendoza, where he has made his home.

Capristo has taken part in numerous group shows, both in Argentina and abroad, and since 1947 he has had sixteen one-man shows, all in his native country. Prizes have been awarded to him at six salons, and works by him are to be found in museums in Tokyo, Buenos Aires and Córdoba (Argentina), and in numerous private collections of that country and the United States.

This first presentation of Capristo's work in Washington has been possible through the cooperation of the following official institutions: Fondo Nacional de las Artes (National Fund for the Arts); Dirección General de Cultura, Ministerio de Educación (Department of Culture, Ministry of Education); Dirección General de Relaciones Culturales, Ministerio de Relaciones Exteriores (Department of Cultural Relations, Ministry of Foreign Affairs).

EXHIBITION LIST[1]

Oils

1. *Cerrándose (Closing)*, 1959, 55 x 46 cm.
2. *Dos tiempos (Two Tempos)*, 1960, 55 x 46 cm.
3. *Dos formas (Two Forms)*, 1960, 38 x 55 cm.
4. *Constelación (Constellation)*, 1960, 114 x 146 cm.
5. *Desplazándose (Moving)*, 1961, 132 x 132 cm.
6. *Círculos ausentes (Absent Circles)*, 1961, 132 x 132 cm.
7. *Crece (It Grows)*, 1961, 104 x 60 cm.
8. *Amanecer estelar (Sidereal Dawn)*, 1962, 132 x 264 cm.
9. *Noche (Night), 1962*, 100 x 50 cm.
10. *Lunar*, 1962, 46 x 55 cm.

December 12, 1963 - January 8, 1964

LEO VINCI OF ARGENTINA: SCULPTURES AND DRAWINGS

Leo Vinci is one of a group of young Argentine sculptors who are seeking to revive in their work the tradition of the pre-Columbian past. The result of this interest, in Vinci's case, can be noted not only in his massive compositions in cement and bronze but also in his fluid line drawings.

[1] This list was not included in the original catalogue, which stated that fifteen paintings (without titles) were exhibited. The list of works sent by the artist for this show included only the ten oils listed here. —*Ed.*

Vinci was born in Buenos Aires in 1931. Among the institutions from which he received training there is the National School of Fine Arts, at which he recently received an appointment as professor of sculpture. In 1961 the National Fund for the Arts awarded him a grant that enabled him to study in France, Italy, Spain, and Switzerland.

It was in 1959 that Vinci exhibited for the first time at the Peuser Gallery in the Argentine capital with the group which calls itself *Grupo del Sur* (Southern Group). He has since continued to present his work with that group at salons and in other collective expositions. In 1962 he participated in the important exhibition *Forty Years of Argentine Art*, in Rio de Janeiro. That same year he held a one-man show in Buenos Aires at the Rubbers Gallery, which is now his sole agent. Examples of his work are to be found not only in important private collections but also in the Museum of Modern Art of Buenos Aires.

This is the first presentation of the compositions of Leo Vinci in the United States and it has been made possible through the cooperation of the following official institutions: Dirección General de Cultura, Ministerio de Educación (Department of Culture, Ministry of Education); Dirección General de Relaciones Culturales, Ministerio de Relaciones Exteriores (Department of Cultural Relations, Ministry of Foreign Affairs).

CATALOGUE

Sculpture

1. *Mineral Organism No. 1*
2. *Mineral Organism No. 2*
3. *Figure in Tension No. 1*
4. *Figure in Tension No. 2*
5. *Figure in Tension No. 3*
6. *Organic Growth*

1-6. Drawings[1]

[1] Titles are unavailable. —*Ed.*

YEAR 1964

January 10 - 27, 1964

CONTEMPORARY ART OF COSTA RICA:
PAINTINGS AND SCULPTURES ASSEMBLED BY THE *GRUPO 8* OF SAN JOSE

The current presentation of works by contemporary artists of Costa Rica constitutes an unusual event in the Pan American Union's program of exhibitions—unusual, because, while Costa Ricans have figured in previous group shows, never before has an exhibit been devoted exclusively to the creative effort of nationals of that country.

The high level of culture attained by that republic is well known. It proudly claims that illiteracy has been banished from its territory and that teachers far outnumber military personnel. While there have been numerous poets and musicians of distinction in the course of the country's cultural history, the spirit of adventure and the breath of originality have been lacking in the plastic arts. The practitioners thereof have exhibited a certain degree of technical competence, but they have clung to simple, conservative traditions, producing work of a highly derivative nature. Of late, however, the rising generation has begun to strike out in more contemporary directions, gradually discovering a whole new language of forms.

It has been the so-called *Grupo 8* (Group of Eight), now numbering about a dozen, which has served in large measure to clear the way for the vitalization of Costa Rican art, providing inspiration for a score of painters, sculptors, and draftsmen. Their work has taken on maturity and has begun to enjoy projection beyond the national frontiers, finding its place in the mainstream of contemporary creative endeavor. Witness to their achievement is borne not only by the present exhibition but also by those recently held at the University of Kansas and the Pennsylvania State University.

Appreciation is here expressed to the Costa Rican Institute of Tourism and to LACSA Airlines which lent assistance in matters of transportation, and to the Esso Standard Oil Company for collaboration which has made this presentation possible.

CATALOGUE

Paintings and Sculptures

Guillermo Combariza
 1. *Etnico terracota (Ethnic Terra-Cotta)*, oil on canvas, 35 x 51"
 2. *La novia (The Bride)*, oil on wood, 20 x 26"

Lola Fernández
 3. *Armonía en rojo (Harmony in Red)*, oil on canvas, 29 x 50"
 4. *Visión (Vision) No. 7*, oil on cardboard, 40 x 30"
 5. *Visión (Vision) No. 2*, 40 x 30"

Harold Fonseca Mora
 6. *Calibú*, oil on canvas, 34 x 40"

7. *Amara*, oil on canvas, 34 x 40"
8. *Cascas (Barks)*, oil on canvas, 36 x 48"

Hernán González
9. *Madre vieja (Old Mother)*, andesite stone sculpture
10. *El hombre y la tierra (Man and Earth)*

Guillermo Jiménez
11. *Tú, mi ángel (You, My Angel)*, oil on canvas, 24 x 46"
12. *Johnnie*, oil on canvas, 24 x 46"

Carlos Moya
13. *Fenix*
14. *Víscera telúrica (Telluric Vein)*

Carlos Poveda
13. *Tres mujeres (Three Women)*, oil on paper, 20 x 34"
14. *Figuras (Figures)*, oil on paper, 14 x 19"
15. *Oda a Kafka (Ode to Kafka)*, oil on paper, 17 x 24"

César Valverde
16. *Desnudo (Nude)*, oil on masonite, 20 x 26"
17. *Maternidad (Maternity)*, oil on canvas, 20 x 27"
18. *Algaba*, oil on canvas, 26 x 40"

ABOUT THE ARTISTS

COMBARIZA, Guillermo. Painter, born in Buga, Colombia, 1924. Studied graphic arts, Art Students League of New York, 1953; painting, Escuela de Bellas Artes, University of Costa Rica, 1960. Traveled in the United States and Latin America. Professor of drawing, University of Caldas, 1954-56, is currently art editor, Inter-American Institute of Agricultural Sciences, OAS, Turrialba. Member of the *Grupo 8* since 1962. Held one individual exhibition in San José. Won Second Prize, First Festival of Plastic Arts organized by *Grupo 8*, San José, 1962. Lives in Costa Rica since 1957.

FERNANDEZ, Lola. Painter, tapestry designer, born in Bogotá, Colombia, 1926. Graduated from the Escuela de Bellas Artes, University of Costa Rica; from the Escuela de Bellas Artes, National University, Bogotá, in oil and fresco painting; from the Academy of Fine Arts, Florence (Italy), with *laurea in pittura*, where she studied under an Italian scholarship, 1954-58. Traveled to the Far East through a UNESCO fellowship, 1961. Currently, she is a professor of drawing at the Escuela de Artes Plásticas and a member of the *Grupo 8*. Held individual exhibitions in Costa Rica, Panama, Colombia, and in Paris. Participated in group exhibitions in Costa Rica; with Italian artists in Rome and Florence, 1954-56; with the international group *New Vision*, London and other cities in England, 1959; Biennial of Mexico, 1958; and several Central American exhibitions in the United States. Lives in Costa Rica since childhood and is a Costa Rican citizen.

FONSECA, Harold. Painter, draftsman, born in San José, 1920. Graduated from the University of Costa Rica with a degree in agronomy. Studied art at the Escuela de Bellas Artes, University of Costa Rica; Art Institute of Chicago; Corcoran School of Art, Washington, D.C. Lived in the United States for twelve years. Co-founder of the *Grupo 8*, San José, 1961. Held his first individual exhibition in Washington, D.C. in 1960. Participated in many group exhibitions in Costa Rica, Central America, and the United States, including *Latin American Art*, Birmingham Museum of Art, Alabama, and *Central American Exhibition*, University of Kansas Museum of Art; Festival Cartagena de Indias, Colombia, 1959. Was awarded a prize, Certamen Nacional de Cultura, El Salvador, 1961.

GONZALEZ, Hernán. Sculptor, born in San José, 1918. Studied at the Art Students League in New York City and under Harvey Fite in Woodstock (New York), 1960. Co-founder of the *Grupo 8*, San José, 1961, with whom he exhibited in Costa Rica, 1961-63. Participated in group exhibitions of the Art Students League in New York City and in Costa Rica. Was awarded First Prize, Juegos Florales, San José, 1963.

JIMENEZ, Guillermo. Painter, born in San José, 1922. Graduated in 1956 from the Academia de Bellas Artes, National University, where he currently is a professor of drawing and vice-dean; he is also a professor of art history and painting, Casa del Artista, San José. Founding member of the *Grupo 8*, San José, 1961. Visited the United States invited by the Department of State. Traveled in Latin America, Europe, Africa, and Asia. Held individual exhibitions in San José since 1950. Participated in national and international group shows, including the biennials of São Paulo (1957) and of Mexico (1958 and 1960).

MOYA, Carlos. Painter, muralist, sculptor, graphic artist, born in Cartago, Costa Rica, 1925. Graduated from the Escuela de Bellas Artes, Universidad de Costa Rica; also studied at Academia de Bellas Artes de San Fernando, and Círculo de Bellas Artes, Madrid, under a fellowship granted by the Instituto de Cultura Hispánica; and at the University of Bloomington, Indiana. At present is a professor in higher education institutions. Held individual exhibitions and participated in group shows in Costa Rica. Was awarded several prizes in national exhibits and Second Prize, Juegos Florales, San José, 1963.

POVEDA, Carlos. Painter, draftsman, graphic artist, born in San José, 1940. Is self-taught as an artist. Member of the *Grupo 8* since 1962, has participated in its exhibitions in San José and Bogotá. Held his first individual exhibition in San José and participated in national group shows, including *National Painters*, National Museum, San José, 1962; and the Biennial of Mexico, 1958. Winner of the *Vignette Contest*, Editorial Costa Rica, 1960.

VALVERDE, César. Painter, muralist, printmaker, born in San José, 1928. Graduated as a lawyer, Universidad de Costa Rica, 1952. Studied art at the Universidad de Costa Rica; Scuola Libera di Nudo and Accademia Belle Arti in Rome; Corcoran School of Art, Washington, D.C.; Regional School of Manchester, England. Co-founder of *Grupo 8*, with whom he exhibited in Costa Rica and Colombia; member of the Asociación de Autores Costarricenses. Held individual exhibitions in San José. Participated in national and international exhibitions, including the biennials of Barcelona (Spain, 1955) and Mexico City (1958), and Costa Rican art shows in the United States. Was awarded an Hors Concours Prize, Palazzo delle Esposizioni, Rome, 1954; and First Prize for Painting, Juegos Florales, San José, 1963.

January 28 - February 13, 1964

VICTOR CHAB OF ARGENTINA: OILS

An outstanding figure in the younger generation of Argentine artists is that of Víctor Chab, who through a devoted study of abstract art in all its forms has achieved an exceptional degree of creative maturity.

Chab was born in Buenos Aires in 1930. While he declares himself to be completely self-taught, lack of professional training did not prevent his appointment as professor of painting at the Higher School of Fine Arts in the Argentine capital. Since 1952 Chab has exhibited at the better known galleries of that city, among them the Plástica, Pizarro, Rubbers, and Van Riel. He gave a one-man show in 1957 at the Galería Arte Bella of Montevideo and last year held another at the Galería Nueva in Buenos Aires. Examples of his work have been included in more than forty group shows in Argentina and abroad. They have been presented at the Venice Biennial, 1956; the Mexico City Biennial, 1958; and the Brussels World's Fair, 1958; and have won several awards.

This is the first exhibition of Víctor Chab's painting in the United States.

CATALOGUE

Oils

1-20. *Untitled*

January 28 - February 13, 1964

OSVALDO ROMBERG OF ARGENTINA: ENGRAVINGS

One of the youngest personalities active in the field of the graphic arts in Argentina today is Osvaldo Romberg, born but two and a half decades ago, in 1938, in Buenos Aires. For some time now he has been both studying and teaching at the School of Architecture of the National University in that same city. In 1957 and 1958 he traveled extensively in Europe and Israel. In the latter he executed a number of murals and bas-reliefs.

Romberg has held several one-man shows in his native Argentina, where he is currently represented by the Rubbers Gallery. He has frequently participated in group shows, both in that country and abroad—in Chile, Mexico, and Spain. He has received numerous prizes and has won great acclaim at his most recent exhibitions for his color woodcuts, particularly the portfolio entitled *Homage to Picasso*.

This is the first presentation of Romberg's work in the United States.

CATALOGUE

Engravings

1. *El ángel del testimonio (Testimonial Angel)*
2. *Recuerdo de N (Remembrance of N)*
3. *El gran controlador (The Great Controller)*
4. *El ángel de la premonición (The Angel of Premonition)*
5. *Homenaje a un pájaro muerto (Homage to a Dead Bird)*
6. *Gato (Cat)*
7. *Figura (Figure)*
8. *Retrato de la señorita I (Portrait of Miss I)*
9. *Figura posesa (Possessed Figure)*
10. *Los sometidos (Enslaved)*
11. *Los sometidos (Enslaved) I*
12. *El hombre en azul (The Man in Blue)*
13. *El mundo de Estela (The World of Stella)*
14. *Figura (Figure)*
15. *Homenaje a Picasso (Homage to Picasso)*

Illustrated Books by the Artist

1. *Homenaje a Picasso (Homage to Picasso)*. Poem by Lorenzo Varela, with two color woodcuts, limited edition of 100, signed by the authors.
2. *Gesto lluvia*. Poem by Pablo Amanía, with two black and white engravings, limited edition of ten, signed by the authors. The text is handwritten by the poet.
3. *Credo poético (Poetic Creed)*. Poem by Arnoldo Liberman, with a color engraving, limited edition of 500. The

first 100 are numbered and signed by the authors. Editorial Stilcograf.

February 14 - March 1, 1964

RAUL VALDIVIESO OF CHILE

With the work of the Chilean Raúl Valdivieso, sculpture has acquired a vigorous new personality. His vision of forms is suggestive both of the pre-Columbian origins of American art and of the anxious curiosity with which modern man faces the unknown.

To the contemporary repertory of forms—the product of a search for primary shapes, of efforts toward mutation of decomposition, of attempts to reveal inner energy—Valdivieso contributes a mingling of animal and vegetable figures which exercise a fascinating effect on the onlooker. In his hands, metal takes on an unusual quality, rich in unexpected surface effects, calling to mind the disintegrative effects of time.

Valdivieso was born in 1931 in Santiago de Chile, where he attended the National School of Fine Arts. He won prizes for his sculpture in 1954 and 1955, and in 1958 the British Council awarded him a scholarship for a brief period of study in London. Subsequently he went to Paris, where he enrolled in the free courses of the Grande Chaumière and attended engraving classes given by S. W. Hayter at his Atelier 17.

The most important of Valdivieso's work dates from the period since 1961, when the artist established a studio in Madrid. He held a very successful one-man show at the Nebli Gallery in that city the following year, and in 1963 an individual exhibition of his works was presented at the Ravenstein Gallery in Brussels.

The latter was hailed by the Belgian press: Urbain Ven de Voorde, critic of *De Standaard*, spoke of Valdivieso as a "remarkable personality;" and André Lemoine, of *Le Peuple*, found the sculptures a symphony of "movement, balance, and fascination." Also L. L. Sosset wrote in the *Journal des Beaux-Arts*: "The art of Valdivieso is rough and passionate, touching us by the energy with which he returns to the early rhythms of life."

This is the first presentation of Valdivieso's sculpture in the United States.

CATALOGUE

Sculpture

1. *La serpiente emplumada (The Plumed Serpent)*
2. *La mano derecha (The Right Hand)*
3. *Reflejo en un ojo dorado (Reflection on a Golden Eye)*
4. *Toro (Bull)*
5. *Autorretrato (Self-Portrait)*
6. *Cabeza de guerrero (Head of a Warrior)*
7. *Cabeza (Head) I*, 1964, bronze, 31 1/2 x 16"
8. *Cabeza (Head) II*
9. *Pájaro (Bird) I*
10. *Pájaro (Bird) II*
11. *Pájaro herido (Wounded Bird)*
12. *Pájaro crucificado (Crucified Bird)*
13. *Torso*
14. *Figura (Figure) I*

15. *Figura (Figure) II*
16. *Figura (Figure) III*
17. *Despertar de la tierra (Awakening of the Earth)*
18. *Cabeza de gato (Face of a Cat)*
19. *Gato herido (Wounded Cat)*
20. *Volcán (Volcano) I*
21. *Volcán (Volcano) II*
22. *Figura (Figure) I*
23. *Figura (Figure) II*

Drawings and Gouaches[1]

March 2 - April 10, 1964

THE ARTIST AS PRINTMAKER II: OMAR RAYO OF COLOMBIA

ABOUT THE ARTIST

For the second presentation in its series *The Artist as Printmaker*, which offers a retrospective view of the activity in the reproductive field of an artist whose work in other areas has previously been shown in the Main Gallery, the Pan American Union has selected the well-known Colombian painter Omar Rayo.

Rayo was born in Roldanillo, in the Department of Valle, in 1928. He initiated his artistic career at the age of nineteen, as an illustrator and caricaturist for newspapers and magazines in Bogotá. Taking up painting, he held several exhibitions in Colombia, after which, in 1954, he traveled through other parts of Latin America, holding one-man shows in Quito and Guayaquil, Ecuador; Lima and Cuzco, Peru; La Paz, Bolivia; and São Paulo, Brazil. In 1956 he exhibited in Rio de Janeiro (twice) and Montevideo; in 1957, in Buenos Aires and Santiago de Chile; in 1958, in the Colombian cities of Cali, Medellín, and Barranquilla. In 1959 he received a fellowship from the Organization of American States to study graphic arts in Mexico City. He remained there for two years, exhibiting at various commercial galleries and at the Palace of Fine Arts; he also had a show in the northern Mexican city of Monterrey. In 1961 Rayo came to the United States where he was given one-man shows at the Pan American Union and at the Contemporaries Gallery in New York. In 1962 he again exhibited at the latter gallery and at the Juan Martín Gallery in Mexico City. Last year he held one-man shows at the Museum of Modern Art in Miami and at the National Library in Bogotá; he was also included in the Pan American Union section at the Seventh São Paulo Biennial. Among other important group shows at which his work has been presented are the Fifth Rio de Janeiro Salon of Modern Art, the Twenty-ninth Venice Biennial, an exhibit of the Print Club of Philadelphia, the Print Exhibition of the Brooklyn Museum, and the annual exhibition of the Boston Museum of Fine Arts. Last year he participated in the Library of Congress Group Show, the large Hispanic-American exhibition in Madrid, and a group show presented at the Contemporaries Gallery in New York.

Works by Omar Rayo are to be found in the modern art museums of New York, Miami, and Mexico City, the Baltimore Museum of Art, the Brooklyn Museum, the Rosenwald Collection, the New York City Public Library, the Library of Congress, the Philadelphia Museum of Art, the Smithsonian Institution, and the Munson-Williams-Proctor Institute.

Limitations of space permit presentation of only a few of the more important examples of Rayo's extensive

[1] Titles are unavailable. —*Ed*.

production in the field of the reproductive arts, emphasis being placed on his intaglios. These are prints in relief, employing neither ink nor type—an interesting variation which Rayo has introduced into the field of so-called pop art. Rather than offering a literal view of the subject in itself, as is the habit of most of the more important representatives of the trend, Rayo subtracts all superfluous elements in presenting an object, generally of a very common nature, thus transforming it into a symbol, by a process of clean, neat stylization.

ABOUT THE MEDIUM

Omar Rayo prefers copper for his intaglios because the metal is both ductile and compact. Of all the metals he has tried in creating his relief prints, copper is the one best suited to the action of the nitric acid that does his etching.

He advises use of plates from 1 1/2 to 2 inches thick and the exercise of great care in varnishing the copper. The varnish must be applied in thick layers, as with any type of aquatint process, to withstand the power of the nitric acid bath. Any other acid, Rayo reminds, bites horizontally and will destroy the plates.

The area where a cavity is desired is simply left free of varnish. The plate is then left in an acid bath until the acid breaks through completely. Every hour or two, depending on the strength of the acid, the plate must be removed from the bath, dried carefully, and then returned until the desired depth has been reached.

Rayo warns that the plate must be absolutely clean when it is being readied for printing. Specially important is the humidity in the paper: the relief loses volume when the paper draws together in drying. When greater depth of relief is desired Rayo advises printing by hand, using the fingers or rounded metal instruments for more pressure.

CATALOGUE

Prints

1959

1. *Fiera (Fiend)*, drypoint and sandpaper over zinc
2. *Paisaje (Landscape)*, drypoint and sandpaper over zinc
3. *Equilibristas (Acrobats)*, drypoint and sandpaper over zinc

1960

4. *Paisaje (Landscape)*, drypoint over zinc, ink and paste
5. *Gato con mariposa (Cat with Butterfly)*, drypoint and chisel over zinc
6. *Toro (Bull)*, drypoint and aquatint over copper
7. *Niña linda (Beautiful Girl)*, drypoint and aquatint over zinc
8. *Hombre esperando (Waiting Man)*, drypoint and polished aquatint
9. *Torso*, drypoint and etching on copper
10. *Torso*, drypoint with lace effect
11. *Hombre (Man)*, drypoint and aquatint over zinc
12. *Hombre (Man)*, drypoint and aquatint applied with rotary movement
13. *Pez herido (Wounded Fish)*, drypoint and aquatint applied with undulating movement
14. *Pez herido (Wounded Fish)*, drypoint and aquatint applied with rotary movement
15. *Domingo en Chapultepec (Sunday in Chapultepec)*, drypoint applied with rotary movement
16. *India boliviana (Bolivian Indian)*, drypoint and etching, inked and cut
17. *Homenaje a Posada (Homage to Posada)*, etching over copper
18. *Homenaje a Posada (Homage to Posada)*, etching over copper applied with rotary movement
19. *Homenaje a Posada (Homage to Posada)*, etching over copper applied with spray

20. *Homenaje a Posada (Homage to Posada) II*, sprayed ink
21. *Homenaje a Posada (Homage to Posada)*, etching
22. *Forma espacial (Spacial Form)*, linoleum
23. *Torsos*, chiseled linoleum
24. *Nubes (Clouds)*, etching over copper printed on metallic paper
25. *Portada (Door)*, cut cardboard
26. *Portada (Door)*, cut cardboard with sprayed ink
27. *Cuerdas (Strings) I*, monocopy sprayed with ink
28. *Cuerdas (Strings) II*, monocopy sprayed with ink
29. *Cuerdas (Strings) III*, monocopy sprayed with ink
30. *The Lunch I*, mixed metals
31. *The Lunch II*, mixed metals
32. *The Lunch III*, mixed metals
33. *Fragmento de máquina (Fragment of a Machine)*, mixed metals
34. *Relieve (Relief)*, various techniques
35. *Monte Albán*, various techniques
36. *Tijeras (Scissors)*, various techniques
37. *Aspecto lunar (Lunar Aspect)*, cut zinc with ink

1961

38. *Ciudad atacada, pared egipcia (Attacked City, Egyptian Wall)*, plastic relief
39. *Homenaje a Posada (Homage to Posada)*, plastic relief
40. *La gran puerta (The Great Door)*, plastic relief, gouache
41. *Formas comunes (Common Forms)*, cut zinc
42. *El vaso (The Vase)*, cut zinc
43. *Vaso vertical (Vertical Glass)*, cut zinc, two plates
44. *Vasos superpuestos (Superimposed Glasses)*, three zinc plates inked with spray
45. *Cuatro formas (Four Forms)*, cut zinc, rubbed ink
46. *Dos vasos (Two Glasses)*, cut zinc, scratched paper
47. *Tres ventanas (Three Windows)*, copper, two plates
48. *Relieve (Relief)*, two copper plates
49. *Composición (Composition) No. 2*, zinc with rubbed ink
50. *Vino horizontal (Horizontal Arrival)*,[1] two copper plates

1962

51. *Two Doors*, two copper plates
52. *To Open the Door*, copper intaglio, two plates
53. *Object of the Sea*, copper intaglio, two plates
54. *Portal negro (Black Door)*, copper intaglio, two plates
55. *September Evening*, copper with soldered forms
56. *La puerta (The Door)*, copper intaglio, three plates

1963

57. *Sobres (Envelopes)*, copper intaglio, multiple surfaces
58. *My Name*, cut copper

[1] Literal translation of this title is "Horizontal Wine." —*Ed*.

59. *Lo efímero (Mayfly) No. 2*,[1] cut copper, three plates
60. *Pop Top*, cut copper, three plates
61. *Do It Yourself*, cut copper, two plates
62. *Portrait*, cut copper, two plates
63. *Last Light*, cut copper, three plates
64. *American Food*, cut copper, four plates
65. *American Food No. 2*, cut copper, two plates
66. *La bata blanca (The White Robe)*, cut copper, three plates
67. *Little Machine*, cut copper, two plates
68. *Only for Men*, cut copper, three plates
69. *Don't Touch*, cut copper, four plates

Numbers 1 through 16 were executed at the Graphic Studio of the Ibero-American University, Mexico City. Numbers 17 through 37 were executed at The Citadel Graphic Studio, Mexico City. Numbers 28 through 69 were executed in the studio of the artist, New York City. Each edition consists of ten copies.

March 2 - 19, 1964

NIRMA ZARATE OF COLOMBIA: OILS

Though a comparative newcomer on the Colombian art scene, Nirma Zárate has won a reputation as an excellent colorist in the abstract expressionist manner, her work having aroused widespread interest from the time it was first placed on public exhibition.

Born in the Colombian capital in 1936, Zárate enrolled in 1955 in both the Art School of the University of Bogotá and the National Conservatory of Music, but soon decided to concentrate on the development of her gift for the plastic arts. By 1958 she had progressed to the point that she not merely had works accepted for inclusion in important group exhibitions but was appointed professor of drawing at the National Pedagogical Institute. In the following year she entered the School of Fine Arts of the National University, from which she graduated in 1960. That same year she held her first individual exhibition at the National Library and won First Prize for Painting at the Francisco A. Cano Salon.

In 1961 Zárate traveled in several South American countries, among them Argentina, where she held exhibits at the Peuser Gallery and the Social Security Institute in Buenos Aires. In 1962 compositions by her were included in a group show of fourteen Colombian artists sponsored by the International Petroleum Company, which toured Germany, Italy, Spain, and Sweden under the auspices of the Colombian government. Last year she received the Acquisition Prize at the Third International Salon in Barranquilla (Colombia), and the Second Prize for Painting at the National Salon in Bogotá.

Works by Zárate are to be found in the Museum of Modern Art of Buenos Aires, Bogotá, and Barranquilla, and in several private collections in the United States, Israel, and South America. This is her first individual exhibition in the United States.

CATALOGUE

1-20. Oils[2]

[1] Literal translation of this title is "The Ephemeral." —*Ed*.

[2] Titles are unavailable. —*Ed*.

March 20 - April 12, 1964

LINCOLN PRESNO OF URUGUAY: TAPESTRIES

Among Uruguayan artists of mature years, Lincoln Presno is outstanding as a tireless innovator. He began as a student of architecture. This he gave up for painting, from which he later turned to experimenting with new materials for murals and to furniture and industrial design. In all these areas he has excelled. His model for a coffee table has enjoyed great success in South America, and a mural he constructed of aluminum and blue stone has won for him an important place in contemporary Uruguayan art. Never one to rest on his laurels, however, he has recently entered into a new field, tapestry design. His tapestries are not of the traditional, woven type; they are composed of sections of lamb pelts, dyed in varying hues and sewed together in an intricate, yet serene, abstract pattern. With their rich, velvety surfaces, they may be displayed either as wall hangings or as rugs. Each is a one-of-a-kind, signed work of art, to be viewed as seriously as a painting or a piece of sculpture. For a stock-raising country such as Uruguay, Presno's novel creations possess the added interest of representing the artistic use of a natural resource.

Lincoln Presno was born in Montevideo in 1917. He began his career in painting at the Fine Arts Circle in 1943, and two years later joined the workshop of Joaquín Torres-García, one of the most significant forerunners of present-day art in Latin America. Torres-García schooled him in the discipline of a rigidly geometric approach to nature. This influence continued to make itself felt even after Presno left the workshop to paint on his own. Beginning in 1952, he has won no less than seven awards at salons and in competitions held in his native country, in several of whose cities murals by his hand are to be seen. A few years ago he and seven other artists founded the so-called *Group of Eight*, which has since represented the most active nucleus of artistic activity in Uruguay.

Presno has participated in group exhibits in Argentina, Brazil, Czechoslovakia, Ecuador, Egypt, Mexico, the Netherlands, Spain, Syria, and the United States, as well as Uruguay. His one-man shows are too numerous to list at length, but among the more recent one may mention a retrospective exhibit held at the Center of Arts and Letters of Montevideo in 1960; an exhibition at the Rubbers Gallery (his exclusive agent) in 1962; and, the same year, a display of his tapestry designs, again at the Center of Arts and Letters. This is the first individual presentation of his work in the Washington area.

CATALOGUE

1-15. Tapestries[1]

April 13 - May 4, 1964

CHANCAY, NEGLECTED CIVILIZATION OF POTTERS AND WEAVERS

Extensive archaeological research, carried out over decades, has given us a reasonably clear picture of the development of pre-Columbian civilizations in Peru from its beginning, among hunters, gatherers, fishermen, and primitive agriculturists, to the elaborate structure of the Inca Empire. Some of the Andean cultures have become better known than others, however, due to the artistic qualities of specimens displayed in the museums of the world. The magnificently realistic anthropomorphic pottery of the Mochicas, the superb gold work of the Chimú Empire in the north, and the highly stylized polychrome pottery and rich textiles of the south coast have aroused the interest not only of scientists and artists but of laymen as well. The cultures of other regions, such as the central coast, have

[1] Titles are unavailable.—*Ed.*

been studied by specialists, and the details of their development are fairly well worked out, but until recently their artistic achievements have been so overshadowed by those of the areas previously mentioned that the general public has been quite unaware of their existence.

One such culture is that known as the Late Chancay, found in the Rimac, Ancón, and Chancay valleys of the central coast. It belongs to the so-called City Builders Period, dating from approximately 1000 to 1450 A.D. During this period, while the Chimús were developing a regional "empire" in the north and the Ica culture flowered in the valleys of the south coast, the Cuismancu Empire arose in the intervening area. A record of this empire appears in chronicles and in tradition, and excavations have been carried out at some of the more important city centers, such as Pachacámac and Ancón; however, this civilization has been less romanticized than that of the Chimús and its artifacts are far from being so well known, though museums have had them in storage for fifty years and more.

Life in this central coast area in the period, just before the Incas brought the whole of Peru as well as parts of Ecuador and Chile beneath their sway, must have been much like that on the north coast, of which we have more thorough knowledge thanks to the historical traditions of the Chimú Empire. Though differing in details from place to place, crafts were basically similar. The most characteristic artifacts of the late urban culture of the central coast consist of pottery, the most striking and interesting of the styles being that known as Chancay black-on-white.

This pottery is thin and highly porous. It was fired completely in an oxidizing atmosphere to a tan, orange, or orange-red hue. Sometimes it exhibits a creamy white wash or slip, poorly and unevenly applied, on which designs have been painted in a strongly contrasting sepia or black. Objects include bowls, jars, bottles with spouts, canteen and football shaped vessels, and human figurines. The last-mentioned are highly characteristic of the period and, like the geometric designs with their cross-hatched and dotted zones, are so distinctive as to permit the archaeologist to identify the style with ease.

Specimens included in this exhibit suggest the range of treatment accorded the figurines. Variations between paired figures give some idea of differences in male and female dress and ornament. Holes in the heads of the females were used to tie thread or yarn, simulating hair; hollows in the heads of males imply some sort of headband or ornament in which feathers or other objects were placed. The painted design in some cases suggests body ornaments or clothing, as well as varying hair styles. These figures were buried with the dead, as grave offerings, along with utilitarian vessels containing food and drink, and elaborately woven textiles. Recovery of such specimens from scientifically excavated grave lots has permitted archaeologists to reconstruct the entire culture and show clearly the development of the Chancay black-on-white from the preceding black-white-red pottery of the coastal Tiahuanaco culture. —*Clifford Evans*, Curator, Division of Archaeology, Smithsonian Institution.

Despite the great interest in pre-Columbian art that has developed in recent years, misguided comparisons with given forms of Old World expression—of both East and West—have prevented proper appreciation of the values to be discovered in certain of the lesser-known, though clearly defined, cultures such as the Chancay.

As Professor Evans points out, the pre-Inca artistic expression of the central coast area of Peru has been overshadowed by the exquisite weavings from Paracas, the Chimú portrait-pots, and the realistic modelings of the Mochica, not to speak of the austerely elegant creations of the great Inca civilization, in which the cultural development of Indian Peru found its culmination.

The textiles and pottery of the Chancay have been neglected because of the clumsiness of the execution and the roughness of the material. People have judged their merit by standards of greater refinement, and have failed to appreciate the expressiveness of these objects, which for more than five centuries lay buried at the foot of the sandy cliffs on the coast of central Peru, oblivious to the fact that, by their persistent use of the same colors and forms in depicting people and animals in clay, and by the strength and vividness of their conceptions, the Chancay had achieved a highly individual and boldly vigorous mode of artistic manifestation. —*J.G-S.*

LENDERS

Smithsonian Institution
Mr. and Mrs. Guillermo Espinosa
Dr. and Mrs. Falcón Briceño
The Ambassador of Venezuela and Mrs. Tejera Paris
Private collections

CATALOGUE

Chancay Region - Cultural Horizon

1. Tiahuanaco woven textiles and pottery
2. Ancón wooden masks with shells
3. Ancón painted wooden ornaments

Chancay

1. Male and female human figurines
2. Small molded figures
3. Hunchback
4. Animals
5. Vessels
6. Painted cotton textile masks
7. Masks with metal ornamentations
8. Mask with human hair
9. Whispering double base
10. Painted textiles
11. Woven textiles

April 13 - May 5, 1964

THE ARTIST AS PRINTMAKER III: ALFREDO DA SILVA OF BOLIVIA

An exhibition of works executed by the Bolivian Alfredo Da Silva since his receipt of an OAS fellowship for advanced study in 1961 constitutes the third in the Pan American Union's series of presentations *The Artist as Printmaker*. It is clearly manifest from these compositions that Da Silva has taken the same approach to graphic production as to painting, albeit with fresh impulse and a deeper sense of synthesis.

Da Silva was born in the old colonial mining town of Potosí in 1936. His early artistic training consisted merely in a brief period of study at the local academy and a short course in drawing at the University of Córdoba (Argentina) in 1957. After receiving awards in his home town in 1954 and at the La Paz Municipal Salon in 1956, he won the highest award for a foreign artist at the Argentine National Salon, 1959. In 1961 he traveled to the United States for a one-man show of his oils at the Pan American Union. This exhibition was enthusiastically received by critics and public alike. Mrs. Leslie Ahlander wrote in the *Washington Post* that Da Silva's work gave the impression of "heavy stone-like areas built up like the walls of some lost Andean city, closely interlocking in tonalities and textures that are infinitely varied and rich. His work suggests the stony mountains and infinite distances of the high Andes, with rocky formations seen against space where the suggestion of a cold moon or sun hangs in a distant sky. They are frozen and rocky and windy, primeval in their timelessness."

Last year Da Silva was the recipient of a Guggenheim Fellowship. He presently resides in New York City, where he attends the Pratt Institute.

CATALOGUE

Prints

1. *Sensación espacial (Spatial Sensation)*, lithograph, one copy, 18 1/2 x 12 1/2"
2. *Movimiento espacial (Spatial Movement)*, lithograph, twelve copies, 21 1/2 x 15 1/2"
3. *Metamorfosis (Metamorphosis)*, lithograph, eight copies, 18 1/2 x 26 1/2"
4. *Cosmos*, lithograph, six copies, 17 x 23"
5. *Metamorfosis (Metamorphosis)*, lithograph, eight copies, 18 3/4 x 26"
6. *Tensión espacial (Spatial Tension)*, lithograph, fourteen copies, 21 1/2 x 15 3/4"
7. *Mitoformas (Mythoform) No. 1*, intaglio and silk screen, ten copies, 8 x 11"
8. *Eternidad (Eternity)*, lithograph, twelve copies, 21 1/2 x 16"
9. *Gris vital (Vital Gray)*, lithograph, ten copies, 22 x 16"
10. *Transfiguración (Transfiguration)*, lithograph, fourteen copies, 21 1/2 x 15 1/2"
11. *Microcosmos* (Microcosms), lithograph, twelve copies, 22 1/2 x 18"
12. *Microformas (Microforms) No. 3*, intaglio, ten copies, 17 3/4 x 12"
13. *Mitoformas (Mythoform) No. 2*, intaglio, ten copies, 9 3/4 x 17 3/4"
14. *Estructura (Structure)*, silkscreen, ten copies, 14 1/2 x 15"
15. *Formas (Forms)*, silkscreen, ten copies, 14 1/2 x 15"
16. *Fusión formal (Formal Fusion)*, silkscreen, ten copies, 16 x 21 3/4"
17. *Cosmogonía (Cosmogony)*, silkscreen, eight copies, 15 1/2 x 21 1/4"
18. *Génesis (Genesis)*, lithograph, sixteen copies, 15 1/2 x 21 1/4"
19. *Desplazamiento (Displacement)*, lithograph, ten copies, 15 x 20 1/2"
20. *Integración espacial (Spatial Integration)*, silkscreen, ten copies, 14 1/4 x 15 1/4"
21. *Luz blanca (White Light)*, silkscreen, fourteen copies, 15 1/4 x 21 1/2"
22. *Destello (Scintillation)*, lithograph, twelve copies, 15 1/2 x 18 1/2"

All works were executed at the Pratt Institute, New York City, 1963.

May 4 - 25, 1964

ERNESTO DEIRA OF ARGENTINA: OILS

Ernesto Deira is a member of a new generation of Argentine artists that has reincorporated the figurative element into composition. Others of this group are Rómulo Macció, Jorge de la Vega, and Luis Felipe Noé. On several occasions they have exhibited jointly: in 1962 in Buenos Aires at the Lirolay and Bonino galleries (the latter is now Deira's exclusive representative); and in 1963 at the National Commission of Fine Arts in Montevideo (Uruguay), in an exhibition called *Another Figuration*. These artists were four of the five to represent their country in the Guggenheim International Award Competition this year, in the Guggenheim Museum, New York.

Deira was born in Buenos Aires in 1928. He studied law—which he also practices—at the city's university, graduating in 1950. Soon thereafter he began his artistic apprenticeship under the direction of Leopoldo Torres Agüero and Leopoldo Presas. He traveled to Europe in 1953 and again in 1962, on the latter occasion on a scholarship awarded by the Argentine National Fund for the Arts.

All five of Deira's one-man shows to date took place in Buenos Aires, between 1958 and 1963. Examples of his

work have been included in numerous group shows in both South America and Europe. Among these one may mention the Third Latin American Art Biennial held in Bogotá in 1963, and the exhibition *Art of America and Spain*, which was presented in Madrid, Barcelona, Naples, and Rome in 1963-64. This year Deira will be presented with other leading Argentine artists at an important exposition at the Walker Art Center in Minneapolis.

In his work Deira employs pure, raw color, with which he achieves intense chromatic effects, producing what might be termed harsh expressionism—the *art brut* of French painters. Good examples of his work can be found in the National Museum of Fine Arts of Buenos Aires and in the Modern Art Museum of Buenos Aires and Caracas.

This is Ernesto Deira's first one-man show in the United States.

EXHIBITION LIST[1]

Industrial Enamel

1. *El contrato (The Contract)*, 97 x 130 cm.
2. *El final de Hotspur (The End of Hotspur)*, 114 x 146 cm.
3. *Verónica*, 146 x 114 cm.
4. *Paz romana (Roman Peace)*, 97 x 130 cm.
5. *Tempo*, 114 x 146 cm.
6. *Viuda-sapo-viuda (Widow-Toad-Widow)*, 97 x 130 cm.
7. *Angulo superior derecho blanco (White Upper Right Angle)*, 146 x 114 cm.
8. *Combate isabelino (Elizabethan Combat)*, 114 x 146 cm.
9. *Adán y Eva (Adam and Eve) No. 1*, 195 x 130 cm.
10. *La Casa Octava (The Eighth House)*, 150 x 150 cm.
11. *Casi señora (Almost a Lady)*, 150 x 150 cm.
12. *Condensación (Condensation)*, 100 x 100 cm.
13. *Historia del ADN (History of ADN) II*, 45 x 35 cm.
14. *Historia del ADN (History of ADN) III*, 30 x 40 cm.
15. *Historia del ADN (History of ADN) V*, 45 x 35 cm.
16. *Historia del ADN (History of ADN) I*, 35 x 45 cm.
17. *En torno a la Casa Octava (About the Eighth House)*, 97 x 130 cm.
18. *Los dos capitanes (Two Captains)*, 115 x 92 cm.
19. *El medio hostil (Hostile Environment)*, 60 x 90 cm.
20. *Presente histórico (Historic Present)*, 60 x 70 cm.
21. *Por un lugar al sol (For a Place Under the Sun)*, 60 x 90 cm.
22. *Equivalencias (Equivalences)*, 60 x 80 cm.
23. *La piel inesperada (The Unexpected Skin)*, 80 x 60 cm.

May 4 - 25, 1964

TAPESTRIES DESIGNED BY GRACIA CUTULI AND CLAUDIO SEGOVIA OF ARGENTINA

The two young Argentine artists whose work is presented here have rung a series of changes upon the traditional techniques of handwoven tapestries to produce imaginative and amusing variations. Applying pieces of fabric,

[1] Although the original catalogue indicates that fifteen untitled oils were exhibited on this occasion, here reproduced is the list of works sent by the artist for this exhibition, which includes twenty-three industrial enamel paintings. —*Ed*.

strands of wool and silk, and other materials to textiles, often in high relief, they have created a fresh technique for producing decorative effects.

Gracia Cutuli was born in 1937 and graduated from the Belgrano National School of Fine Arts in 1952 and the Pueyrredón Academy in 1957. The following year she studied painting in the studio of Juan Batlle Planas.

In 1960 and 1961 Cutuli lived in Paris, where she studied the development of the plastic arts with Pierre Francastel at the Sorbonne and engraving in the studio of Johnny Friedlaender. She took part in the founding of the Center for the Study of Tapestry established by de Pirsine, Director of the Aubusson Gallery, and studied at the Gobelin works.

The artist visited tapestry schools in Italy, Germany, Switzerland, Sweden, Denmark, Norway, and Spain before returning to Buenos Aires in 1962. She is now a professional carpet designer for leading Buenos Aires manufacturers.

Claudio Segovia was born in the Argentine capital in 1933 and attended the same schools as Cutuli four years earlier. A fellowship from the National Culture Administration enabled him to study scenography at the Ernesto de la Cárcova Advanced School of Fine Arts in 1954.

Segovia has exhibited paintings in the capital cities of several Argentine provinces: Córdoba, Mar del Plata, Rosario, Tucumán, and Mendoza, and at the Müller and Peuser galleries in Buenos Aires. In 1955 the French government invited Segovia to spend a year in Paris, where he exhibited at the Club des 4 Vents.

In 1960 Segovia studied Indian crafts in Brazil and visited Upper Paraná, the Amazonas, and the Mato Grosso. On his 1963 trip through northwestern Argentina and Bolivia he collected Indian textiles for an exhibition in Buenos Aires.

Segovia traveled extensively in Europe in 1956 and in 1962, visiting Italy, France, Germany, Switzerland, and Spain, and on the second trip an exhibit of his paintings was held at the Institute of Hispanic Culture in Madrid.

The Museum of Modern Art of Buenos Aires had a joint exhibit of the tapestries of Gracia Cutuli and Claudio Segovia in 1963.

This is the first presentation of these tapestries in the United States.

CATALOGUE

Tapestries

1. *Tapiz (Tapestry) I*
2. *Tapiz (Tapestry) II*
3. *Maceta (Flowerpot) I*
4. *Maceta (Flowerpot) II*
5. *Perros (Dogs)*
6. *Perro (Dog) I*
7. *Perro (Dog) II*

Tapestries for Children

8. *Pecosa (Girl with Freckles)*
9. *Ecuyère (Horsewoman)*
10. *Gato (Cat)*

10. *Gato (Cat)*
11. *Perros (Dogs)*
12. *Pedrito*

All tapestries were executed by Sara Gómez Díaz.

May 21 - June 10, 1964

NINE CONTEMPORARY PAINTERS: USA

In its program of art exhibitions, the Pan American Union has long concentrated upon presenting Latin Americans, usually representative of the avant-garde, who despite the high quality of their work have not yet attained the prestige they merit in their native countries. In many cases an exhibition in Washington has sufficed to bring an artist immediate recognition both at home and on the international scene. It is a source of much satisfaction to the Pan American Union that it has thus been able to serve as the portal to fame for a number of the more significant figures in the world of contemporary art.

With the current show an operation is being initiated in another direction, with a view to presenting in selected cities of Latin America, after exhibition at the Pan American Union, works by young or little known talents of the United States.

Factors of varying nature have rendered it impossible to make this first selection on a national basis. It was therefore decided to present a group of artists from Washington, the city in which the Latin Americans have made their debut, augmented by two figures from the New York area closely associated with the artistic life of the capital. It is hoped that similar exhibitions may be organized on a biennial basis to demonstrate the variety, strength, and continuous growth of creative endeavor in the United States to the art public of its neighbors to the south. —*J. G-S.*

NOTES ON THE PAINTERS

The choice of the United States avant-garde artists seems to be between poles of pure abstract painting and pop art (with its load of objects from and references to the environment incorporated in the work of art). Another direction, that of the textural elaboration of high paint, much seen in Latin American and European art, is rare as in expressionism at the present time. This exhibition concentrates on the pure painting possibility, as is natural in a sample of work being done in Washington, D.C. The fact is, several cities besides New York possess characteristic groups or tendencies: Chicago is linked with figurative art, San Francisco with object-makers, and Los Angeles has indigenous pop and abstract artists. In Washington a constant of several painters has been the use of flat color on unprimed canvas. Frequently, the color is used systematically, without any drama of handling, and without renewed formal invention. On the contrary, the repetition of a single image is typical of this kind of painting in which color, its tensions and its variables, is central. One image painting is in no sense, of course, a narrowing of the resources of art, but merely a technical limitation within which, as this exhibition shows, artists of different characters are free to expand independently.

All of Downing's painting in this exhibition are not variations on a theme (because that would imply one main statement, with secondary developments), but statements of equal possibilities within certain self-determined rules. By turning a square canvas (as in the *Helix* series) so that it stands on end instead of on one of its sides, its geometry is transformed in the spectator's attention. Instead of a contained form, one is faced by an expanding area. Across this dynamic form Downing lays his color in flat, curved bands, the strong continuity of which enables one to read them as, at points, leaving the canvas and, as it were, returning. Thus, in each of the paintings shown one

paintings shown here there are three colors in four areas, or three in five, or four in five. The color, hard and strong as it unwinds across the diamond-shaped area, defines the painted surface richly and fully; at the same time the surrounding space is under pressure from the expanding color in relation to the format.

Davis's repetitive vertical bands of color are ranged in even rows. The colors sometimes exist in isolation and sometimes are phased in groups, with the result that the parade of forms opens and closes, tightens and relaxes, as one's eye goes along it. A horizontal rhythm emerges from the vertical sequence. The openness of the ordered run gives an impression of endlessness, as if the bands could ripple on the variations of phasing forever. The artist holds the painting between being there, before us as a legible form, and implications of continuity and extension into space.

Like Downing and Davis, Meyer uses a plastic paint that impregnates the canvas rather than rests, as a solid paste, on top of it. The paint in the tondos is a smooth luxurious skin, of spectrally related colors, defining curved forms that roll in from the outer edge of the canvas. Whereas Downing's forms open toward the surrounding space, Meyer's home is in a central area or point. However, it is not sufficient to characterize an artist's work in contrast to that of others. One must also compare the individual pictures within an artist's oeuvre to detect, as in Meyer's case, the delicate shifts in color relationships, the different speeds at which the undulant forms contract toward the (variously shaped) center.

The properties of plastic paint as seen in the works of Downing, Davis, and Meyer on unprimed canvas are clear, smooth, even, soaked in. In *Spring Light* and *Bacchanalia* by Sam Gilliam, the dye-like smoothness is replaced by the harder, more eventful surfaces of oil paint, retentive of brush directions and hand pressures. The layout of the two paintings, however, is identical, except for an inversion of one color division. The structure is symmetrical, with color changes free to function optically in a lucid format so that figure-field divisions are scrambled, and drawing (the invention of form in a linear manner) is cut out by color activity.

The stylistic connections that can be found among Downing, Davis, Meyer, and Gilliam (despite a reference to earlier geometric abstract art in his subdivisions of the picture plane) do not extend to the remaining painters in the exhibition. Stokes's paintings are like landscapes, with a desert-like horizon; then the foreground, instead of holding firm, drops away to a melting underside. The spatial effect is of a forgetful Terran on an asteroid, believing he can rely on his customary space orientation, who suddenly remembers that his world is only a small rock. The vaporous forms are held with studs of detail, like warts of bullet holes. In Cuatrecasas the horizontal strips are hard and clear, but the paint is heavy and fat. It swells above the sharp edges in heavy masses that invoke earthy volumes by the dark tonality of the textured surface. McGowin, on quartered grounds or color squares, gestures with freely painted loops. The paintings state, nonchalantly, a theme of containment, the rings in the places, placed as by a top deck quoits player. —*Lawrence Alloway*

THE DRAFTSMEN

In the words of Kirby Congdon the work of Lowell Nesbitt "portrays in conjunction the romance of the visual body with that of the supervisual mechanical aided vision of the X-ray. This bifocal vision is underscored by the geometrical shapes related to the body's movement and intensified by the positions of the body, such as the ambiguous doubled fist or the posed torsos." Beside these formal considerations we may add that Nesbitt's world translates through this counterpoint, underlined by Congdon, the content and ambiguity of man's plight in the modern world. The tension between nature and the machine age, the tension between sex and the sex pill are terms that Nesbitt accepts and tries to harmonize rather than flee from like Gauguin, his predecessor, in the face of a similar challenge. If life is to be preserved and man cannot scape the machine and the vision through the machine, someone must try and bring it into harmony with the human. I think that along these lines lie the queries that Nesbitt poses in the different levels of an expanding consciousness, and I think that the translation of these queries in terms of the visual speaks of the richness of his work.

Brian Lord is a young artist whose path appears to lie in the realms of spontaneity and whose vision is also linked with the machine. In his nervous pen drawings he tries to capture the romantic vision of movement through an empathy with the objects of his inspiration. These are no doubt the first steps toward a vision that will clarify itself as the artist walks the path of discipline. What is important to note is that a keen curiosity is always auspicious as a sign of promise, and this endeavor upon which Lord has embarked is sure to give happy results in one who, at this early stage, can already show a firm vocation in the search for visual meaning with the aid of fantasy and an elegant aesthetic sensibility. —*Rafael Squirru*

CATALOGUE

Paintings and Drawings

Gil Cuatrecasas
 1. *Stauros*, 1963, 60 x 46"
 2. *Untitled*, 1963, 50 x 40"
 3. *Tropic*, 1963, 38 x 31"
 4. *Untitled*, 1963, 23 x 20"

Gene Davis
 5. *Staccato*
 6. *Red Pulse*

Tom Downing
 7. *Helix 5*, 75" across
 8. *Helix 13*, 13" across
 9. *Helix 14*, 75" across
10. *Helix 9*, 51" across

Sam Gilliam
11. *Bacchanalia*, 36 x 36"
12. *Blue Glow*, 16 x 70"
13. *Spring Light*, 36 x 36"

Brian Lord
14. *Wheel in Motion*
15. *Invention I*
16. *Invention II*
17. *Invention III*

Ed McGowin
18. *Nota*
19. *King*
20. *Drom*

Mary Meyer
21. *Fire Island II*, 1963
22. *Clearing*, 1963
23. *Foxglove*, 1963

Lowell Nesbitt
24. *Chartreuse*, 1963, colored pencil, 52 x 36"
25. *Black Shoulders*, 1963, pencil and etching ink, 52 x 36"
26. *Variations - Hands and Rose II*, 1964, pencil and etching ink, 52 x 36"

Tom Stokes
27. *Elegy*, oil, 40 x 50"
28. *Dialogue*, oil, 40 x 50"
29. *Landscape of the Heart II*, oil, 50 x 60"

ABOUT THE ARTIST

CUATRECASAS, Gil. Was born in Madrid in 1935 and has lived in France, Colombia, and Argentina. He is now a United States citizen. Cuatrecasas studied at Harvard College (B.A., 1957), the Yale University Art School, the Corcoran Art School, the Chicago Art Institute, and, with an Organization of American States fellowship, at the National School of Plastic Arts in Mexico City. He will hold his first one-man show at the Corcoran Gallery of Art, Washington, D.C., in 1965.

DAVIS, Gene. Was born in Washington, D.C., in 1920. He is a self-taught artist. Davis's work was first shown at the Seventh Annual Area Exhibition of the Corcoran Gallery of Art in 1952. Since that time he has held several one-man shows in Washington: Catholic University, 1953; American University, 1955; Franz Bader Gallery, 1956, and the Jefferson Place Gallery, 1959, 1961, and 1962. In New York City he has exhibited at the Poindexter Gallery, 1963.

DOWNING, Tom. Was born in Ivor, Virginia, in 1928. He attended Randolph Macon College, Ashland, Virginia; the Pratt Institute, New York City; Académie Julian, Paris; and Catholic University, Washington, D.C. Downing has held several one-man shows in this city and in New York, where he is represented by the Stable Gallery through whose courtesy these paintings are shown.

GILLIAM, Sam. Was born in Tupelo, Mississippi, in 1933. He attended the University of Louisville, where he received a master's degree in painting in 1961 and where he held his first one-man show in 1955. He has exhibited in Washington at the Adams-Morgan Gallery and in Louisville at the Frame House Gallery.

LORD, Brian. Was born in Fall River, Massachusetts, in 1942. A self-taught artist, he specializes in mechanical subject matter and vehicles in motion. He has held one-man shows in Washington at the Adams-Morgan Gallery in 1962, and in Madrid (Spain) at the Atril Gallery in 1963.

McGOWIN, Ed. Was born in Hattiesburg, Mississippi, in 1938. He graduated from the University of Southern Mississippi in 1960. McGowin has held one-man shows at the Corcoran Gallery of Art, 1962; the University of Alabama, 1963, where he is presently doing graduate work; and the Henri Gallery, Alexandria, Virginia, 1964, through whose courtesy these works are presented.

MEYER, Mary. Was born in New York City. She graduated from Vassar College and later studied at the Art Students League in New York; the Cambridge School of Design in Massachusetts; and the American University, Washington, D.C., where she has also exhibited her work.

NESBITT, Lowell. Was born in Baltimore in 1933. He graduated from Temple University in Philadelphia and later did advanced work in stained glass and etching at the Royal College of Art in London (England). Back in the United States he served with the Armed Forces in the capacity of art director of the Color Television Division of the Walter Reed Army Medical Center. Presently living in New York, Mr. Nesbitt is working in the field of metarealism based on the representation of the human form combined with illuminated X-rays. His paintings are presented through the

courtesy of Franz Bader Gallery, Washington, D.C.

STOKES, Tom. Was born in 1934. He studied at the University of Florida, where he graduated in 1956. Stokes traveled to Europe for independent study in 1957 and again in 1962. His work was presented in a group show at the Royal Athena II Gallery in New York in 1963.

May 26 - June 16, 1964

ELISA ELVIRA ZULOAGA OF VENEZUELA: ENGRAVINGS

Continuing its series of exhibitions of the print work of artists active in other media, the Pan American Union currently presents a group of experimental engravings by the Venezuelan Elisa Elvira Zuloaga. Well known in art circles for her painting, she has of late devoted herself almost entirely to copperplate. To date she has produced sixty prints, the first of which were made at S. W. Hayter's Atelier 17 in Paris and the remainder in her own Caracas workshop. Limitations of space permit display of only a selection from this work.

Zuloaga was born in Caracas and attended its School of Fine Arts, later pursuing her studies at the André Lhote Academy of Art in Paris and Amédée Ozenfant's workshop in New York City. Since 1941 her works have been hung regularly at the official Venezuelan Salon in Caracas. Her painting won for her the First Prize in the Planchart Salon in 1951 and the First National Prize in 1952. They have been included in her country's representation at the Inter-American Biennial in Mexico and the Biennial of Engraving in Chile, and have also figured in numerous foreign exhibitions along with those by other artists associated with Atelier 17. Last year she had an individual show of her graphic work at the Mendoza Gallery in her native city.

Zuloaga has combined her creative career with one of government service. She has held several important official positions, including that of director of culture in the Ministry of Education. She is, moreover, a driving force in several art organizations in her country.

This is the first presentation of her work in any medium in the Washington area.

CATALOGUE

Engravings

1. *Abstraction I*
2. *Branches*
3. *Minerals*
4. *Abstraction II*
5. *Geology I*
6. *Tide I*
7. *Tide II*
8. *Desde el aire (From the Air)*
9. *Estrellado (Starry)*
10. *Vuelo nocturno (Night Flight)*
11. *Vuelo (Flight)*
12. *Traya I*
13. *La selva (In the Forest)*
14. *Gacela (Gazelle) I*
15. *Gacela (Gazelle) II*

16. *Traya II*
17. *Cliff*
18. *Birth Place of Rivero*
19. *Soñando con las islas (Dream Islands)*
20. *Hacia la luz (Toward Light)*
21. *Andes*
22. *Twilight I*
23. *Twilight II*
24. *Geology II*
25. *Airborne*
26. *Winter Feeling*
27. *Maze*
28. *Maternidad (Maternity)*
29. *Head of Christ*
30. *Toward a Remote Era*
31. *Nocturnal*
32. *Geology III*
33. *Aragua*
34. *Caroní*

June 17 - July 8, 1964

ENRIQUE TABARA OF ECUADOR: OILS

Among artists who have broken with the Indianist trend that until recently characterized Ecuadorian painting, Enrique Tábara has won a place of distinction. Rather than the champion of a single mode of expression, he is essentially an experimentalist, assimilating and employing for original effects a variety of techniques. His work is a pageant of form, texture, and rhythm which seems to spring from the hieroglyphs of pre-Columbian America and yet is thoroughly modern in spirit.

Tábara was born in Guayaquil in 1930 and studied at the local School of Fine Arts. He first exhibited at the National Salon in Quito in 1951. The acceptance accorded him on that occasion laid the foundation of a now firmly established national reputation. One-man shows of his work were given at the House of Culture in Guayaquil in 1953 and 1954, and in 1955 Tábara received a scholarship from the Ecuadorian government to study at the School of Fine Arts in Barcelona, Spain. Three leading galleries of that city presented his work in 1957 and 1958, and an exhibition in Madrid followed in 1959. Since 1960 Tábara has had one-man shows in Lausanne and Basel, Switzerland; Munich and Bremen, Germany; and Milan, Italy. In addition, examples of his work have been included in important group exhibits in Belgium, France, Germany, Italy, Spain, and Switzerland, and even in far-off Formosa and Japan. In 1953 the René Metrás Gallery of Barcelona became his exclusive agent.

Compositions by Tábara may be found in the Museum of Contemporary Art, Barcelona; the Museum of Modern Art, São Paulo; the House of Culture in Guayaquil and Quito; the Art Museum, Lausanne; and many private collections in Europe, Latin America, and the United States.

This is the first individual presentation of Enrique Tábara's work in the United States.

CATALOGUE

Oils

1. *Chichén Itzá*
2. *Imagen ritual gris (Grey Ritual Image)*
3. *Imagen de repeticiones (Image of Repetitions)*
4. *Tiahuanaco*
5. *Presagio (Omen)*
6. *Rivalidad ancestral (Ancestral Rivalry)*
7. *Ritual americano (American Ritual)*
8. *Tabú (Taboo)*
9. *Homenaje a Pachacutec (Homage to Pachacutec)*
10. *Tikal*
11. *Ritual en Cuzco (Ritual in Cuzco)*
12. *Magia (Magic)*
13. *Ornamentación en verde (Green Ornamentation)*
14. *Viracocha*
15. *Mariposas sobre un fondo gris rosa (Butterflies on a Grey-Pink Background)*
16. *Rito de Mitla (Mitla Rite)*
17. *Negro rosa (Rose Black)*
18. *Superstición (Superstition)*
19. *Figura (Figure)*
20. *Estructural azul (Structural Blue)*
21. *Idolo grotesco (Grotesque Idol)*
22. *Alienado (Alienated)*
23. *Las tres almas (The Three Souls)*
24. *Rito fúnebre (Funeral Rite)*
25. *Pintura objeto (Object Painting)*
26. *Zorro*
27. *Ritual azul (Blue Ritual)*

July 13 - 28, 1964

RAMON VERGARA GREZ OF CHILE: OILS

The Chilean painter Ramón Vergara Grez is a follower of the sharp-edge trend, which has been one of the constants in Latin American art in recent years. As a figurative artist, he turned out neat still lifes, in which each object was cleanly defined by precise lines, with no allowance for shadow, atmosphere, or transition of any sort. Later he applied this technique in the area of abstraction, as represented by this exhibition.

In adopting the sharp-edge tendency, Vergara Grez was largely influenced by the celebrated Emilio Pettoruti—a forerunner of both cubism and abstractionism in Latin America—with whom he studied in Buenos Aires. Previously he had attended the School of Fine Arts of the University of Chicago, from which he graduated in 1945. He has twice been the recipient of scholarships for study abroad, having received an award from the government of Brazil in 1948 and one from the government of Italy in 1954.

Vergara Grez has participated in numerous official salons in Chile since 1943; at the one in 1951 he received First Prize. His works have been included in Chilean group exhibits in Bogotá, Buenos Aires, Lima, Madrid,

Montevideo, Rio de Janeiro, and Washington, D.C. He is currently a professor of drawing at the School of Fine Arts of the University of Chile.

This is the first one-man show of Vergara Grez's compositions in the United States.

CATALOGUE

1-20. Oils[1]

July 29 - August 13, 1964

CASTILLO OF PERU

In the opinion of one of the most distinguished personalities of his country's artistic circles, Carlos Castillo is among the top representatives of Peruvian modern painting. This is his first exhibition in the United States, and one showing his most recent creative trend. To some extent, his work also reflects the evolution now being experienced by many Peruvian painters, who are gradually moving out of the abstract field and returning to a figurative expressionism.

In years past, while most of his Peruvian colleagues devoted themselves to capture the natural ambience, Castillo, living in Argentina at the time, abandoned his original preoccupation for the multiple *isms* of the 1930s in search of a wider horizon for South American motives. In a way, he was coming close to the so-called *Peruvian indigenism*, then personified by José Sabogal.

Back in Peru, his art moved over to the sphere of social concern, paying special attention to both the man and landscape of the Peruvian coast. Shortly afterwards, he was absorbed by abstractionism, which was forcefully incorporating all new generations of American painters.

Later, encloistered in a world of his own, both his use of materials and his concept of form revealed a trend to moderation, stressed by his rather soft range of color. Then, all logical molds and inhibitions were broken by the impulse of his personality. Color was exalted, form was given more freedom and the black began to act as a factor of violence. Romantic inspiration was thus manifested in a struggle for a more definite expression.

As in the case of many other Peruvian painters, Castillo has now discovered an element of frustration in his abstractionist experience. He wants something more. He needs a transcendental world. He has, in fact, created a universe of strange characters and warriors present in this show and reminiscent of our ancient art. In this manner, Castillo has recaptured form and profile from a previous exuberance of pure color. Nevertheless, the audacious and vigorous personality shaped up during his abstractionist period enables him to fully preserve and enjoy his freedom.

Carlos Aitor Castillo, born in Lima, Peru, in 1913, is currently a teacher at the Escuela Nacional de Bellas Artes in his native city. He studied in Argentina under Spilimbergo, among other masters. While in that country, he was awarded several first prizes for drawing and painting in Tucumán as well as at the Salón del Norte Argentino. His work was also displayed at various Autumn Salons conducted by the Argentinean Society of Plastic Arts in Buenos Aires. Castillo returned to Peru in 1951 and was awarded the First Prize and Gold Medal at the City Council Gallery in 1954. Among several other prizes, he also won in 1961 the Premio Nacional de Escenografía (National Prize for Stage Design) awarded by San Marcos University.

[1] Titles are unavailable. —*Ed*.

Castillo has been among the painters representing Peru at the biennials of São Paulo, of Mexico, and of Havana. His works have been included in all recent shows of Peruvian paintings in foreign countries. He has held individual exhibits in Lima, Quito, La Paz, and various cities in Argentina.

He is a member of the International Association of Art Critics and has contributed with articles to *La Prensa* of Lima and other important newspapers and magazines. Among other activities, Castillo performed as director of Tucumán's Children School of Plastic Arts.

CATALOGUE

Paintings

1. *Máscara de un guerrero (Mask of a Warrior)*
2. *Pájaro agorero (Bird Diviner)*
3. *Kashi-Oor, el narrador de historias (Kashi-Oor, the Storyteller)*
4. *Habitantes de la noche roja (Residents of the Red Night)*
5. *Tumacc, el de las dos lanzas (Two-Spear Tumacc)*
6. *La luna del guerrero (Warrior's Moon)*
7. *El hacedor de hechizos (Witchdoctor)*
8. *Brujos de la tribu Cahuacc (Sorcerers of the Cahuacc Tribe)*
9. *Escuderos (Shield Bearers)*
10. *Antarkay, el triunfador (The Victorious Antarkay)*
11. *Los alegres guerreros (Happy Warriors)*
12. *Los hermanos Ayar-Acku (The Brothers Ayar-Acku)*
13. *Cusi-Kcollor, la mujer del guerrero (Cusi-Kcollor, the Warrior's Wife)*
14. *Manko, el joven combatiente (Manko, the Young Fighter)*
15. *Flor para un guerrero (Flower for a Warrior)*
16. *El Gran Chimú (The Great Chimú)*
17. *Guerrero con lanza y escudo (Warrior with Spear and Shield)*
18. *Guerrero sentado (Sitting Warrior)*
19. *Los chankas de la lanza de oro (Chankas of the Golden Spear)*
20. *El prisionero (The Prisoner)*
21. *El guerrero blanco (The White Warrior)*
22. *El guerrero negro (The Black Warrior)*
23. *El guerrero rojo (The Red Warrior)*
24. *El guerrero verde (The Green Warrior)*
25. *Muerte de todos los guerreros (Death of All Warriors)*

August 18 - September 8, 1964

LUIS GUZMAN REYES OF CHILE: CERAMICS

The ceramist Luis Guzmán Reyes, whose work is here being presented for the first time in the United States, was born in Villa Prat, Chile, on March 6, 1914. He received training in applied arts at the university level in his own country, after which he attended the Central School of Arts and Crafts in London, and several other art schools both in Europe and in the United States, in part thanks to a fellowship received from UNESCO.

He has practiced sculpture, ceramics, and painting, winning awards in all three genres. In addition to participating in group exhibitions, he has held a number of one-man shows. Examples of his work may be found in museums

in Chile, England, and France, and in various private collections.

At several periods in his career Guzmán Reyes has taught art. He has recently founded a magazine devoted to ceramics, the first of its kind to be published in Chile.

EXHIBITION LIST[1]

Ceramics

 1. *Cock*, terra-cotta with mosaics
 2. *Vase with Roosters*
 3. *Vase with Children Dancing*
 4-5. *Fruit Vase*
 6. *Gray Vase*
 7-8. *Plate*, engobed
 9. *Jar with Flowers*
10-12. *Teapots*
 13. *Bowl with Horses*
14-16. *Cuecas (Mugs for Beer)*
17-18. *Plate*, terra-cotta and glaze
19-24. *Figure*
25-28. *Plate*, terra-cotta and engobe
29-37. *Plate*, glazed
 38. *Peasant Woman*
 39. *Two Women*, lamp stand
 40. *Fisherman from Chiloé*
 41. *Fish*, lamp stand
 42. *Women*, lamp stand
 43. *Little Fisherman*, lamp stand
 44. *Bird*
 45. *Pitchers*
 46. *Flowerpots*
 47. *Madonna*
 48. *Horsemen*, jug

September 9 - October 4, 1964

CONSTANCIA CALDERON OF PANAMA

A new personality that has emerged upon the lively artistic scene of Panama is that of Constancia Calderón who, with the present show, is receiving her first individual exhibition in the United States. A practitioner for some years of abstract expressionism, she has arrived at a highly personal conception of color, which imparts a distinctly individual stamp on her work.

Calderón was born in Panama City in 1937. She studied, however, in Pennsylvania, receiving a bachelor's degree in fine arts from Rosemont College. In view of her natural talent for painting, she was sent by her family to Paris

[1] Not included in the original catalogue. —*Ed.*

to continue her training at the Grande Chaumière, the Académie Julian, and the Sorbonne. Since returning from Europe she has established permanent residence in New York, although she makes frequent visits to her native country.

Individual exhibitions of Calderón's work have been held at the Galerie Schumacher in Munich, 1961; the Galerie du Pont Neuf in Paris; and the Panamanian Art Institute in Panama City, 1962. In May of this year she participated in the international exhibit presented at the Pepsi Cola Gallery, and her work can currently be seen at the Central American and Panamanian Pavilion at the New York World's Fair.

CATALOGUE

Oils

1. *Amagansett*,1964, 45 x 50"
2. *Composition V*, 1964, 45 x 50"
3. *Goliff*, 1964, 40 x 50"
4. *Dunes II*, 1964, 40 x 50"
5. *Hedges Lane*, 1964, 40 x 50"
6. *Michoacán*, 1964, 40 x 50"
7. *Uxmal II*, 1964, 40 x 50"
8. *Hedges*, 1964, 42 x 44"
9. *Path III*, 1964, 42 x 44"
10. *New York I*, 1964, 40 x 40"
11. *Nepenthe II*, 1964, 40 x 40"
12. *Greenport*, 1964, 40 x 40"
13. *Dunes I*, 1964, 30 x 43"
14. *Nepenthe I*, 1964, 30 x 43"
15. *81st Street*, 1963, 28 x 44"
16. *Long Island Landscape*, 1964, 30 x 40"
17. *Homage to Franz Kline*, 1964, 27 x 36"
18. *Uxmal*, 1964, 26 x 36"
19. *Hampton*, 1964, 21 x 25

September 9 - October 4, 1964

JULIO ZACHRISSON OF PANAMA

In the broad spectrum of tendencies in contemporary Panamanian art, figurative expressionism finds a distinguished representative in Julio Zachrisson. Although closely linked with painting, a genre which he practices with proficiency, he is primarily identified with the graphic arts, having won renown both at home and abroad as an engraver.

Zachrisson was born in Panama in 1930 and there initiated his artistic studies. These he continued in Mexico City and later in Europe, enrolling first at the Accademia Pietro Vanucci in Perugia (Italy), and then at the Higher School of Fine Arts in Madrid (Spain). He has remained as a resident of the last mentioned city.

Zachrisson has had one-man shows at the Galería Argos, Mexico City, 1959; at the University of Panama, 1960; at the Institute for Hispanic Culture, Madrid, 1961; and in the Spanish cities of Granada, Salamanca, and Zaragoza in 1962. In 1963 he exhibited in Spain at the Galería Forum in Madrid and at the Galería Tartessos in Málaga, and

in Panama City at the Panamanian Art Institute. This year his work was presented at the Pioneer Museum and Haquin Galleries in Stockton, California. Zachrisson has participated in group shows in Guatemala, Italy, Mexico, Spain, and New York; most recently in last year's exhibition in Madrid, entitled *Art of America and Spain*. Examples of his work are to be found in numerous private collections in Latin America, the United States, Europe, Australia, and Japan. They likewise figure in the collections of the Museum of Modern Art, the Metropolitan Museum, and the Brooklyn Museum, all in New York City.

CATALOGUE

Etchings and Lithographs

1. *Habitante muerto (Dead Inhabitant)*, 1964, etching, 15 prints
2. *Bufones (Jesters)*, 1963, etching, 15 prints
3. *Muerte del brujo (Death of a Witch)*, 1963, etching, 15 prints
4. *Cipriano's Daughter*, 1964, lithograph, 14 prints
5. *Doña Prudencia*, 1964, lithograph, 17 prints
6. *Doña María*, 1964, lithograph, 16 prints
7. *Bailaora (Dancer)*, 1964, lithograph, 12 prints
8. *Toro, juego y tragedia (Bull, Game, and Tragedy)*, 1964, lithograph, 12 prints
9. *The Madman*, 1964, lithograph, 17 prints
10. *Muerte de Pancha Manchá (Death of Pancha Manchá)*, 1963, etching, 15 prints
11. *Cabeza (Head)*, 1963, etching, 15 prints
12. *La puerta (The Door)*, 1964, etching, 20 prints
13. *Duende (The Ghost)*, 1964, etching, 20 prints
14. *El toro (The Bull)*, 1964, etching, 15 prints
15. *El brujo Cirilo (Cirilo the Witchdoctor)*, 1963, etching, 15 prints
16. *Muerte de Chimbombó (Death of Chimbombó)*, 1963, etching, 15 prints
17. *Yunga the Whistler*, 1964, lithograph, 21 prints
18. *Toro, Juego y Tragedia (Bull, Game, and Tragedy)*, 1964, lithograph, 10 prints

October 5 - 20, 1964

IGNACIO M. BETETA OF MEXICO: WATERCOLORS

The regular program of exhibition of the avant-garde in Latin American art is interrupted on this occasion to present the work of an artist who follows the academic tradition, demonstrating a total command of the watercolor medium. And there is a second innovation. Many of the artists we have presented also have another occupation as a means of earning a living; the present show adds a new profession to our list. This is the first time that we have shown the work of an artist who is also a military man in active service with the rank of lieutenant general.

General Ignacio M. Beteta was born in the capital of Mexico in 1898, and took part in the Mexican Revolution when he was still a young man. He attended the San Carlos School of Fine Arts, where he was a pupil of the famous Mexican masters Dr. Atl, Germán Gedovius, Saturnino Herrán, and Eduardo Solares.

General Beteta has traveled extensively in Mexico and abroad. He has converted landscapes, urban scenes, and details of towns he has visited into competently executed watercolors. His works are represented in the Museum of Art in Tel Aviv and the Presidential Palace in Djakarta, as well as in numerous private collections in Europe and this hemisphere. During the past ten years he has held one man shows in nine of his country's major cities as well as six one-man shows in Mexico City itself. He has also held one-man shows in Rome (Italy), 1954 and 1957; in

Miami (Florida) and in New Orleans, both in 1958; and in Djakarta, 1962. General Beteta is a professor of drawing and watercolor at the School of Architecture of the National University of Mexico.

CATALOGUE

Watercolors

1. *Cabeza olmeca (Olmec Head)*
2. *Panorama de la Ciudad de México (Panoramic View of Mexico City)*
3. *Calle de un pueblo mexicano (Street in a Mexican Town)*
4. *México al atardecer (Mexico at Sundown)*
5. *Cúpula de catedral (Cupola of Cathedral)*
6. *Calle de Roma (Roman Street)*
7. *Una calle de Acapulco (A Street in Acapulco)*
8. *Pueblo del altiplano de México (Town in the Highlands of Mexico)*
9. *Lomas de Santa Fe (Hills of Santa Fe)*
10. *Vista del Tepozteco (View of Tepozteco)*
11. *Central Park, New York*
12. *Pueblo tropical (Tropical Town)*
13. *Vaso del Lago de Texcoco (Texcoco Crater Lake)*
14. *Pueblo costeño (Coastal Town)*
15. *Barrio proletario (Neighborhood of the Poor)*
16. *Callejón de San Angel (San Angel Alley)*
17. *Hornos de ladrillo (Brick Ovens)*
18. *Barrio industrial (Industrial Area)*
19. *Suburbio neoyorquino (New York Suburb)*
20. *Orillas del río Grijalba (The Banks of the Grijalba River)*
21. *San Francisco, Puebla*
22. *La jungla (The Jungle)*
23. *Iglesia de Santo Domingo (The Church of Santo Domingo)*
24. *Atardecer en el valle (Sundown in the Valley)*
25. *Panorama del México antiguo (View of Old Mexico)*
26. *Paisaje de Chiapas (Chiapas Landscape)*
27. *Calle de San Angel, México, D.F. (Street of San Angel in Mexico City)*
28. *Calzada de los Muertos, Teotihuacán (Highway of the Dead, Teotihuacán)*
29. *Indio zapoteca (Zapotec Indian)*
30. *Calle provinciana (Provincial Street)*
31. *Iglesia de Chimalistac (Church in Chimalistac)*
32. *Panorama del Valle de México (Panorama of the Valley of Mexico)*
33. *Castillo de Santa Marinella, Italia (Castle of Santa Marinella, Italy)*
34. *Plaza de Dubrovnik, Yugoeslavia (Dubrovnik Square, Yugoslavia)*

October 26 - November 16, 1964

LUIS A. SOLARI OF URUGUAY: DRAWINGS, COLLAGES, AND ENGRAVINGS

Once again the Pan American Union has the pleasure of presenting for the first time in the United States the work of an artist of the generation currently coming to maturity in Latin America. Luis A. Solari is relatively little known, even in his native Uruguay. He was born in 1918 in the small city of Fray Bentos, and there he makes his

home today. He has, however, twice traveled in Europe—in 1952 and in 1961—and much of his youth was spent in Montevideo, where he received training at the Fine Arts Circle. Upon the completion of his studies he returned to his birthplace to take up the teaching of art in the local high school, and it is in Fray Bentos that he has produced his highly imaginative work, imbued with a courtly flavor which is perhaps imparted by the leisurely, old fashioned tenor of provincial life. He excels in the medium of collage, producing strange personages and figures that seem to have stepped from a fairy tale or materialized from a dream.

Solari has lectured extensively both at home and abroad and has participated in important group exhibits not only in Uruguay but in Argentina, Brazil, Mexico, Spain, and Switzerland. He has had more than twenty one-man shows in his native land since 1947; in 1961 he enjoyed individual presentation in Paris and last year received one in Pôrto Alegre, Brazil. The quality of his work has won for him some thirty prizes and other awards at salons and other exhibitions.

CATALOGUE

Monotypes and Drawings

1. *El oso y la dama (The Bear and the Maiden)*, 1950, monotype, 31 x 41 cm.
2. *Máscara del rebozo (Masked Figure with Shawl)*, 1950, monotype, 31 1/2 x 47 cm.
3. *Máscaras de pie (Upright Mask)*, 1950, monotype, 31 x 43 cm.
4. *Máscaras alegóricas (Allegorical Masks)*, 1950, monotype, 31 x 43 cm.
5. *El Rey Lengua (The Tongue King)*, 1950, monotype, 31 1/2 x 47 cm.
6. *Carroza y perros (Coach and Dogs)*, 1950, monotype, 30 x 38 1/2 cm.
7. *Dibujo alegórico (Allegorical Drawing)*, 1950, monotype, 42 x 53 cm.
8. *Minotauresa (Minotaur Lady)*, 1959, ink, 18 x 45 1/2 cm.
9. *Centauro (Centaur)*, 1959, ink, 51 x 42 cm.
10. *El minotauro y el globo (The Minotaur and the Sphere)*, 1959, ink, 40 1/2 x 52 cm.
11. *Dios Marte (The God Mars)*, 1959, ink, 24 x 31 cm.
12. *Quimera cabrona (The Quarrelsome Goat)*, 1959, ink, 23 x 32 cm.
13. *El pájaro blanco (The White Bird)*, 1959, ink, 59 x 80 cm.

Collages with Drawing

14. *Sota de oros (Knave of Gold)*, 1963, 80 x 100 cm.
15. *Figura para los siete pecados (Figure for the Seven Sins) I*, 1963, 60 x 85 cm.
16. *Figura para los siete pecados (Figure for the Seven Sins) II*, 1964, 60 x 80 cm.
17. *Tal vez dama (Perhaps a Maiden)*, 1964, 40 x 50 cm.
18. *Máscara con puñal (Mask with Knife)*, 1964, 46 x 56 cm.
19. *Otra con puñal (Another with Knife)*, 1964, 46 x 56 cm.
20. *The Griffin*

Collages

21. *Quimera retazo (Belligerent She-Monster)*, 1962, 45 x 66 cm.
22. *Guerrero (Warrior)*, 1962, 32 x 50 cm.
23. *Carretero de la muerte (Vehicle of Death)*, 1962, 33 1/2 x 58 1/2 cm.
24. *Galera florida (Flowered Top Hat)*, 1962, 50 x 66 cm.
25. *Casi payaso (Almost a Clown)*, 1962, 50 x 66 cm.
26. *Fantasmón (Phantom)*, 1963, 60 x 80 cm.
27. *El orador (The Orator)*, 1963, 40 x 50 cm.

28. *El cuco (The Cuckoo)*,[1] 1963, 44 x 54 cm.
29. *El gallo (The Rooster)*

November 17 - December 9, 1964

THE ARTIST AS PRINTMAKER IV: ENRIQUE GRAU OF COLOMBIA

The fourth in the series of exhibitions *The Artist as Printmaker* brings together the graphic work of Enrique Grau, one of the leading personalities in contemporary Colombian art. Grau is primarily a painter, and his activity in the media here presented has been of an episodic nature. It dates, in general, from three distinct periods: the first is that of his apprenticeship in New York, when he studied with Harry Sternberg, Morris Kantor, and George Grosz; the second is that of his sojourn in Italy, when he began to define and mature a personal form of expression; the third is represented by the current year, spent almost entirely in New York, where for lack of a suitable studio for painting Grau has returned to printmaking.

Grau was born in Cartagena, Colombia, in 1920. He studied first at the local School of Fine Arts and later at the National School in Bogotá. In 1941 he traveled to the United States and enrolled at the Art Students League in New York. Upon the completion of his studies he returned to his native country, serving as an instructor at the School of Fine Arts in the capital from 1949 to 1951. From 1952 to 1955 he was a member of the faculty of the University of the Andes, likewise in Bogotá, and at this time he was also active in set design for the stage and television. In 1953 Grau vacationed in Mexico, where contact with the artists of that country caused him to turn from works of soft, synthetic realism to ones characterized by forms of monumental intent. In 1956 he spent a year in Italy, where he engaged intensively in painting. From 1958 to 1960 he again served on the faculty of the School of Fine Arts in Bogotá.

Grau has frequently participated in biennials and group shows in Brazil, Colombia, Spain, and the United States. Those in the last mentioned country include the ones held at the Guggenheim Museum in New York, the Milwaukee Art Center, and the Houston Museum of Fine Arts. Grau has had numerous one-man shows of his work in Colombia. While in Italy he exhibited at the Galleria L'Asterisco in Rome, and in 1958 his painting was presented at the Pan American Union. That same year it was also on view at the Ronald de Aenlle Gallery in New York. It has won for him a number of major art prizes.

This current retrospective is the first presentation of Grau's activity in the printmaking area.

CATALOGUE

Graphics

1. *Yellow Nude*, 1942, silk screen, 8 1/2 x 9", 6 copies
2. *Green Nude*, 1942, silk screen, 8 1/2 x 16", 6 copies
3. *Angel*, 1942, etching, 7 x 10", 6 copies
4. *Arbol (Tree)*, 1942, etching, 6 x 7"
5. *Head*, 1942, lithograph, 8 1/4 x 10", 10 copies
6. *Esther*, 1942, lithograph, 12 x 12 1/4", 10 copies
7. *Cristo (Christ)*, 1943, silk screen and woodcut, 1 1/4 x 7 1/2", 6 copies
8. *Cristo (Christ)*, 1943, woodcut, 1 1/4 x 7 1/2", 12 copies

[1] Literal translation of this title is "The Bogeyman." —*Ed.*

9. *Cristo con espinas (Christ with Thorns)*, 1943, etching, 5 x 4", 6 copies
10. *Rest*, 1943, etching, 7 3/4 x 5 3/4", 6 copies
11. *Victim*, 1943, lithograph, 12 1/4 x 10 3/4", 10 copies
12. *Mujer con flor (Woman with Flower)*, 1945, woodcut, 7 1/2 x 11 1/2", 6 copies
13. *Niña con trenzas (Girl with Braids)*, 1945, woodcut, 7 1/4 x 10 1/2", 6 copies
14. *Profeta (Prophet)*, 1946, woodcut, 16 x 12 1/2", 6 copies
15. *Cristo con soldado (Christ with Soldier)*, 1946, woodcut, 16 x 12 1/2", 6 copies
16. *Muchacha (Girl)*, 1949, linoleum, 6 x 6 3/4", 14 copies
17. *La adivina (Fortune Teller)*, 1956, etching, 5 3/4 x 7 1/2", 12 copies
18. *Muchacho (Boy)*, 1956, etching, 5 3/4 x 8 1/4", 12 copies
19. *Prima colazione a Firenze (Breakfast in Florence)*, 1956, etching, 11 1/2 x 9 1/2", 12 copies
20. *Mujer con flor (Woman with Flower)*, second edition, 1964, woodcut, 7 1/2 x 11 1/2", 4 copies
21. *Niña con trenzas (Girl with Braids)*, second edition, 1964, woodcut, 7 1/4 x 10 1/2", 4 copies
22. *Profeta (Prophet)*, second edition, 1964, woodcut, 16 x 12 1/2", 4 copies
23. *Cristo con soldado (Christ with Soldier)*, second edition, 1964, woodcut, 16 x 12 1/2", 4 copies
24. *Angel*, second edition, 1964, etching, 7 x 10", 4 copies
25. *Arbol (Tree)*, 1964, etching, 6 x 7", 4 copies
26. *Cristo con espinas (Christ with Thorns)*, second edition, 1964, etching, 5 x 4", 4 copies
27. *Rest*, second edition, 1964, etching, 7 3/4 x 5 3/4", 6 copies
28. *La adivina (Fortune Teller)*, second edition, 1964, etching, 5 3/4 x 5 1/2", 5 copies
29. *Muchacho (Boy)*, second edition, 1964, etching, 5 3/4 x 8 1/4", 7 copies
30. *Prima colazione a Firenze (Breakfast in Florence)*, second edition, 1964, etching, 11 1/2 x 9 1/2", 8 copies

Las cuatro estaciones de la duquesa (The Four Seasons of the Duchess)

31. *La Duquesa (The Duchess)*, 1964, lithograph and watercolor, 16 x 20", 10 copies
32. *Primavera (Spring)*, 1964, lithograph and watercolor, 16 x 20", 10 copies
33. *Verano (Summer)*, 1964, lithograph and watercolor, 16 x 20", 10 copies
34. *Otoño (Autumn)*, 1964, lithograph and watercolor, 16 x 20", 10 copies
35. *Invierno (Winter)*, 1964, lithograph and watercolor, 10 copies, 16 x 20"

Mito de Pigmalión y Galatea (Myth of Pygmalion and Galatea)

36. *Teorema (Theorem)*, 1964, lithograph, 16 x 20", 11 copies
37. *Construcción (Construction)*, 1964, lithograph, 16 x 20", 11 copies
38. *Romance*, 1964, lithograph, 16 x 20", 11 copies
39. *Metamorfosis (Metamorphosis)*, 1964, lithograph, 16 x 20", 11 copies
40. *Still Life*, 1964, burin and aquatint, 7 x 5 1/4", 5 copies

Works printed at:

Arts Students League, New York City, no. 1-11, 24-27, and 40
Artist's atelier, Bogotá, no. 12-16, and 20-23
Academy of San Marco, Florence, Italy, no. 17-19, and 28-30
George C. Miller and Son, New York City, no. 31-39

November 17 - December 9, 1964

ANGEL LOOCHKARTT OF COLOMBIA: OILS

A new figurative trend, based upon an expressionist approach to subject matter, has recently taken on much

importance in Colombia. This trend has as its point of departure the work of the well-known painter Fernando Botero.

Angel Loochkartt is an exponent of the movement in the coastal city of Barranquilla. It was there that he was born in 1933 and that he attended art school from 1951 to 1955. In 1956 he undertook study at the Academy of San Giacomo, the Academy of Fine Arts, and the Arts and Crafts Center in Rome. Upon his return to Barranquilla he was appointed to the faculty of the local School of Fine Arts, of which he is currently director.

Loochkartt has held numerous one-man shows in his native country (Cartagena, 1959; Bogotá, 1959, 1962, and 1964; Barranquilla, 1961, 1962, and 1964), and he has enjoyed three individual presentations in Madrid, 1960, 1962, and 1964. He has participated in salons in Colombia, Italy, and the United States. This is the first exhibition of his work in the Washington area.

CATALOGUE

Oils, 1964

1. *La musa de Cocteau (The Muse of Cocteau)*, 45 x 80 cm.
2. *Fiora Giurissich*, 45 x 80 cm.
3. *Concierto barroco (Baroque Concert)*, 45 x 80 cm.
4. *Serenata a Rimbaud (Seranade to Rimbaud)*, 45 x 80 cm.
5. *Los sueños del Angel Miguel (The Dreams of Angel Michael)*, 45 x 80 cm.
6. *Catalina Max y su hermano (Catalina Max and Her Brother)*, 100 x 70 cm.
7. *De Rubens a mí (From Rubens to Me)*, 100 x 70 cm.
8. *Escuela vaticana (Vatican School)*, 45 x 80 cm.
9. *Homenaje a Adán y Eva (Homage to Adam and Eve)*, 45 x 80 cm.
10. *En la corte de Felipe el Hermoso (In the Court of Phillip the Handsome)*, 45 x 80 cm.
11. *Sobre el amor (About Love)*, 100 x 70 cm.
12. *Toritos (Little Bulls)*, 100 x 70 cm.

December 11, 1964 - January 5, 1965

A PANORAMA OF CUBAN ART ABROAD

Although the present Cuban government has been excluded from participation in the representative bodies of the Organization of American States, the Cubans continue to be an American people and to share in those ideals which have guided the course of history in the New World. As individuals of courage and conviction, Cuban painters and sculptors in exile are here given the opportunity to exhibit together work produced in that atmosphere of freedom which is essential to their spiritual self-realization as artists and as men. —*J.G-S.*

PARTICIPATING ARTISTS[1]

Sergio Alarcón
Wilfredo Alcover
Concha Barreto
Tomás Besosa

[1] The list of works exhibited is unavailable. —*Ed.*

Julio Crews
Manuel Delgado
Waldo Díaz Balart
José Luis Díaz de Villegas
Ramón Dorrego
Roberto Estopiñán
Gisela
Lourdes Gómez Franca
Sita Gómez de Kanelba
Ileana Govantes
Rolando Gutiérrez
Rolando López Dirube
Rosana McAllister
Alberto Menocal
Antonio Molina
Felipe Orlando
Jorge Pérez Castaño
Dionisio Perkins
Arnaldo Ravelo
José Miguel Rodríguez
Manuel Rodulfo Tardo
Baruj Salinas
Raúl San Miguel
Juan José Sicre
Gabriel Sorzano
Raúl Tapia

BIOGRAPHICAL NOTES[1]

ALARCON, Sergio. Sculptor, painter, born in Cuba, 1924. Exhibited in Cuba and the United States, where he presently lives.

ALCOVER, Wilfredo. Painter, draftsman, born in Havana, 1919. Self-taught as an artist. For twenty-four years worked as a technician at the Laboratorio de Anatomía Patológica, Instituto del Radium, Hospital Nuestra Señora de las Mercedes, Havana. Founder of the Asociación Cubana de Artes Plásticas en el Exilio, Miami, Florida, and its monthly magazine. Has illustrated many scientific books and magazines. Painted a collection of Cuban birds. Exhibited in Havana and Miami, where he has lived since 1961.

BESOSA, Tomás. Painter, born in Havana, 1936. Studied for a short period at the Escuela Nacional de Bellas Artes San Alejandro, Havana; Corcoran School of Art, Washington, D.C. Traveled in Europe, mainly Spain. Assisted the Argentine artist Vicente Forte in executing a mural in Maryland. Exhibited in the United States, where he presently lives.

DIAZ BALART, Waldo or BALART, Waldo. Painter, born in Banes, Oriente, Cuba, 1931. Studied business administration, University of Havana, with post-graduate studies at Villanueva University; and studied art, the Museum of Modern Art, New York, 1959-1962. Held individual exhibitions in New York and Paris. Participated in numerous group shows, including in Madrid, Barcelona, and New York, among other cities, and at the Museum of Fine Arts of Mexico. Has lived in the United States since 1959.

[1] Not included in the original catalogue. See Index of Artists for reference on those not listed here. —*Ed*.

DORREGO, Ramón. Painter, born in Cuba. His work has been exhibited in Cuba and abroad, including the Second Inter-American Biennial of Mexico, 1960.

GISELA (Gisela Valentina Hernández). Painter, draftsman, born in Matanzas, Cuba, 1922. Graduated from the School of Fine Arts, Matanzas. Later traveled to Mexico to study Aztec and Mayan art, and to the United States to study American art, 1948-49. Returned to Cuba where she worked as an art teacher for several years. Selected exhibitions include Dominican Republic, 1942; Albany Museum, New York, 1949; *Art Cubain Contemporain*, Musée National d'Art Moderne, Paris, 1951; Biennial of Spanish-American Art, Madrid, 1952. Lives in the United States.

GOMEZ FRANCA, Lourdes. Draftsman, poet, born in Cuba. Studied at the Escuela Nacional de Bellas Artes San Alejandro, Havana, 1953; with André Lhote and Stanley W. Hayter, Paris, 1957. Exhibited in Miami, where she lives and is a member of the Asociación Cubana de Artes Plásticas en el Exilio.

GOMEZ DE KANELBA, Sita. Painter, born in France, 1932. Cuban citizen. Studied at Parsons School of Design, New York. Exhibited in individual and group shows in New York, where she has lived since 1958.

GOVANTES, Ileana. Painter, muralist, draftsman, born in Havana. Graduated from the Escuela Nacional de Bellas Artes San Alejandro, Havana. Taught art at the University of Havana, 1954, where she also was the coordinating director of the Plastic Arts Section of the Fine Arts Department. Organized art exhibitions and festivals in Cuba. Executed numerous murals in public and private buildings in Havana. Has exhibited in Cuba and abroad. Has lived in Virginia since 1963.

McALLISTER, Rosana. Painter, born in Buenos Aires, Argentina. Studied drawing at the Municipal School and Mandelli Academy, Buenos Aires; watercolor at Alfredo Corengia Studio and with Z. Koslowsky, Buenos Aires; oil painting with Antonio Martínez Andrés and Félix Ramos, Havana; and at the University of Miami, Florida. Member of the Asociación Cubana de Artes Plásticas en el Exilio, Miami. Exhibited in Buenos Aires, Havana, and Miami. Lived in Cuba and is identified with the Cuban community in Miami, where she now lives in exile.

MENOCAL VILLALON, Alberto. Painter, born in Cuba. Exhibited individually and in group exhibitions in Havana, where he won a prize at the National Salon, 1956.

MOLINA, Antonio. Painter, muralist, draftsman, born in Sancti-Spiritus, Cuba, 1928. Studied business administration at the University of Havana. Considers himself a self-taught artist. Exhibited in individual and group shows in Havana. Lives in Puerto Rico.

PEREZ CASTAÑO, Jorge. Painter, muralist, graphic artist, ceramist, born in Havana, 1932. Studied with Víctor Manuel, Havana, 1956. Was professor of ceramics, Santiago de las Vegas, Cuba. Traveled to Paris under a Cuban scholarship, 1960. Has exhibited in individual and group shows in Havana since 1959, including *Exposición de Cerámica Cubana*, Palacio de Bellas Artes (1959) and the Second Inter-American Biennial, Mexico City, 1960. Was awarded a medal at the Salón del Círculo de Bellas Artes and Second Prize at the Salón de Bodas de Oro, El Arte, Havana, 1959. Has lived in Paris since 1960.

RAVELO, Arnaldo. Painter, draftsman, sculptor, ceramist, poet, born in Havana, 1928. Graduated in painting and drawing (1952), and in sculpture and drawing (1957), Escuela Nacional de Bellas Artes San Alejandro, Havana; studied ceramics, La Moncloa School of Ceramics, Madrid, 1958-59. Traveled to Madrid under a grant of the Instituto de Cultura Hispánica, 1958-60. Was professor of modeling, drawing, and art history, Havana, 1951-53; lecturer on art history in Cuba, Spain, and New York. Held individual exhibitions of paintings and ceramics in Cuba, New York, and Madrid. Participated in group shows in Cuba and abroad, including the exhibition of twenty-eight Cuban landscapists, inaugurated at the Círculo de Bellas Artes, Madrid, and circulating in Europe and Latin America, 1957-59. Was awarded a prize for Ceramics, Second Hispanic American Biennial, Havana, 1954.

Has lived in the United States since 1960.

SAN MIGUEL, Raúl. Painter, stage designer, born in Havana, 1932. Studied architecture in Havana. Self-taught as a painter. Started painting when very young, but devoted entirely to art in 1957. Exhibited in Cuba and abroad, including *Pintura Contemporânea em Cuba*, Museu de Arte Moderna of São Paulo (1960) and the Second Inter-American Biennial, Mexico, 1960.

SICRE, Juan José. Sculptor, born in Carlos Rojas, Matanzas, Cuba, 1898. Studied at the Fundación Aurelio Melero in Villate (1916) and Escuela Nacional de Bellas Artes San Alejandro (1918), Havana; under a Cuban scholarship, at the Escuela Superior de Bellas Artes San Fernando, Madrid, 1921-22, with Moreno Carbonero and Miguel Baly; Académie de la Grande Chaumière, Paris, 1923, under the direction of Emile Antoine Bourdelle; with José de Creeft, Paris, 1925; and with Trentacoste, Florence (Italy), where he lived two years. Returned to Cuba, 1927, and was appointed professor at the Escuela Nacional de Bellas Artes San Alejandro, Havana. Also taught at the Escuela de Bellas Artes in Caracas. Held individual exhibitions in Paris, Florence, and Cuba. Participated in numerous group exhibitions in Cuba and abroad, including Parisian art salons. Was awarded many prizes in Europe and Latin America. Lives in the United States.

SORZANO, Gabriel. Painter, draftsman, printmaker, sculptor, born in Cuba. Exhibited in individual and group shows in Cuba and Miami, where he now lives.

TAPIA, Raúl. Painter, born in Matanzas, Cuba, 1937. Studied sculpture and painting at Cornell University. Traveled in Europe. Held individual exhibitions in Havana, where he also participated in group shows. Was included in the Second Inter-American Biennial, Mexico, 1960. Lives in the United States.

INDEX OF ARTISTS

Due to the chronological format of this compilation of exhibitions, it was decided to list the date(s) of the exhibition(s) instead of page number(s) under each artist's entry. This approach increases the usefulness of this index, because it will allow the researcher to find exhibition dates without searching in the catalogue. Dates in *italics* indicate that information about the artist is included in the catalogue. Due to peculiarities of Spanish last names, alphabetizing of the entries was done by the first last name, followed by the first name; therefore, AGÜERO VERA, Raúl appears before AGÜERO SOSA, René.

ANDRADA, Elsa (Elsa Andrada de Torres, Uruguay, 1920-). Painter.
Feb.2/50.

ANDRES RIBEIRO, Maria Helena (Brazil, 1922-). Painter, draftsman.
Mar.17/61.

ANDREU DE BICARD, Lilian Cristina. See BICARD, Licry.

ANDUJAR, Juan Plutarco. See PLUTARCO, Juan Andújar.

ANGEL, Abraham (Mexico, 1905-1924). Painter, muralist.
Apr.18/60.

ANNA LETYCIA (Anna Letycia Quadros, b. Brazil, 1929-). Printmaker.
Mar.18/60.

ANTOINE, Montas (Haiti, 1926-). Painter.
Apr.15/63.

ANTONIO HENRIQUE. See AMARAL, Antônio Henrique.

ANTROBUS, Vivian (British Guiana, 19?-).
Feb.6/57.

ANTUNEZ, Carmen (Mexico, ?). Sculptress.
Apr.15/52.

ANTUNEZ, Nemesio (Chile, 1918-1993). Painter, draftsman, printmaker, illustrator, architect.
May 2/49; Nov.14/56; *Nov.21/62.*

ANZUETO, Julio César (Guatemala, 19?-). Photographer.
Oct.29/56.

ARAMBURU LECAROS, Helena (Peru, 1902-). Draftsman, painter, writer.
Mar.14/50.

ARANA, Alfonso (Puerto Rico, b. United States, 1927-). Painter, draftsman, printmaker.
Feb.6/57; *Mar.2/57.*

ARANA, Solange (Puerto Rico, ?).
Mar.2/57.

ARANIS, Graciela (Chile, 1905-). Painter, draftsman.
Jan.25/56.

ARAUJO, Crisójeno (Venezuela; 19?). Painter.
Feb.6/57.

ARBOLEDA, Alberto (Colombia, 1926-). Sculptor, ceramist.
Jun.21/60.

ARBOLEDA, Simón (Colombia, 1912-). Draftsman, caricaturist, foreign service officer.
Jun.6/50.

ARELLANO, Juan de (Spain, 1614-1676). Painter, engraver.
Feb.14/51.

ARIAS, Enrique (Cuba, 1918-). Painter, draftsman, caricaturist, musician.
Nov.19/57.

ARIZA, Gonzalo (Colombia, 1912-). Painter, draftsman, printmaker, illustrator, art critic.
Dec.1/49; *Jun.21/60.*

ARNAL, Enrique (Bolivia, 1932-). Painter, draftsman.
Apr.13/59.

ARP, Jean (France, 1887-1966). Sculptor, painter, poet.
Sep.20/57.

ASHER, Lila Oliver (United States, 1921-). Painter, printmaker, sculptress, draftsman.
Jul.8/53.

ASSELINEAU, Léon-Auguste (France, b. Germany, 1808-1889). Lithographer.
Aug.13/53.

ATELIERS SAINT VIATEUR, Les (Canada). Painting, sculpture, stained glass, and others.
Mar.21/56.

ATKYNS, Lee (Willie)(United States, 1913-). Painter, printmaker, illustrator.
Jul.8/53.

ATL, Dr. (Gerardo Murillo, Mexico 1875-1964). Painter, draftsman, writer, vulcanologist.
Sep.4/47; *Apr.18/60.*

AUGUSTE, Lily A. (St. Lucia, ?).
Feb.6/57.

AYZANOA, Alfredo (Peru, 1932-). Painter.
Dec.15/61.

BABAROVIC, Ivo (Chile, b. Argentina, 1924-). Painter, civil engineer.
Aug.7/57.

BADARACCO, Alberto (Curaçao, 19?-). Painter, architect.
Feb.6/57.

BADI, Aquiles (Argentina, 1894-1976). Painter, draftsman.
Jun.1/48.

BAKER, Sarah M. (United States, 1899-). Painter, printmaker.
Sep.1/48; Jul.1/49.

BALART, Waldo (Waldo Díaz Balart, b. Cuba, 1931-). Painter.
Dec.11/64.

BANDERAS, Héctor (Chile, 1903-). Painter, ceramist, illustrator, stained glass artist.
Jan.25/56.

BARAÑANO, Leonardo (Cuba, active mid-19th century). Draftsman.
Aug.13/53.

BARNES, Therold (Barbados, ?).
Feb.6/57.

BARRAGAN, Luis (Argentina, 1914-). Painter.
May 31/60.

BARREDA, Ernesto (Chile, b. France, 1927-). Painter, architect.
Nov.21/62.

BARREDO CARNEIRO, Mário Augusto de. See CARNEIRO, Mário Augusto de Barredo.

BARRETO, Concha (Cuba, ?). Painter.
Dec.11/64.

BARRINGTON, Patrick (British Guiana, ?).
Feb.6/57.

BARRIOS, Armando (Venezuela, 1920-). Painter.
Mar.12/54.

BARTLEY, Lloyd (Panama, 1915-). Painter.
Nov.12/53.

BASALDUA, Héctor (Argentina, 1895-1976). Painter, scenographer, illustrator.
Jun.1/48; Apr.4/61.

BASURCO, Alfredo (Alfredo González Basurco, Peru, 1926-). Painter, printmaker.
Dec.15/61.

BATLLE PLANAS, Juan (Argentina, b. Spain, 1911-1966). Painter, muralist, draftsman, printmaker, illustrator, stage designer.
May 31/60; Apr.4/61.

BAYOT, Adolph Jean Baptiste (France, b. Italy 1810-?). Painter, lithographer.
Aug.13/53.

BAZILE, Castera (Haiti, 1923-1965). Painter, muralist.
Feb.6/57.

BEAUGRAND, Gilles (Canada, ?). Goldsmith.
Mar.21/56.

BEDON, Fray Pedro (Ecuador, 1556-1621). Painter, draftsman, Dominican brother.
Dec.6/48.

BEEBE, Morton (United States, ?). Photographer.
Oct.28/63.

BEHRING, Edith (Brazil, 1916-). Printmaker, draftsman, painter.
Mar.18/60.

BELAIN, Fernando (Mexico, 1921-). Painter, draftsman, stage designer.
Aug.9/56.

BENACERRAF, Moisés F. (Venezuela, 1924-). Architect.
Sep.20/57.

BENITEZ, Isaac Leonardo (Panama, 1927-1968), Painter.
Nov.12/53.

BERDECIO, Roberto (Bolivia, 1913-). Painter, muralist, draftsman, printmaker.
Apr.14/53.

BERESTEIN, Julio (Julio López Berestein, Cuba, 1917-). Photographer, foreign service officer.
Mar.17/52.

BERMAN, Eugene (United States, b. Russia, 1899-1972). Painter, graphic artist.
Nov.19/51.

BERMUDEZ, Cundo (Cuba, 1914-). Painter, draftsman, printmaker.
Dec.1/46; *Apr.1/48*; *Aug.15/52*; Apr.13/59.

BERMUDEZ BRICEÑO, Guido (Venezuela, 1925-). Architect.
Sep.20/57.

BERMUDEZ, José Y. (Cuba, 1922-), Sculptor, painter, draftsman.
Apr.13/59; *Jan.29/62.*

BERNABO, Héctor J. See CARYBE.

BERNARDO, Mane (Argentina, 1913-). Painter, sculptress, printmaker, illustrator, stage designer, puppeteer, puppet designer, stage director.
Jun.1/48; *Feb.27/63.*

BERNI, Antonio (Argentina, 1905-1981). Painter, draftsman, printmaker, illustrator, scenographer.
Jun.1/48; *Apr.12/55.*

BERREDO CARNEIRO, Mário Augusto de. See CARNEIRO, Mário Augusto de Berrêdo.

BESOSA, Tomás (Cuba, 1936-). Painter.
Dec.11/64.

BESTARD, Jaime (Paraguay, 1892-1965). Painter, draftsman, sculptor, writer.
Apr.12/55.

BETETA, Ignacio M. (Mexico,1898-19?). Painter, draftsman, lieutenant general.
Oct.5/64.

BETTIOL, Zorávia (Brazil, 1935-). Painter, printmaker, draftsman, tapestry maker.
Apr.3/62.

BIGATTI, Alfredo (Argentina, 1898-1964). Sculptor, draftsman, printmaker.
Jun.1/48; *Oct.22/57*

BIGAUD, Wilson (Haiti, 1931-). Painter, muralist.
Feb.6/57.

BIRDSEYE LANG, Katharine. See LANG, Katharine Birdseye.

BLANCHARD, Pharamond (Henri Pierre Léon Pharamond Blanchard, France, 1805-1873). Painter, engraver.
Feb.14/51.

BLATTER, Jane Orcutt (United States, ?). Painter.
Dec.19/55.

BOCAYUVA MINDLIN, Vera (or Vera Bocayuva Cunha, b. Brazil, 1920-). Printmaker, painter.
Mar.18/60.

BOLTON, Mimi DuBois (United States, b. France, 1902-). Painter.
Jul.8/53.

BONDI, Freda Jardim. See FREDA.

BONEVARDI, Marcelo (Argentina, 1929-). Painter, draftsman, architect.
Aug.1/60.

BONILLA NORAT, Félix (Puerto Rico, 1912-). Painter, graphic artist.
Mar.2/57.

BONOME, Rodrigo (Argentina, 1906-). Painter, art critic.
Jun.1/48.

BONOMI, Maria (Brazil, b. Italy, 1935-). Printmaker, painter, set designer.
Jan.12/59; Mar.18/60.

BONTA, Marco A. (Chile, 1898-1974). Painter, muralist, draftsman, printmaker.
Jan.25/56.

BOOKATZ, Sam (Samuel Bookatz, United States, 1910-). Painter, sculptor.
Jul.8/53.

BORGES, Norah (Norah Borges de Torre, Argentina, 1901-). Painter, draftsman, illustrator, stage designer.
Jun.1/48; Apr.4/61.

BORNHORST, Dirk (?). Architect.
Sep.20/57.

BORNO, Maurice L. (Haiti, 1917-). Painter, draftsman, lawyer.
Feb.24/48; Feb.6/57.

BOTERO, Fernando (Colombia, 1932-). Painter, draftsman, sculptor.
Apr.17/57; Jun.21/60; Apr.13/62.

BOTTEX, Jean-Baptiste (Haiti, 1918-). Painter, sculptor.
Feb.24/48.

BOUCHER, Father Maximilien (Canada, 1918-). Sculptor.
Mar.21/56.

BOULTON, Alfredo (Venezuela, 1908-). Art critic and historian, photographer.
Jan.12/49.

BOUQUET. (Active 19th century). Engraver.
Aug.13/53.

BOWLES, John (England, active 18th century). Draftsman, engraver.
Aug.13/53.

BOWMAN, Alvin (British Guiana, ?).
Feb.6/57.

BRADLEY, Carolyn G. (United States, ? -1954). Painter.
Jun./45; Nov.12/47; Nov.19/51.

BRADLEY, John (United States, active 1836-1847). Painter.
Apr.15/63.

BRANDO, Carlos A. (Venezuela, 19?-). Architect.
Sep.20/57.

BRANDT, Alberto (Venezuela, 1924-1970). Painter, pianist.
May 21/63.

BRATHWAITE, Hubert (Barbados, 1930-). Painter, graphic artist.
Feb.6/57.

BRETTES, Joseph Gaston de (St. Lucia, ?).
Feb.6/57.

BRISBANE, Owen Douglas, Jr. (St. Vincent, ?).
Feb.6/57.

BROWN, Douglas (United States, 1904-). Painter.
Jul.1/49.

BROWN, Stanley (Suriname, ?).
Feb.6/57.

BROWNE, Franklin (St. Kitts, ?).
Feb.6/57.

BUCKNER, Melvin (United States, 1915-). Painter, designer.
Jul.8/53.

BUESO, Andrés (Puerto Rico, b. Mexico, 19?-). Graphic artist.
Mar.2/57.

BURCHARD EGGELING, Pablo (Chile, 1875-1964). Painter, architect.
Jan.25/56.

BURCHARD G., Pablo A. (Chile, 1919-). Painter, muralist, architect.
Apr.3/50; Apr.14/53; Nov.14/56.

BURCHARD, Pedro (Chile, 1922-). Painter, architect.
Nov.14/56.

BURGESS, Marguerite (United States, 1913-). Painter, printmaker, designer.
Jul.1/49.

BURGOS, Ralph de (United States, ?). Painter.
Jul.8/53.

BURGOS, Ramón (Venezuela, b. Chile, 19?-). Architect.
Sep.20/57.

BURLE MARX, Roberto (Brazil, 1909-1994). Painter, draftsman, architect, landscape designer.
May 18/54; Apr.12/55; Apr.13/59; Jan.29/62.

BUSSER, Dister (Chile, 19?-). Printmaker.
Jan.25/56.

BUSTAMANTE, E. (Cuba, ?). Painter.
Apr.15/63.

BUTLER, Father Guillermo (Juan Butler, Argentina, 1880-1961). Painter, Catholic priest.
Apr.20/47.

BUTLER, Horacio A. (Argentina, 1897-?). Painter, draftsman, illustrator, and tapestry, stage, and costume designer.
Apr.4/47; *Jun.1/48.*

BUTTAZZON (active in Italy around mid-19th century). Engraver.
Aug.13/53.

CABALLERO, Jorge (Chile, 1902-). Painter.
Jan.25/56.

CABEZON, Isaías (Chile, 1893-1963). Painter.
Jan.25/56.

CABRERA, Geles (Mexico, 1928-). Sculptress.
Aug.9/56.

CABRERA, Roberto (Guatemala, 1939-). Painter, draftsman, printmaker.
Oct.25/62.

CABRERA MORENO, Servando (Cuba, 1923-). Painter, draftsman.
Jan.12/59; Apr.13/59.

CACERES, Héctor (Chile, 1900-1980). Painter, draftsman.
Jan.25/56.

CACERES, Luis Alfredo (El Salvador, 1908-1952). Painter, draftsman.
Apr.4/47.

CAJAHUARINGA, Milner. See MILNER CAJAHUARINGA, José.

CAJIGAS, Luis Germán (Puerto Rico, 1934-). Painter, muralist, graphic artist.
Mar.2/57.

CALDER, Alexander (United States, 1898-1976). Sculptor.
Sep.20/57.

CALDERON, Constancia (Constance Calderón de Augrain, Panama, 1937-). Painter.
Sep.9/64.

CALFEE, William H. (United States, 1909-). Painter, muralist, sculptor.
Sep.1/48; Jul.1/49; Nov.19/51.

CAMACHO, Jorge (Cuba, 1934-). Painter, draftsman, printmaker.
May 15/58.

CAMARGO, Iberê (Brazil, 1914-1994). Painter, printmaker, draftsman.
Mar.2/59; *Mar.18/60.*

CAMERON, John (Scotland, ca.1828-?). Lithographer.
Aug.13/53.

CAMINO BRENT, Enrique (Peru, 1909-1960). Painter.
Oct.6/55.

CAMPBELL, Ralph (Jamaica, 1921-). Painter.
Feb. 6/57.

CAMPILLO, J. (Mexico, active 19th century). Draftsman.
Aug.13/53.

CAMPS, Pedro (Mexico, ?). Photographer.
Jan.12/49.

CANDHALES, Dándolo Rodríguez (Dándolo Hordeñana) (Uruguay, 1917-). Painter, draftsman, soccer-player.
May 1/63.

CANOT, C. (?). Engraver.
Aug.13/53.

CANTU, Federico (Mexico, 1908-). Painter, muralist, draftsman, printmaker, sculptor, stained glass artist.
Sep.4/47; *Dec.5/49.*

CAPDEPONT, Lucía (Lucía Capdepont de Butler, Argentina, 1899-?). Painter, draftsman.
Jun.1/48.

CAPRISTO, Oscar (Argentina, 1921-). Painter, muralist, printmaker, illustrator, stage designer.
Dec.12/63.

CARACCI, José (Chile, b. Italy, 1887-1979). Painter, draftsman.
Jan.25/56.

CARBONELL, Diego (Venezuela, 19?-). Architect.
Sep.20/57.

CARDENAL, Father Ernesto (Nicaragua, 1925-). Sculptor, poet, writer, Catholic priest.
Feb.14/57.

CARDOZA TORRES, Francisco Gilberto. See GIL.

CARMELO (Carmelo González, Cuba, 1920-). Painter, draftsman, printmaker.
Dec.1/46.

CARNEIRO, Edíria (Brazil, 1925-). Printmaker, draftsman.
Apr.3/62.

CARNEIRO, Mário Augusto de Berrêdo (Brazil, 1930-). Painter, draftsman, printmaker, photographer, architect.
Mar.18/60.

CARNELLI, Walter T. (United States, ?). Draftsman.
Jul.1/49.

CARNICERO, Antonio (Spain, 1748-1814). Painter, engraver, etcher.
Feb.14/51.

CARO, Manuel (Mexico, 1761-1820). Painter.
Dec.6/48.

CARPI TURNIER, Luce. See TURNIER, Luce Carpi.

CARPIO, Oscar (Venezuela, 19?-). Architect.
Sep.20/57.

CARREÑO, Mario (Chile, b. Cuba, 1913-). Painter, draftsman, muralist, illustrator.
Dec.1/46; *Apr.4/47*; *Aug.15/52*; Apr.13/59; Jan.29/62.

CARRILLO, Lilia (Mexico, 1929-1974). Painter, draftsman, printmaker.
Mar.2/60; Apr.18/60.

CARRILLO, Manuel (Mexico, 1906-). Photographer.
Jun.19/62.

CARRINGTON, Omar R. (United States, 1904-). Painter, printmaker, illustrator.
Jul.8/53.

CARVACHO, Víctor (Chile, 1916-). Painter, art critic.
Dec.19/57.

CARVALHO, Luiz Woods de (Brazil 1935-). Painter.
Dec.18/62.

CARVALLO, Feliciano (Venezuela, 1920-). Painter.
Apr.15/63.

CARYBE (Héctor Julio Bernabó, Brazil, b. Argentina, 1911-). Painter, draftsman, printmaker.
Jun.1/48; *Oct.16/58*; Apr.13/59; Jun.28/61.

CASAS ARMENGOL, Miguel (Venezuela, 19?-). Architect.
Sep.20/57.

CASTAGNA, Rodolfo (Argentina, 1910-). Painter, printmaker, illustrator.
Sep.23/46; Apr.4/61.

CASTAGNINO, Juan Carlos (Argentina, 1908-1972). Painter, draftsman, muralist, illustrator, architect.
Jun.1/48; Apr.13/59; *May 31/60.*

CASTILLO, Carlos Aitor (Peru, 1913-). Painter, draftsman, stage designer, art critic.
Jul.29/64.

CASTILLO, José (Mexico, ?). Painter.
Apr.18/60.

CASTILLO, Luis (Cuba, 1935-). Graphic artist, caricaturist, cartoonist.
Nov.19/57.

CASTILLO, Sergio (Chile, 1925-). Sculptor.
Nov.28/62.

CASTRO TAGLE, Augusto de. See TAGLE, Augusto de Castro.

CASTRO, Casimiro (Mexico, active 19th century). Lithographer.
Aug.13/53.

CASTRO-CID, Enrique (Chile, 1937-). Painter, draftsman.
Jul.24/61.

CASTRO DE VELASCO, Palomino. See PALOMINO DE CASTRO Y VELASCO, Acisclo Antonio.

CAVALCANTI, Emiliano Di (Brazil, 1897-1976). Painter, draftsman, caricaturist, illustrator.
Apr.12/55.

CAVALCANTI, Freda Jardim. See FREDA.

CAVIGIOLI, Florence (British Guiana, ?).
Feb.6/57.

CEDEÑO, Juan Manuel (Panama, 1916-). Painter.
Nov.12/53.

CENTURION, Emilio (Argentina, 1894-1970). Painter, muralist, illustrator.
Apr.4/61.

CENTURION, Luis (Argentina, 1922-). Painter, draftsman.
May 31/60.

CHAB, Víctor (Argentina, 1930-). Painter, printmaker.
May 31/60; Jan.28/64.

CHAMBI, Martín (Peru, ?). Photographer.
Jan.12/49.

CHANG, Carlisle Fenwick (Trinidad and Tobago, 1921-). Painter, muralist, photographer, set and costume designer, dancer.
Feb.6/57.

CHARLES, Rosemary (Grenada, ?).
Feb.6/57.

CHARLOT, Jean (Mexico, b. France, 1898-1979). Painter, muralist, draftsman, printmaker, illustrator.
Sep.4/47.

CHARUET (Canada, ?).
Mar.21/56.

CHAVARITO, Domingo (Spain, 1676-1750). Painter, engraver.
Feb.14/51.

CHAVES, João Luiz (Brazil, 1921-). Printmaker, painter.
Mar.18/60.

CHIAPPINI, Jean (Haiti, b. Dominican Republic, 1922-). Painter.
Apr.15/63.

CHIÑAS, Joaquín (Mexico, 1923-). Draftsman, seaman, gardener, carpenter.
Mar.18/59.

CLARK, Lygia (Brazil, 1920-1988). Sculptress, painter.
Jul.8/63.

CLARKE, Briggs A. (Barbados, 1905-). Painter, draftsman.
Feb.6/57.

CLAUSELL, Joaquín (Mexico, 1866-1935). Painter, lawyer.
Apr.18/60.

CLAYTON, Alexander (United States, ?). Painter.
Jul.1/49.

CODALLO, Alfredo (Trinidad and Tobago, 19?-). Painter, draftsman.
Feb.6/57.

COLOMBO, Francisco (Argentina, 1878-1953). Book printer, founder of Colombo Press.
Apr.4/61.

COLOMBO, Ismael (Argentina, 19 ?). Book printer.
Apr.4/61.

COLOMBO, Osvaldo (Argentina, 19 ?). Book printer.
Apr.4/61.

COLSON, Jaime (Jaime González Colson, Dominican Republic, 1901-1975). Painter, draftsman, printmaker.
Apr.4/47.

COMBARIZA, Guillermo (Costa Rica, b. Colombia, 1924-). Painter, draftsman.
Jan.10/64.

CONDE, Raúl (Mexico, ?). Photographer.
Jan.12/49.

CONNELL, Harold C. (Barbados, ?).
Feb.6/57.

CONOVER, Alida (United States, ?). Painter, draftsman.
Jul.1/49.

CONSUEGRA, Hugo (Cuba, 1929-). Painter, draftsman, printmaker, architect.
May 21/56; Apr.13/59.

COOPER, George Victor (United States, 1810-1878). Painter, draftsman, sculptor, lithographer, illustrator.
Aug.13/53.

COPPOLA, Grete (Argentina, ?). Photographer.
Jun.1/48.

CORBEIL, Father Wilfrid (Canada, 1893- ?). Painter, sculptor.
Mar.21/56.

CORI, Isi (Chile, 1898-?). Painter.
Nov.14/56.

CORTES, Ana (Chile, 1906-). Painter, printmaker.
Jan.25/56.

COZIER, E.L. (St. Lucia, ?).
Feb.6/57.

CRAVO, Mário (Brazil, 1923-). Sculptor, painter, draftsman, printmaker.
Jul.8/63.

CREWS, Julio (Cuba, 19?-).
Dec.11/64.

CRISTI, Ximena (Chile, 1920-). Painter, draftsman, printmaker.
Jan.25/56.

CROES MICHELENA, René (Venezuela, ?).
Feb.6/57.

CROMWELL, Joseph (Trinidad and Tobago, 19?-). Painter.
Feb.6/57.

CRUCET, Enrique (Cuba, 1895-?). Painter.
May 20/52.

CRUZ, José A. See PECRUZ.

CRUZAT, Jorge (Chile,19 ?-). Painter, printmaker.
Jan.25/56.

CUADROS, Miguel Angel (Peru, 1928-). Painter, draftsman.
Dec.15/61.

CUATRECASAS, Gil (United States, b. Spain, 1935-). Painter.
May 21/64.

CUEVAS, José Luis (Mexico, 1933-). Draftsman, printmaker, illustrator.
Jul.14/54; Apr.13/59; Apr.18/60; Jun.28/61; Apr.13/62; *Jul.16/63*.

CUNHA, Vera Bocayuva. See BOCAYUVA MINDLIN, Vera.

CUTULI, Gracia (Argentina, 1937-). Tapestry designer and weaver.
May 4/64.

CUVILLIER (France, active 19th century). Lithographer.
Aug.13/53.

DAMIANI, Jorge (Uruguay, b. Italy, 1931-). Painter, draftsman.
Jun.5/61.

DANIEL, Albert E. (St. Thomas, ?).
Feb.6/57.

DAOUST, Sylvia (Canada, 1902-). Sculptress.
Mar.21/56.

DAUMONT (France, ?).
Aug.13/53.

DAVID, Juan (Cuba, 1911-). Draftsman, caricaturist.
Nov.19/57.

DAVILA, Alberto (Peru, 1912-). Painter.
Jun.21/57.

DAVIS, Gene (United States, 1920-). Painter.
May 21/64.

DEBRAY (?). Lithographer.
Aug.13/53.

DECKER, Alice (United States, 1901-). Sculptress.
Jul.1/49.

DEERY DE PHELPS, Kathleen. See PHELPS, Kathleen Deery de.

DEIRA, Ernesto (Argentina, 1928-1986). Painter, draftsman, lawyer.
May 4/64.

DELGADO, Manuel (Cuba, 19?-).
Dec.11/64.

DEMPSEY, Richard Williams (United States, 1909-). Painter.
Nov.19/51.

DEROI (Active 19th century). Lithographer.
Aug.13/53.

DIAGO, Roberto (Cuba, 1920-1955). Painter, draftsman, printmaker, illustrator.
Dec.1/46; *Aug.15/52; Sep.17/53*.

DIAZ, Irma (Mexico, 19?-). Sculptress.
Jul.6/55.

DIAZ DE VILLEGAS, José Luis (Cuba, 1925-). Draftsman, painter, caricaturist, cartoonist, civil engineer.
Nov.19/57; Dec.11/64.

DIAZ, Julia (El Salvador, 1917-). Painter.
May 21/57.

DIAZ, Miguel Salvador (Venezuela, 19?-). Architect.
Sep.20/57.

DIAZ BALART, Waldo. See BALART, Waldo.

DIOMEDE, Miguel (Argentina, 1902-1974). Painter.
Jul.14/59.

DIRUBE, Rolando. See LOPEZ DIRUBE, Rolando

DJANIRA (Djanira Gomes Pereira or Djanira da Motta e Silva, Brazil, 1914-1978). Painter, draftsman, printmaker, illustrator, tapestry designer.
Jan.6/47.

DOMINGO, Casimiro (Argentina, b. Spain, 1882-19?-). Painter, shoemaker.
Apr.15/63.

DOMINGUEZ, Cipriano (Venezuela, 1904-). Architect, civil engineer.
Sep.20/57.

DOMINGUEZ NEIRA, Pedro (Argentina, 1894-1970). Painter.
Jun.1/48.

DONNA, Federico (Paraguay, ?). Photographer.
Jan.12/49.

DONOSO, Eduardo (Chile, 1902-). Painter.
Jan.25/56.

DORREGO, Ramón (Cuba, 19?-). Painter.
Dec.11/64.

DOSAMANTES, Francisco (Mexico, 1911-). Painter, muralist, draftsman, printmaker.
Sep.4/47; *Jan.19/48*.

DOUGLAS, Laura Glenn (United States, 1896-?). Painter, draftsman, decorator.
Jul.1/49.

DOWNING, Tom (Thomas Downing, United States, 1928-). Painter.
May 21/64.

DUFFAUT, Préfète (Haiti, 1923-). Painter, muralist, poet.
Apr.15/63.

DULIN, J.D. (France, 1839-1919). Draftsman, lithographer, cartographer.
Aug.13/53.

DUNN, Charles (United States, 1895-). Painter.
Jul.8/53.

DUPOND, Marcel (Canada, ?). Painter.
Mar.21/56.

DUPUY, Carlos (Venezuela, 19?-). Architect.
Sep.20/57.

DURNFORD, Elias (?). Draftsman, engineer.
Aug.13/53.

DURUY, Jean Alexandre (France, active 19th century). Lithographer.
Aug.13/53.

DUTARY, Alberto (Panama, 1932-). Painter, draftsman.
Jan.9/61; Apr.13/62.

DUTTENHOFER, Christian Friedrich (Germany, 1778-1846). Engraver.
Aug.13/53.

ECHAVE, José (Uruguay, 1921-). Painter, stage and costume designer.
Jul.10/56.

ECHEVERRIA, Enrique (Mexico, 1923-1972). Painter, draftsman.
Jul.6/55.

ECKEL, Julia (United States, ?). Painter.
Jul.1/49.

EDGERTON, Bob (Honduras, ?). Photographer.
Jan.18/50.

EGUILUZ, Augusto (Chile, 1893-1969). Painter.
Jan.25/56.

ELAS REYES, Raúl (El Salvador, 1918-). Painter, muralist.
May 21/57.

ELESKA, Elena (Bolivia, b. Austria, U.S. citizen). Painter, designer, anthropologist.
Apr.2/63.

ELIAS, Maxim (United States, ?). Sculptor.
Jul.1/49.

ELLIOTT, Jorge (Chile, 1916-). Painter, writer, theater director.
Jan.25/56.

ELLIS, Robert C. (United States, 1925-). Painter.
Dec.19/55.

ENDICOTT, G. & W. (George Endicott, United States, 1802-1842; William Endicott, United States, 1816-1851). Lithographers.
Aug.13/53.

ENGELMANN, Godefroi (France, 1788-1839). Painter, lithographer.
Aug.13/53.

ENGELS, Lucila (Curaçao, 1920-). Painter, sculptress.
Feb.6/57.

ENGLAND, Paul (United States, 1918-). Painter, sculptor, writer.
Nov.19/51.

ENRIQUEZ, Carlos (Cuba, 1901-1957). Painter, muralist, draftsman, writer, engineer.
Dec.1/46; *Apr.14/53.*

ESCALERA, José Nicolás de la (Cuba, 1734-1804). Painter.
Apr.12/55.

ESCAMEZ, Julio (Chile, 1926-). Painter, muralist, draftsman, printmaker.
Jan.25/56.

ESCOBAR, Estela (Colombia, ?). Painter.
Dec.1/49.

ESCOFFERY, Gloria (Jamaica, 1923-). Painter, art teacher, journalist.
Feb.6/57.

ESCOTE, Ricardo (Argentina, 1912-). Painter, decorative and industrial designer.
Jun.23/52.

ESTOPIÑAN, Roberto (Cuba, 1921-). Sculptor.
Dec.11/64.

ESTRADA DISCUA, Raúl (Honduras, 19?-). Photographer.
Jan.18/50.

EVANS FERREL, Lucile (United States, 1894-?). Painter, draftsman, printmaker.
Jul.1/49.

FARINA, Ernesto (Argentina, 1912-). Painter.
Nov.21/62.

FAVERY, A. (Suriname, 1905-19 ?). Painter.
Feb.6/57.

FAZ, Carlos (Chile, 1931-1953). Painter, printmaker.
Mar.16/53.

FELGUEREZ, Manuel (Mexico, 1928-). Painter, sculptor.
Mar.2/60; Apr.18/60.

FENDERICH, Charles (United States, b. Germany, 1815-1870). Painter, draftsman, lithographer.
Aug.13/53.

FERNANDEZ MEDEROS, Agustín (Cuba, 1928-). Painter, printmaker.
Apr.20/54.

FERNANDEZ DE HERRERA, Carmen. See LAGUARDIA.

FERNANDEZ MURO, José Antonio (Argentina, b. Spain, 1920-). Painter,
Jan.14/57; *Nov.21/62.*

FERNANDEZ, Lola (Costa Rica, b. Colombia, 1926-). Painter, tapestry designer.
Jan.10/64.

FERNANDEZ, Simón (Venezuela, 19?-). Architect.
Sep.20/57.

FERREL, Lucile Evans. See EVANS FERREL, Lucile.

FERRER GOVANTES, Ileana. See GOVANTES, Ileana.

FERRIS, Julián (Venezuela, 1921-). Architect.
Sep.20/57.

FERRY, Frances (United States, ?). Draftsman.
Jul.1/49.

FIELD, Joyce (United States, ?). Painter.
Jul.8/53.

FIERRO, Pancho (Peru, 1803-1879). Painter, draftsman.
Feb.14/51.

FIGARI, Pedro (Uruguay, 1861-1938). Painter.
Sep.3/46; Apr.4/47; Apr.14/53; Apr.12/55.

FIGUEROA, Gabriel (Mexico, 1907-). Photographer, cameraman.
May 1/50.

FINN, Gloria (United States, 19 ?-). Tapestry designer and weaver.
Jan.29/62.

FIORAVANTI, José (Argentina, 1896- ?). Sculptor.
Apr.12/55.

FONSECA, Gonzalo (Uruguay. 1922-). Painter, muralist, draftsman, sculptor, architect.
Feb.2/50.

FONSECA MORA, Harold (Costa Rica, 1920-). Painter, draftsman, agricultural engineer.
Jan.10/64.

FONTANILLAS, Silvio (Cuba, 1913-). Caricaturist.
Nov.19/57.

FORNER, Raquel (Argentina, 1902-1988). Painter, draftsman, printmaker.
Jun.1/48; Apr.14/53; *Oct.22/57*; Apr.13/59; *Nov.21/62.*

FORTE, Vicente (Argentina, 1912-1980). Painter, printmaker.
May 31/60; *Mar.12/62.*

FORTUNY, Mariano (Mariano José María Bernardo Fortuny y Carbó, b. Spain, 1838-1874). Painter, engraver.
Feb.14/51.

FRASCONI, Antonio (Uruguay, b. Argentina, 1919-). Painter, printmaker.
Feb.16/49.

FREDA (Freda Jardim Bondi or Freda Jardim Cavalcanti, Brazil, 1930-). Mosaic artist, ceramist, tapestry weaver.
Sep.3/63.

FREITAS, Albert de (British Guiana, ?).
Feb.6/57.

FRESQUET BRAÑA, Lázaro (Cuba, 1931-). Painter, draftsman, caricaturist, cartoonist, stage designer, writer.
Nov.19/57.

FRIEDEBERG, Pedro (Mexico, b. Italy, 1937-). Painter, draftsman, graphic artist, sculptor, architect.
Oct.1/63.

FRIEDRICS, A. (Paraguay, ?). Photographer.
Jan.12/49.

FRUHAUF, Aline (United States, 1907-). Printmaker.
Jul.1/49.

FUENTE, Gregorio de la (Chile, 1910-). Painter, muralist.
Jan.25/56.

FUENTES PONS, Alfredo. See PONCE DE LEON, Fidelio.

FUENZALIDA, Graciela (Chile, 1916-). Draftsman, printmaker, sculptress.
Jan.25/56.

FUMAGALLI (Active 19th century). Engraver.
Aug.13/53.

GADBOIS, Loise (Canada,1896-?). Painter.
Mar.21/56.

GALDOS RIVAS, Enrique (Peru, 1933-). Painter, draftsman, printmaker.
Dec.15/61.

GALIA, José Miguel (Venezuela, b. Uruguay, 1919-). Architect.
Sep.20/57.

GALLINATO, René (Chile, ?). Printmaker.
Jan.25/56.

GALLOWAY, John C. (United States, 1915-). Painter, draftsman.
Sep.1/48; Jul.1/49.

GAMARRA, José (Uruguay, 1934-). Painter, printmaker.
Nov.21/62.

GAMBARTES, Leónidas (Argentina, 1909-1963). Painter.
Nov.21/62.

GAMBINO, Pascual (Chile, b. Uruguay, 1891- ?). Painter, draftsman, printmaker.
Jan.25/56.

GARAFULIC, Lily (Chile, 1914-). Sculptress, printmaker.
Jan.25/56.

GARAVAGLIA, Florencio (Argentina, 1916-). Painter.
Jan.9/62.

GARAVITO, Humberto (Guatemala, 1897-?). Painter.
Oct.1/48.

GARCIA TERMINELL, David (Cuba, 1921-). Caricaturist.
Nov.19/57.

GARCIA, Delfino (Mexico, 1915-). Painter.
Sep.4/47.

GARCIA NAREZO, José (Mexico, b. Spain, 1922-). Painter, draftsman, illustrator.
Sep.13/50.

GARCIA CAMBIER, Liliana (Dominican Republic, 1929-). Painter.
Feb.6/57.

GARCIA, Manuel. See VICTOR MANUEL.

GARCIA, Víctor Manuel. See VICTOR MANUEL.

GARFIAS, Gabriela (Chile, 1921-). Painter.
Nov.14/56.

GASOMER, G. (United States, 1811-1861). Painter.
Apr.15/63.

GATES, Margaret Casey (United States, ?). Painter, draftsman.
Jul.1/49.

GATES, Robert F. (United States, 1906-). Painter, draftsman.
Sep.1/48; *Jul.1/49.*

GAVIDIA CAMPOS, Dante (Peru, 1927-). Painter, draftsman, printmaker.
Dec.15/61.

GEIJSKES, D.C. (Suriname, 19?-).
Feb.6/57.

GERARD, George H. (United States, ?). Photographer, writer, interpreter.
Dec.29/53.

GERSHOY, Eugenie (United States, b. Russia, 1905-). Painter, sculptor, printmaker.
Nov.19/51.

GERSTEIN, Noemí (Argentina, 1910-). Sculptress.
Dec.9/60.

GIESE, Harold (United States, ?). Painter.
Jul.1/49.

GIGOUX, Byron (Chile, 1900-). Painter, journalist, writer.
Nov.14/56.

GILLIAM, Sam (United States, 1933-). Painter.
May 21/64.

GIRONA, Julio (Cuba, 1914-). Painter, sculptor, draftsman.
Dec.1/46.

GIRONELLA, Alberto (Mexico, 1929-). Painter, draftsman, printmaker, illustrator.
Mar.18/59; Apr.13/59; Apr.18/60.

GISELA (Gisela Valentina Hernández, Cuba, 1922-). Painter, draftsman.
Dec.11/64.

GIUDICELLI, Paul (Dominican Republic, 1921-1965). Painter, muralist, draftsman, ceramist.
Feb.6/57.

GOELDI, Oswaldo (Brazil, 1895-1961). Printmaker.
Mar.18/60.

GOMES PEREIRA, Djanira. See DJANIRA.

GOMEZ MAYORGA, Guillermo. (Mexico, 1890-1962). Painter, muralist, draftsman, printmaker.
Apr.18/60.

GOMEZ JARAMILLO, Ignacio (Colombia, 1910-1970). Painter, muralist, draftsman, printmaker.
Dec.12/56; Jun.21/60.

GOMEZ FRANCA, Lourdes (Cuba, 1933-). Draftsman, poet.
Dec.11/64.

GOMEZ, Manuel Vicente (Venezuela, 1918-). Painter.
Feb.6/57.

GOMEZ, Nel. See NEL GOMEZ, Pedro.

GOMEZ CORNET, Ramón (Argentina, 1898-1964). Painter, draftsman, printmaker.
May 31/60.

GOMEZ DIAZ, Sara (Argentina, ?). Tapestry weaver.
May 4/64.

GOMEZ DE KANELBA, Sita (Cuba, b. France, 1932-). Painter.
Dec.11/64.

GONÇALVES, Danubio Vilamil (Brazil, 1925-). Printmaker.
Apr.3/62.

GONGORA, Leonel (Colombia, 1932-). Painter, draftsman, printmaker.
Oct.8/62.

GONZALEZ SALAZAR (Peru, ?). Photographer.
Jan.12/49.

GONZALEZ BASURCO, Alfredo. See BASURCO, Alfredo.

GONZALEZ, Carlos (Mexico, ?). Painter.
Sep.4/47.

GONZALEZ, Carmelo. See CARMELO.

GONZALEZ, Hernán (Costa Rica, 1918-). Sculptor.
Jan.10/64.

GONZALEZ COLSON, Jaime. See COLSON, Jaime.

GONZALEZ, Juan Francisco (Chile, 1853-1933). Painter.
Jan.25/56.

GONZALEZ GOYRI, Roberto (Guatemala, 1924-). Painter, muralist, draftsman, sculptor.
Jun.5/51.

GOODNOUGH, Robert (United States, 1917-). Painter.
Jan.29/62.

GORDON VARGAS, Arturo (Chile, 1883-1944). Painter, illustrator.
Jan.25/56.

GOURGUE, Enguerrand (Haiti, 1930-). Painter, draftsman.
Feb.6/57.

GOVANTES, Ileana (Ileana Ferrer Govantes, Cuba, 19?-). Painter, muralist, draftsman.
Dec.11/64.

GOYA Y LUCIENTES, Francisco de (Spain, 1746-1828). Painter, draftsman, printmaker.
Feb.14/51.

GRAMCKO, Elsa (Venezuela, 1925-). Painter, sculptress.
May 13/59.

GRANADA, Carlos (Colombia, 1933-). Painter, draftsman.
Apr.13/62; *Jun.12/62.*

GRASSMANN, Marcelo (Brazil, 1925-). Draftsman, printmaker.
Apr.13/59; *Jul.12/60*; Jun.28/61.

GRAU, Enrique (Colombia, 1920-). Painter, draftsman, printmaker, illustrator, stage designer.
Mar.14/58; Apr.13/59; Jun.21/60; *Nov.17/64.*

GRAU, Ricardo (Peru, b. France, 1908-). Painter.
Oct.2/60.

GREEN, Cynthia (United States, ?). Painter.
Dec.19/55.

GREENFIELD, Albert (United States, 1906-). Photographer, painter.
Dec.22/52.

GREGORIO, Eduardo (Venezuela, b. Spain, 1904-). Ceramist.
Aug.15/63.

GREGORY, Ruth M. (St. Croix, ?).
Feb.6/57.

GRIFASI, Alfio (Argentina, 1927-). Painter.
Nov.21/62.

GRIFFITH, Cynric (St. Kitts, ?).
Feb.6/57.

GRILO, Sarah (Argentina, 1920-). Painter, draftsman.
Jan.14/57.

GRYPINICH, Louis (Canada, ?).
Mar.21/56.

GUAYASAMIN, Oswaldo (Ecuador, 1919-). Painter, muralist, draftsman, printmaker.
Jun.6/55.

GUERRERO GALVAN, Jesús (Mexico, 1910-1973). Painter, muralist, draftsman, printmaker.
Apr.18/60.

GUERRERO, Xavier (Mexico, 1898-1974). Painter, muralist, draftsman, printmaker.
Sep.4/47.

GUEVARA, Laureano (Chile, 1889-1968). Painter, muralist, draftsman.
Jan.25/56.

GUEVARA, Susana (Susana Guevara de Mueller, Chile, 1896-?). Painter, printmaker.
Jul.15/52.

GUILLEN M., A. (Peru, ?). Photographer.
Jan.12/49.

GUILLEN, Asilia (Nicaragua, 1887-1964). Painter, embroiderer.
Feb.14/57; *Jun.29/62*; Apr.15/63.

GUINAND BALDO, Carlos (Venezuela, 19?-). Architect.
Sep.20/57.

GURVICH, José (Zusmanas Gurvicius Galperaites, Uruguay, b. Lithuania, 1927-). Painter.
Feb.2/50.

GUSTON, Philip (United States, b. Canada, 1913-1980). Painter.
Apr.12/55.

GUTIERREZ, Osvaldo (Cuba, 1917-). Painter.
Dec.1/46.

GUTIERREZ, Rolando (Cuba, 1919-). Sculptor, graphic artist.
Dec.11/64.

GUTIERREZ, Sérvulo (Peru, 1914-1961). Painter, sculptor, boxer.
Jun.21/57.

GUZMAN REYES, Luis (Chile, 1914-). Sculptor, ceramist, painter.
Aug.18/64.

HALEGUA, Alfredo (Uruguay, 1930-). Sculptor.
Sep.10/62.

HALTY DUBE, Adolfo (Uruguay, 1915-). Painter, illustrator, stage and costume designer, architect.
Nov.21/52.

HARTLEY, Elaine (United States, ?). Painter.
Jul.8/53.

HASENCLEVER, Arnold (United States, b. Germany, 1908-). Photographer, actor, documentary film maker.
Jul.9/51.

HASSAM, Childe (United States, 1859-1935). Painter, printmaker, illustrator.
Apr.12/55.

HAWEIS, Stephen (Dominica, ?).
Feb.6/57.

HAYLING, George N. (Grenada, ?).
Feb.6/57.

HEDIN, Arvid (United States, ?). Painter.
Jul.8/53.

HENDRICKS, Ana (Jamaica, 19?-).
Feb.6/57.

HENRIQUE ANTONIO. See AMARAL, Antônio Henrique.

HENRY, E.T. (Antigua, ?).
Feb.6/57.

HERMAN, Samuel (United States, ?). Painter.
Dec.19/55.

HERMANSEN, Emilio (Chile, 1919-). Painter.
Nov.14/56.

HERMOSILLA, Carlos (Chile, 1905-). Painter, draftsman, printmaker, poet.
Jan.25/56.

HERNANDEZ RIOS, Anhelo (Uruguay, 1922-). Painter, muralist, draftsman, printmaker.
Feb.2/50.

HERNANDEZ ORTEGA, Gilberto (Dominican Republic, 1924-). Painter.
Apr.14/53.

HERNANDEZ, Gisela Valentina. See GISELA.

HERNANDEZ GOMEZ, Manuel (Colombia, 1928-). Painter.
Jul.22/63.

HERNANDEZ ACEVEDO, Manuel (Puerto Rico, 1921-). Painter, graphic artist.
Feb.6/57; *Mar.2/57.*

HERRERA, Carmen Fernández de. See LAGUARDIA.

HICKS, Edward (United States, 1780-1849). Painter.
Apr.15/63.

HIMELY, Segismond (France, 1801-1872). Painter, engraver.
Aug.13/53.

HOFFMANN, José (Venezuela, 19?-). Architect.
Sep.20/57.

HOFMAN, Charles (United States, active 1872-1878). Painter.
Apr.15/63.

HOMAR, Lorenzo (Puerto Rico, 1913-). Painter, muralist, draftsman, printmaker, graphic artist, jewelry and stage designer.
Mar.2/57.

HONORIEN, Raymond (Martinique, ?).
Feb.6/57.

HOOD, Dorothy (United States, 1919-). Draftsman, printmaker.
Dec.19/55.

HOOVER, Charles (United States, ?). Painter.
Jul.8/53.

HOSMANN, Elena (Argentina, ?). Photographer.
Nov.2/49.

HOVNANIAN, Mary (United States, ?). Painter.
Jul.8/53.

HOYT, Edith (United States, 1894-?). Painter, illustrator.
Nov.19/51.

HUIE, Albert (Jamaica, 1920-). Painter, art teacher.
Feb.6/57.

HUMBOLDT, Alexander Friedrich Heinrich Baron von (Germany, 1769-1859). Scientist, explorer, draftsman.
Aug.13/53.

HUMERES, Roberto (Chile, 1903-). Painter, architect.
Jan.25/56.

HUNEEUS DE VERA, Virginia. See VERA, Virginia de.

HURTADO, Angel (Venezuela, 1927-). Painter, printmaker, documentary film maker.
May 13/59.

HURTADO MANRIQUE, Juan (Venezuela, 1837-1896). Architect, engineer.
Sep.20/57.

HYPPOLITE, Hector (Haiti, 1894-1948). Painter.
Apr.14/53; *Apr.15/63.*

ILER, Walter (United States, ?). Painter.
Nov.19/51.

INFANTE, Raimundo (Chile, 1928-). Painter, architect.
Nov.14/56.

IRARRAZAVAL, Ricardo. See YRARRAZAVAL, Ricardo.

IRIZARRY, Epifanio (Puerto Rico, 1915-). Painter, graphic artist.
Mar.2/57.

IZQUIERDO, María (Mexico, 1907-1955). Painter, draftsman.
Sep.4/47; *Apr.18/60.*

JACKSON, Harlan (United States, ?). Painter.
Nov.19/51.

JACKSON, Rhoda (Jamaica, 19?-). Painter, muralist, textile designer.
Feb.6/57.

JACOTTET, Louis Julien (France, 1806-?). Painter, lithographer.
Aug.13/53.

JAIMES SANCHEZ, (Angel) Humberto (Venezuela, 1930-). Painter, printmaker, stage designer.
Mar.12/54; *Nov.19/57*; Jan.29/62.

JAMESON, Minor (United States, ?). Painter.
Jul.8/53.

JAMIESON, Mitchell (United States, ?). Painter.
Jul.1/49.

JARAMILLO GIRALDO, Alipio (Colombia, 1913-). Painter, muralist, draftsman, printmaker.
Jun.21/60.

JARAMILLO, Luciano (Colombia, 1938-1984). Painter.
Jun.21/60.

JARDIM, Freda Bondi. See FREDA.

JARDIM CAVALCANTI. See FREDA.

JEANINE, Juan Bautista (Panama, 1922-). Painter, draftsman, sculptor.
Nov.12/53.

JIMENEZ, Guillermo (Costa Rica, 1922-). Painter.
Jan.10/64.

JIMENEZ SOLOGUREN, Manuel (Peru, 1935-). Painter, draftsman.
Feb.15/62.

JONES, Lois Mailou. See PIERRE-NOEL, Lois Mailou.

JOSEPH, Antonio (Haiti, b. Dominican Republic, 1921-). Painter, printmaker.
Jun.16/54; Feb.6/57.

JULIA, Luis (Luis Juliá y Carrera, b. Spain, 18?-1910). Painter.
Feb.14/51.

KAGY, Sheffield Harold (United States, 1907-). Painter, printmaker.
Jul.1/49.

KAHN, María (El Salvador, 1941-). Painter.
May 7/85.

KAINEN, Jacob (United States, 1909-). Painter, printmaker.
Jul.1/49.

KAMYS, Walter (United States, 1917-). Painter, educator.
Dec.19/55.

KANE, John (United States, b. Scotland, 1860-1934). Painter.
Apr.15/63.

KANE, Theodora (United States, ?). Painter.
Nov.19/51; Jul.8/53; Dec.19/55.

KANELBA, Sita de. See GOMEZ DE KANELBA.

KAPLAN, Isidoro. (Ecuador, b. Latvia, 1898-?). Tapestry designer, photographer, physician.
Oct.16/58.

KEAN, Aline M. (St. Thomas, 19?-).
Feb.6/57.

KELLY, McAllister. See McALLISTER KELLY, Rosana.

KELBAUGH, Peggy (Canada, ?). Painter.
Apr.14/53.

KENT, Frank W. (United States, ?). Painter.
Dec.19/55.

KIMMEL, Enid (St. Thomas, ?).
Feb.6/57.

KINGMAN, Eduardo (Ecuador, 1913-). Painter, muralist, draftsman, printmaker.
Jan.31/47; Apr.4/47; Apr.14/53; Apr.12/55.

KIRBY, Sheldon (United States, ?). Painter.
Dec.19/55.

KLEISER, Enrique (Peru, b. Switzerland, 1901-). Painter.
Jun.21/57.

KOCH (Germany, active 19th century). Draftsman.
Aug.13/53.

KORNBLITH, Babette (United States, ?). Painter.
Dec.19/55.

KUBOTTA, Arturo (Peru, 1932-). Painter, printmaker.
Apr.12/61; Dec.15/61; *Mar.19/63.*

KUIPERI, Leo (Aruba, ?).
Feb.6/57.

LABAUTIERE, Jeanne (Martinique, ?).
Feb.6/57.

LAGUARDIA (Carmen Fernández de Herrera, b. Paraguay, 1918-). Painter.
Sep.22/52; Apr.14/53.

LAM, Wifredo (Cuba, 1902-1982). Painter, draftsman, printmaker, illustrator.
Apr.13/59.

LAMMING, Nina G. (Trinidad, ?).
Feb.6/57.

LAMONICA, Roberto De (Brazil, 1933-). Printmaker.
Mar.18/60; *Sep.19/61*.

LAMPE, John C. (Aruba, ?).
Feb.6/57.

LANDRY, Yvan (Canada, ?). Ceramist.
Mar.21/56.

LANG, Katharine Birdseye. (United States, ?). Painter, draftsman.
Nov.3/46.

LANGLOIS (France, active 19th century). Printer.
Aug.13/53.

LAPLANTE, Eduardo (Cuba, b. France, 1818- ?). Painter, draftsman, lithographer.
Aug.13/53.

LARCO, Jorge (Argentina, 1897-1968). Painter, draftsman, illustrator, stage designer.
Jun.1/48; *May 5/55*.

LAURENS, Henri (France, 1885-1954). Sculptor, printmaker.
Sep.20/57.

LAUVERGNE, Barthélemy (France, 1805-1871). Painter, draftsman, lithographer.
Aug.13/53.

LAZARD, Lucner (Haiti, 1928-). Painter, draftsman.
Feb.24/48.

LAZZARI, Pietro (United States, b. Italy, 1898-?). Painter, draftsman.
Sep.1/48; Jul.1/49.

LECAROS, Juana (Chile, 1920-). Painter, draftsman, printmaker.
Nov.14/56.

LECOUTEY, Father André (Canada, ?). Painter, sculptor.
Mar.21/56.

LEGER, Fernand (France, 1881-1955). Painter,
Sep.20/57.

LEINBACH, Inez (United States, ?). Painter.
Jul.8/53.

LEMERCIER, Joseph (France, 1803-1887). Lithographer.
Aug.13/53.

LEMOS, Fernando (Brazil, b. Portugal, 1926-). Painter, draftsman, printmaker, illustrator, photographer, poet.
Apr.13/59.

LEND (Aruba, 19?-).
Feb.6/57.

LEON, Amanda de (Venezuela, b. Spain, 1908-). Painter.
Jun.20/56.

LEON, Noé (Colombia, 1907-1978). Painter, policeman.
Apr.15/63.

LEON, Omar d' (Nicaragua, 1929-). Painter, draftsman.
Feb.14/57.

LEON, Pedro (Ecuador, 1895-?). Painter, muralist, stage designer.
Jul.3/50.

LEONTUS, Adam (Haiti, 1928-). Painter.
Feb.6/57.

LETELIER, Jorge (Chile, 1887-?). Painter.
Jan.25/56.

LETYCIA, Anna. See ANNA LETYCIA.

LEWIS, Roberto (Panama, 1874-1949). Painter, muralist, sculptor.
Apr.14/53.

LIAUTAUD, Georges (Haiti, 1899- ?). Sculptor.
Sep.15/60; Apr.15/63.

LINARES, Alfredo (Bolivia, ?). Photographer.
Jan.12/49.

LISBOA, Antônio Francisco de. See ALEIJADINHO.

LLUBERES D., Pedro (Venezuela, 19?-). Architect.
Sep.20/57.

LOBO, Balthazar (Spain, 1911-). Sculptor.
Sep.20/57.

LOBOS, Pedro (Chile, 1918-). Painter, draftsman, printmaker, musician.
Jan.25/56.

LOCKHART, Alfred (St. Thomas, ?).
Feb.6/57.

LOOCHKARTT, Angel (Colombia, 1933-). Painter.
Nov.17/64.

LOPEZ RUZ, Alberto (Chile, ?). Sculptor, draftsman.
Jan.25/56.

LOPEZ, Hilda (Uruguay, 1922-). Painter.
Sep.8/61.

LOPEZ, Ignacio. See LOPEZ, Nacho.

LOPEZ BERESTEIN, Julio. See BERESTEIN.

LOPEZ-REY, Lucio (Mexican, b. Spain, 1904-). Painter, muralist, printmaker, ceramist, illustrator.
Mar.4/47

LOPEZ, Nacho (Ignacio López, Mexico, 1925-). Photographer, graphic reporter, cameraman.
Aug.28/56.

LOPEZ DIRUBE, Rolando (Cuba, 1928-). Sculptor.
Dec.11/64.

LORD, Brian (United States, 1942-). Painter, draftsman.
May 21/64.

LOVE, Jane (United States, ?). Sculptress.
Jul.8/53.

LOZANO, Magdalena (Chile, b. Spain, 1913-). Painter.
Nov.14/56.

LUACES VILLAURRUTIA, Alfonso (Cuba, 1922-). Caricaturist.
Nov.19/57.

LUCAS Y PADILLA, Eugenio (Spain, 1824-1870). Painter.
Feb.14/51.

LUCO, Alfonso (Chile, 1925-). Painter, architect.
Nov.14/56.

LUHRSEN, Nicolás. See NIKO.

LUMERMAN, Juana (Argentina, 1905-). Painter, draftsman.
Jun.1/48.

LUZA, Reynaldo (Peru, 1893-?). Painter, draftsman.
May 24/50.

MABE, Manabu (Brazil, b. Japan, 1924-). Painter.
Apr.12.61; Jun.28/61; *May 10/62*; *Nov.21/62.*

McALLISTER KELLY, Rosana (Cuba, b. Argentina, 1931-). Painter.
Dec.11/64.

MACCIO, Rómulo (Argentina, 1931-). Painter, draftsman, illustrator.
May 31/60; Apr.4/61; Apr.13/62; *Nov.21/62.*

MACEDO, Francisco Riopardense de (Brazil, 1921-). Printmaker, civil engineer.
Apr.3/62.

McGOWIN, Ed (William Edward McGowin, United States, 1938-). Painter.
May 21/64.

McKINNIE, Miriam (United States, ?). Painter.
Nov.19/51.

MacLEOD, Robert J. (Barbados, ?).
Feb.6/57.

MAGALHAES, Aloisio (Brazil, 1927-1982). Painter, draftsman.
Nov.23/56.

MAGNO, Salvador (Argentina, ?). Painter, draftsman, ornithologist.
Oct.7/54.

MAILOU, Lois. See PIERRE NOEL, Lois Mailou.

MALESPINE, Jacques (Guadeloupe, ?).
Feb.6/57.

MALLO LOPEZ, Samuel (Argentina, 1905-). Painter, sculptor, draftsman, physician.
Aug.13/51.

MANAURE, Mateo (Venezuela, 1926-). Painter, printmaker.
Mar.12/54; Sep.20/57.

MANET, Edouard (France, 1832-1883). Painter, lithographer.
Aug.13/53.

MANGALLON, Ginette (Martinique, ?).
Feb.6/57.

MANN, Hans (Germany, 19?-). Photographer.
Jan.23/58.

MANN, Morris (British Guiana, ?).
Feb.6/57.

MANSON, Sasha (St. Croix, ?).
Feb.6/57.

MANUEL, Víctor. See VICTOR MANUEL.

MANZUR, David (Colombia, 1929-). Painter, muralist, printmaker, stage designer, actor.
Feb.23/61.

MARCHAIS (France, active 19th century). Draftsman.
Aug.13/53.

MARCHENA, Rudolf V. (Curaçao, 1914-). Painter.
Feb.6/57.

MARCOS, Fernando (Chile, 1919-). Painter.
Nov.14/56.

MARIA LUISA. See PACHECO, María Luisa.

MARIANNE (Mexico, ?). Photographer.
Jan.12/49.

MARIANO (Mariano Rodríguez, Cuba, 1912-). Painter, graphic artist, illustrator, ceramist.
Dec.1/46.

MARICHAL, Carlos (Puerto Rico, b. Canary Islands, 1923-1969). Painter, draftsman, graphic artist, stage and costume designer.
Mar.2/57.

MARIE-CLAIRE, Claudine (Martinique, ?).
Feb.6/57.

MARIL, Herman (United States, 1908-). Painter, printmaker.
Jul.1/49.

MARIN, Hugo (Chile, 1930-). Painter, illustrator.
May 21/57.

MARIÑO SOUTO, Antonio. See ÑICO.

MARQUEZ, Judith (Colombia, 1919-). Painter.
May 11/60; Jun.21/60.

MARQUEZ, Luis (Mexico, ?). Photographer.
Jan.12/49.

MARQUIER, L. (active 19th century). Lithographer.
Aug.13/53.

MARTIN, Santiago (active in Cuba in the 19th century). Lithographer.
Aug.13/53.

MARTIN, Vicente (Uruguay, 1911-). Painter.
Feb.21/56; *Nov.21/62.*

MARTINEZ D'UBAGO, Eduardo (Dominican Republic, b. Spain, 19?-). Painter, muralist, stage designer.
Feb.6/57.

MARTINEZ PEDRO, Luis (Cuba, 1910-). Painter, draftsman.
Dec.1/46; *Sep.24/51*; *Aug.15/52*; Apr.13/59;
Jan.29/62.

MARTINO, Federico (Argentina, 1930-). Painter, printmaker.
May 1/63.

MARTINS, Aldemir (Brazil, 1922-). Draftsman, painter, printmaker, illustrator.
Jan.23/58; Apr.13/59.

MARY, Olga. See OLGA MARY.

MASON, Jacob (England, 1710-1780). Engraver.
Aug.13/53.

MASSAGUER, Conrado (Cuba, 1889-1965). Caricaturist, painter.
Nov.19/57.

MATEUS, Alfonso (Colombia, 1927-). Painter, draftsman.
Jun.21/60; *Sep.24/63.*

MATTA, Roberto (Chile, 1912-). Painter, draftsman, printmaker, architect.
Feb.16/55; Apr.13/59.

MATURANA, Draco (Chile, 19?-). Painter, printmaker, engineer.
Jan.25/56.

MAYO, Agustín (Mexico, ?). Photographer.
Jan.12/49.

MAYOL, Bart (Puerto Rico, 19?-).
Feb.6/57.

MAZA, Fernando (Argentina, 1936-). Painter, printmaker.
Aug.1/60.

MAZO, Norma (United States, ?). Painter.
Jul.1/49.

MELLA, Noemí (Dominican Republic, 1929-). Painter, draftsman, illustrator.
May 6/53.

MENDEZ, Leopoldo (Mexico, 1902-1969). Printmaker, illustrator.
May 1/45.

MENDOZA LIMON, Federico (Mexico, 1910-). Sculptor.
Dec.27/44.

MENOCAL VILLALON, Alberto (Cuba, 19?-). Painter.
Dec.11/64.

MERCADO, Mateo (Honduras, ?). Photographer.
Jan.18/50.

MERCHAN, Cristina (Venezuela, 1927-). Ceramist.
Aug.15/63.

MERIDA, Carlos (Guatemala, 1891-1984). Painter, muralist, printmaker, stage designer.
Mar.1/45; Apr.4/47; Sep.13/50; *Dec.20/51*;
Apr.14/53; Jan.29/62.

MESTRE BADELL, Carlos (Cuba, 1918-). Caricaturist.
Nov.19/57.

MEYER, Mary (United States, 19?-). Painter.
May 21/64.

MEZA, Guillermo (Mexico, 1917-). Painter, draftsman, graphic artist.
Apr.18/60.

MIJARES, José Manuel (Venezuela, 19?-). Architect.
Sep.20/57.

MILIAN, Raúl (Cuba, 1914-). Draftsman.
Oct.10/56.

MILLAN, Víctor (Venezuela, 1919-). Painter.
Apr.15/63.

MILLER, Richard K. (United States, 1930-). Painter.
Apr.14/53.

MILLER, Whitney (Jamaica, 1930-). Painter, draftsman, sculptor.
Feb.6/57.

MILNER CAJAHUARINGA, José (Peru, 1932-). Painter.
Dec.15/61.

MINDLIN, Vera Bocayuva. See BOCAYUVA MINDLIN, Vera.

MINSHALL, Wilson (Trinidad and Tobago, ?).
Feb.6/57.

MISHAAN, Rodolfo (Guatemala, 1924-). Painter, textile designer.
May 11/61.

MOHALYI, Yolanda (Brazil, b. Hungary, 1909-). Painter.
Nov.21/62.

MOLINA, Antonio (Cuba, 1928-). Painter, muralist, draftsman.
Dec.11/64.

MOLL, Eduardo (Peru, b. Germany, 1929-). Painter, graphic artist, art critic.
Aug.13/59.

MOLLER, Hans (United States, b. Germany, 1905-). Painter.
Jan.29/62.

MONCALVO, Ana María (Argentina, 1921-). Printmaker.
Dec.4/61.

MONSERRATE, Fernando M. (Puerto Rico, 19?-).
Feb.6/57.

MONTECINO, Sergio (Chile, 1916-). Painter.
Jan.25/56.

MONTERO, Germán (Chile, ?). Ceramist, sculptor.
Jan.25/56.

MONTERO, Javier A. (Cuba, ?). Painter, sculptor.
Mar.3/47.

MONTIEL, Jonio (Uruguay, b. Italy, 1924-). Painter.
Feb.2/50.

MOORE, Anita (United States, ?). Photographer, art lecturer.
Feb.18/53.

MOORE, Marie (St. Thomas, ?). Painter.
Feb.6/57.

MORALES, Armando (Nicaragua, 1927-). Painter, draftsman, printmaker.
Feb.14/57; *Mar.23/62*; Apr.13/62.

MOREL, Olga (Chile, 19?-). Painter.
Jan.25/56.

MORENO KIERNAN, María (Argentina, 1914-). Printmaker, illustrator.
Jun.16/59.

MORENO, Rafael (Cuba, b. Spain, 1887-1955). Painter, muralist.
Apr.15/63.

MORGAN, Cleveland (Jamaica, 1934-). Painter, sculptor.
Feb.6/57.

MORRIS, Leonard (Jamaica, 19?-). Painter.
Feb.6/57.

MORRIS, T. (England, active 18th century). Engraver.
Aug.13/53.

MOTTA E SILVA, djanira. See DJANIRA.

MOTTA, Helou (Heloisa Lourdes Alves de Lima e Motta, Brazil, 1925-). Sculptress, ceramist.
Dec.16/58.

MOYA BARAHONA, Carlos (Costa Rica, 1925-). Painter, muralist, sculptor, graphic artist.
Jan.10/64.

MOYA, Pedro de (Spain, 1610-1666). Painter.
Feb.14/51.

MUCHNIK, Carolina (Argentina, 19?-). Painter.
Apr.13/62.

MULDER, Joseph (Netherlands, 1659-ca.1735). Engraver, draftsman.
Aug.13/53.

MUNDY, Clarence (Chile, 1920-). Painter, draftsman, cartoonist, illustrator.
Sep.17/54.

MUNTAÑOLA, Roser (Panama, b. Spain, 1928-). Painter.
Nov.12/53; *Apr.13/60.*

MURILLO, Gerardo. See ATL, Dr.

NAMUTH, Hans (United States, b. Germany, 1915-). Photographer.
Jun.1/49.

NAVARRO, Pascual (Venezuela, 1923-1985). Painter, draftsman, muralist.
Sep.20/57.

NEBEL, Carl (Germany, 1800-1865). Draftsman, archaeologist, architect.
Aug.13/53.

NEGREIROS, Maria Thereza (Colombia, b. Brazil, 1930-). Painter, draftsman.
Nov.26/63.

NEGRET, Edgar (Colombia, 1920-). Sculptor.
Jan.20/56; Jun.21/60.

NEL GOMEZ, Pedro (Colombia, 1899-1984). Painter, muralist, architect.
Jun.21/60.

NESBITT, Lowell (United States, 1933-). Painter, draftsman.
May 21/64.

NEUBERGER, Pedro (?). Architect.
Sep.20/57.

NEWBERRY, Tomás (Argentina, 1928-). Painter, sculptor.
Oct.17/49.

NICASIO, Alberto (Argentina, 1902-). Printmaker.
Sep.12/49.

ÑICO (Antonio Mariño Souto, Cuba, 1936-). Draftsman, caricaturist.
Nov.19/57.

NIKO (Nicolás Luhrsen, Cuba, 1916-). Caricaturist, cartoonist.
Nov.19/57.

NISHIZAWA, Luis (Mexico, 1920-). Painter, printmaker.
Apr.12/61.

NOE, Luis Felipe (Argentina, 1933-). Painter, draftsman, illustrator, art critic.
Apr.4/61; *Apr.13/62.*

NOELLNER PEDROZA, Olga Mary Sassetti. See OLGA MARY.

NORMIL, André (Haiti, ?). Painter.
Feb.6/57.

NOVOA, Leopoldo (Uruguay, b. Spain, 1919-). Painter, draftsman, printmaker.
Aug.20/57.

NUEZ, René de la (Cuba, 1938-). Caricaturist.
Nov.19/57.

NUÑEZ DEL PRADO, Marina (Bolivia, 1910-). Sculptress.
May 22/41; Apr.12/55.

NYQUIST, Carl (United States, ?). Painter.
Jul.1/49.

OBIN, Philomé (Haiti, 1892-1987). Painter.
Apr.4/47; Apr.15/63.

OBREGON, Alejandro (Colombia, b. Spain, 1920-1992). Painter.
Apr.14/53; *Jan.18/55*; Apr.13/59; Jun.21/60.

ODUBER, Ciro S. (Panama, 1921-). Painter, draftsman.
Nov.12/53; Apr.13/59; *Apr.13/60.*

O'HARA, Eliot (United States, 1890- ?). Painter, printmaker.
Jul.1/49.

OKADA, Kenzo (United States, b. Japan, 1902-). Painter.
Apr.12/61.

OLGA-MARY (Olga-Mary Sassetti Noellner Pedroza, Brazil, 1891-1963). Painter.
Nov.1/48.

OLIVER, José R. (Puerto Rico, 1901-1979). Painter, muralist, sculptor, chemist.
Mar.2/57.

OPAZO, Rodolfo (Chile, 1935-). Painter, draftsman, printmaker.
Aug.20/62.

ORCUTT BLATTER, Jane. See BLATTER, Jane Orcutt.

ORLANDO, Felipe (Cuba, 1911-). Painter, printmaker, illustrator.
Dec.1/46; *Aug.4/47*; *Aug.15/52*; Dec.11/64.

OROZCO, José Clemente (Mexico, 1883-1949). Painter, draftsman, muralist, printmaker.
Sep.4/47; *May 15/52*; Apr.14/53; Apr.18/60.

OSPINA, Marco (Colombia, 1912-1983). Painter, muralist.
Dec.1/49; *Jun.21/60.*

OSSANDON, Carlos (Chile, 1900-1977). Painter, art critic, writer.
Jan.25/56.

OSSAYE, Roberto (Guatemala, 1927-1954). Painter.
Jun.5/51.

OSTROWER, Fayga (Brazil, b. Poland, 1920-). Printmaker, illustrator, textile and jewelry designer.
Sep.12/55; *Mar.18/60.*

OSVALDO. See GUTIERREZ, Osvaldo.

OTERO, Alejandro (Venezuela, 1921-1990). Painter, printmaker, sculptor.
Dec.28/48; Apr.14/53; Jan.29/62.

OTERO, Carlos (Venezuela, 1886-1977). Painter.
Jun.28/48.

OTTA, Francisco (Chile, b. Czechoslovakia, 1908-). Painter, printmaker.
Feb.3/54; Jan.25/56.

PACHECO, Armando (Bolivia, 1910-). Painter, draftsman.
Aug.2/48.

PACHECO ALTAMIRANO, Arturo (Chile, 1905-). Painter.
Oct.22/51.

PACHECO, María Luisa (Bolivia, 1919-1982). Painter, draftsman, illustrator, textile designer.
Jul.16/57; Apr.13/59; Jan.29/62.

PACHECO, Máximo (Mexico, 1905-). Painter, muralist, draftsman.
Apr.18/60.

PADILLA, Saúl (Venezuela, ?).
Feb.6/57.

PAEZ VILARO, Carlos (Uruguay, 1923-). Painter, muralist, draftsman, illustrator, sculptor, ceramist, writer, popular music composer.
Dec.23/57; *Dec.16/58*; *Dec.25/60.*

PAEZ, Jorge (Uruguay, 1921-). Painter.
Nov.28/61; *Nov.21/62.*

PALACIOS, Francisco (Puerto Rico, 1915-). Painter, graphic artist.
Mar.2/57.

PALACIOS, Gonzalo (Venezuela, 1916-). Ceramist.
Aug.15/63.

PALACIOS, Luisa (Venezuela, 1923-). Painter, printmaker, ceramist.
Aug.15/63.

PALLIERE, Jean Léon (Jean Pierre Léon Pallière Grandjean Ferreira, France, b. Brazil, 1823-1887). Painter, draftsman, lithographer.
Aug.13/53.

PALOMINO DE CASTRO Y VELASCO, Acisclo Antonio (Spain, 1653-1726). Painter, art writer.
Feb.14/51.

PAPE, Lygia (Brazil, 1929-). Printmaker, painter.
Mar.18/60.

PARADA, Francisco (Chile, 1910-1959). Painter, printmaker, architect.
Jan.25/56.

PARIENTE AMARO, Mario (Uruguay, 1915-). Painter, draftsman, musician, writer.
Sep.4/63.

PARISOT, Father Jean (Haiti, 1918-). Painter, Catholic priest.
Feb.24/48.

PAYNE, Ivan (Barbados, ?).
Feb.6/57.

PECRUZ (José A. Cruz, Cuba, 1937-). Caricaturist.
Nov.19/57.

PEDRAZA, Carlos (Chile, 1913-). Painter.
Jan.25/56.

PEDROZA, Olga Mary. See OLGA MARY.

PELAEZ, Amelia (Cuba, 1897-1968). Painter, draftsman.
Dec.1/46; *Aug.15/52*; Apr.12/55; Apr.13/59; Jan.29/62.

PELICARIC, Sime (Argentina, b. Yugoslavia, 1915-). Ceramist, lawyer, diplomat.
Dec.16/58.

PELUFFO, Martha (Argentina, 1931-1979). Painter.
May 31/60.

PELVILAIN, Julio (Argentina, b. France, ?-1871). Lithographer.
Aug.13/53.

PEÑALBA, Rodrigo (Nicaragua, 1908-1979). Painter, caricaturist.
Jun.15/47; Apr.14/53; *Feb.14/57.*

PERALTA, Tole (Chile, 1920-). Painter.
Jan.25/56.

PEREIRA, Djanira Gomes. See DJANIRA.

PEREZ, Francisco Edmundo, (Venezuela, 19?-), Photographer.
Nov.25/47.

PEREZ, Gilberto (Cuba, 1943-). Caricaturist.
Nov.19/57.

PEREZ CASTAÑO, Jorge (Cuba, 1932-). Painter, muralist, graphic artist, ceramist.
Dec.11/64.

PEREZ, Matilde (Matilde Pérez Cerda de Carrasco, Chile, 1924-). Painter.
Jan.25/56.

PEREZ, Rossini (Brazil, 1932-). Printmaker, illustrator.
Mar.18/60.

PERKINS, Dionisio (Cuba, 1929-). Painter.
Dec.11/64.

PERKINS SAFFORD, Ruth. See SAFFORD, Ruth Perkins.

PERLMUTTER, Jack (United States, 1920-). Painter, printmaker.
Jul.1/49; Jul.8/53.

PEROTTI RONZONI, José (Chile, 1898-1956). Painter, draftsman, printmaker, sculptor, ceramist.
Jan.25/56.

PETTORUTI, Emilio (Argentina, 1892-1971). Painter, draftsman.
Apr.12/55.

PETTRELLUZZ-QUESTEL, Solange (Guadeloupe, ?).
Feb.6/57.

PEVSNER, Antoine (France, b. Russia, 1884-1962). Painter, sculptor.
Sep.20/57.

PHELPS, Kathleen Deery de (Venezuela, b. Australia, 19?-). Painter.
Apr.27/56.

PIERRE, Fernand (Haiti, 1922-). Painter.
Feb.6/57.

PIERRE-NOEL, Lois Mailou (Lois Mailou Pierre-Noël or Lois Mailou Jones, United States, 1905-). Painter, designer.
Jul.1/49; *Jan.28/55.*

PIETRI PIETRI, Alejandro (Venezuela, 1924-). Architect.
Sep.20/57.

PINEDO, Maruja (Chile, 1907-). Painter, draftsman.
Jan.25/56.

PINO, Héctor (Chile, 19?-). Draftsman, printmaker.
Jan.25/56.

PINTO, Joaquín (Ecuador, 1842-1906). Painter,
Dec.6/48.

PIRIA, María Olga (Uruguay, 1927-). Painter, musician.
Feb.2/50.

PIZA, Arthur Luiz (Brazil, 1928-). Printmaker.
Sep.12/55; *Mar.18/60.*

PIZANO RESTREPO, Roberto (Colombia, 1896-1929). Painter.
Jun.21/60.

PLAMONDON, Marius (Canada, 19?-). Sculptor, stained glass artist.
Mar.21/56.

PLAZA, Exequiel (Chile, 1892-1947). Painter.
Jan.25/56.

PLUTARCO ANDUJAR, Juan (Dominican Republic, 1931-). Painter, muralist.
Feb.6/57.

POBLETE, Aída (Chile, 1916-). Painter.
Jan.25/56.

POISSON, Louverture (Haiti, 1914-). Painter.
Apr.15/63.

POITEAU (France, active 19th century). Draftsman.
Aug.13/53.

POLEO, Héctor (Venezuela, 1918-). Painter, draftsman, printmaker, tapestry designer.
Oct.1/45; Apr.4/47; Apr.12/55.

POLESELLO, Rogelio (Argentina, 1939-). Painter, printmaker, graphic artist.
May 31/60; *Oct.17/61.*

POLLARD, Jeanette (Trinidad, ?).
Feb.6/57.

PONCE DE LEON, Fidelio (Alfredo Fuentes Pons, Cuba, 1895-1949). Painter, draftsman.
Dec.1/46.

PONS, Isabel (Brazil, b. Spain, 1912-). Printmaker.
Mar.18/60.

PORRAS, Cecilia (Colombia, 1920-1971). Painter.
May 11/60; Jun.21/60.

PORTINARI, Cândido (Brazil, 1903-1962). Painter, muralist, draftsman, printmaker, illustrator, poet.
Apr.4/47; *Jun.30/47;* Apr.14/53.

PORTOCARRERO, René (Cuba, 1912-1985). Painter, muralist, draftsman, ceramist, illustrator, stage and costume designer.
Dec.1/46; *Aug.15/52;* Oct.10/56.

POSADA, José Luis (Cuba, 1929-). Caricaturist.
Nov.19/57.

POST, Charles Johnson (United States, ?). Painter.
Dec.19/55.

POVEDA, Carlos (Costa Rica, 1940-). Painter, draftsman, graphic artist.
Jan.10/64.

PRADO, Antônio (Brazil, 1927-). Painter, architect.
Sep.12/57; Jun.28/61.

PRADO, Carlos (Carlos Silva Prado, Brazil, 1908-). Painter, draftsman.
Dec.10/47.

PRADO, Gina (Brazil, 19?-). Tapestry weaver.
Oct.16/58; *Jun.28/61.*

PRADO, Vasco (Brazil, 1914-). Printmaker, sculptor.
Apr.3/62.

PRATT, Walter A. (Antigua, ?)
Feb.6/57.

PRAZERES, Heitor dos (Brazil, 1902-1966). Painter, popular music composer.
Apr.15/63.

PRESAS, Leopoldo (Argentina, 1915-). Painter, draftsman, illustrator.
May 31/60; Apr.4/61; *Nov.21/62.*

PRESNO, Lincoln (Uruguay, 1917-). Painter, draftsman, graphic artist, industrial designer, tapestry designer, sculptor.
Mar.20/64.

PRETE, Danilo Di (Brazil, b. Italy 1911-). Painter.
Nov.21/62.

PRETE, Juan Del (Argentina, b. Italy, 1897-19?). Painter, sculptor.
May 31/60.

PRICE, Lucien (Haiti, 1914-). Draftsman.
Feb.24/48; *Feb.15/62.*

PRINCE, A.G. (Antigua, ?).
Feb.6/57.

PRUNES, Eduardo (Mexico, ?). Painter.
Apr.18/60.

PUCCIARELLI, Mario (Argentina, 1928-). Painter.
May 31/60; *Oct.24/60.*

QUADROS, Anna Letycia. See ANNA LETYCIA.

QUALIA, Anthony (United States, ?). Painter.
Jul.8/53.

QUINTANILLA DEL MAR, Alberto (Peru, 1934-). Painter.
Dec.15/61.

QUINTERO, Francisco (Chile, 19?-). Printmaker.
Jan.25/56.

QUIROA, Marco Augusto (Guatemala, 1937-). Painter.
Oct.25/62.

RACZ, André (United States, b. Rumania, 1916-). Painter, printmaker, draftsman.
Oct.1/47.

RAMIREZ FAJARDO, Alfonso (Colombia, ca.1900-1969). Painter, draftsman.
Dec.1/49.

RAMIREZ VILLAMIZAR, Eduardo (Colombia, 1923-). Painter, draftsman, sculptor.
Dec.1/49; *Sep.11/56;* Apr.13/59; Jun.21/60; Jan.29/62.

RAMOS MINAYA, Alberto (Peru, 1930-). Painter.
Dec.15/61.

RAMOS DE LOS REYES, Francisca (Argentina, 1925-). Painter, draftsman, printmaker.
May 31/60.

RAMSEY, David (United States, ?). Draftsman.
Dec.19/55.

RAMSEY, Thea (United States, ?). Draftsman.
Dec.19/55.

RANUCCI, Luciano (Costa Rica, b. Italy, ?). Painter.
Apr.14/53.

RAVELO, Arnaldo (Cuba, 1928-). Painter, draftsman, sculptor, ceramist, poet.
Dec.11/64.

RAVELO, Juvenal (Venezuela, 1931-). Painter.
Feb.6/57.

RAYMOND, Maurice (Canada, 1912-). Painter, muralist.
Mar.21/56.

RAYO, Omar (Colombia, 1928-). Painter, draftsman, printmaker.
Jun.28/61; *Mar.2/64.*

REAL, João (Brazil, 19?-). Painter.
Apr.15/63.

REBUFFO, Víctor (Argentina, b. Italy, 1903-). Printmaker.
Sep.12/49.

REMPONEAU, Géo (George Remponeau, Haiti, 1916-). Painter.
Feb.24/48.

RENDON, Manuel (Ecuador, b. France, 1894-1980). Painter.
Mar.16/55; Jan.29/62.

RENNIE, Helen Sewell (United States, ?). Painter, draftsman, designer.
Jul.1/49; Jul.8/53.

REQUE MERUVIA, Arturo (Bolivia, 1906-). Painter, muralist, printmaker.
Dec.8/54.

RESTREPO, Pedro (Colombia, 1919-). Painter.
Jan.23/53.

RICHARDSON, Sybil (Trinidad, ?).
Feb.6/57.

RIDDER, J. De (Peru, ?). Photographer.
Jan.12/49.

RIEUX, Louis de (France, active 19th century). Engraver, draftsman.
Aug.13/53.

RINK, Paul Philip (Paulus Philippus Rink, b. Holland, 1862-1903). Painter.
Feb.14/51.

RIOPARDENSE DE MACEDO, Francisco. See MACEDO, Francisco Riopardense de.

RIVERA, Carlos Raquel (Puerto Rico, 1923-). Painter, graphic artist.
Mar.2/57.

RIVERA, Diego (Mexico, 1886-1957). Painter, draftsman, muralist, printmaker.
Sep.4/47; Apr.18/60.

ROA, Israel (Chile, 1909-). Painter, muralist.
Apr.4/47; Jan.25/56.

ROBINSON, John (United States, ?). Painter.
Jul.1/49.

ROBLES DE MEDINA, Stuart (Suriname, 1930-). Painter.
Feb.6/57.

ROCA REY, Joaquín (Peru, 1923-). Sculptor.
Jun.16/59.

RODA, Juan Antonio (Colombia, b. Spain, 1921-). Painter, muralist, draftsman, graphic artist.
Jun.21/60.

RODIG, Laura (Chile, 1901-). Sculptress, painter, printmaker.
Jan.25/56.

RODRIGUEZ, Bernardo (Ecuador, active 18th century). Painter.
Apr.12/55.

RODRIGUEZ CANDHALES, Dándolo. See CANDHALES, Dándolo Rodríguez.

RODRIGUEZ, Hugo (Cuba, 1929-). Painter, draftsman.
May 15/58.

RODRIGUEZ, José Miguel (Cuba, 19?-).
Dec.11/64.

RODRIGUEZ DE GUZMAN, Manuel (Spain, 1818-1867). Painter.
Feb.14/51.

RODRIGUEZ, Mariano. See MARIANO.

RODULFO TARDO, Manuel (Cuba, 1913-). Sculptor, painter, draftsman.
Dec.11/64.

ROJAS HERAZO, Héctor (Colombia, 1921-). Painter, poet, writer.
Jun.21/60.

ROLANDO, Maruja (Venezuela, 1923-1971). Painter, printmaker.
Aug.17/61.

ROMAN, Benito (Chile, 1915-). Sculptor, ceramist.
Jan.25/56.

ROMAN, Héctor (Chile, 19?-). Sculptor, ceramist.
Jan.25/56.

ROMAN ROJAS, Samuel (Chile, 1907-). Sculptor.
Apr.12/55.

ROMBERG, Osvaldo (Argentina, 1938-). Printmaker, illustrator.
Jan.28/64.

ROMERO GUTIERREZ, Jorge (Venezuela, 19?-). Architect.
Sep.20/57.

ROSADO DEL VALLE, Julio (Puerto Rico, 1922-). Painter, muralist, draftsman, graphic artist.
Mar.2/57.

ROSE, Ruth Starr (United States, ?). Printmaker.
Nov.19/51.

RUBIO, Antonio (Cuba, 1921-). Caricaturist, painter.
Nov.19/57.

RUGENDAS, Johann Moritz (Germany, 1802-1858). Painter, draftsman, printmaker.
Aug.13/53.

RUNYAN, Pablo (Panama, 1925-). Painter.
Nov.12/53.

SABOGAL, José (Peru, 1888-1956). Painter, printmaker.
Apr.4/47.

SABOGAL, Otto (José Otto Sabogal, Colombia, 1935-). Sculptor.
Jun. 21/60

SAFFORD, Ruth Perkins (United States, ?). Painter.
Dec.19/55.

SAFORCADA, Hemilce (Argentina, 1912-). Painter, printmaker, illustrator.
Sep.23/46; *Apr.4/61.*

SAGASTEGUI CORDOVA, Oswaldo (Peru, 1936-). Painter.
Dec.15/61.

ST. ALBANS, Mary (United States, ?). Photographer.
Oct.23/47.

ST. OMER, Dunstan (St. Lucia, ?).
Feb.6/57.

SAINT-VIATEUR, Les Ateliers (Canada).
Mar.21/56.

SAKAI, Kazuya (Argentina, 1927-). Painter, draftsman, printmaker.
Apr.13/59; *Apr.12/61.*

SALAS, César (Colombia, ?). Painter.
Dec.1/49.

SALAS, Gilberto (Colombia, ?). Painter.
Dec.1/49.

SALAS, Marco (Colombia, ?). Painter.
Dec.1/49.

SALAS VEGA, Marco (Colombia, ?). Painter.
Dec.1/49.

SALAS, Mercedes (Colombia, ?). Painter.
Dec.1/49.

SALAS, Piedad (Colombia, ?). Painter.
Dec.1/49.

SALAS, Rafael (Colombia, ?). Painter.
Dec.1/49.

SALINAS, Baruj (Cuba, 1935-). Painter, printmaker.
Dec.11/64.

SALVO, Lily (Uruguay, b. Argentina, 1928-). Painter.
Feb.2/50.

SANABRIA ESCOBAR, Tomás José (Venezuela, 1922-). Architect, civil engineer.
Sep.20/57.

SANCHEZ, M.A. (Honduras, 19?-). Photographer.
Jan.18/50.

SANCHEZ HERRERA, Samuel (Puerto Rico, 1929-). Painter, graphic artist.
Feb.6/57; *Mar.2/57.*

SANGRONIZ, Luis Alberto de (Chile, 1896-?). Painter, illustrator.
Mar.25/57.

SAN MIGUEL, Raúl (Cuba, 1932-). Painter, stage designer.
Dec.11/64.

SANTAMARIA, Andrés de (Colombia, 1860-1945). Painter.
Jun.21/60.

SANTELICES, Raúl (Chile, 1916-). Painter.
Jan.25/56.

SANTOS, Agnaldo Manoel dos (Brazil, 1926-1962). Sculptor.
Jul.8/63.

SARAGONI, Fernando (Chile, 19?-). Printmaker.
Jan.25/56.

SARAVIA, Fernando (Nicaragua, 1922-). Sculptor, painter.
Feb.14/57.

SASSETTI NOELLNER PEDROZA, Olga-Mary. See OLGA-MARY.

SASTRO, Soekimin (Suriname, ?).
Feb.6/57.

SAWKINS, James Gay (England, 1806-1878). Painter, draftsman, geologist.
Aug.13/53.

SCASSO, J.A. (Uruguay, 19?-). Architect, landscapist.
May 9/50.

SCHENCK, Pieter (Germany, 1660-1718). Engraver.
Aug.13/53.

SCHMILL, José Manuel (Mexico, 1924-). Draftsman.
Oct.8/62.

SCHREUDER, Jan (Ecuador, b. Netherlands, 1904-). Painter.
Nov.16/60.

SEGALL, Lasar (Brazil, b. Lithuania, 1890-1957). Painter, draftsman, printmaker, sculptor.
May 3/48.

SEGNI, Franco Di (Argentina, b. Italy, 1910-). Painter.
Dec.9/60.

SEGOVIA, Claudio (Argentina, 1933-). Painter, scenographer, tapestry designer and weaver.
May 4/64.

SEGUI, Antonio (Argentina, 1934-). Painter, draftsman, printmaker.
Nov.21/62.

SEKA (Seka Tudja Severin, Venezuela, b. Yugoslavia, 1923-). Ceramist.
Aug.15/63.

SELEY, Jason (United States, 1919-). Sculptor.
Nov.19/51.

SEOANE, Luis (Argentina, 1910-1979). Painter, muralist, draftsman, printmaker, illustrator, lawyer.
Apr.13/59.

SEPULVEDA, Viterbo (Chile, 1926-). Printmaker, ceramist.
Jan.25/56.

SERPA, Ivan (Brazil, 1923-1973). Painter, draftsman.
Aug.17/54; *Nov.21/62.*

SERRES, Dominique. (France, 1722-1793). Painter, draftsman, navy officer.
Aug.13/53.

SESSAREGO, Rómulo M. (Peru, ?). Photographer.
Jan.12/49.

SHARPLES, R.G. (British Guiana, ?).
Feb.6/57.

SHEETS, Millard Owen (United States, 1907-). Painter, designer.
Dec.19/55.

SICA, Armando (Argentina, 1917-). Painter, draftsman, printmaker, illustrator.
Oct.27/48; Apr.4/61.

SICRE, Juan José (Cuba, 1898-1974). Sculptor.
Dec.11/64.

SILBERMAN, Sarah (United States, ?). Sculptress.
Jul.1/49.

SILVA, Alfredo Da (Bolivia, 1936-). Painter, draftsman, printmaker.
Mar.17/61; *Apr.13/64.*

SILVA PRADO, Carlos. See PRADO, Carlos.

SILVA, Carmen (Chile, 1930-). Painter, draftsman, printmaker.
Nov.14/56; *Apr.13/59.*

SILVA, Ciro (Chile, 19?-). Printmaker.
Jan.25/56.

SILVA, Guillermo (Colombia, 1921-). Painter, printmaker, stained glass artist.
Dec.1/49; *Mar.14/58.*

SILVERA, Eudoro (Panama, 1917-). Painter, illustrator, musician.
Nov.12/53; *Nov.16/55.*

SIMMONS, Harold F. C. (St. Lucia, ?).
Feb.6/57.

SIMON, Virginia (Dominican Republic, ?).
Feb.6/57.

SINCLAIR BALLESTEROS, Alfredo (Panama, 1915-). Painter, printmaker.
Nov.12/53; *Feb.7/63.*

SIQUEIROS, David Alfaro (Mexico, 1896-1974). Painter, muralist, draftsman, printmaker.
Sep.4/47; Apr.12/55; *Apr.18/60.*

SMITH HERMANOS Y CA. (Cuba, active 19th-century). Lithographers.
Aug.13/53.

SMITH, Joseph B. (British Guiana, ?).
Feb.6/57.

SNOW, Mary Ruth (United States, 1908-). Painter.
Jul.8/53.

SOLARI HERMOSILLA, José (Peru, ?). Painter.
Jul.15/48.

SOLARI, Luis A. (Uruguay, 1918-1993). Painter, draftsman, printmaker.
Oct.26/64.

SOLDI, Raúl (Argentina, 1905-). Painter, muralist, draftsman, printmaker, illustrator, movie and theater stage designer.
Jun.1/48; *May 31/60*; Apr.4/61.

SOLER VICENS, Mónica (Chile, 1926-). Painter.
Nov.14/56.

SOLON ROMERO, Walter (Bolivia, 1925-). Painter, muralist, printmaker.
Jan.25/56.

SORZANO, Gabriel (Cuba, 19?-). Painter, draftsman, printmaker, sculptor.
Dec.11/64.

SOTOMAYOR, Antonio (Bolivia, 1904-1985). Painter, draftsman, sculptor, caricaturist, illustrator.
Apr./46; Apr.4/47.

SPILIMBERGO, Lino E. (Argentina, 1896-1964). Painter, muralist, printmaker, illustrator.
Apr.4/61.

SPOSITO, Américo (Uruguay, 1924-). Painter.
Nov.21/62.

STEPPAT, Leo (United States, b. Austria, 1910-). Painter, sculptor.
Sep.1/48; Jul.1/49.

STERLIN, Philippe (Haiti, 19?-). Sculptor.
Feb.15/62.

STEVENS, Edward John, Jr. (United States, 1923-). Painter.
Nov.19/51.

STOCKINGER, Francisco (Brazil, b. Austria, 1919-). Sculptor, printmaker.
Apr.3/62.

STOKES, Tom (United States, 1934-). Painter.
May 21/64.

STONE, Doris (Honduras, ?). Photographer.
Jan.18/50.

STROCEN, Stefan (Argentina, 1930-). Painter, printmaker.
Oct.11/63.

STURLA, Juan Manuel (Agentina, 1907-). Painter.
Jan.7/48.

SUAREZ, Guillermo A. (Venezuela, 19?-). Architect.
Sep.20/57.

SUMMERFORD, Joe (United States, 1924-). Painter.
Sep.1/48.

SZALAY, Lajos (Argentina, b. Hungary, 1909-). Draftsman, illustrator.
Jul.17/58.

SZYK, Arthur (United States, b. Poland, 1894-1951). Painter, draftsman, illustrator.
Apr.14/52.

SZYSZLO, Fernando de (Peru, 1925-). Painter, draftsman, printmaker.
Apr.14/53; *Jun.8/53*; Apr.13/59.

TABARA, Enrique (Ecuador, 1930-). Painter, draftsman, graphic artist.
Jun.17/64.

TABARY, Celine (United States, ?). Painter.
Jul.1/49.

TABOIS, Gaston (Jamaica, 1931-). Painter.
Feb.6/57; *Apr.15/63*.

TAFUR, Alicia (Colombia, 1934-). Sculptress, ceramist.
Nov.18/58; *Dec.16/58*.

TAGLE, Augusto de Castro (Cuba, 1920-1974). Photographer, foreign service officer.
Mar.17/52.

TAHARALLY, Alma (British Guiana, ?).
Feb.6/57.

TALAVERA, Jesús M. (Mexico, ?). Photographer.
Jan.12/49.

TAMAYO, Rufino (Mexico, 1899-1991). Painter, draftsman, muralist, printmaker, sculptor.
Apr.4/47; Sep.4/47; *Oct.14/52*; Apr.12/55; Apr.13/59; Apr.18/60.

TAPIA, Raúl (Cuba,1937-). Painter.
Dec.11/64.

TAYLOR, Prentiss (United States, 1907-). Painter.
Jul.1/49; Nov.19/51.

TEJADA, Lucy (Colombia, 1924-). Painter, printmaker.
May 11/60; Jun.21/60.

TESTA, Clorindo (Argentina, b. Italy, 1923-). Painter, muralist, draftsman, architect.
Apr.13/59.

TESTONI, Alfredo (Uruguay, 1919-). Photographer, photographic reporter.
Apr.13/61.

THIBAULT, René (Canada, 19-). Sculptor.
Mar.21/56.

THOMPSON, Basil Angold (British Guiana, ?).
Feb.6/57.

THOMPSON, William N. (United States, ?). Painter.
Jul.1/49.

TILSA. See TSUCHIYA, Tilsa.

TIQUANT, Germain (Martinique, ?).
Feb.6/57.

TOFANO, Tecla (Venezuela, b. Italy, 1927-). Ceramist.
Aug.15/63.

TORIBIO, Antonio (Dominican Republic, 1931-). Sculptor, draftsman.
Jun.15/60.

TORO, Antonio (Colombia, ?). Painter.
Dec.1/49.

TORRES, Augusto (Uruguay, b. Spain, 1913-). Painter, muralist, sculptor.
Feb.2/50.

TORRES, Horacio (Uruguay, b. Italy, 1924-1976). Painter.
Feb.2/50.

TORRES-GARCIA, Joaquín (Uruguay, 1874-1949). Painter, draftsman.
Feb.2/50; *Apr.19/61*.

TORRES MARTINO, José A. (Puerto Rico, 1916-). Painter, graphic artist, novelist.
Mar.2/57.

TORRES AGÜERO, Leopoldo (Argentina, 1924-). Painter, draftsman, illustrator.
Apr.13/59; *Apr.4/61*.

TOULON, Francis Anthony (Dominica, ?).
Feb.6/57.

TOVAR, María Luisa de (Venezuela, 1902-). Ceramist.
Aug.15/63.

TREJO, F. (El Salvador, ?). Painter.
Apr.15/63.

TRUITT, Anne (United States, 1921-). Sculptress.
Dec.19/55.

TRUJILLO, Guillermo (Panama, 1927-). Painter, muralist, draftsman, graphic artist, tapestry designer, architect, landscape designer.
Nov.12/53; *Sep.25/61*; Apr.13/62.

TRUJILLO MAGNENAT, Sergio (Colombia, 1911-). Painter, muralist, draftsman.
Dec.1/49.

TUDJA, Seka Severin. See SEKA.

TSUCHIYA, Tilsa (Peru, 1936-1984). Painter.
Dec.15/61.

TUFIÑO, Rafael (Puerto Rico, b. United States, 1922-). Painter, graphic artist.
Mar.2/57.

TULLY, Kendrick (Antigua, ?).
Feb.6/57.

TUMIÑA, Francisco (Colombia, 1926-). Draftsman.
Dec.1/49.

TURNIER, Luce Carpi (Haiti, 1924-). Painter, draftsman.
Feb.24/48; *Aug.10/55*.

TURPIN, Pierre Jean François (France, 1775-1840). Botanist, draftsman.
Aug.13/53.

TWORKOV, Jack (United States, b. Poland, 1900-). Painter, draftsman.
Sep.1/48.

UBERTALLI, Héctor (Argentina, 1928-). Sculptor, mask maker.
Jul.24/61.

URRUCHUA, Demetrio (Argentina, 1902-1978). Painter, muralist, draftsman, printmaker, cabinet maker.
Jun.1/48.

VALDES, Humberto (Cuba, 1923-). Caricaturist.
Nov.19/57.

VALDIVIESO, Raúl (Chile, 1931-). Sculptor, painter, draftsman.
Feb.14/64.

VALENCIA, César (Ecuador, 1918-). Painter.
Nov.5/63.

VALENZUELA LLANOS, Alberto (Chile, 1869-1925). Painter.
Jan.25/56.

VALENZUELA, Arturo (Chile. 1900-). Painter.
Jan.25/56.

VALVERDE, César (Costa Rica, 1928-). Painter, muralist, printmaker, lawyer.
Jan.10/64.

VANGI, Giuliano (Brazil, b. Italy, 1931-). Sculptor.
Jul.8/63.

VAN NATTER, Hazel (United States, ?). Sculptress.
Jul.8/53.

VAN VLIET, Antoon W. (Suriname, ?).
Feb.6/57.

VARONA, Esteban A. de (Costa Rica, ?). Photographer.
Jan.12/49.

VASARELY, Victor (France, b. Hungary, 1908-). Painter, lithographer, tapestry designer.
Sep.20/57.

VASCONCELLOS, María L. (Uruguay, ?). Painter.
Feb.2/50.

VASQUEZ DE ARCE Y CEBALLOS, Gregorio (Colombia, 1638-1711). Painter, draftsman.
Apr.12/55.

VAUCROSSON, Noel (Trinidad, 1932-). Painter, architect.
Feb.6/57.

VEGA, Jorge de la (Argentina, 1930-1971). Painter, draftsman.
Apr.13/62; *Jun.11/63*.

VEGAS, Juan Andrés (Venezuela, 19?-). Architect.
Sep.20/57.

VEGAS PACHECO, Martín (Venezuela, 1926-). Architect.
Sep.20/57.

VELASCO, José María (Mexico, 1840-1912). Painter, draftsman, lithographer.
Apr.18/60.

VELASQUEZ, José Antonio (Honduras, 1906-1983). Painter.
Apr.14/53; *Nov.9/54*; Apr.15/63.

VELAZQUEZ L., Ricardo (Dominican Republic, ?).
Feb.6/57.

VERA CORTES, Eduardo (Puerto Rico, 1926-). Painter, graphic artist, woodcarver.
Feb.6/57; *Mar.2/57.*

VERA, Virginia de (Virginia Huneeus de Vera, b. Chile, 1930-). Painter, art teacher and critic.
Aug.25/60.

VERGARA GREZ, Ramón (Chile,1920-). Painter.
Jan.25/56; *Jul.13/64.*

VESTUTI, Emile (?). Architect.
Sep.20/57.

VICTOR MANUEL or GARCIA, Manuel (Víctor Manuel García, Cuba, 1897-1969). Painter, draftsman, printmaker.
Dec.1/46.

VIDAL, Carlos (Cuba, 1920-). Draftsman, caricaturist.
Nov.19/57.

VIGAS, Oswaldo (Venezuela, 1926-). Painter, draftsman, printmaker, physician.
Mar.12/54; *Apr.15/58*; Apr.13/59.

VILLACIS, Aníbal (Ecuador, 1927-). Painter, draftsman.
Jul.25/62.

VILLANUEVA (Mexico, ?). Painter.
Sep.4/47.

VILLANUEVA, Carlos Raúl (Venezuela, b. England, 1900-1975). Architect.
Sep.20/57.

VILLEGAS, Armando (Colombia, b. Peru, 1926-). Painter, printmaker.
Nov.18/58; Jun.21/60; Jun.28/61.

VINCI, Leo (Argentina, 1931-). Sculptor, draftsman.
Dec.12/63.

VIOLA, Roberto J. (Argentina, 1907-). Painter, sculptor.
May 31/60; *Nov.21/62.*

VOLANTE, Julio C. (?). Architect.
Sep.20/57.

VRIES, Erwin de (Suriname, 1929-). Painter, sculptor.
Feb.6/57.

WARNEKE, Heinz (United States, b. Germany, 1895- ?). Sculptor.
Jul.1/49.

WARSEWICZ, A.J. (active 19th century). Lithographer.
Aug.13/53.

WATKINS, Mary Bradley (United States, ?). Painter.
Jul.1/49.

WHITE, Golde M. (Barbados, 1890-1977). Painter.
Feb.6/57.

WHITING, Daniel Powers (United States, active 19th century). Painter, military captain.
Aug.13/53.

WIEDEMANN, Guillermo (Colombia, b. Germany, 1905-1969). Painter.
Jun.21/60; *Nov.8/61.*

WILD. (?). Printer (?).
Aug.13/53.

WILKIN, Eva (Nevis, ?).
Feb.6/57.

WILLIS, Bob (United States, ?). Painter.
Jul.8/53.

WILSON VALERA, Luis F. (Cuba, 1931-). Caricaturist.
Nov.19/57.

WINDT, Elmar E. de (Curaçao, 1927-). Draftsman.
Feb.6/57.

WLADYSLAW, Anatol (Brazil, b. Poland, 1913-). Painter, draftsman, engineer.
Feb.27/63.

WOODS DE CARVALHO, Luiz. See CARVALHO, Luiz Woods de.

WORNER BAZ, Marysole (Mexico, 1936-). Painter.
Feb.1/61.

YANG, Ronald (Curaçao, 1932-196?).
Feb.6/57.

YRARRAZAVAL, Ricardo (Chile, 1931-). Painter, draftsman, ceramist.
Nov.14/56; *Dec.16/58.*

ZACHRISSON, Julio (Panama, 1930-). Painter, draftsman, printmaker.
Sep.9/64.

ZADIK, Julio (Guatemala, ?). Photographer.
Jan.12/49.

ZAÑARTU, Enrique (Chile, b. France, 1921-). Painter, draftsman, printmaker, illustrator.
Apr.12/56; Apr.13/59.

ZANETTI (active 19th century). Engraver.
Aug.13/53.

ZARATE, Nirma (Colombia, 1936-). Painter.
Mar.2/64.

ZEREGA, Andrea Pietro (United States, ?). Draftsman.
Jul.1/49.

ZIELKE, Gottfried (Venezuela, b. Germany, 1929-). Ceramist.
 Aug.15/63.
ZIELKE, Thekla (Venezuela, b. Germany, 1928-). Ceramist.
 Aug.15/63.
ZINGG, David (?). Photographer.
 Jul.8/63.
ZOGBE, Bibí (Argentina, b. Lebanon). Painter, draftsman.
 Oct.21/53.
ZOHN, Alejandro (Mexico, ?). Architect.
 Apr.11/66.
ZULOAGA, Elisa Elvira (Venezuela, 1900-1980). Painter, printmaker.
 May 26/64.
ZUÑIGA, Francisco (Costa Rica, 1912-). Sculptor, draftsman, printmaker.
 Apr.12/55.
ZURBARAN, Francisco de (Spain, 1598-1664). Painter.
 Feb.14/51.

INDEX OF EXHIBITIONS
BY COUNTRY

ANTIGUA

Fine Art of the Caribbean Feb.6/57
 (E.T.Henry, Walter A. Pratt, A.G. Prince, Kendrick Tully)

ARGENTINA

Sixty-five Woodcuts from Argentina Mar.23/45
José Alonso: Sculptures Aug.5/46
Castagna: Oils. Saforcada: Prints Sep.23/46
Contemporary Latin Americans Apr.4/47
 (Horacio A. Butler)
Father Guillermo Butler: Landscapes Apr.20/47
Juan Manuel Sturla: Paintings of Argentina Jan.7/48
Watercolors, Drawings, Temperas by Artists of Argentina Jun.1/48
 (Aquiles Badi, Héctor Basaldúa, Antonio Berni, Mane Bernardo,
 Alfredo Bigatti, Rodrigo Bonome, Norah Borges, Horacio Butler,
 Lucía Capdepont, Carybé, Juan Carlos Castagnino, Pedro Domínguez
 Neira, Raquel Forner, Jorge Larco, Juana Lumerman, Raúl Soldi,
 Demetrio Urruchúa, Grete Coppola)
Armando Sica: Paintings of the Americas Oct.27/48
Three Engravers of Argentina: Amadeo dell'Acqua, Alberto Nicasio, Víctor Rebuffo Sep.12/49
Tomás Newberry Oct.17/49
Martín Fierro. Photographic Interpretation by Arnold Hasenclever Jul.9/51
Samuel Mallo López: Painting, Sculpture Aug.13/51
Ricardo Escoté: Landscapes of Argentina Jun.23/52
Artists of the Americas. An Exhibition in Commemoration of Pan American Day Apr.14/53
 (Raquel Forner)
Latin America through European Eyes: Prints of the 17th, 18th, and 19th Centuries Aug.13/53
Flowers of Argentina by Bibí Zogbé Oct.21/53
Birds of Argentina by Salvador Magno Oct.7/54
Art of the Americas in Celebration of Pan American Week Apr.12/55
 (Antonio Berni, José Fioravanti, Emilio Pettoruti)
Jorge Larco of Argentina May 5/55
Sarah Grilo and Fernández Muro of Argentina Jan.14/57
Alfredo Bigatti of Argentina: Drawings and Monotypes Oct.22/57
Raquel Forner of Argentina Oct.22/57
Szalay of Argentina: Ink Drawings Jul.17/58
Modern Ceramics from Latin America Dec.16/58
 (Sime Pelicaric)
Contemporary Drawings from Latin America Apr.13/59
 (Juan Carlos Castagnino, Raquel Forner, Kasuya Sakai, Luis Seoane,
 Clorindo Testa, Leopoldo Torres Agüero)
María Moreno Kierman of Argentina: Engravings Jun.16/59
Miguel Diomede of Argentina: Paintings Jul.14/59

Seventeen Painters of Argentina May 31/60
 (Carlos Alonso, Luis Barragán, Juan Batlle Planas, Juan Carlos
 Castagnino, Luis Centurión, Víctor Chab, Vicente Forte, Ramón
 Gómez Cornet, Rómulo Macció, Martha Peluffo, Rogelio Polesello,
 Leopoldo Presas, Juan Del Prete, Mario Pucciarelli, Francisca
 Ramos de los Reyes, Raúl Soldi, Roberto J. Viola)
Marcelo Bonevardi and Fernando Maza of Argentina: Paintings Aug.1/60
Mario Pucciarelli of Argentina: Oils Oct.24/60
Sculptures by Noemí Gerstein and Paintings by Franco Di Segni of Argentina Dec.9/60
The Colombo Press of Argentina: A Selection of First and De Luxe Editions Apr.4/61
 (Héctor Basaldúa, Juan Batlle Planas, Norah Borges, Rodolfo
 Castagna, Emilio Centurión, Rómulo Macció, Luis Felipe Noé,
 Leopoldo Presas, Hemilce Saforcada, Armando Sica, Raúl Soldi,
 Lino E. Spilimbergo, Leopoldo Torres Agüero, and others)
Japanese Artists of the Americas Apr.12/61
 (Kazuya Sakai)
Masks by Héctor Ubertalli Jul.24/61
Rogelio Polesello of Argentina: Oils and Monotypes Oct.17/61
Ana María Moncalvo of Argentina: Engravings Dec.4/61
Florencio Garavaglia of Argentina: Oils Jan.9/62
Vicente Forte of Argentina: Oils Mar.12/62
Neo-Figurative Painting in Latin America: Oils Apr.13/62
 (Rómulo Macció, Carolina Muchnik, Luis Felipe Noé, Jorge de la Vega)
New Directions of Art from South America:
 Paintings from Argentina, Chile, Brazil, and Uruguay Nov.21/62
 (Ernesto Farina, José Antonio Fernández Muro, Raquel Forner,
 Leónidas Gambartes, Alfio Grifasi, Rómulo Macció, Leopoldo
 Presas, Antonio Seguí, Roberto Viola)
Mane Bernardo of Argentina: Recent Paintings Feb.27/63
Primitive Artists of the Americas in Celebration of Pan American Week 1963 Apr.15/63
 (Casimiro Domingo)
Federico Martino of Argentina: Recent Paintings May 1/63
Jorge de la Vega of Argentina: Oils Jun.11/63
Stefan Strocen of Argentina: Paintings Oct.11/63
Oscar Capristo of Argentina: Oils Dec.12/63
Leo Vinci of Argentina: Sculptures and Drawings Dec.12/63
Víctor Chab of Argentina: Oils Jan.28/64
Osvaldo Romberg of Argentina: Engravings Jan.28/64
Ernesto Deira of Argentina: Oils May 4/64
Tapestries Designed by Gracia Cutuli and Claudio Segovia of Argentina May 4/64
 (Weaver: Sara Gómez Díaz)

ARUBA

Fine Art of the Caribbean Feb.6/57
 (Leo Kuiperi, John C. Lampe)

BARBADOS

Fine Art of the Caribbean Feb.6/57
 (Therold Barnes, Hubert Brathwaite, Briggs A. Clarke, Harold C.

Aldemir Martins of Brazil Jan.23/58
The Prophets by Aleijadinho Photographed by Hans Mann Jan.23/58
Carybé of Brazil Oct.16/58
Modern Ceramics from Latin America Dec.16/58
 (Helou Motta)
Maria Bonomi of Brazil Jan.12/59
Iberê Camargo of Brazil Mar.2/59
Contemporary Drawings from Latin America Apr.13/59
 (Roberto Burle Marx, Carybé, Marcelo Grassmann, Fernando Lemos,
 Aldemir Martins)
Antônio Henrique of Brazil Apr.21/59
Contemporary Graphic Arts of Brazil Mar.18/60
 (Lívio Abramo, Antônio Henrique Amaral, Anna Letycia, Edith
 Behring, Vera Bocayuva Mindlin, Maria Bonomi, Iberê Camargo,
 Mário Augusto Berrêdo Carneiro, João Luiz Chaves, Oswaldo
 Goeldi, Roberto De Lamônica, Fayga Ostrower, Lygia
 Pape, Rossini Perez, Arthur Luiz Piza, Isabel Pons)
Marcelo Grassmann of Brazil: Drawings and Prints Jul.12/60
Maria Helena Andrés of Brazil: Pastels Mar.17/61
Japanese Artists of the Americas Apr.12/61
 (Manabu Mabe)
Gina Prado of Brazil: Tapestries Jun.28/61
 (Designs by Marcelo Grassmann, Antônio Prado, Carybé, Manabu Mabe)
Roberto De Lamônica of Brazil: Engravings Sep.19/61
Rugs Designed by Artists of the Americas Jan.29/62
 (Roberto Burle Marx)
Brazilian Woodcuts from the State of Rio Grande do Sul Apr.3/62
 (Joel Amaral, Zorávia Bettiol, Edíria Carneiro, Danubio Vilamil Gonçalves,
 Francisco Riopardense de Macedo, Vasco Prado, Francisco Stockinger)
Manabu Mabe of Brazil: Oils May 10/62
New Directions of Art from South America: Paintings from Argentina, Chile, Nov.21/62
 Brazil, and Uruguay
 (Manabu Mabe, Yolanda Mohalyi, Danilo Di Prete, Ivan Serpa)
Luiz de Carvalho of Brazil: Paintings Dec.18/62
Anatol Wladyslaw of Brazil: Recent Drawings Feb.27/63
Primitive Artists of the Americas in Celebration of Pan American Week 1963 Apr.15/63
 (Heitor dos Prazares, João Real)
Photographs of Brazil by David Zingg. Original Sculptures by Lygia Clark, Jul.8/63
 Mário Cravo, Agnaldo dos Santos, and Giuliano Vangi
Freda of Brazil: Mosaics Sep.3/63
Maria Thereza Negreiros of Colombia and Brazil: Paintings and Drawings Nov.26/63

BRITISH GUIANA

Fine Art of the Caribbean Feb.6/57
 (Vivian Antrobus, Patrick Barrington, Alvin Bowman,
 Florence Cavigioli, Albert de Freitas, Morris Mann,
 R.G. Sharples, Joseph B. Smith, Alma Taharally, Basil
 Angold Thompson)

Marco Ospina, Roberto Pizano, Cecilia Porras, Eduardo Ramírez Villamizar, Juan
Antonio Roda, Héctor Rojas Herazo, Otto Sabogal, Andrés de Santamaría, Lucy
Tejada, Armando Villegas, Guillermo Wiedemann)

David Manzur of Colombia	Feb.23/61
Omar Rayo of Colombia: Paintings	Jun.28/61
Gina Prado of Brazil: Tapestries	Jun.28/61
(One design by Armando Villegas)	
Guillermo Wiedemann of Colombia: Oils and Watercolors	Nov.8/61
Rugs Designed by Artists of the Americas	Jan.29/62
(Eduardo Ramírez Villamizar)	
Neo-Figurative Painting in Latin America: Oils	Apr.13/62
(Fernando Botero, Carlos Granada)	
Carlos Granada of Colombia: Oils and Drawings	Jun.12/62
Leonel Góngora of Colombia: Drawings	Oct.8/62
Primitive Artists of the Americas in Celebration of Pan American Week 1963	Apr.15/63
(Anonymous, Noé León)	
Manuel Hernández of Colombia: Oils	Jul.22/63
Alfonso Mateus of Colombia: Oils	Sep.24/63
Maria Thereza Negreiros of Colombia and Brazil: Paintings and Drawings	Nov.26/63
The Artist as Printmaker II: Omar Rayo of Colombia	Mar.2/64
Nirma Zárate of Colombia: Oils	Mar.2/64
The Artist as Printmaker IV: Enrique Grau of Colombia	Nov.17/64
Angel Loochkartt of Colombia: Oils	Nov.17/64

COSTA RICA

Watercolors and Drawings by Francisco Amighetti Ruiz of Costa Rica	Nov.4/43
Contemporary Latin Americans	Apr.4/47
(Francisco Amighetti)	
First International Exhibition of Latin American Photography	Jan.12/49
(Esteban A. de Varona)	
Artists of the Americas. An Exhibition in Commemoration of Pan American Day	Apr.14/53
(Ranucci)	
Art of the Americas in Celebration of Pan American Week	Apr.12/55
(Francisco Zúñiga)	
Contemporary Art of Costa Rica: Paintings and Sculptures Assembled by the Grupo 8	Jan.10/64
of San José	
(Guillermo Combariza, Lola Fernández, Harold Fonseca Mora, Hernán González,	
Guillermo Jiménez, Carlos Moya, Carlos Poveda, César Valverde)	

CUBA

Cuban Modern Paintings in Washington Collections	Dec.1/46
(Cundo Bermúdez, Carmelo, Mario Carreño, Roberto Diago, Carlos Enríquez,	
Julio Girona, Mariano, Luis Martínez Pedro, Felipe Orlando, Osvaldo Gutiérrez,	
Amelia Peláez, Fidelio Ponce, René Portocarrero, Víctor Manuel)	
Leather Portraits of the Presidents of the United States by Javier A. Montero	Mar.3/47
Contemporary Latin Americans	Apr.4/47
(Mario Carreño)	
Felipe Orlando: Recent Paintings	Aug.4/47
Cundo Bermúdez: Oils and Gouaches	Apr.1/48

GUADELOUPE

Fine Art of the Caribbean Feb.6/57
(Jacques Malespine, Solange Pettrelluzz-Questel)

GUATEMALA

Carlos Mérida: Color Prints of Mexico and Guatemala Mar.1/45
Watercolors of Guatemala by Carolyn Bradley Jun./45
Contemporary Latin Americans Apr.4/47
(Carlos Mérida)
Landscapes of Guatemala: Oils by Humberto Garavito Oct.1/48
Some Religious Paintings of Latin America Dec.6/48
(19th century unknown artists)
First International Exhibition of Latin American Photography Jan.12/49
(Julio Zadik)
Guatemala, Fifty Photographic Studies by Hans Namuth Jun.1/49
Iconography and Bibliography of Popol Vuh Sep.13/50
(Carlos Mérida, José García Narezo)
Two Artists of Guatemala: Roberto Ossaye, Roberto González Goyri Jun.5/51
Carlos Mérida: Paintings and Mural Projects Dec.20/51
Artists of the Americas. An Exhibition in Commemoration of Pan American Day Apr.14/53
(Carlos Mérida)
Bonampak, Mayas of Yesterday and Today. Photogrtaphs by G. Gerard Dec.29/53
Abularach of Guatemala Feb.6/59
Contemporary Drawings from Latin America Apr.13/59
(Rodolfo Abularach)
Rodolfo Mishaan of Guatemala: Paintings May 11/61
Rugs Designed by Artists of the Americas Jan.29/62
(Carlos Mérida)
Drawings by Roberto Cabrera and Paintings by Marco Augusto Quiroa of Guatemala Oct.25/62
Primitive Artists of the Americas in Celebration of Pan American Week 1963 Apr.15/63
(Anonymous)

HAITI

Contemporary Latin Americans Apr.4/47
(Philomé Obin)
Paintings from Haiti Feb.24/48
(Léon Agnant, Maurice Borno, Jean-Baptiste Bottex, Lucner Lazard, Father Jean
Parisot, Lucien Price, Géo Remponeau, Luce Turnier)
Highlights of the Caribbean: Photographs by Albert Greenfield, APSA Dec.22/52
Artists of the Americas. An Exhibition in Commemoration of Pan American Day Apr.14/53
(Hector Hyppolite)
Impressions of the U.S.A. by Haitian Painter: Antonio Joseph Jun.16/54
Special Exhibition of Paintings by Lois Mailou Pierre-Noël in Honor of the Jan.28/55
President of Haiti and Madame Magloire
Luce Carpi Turnier of Haiti Aug.10/55
Fine Art of the Caribbean Feb.6/57
(Castera Bazile, Wilson Bigaud, Maurice Borno, Enguerrand Gourgue, Antonio
Joseph, Adam Léontus, André Normil, Fernand Pierre)

First International Exhibition of Latin American Photography Jan.12/49
 (Lola Alvarez Bravo, Pedro Camps, Raúl Conde, Marianne, Luis Márquez, Agustín
Mayo, Jesús M. Talavera)

Federico Cantú Dec.5/49

Gabriel Figueroa, Mexican Cinematographer: Still Pictures from Some of His Films May 1/50

Iconography and Bibliography of Popol Vuh Sep.13/50
 (José García Narezo)

Dances and Types of Mexico: Wax Figures by Carmen de Antúnez Apr.15/52

The Graphic Works of Orozco May 15/52

Tamayo Oct.14/52

Artists of the Americas. An Exhibition in Commemoration of Pan American Day Apr.14/53
 (José Clemente Orozco)

Latin America through European Eyes: Prints of the 17th, 18th, and 19th Centuries Aug.13/53

Bonampak, Mayas of Yesterday and Today. Photogtasphs by G. Gerard Dec.29/53

José Luis Cuevas: Drawings Jul.14/54

Art of the Americas in Celebration of Pan American Week Apr.12/55
 (Rufino Tamayo, David Alfaro Siqueiros)

Enrique Echeverría of Mexico Jul.6/55

Irma Díaz of Mexico Jul.6/55

Two Artists from Mexico: Fernando Belain, Geles Cabrera Aug.9/56

Nacho López, Photographer of Mexico Aug.28/56

Gilberto Aceves Navarro of Mexico Sep.19/58

Joaquín Chiñas of Mexico Mar.18/59

Alberto Gironella of Mexico Mar.18/59

Contemporary Drawings from Latin America Apr.13/59
 (José Luis Cuevas, Alberto Gironella, Rufino Tamayo)

Lilia Carrillo and Manuel Felguérez of Mexico Mar.2/60

Mexican Paintings Apr.18/60
 (Abrahan Angel, Anonynous (19th century), Dr. Atl, Lilia Carrillo, José
Castillo, Joaquín Clausell, José Luis Cuevas, Manuel Felguérez, Alberto
Gironella, Guillermo Gómez Mayorga, Jesús Guerrero Galván, María Izquierdo,
Guillermo Meza, José Clemente Orozco, Máximo Pacheco, Eduardo Prunés, Diego
Rivera, David Alfaro Siqueiros, Rufino Tamayo, José Marí Velasco)

Marysole Worner of Mexico: Oils Feb.1/61

Japanese Artists of the Americas Apr.12/61
 (Luis Nishizawa)

Gina Prado of Brazil: Tapestries Jun.28/61
 (One design by José Luis Cuevas)

Neo-Figurative Painting in Latin America: Oils Apr.13/62
 (José Luis Cuevas)

Mi Pueblo, *Photographs by Manuel Carrillo of Mexico* Jun.19/62

José Manuel Schmill of Mexico: Drawings Oct.8/62

Amado Aldaraca of Mexico: Paintings Jan.15/63

Primitive Artists of the Americas in Celebration of Pan American Week 1963 Apr.15/63
 (Anonymous)

The Artists as Printmaker I: José Luis Cuevas of Mexico Jul.16/63

Pedro Friedeberg of Mexico: Drawings Oct.1/63

Ignacio M. Beteta of Mexico: Watercolors Oct.5/64

NEVIS

NICARAGUA

PANAMA

PARAGUAY

Latin America through European Eyes: Prints of the 17th, 18th, and 19th Centuries Aug.13/53
Art of the Americas in Celebration of Pan American Week Apr.12/55
 (Jaime Bestard)

PERU

Contemporary Latin Americans Apr.4/47
 (José Sabogal)
Ancient Peruvian Textiles May 8/47
José Solari Hermosilla: Watercolors of Latin America Jul.15/48
Some Religious Paintings of Latin America Dec.6/48
 (17th century unknown artists)
First International Exhibition of Latin American Photography Jan.12/49
 (Martín Chambi, González Salazar, A. Guillén M., J. De Ridder,
 Rómulo M. Sessarego)
The Highlands of South America: Photographs of Bolivia and Peru by Elena Hosmann Nov.2/49
Helena Aramburú: Drawings Mar.14/50
Reynaldo Luza: Portraits May 24/50
Highlights from the Collection of the Peruvian Ambassador, Feb.14/51
 His Excellency Don Fernando Berckemeyer
 (Pancho Fierro, unknown artists of the Cuzco and Spanish colonial schools, and
 European artists)
Arts of Peru May 7/51
 (17th and 18th century paintings, retablos, mask, pre-Columbian textile,
 silverwork, pottery, etc.)
Artists of the Americas. An Exhibition in Commemoration of Pan American Day Apr.14/53
 (Fernando de Szyszlo)
Fernando de Szyszlo Jun.8/53
Latin America through European Eyes: Prints of the 17th, 18th, and 19th Centuries Aug.13/53
Art of the Americas in Celebration of Pan American Week Apr.12/55
 (Cuzco school, 18th century)
Enrique Camino Brent of Peru Oct.6/55
Three Painters of Peru Jun.21/57
 (Alberto Dávila, Sérvulo Gutiérrez, Enrique Kleiser)
The Cuzco School of Painting. A Selection Jun.17/58
Armando Villegas of Peru Nov.18/58
Contemporary Drawings from Latin America Apr.13/59
 (Fernando de Szyszlo)
Joaquín Roca Rey of Peru Jun.16/59
Eduardo Moll of Peru: Paintings Aug.13/59
Ricardo Grau: Oils Oct.2/60
Japanese Artists of the Americas Apr.12/61
 (Arturo Kubotta)
Young Peruvian Artists: Oils Dec.15/61
 (Alfredo Ayzanoa, Alfredo Basurco, Miguel Angel Cuadros, Enrique Galdós, Dante
 Gavidia, Arturo Kubotta, José Milner, Alberto Quintanilla, Alberto Ramos,
 Oswaldo Sagástegui, Tilsa Tsuchiya)
Manuel Jiménez of Peru: Oils, Drawings, Collages, and Gouaches Feb.15/62
Arturo Kubotta of Peru: Paintings and Lithographs Mar.19/63
Chancay, Neglected Civilization of Potters and Weavers Apr.13/64
Castillo of Peru Jul.29/64

PUERTO RICO

Fine Art of the Caribbean Feb.6/57
(Alfonso Arana, Manuel Hernández Acevedo, Bart Mayol, Fernando M. Monserrate, Samuel Sánchez, Eduardo Vera Cortés)

Artists of Puerto Rico Mar.2/57
(Olga Albizu, Alfonso Arana, Félix Bonilla Norat, Andrés Bueso, Luis Germán Cajigas, Manuel Hernández Acevedo, Lorenzo Homar, Epifanio Irizarry, Carlos Marichal, José R. Oliver, Francisco Palacios, Carlos Raquel Rivera, Julio Rosado del Valle, Samuel Sánchez, José A. Torres Martinó, Rafael Tufiño, Eduardo Vera)

ST. CROIX

Fine Art of the Caribbean Feb.6/57
(Ruth M. Gregory, Sasha Manson)

ST. KITTS

Fine Art of the Caribbean Feb.6/57
(Franklin Browne, Cynric Griffith)

ST. LUCIA

Fine Art of the Caribbean Feb.6/57
(Lily A. Auguste, Joseph Gaston de Brettes, E.L. Cozier, Dunstan St. Omer, Harold F.C. Simmons)

ST. THOMAS

Fine Art of the Caribbean Feb.6/57
(Albert E. Daniel, Aline M. Kean, Enid Kimmel, Alfred Lockhart, Marie Moore)

ST. VINCENT

Fine Art of the Caribbean Feb.6/57
(Owen Douglas Brisbane, Jr.)

SURINAME

Highlights of the Caribbean: Photographs by Albert Greenfield, APSA Dec.22/52
Fine Art of the Caribbean Feb.6/57
(Stanley Brown, A.T. Favery, D.C. Geijskes, Stuart Robles de Medina, Soekimin Sastro, Antoon W. Van Vliet, Erwin de Vries)

TRINIDAD

Highlights of the Caribbean: Photographs by Albert Greenfield, APSA Dec.22/52
Fine Art of the Caribbean Feb.6/57
(Carlisle Fenwick Chang, Alfredo Codallo, Joseph Cromwell, Nina G. Lamming, Wilson Minshall, Jeanette Pollard, Sybil Richardson, Noel Vaucrosson)

UNITED STATES

Watercolors of Guatemala by Carolyn Bradley	Jun./45
The Drama of the Aztec Manuscripts. An Exhibition of Watercolor Reproductions and Commentaries by Katharine Birdseye Land	Nov.3/46
Leather Portraits of the Presidents of the United States by Javier A. Montero	Mar.3/47
Engravings by André Racz on the Prophets by Aleijadinho	Oct.1/47
Mary St. Albans: Photographs of Mexico	Oct.23/47
Carolyn Bradley: Impressions of Chile	Nov.12/47
Facultry Artists, Department of Fine Arts, The American University	Sep.1/48

 (Sarah Baker, William Calfee, John Galloway, Robert Gates, Pietro Lazzari, Leo Steppat, Joe Summerford, Jack Toworkov)

Guatemala, Fifty Photographic Studies by Hans Namuth	Jun.1/49
Artists'Guild of Washington	Jul.1/49

 (Sarah Baker, Doublas Brown, Marguerite Burgess, William H. Calfee, Walter T. Carnelli, Alexander Clayton, Alida Conover, Alice Decker, Laura Glenn Douglas, Julia Eckel, Maxim Elias, Lucile Evans, Frances Ferry, Aline Fruhauf, John Crozier Galloway, Margaret Casey Gates, Robert Franklin Gates, Harold Giese, Mitchell Jamieson, Lois Mailou Jones, Sheffield Kagy, Jacob Kainen, Pietro Lazzari, Herman Maril, Norma Mazo, Carl Nyquist, Eliot O'Hara, Jack Perlmutter, Helen Rennie, John Robinson, Sarah Silberman, Leo Steppat, Celine Tabary, Prentiss Taylor, William N. Thompson, Heinz Warneke, Mary Bradley Watkins, Andrea Pietro Zerega)

Martín Fierro. Photographic Interpretation by Arnold Hasenclever	Jul.9/51
Artists of the United States in Latin America	Nov.19/51

 (Eugene Berman, Carolyn Bradley, William Calfee, Richard Dempsey, Paul England, Eugenie Gershoy, Edith Hoyt, Walter Iler, Harlan Jackson, Theodora Kane, Miriam McKinnie, Ruth Starr Rose, Jason Seley, Edward John Stevens, Prentiss Taylor)

Spanish Influence in the Popular Arts of the Southwest of the United States	Jan.23/52
Simón Bolívar and His Time: Fifty-one Miniatures by Arthur Szyk	Apr.14/52
Highlights of the Caribbean: Photographs by Albert Greenfield, APSA	Dec.22/52
The Art of Brazil: A Photographic Survey in Color by Anita Moore	Feb.18/53
Artists of the Americas. An Exhibition in Commemoration of Pan American Day	Apr.14/53

 (Richard Miller)

As I See It: Latin America in the Imagination of the Members of the Society of Washington Artists	Jul.8/53

 (Lila Asher, Lee Atkyns, Mimi DuBois Bolton, Sam Bookats, Melvin Buckner, Ralph de Burgos, Omar Carrington, Charles Dunn, Joyce Field, Elaine Hartley, Arvid Hedin, Charles Hoover, Mary Hovnanian, Minor Jameson, Theodora Kane, Inez Leinbach, Jane Love, Jack Perlmutter, Anthony Qualia, Helen Rennie, Mary Ruth Snow, Hazel Van Natter, Bob Willis)

Bonampak, Mayas of Yesterday and Today. Photographs by G. Gerard	Dec.29/53
Special Exhibition of Paintings by Lois Mailou Pierre-Noël in Honor of the President of Haiti and Madame Magloire	Jan.28/55
Art of the Americas in Celebration of Pan American Week	Apr.12/55

 (Philip Guston, Childe Hassam)

Artists of the United States in Latin America II	Dec.19/55

 (Jane Orcutt Blatter, Robert C. Ellis, Cynthia Green, Samuel Herman, Dorothy Hood, Walter Kamys, Theodora Kane, Frank W. Kent, Sheldon Kirby, Babette Kornblith, Charles Johnson Post, David Ramsey, Thea Ramsey, Ruth Perkins Safford,

Millard Sheets, Anne Truitt)

Japanese Artists of the Americas	Apr.12/61
(Kenzo Okada)	
Rugs Designed by Artists of the Americas and Executed, Interpreted, and Supervised	Jan.29/62
Gloria Finn of the United States	
(Robert Goodnough, Hans Moller)	
Andean Handicrafts by Andea of Bolivia, under the Direction of Mme. Elena Eleska	Apr.2/63
Primitive Artists of the Americas in Celebration of Pan American Week 1963	Apr.15/63
(Anonymous, John Bradley, G. Gasomer, Edward Hicks, Charles Hofman, John Kane)	
Artists of Latin America: Photographs by Morton Beebe	Oct.28/63
Nine Contemporary Painters: USA	May 21/64
(Gil Cuatrecasas, Gene Davis, Tom Downing, Sam Gilliam, Brian Lord, Ed McGowin, Mary Meyer, Lowell Nesbitt, Tom Stokes)	

URUGUAY

Pedro Figari (1861-1938)	Sep.3/46
Contemporary Latin Americans	Apr.4/47
(Pedro Figari)	
Antonio Frasconi	Feb.16/49
Torres-García and His Workshop	Feb.2/50
(Julio U. Alpuy, Elsa Andrada, Gonzalo Fonseca, José Gurvich, Anhelo Hernández, Jonio Montiel, María Olga Piria, Lily Salvo, Augusto Torres, Horacio Torres, Joaquín Torres-García, María L. Vasconcellos)	
Parks, Gardens, and Public Beaches of the City of Montevideo, Uruguay: Photographs	May 9/50
Halty Dubé: Paintings and Stage Design	Nov.21/52
Artists of the Americas. An Exhibition in Commemoration of Pan American Day	Apr.14/53
(Pedro Figari)	
Art of the Americas in Celebration of Pan American Week	Apr.12/55
(Pedro Figari)	
Vicente Martín of Uruguay: Oils	Feb.21/56
José Echave of Uruguay	Jul.10/56
Leopoldo Nóvoa of Uruguay	Aug.20/57
Carlos Páez Vilaró of Uruguay	Dec.23/57
Modern Ceramics from Latin America	Dec.16/58
(Carlos Páez Vilaró)	
Raíces de la paz (Roots of Peace): *Mural by Carlos Páez Vilaró. Inauguration*	Dec.25/60
Two Photographic Essays by Alfredo Testoni of Uruguay	Apr.13/61
Joaquín Torres-García (1874-1949) of Uruguay	Apr.19/61
Jorge Damiani of Uruguay: Paintings	Jun.5/61
Hilda López: Streets and Inlets of Montevideo, Oils	Sep.8/61
Jorge Páez of Uruguay: Oils	Nov.28/61
Alfredo Halegua of Uruguay: Sculptures	Sep.10/62
New Directions of Art from South America: Paintings from Argentina, Chile, Brazil, and Uruguay	Nov.21/62
(José Gamarra, Vicente Martín, Jorge Páez, Américo Spósito)	
Rodríguez Candhales of Uruguay: Drawings	May 1/63
Mario Pariente Amaro of Uruguay: Oils, Gouaches, and Drawings	Sep.4/63
Lincoln Presno of Uruguay: Tapestries	Mar.20/64
Luis A. Solari of Uruguay: Drawings, Collages, and Engravings	Oct.26/64

VENEZUELA

Paintings and Drawings by Héctor Poleo of Venezuela	Oct.1/45
Contemporary Latin Americans	Apr.4/47
(Héctor Poleo)	
St. John's Day in Barlovento. Photographs by Francisco Edmundo Pérez	Nov.25/47
Carlos Otero	Jun.28/48
Some Religious Paintings of Latin America	Dec.6/48
(18th and 19th century unknown artists)	
Alejandro Otero: Still Life, Themes, and Variations	Dec.28/48
First International Exhibition of Latin American Photography	Jan.12/49
(Alfredo Boulton)	
Simón Bolívar and His Time: Fifty-one Miniatures by Arthur Szyk	Apr.14/52
Highlights of the Caribbean: Photographs by Albert Greenfield, APSA	Dec.22/52
Artists of the Americas. An Exhibition in Commemoration of Pan American Day	Apr.14/53
(Alejandro Otero)	
Painters of Venezuela: Abreu, Barrios, Jaimes Sánchez, Manaure, Vigas	Mar.12/54
Art of the Americas in Celebration of Pan American Week	Apr.12/55
(Héctor Poleo)	
Venezuelan Birds by Kathleen Deery de Phelps	Apr.27/56
Amanda de León of Venezuela	Jun.20/56
Fine Art of the Caribbean	Feb.6/57
(Crisójeno Araujo, René Croes Michelena, Manuel Vicente Gómez, Saúl Padilla, Juvenal Ravelo)	
Architecture in Venezuela	Sep.20/57
(Moisés F. Benacerraf, Guido Bermúdez B., Dirk Bornhorst, Carlos A. Brando, Ramón Burgos, Diego Carbonell, Oscar Carpio, Miguel Casas Armengol, Miguel Salvador Díaz, Cipriano Domínguez, Carlos Dupuy, Simón Fernández, Julián Ferris, José Miguel Galia, Carlos Guinand Baldó, José Hoffmann, Juan Hurtado Manrique, Pedro Lluberes D., Mateo Manaure, José Manuel Mijares, Pascual Navarro, Pedro Neuberger, Alejandro Pietri Pietri, Jorge Romero Gutiérrez, Tomás José Sanabria, Guillermo A. Suárez, Juan Andrés Vegas, Martín Vegas, Emile Vestuti, Carlos Raúl Villanueva, Julio C. Volante)	
Humberto Jaimes Sánchez of Venezuela	Nov.19/57
Oswaldo Vigas of Venezuela: Paintings	Apr.15/58
Contemporary Drawings from Latin America	Apr.13/59
(Oswaldo Vigas)	
Elsa Gramcko of Venezuela	May 13/59
Angel Hurtado of Venezuela	May 13/59
Maruja Rolando of Venezuela: Paintings	Aug.17/61
Rugs Designed by Artists of the Americas	Jan.29/62
(Humberto Jaimes Sánchez, Alejandro Otero)	
Primitive Artists of the Americas in Celebration of Pan American Week 1963	Apr.15/63
(Feliciano Carvallo, Víctor Millán)	
Alberto Brandt of Venezuela	May 21/63
Venezuelan Pottery: The Artists, Their Pottery	Aug.15/63
(Eduardo Gregorio, Cristina Merchán, Luisa and Gonzalo Palacios, Seka, Tecla Tofano, María Luisa de Tovar, Thekla and Gottfried Zielke)	
Elisa Elvira Zuloaga of Venezuela: Engravings	May 26/64

ABOUT THE EDITOR

Annick Sanjurjo (M.A. Romance Languages and Literature, Asunción, Paraguay) edited the two volumes of *Contemporary Latin American Artists* and wrote the biographical information not included catalogues. Before coming to Washington, D.C., to work as an archivist at the Museum of Modern Art of Latin America, Organization of the American States (1978-89), she worked at the Museum of Modern Art's International Council, Latin American Archives in New York (1977-78). In 1976, she assisted Ms. Barbara Duncan with the preparation of the traveling exhibition *Recent Latin American Drawings (1969-1976)/Lines of Vision* sponsored by the International Exhibitions Foundation, Washington, D.C.

Annick Sanjurjo was also the Contributing Editor, Books, (1981-82) and the Contributing Editor, Art, (1978-91) for *Américas* magazine. In 1989, she was the curator of a major exhibit, *Masters of Latin American and the Caribbean*. She is the author of several publications and award-winning media productions on Latin American art and culture. Among them are: *Botero, Magic and Reality; Behind the Lines of José Luis Cuevas; Fernando de Szyszlo;* and *Ñanduti, the Flower in the Spider's Web*. She has written the script of a documentary work in progress about the late master, Rufino Tamayo.